O'Keeffe, Stieglitz

and the Critics, 1916-1929

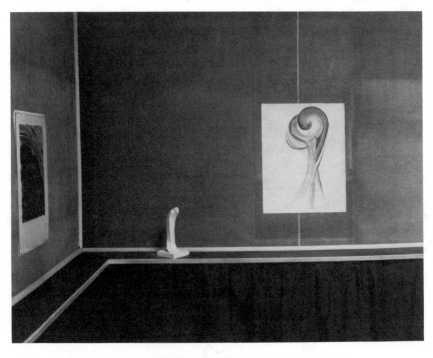

Alfred Stieglitz, *Georgia O'Keeffe: A Portrait—Show at "291,"* 1917
Gelatin silver print, 7¹/₂ × 9⁵/₈ in.
(*National Gallery of Art, Washington, D.C., Alfred Stieglitz Collection*)

O'Keeffe, Stieglitz

and the Critics, 1916-1929

by
Barbara Buhler Lynes

The University of Chicago Press
Chicago and London

The University of Chicago Press, Chicago 60637
The University of Chicago Press, Ltd., London

99 98 97 96 95 94 93 92 91 6 5 4 3 2 1

Library of Congress Cataloging-in-Publication Data

Lynes, Barbara Buhler, 1942–
 O'Keeffe, Stieglitz, and the critics, 1916–1929 / by
 Barbara Buhler Lynes. — University of Chicago Press ed.
 p. cm.
 Reprint. Originally published: Ann Arbor, Mich. : UMI
 Research Press, c1989.
 Includes bibliographical references and index.
 ISBN 0-226-49824-7 (pbk.)
 1. O'Keeffe, Georgia, 1887–1986—Criticism and
 interpretation. 2. Stieglitz, Alfred, 1864–1946—Influence.
 3. Stieglitz, Alfred, 1864–1946—Relations with women.
 4. Art criticism—United States—History—20th century.
 I. Title.
 ND237.05L96 1991
 759.13—dc20 90-48860
 CIP

♾ The paper used in this publication meets the minimum requirements of the American National Standard for Information Sciences—Permanence of Paper for Printed Library Materials, ANSI Z39.48-1984

Contents

List of Illustrations *vii*

Acknowledgments *ix*

Note to the Reader *xi*

Introduction *1*

1 The Background and the Early Reviews *3*

2 The Woman in the Photographs *27*

3 Georgia O'Keeffe, American *55*

4 A Period of Adjustment *89*

5 Matters of Fact and Matters of Opinion *113*

6 Across the Final Surface *131*

Conclusion *157*

Appendix A: O'Keeffe and Her Work:
 Selected Commentary, 1916–1929 *165*

Appendix B: Contributors to the Criticism *307*

Notes *319*

Selected Bibliography *345*

Index *363*

Illustrations

Alfred Stieglitz, *Georgia O'Keeffe: A Portrait—Show at "291,"* 1917 *frontispiece*

1. Alfred Stieglitz, *Georgia O'Keeffe: A Portrait—Head*, 1918 *38*

2. Alfred Stieglitz, *Georgia O'Keeffe: A Portrait—Head*, 1918 *39*

3. Alfred Stieglitz, *Georgia O'Keeffe: A Portrait*, 1918 *40*

4. Alfred Stieglitz, *Georgia O'Keeffe: A Portrait*, 1918 *42*

5. Alfred Stieglitz, *Georgia O'Keeffe: A Portrait*, 1920 *47*

6. Alfred Stieglitz, *Georgia O'Keeffe: A Portrait—Painting and Sculpture*, 1919 *51*

7. Alfred Stieglitz, *Georgia O'Keeffe: A Portrait*, 1918 *59*

8. Georgia O'Keeffe, *Blue and Green Music*, 1919 *64*

9. Georgia O'Keeffe, *Plums*, 1920 *65*

10. Georgia O'Keeffe, *Pattern of Leaves*, ca. 1923 *74*

11. Georgia O'Keeffe, *Birch Trees at Dawn at Lake George*, 1923 *75*

12. Alfred Stieglitz, *Georgia O'Keeffe: A Portrait—Head*, 1923 *82*

13. Alfred Stieglitz, *Georgia O'Keeffe: A Portrait—Head*, 1922 *83*

14. Georgia O'Keeffe, *Pink Tulip*, 1926 93

15. Georgia O'Keeffe, *Black Iris III*, 1926 94

16. Alfred Stieglitz, *Georgia O'Keeffe: A Portrait—Head*, 1920 114

17. Georgia O'Keeffe, *East River from Shelton*, 1927–28 119

18. Georgia O'Keeffe, *Abstraction*, 1926 127

19. Georgia O'Keeffe, *The Shelton with Sunspots*, 1926 129

20. Alfred Stieglitz, *Georgia O'Keeffe: A Portrait*, 1918 145

21. Alfred Stieglitz, *Georgia O'Keeffe: A Portrait—Head*, 1919? 146

22. Georgia O'Keeffe, *Single Lily with Red*, 1928 151

23. Alfred Stieglitz, *Georgia O'Keeffe: A Portrait—After Return from New Mexico*, 1929 163

Acknowledgments

This book could not have been completed without the generous assistance of many individuals. I am especially grateful to Shirley Neilsen Blum, Wanda M. Corn, Patricia Stablein Harris, Jane Eblen Keller, and Josephine Withers for their perceptive reading of portions of the manuscript. Bruce Altshuler, Simon R. Ansell, Lynda Bailey, Marcia Bickoff, Caroline Blum, Vivienne Bourkoff, Lawrence Campbell, Jan Garden Castro, Laura Coyle, Anita Duquette, Donald Gallup, Sarah Greenough, Margaret Grasselli, Dianne Hoffman, William I. Homer, Midge Keator, Ann Lapides, Cynthia Lukens, Anthony Mullan, Jennifer Newman, Carlotta Owens, James R. Palmer, Sarah W. Peters, Charlie Ritchie, Karen Schneider, Beth Schneiderman, Elizabeth L. White, and Patricia C. Willis answered numerous questions or helped me gain access to information or gain permission to use valuable materials.

Personnel at the following institutions have been extremely helpful: the Archives of American Art, Smithsonian Institution; the Beinecke Rare Book and Manuscript Library, Yale University; the Brooklyn Public Library; the Eisenhower Library, the Johns Hopkins University; the Enoch Pratt Free Library, Baltimore; the Library of Congress and its Copyright Card Catalog; the McKeldin and the Art Libraries, the University of Maryland, College Park; the National Gallery of Art Library, Washington, D.C.; the National Museum of American Art/National Portrait Gallery Library, Smithsonian Institution; the New York Public Library; and the Whitney Museum of American Art Library.

I wish to thank the institutions or individuals who granted me permission to quote from unpublished materials, to reprint portions of publications, or to reproduce the paintings and some of the photographs that accompany the text: the Alfred Stieglitz Archive and the Collection of American Literature, the Beinecke Rare Book and Manuscript Library, Yale University; the Art Institute of Chicago; the Baltimore Museum of Art; Condé Nast Publications, Inc.; William C. Dove;

Hacker Art Books, Inc.; I.H.T. Corporation; the Metropolitan Museum of Art; the Museum of Modern Art, New York; the New Jersey State Museum Collection; the New York Times Company; the New Yorker Magazine, Inc.; the Phillips Collection and the Phillips Collection Archives; the Rare Books and Manuscripts Division, the New York Public Library, Astor, Lenox and Tilden Foundations; the Saint Louis Art Museum; Paul and Tina Schmid; the Special Collections Department, Van Pelt Library, University of Pennsylvania; Whiteman World-Wide Marketing Corporation; the Whitney Museum of American Art; and the Zabriskie Gallery, New York.

I particularly wish to thank Juan Hamilton and the Representatives of the Estate of Georgia O'Keeffe for their cooperation with this project. Mr. Hamilton has been gracious in granting me permission to use as illustrations twelve photographs from the composite portrait of Georgia O'Keeffe by Alfred Stieglitz, prints of which are in the Alfred Stieglitz Collection, National Gallery of Art, Washington, D.C., and in approving my use of additional photographs from the O'Keeffe portrait, prints of which are in the collections of the Baltimore Museum of Art and the Zabriskie Gallery, New York. The Representatives of the Estate of Georgia O'Keeffe have kindly granted me permission to quote extensively from the unpublished and published writings of Georgia O'Keeffe and Alfred Stieglitz.

I appreciate the special encouragement I have received from Jean Hall, Mary Kelley, Robert Eaton Kelley, Anne Rist, Joan Rosenstein, Claire Richter Sherman, Esmé Thompson, and Kathryn Elizabeth Walsh. Above all, I am indebted to Lamar Lynes, who has been extremely sensitive to the complexities of this enterprise and has helped me with every aspect of it.

Note to the Reader

There are numerous spelling, punctuation, and grammatical irregularities in the material quoted in this book. That is particularly true of the letters and published statements written by Georgia O'Keeffe, in which she frequently, but not consistently, misspelled words, omitted punctuation marks (especially apostrophes), and used dashes liberally and erratically, often substituting them for periods and commas. All passages from her writing, as well as from Alfred Stieglitz's, have been quoted exactly as they appear in the sources cited; and attention has been called only to peculiarities that might obscure meaning.

The prose of the critics quoted in the text and reprinted in Appendix A is characterized by spelling, punctuation, or grammatical conventions now considered obsolete and, overwhelmingly, by invented words. Furthermore, in much of this material, capitalization, italicization, and, often, spelling were dictated by the house style of the periodical or newspaper that published it. To preserve the character of the writing, only changes that facilitate reading have been made.

Thus, spelling or punctuation aberrations that are obviously typographical have been corrected in brackets, and attention has been called only to misspelled proper names, to misquotations, and to certain other errors that compromise the sense of the material. But nothing has been done to flag, for example, irregularities of capitalization or italicization, coinages, and, in the text, names that are misspelled because of a missing or incorrectly used accent mark. And except in bibliographic citations, occurrences of one of the most curious characteristics of the criticism as a whole—the continual misspelling of O'Keeffe's name—remain unmarked.

Wherever necessary, Stieglitz photographs from the O'Keeffe portrait are identified by using original accession numbers assigned to the prints of them in the Alfred Stieglitz Collection, National Gallery of Art, Washington, D.C. (NGA).

Introduction

Georgia O'Keeffe emerged from relative obscurity in the early twenties, and by the end of the decade, she had become one of America's most acclaimed artists. Her spectacular rise to fame was due, largely, to Alfred Stieglitz. He was captivated by her work from the moment he first saw it, and he began to promote it with great enthusiasm a few months later, in the spring of 1916.

Already Stieglitz's professional obsession when she moved from Texas to New York in 1918 at his invitation, O'Keeffe soon became his personal obsession as well. She was immediately thrust into the intellectual, cultural, and social milieu in which he had thrived for almost thirty years, and for over a decade, they lived and worked together almost without separation either in midtown Manhattan or at Lake George. Without doubt, the paintings she accomplished during those years include some of the finest of her career; but O'Keeffe realized toward the end of the twenties that neither she nor her work could continue to remain defined solely within the boundaries of the world she shared with Stieglitz. So in 1929, she returned to the Southwest for four months and discovered an environment in New Mexico that, to one degree or another, would sustain her and inspire her art for the rest of her life.

From the beginning, O'Keeffe's work had great appeal, and it gained acceptance quickly. Stieglitz was a masterful publicist and a convincing advocate, and with his promotion, O'Keeffe soon gained wide public support. Furthermore, he had earned a reputation for being something of a prophet when it came to recognizing promising young artists. As soon as he introduced O'Keeffe's work, it attracted critical attention, and by the end of the twenties, it had become the subject of a sizeable body of literature.

What was written about O'Keeffe's art provides a fascinating picture of how the male-dominated art community in New York responded to the work of a female modernist. It demonstrates that although the

critics overwhelmingly praised the quality of her work, they were baf-
fled by its imagery. At first, they interpreted it almost exclusively within
the context of theories about women and the creative process, and in
the early twenties, many adopted an approach to it that had been publi-
cized by Stieglitz in 1916—that her imagery was an expression of female
eroticism and, thus, could be understood in Freudian terms. Although
Stieglitz and his circle continued to use sensational theories to promote
her art, by the end of the twenties, other critics had offered alternative
opinions.

This was the period in which O'Keeffe's struggle to define herself
as an artist was most intense. Her published responses to questions
from journalists, the statements she prepared for publications, and the
letters she wrote suggest how she perceived herself between 1916 and
1929. But there are relatively few such documents. She disliked giving
interviews, and she was never a prolific writer. Furthermore, access to
a significant portion of her personal correspondence remains restricted.[1]
The picture of O'Keeffe that emerges from available records, therefore,
cannot be considered definitive. Precisely what she was thinking about
herself, about her work, and about how others interpreted it during this
important period of her career is not always clear.

It can be demonstrated, however, that throughout the teens and
twenties O'Keeffe could only have concurred with critics who believed
that the character of her imagery was intricately bound to her biological
nature. Yet she objected strongly to the Stieglitz-inspired idea that her
art was an expression of unrepressed female eroticism and to the exotic
image of her that idea created. In fact, as early as 1922, she began to
offer an alternative image by publicizing information that she believed
appropriately described herself and her intentions as an artist; and by
the end of the decade, the counter-image she promoted had been as-
similated into the criticism. During this period, however, she never
refuted opinions about her art in a public way and never acknowledged
any awareness of Stieglitz's role in inspiring or perpetuating the ones
she objected to most strongly.

This study includes reprints of ninety responses to O'Keeffe's art
that were published before 1930 (see Appendix A)[2] and examines them
within their historical context. It demonstrates that the critical reception
of her work in this period was far more complex than has been previ-
ously suggested and charts the origins and development of two contra-
dictory images of O'Keeffe that struggled for dominance in the criti-
cism—one inspired by Stieglitz and another by O'Keeffe herself. It de-
fines the role she played in trying to direct critical thinking about her
work, and finally, it documents her success at promoting her own image
in the second half of the decade.

1

The Background and the Early Reviews

In mid-October of 1915, about a month before her twenty-eighth birthday, Georgia O'Keeffe decided to put away all the art she had been making and to begin again. Relatively isolated in Columbia, South Carolina, where she was teaching, she had given much thought to her work and realized she had made most of it to please other people. Determined to try to express what she was feeling in a way that would please *her*, she began making drawings using only charcoal and white paper. From the beginning, she was aware of the difficulty of what she had undertaken to do.

For several months, O'Keeffe had been corresponding with Anita Pollitzer, with whom she had taken classes the year before at Teachers College, Columbia University, and a few days before she began the drawings, she wrote to her friend who was still studying in New York:[1]

> It is curious how hard it seems to be for me right now not to cater to someone when I work—rather than just express myself[.] . . .
> During the summer—I didn't work for anyone—I just sort of went mad usually—I wanted to say "Let them all be damned—I'll do as I please" . . . , but—now . . . I find myself catering to opinion again—and I think I'll just stop it.[2]

At the end of October, feeling very unsure of the results of her experiment, she wondered in another letter to Pollitzer if she really had anything to say: "You get mightily twisted with yourself at the tail end of the earth with no one to talk to . . . when you wonder and fight and think alone. . . . I dont know that my heart or head or anything in me is worth living on paper."[3]

A few weeks later, O'Keeffe sent Pollitzer several of the drawings, and Pollitzer responded with encouragement: "They came today. . . . I like the one in black & gray on the very white charcoal paper. . . . The other is quite dramatic. . . . I don't know what to say about it . . . but

keep on working this way like the devil. Hear Victrola Records, Read Poetry, Think of people & put your reactions on paper."[4]

O'Keeffe continued to draw, and in early December, she wrote Pollitzer:

Its a wonderful night—

I've been hanging out the window wanting to tell someone about it—wondering how I could—I've labored on the violin till all my fingers are sore—You never in your wildest dreams imagined anything worse than the noises I get out of it—That was before supper—Now I imagine I could tell about the sky tonight if I could only get the noises I want to out of it—Isn't it funny!

So I thought for a long time—and wished you were here—but Im going to try to tell you—about tonight—another way—Im going to try to tell you about the music of it—with charcoal—a miserable medium—for things that seem alive—and sing—only I wanted to tell you first that I was going to try to do it because I want to have you right by me and say it to you.[5]

By mid-month, she had become obsessed with visualizing her feelings, and her expression of them was approaching pure form. During those days, she felt either lifted to new heights of creative and personal exhilaration or grounded in the frustration of self-doubt. She began to wonder if she were "a raving lunatic for trying to make these things" and if they could mean anything to anyone else.[6] She decided, in late December, to send some of the drawings to Pollitzer.[7]

Despite O'Keeffe's ambivalence concerning their meaning, the drawings Pollitzer received from her would be described some seventy years later as possessing an "authenticity and singularity [that] justifiably catapulted . . . [O'Keeffe] into the highest ranks of American artists."[8] Though she had neither the training nor the experience to suspect what they might mean to future generations of artists and art historians, Pollitzer immediately recognized the extraordinary quality of the drawings. As she later pointed out: "They were expressing what I felt had not been said in any art I had seen."[9] Despite O'Keeffe's instructions that no one else be allowed to see them, Pollitzer determined that there was another person in New York who should. And so, on 1 January 1916, the day she picked them up at the post office, she took the drawings to Alfred Stieglitz.[10]

At fifty-two, Stieglitz was a formidable presence in the New York art community. He had been recognized internationally for his work in photography for over twenty years and, for almost ten, had gained additional prominence through his campaign to promote modern art in this country. His ongoing efforts in that regard were 291, the gallery he

opened in 1905 as the Little Galleries of the Photo-Secession, and *Camera Work*, the periodical he had begun publishing in 1903.

By the time he saw O'Keeffe's work for the first time, he had organized twenty-two exhibitions of photography and forty-seven of European and American art at 291, and the gallery had developed an international reputation for its uncompromising support of the avant-garde. One of the most important intellectual and artistic circles in New York had grown up around this enterprise, and *Camera Work* had increasingly reflected its spirit. The latest Stieglitz venture had been to help sponsor the publication of a magazine, *291*, that was even more experimental and radical than *Camera Work*.

In 1907, when Stieglitz began displaying art in addition to photography at 291, unqualified critical acclaim was usually reserved for art formulated on academic principles. The role he undertook in championing artists whose work challenged those principles immediately placed him at the center of heated controversies about the nature and significance of modern art. The fact that he relished such a position is reflected in the kinds of exhibitions he continued to mount at 291 and in his decision to reprint in *Camera Work* the reviews those exhibitions generated.

Before the Armory Show, he had introduced the work of Cézanne, Matisse, and Picasso to this country. He had also exhibited a number of relatively unknown young American painters, such as Arthur B. Carles, Arthur Dove, Marsden Hartley, John Marin, Alfred Maurer, and Max Weber. Many of these exhibitions, along with others equally provocative, were greeted with hostility by critics, although Stieglitz was frequently cited for providing a forum for the new or, as one critic put it, "for his pioneer work in the matter of bringing to the ken of art lovers the more recent art manifestations of Paris, Hades and Buxtehude."[11] Such comments became less ironical after the revelations of the Armory Show, which confirmed to many the foresight of Stieglitz's connoisseurship.[12]

It is unlikely, then, that O'Keeffe's drawings could have been received more sympathetically anywhere else in this country in 1916. Stieglitz was committed to modernism, and by the mid-teens, he had begun to devote himself almost exclusively to the promotion of American art. Furthermore, he thrived on the unexpected and did not hesitate to give his attention to the work of an unknown artist. One aspect of his progressivism was particularly relevant to O'Keeffe; for unlike most of his contemporaries, he did not believe the production of art to be an

exclusively male endeavor. Before 1910, he had exhibited the work of Pamela Colman Smith three times at 291, and by 1916, he had given a show to two other women, Marion Beckett and Katharine Rhoades.

Thus, Stieglitz was not concerned that O'Keeffe was unknown in New York, that her drawings were abstract, or that they had been done by a woman. In fact, he soon came to believe that in O'Keeffe he had discovered America's first woman modernist.[13] But he was overwhelmed by her drawings from the beginning. As he said to Pollitzer on 1 January 1916: "Why they're genuinely fine things—you say a woman did these—She's an unusual woman—She's broad minded, she's bigger than most women, but she's got the sensitive emotion—I'd know she was a woman O Look at that line." Although at the time Stieglitz knew Pollitzer only slightly and O'Keeffe not at all, he was so impressed with the drawings that he told Pollitzer he "wouldn't mind showing them in one of these rooms one bit"; that they were the "purest, finest, sincerest things that have entered 291 in a long while."[14]

The available correspondence between O'Keeffe and Stieglitz during the years 1916–18 reveals that Stieglitz continued to express himself on the subject of her art.[15] O'Keeffe first wrote to him shortly after she had received a report from Pollitzer of his reaction to her drawings. In that letter, she asked Stieglitz to tell her "what they said" to him.[16] He replied: "It is impossible for me to put into words what I saw and felt in your drawings. . . . If you and I were to meet and talk about life . . . then through such a conversation I might make you feel what your drawings gave me. . . . They were a real surprise and above all I felt that they were a genuine expression of yourself." And he reiterated his interest in exhibiting the drawings: "If at all possible I would like to show them, but we will see about that. I do not quite know where I am just at present."[17]

By the spring, he had made up his mind. When he organized the last exhibition of the season at 291, he decided—without consulting O'Keeffe—to feature ten of her drawings in a group show that included the work of two other artists who were also unknown in New York: Charles Duncan and Réné Lafferty.[18] O'Keeffe was in the city at the time taking classes at Teachers College, and when she heard from someone that the drawings of "Virginia" O'Keeffe were on display at 291, she knew they were hers. She was so outraged that Stieglitz would presume to exhibit the drawings without her permission that she confronted him at the gallery and demanded they be taken down.[19] But she and Stieglitz talked, and the drawings stayed up.[20]

Soon thereafter, O'Keeffe left New York to teach a summer term

in Virginia, and in a letter written to her while the show was still on view, Stieglitz demonstrated that he associated her work with her vitality. He wrote: "Your drawings on the walls of 291 would not be so living for me did I not see you in them. Really see. . . . How I understand them. They are as if I saw a part of myself—Queer!"[21] His comment implies that he also associated his own vitality with the expressive quality of O'Keeffe's drawings and, thus, responded to them, in part, as an extension of himself.

Just after the show closed, he wrote her again: "Little did I dream that one day she [Pollitzer] would bring me drawings that would mean so much to 291 as yours have meant—nor did you dream when you did them that they would—or could—ever mean so much to anyone as they have to 291."[22] To Stieglitz, he and 291 were the same—his spirit was its spirit.[23]

In mid-July, Stieglitz apparently wrote that he would like to have one of the drawings. In response, O'Keeffe wondered which one he wanted, and he replied: "The one I want most is the one that hung on the left wall—to the right of the *seething* one—The one I considered by far the finest—the most expressive. It's very wonderful—all of it—There are others running it a close second—but none gives me what that one does."[24] From all of Stieglitz's comments about O'Keeffe's early drawings it is clear that he responded most strongly to those in which he could sense the intensity of O'Keeffe's feelings.

Stieglitz included O'Keeffe's drawings in a group show that opened at 291 in late November, several months after she had moved to Canyon, Texas, to teach at West Texas State Normal College. Sometime later, he wrote to thank her for a new group of drawings he had received and to let her know, once again, how important her work had become to him: "This is merely to tell you the drawings are safely in my hands and that I am grateful—as I have ever been to you since I was first given the privilege to see your self-expression."[25] Stieglitz now looked upon his custodianship of her work as an honor.

He staged her first one-woman show in the spring of 1917, and because he closed the doors of 291 that summer, O'Keeffe's was the last show ever seen there. She traveled to New York shortly after the exhibition closed and spent ten days there—much of the time with Stieglitz. In March of 1918 he wrote to her in Texas: "Of course I am wondering what you have been painting—what it looks like—what you have been full of—The Great Child pouring out some more of her Woman self on paper—purely—truly—unspoiled."[26]

O'Keeffe was known later in her life to object to being called a

woman artist rather than an artist; thus, it would be easy to assume that she found such words from Stieglitz in 1918 offensive.[27] But that is not likely. O'Keeffe herself had recognized certain aspects of her imagery as an expression of her sex, a fact that can be seen in a letter she wrote to Pollitzer in January of 1916, thanking her for taking her drawings to Stieglitz.[28] Referring to her most recent work, she explained:

> The thing seems to express in a way what I want it to but—it also seems rather effeminate—it is essentially a womans feeling—satisfies me in a way—I dont know whether the fault is with the execution or with what I tried to say—Ive doubted over it—and wondered over it till I had just about decided it wasnt any use to keep on amusing myself ruining perfectly good paper trying to express myself—I wasn't even sure that I had anything worth expressing—[.][29]

Because O'Keeffe was unsure of what she was doing and hesitant about an aspect of her work she considered to be an expression of "a womans feeling," Stieglitz's positive response to this dimension of her self-expression ("I'd know she was a woman O Look at that line"), among his other comments, was quite reassuring. As she reported to Pollitzer after hearing of his initial reaction to her work: "It makes me want to keep on—and I had almost decided that it was a fool's game—[.]"[30]

In the spring of 1918, Stieglitz made preparations for her to live in New York. He asked his niece, Elizabeth, whose studio apartment he had used off and on to work in, if she would offer it to O'Keeffe as a place to live and paint. When he heard from O'Keeffe in mid-May and learned that she had given up her teaching position, he immediately asked his protégé, photographer Paul Strand, to travel to Texas and discuss Elizabeth's offer with her. O'Keeffe agreed to come to New York, and on 10 June, she and Strand arrived at Grand Central Station.

Within a month, Stieglitz and O'Keeffe had fallen in love, and he had removed his belongings from the house he shared with his wife and daughter, initiated divorce proceedings, and moved into O'Keeffe's studio. From this time until the summer of 1929, they lived and worked together almost without interruption, spending winters in New York City and summers at the Stieglitz family estate at Lake George. They were married in December of 1924, after Stieglitz's long-awaited divorce was granted.

Stieglitz's professional commitment to O'Keeffe was clear from August of 1918, when he saw to financial arrangements that made it possible for her to spend the following year painting. From that time until his death in 1946, she was the one woman among the artists

Stieglitz regularly promoted, and he made no distinction between the kind of support he offered her and the kind he continued to make available to two men whose work he had also introduced to New York at 291—painters Dove and Marin.

During the years 1926–29, Stieglitz presented O'Keeffe shows annually at the Intimate Gallery. But between the time he closed 291 in July of 1917 and opened the Intimate Gallery in December of 1925, he had no place of his own to hold exhibitions. It was in those years, however, that O'Keeffe's career took hold, with Stieglitz masterminding the promotion of her work. He had submitted two O'Keeffes to the Society of Independent Artists exhibition in New York in 1917 before 291 closed, and between then and mid-1922, he arranged to have her work included in three other group shows.[31]

Her art received its most significant exposure in the early twenties, however, in exhibitions Stieglitz organized at the Anderson Galleries. In three consecutive years, 1923–25, O'Keeffe's work was seen there: first, in a large one-woman show; next, in an exhibition simultaneous with one of photographs by Stieglitz; and finally, as part of the only group show Stieglitz sponsored in the twenties. That show, which he called "Seven Americans," included his own work as well as that of Charles Demuth, Dove, Hartley, Marin, O'Keeffe, and Strand.

It is clear from Stieglitz's first reactions to O'Keeffe's art that he was impressed with two aspects of it: what he perceived to be its feminine dimensions and its modernism. He responded to it as the art of a woman, but he also responded to it because he sensed it exemplified issues he had long believed were fundamental to modern art: that unconscious states of being were the real subject matter of the artist and that the unconscious could be most appropriately articulated through abstraction. Furthermore, by referring to O'Keeffe as "The Great Child pouring out . . . her Woman self" in a manner that was "purely—truly—unspoiled," Stieglitz revealed another dimension of his understanding of her art. He associated her "Woman" feelings with innocence and purity, qualities he admired in the art of children and the art of so-called primitive cultures.

In 1912, 1914, and 1915, he had shown children's art at 291, and in the group show he organized in the fall of 1916, he displayed the drawings of his ten-year-old niece, Georgia Engelhard, along with paintings and drawings by Hartley, Stanton Macdonald-Wright, Marin, O'Keeffe, and Abraham Walkowitz. In 1914, he had also exhibited African sculpture at 291, and in 1914 and 1915, archaic Mexican pottery. When he communicated with O'Keeffe in late May of 1917 to tell her he had

decided to close the gallery, he admitted: "I have decided to rip 291 to pieces after all—I can't bear to think that its walls which held your drawings & the children's should be in charge of any one else but myself."[32]

Stieglitz's commitment to the idea that the expression of children and of what he regarded as primitive peoples was relevant to the concerns of modern artists is a reflection of the value he assigned the unconscious. The role the unconscious played in modern art was an important part of the thinking of the Stieglitz circle, and for years, *Camera Work* had included essays by such Stieglitz associates as Charles Caffin, Benjamin De Casseres, Marius De Zayas, and Sadakichi Hartmann that addressed this issue.

As De Zayas pointed out in an article of 1913, the modern artist "has had to abandon the complex study of realistic form, to which he had limited himself for so many centuries, and turn to the imaginative and fantastic expressions of Form in order to have a complete understanding of the possibilities of its expression."[33] He felt that the modern artist had substituted for form "the abstract expression of feeling[s], like those produced by music, entering into more complex speculations and pure psychological analysis." Once the abstract expression of feelings was explored and understood, he continued, the artist could return to form as it was "expressed by the uncivilized peoples" to develop "new canons, new theories, new schools, drawn from their *structures*."[34]

In an earlier article, De Zayas had assigned the unconscious a primary role in the creation of art. He wrote that while art had to display the "element of imagination and the result of the operation of the reflective faculties," its most important quality was the expression of "sensations" and "intense perceptions" that, in the art of children and primitive peoples, emerged directly from the "unconscious" and not the mind.[35]

De Casseres had also referred to the relationship between mind, sensation, and the unconscious in modern art. He believed that "out of the head of the artist" came "all the beauty that is transferred to canvas," but its ultimate source lay in the "imagination," which was "the dream of the Unconscious." Like De Zayas, De Casseres claimed that, in the artist, intellect was second in importance to the unconscious:

> Conscious effort, conscious willing, the open-eyed act is always the last of a series, and not the first. It is the flower of preceding incalculable sowings in the Unconscious. Consciousness in art is only the antenna of the blind unknowable Force and intelligence is only its nerve.[36]

Thus, though "intelligence" was not the source of expression in art, it was the means through which the unconscious, the "blind unknowable Force," could be made known.

Central to the thinking of the Stieglitz circle during these years were theories about art and the creative process that had been most recently set forth by Henri Bergson and Wassily Kandinsky. In a 1912 issue of *Camera Work*, Stieglitz printed an extract from Bergson's *Laughter* of 1911, in which Bergson indicated that the "loftiest ambition of art" was to reveal nature and that artists "contrive to make us see something of what they have seen . . . things that speech was not calculated to express." Artists "grasp . . . certain rhythms of life and breath that are closer to man than his inmost feelings, being the living law . . . of his enthusiasm and despair, his hopes and regrets."[37] Furthermore, Bergson likened to music the "rhythms of life and breath" that he felt the artist expressed, and he explained the relationship between artistic expression and "reality":

> By setting free and emphasizing this music . . . [artists] impel us to set in motion, in the depths of our being, some secret chord which was only waiting to thrill. . . . Art . . . has no other object than to brush aside . . . everything that veils reality from us, in order to bring us face to face with reality itself.[38]

When set within the context of how he defined the creative process, Bergson's conclusion that "art is certainly only a more direct vision of reality"[39] was clearly related to the significance he attached to the unconscious and intuitive, as opposed to the rational, forces within human nature. In *Creative Evolution*, which was published in 1911 and reprinted in part in *Camera Work* that year, Bergson had postulated the existence of a parallel relationship between the dynamic forces of human nature and the dynamic forces at work in the natural world. He reasoned that, because unseen energies in nature moved forms upward as they grew, the invisible powers of intuition could propel humans in a similar way. He defined intuition as "instinct that has become disinterested, self-conscious, capable of reflecting upon its object and of enlarging it indefinitely" and asserted that, although "intuition . . . transcends intelligence," the two were intimately related and mutually dependent upon one another:

> Intelligence remains the luminous nucleus around which instinct, even enlarged and purified into intuition, forms only a vague nebulosity. . . . It is from intelligence that has come the push that has made . . . [intuition] rise to the point it has reached. Without intelligence, it would have remained in the form of instinct.[40]

Through intuition, humans could understand what "intelligence fails to give us"[41] and experience their own dynamic as a component of the universal life force—what Bergson called the *élan vital.*

He ranked the powers of intuition and the unconscious above the powers of the mind as sources of creativity. In this respect, his notions paralleled those of Kandinsky, whose book *Concerning the Spiritual in Art* was also published in 1911 and was partially reprinted by Stieglitz in *Camera Work* in 1912. Kandinsky was committed to the concept of a future in which art would be equated with the spiritual, and he noted that an awakening of the spirit in man had just begun: "This all-important spark of inner life today is at present only a spark."[42]

Kandinsky observed that in the past what humans had created with their hands, guided by their minds, was the "nightmare of materialism, which has turned the life of the universe into an evil, useless game." But he believed that the human spirit, the "soul," could sense an alternative, "a feeble light," which he felt contained "the seed of the future itself." And the inner human spirit was a progressive force: "The spiritual life . . . is a complicated but definite and easily definable movement forwards and upwards. This movement is the movement of experience." Experience, in turn, activated spiritual progress and thereby defined the future.[43]

Specifically, Kandinsky thought that painting should aspire to express an "inner" spiritual harmony and that, in its journey toward "the abstract, the non-material," it could learn much from music. Like Bergson, Kandinsky drew parallels between art and music, using, for example, the words "melodic" and "symphonic" to describe compositional alternatives in painting. But consistently, he equated the expressive power of color and form in abstract painting with that of musical sound.[44]

And so, when Pollitzer brought O'Keeffe's intuitively realized, abstract drawings to Stieglitz in 1916, he and his friends had been advocating the significance of the unconscious in art for half a decade. Their position was a direct challenge to the idea that the intellect was the most distinguishing feature of the human species and the source of its creative accomplishments. That idea had prevailed for centuries in Western culture and had won the solid support of the nineteenth-century scientific community.

Among those in the nineteenth century whose theories had given new authority to the concept that linked creativity with intellect were evolutionists Charles Darwin and Herbert Spencer. Through their research, Darwin and Spencer had confirmed a belief that had been born in the concept of creationism underlying Greek and Judeo-Christian

myth—that the creative powers of women were separate, different, and inferior to those of men.[45] Their conclusions, along with those of craniologists, such as Carl Vogt, were decidedly biased against women and were still very much in vogue in the early years of the twentieth century.[46] An exposition of their emphasis on the primacy of the intellect helps demonstrate the extent to which Stieglitz's position regarding the creative process, and especially regarding creativity in women, must be seen as progressive.

Through his studies of developing life forms, Darwin formulated a theory of natural evolution whose dynamics he set forth in *On the Origin of Species* (1859) and in *The Descent of Man* (1871). In the latter work, he made the point that metabolic rates were greater in males than in females, and he claimed that as humans evolved, this difference had led to others. For example, women were smaller than men and thus not as physically capable; they were passive, shy, and highly emotional, whereas men were aggressive, bold, and rational.

He theorized that human beings had originated as an undifferentiated species. In ascertaining that "at a very early embryonic period both sexes possess true male and female glands," Darwin proposed that males and females ultimately came from "some remote progenitor of the whole vertebrate kingdom [that] appears to have been hermaphrodite or androgynous."[47] At some indefinite point in time, men and women were separated, and from that moment forward, each began to chart a different and independent evolutionary path.

The anthropometrical findings of Vogt, published in 1864 as *Lectures on Man*, were quoted without reservation by Darwin in *The Descent of Man* to support his opinions about differences in the creative capacities of women and men. Vogt had proven that the brains of "civilized" males were the largest of the human species and that the brains of women were smaller, comparable in size to those of either children or non-Caucasians.[48] Darwin proposed that their larger brains had given men a capacity for rational thought and "inventive genius" that, by implication, women's smaller brains simply could not accommodate.[49] Men had evolved beyond women not only physically but also intellectually, and this explained why, historically, men had attained "a higher eminence" in matters that required "deep thought, reason, or imagination, or merely the use of the senses and hands." There could be little question, then, of the superiority of men's creative abilities:

> If two lists were made of the most eminent men and women in poetry, painting, sculpture, music . . . , history, science, and philosophy, with half-a-dozen names under each subject, the two lists would not bear comparison.[50]

On the other hand, Darwin discerned that women's greatest strengths lay in their "powers of intuition, of rapid perception, and perhaps of imitation."[51] These three qualities in women seemed analogous to similar qualities in lower species. Women's intuition could be linked with instinct in animals, whose perception and imitative skills were also highly developed. Furthermore, the autonomous, cyclic activities of the female reproductive organs were closely related to the cyclic rhythms of nature, and the ability of the womb to produce and nurture new life was reflected in natural phenomena. Thus, creativity in woman could be most reasonably associated with her body and, in particular, with its capacity to conceive and bear children.

Darwin's understanding of the differences between men and women takes on additional significance when seen within the context of similar patterns of thinking in the ideas of his contemporary, Herbert Spencer. By the 1880s, Spencer had developed theories about growth in the natural world and about the finite energy systems of its animate forms, and he used the findings of anthropologists, biologists, craniologists, and sociologists to substantiate them. Spencer asserted that living forms were powered by vital fluids and that every function of the human body expended some of them. Because much of these fluids in women was needed for reproduction, they could not be given over to development and growth. Thus, he was convinced that females, who were visibly smaller and less aggressive than males, had been stunted in their evolutionary growth by the needs of their reproductive systems.

Spencer contended that men were destined to be superior to women. If women used their vital fluids to fuel the development of their brains, they could severely threaten their abilities to bear children. Therefore, they should be discouraged from doing so. But because the procreative act in men required only small quantities of their vital fluids, male intellectual activity did not jeopardize the continuation of the species. In fact, Spencer believed that almost all of men's vital fluids had been directed toward the nourishment of the intellect and, thus, that the different demands of the reproductive functions of males and females were ultimately responsible for the respective size and developmental differences of their brains. Moreover, he assumed that women, with their smaller brains, were unable to think in the same ways as men and that men's greater capacity for logical thought accounted for their dominance in creative endeavors.[52]

Outside scientific circles at the end of the nineteenth century, thinking that differentiated between the creative abilities of women and men on the basis of biological and sociological theories found eloquent ex-

pression in George Moore's widely influential *Modern Painting*. Moore's expressly biased opinions against women artists still commanded considerable authority well into the third decade of this century, and it is interesting that Stieglitz and several of O'Keeffe's critics in the mid-twenties made a point of announcing their disagreement with what had been considered truth about the nature of women artists by refuting Moore's assertions.[53]

Moore resolved, as had Darwin and Spencer, that men rather than women were responsible for the creation of culture. "In painting, in music, and literature," he claimed, the "achievements [of women] are slight indeed—best when confined to the arrangements of themes invented by men—amiable transpositions suitable to boudoirs and fans."[54] Women's art was less significant than men's because it was imitative rather than inventive. Instead of having the force and power of the new, the subject matter and themes of women's art were lightweight imitations of men's ideas. He believed that "women have created nothing"; that because of a "want of originality" in women's art only the paintings of Berthe Morisot "could not be destroyed without creating a blank, a hiatus in the history of art."[55]

Moore supposed a connection between the art men and women made and their sociological and biological differences, thus grounding his ideas in scientific fact. The male artist, unlike the female, he proposed, was a rational being whose "whole mind is given to his art." Male artists were thus free from "all vague philanderings and sentimental musings" that were particular to females. Moreover, because the brains of men were more highly developed than those of women, men could transcend the part of themselves that he believed dominated the female—"sentimental cravings of natural affection." It followed, therefore, that man's mental capacity was "infinitely higher than woman's."[56]

Following the publication of his book, the premise of Moore's viewpoint was discussed frequently in print. A 1918 essay by Arthur Edwin Bye, called "Women and the World of Art," is a demonstration of the persuasiveness of Moore's argument.[57] In it, Bye raised the question of whether women had "the force, the strength, the powers of concentration, [or] the prophetic insight" to become artists. To demonstrate that he thought not, he offered a definition of the specific nature of female creativity:

There is one thing preeminently that a woman can create and that is her child. To create that child is the greatest aspiration of her life, and when she can do that she

rightly cares for nothing else. This is a passion with her as it never can be with a man. He can have his children and yet pursue his great objective in life—success in his career; but a woman's life is lost in her children.[58]

Because he believed that woman's strongest creative impulses were limited to childbearing, Bye could not consider her as an artist within "man's sphere . . . , that of creation and alas! of destruction." Her only role in art could be one of "preservation and nourishment,"[59] a fact that Moore had also proclaimed.

As early as the first decade of this century, Stieglitz began supporting the art of women and thus assumed a position that placed him at odds with many of his contemporaries. Unlike Moore and Bye, for instance, he insisted that women's art was worthwhile, and he made a public declaration of his commitment to this idea in 1907 by exhibiting the work of a woman at 291. Moreover, because he agreed with Bergson's and Kandinsky's theories, Stieglitz had come to believe that reason ranked below the unconscious as the source of creativity. "Art begins where thinking ends," he claimed.[60]

If Stieglitz maintained that unconscious powers initiated the creative process and that they, as the scientists had proclaimed, were stronger and more developed in women, he might have reasoned that women could excel at expression in art, producing work more distinctive than that of men. It is clear that he understood O'Keeffe's art as the pure expression of her unconscious. She was "pouring out . . . her Woman self on paper—purely—truly—unspoiled." Yet, there is nothing to suggest that Stieglitz ever concluded that O'Keeffe's work could surpass his own or that of other men. It is unlikely that either he or anyone else in the patriarchy of the New York art community in the first two decades of this century could have conceived of the superiority of women's art, though in the mid-twenties certain artists and critics approached that notion in their assessments of the transcendence of O'Keeffe's painting. (Before 1920, Dove admitted to Stieglitz: "This girl is doing naturally what many of us fellows are trying to do, and failing.")[61] Stieglitz did, however, become a ground-breaking advocate of the most progressive attitude toward female artists to emerge in the teens: that it was possible for them to become the equals of male artists.

In 1919, after he had been around O'Keeffe and her work for over a year, he made his conception of the potential equality between men and women artists quite explicit. In an essay called "Woman in Art," he stated that "if these Woman produced things which are distinctively feminine can live side by side with male produced Art—hold their

own—we will find that the underlying aesthetic laws governing the one govern the other."[62]

There can be no question that Stieglitz's promotion of O'Keeffe's work between 1916 and the time he composed "Woman in Art" did much to call attention to his advanced thinking toward women artists. Certainly, the broadest dimensions of his progressivism had been made clear for years through the editorial policy of *Camera Work* and the content of exhibitions at 291. The impact of his theorizing about modern art was widespread—a testimony to his remarkable powers of persuasion.[63] And although with O'Keeffe's work he was advocating not only modern art but modern art that had been made by a woman, the reviews of her shows at 291 demonstrate the extent to which Stieglitz's ideas about modernism in general and O'Keeffe's modernism in particular were reflected in the thinking of the critics.

There were two articles that referred to O'Keeffe's exhibition of charcoal drawings in 1916 and two reviews of her one-woman show of drawings, watercolors, and oils in 1917. Throughout, the influence of Stieglitz's ideas over what was being written cannot be overemphasized. In fact, it seems certain that Stieglitz wrote one of the two articles that discussed the O'Keeffe-Duncan-Lafferty show in 1916—a brief commentary in the October issue of *Camera Work*.[64] The other was written by Henry Tyrrell and was published in *The Christian Science Monitor* on 2 June, while the show was still on view. Tyrrell also reviewed O'Keeffe's 1917 exhibition in an article published in the *Monitor* on 4 May, and the show's second review was written by William Murrell Fisher for the June 1917 issue of *Camera Work*.

Tyrrell had reviewed earlier exhibitions at 291, and many of his comments had been reprinted in *Camera Work*.[65] His guarded but tolerant attitude toward the goings-on at Stieglitz's gallery is clear from his 1916 review, in which he remarked that 291 was "unique," a "sanctuary or no-man's-land that offers a temporary resting place to any and every strange new thing that comes along" (Appendix A, no. 1). Fisher did not comment about 291 in his 1917 review of O'Keeffe's show, but he had contributed to an earlier issue of *Camera Work* and was decidedly sympathetic to the ideas of the Stieglitz circle and to modern art.[66]

Thus, what O'Keeffe's earliest critics shared, in varying degrees, was a support of modernist ideas, and they did not concern themselves with assessing the validity of her work as art. What Fisher, Tyrrell, and Stieglitz attempted to do was determine its meaning, and as a result, their reviews announced three different approaches to an understanding of O'Keeffe's imagery.

Reflecting ideas about interrelationships between the arts that had been voiced within the Stieglitz circle for over a decade, Fisher declared that there were significant correlations between O'Keeffe's work and music.[67] He wrote that her "mystic and musical drawings" contained "emotional forms quite beyond the reach of conscious design," and he pointed out that "there have been many deliberate attempts to translate into line and color the *visual* effect of emotions aroused by music"; these had "failed just because they were so deliberate" (Appendix A, no. 4). To be successful "one must become . . . a channel, a willing medium, through which this visible music flows." Fisher believed that O'Keeffe had succeeded: "There is an inner law of harmony at work in the composition of these drawings and paintings by Miss O'Keeffe, and they are more truly inspired than any work I have seen."

Fisher was basing his observations, largely, on O'Keeffe's extraordinarily direct use of color in the watercolors of this period, like *Sunrise and Little Clouds II* (1916, Estate of Georgia O'Keeffe).[68] In the next few years, her use of color became more complex, and the highly personal color statements that distinguish a group of abstract oil paintings of 1918–20, *Series I*—of which *Series I, No. 8* (1919, Estate of Georgia O'Keeffe) is a good example—and such individual works as *Red and Orange Streak* (1919, Estate of Georgia O'Keeffe) inspired Stieglitz to write persuasively about this aspect of her work. He made the point in "Woman in Art" that O'Keeffe had "the sense of Color, in the modern acceptance of the word Color—it is part of her very *self*—as music is part of the Composer."[69] In fact, it became well known among O'Keeffe's critics that Stieglitz referred to her art as "color music."[70]

But though Fisher's was the first published declaration that correspondences existed between O'Keeffe's painting and music, Paul Rosenfeld's preview in *Vanity Fair* of O'Keeffe's 1923 show contained the first elaborate exposition of the theme. Rosenfeld wrote:

> The polyharmonies of the compositions of Stravinsky and of Leo Ornstein seem to have begotten sisters in the sister art of painting.
>
> Her work exhibits passage upon passage comparable to nothing more justly than to the powerfully resistant planes of close intricate harmony characteristic of some of the modern music. She appears to have a power like the composers, of creating deft, subtle, intricate chords and of concentrating two such complexes with all the oppositional power of two simple complementary colors. (Appendix A, no. 8)

The impression of O'Keeffe as a "musician of color" was kept alive throughout the twenties, primarily by critics associated with the Stieglitz circle.[71]

Tyrrell suggested another approach to O'Keeffe's art in his review

of 1916. Her work exhibited that year was restricted to black and white and, like that of the other two artists included in the show, contained few if any descriptive components. Therefore, it could have reminded no one of either the subject matter or formal elements that were associated with "traditional" concerns of women artists, such as "flowers, babies and delicate color schemes."[72] Yet Tyrrell's response to O'Keeffe's charcoal drawings implied that they could be best understood as the inventions of a woman.

Tyrrell based his assessment of the show on his belief that the way women created art was fundamentally different from the way men did. He made this clear in the following passage:

> But while Miss O'Keeffe looks within herself and draws with unconscious naïveté what purports to be the innermost unfolding of a girl's being, like the germinating of a flower, the two men essay little journeys into space and try to symbolize mentality as a fountain or a ray, playing against abysmal depths of ether, amidst wheeling suns, and ever falling back into the same vast circular basin. (Appendix A, no. 1)

In characterizing the works of Duncan and Lafferty as symbolic interpretations of human thought and O'Keeffe's as the manifestation of her physical self, Tyrrell demonstrated his alliance with traditional definitions of creativity. It is apparent that Tyrrell agreed with creationists and evolutionists that creativity in men, but not in women, was primarily a conscious, intellectual process. He indicated that the men had tried "to symbolize mentality" and that, to achieve this, they moved outside themselves and upward into "space." On the other hand, O'Keeffe did not seek inspiration beyond herself. Although Tyrrell initially declared that her drawings were "alleged to be of thoughts, not things," he implied that their energies surged forth without conscious interference. That is, O'Keeffe's work represented the "innermost unfolding of a girl's being, like the germinating of a flower."

The words Tyrrell used, "germinating of a flower," can be interpreted several ways. Recent studies have suggested the sexist implications of such language in the O'Keeffe criticism.[73] It has also been more generally argued that themes relating women to forms in nature, such as woman-as-flower and woman-as-tree, are among the most significantly misogynous of the art of the late nineteenth and early twentieth centuries, because they define women as powerless, rooted, passive, and nonthinking beings.[74] Thus, it would seem that the suppositions underlying Tyrrell's remark are biased against women.

Yet within the group of people who were attracted to Stieglitz and his activities, such words were used in a way that was not intended to

be demeaning to women. Charles Duncan, for example, who was O'Keeffe's fellow-exhibitor at 291 in 1916, wrote a critique of her art (at Stieglitz's request) that is clearly a tribute. He described it as "tremulous, giving—a flower" but also associated it with powerful forces in nature: her works were "colossal with rise and surge of interwinding Niagara rapid" (Appendix A, no. 2).

Stieglitz and his friends likened the creative process to the concept of growth; in particular, to the autonomous development of forms in nature and the strength associated with their maturation. Therefore, they used words like Tyrrell's and Duncan's to describe the art of *both* women and men. And although it cannot be confirmed in their writings before the 1920s that members of the Stieglitz circle applied this language to the art of men as well as women, its importance to the meaning of certain essays about creativity published in *Camera Work* as early as 1911 implies its general usage by the group in the mid-teens.[75]

Stieglitz made his belief in the relationship between art and natural growth very clear in a letter of 1925 to writer Sherwood Anderson:

> A Frenchman . . . said nothing abroad was like it [the work of O'Keeffe and Dove]. I should come over at once. He'd get the Gallery. The pictures would sell—and all that.—I told him the Soil was here—the planting was here—the growing where the planting—in the Soil right here.[76]

But he drew a more elaborate analogy between art and nature in 1937, demonstrating his commitment to this idea for at least two decades. Making art, he pointed out, was like "the subconscious pushing through the conscious, driven by an urge coming from beyond its own knowing, its own control." The unconscious, creative forces within human beings, he stated, were "trying to live in the light, like the seed pushing up through the earth." These dynamic and creative powers had to be explored, according to Stieglitz, for they "will alone have roots, can alone be fertile."[77]

O'Keeffe can have found no fault with such language, since she used it in the twenties and thirties to describe herself. In 1926, for example, on one of the rare occasions in which she referred to her relationship with Stieglitz in a letter, she wrote to critic Blanche Matthias: "I feel like a little plant that he has watered and weeded and dug around—and he seems to have been able to grow himself—without anyone watering or weeding or digging around him—[.]"[78] She continued to associate herself with the dynamics of growth in nature as late as 1934, when she communicated with writer Jean Toomer: "My center does not come from my mind—it feels in me like a plot of warm moist

well tilled earth with the sun shining hot on it—nothing with a spark of possibility of growth seems seeded in it at the moment—[.]"[79]

It is a fact that many people important to the development of American art and literature in the early twentieth century used a similar language, associating the creative force with the forces of nature. Some writers affiliated with the Stieglitz circle in the teens, such as Randolph Bourne, Van Wyck Brooks, Waldo Frank, James Oppenheim, and Rosenfeld, promoted the idea, as William Wasserstrom has pointed out, that "a work of art realizes itself only when an individual incorporates its organic life into his own organicism; only then do men experience a new fecundating force that fires them to recreate their lives, personal and national, in harmony with their vision of the wholeness of art."[80]

In his book *Time Exposures*, which was published in 1926, Frank described the relationship between O'Keeffe and her work as organic:

> O'Keeffe is very like a tree. . . . If a tree speaks or smiles, it is with all its body. So O'Keeffe whose paintings are but the leaves and flowers of herself. (Appendix A, no. 54)

Similarly, in 1922, Paul Rosenfeld had paralleled the strength and steady development of Marin's art to the growth of a tree:

> John Marin is fast in the American life of the hour as a fibrous, tough little apple-tree is lodged and rooted in the ground. . . . His branches grow fruits; like a hardy *pyrus malus* he is restlessly, unconsciously busied in transforming the materials amid which he is set, dayshine and moisture and minerals, pigment and water . . . into the fresh firm, savourous pulp of his art.[81]

Rosenfeld used the image of a tree to suggest strength, vitality, and productivity; moreover, neither he nor Frank used it to convey negative meanings like immobility and mindlessness. And both men thought analogies of this sort were appropriate to describe either men or women. In like manner, although recent scholarship has defined such words as "soil," "root," "seed," "plant," "bud," "fruit," "flower," and "tree" as demeaning when applied to women, within the Stieglitz circle an earthbound language was intended to carry positive connotations when applied to either sex.[82]

It was Stieglitz's habit to invite critics to the exhibitions he organized and to lead them around the gallery, talking incessantly and convincingly about the work on display. When Edmund Wilson described the experience sometime later, he revealed how difficult it had been to separate his own ideas from Stieglitz's, agreeing with a critic-friend

whose similar experience had caused him to remark: "When I came away, I couldn't help wondering a little whether it hadn't been a case of the innocent young serpent being swallowed by the wily old dove."[83]

Tyrrell began his essay in 1916 by quoting one of Stieglitz's statements: "Never since the tower of Babel has there been such general chaos of utterance and confusion of understanding as prevails in the art world today." And it seems more than probable that Tyrrell's use of the words "germinating of a flower" in the same essay to describe O'Keeffe's art derived from Stieglitz. In fact, because Tyrrell wrote that "while Miss O'Keeffe looks within herself and draws with unconscious naïveté what *purports* [my emphasis] to be the innermost unfolding of a girl's being, like the germinating of a flower," it is likely that he was paraphrasing, if not quoting, a Stieglitz monologue on the subject of O'Keeffe's art and its relationship to natural growth.

Whenever similar language was used in reference to O'Keeffe throughout the period, it reflected ideas that carried positive value within the Stieglitz circle. In his review of 1917, in fact, Tyrrell derived his elaborate interpretation of an O'Keeffe directly from the Stieglitz-promoted idea of a correlation between art and growth in nature. In a work undoubtedly from a series that culminated in the watercolor *Blue Lines X* (1916, Metropolitan Museum of Art, Alfred Stieglitz Collection), Tyrrell found the interaction between two forms analogous to interactions between forms in nature and, in addition, between males and females:

> "Two Lives," a man's and a woman's, distinct yet invisibly joined together by mutual attraction, grow out of the earth like two graceful saplings, side by side, straight and slender, though their fluid lines undulate in unconscious rhythmic sympathy, as they act and react upon one another. . . . But as the man's line broadens or thickens, with worldly growth, the woman's becomes finer as it aspires spiritually upward, until it faints and falls off sharply—not to break, however, but to recover firmness and resume its growth, straight heavenward as before, farther apart from the "other self," and though never wholly sundered, yet never actually joined.
>
> This is one of the "drawings," purely symbolistic, a sort of allegory in sensitized line.[84] (Appendix A, no. 3)

Writing about O'Keeffe's art again in 1923, Tyrrell recalled his associations of her early abstract work with nature: "It is now about a decade since Miss O'Keefe's timorous drawings of flower germination and embryonic life first appeared" (Appendix A, no. 15). The following year, Rosenfeld stated that O'Keeffe's work emerged from "her deep uncon-

scious principle" (Appendix A, no. 28), and he described it, in part, as follows:

> Gnarled apples; smooth, naked tree trunks; abstract forms . . . [are] informed by the elemental forces that toss the earth. . . . There are canvases of O'Keeffe's that make one to feel life in the dim regions where human, animal and plant are one, undistinguishable, and where the state of existence is blind pressure and dumb unfolding. There are spots in this work wherein the artist seems to bring before one the outline of a whole universe, a full course of life: mysterious cycles of birth and reproduction and death.

He added that O'Keeffe's work was the product of one who bore "no traces of intellectualization" but had "a mind born of profoundest feeling," and in so doing he was reflecting the idea espoused by the Stieglitz circle that the unconscious was the fountainhead of all creativity. It is clear, therefore, that by pointing out its sources in her feelings, he intended to assign O'Keeffe's work positive value.

Thus although Tyrrell's distinctions between the nature of male and female creativity were traditional in derivation, what he wrote about O'Keeffe's art—that she drew "with unconscious naïveté," carried positive connotations within the Stieglitz circle. In fact, whether he intended it or not, his idea about the source of O'Keeffe's expression was in line with a Stieglitz-promoted theory that validated her art precisely because it derived from the unconscious.

The way Stieglitz chose to explain O'Keeffe's art in his 1916 review related its meaning to a more specific dimension of the unconscious. Referring to the O'Keeffe-Duncan-Lafferty exhibition, he wrote:

> This exhibition, mainly owing to Miss O'Keeffe's drawings, attracted many visitors and aroused unusual interest and discussion. It was different from anything that had been shown at "291." Three big, fine natures were represented. Miss O'Keeffe's drawings besides their other value were of intense interest from a psycho-analytical point of view. "291" had never before seen woman express herself so frankly on paper. (Appendix A, no. 2)

The language of this brief assessment both defined what Stieglitz thought to be a significantly modern dimension of O'Keeffe's art—its expressive dependence upon her sexual feelings—and suggested that her work could be understood within the context of theories recently set forth by Sigmund Freud.[85] Furthermore, his remarks promoted the notion that, because O'Keeffe's art was a revelation of her psycho-sexual energies, it had already attracted "unusual interest," and thereby, he implicitly invited others to respond to it in terms of modern

concepts of human sexuality. To emphasize his point, he followed his statement with two other responses to O'Keeffe's work: the critique he had asked Duncan to write and a letter he had received from Evelyn Sayer.[86]

In describing O'Keeffe's drawings, Duncan stated: "Behind these delicate, frequently immense, feminine forms the world is distant. Poised and quick—elate—teeming a deep rain; erect, high, wide turning, unrequited in silent space this vision is exclusive to a simple reality." The "simple reality" he referred to was O'Keeffe's sexuality, and it seems obvious that he imagined her drawings to be revelations of it.

Evelyn Sayer's assessment of the drawings related their imagery unequivocally to O'Keeffe's sexual feelings. Her letter made it clear that she had been overwhelmed by this dimension of O'Keeffe's art:

> I feel very hesitant about trying to write an appreciation of the woman pictures.
> I was startled at their frankness; startled into admiration of the self-knowledge in them. How new a field of expression such sex consciousness will open.
> I felt carried on a wave which took me very near to understanding how to free and so create forces—it has receded now and leaves me without the words.
> I shall never forget the moment of freedom I felt—or the inspiration of how to use it.

Without question, Stieglitz felt O'Keeffe's art was, most fundamentally, a revelation of her sexuality. And because he was the voice of one of the most important avant-garde circles in America, his belief in the relationship of O'Keeffe's sexuality to her art was especially difficult to dismiss. Furthermore, it carried the authority of the scientific theory upon which it was based, a theory that was being adopted rapidly by important members of the medical community in America and Europe.[87]

In addition to believing that a psychoanalytical approach to O'Keeffe's imagery was a key to understanding the nature of its expressiveness, Stieglitz could not have been unaware that Freudian theory held sensational appeal, quite aside from the appeal of its authority. And although recent scholarship has defined the sexist dimensions of Freud's assumptions about women, it is unlikely that in 1916 Stieglitz would have been conscious of these biases within them.[88] Thus, although he could not have realized how it might be used to exploit O'Keeffe's art, Stieglitz did not hesitate to use Freudian theory as a promotional device.

Of the two reviews of O'Keeffe's show in 1917, only Tyrrell's was affected by this aspect of Stieglitz's opinions about her art. He had not alluded to O'Keeffe's sexuality in 1916, although he displayed his de-

pendence on at least one of Stieglitz's theories by using terms like "germinating of a flower" to describe her work. The following year, in addition to reiterating the theme of natural growth, he also adopted the "psycho-analytical" approach to O'Keeffe's imagery that had been suggested by Stieglitz and demonstrated by Duncan and Sayer in their responses to her drawings in the October 1916 issue of *Camera Work*.

Tyrrell's 1917 review contended that the key to the meaning of O'Keeffe's imagery was her "interesting but little-known personality"; that within her work "there is an appeal to sympathy, intuition, sensibility and faith in certain new ideals to which her sex aspires" (Appendix A, no. 3). O'Keeffe, Tyrrell stated, "has found expression in delicately veiled symbolism for 'what every woman knows,' but what women heretofore have kept to themselves, either instinctively or through a universal conspiracy of silence." In short, she had made visual "new aspirations, and yearnings until now suppressed or concealed."

It is ironic that Stieglitz was the first to publish an interpretation of O'Keeffe's art that linked it to her sexuality. His early support of female modernists and his ultimate conclusions about the equality between male and female artists leave little doubt that his attitudes toward women as artists were enlightened. It may be, in fact, his enlightenment that can explain his early intimation that O'Keeffe made art the way she did specifically because she was an unrepressed female.

Like all of O'Keeffe's critics in the teens and twenties, Stieglitz was unable to separate the meaning of her art from the fact that a woman had made it. But in its straightforwardness, if nothing else, what O'Keeffe was producing in 1916 bore little resemblance to any other art that had been produced by a woman. To explain the inexplicable, then, Stieglitz made it clear that O'Keeffe's imagery could be best understood in Freudian terms, and his position was an indication both of his and of O'Keeffe's modernity. Because Freud's theories were novel as well as popular in the period and because a connection between art and female sexuality was an extraordinarily provocative idea, Stieglitz's approach to O'Keeffe's imagery was widely adopted by others.

O'Keeffe's next exhibition was held in 1923, and Freudian interpretations were very much a part of the criticism that year. But the language of most of the reviews was sensational not only because it implied that O'Keeffe was a sexually obsessed woman but also because it described her art as if it were an extension of the forms of her body. It can be attributed only partially, then, to the language that characterized either Stieglitz's or Tyrrell's writing in 1916 and 1917, indicating an apparent lack of continuity between the reviews of the teens and those

of 1923. But Stieglitz believed he had made an important discovery in O'Keeffe, and he continued to promote her work during the five and one-half years it was not seen by the general public. One result was that O'Keeffe and her art were discussed in print five times between 1917 and 1923, and some of the criticism of these interim years was extraordinarily influential for the remainder of the twenties.

Most immediately, the sources of the language of the criticism in 1923 that drew parallels between O'Keeffe's art and her body can be found in essays written by Stieglitz intimate Paul Rosenfeld and published in 1921 and 1922. Though Rosenfeld knew O'Keeffe's work well, what he wrote is less a reflection of how he perceived it than of how he perceived O'Keeffe herself. That is also true of another Stieglitz associate, Marsden Hartley, who wrote the first essay about O'Keeffe to be published in the twenties. And in large measure, both Hartley and Rosenfeld based their perceptions of O'Keeffe on aspects of what was revealed in a comprehensive photographic portrait of her Stieglitz exhibited early in 1921.

The Woman in the Photographs

The forty-five photographs of O'Keeffe that Stieglitz exhibited at the Anderson Galleries in February of 1921 were dated 1918–20 and represented almost half of the total number he had made of her since 1917. His early photographs of her provide an extensive and invaluable source of information about Stieglitz's conception of O'Keeffe during their first years together. If they are analyzed in connection with other documents he created both before and after he began living with her, it becomes clear that his relationship with O'Keeffe confirmed many of his assumptions about the nature of women and women artists.

Several years before he met O'Keeffe, Stieglitz began to experience one of the least satisfying periods of his life. The depth of his involvement with the promotion of modern art had compromised the time he needed for his own work as a photographer, and that depressed him. In addition, he reacted very strongly to the outbreak of World War I, considering it a political and spiritual outrage, and by early 1915, he was feeling the effect of the war in America.

General interest in the arts had waned. Attendance was down at 291, and he was finding it more and more difficult to attain the financial backing he needed to run the gallery. *Camera Work*, too, after over ten years of publication, was foundering. The periodical would continue to appear sporadically into 1917, but by 1915, its subscribers had dwindled to only thirty-seven, though this was at least in part because of the increasingly radical stance it had assumed.[1]

Stieglitz's personal life was equally frustrating. For years, he had been essentially estranged from his wife, who shared none of his professional interests. In addition, many of the friends with whom he had worked over the years to shape 291 and *Camera Work* had withdrawn from him.[2]

Among the friends who remained, De Zayas, Paul B. Haviland, and Agnes Ernst Meyer were especially supportive. Sensing his malaise and

his predicament with 291, they encouraged him to become involved with the publication of a new magazine to be called *291*, which would be an effort, in part, to revitalize interest in the gallery.[3] The war had revolutionized thinking among the European and American avant-garde, and the magazine was to be dedicated specifically to the exploration of that thinking, to the most up-to-date experiments in design and typography, and to satire—one of Stieglitz's long-standing interests. He agreed to participate, and work on the magazine proceeded from headquarters at 291.

The first issue, which appeared in March of 1915, included a Stieg-litz poem entitled "One Hour's Sleep Three Dreams."[4] The poem is interesting for two reasons. First, although Stieglitz's involvement with *291* had temporarily lifted his spirits, the dreams recalled in the poem suggest the extent to which his despair had progressed by early 1915. In addition, through its account of three different females he confronts in the dreams, the poem reveals a great deal about Stieglitz's conception of women. It provides, in fact, the best evidence of what he thought about women before he met O'Keeffe, and it was the only such evidence to be published before she came into his life in 1918.

The poem's first stanza recounted a dream in which Stieglitz was dead, and a woman tried to revive him.

I

I was to be buried. The whole family stood about. Also hundreds of friends. My wish was carried out. Not a word was uttered. There was not a single tear. All was silence and all seemed blackness. A door opened and a woman came in. As the woman came in I stood up; my eyes opened. But I was dead. All screamed and rushed away. There was a general panic. Some jumped out of the windows. Only the Woman remained. Her gaze was fixed upon me. Eye to Eye. She said: "Friend, are you really dead?" The voice was firm and clear. No answer. The Woman asked three times. No answer. As she asked the third time I returned to my original position and was ready to be buried.—I heard one great sob. I awoke.

In the midst of the grim silence of his own funeral, a woman sud-denly appeared who brought Stieglitz temporarily back to life. While the reality of his return to life so frightened members of his "family" and his "hundreds of friends" that they abandoned him, its spiritual source was unafraid to look at him "Eye to Eye" and ask three times if he were "really dead." Because he could not communicate with the woman who questioned him, he returned to his "original position and was ready to be buried," and as the woman sobbed, she woke him from his dream.

In the poem's second stanza, Stieglitz dreamed that, despite his illness, he undertook a journey with a woman.

II

I was very ill and everyone asked me to take a rest. No one succeeded to induce me. Finally a Woman said: "I will go with you. Will you go?" We went. We tramped together day and night. In the mountains. Over snow. In the moonlight. In the glaring sun. We had no food. Not a word was said. The Woman grew paler and paler as the days and nights passed by. She could hardly walk. I helped her. And still not a word was uttered. Finally the Woman collapsed and she said, in a voice hardly audible: "Food—Food—I must have food." And I answered: "Food—Food—, Child, we are in a world where there is no Food—just Spirit—Will."—And the Woman looked piteously at me and said, half dead: "Food—Food"—and I kissed the Woman, and as I did that there stood before the Woman all sorts of wonderful food—on a simple wooden table, and it was Springtime. And as the Woman began to eat ravenously—conscious of nothing but Nature's Cry for Food, I slipped away. And I continued walking Onward.—I heard a distant cry. I awoke.

Like the woman in his first dream, the woman here was unafraid and bold. Yet, in the world of "just Spirit—[and] Will" in which she and Stieglitz traveled, she could not survive without nourishment. When he kissed her, Stieglitz provided the food she cried out for. But her physical needs prevented her from continuing her journey with him, and her cry in the end had the power to wake him.

In the third dream, Stieglitz imagined a woman who murdered him.

III

The Woman and I were alone in a room. She told me a Love Story. I knew it was her own. I understood why she could not love me. And as the Woman told me the story—she suddenly became mad—she kissed me in her ravings—she tore her clothes and mine—she tore her hair. Her eyes were wild—and nearly blank. I saw them looking into mine. She kissed me passionately and cried: "Why are you not HE?" "Why not?" and I tried to calm her. But did not succeed. And finally she cried: "What makes me kiss you—it is He I want, not you. And yet I kissed you. Kissed you as if it were He."—I didn't dare to move. It was not fear that made me stand still. It was all much too terrible for Fear. I stood there spell-bound. Suddenly the woman moved away—it was ghastly. Her look.—Her eyes.—The Woman stood immovable, her eyes glued on mine; when suddenly she screeched: "Tell me you are He—tell me—you are He. And if you are not He I will kill you. For I kissed you." I stood there and calmly said, what I really did not want to say, for I knew the Woman was irresponsible and mad. I said, "I am not He." And as I said that the Woman took a knife from the folds of her dress and rushed at me. She struck the heart. The blood spurted straight ahead, as if it had been waiting for an outlet. And as the

Woman saw the blood and saw me drop dead she became perfectly sane. She stood motionless. With no expression. She turned around. Upon the immaculate white wall she saw written in Blood Red letters: "He killed himself. He understood the kisses."—There was a scream. I awoke.

In talking of her feelings of love, the woman became passionate. She kissed Stieglitz. She "tore her clothes and mine—she tore her hair. Her eyes were wild—and nearly blank." She demanded, "Tell me you are He—tell me—you are He." When Stieglitz refused to lie to her, knowing full well that "the Woman was irresponsible and mad," she killed him. His death restored her sanity, and she read the words that had been written in blood on an "immaculate white wall" behind her— "He killed himself. He understood the kisses." As she read those exonerating words, she screamed in relief, and the sound awakened Stieglitz.

On one level, the poem, through its themes of abandonment, illness, and death, poignantly conveyed the hopelessness and isolation Stieglitz was feeling in 1915. On another, it defined the conception of woman that Stieglitz held before he met O'Keeffe—a conception that, in most respects, reflected ways in which males traditionally had thought of females. Stieglitz's dream-women were highly emotional creatures; they sobbed, cried, and screamed. They were also closely tied to nature and to their bodies—more so than men. The woman in the second stanza of the poem, for example, could not survive in the spiritual world she entered with Stieglitz. Her body demanded a form of nourishment that he could provide but that his body did not require.

The women in his dreams mirrored female stereotypes, both good and evil, that had reigned in Western art and literature for centuries. The combination of boldness and innocence of all three made them resemble the virgin heroines found in mythology and in religious narratives. The passion of the third, which turned her into a madwoman and murderess, defined her as another type: she was the temptress, Eve—a *femme fatale*. Yet, in his dreams, Stieglitz was unafraid of the powers of such women.[5]

He evidently envisioned the ideal woman as a being with whom he could share a relationship both spiritual and passionate. From his perspective in 1915, that kind of woman was a fantasy; clearly, he had not found her in his wife. But ten months after the poem was first published, while he was still in a state of despair, he saw O'Keeffe's drawings and knew immediately that the woman who had made them was extraordinary. She was "unusual . . . , broad minded, . . . bigger than most women"; and although he had no idea of what O'Keeffe

would eventually come to mean to him personally, he was quite moved by the "sensitive emotion" he sensed in her work. As Stieglitz's friend Walkowitz suggested, "from that first moment," O'Keeffe became, like her work, "an important factor in the great experiment being conducted at 291."[6]

Other dimensions of O'Keeffe's distinctiveness were made clear to Stieglitz after he displayed her drawings without her permission at 291. She considered her work too personal for public exhibition and was furious with him for showing it without consulting her. Stieglitz countered her demand to remove the drawings by arguing that her work was of great importance to American art. Although his will prevailed, the encounter demonstrated to him that she was a woman who believed strongly in her personal rights, had a passionate commitment to her work, and was determined to protect her privacy. In response to continuing, probing questions from Stieglitz about how she had come to make certain drawings, she had finally replied: "Do you think I am an idiot? I refuse to say anything more."[7]

During the years 1916–18, Stieglitz was careful to keep O'Keeffe informed of decisions he made with respect to her work and of his plans for 291; and in the process, he conveyed to her his growing professional despair. She was aware that he was planning to close the gallery after her one-woman exhibition there in the spring of 1917, and in May, after her classes had ended, she decided on the spur of the moment to go to New York to see her show. She arrived nine days after it had closed, but Stieglitz rehung it for her, and the time they spent together lifted him temporarily out of his gloom. He became motivated enough to photograph O'Keeffe, and she received prints from him shortly after her return to Texas.[8]

Their feelings for each other intensified over the next year, and soon after her arrival in New York in June 1918, they were deeply in love. In August, when he first took O'Keeffe with him to the Stieglitz estate at Lake George, his family and friends noticed his new happiness and sense of well-being. They were aware of his renewed zest for life and work and remarked that his love for O'Keeffe had effectively dispelled his somber moods of earlier years.

Although O'Keeffe was almost twenty-four years younger than Stieglitz, he found levels of satisfaction in his relationship with her that he had never enjoyed with his wife. It meant a great deal to him that O'Keeffe understood and respected his work, and it was very important to him that they could communicate about art.[9]

Many things about O'Keeffe fascinated Stieglitz. Her intensity, her

unselfconscious attitude about herself, and her openness—all—were amazing to him. As he explained in a letter to Dove in June of 1918:

> She is much more extraordinary than even I had believed. In fact I don't believe there ever has been anything like her mind and feeling. Very clear—spontaneous—and uncannily beautiful—absolutely living every pulse beat.[10]

Although Stieglitz claimed that there had never been anything like O'Keeffe, he also felt she had qualities that reminded him of himself. Another letter to Dove of 1918 goes much further to make the point than his earlier letter to O'Keeffe in which he stated that he saw "a part" of himself in her drawings. As he explained: "We are at least 90% alike—she a purer form of myself—The 10% difference is really perhaps a too liberal estimate—but the difference is really negligible."[11]

His experience with O'Keeffe provided Stieglitz more and more evidence to support and strengthen his belief that women were evolving. She was proof of the existence of a new and modern woman whose strengths as an artist could be defined as comparable to man's. This can be seen in his essay, "Woman in Art," of 1919, in which he argued equality for women as artists.

Stieglitz reasoned in the essay that men, who had traditionally dominated the field of art, could be blamed for the historical deficiency of noteworthy women artists. The system through which art had been taught in the academies had been developed by men; and, Stieglitz claimed, because that system had been designed for men, it simply could not work for women. In demanding that a woman become "what her teacher was to her," the academic tradition asked women to set unrealistic goals for themselves.[12]

Thus, the woman artist was "attempting the impossible," Stieglitz asserted, "not really realizing that she never could do what he [her teacher] did." And man had convinced himself "that no woman could ever produce a painting or bit of sculpture that was Art"; that woman's real "creative sphere was childbearing." With this statement, Stieglitz paralleled the thinking of male artist-teachers with the discoveries of male scientists, discoveries that had proven that the making of art was man's natural domain.

While Stieglitz realized that such distinctions between female and male creativity might have been true in the past, he also felt "The Social Order" was changing; the idea that true expression in the arts could only be achieved by men was no longer supportable. A woman, namely

O'Keeffe, was making art that was equal to any man's, he had determined. But while O'Keeffe's work could be seen as equal to men's, Stieglitz also believed it was different from theirs, and he was quite specific about why. The art of women and men was "differentiated through the difference in their sex make-up," he stated. "Woman *feels* the World *differently* than Man feels it." And although Stieglitz was not precise about the origin of the emotions men felt and conveyed through their work, he was quite specific about the source of emotions in women: "The Woman receives the World through her Womb. That is the seat of her deepest feeling."[13]

But Stieglitz also wrote: "Of course Mind plays a great role in the development of Art," declaring his belief that although expression in art was fundamentally dependent upon the unconscious, its realization could not be achieved without the powers of intellect—a belief he had shared with other members of his circle for years.[14] He insisted that all inventive impulses, though derived from the unconscious, were filtered through the intellect at some point during the process of making art and that women artists made the same rational, technical decisions with respect to their work that men did. Although he proclaimed that O'Keeffe experienced the world first in terms of her feelings, he added that these "experiences gradually take form in her mind—& then she puts this down on canvas or paper."

Because he was committed to the notion that the unconscious was the source of all human creativity, he assumed that the same sequence of events occurred when men created art: the process was initiated by feeling and then actualized through the intellect. This order, then, was fundamental to the making of art, only "the original generating feeling" was different in men and women. But if Stieglitz believed that the creative process was the same in both women and men and that the feelings of women came from organs associated with their sexuality, it seems probable that he also believed men's feelings were different from women's because they originated in specifically male organs.

He had initially described O'Keeffe as "unusual," and his essay makes it clear that he had been referring to the power of her feelings. They distinguished her from other women:

> In the past a few women may have attempted to express themselves in painting. . . . But somehow all the attempts I had seen, until O'Keeffe, were weak because the elemental force & vision back of them were never overpowering enough to throw off the Male Shackles.

He maintained that women had always had strong feelings as artists but that, "until O'Keeffe," no woman had been strong enough or determined enough to break away from the patterns of making art that had been invented by men and taught to women by male teachers.

The fact that O'Keeffe had rejected a fundamental premise of what she had been taught in 1905–6 at the Chicago Art Institute and in 1907–8 at the Art Students League in New York was one indication of her strength and determination. In the summer of 1908, she had temporarily dismissed the idea of becoming an artist because she could see no alternative to painting in the ways her training had demanded—representationally and mimetically—and she found those ways both uninteresting and unproductive. Her enthusiasm about art had been rekindled in 1912 by the modernist concepts of Alon Bement, a professor from Columbia University who was teaching summer school at the University of Virginia. Bement introduced O'Keeffe to the theories of the head of the fine arts department at Columbia, Arthur Wesley Dow, who had worked with Paul Gauguin at Pont-Aven and, in addition, had developed a profound understanding of Eastern art through his association with the noted Orientalist, Ernest Fenollosa. Dow's approach to harmonious pictorial organization was thus decidedly outside the mainstream academic tradition, and O'Keeffe learned it firsthand in 1914–15 by taking courses with him at Columbia.[15]

O'Keeffe had made another important, liberating decision concerning the focus of her art when she determined in the fall of 1915 that she would work to please herself, rather than her former teachers or anyone else. The drawings that brought her to Stieglitz's attention had been the result of that decision, and by 1919, Stieglitz was convinced that the "elemental force & vision" that he had seen in those drawings and in her subsequent work was evidence that she had transcended the "Male Shackles." He declared that "in O'Keeffe's work we have the Woman unafraid—the child—finally actually producing Art!"

There was no question in Stieglitz's mind that what O'Keeffe—this unafraid and innocent child-woman—was making was art: "*Her* Vision of the World," her "pictures or whatever you wish to call them . . . make us *feel* a bigness—something that Art always does—a religious intensity . . . [that can] satisfy our aesthetic sense." As a woman, her "Vision of the World" was "intimately related to Man's—nearly identical," and her "feeling for Nature . . . [and] for life" was "quite as creative as any man's I've met." Thus, his experience with O'Keeffe allowed Stieglitz to conclude his essay with the claim: "Woman is beginning [to make art]—the interesting thing is *she has actually begun.*"

By the time he wrote "Woman in Art," Stieglitz had decided that

O'Keeffe's work generated the aesthetic response "that Art always does," and thus was as expressive as men's art: it could make him feel a "bigness" that he described in religious terms. But he was also committed to the idea that, although O'Keeffe's art might be equal to men's art, it was also significantly different. In fact, in Stieglitz's view, O'Keeffe's art was "different from anything we have ever seen," and thus, it was incomparable to men's art. It was in a class by itself.

He had reached the conclusion in 1916 O'Keeffe's work revealed a new truth about female nature. This idea, which would be extremely important to the criticism her art generated in the twenties, was restated with conviction in "Woman in Art." Before O'Keeffe, he wrote, woman had kept *"her* secret"; she had been "Man's Sphinx!!" But the "Woman unafraid" Stieglitz perceived in O'Keeffe had permitted her work to express what every other woman artist had kept to herself—her sexual feelings.[16]

Stieglitz's review of O'Keeffe's first show at 291 demonstrated that he understood her work as an expression of sexual power, and the fact that he continued to do so into the twenties is made clear in two poems that were first published in 1922, though he had written them by early April of 1918.[17] Sometime after they were written, each was titled "Portrait—1918," which links the poems to the year O'Keeffe moved to New York.

The subject of the poems is the same: the union between a man and a woman. And although the degree of intimacy between O'Keeffe and Stieglitz before they began living together in July of 1918 can only be a matter of speculation, the poems must have been inspired by his fantasies about their developing relationship.[18]

In the first poem, Stieglitz portrayed a woman who was a composite of the courageous, pure, and passionate women of his earlier dream-poems.

> The Stars are Playing in the Skies
> The Earth's Asleep—
> One Soul's Awake
> A woman
>
> The Stars Beckon—
>
> Her Room is a Whiteness
> Whiteness Opens its Door
> She Walks into Darkness
> Alone
> With the Night—alone with the Stars

A Mountain nearby
Its peak near those Stars—
She climbs the Steep Mountain
Alone—
To the Top.

Her bed is its back
Her blanket the sky
Her eyes smiling Starlight
Her lips are half-open
And moist with Night's Dew

The Blue of the Heavens
Comes Down to those Lips
Takes Form

The Stars are Playing in the Skies

The Woman Walks Homeward
To her Little White Room
No longer Alone
She Carries Dawn
In Her Womb.

Stieglitz no longer imagined himself isolated, impotent, or dead. Rather, he was the godlike "Blue of the Heavens" whose creative powers were active. He made love to a soul of whiteness that he imagined as a form in nature, a mountain—Mother Earth. His communion with this solid, pure, and powerful female spirit, furthermore, did not lead to a destructive end as he had imagined in his poem of 1915. Rather, as the pure white spirit received "those Lips," she, in union with him, became capable of creating the future: she walked "Homeward" carrying "Dawn In Her Womb." Clearly, Stieglitz associated every aspect of woman's creativity with her womb, but his poem further implied that her creativity was a component of her sexuality and therefore was irrevocably dependent on man for its realization.

In the second poem, Stieglitz made this dependence clearer as he celebrated his ability to nourish the hungers of a passionate and pure being.

The flesh is starving
Its soul is moving starward
Seeking its own particular star
A man intercepts
Receives the flesh
Millions were ready to receive it
The flesh is no longer starving

Its soul keeps moving starward
Seeking its own particular star.

Apparently, the woman of these poems transcended the female types Stieglitz had imagined in "One Hour's Sleep Three Dreams." She, and the intensity of their relationship, had restored him to life: he was able to "intercept" the "soul" and to "receive the flesh." And from the line "The flesh is no longer starving," one can only assume that he envisioned the woman's creativity as dependent on his own, transferred to her through their sexual union.

It is not possible to know whether Stieglitz believed he was fueling O'Keeffe's creativity in their early days together in New York (as he had with the woman of the second poem). It is clear, however, that soon after they started their life together, the excitement and intensity of their relationship rekindled Stieglitz's creative powers. In 1918, with great energy, he began a photographic study of O'Keeffe that would document the extent of his passion for her and, over a period of two decades, how the nature of that passion evolved. The photographs Stieglitz had made of her when she visited him in June of 1917, though distinctive, do little to suggest the authority of the ones he made after she moved to New York. With an eloquence rare in any medium, those prints began to express the complexities of his relationship with O'Keeffe and, at the same time, the complexities of her nature and personality (figs. 1–3).

The composite "portrait," as he referred to it, recorded almost every dimension of O'Keeffe and almost every part of her body in sharply focused, straightforward photographs.[19] Sometimes she stood before his camera and stared directly into it, conveying the power of her presence and directness of her manner. In some of these prints, she was dressed in starkly tailored suits and crisp hats, or she posed with a cape wrapped dramatically around her body. She seemed bold, daring, and sure of herself, rather like the courageous women Stieglitz had dreamed of in 1915.

In other prints, however, she wore a simple dress or a blouse and skirt, looked away from the viewer, and conveyed a passive and demure innocence. In this guise, she can be likened to the vulnerable women of his first and second dreams.

From photographs that presented O'Keeffe as a sexual creature, a third type of woman emerged. Whether she confronted or seemed unaware of the camera, Stieglitz photographed her body in a variety of exotic poses. Often she wore a white chemise or dressing gown, which fell loosely around her body, or she posed completely in the nude,

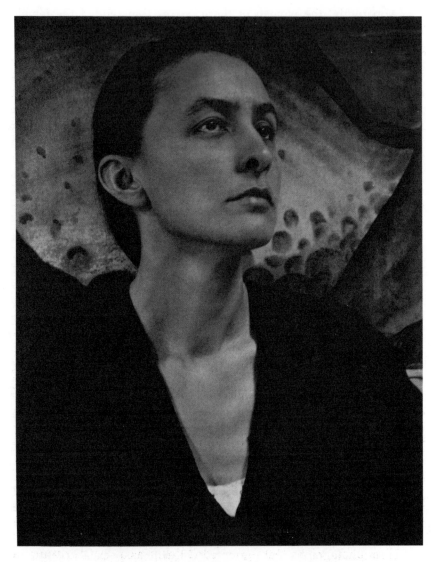

Figure 1. Alfred Stieglitz, *Georgia O'Keeffe: A Portrait—Head*, 1918
Palladium print, 9¹/₂ × 7⁵/₈ in.
(*National Gallery of Art, Washington, D.C., Alfred Stieglitz Collection*)

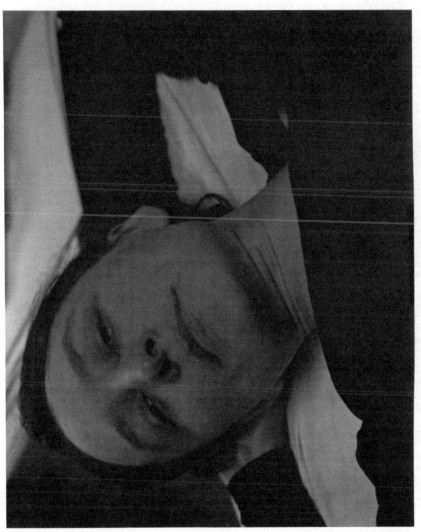

Figure 2. Alfred Stieglitz, *Georgia O'Keeffe: A Portrait—Head*, 1918
Palladium print, 7^{13}/$_{16}$ × 9^9/$_{16}$ in.
(National Gallery of Art, Washington, D.C., Alfred Stieglitz Collection)

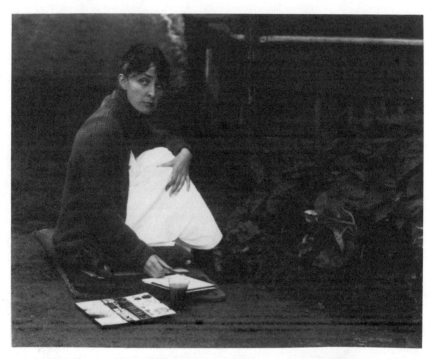

Figure 3. Alfred Stieglitz, *Georgia O'Keeffe: A Portrait*, 1918
Gelatin silver print, $3^9/_{16} \times 4^1/_2$ in.
(*The Baltimore Museum of Art. Gift of Cary Ross.* BMA 1940.124)

sometimes lying amidst crumpled bed sheets. In these photographs, she became an alluring and provocative female.[20] In others, using only portions of O'Keeffe's body, Stieglitz conveyed the essence of her sexual power at the same time that he overtly declared his compositional skills as a photographer. Throughout, O'Keeffe seemed completely at ease with herself.

Stieglitz made numerous close-up shots of head, neck, shoulders, breasts, torso, legs, and feet. He photographed her at such close range, in fact, that his intention seems to have been to record the configuration of and, at the same time, to suggest the energy contained within every surface aspect of O'Keeffe's body.

By repeatedly posing her with her work, Stieglitz also made it clear that the woman in his photographs was an artist, and in this persona, O'Keeffe often seemed quite serious and intense (fig. 1). Occasionally, however, she stood self-consciously in front of a drawing or a painting, like a shy adolescent. In the photographs he made of her arms, hands, or fingers gesturing before her work, Stieglitz established visual correlations between the forms of O'Keeffe's imagery and those of her body and thereby implied a dynamic relationship between the two (fig. 4).

Stieglitz had been photographing O'Keeffe steadily for over two years when Mitchell Kennerley, owner of the Anderson Galleries, asked him in December of 1920 if he would be interested in exhibiting his work there the following February. Stieglitz welcomed the opportunity and decided that the presentation would be retrospective. But his agreement to get an exhibition ready on such short notice suggests his confidence in the importance of his newest work, which, as Henry McBride's review in the *New York Herald* pointed out, had already generated "much private conjecture."[21]

The show opened on 7 February and was entitled "An Exhibition of Photography, by Alfred Stieglitz [145 Prints, Over 128 of Which Have Never Been Publicly Shown, Dating from 1886–1921]." Because Stieglitz had not exhibited his photographs since 1913 and because he had been essentially absent from the art world since 291 closed in 1917, the show was the occasion of a celebration both of his life work and of his return to prominence in the art world. Reviewers were convinced that the exhibition confirmed his position as America's leading photographer, and the fact that Stieglitz and his talk (which McBride described as "copious, continuous and revolutionary as ever") were again present in a gallery made it seem to his friends that the spirit of 291 had resurfaced at the Anderson.[22]

Almost one-third of the prints Stieglitz exhibited were of O'Keeffe, and anyone who had been unaware of her before the show would

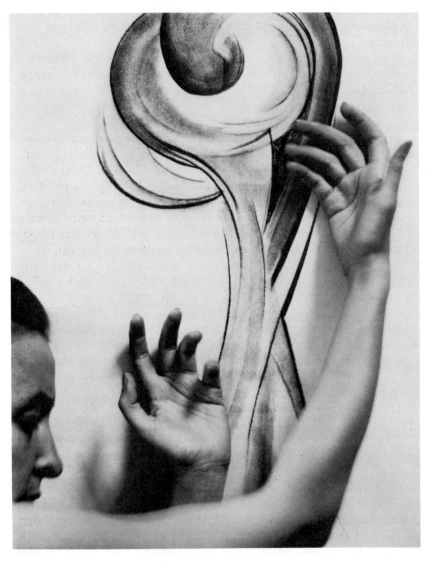

Figure 4. Alfred Stieglitz, *Georgia O'Keeffe: A Portrait*, 1918
Gelatin silver print, 9⁷/₁₆ × 7¹/₂ in.
(*National Gallery of Art, Washington, D.C., Alfred Stieglitz Collection*)

certainly never forget her after seeing it. As McBride later recalled, the photographs depicted "every conceivable aspect of O'Keeffe" and were "a new effort in photography and something new in the way of introducing a budding artist." About the show, he continued: "It made a stir. Mona Lisa got but one portrait of herself worth talking about. O'Keeffe got a hundred. It put her at once on the map. Everybody knew the name. She became what is known as a newspaper personality."[23]

The sensation the O'Keeffe prints created could not have surprised Stieglitz. Although the female nude as subject was a traditional one for artists and had long been taken up by photographers, sharply focused photographs of the female nude were hardly regular fare in New York art galleries.[24] But Stieglitz was not only aware that the nudes in his O'Keeffe portrait would create a stir, he also could not resist initiating even more controversy. He tantalized visitors to the exhibition by implying in the catalogue that the works on view were among his more modest achievements: "Some important prints of this period are not being shown, as I feel that the general public is not quite ready to receive them."[25]

McBride's second review, which was published in the April 1921 issue of the *Dial*, reported another way in which Stieglitz had heightened the sensation of the show.

> Alfred Stieglitz, with his photographs, provided the nearest approach to an excitement that we have had in a month. People did stop you on the street to tell you that you ought to see them and people did dispute about them. Alfred's former disciples from the old Gallery of the Photo-Secession clung to him loyally. To a man they vowed that every one of the photos was great—the greatest ever. Professional photographers whom I chanced to meet told me that they didn't like them—didn't like them at all in fact. One professional photographer told me that he actually felt physical pain when he beheld them and he clapped his hands to his side as though the agonies were to begin all over again at the mere thought. And then, all at once, someone ran down Fifth Avenue crying that Alfred Stieglitz had put a price of $5,000 on one of the photographs, a nude, one that was a unique impression with the plate destroyed. Gracious Heavens! $5,000 for a mere photograph! And then everyone had to go see the exhibition over again, the crowd about the nude being particularly dense.
>
> But that's Alfred for you.[26]

By asking $5,000 for one of his photographs, Stieglitz equated its value with what would have been, in 1921, an expensive painting. The gesture drew everyone's attention, thereby heightening the appeal of the show and increasing attendance. But Stieglitz was not asking $5,000 merely for a photograph, he was asking it for a photograph of O'Keeffe

in the nude. Although from the beginning the exhibition had created much talk about the photographer and his model, Stieglitz's action could only have increased public speculation. And whether he intended to do it or not, by implying that this fascinating woman and artist was his high-priced and exclusive property, he objectified O'Keeffe even more than his photographs may have on their own.[27]

If the people who were attracted to the exhibition were not convinced of Stieglitz's assertion of the value of his photographs, apparently they could not help being profoundly affected by them.[28] As Stieglitz observed: "People came again and again. At times, hundreds crowded into the rooms. All seemed deeply moved. There was the silence of a church."[29] Several of Stieglitz's associates later recalled that they had responded to the photographs of O'Keeffe as documents of Stieglitz's love for her and, at the same time, as explorations of the nature of love in its broadest sense.[30]

How Stieglitz's work was perceived at the time by his associates is made clear in the essays Strand and Rosenfeld wrote in response to the show.[31] Both men maintained that Stieglitz had elevated photography to the status of art. And, moreover, by creating art with the camera, a relatively new, scientific tool, Stieglitz had unified two seemingly incompatible forces within twentieth-century American culture.

Strand interpreted the synthesis of these polarities as a major step in the history of photography, but he did not refer directly to the photographs shown at Anderson's in his elaborate discussion of this dimension of Stieglitz's accomplishment. Rosenfeld stated that "each of the instants fixed by Stieglitz and his machine [has] the weight of a sum of life";[32] and unlike Strand, in addition to celebrating the photographs as art and as universal statements, he also described both how they looked and how they affected him.

Rosenfeld's commentary is an indication of the complexity of his response to the woman he saw in Stieglitz's portrait of O'Keeffe. She was an ethereal creature, "a pure and high expression of the human spirit," but she was also "something of what human life always is." She appeared to be a quintessential female, a form that, with "white cloths draping the arms, stands ecstatic in the window-light, greeting the light no man can see." But who was she really? "Is it the call to death the releaser?" Rosenfeld asked. "Is it the piercing cry of the human being for the life of its soul?"[33]

A suggestion of timelessness in "the brief sudden smile or fixation of the gaze, . . . the restless play of the hands," however, transformed O'Keeffe into "something that looks out over the ages, questioningly,

wistfully, pityingly." She became "a sort of epilogue to the relations of women and men." In Stieglitz's exhibition, Rosenfeld declared, "Sphinxes look out over the world again," and "these arrested movements are nothing but every woman speaking to every man."[34]

But, of course, sphinxes were also symbols of the mysterious sexual powers of women, and Stieglitz had made the reality of O'Keeffe's sexuality explicit. As Rosenfeld pointed out:

[He has] based pictures not alone on faces and hands and backs of heads, on feet naked and feet stockinged and shod, on breasts and torsos, thighs and buttocks. He has based them on the navel, the *mons veneris*, the armpits, the bones underneath the skin of the neck and collar. He has brought the lens close to the epidermis in order to photograph, and shown us the life of the pores, of the hairs along the shin-bone, of the veining of the pulse and the liquid moisture on the upper lip.[35]

There can be little question that Rosenfeld found these images erotic. He stated that he had an urge to "touch" them and wanted to experience what Stieglitz had "felt" in making them: "the life of every portion of the body of [woman]." But Rosenfeld perceived all of the photographs in sexual terms—as documents of the submission of their subjects, animate or inanimate, to Stieglitz's will and desire. As he explained in his essay, whether the photographs were of "the dirt of an unwashed window pane, a brick wall, a piece of tattered matting, [or] the worn shawls of immigrant women," they were "as wonderful, as germane to his spirit, as the visage of a glorious woman, the regard of ineffable love out of lucent unfathomable eyes, the gesture of chaste and impassioned surrender."[36] For Rosenfeld, the photographs of O'Keeffe, like all of Stieglitz's work, were a revelation of the photographer's own claim: "Each time I photograph I make love."[37]

The extent to which Stieglitz's photographs of O'Keeffe affected Rosenfeld's perception of her and her art is evident in two essays he wrote in 1921–22. Some ten months after the Stieglitz exhibition, an article by Rosenfeld called "American Painting" was published in the *Dial*, and O'Keeffe was among the younger artists he considered, along with Dove, Hartley, and Marin (Appendix A, no. 6). Although her work had not been on public display since 1917, Rosenfeld had been able to see it regularly. O'Keeffe worked in the rooms she and Stieglitz shared, and their living quarters had become as much a gathering place for the Stieglitz circle as 291 had been before it closed. In 1922, Rosenfeld also previewed O'Keeffe's 1923 show in the October issue of *Vanity Fair*[38] (Appendix A, no. 8). That article, which was illustrated with a Stieglitz photograph of her (fig. 5), was essentially a more polished and elaborate

version of his comments about O'Keeffe in "American Painting." Thus, both can be discussed as one.

Rosenfeld referred to O'Keeffe precisely in terms of the female types Stieglitz's photographs had suggested—"a white radiance," an "innocent one," "a girl." And, in words that seem to derive almost exactly from Stieglitz's essay "Woman in Art," he made it clear that he believed O'Keeffe's art emanated from her womb. Her paintings, he stated, "registered the manner of perception anchored in the constitution of the woman. The organs that differentiate the sex speak. Women . . . always feel, when they feel strongly, through the womb"[39] (Appendix A, no. 6).

Rosenfeld evidently agreed with Stieglitz that O'Keeffe was an unusual woman, and he implied that the seat of O'Keeffe's feelings, combined with her "[artist's] orientation," is what made her rare: "Because she feels clearly where she is woman most; because she decides in life as though her consciousness were seated beneath her heart where the race begins; she . . . perceives as few others have perceived." He declared that "what she is within herself . . . becomes visible to her in external objects" (Appendix A, no. 8).

She was, in fact, "one of those who seem the forerunners of a more biologically evolved humanity" because "her consciousness is akin to something that one feels stirring blindly and anguishedly in the newest men and women all through the land." He described her as a female counterpart to D. H. Lawrence—"one of those persons of the hour who . . . show[s] an insight into the facts of life of an order wellnigh intenser than we have known" (Appendix A, no. 8).

Rosenfeld was also convinced, like Stieglitz, that O'Keeffe's paintings were revelations of her sexuality: they led man "further and further into the truth of a woman's life."

> The pure, now flaming, now icy colours of this painter, reveal the woman polarizing herself, accepting fully the nature long denied, spiritualizing her sex. Her art is gloriously female. Her great painful and ecstatic climaxes make us at last to know something the man has always wanted to know. . . . All is ecstasy here, ecstasy of pain as well as ecstasy of fulfilment. (Appendix A, no. 6)

But Rosenfeld did not apply his understanding of the sexual dimensions of art merely to O'Keeffe's work. In agreement with Stieglitz and theorists in the field of human sexuality like Freud and Havelock Ellis, Rosenfeld was of the opinion that sexual drive played a major role in the creation of all art—whether it was the work of a man or a woman. In 1906, Ellis had written: "The stuff of the sexual life . . . is the stuff of

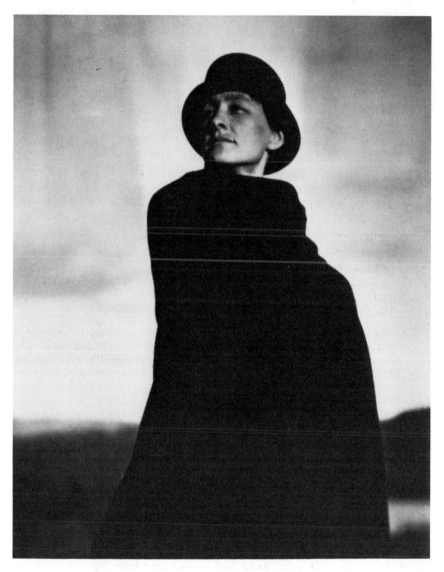

Figure 5. Alfred Stieglitz, *Georgia O'Keeffe: A Portrait*, 1920
Gelatin silver print, $4^9/_{16} \times 3^9/_{16}$ in.
(*National Gallery of Art, Washington, D.C., Alfred Stieglitz Collection*)

art."[40] The manifestations of O'Keeffe's sexuality in her art were not only exciting to Rosenfeld, but they also made it possible for him to argue for another of Stieglitz's contentions, that her art could be equated with a man's.

In 1924, Rosenfeld included in his book *Port of New York* an essay about Dove in which he compared his art with O'Keeffe's: "[Dove's] manner of uniting with his subject matter manifests the mechanism proper to his sex as simply as O'Keeffe's method manifests the mechanism proper to her own" (Appendix A, no. 27). He had stated in "American Painting" in 1921 that Dove's talent was "virile" and part of a man who "exhibits a grasp of the whole life, takes in the animal with the spiritual, the gross teeming earth with a translucent sky."[41] O'Keeffe's art, he believed, was "gloriously female" and "leaves us breast to breast with the fluent unformed electric nature of things" (Appendix A, no. 6).

The vital sexual forces that were present in O'Keeffe's and Dove's work, however, were blatantly absent in, for example, Albert Pinkham Ryder's, as Rosenfeld had also demonstrated in "American Painting." Seen in Rosenfeld's eyes, Ryder's work was "the first great expression of the American world in the medium of paint," but it also revealed the "incapacity of his genius." As he explained:

> The canvases of Rubens and of Renoir, men born fully contacting life, fully developed in body and ghost; the canvases of Cézanne, of Greco, of Rembrandt at his best, men born Puritans, like Ryder, but born powerful enough to overcome their limitation, are convex at the very base of the canvas, commence swelling with forms of large amount in their foreground. Forms tangle and increase and burst, launch themselves from the edge of the frame into the middle and the backgrounds of the paintings. And the middle-ground and the background [are] no less full and exciting than the immediate fore. For in these men, the animal nature was fully spiritualized; the genitals were not excluded from the dream of beauty, but contributed to it; and the portion of the canvas which is most directly related to the abdominal centres of the human being, the foreground, was made as rich and expressive as any of the painting. . . . The Ryders, which stem from the undeveloped sensuality of the gilded age, . . . almost never . . . commence their swell at the lower edge of the picture. The lower edge of your Ryder, indeed, is almost sure to be an evasion, a space hidden in darkness, passed over.[42]

Obviously, Rosenfeld believed that Ryder's sexual repression affected his work. O'Keeffe, as he had determined from Stieglitz's photographs of her, was not similarly repressed. She was, in fact, "pouring out . . . her Woman self," as Stieglitz had put it, with such an intensity that her art was permeated with sexual power—what Rosenfeld called "the truth of a woman's life" (Appendix A, no. 6).

Rosenfeld asserted that a "male vitality" was being "released" in Dove's work that came directly from the "nether trunk, the gross and vital organs, the human being as the indelicate processes of nature have shaped him."[43] O'Keeffe's art was releasing a similar vitality; in it, "there appears to be nothing that cannot be transfused utterly with spirit, with high feeling, with fierce clean passion" (Appendix A, no. 6).

Yet the language Rosenfeld used to describe O'Keeffe's and Dove's art indicates that he understood the power of art, whether made by a woman or a man, in terms that were beyond mere sexual energy. For example, although Rosenfeld described O'Keeffe's art as an outpouring of her womb, which implied that her expression derived from sources solely within herself, he also characterized it using words that suggested its dependence on a force outside herself. Early in the *Vanity Fair* essay, he wrote: "Chords of complementary colors are made to abut their flames directly upon one another, filling with delicate and forceful thrust and counterthrust the spaces of her canvases" (Appendix A, no. 8). And later, he added:

> Precisely as in her harmonies, the widest plunges and the tenderest gradations play against each other, and fuse marvellously, so do severe, almost harsh forms combine with strangest, most sensitive flower-like shapes. In these masses there lives the same subtlety in bold strokes, the same profound effects in daintiness. Rigid, hard-edged forms traverse her canvases like swords through cringing flesh. Great rectangular menhirs plow through veil-like textures; lie in the midst of diaphanous color[,] like stones in quivering membranes. . . .
>
> But, intertwined with these naked spires thrusting upward like Alp-pin[n]acles, there lie the strangest, unfurling, blossom-delicate forms . . . [that] seem slowly, ecstatically to unfold before the eye. It is as though one had been given to see the mysterious parting movement of petals under the rays of sudden fierce heat.

It is clear that, by imposing a language upon his description of O'Keeffe's art that suggested the rhythms and movements of the sexual act, Rosenfeld perceived it as an expression of sexual union.

He heightened the sensuality of his description of her work by including words that related to the body: "organs," "recumbent figure," "flesh," "membranes," "naked," "unbound hair," "long tresses," "cheeks and brows," "full-breasted," and "trembling lips." He even characterized passages in her paintings as moving from "breast to breast," and suggested that the lines within her works seemed to have been "licked on with the point of the tongue."

Such language is especially interesting considering the rarity of human figures in O'Keeffe's art and the high degree of abstraction of those that exist. It can only have been O'Keeffe herself that inspired this aspect of Rosenfeld's writing; when he looked at her painting, what he

had seen in Stieglitz's photographs dominated his perception. As a consequence, his reading of her art was informed by his reading of Stieglitz's portrait of her.

The fact that Stieglitz also thought of O'Keeffe's imagery as an expression of her eroticism can be seen in one of the photographs he exhibited in 1921 (fig. 6). It shows two extremely provocative examples of her work, a phallus-shaped plaster sculpture that O'Keeffe made in 1916 and a painting she completed three years later, *Music—Pink and Blue, I* (1919, The Barney Ebsworth Collection), containing a form that strongly resembles female sexual anatomy. Stieglitz's juxtaposition of the two suggests an interaction between them.

Rosenfeld had made reference to this photograph in his review of Stieglitz's exhibition. Within a composite description of the photographs of O'Keeffe, he wrote:

> Pain coils a human being in its brazen hell, as an arm coils about a recumbent form. Sorrowful and knowing eyes gaze out; the navel is the centre of anguish, the point of an anguish that eats away the life within; a human being at bay flares up like a lioness threatened; breasts hang tired and sensitive, sore from too much pain. A tiny phallic statuette weeps; is bowed over itself in weeping; while behind, like watered silk, there waves the sunlight of creation.[44]

He used an extraordinarily similar language when he wrote about O'Keeffe's art. For example:

> Pain treads upon the recumbent figure. Pain tears the body with knives. Pain sets the universe with shark's teeth. Then again, the span of heaven is an arch of bloom. A little red flower with pistil of flame is in paradise. A climax of many seraphic tints holds as though the final great burst of the Liebestod were sustained many minutes. Veils of ineffable purity rise as the mists of the summer morning from lakewater. (Appendix A, no. 6)

Stieglitz's portrait presented a woman whose sexual nature was only one dimension of her being. And although Rosenfeld's perception of O'Keeffe was clearly based on Stieglitz's perception of her, he failed to call attention to many of the dimensions of O'Keeffe that emerged in the photographs. Rather, he concentrated on the aspect of her that he felt most relevant to the forms of her imagery and, obviously, that was most exciting to him—her sexuality.

Before either of the Rosenfeld articles appeared, Marsden Hartley included a discussion of O'Keeffe in "Some Women Artists in Modern Painting," the thirteenth chapter of his book *Adventures in the Arts*, which was published in September of 1921.[45] Hartley also assumed that

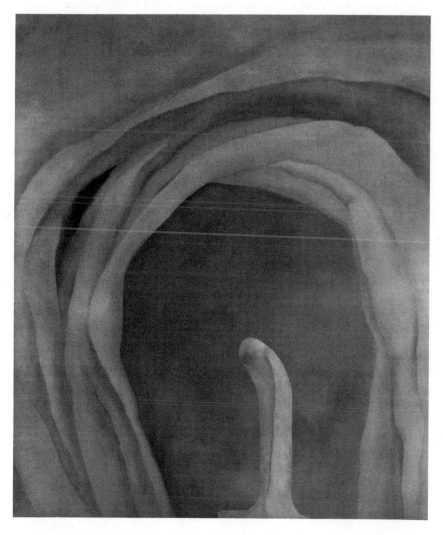

Figure 6. Alfred Stieglitz, *Georgia O'Keeffe: A Portrait—Painting and Sculpture,*
1919
Palladium print, $9^3/_{16} \times 7^5/_8$ in.
(National Gallery of Art, Washington, D.C., Alfred Stieglitz Collection)

O'Keeffe's art was an expression of sensibilities that were different from a man's, and though less directly than Rosenfeld, he suggested that her work could be understood as the passionate outpouring of her womb. "With Georgia O'Keeffe," he wrote, "one takes a far jump into volcanic crateral ethers, and sees the world of a woman turned inside out" (Appendix A, no. 5), intimating that O'Keeffe's paintings had externalized the internal; that her art originated from within her body.

Throughout his essay it is clear that Hartley, like Rosenfeld, responded to O'Keeffe and her imagery in terms of Stieglitz's photographs of her. He described her as "gaping with deep open eyes and fixed mouth at the rather trivial world of living people" and called her art "unqualified nakedness of statement." It had been made, moreover, by a woman who met life unafraid: she "has had her feet scorched in the laval effusiveness of terrible experience; she has walked on fire and listened to the hissing vapors round her person." As a result, to Hartley, her paintings were "probably as living and shameless private documents as exist"—a clear reference to the unrepressed sexuality of the woman in some of Stieglitz's photographs.

Hartley's characterization of O'Keeffe was directly dependent upon the female types Stieglitz had portrayed in his photographs. She was both an exemplar of the pure and the passionate, a spirit of good and evil, a symbol of salvation and sin. On the one hand, she was "nearer to St. Theresa's version of life as experience than she could ever be to that of Catherine the Great or Lucrezia Borgia." As he explained: "[She] wears no poisoned emeralds. She wears too much white; she is impaled with a white consciousness." On the other hand, she was a "Sphynxian sniffer at the value of a secret"; a woman who "had seen hell" but whose paintings were necessarily abstractions because of her "too vicarious experience with actual life."

Some of what Hartley thought about O'Keeffe must be assumed from what he wrote about color in her work. He found "more red in her pictures than any other color." But by the time he discussed the red in O'Keeffe's paintings, he had already assigned it a very specific meaning in *Adventures in the Arts*. In the book's seventh chapter, "Our Imaginatives," he made a specific association between the color red and a female. When he wrote about the art of George Fuller, he asked: "Why is it I think of Hawthorne when I think of Fuller? Is there a relationship here, or is it only a similarity of eeriness in temper? I would suspect Fuller of having painted a Hester Prynne excepting that he could never have come to so much red in one place in his pictures."[46]

The nature of O'Keeffe's relationship with Stieglitz, though hardly a secret from the beginning, had been made quite public in Stieglitz's

exhibition in early 1921. In fact, much of the expressive power of all Stieglitz's early photographs of O'Keeffe is contained within the intimacy they describe between photographer and model. It seems clear that, whether he was conscious of it or not, Hartley was alluding to that intimacy in *Adventures in the Arts*. Certainly, through the organization of the book, he invited careful readers to draw parallels between his remarks about the red in Fuller's paintings and the red in O'Keeffe's paintings and thus to associate O'Keeffe herself with Hawthorne's famous adulteress and the devastating sexual urges that controlled her nature.

Nothing in the essays Hartley and Rosenfeld wrote about O'Keeffe in 1921–22 indicates that they responded to the Stieglitz portrait for what it conveyed about her identity and independence as an artist and about her commitment to her work. Before anything else, they saw O'Keeffe as the erotic creature Stieglitz had defined in some of the prints, and they understood her work as he did—as a manifestation of her sexuality. As a consequence, their descriptions of her work contributed as much as their descriptions of her to the elaborate, provocative image of her that emerged from their essays.

In 1922, when she was given the opportunity to do so, O'Keeffe introduced her own voice into the criticism. The way she chose to publicize herself demonstrates her fundamental disagreement with how she had been promoted by Hartley and Rosenfeld and, for that matter, by everyone else who had written about her. Her efforts along these lines are the first indication of the role she would play in developing an image of herself in the twenties and in trying to redirect the criticism.

3

Georgia O'Keeffe, American

It is impossible to believe that O'Keeffe did not suspect how controversial Stieglitz's photographs of her would be when they were exhibited. They expressed the intensity of the earliest period of their relationship—an intensity O'Keeffe referred to obliquely when she recalled the 1921 exhibition much later:

> Several men—after looking around awhile—asked Stieglitz if he would photograph their wives or girlfriends the way he photographed me. He was very amused and laughed about it. If they had known what a close relationship he would have needed to have to photograph their wives or girlfriends the way he photographed me—I think they wouldn't have been interested.[1]

But how O'Keeffe thought the photographs might be received or how she reacted to the way they were received can only be a matter of speculation. There are no documents available that indicate either. In addition, there is no record that she ever communicated to anyone displeasure with the fact that Stieglitz exhibited them. She did, however, express her reaction to Stieglitz's persistence in asking her to pose and to the difficulties involved with the long exposure times some of the photographs required. Late in her life, for example, she recalled Stieglitz's annoyance when she was unable to hold still: "I was often spoiling a photograph because I couldn't help moving—and a great deal of fuss was made about it."[2]

A remark she once made to Pollitzer about the photographs may be the best indication of O'Keeffe's ultimate reaction to being their subject. She said: "I felt somehow that the photographs had nothing to do with me personally."[3] And in 1978, she wrote about how distant from them she had become:

> When I look over the photographs Stieglitz took of me—some of them more than sixty years ago—I wonder who that person is. It is as if in my one life I have lived

many lives. If the person in the photographs were living in the world today, she would be quite a different person—but it doesn't matter—Stieglitz photographed her then.[4]

Pollitzer noted that O'Keeffe "had a profound respect for . . . [Stieglitz's] work and what he was achieving through it" and that in posing for the photographs, she was assisting him with a problem he had long been interested in. As she explained about the beginning of the project:

> Stieglitz had had the idea for some time, long before he knew Georgia, of doing a series of photographs on woman—not woman stylishly gowned or languorously draped—but woman. This was the first period when he did not have a place of his own in which to work, but here at last was someone who understood the importance of his photographs and wished to help him get the pictures he wanted.[5]

Although there is no question that Stieglitz objectified the female body in some of the photographs, in others he defined a strong, spirited, serious artist and woman. He conveyed the depth of O'Keeffe's character and the vibrancy of her being, as well as the beauty of her form. Despite her later reaction to the photographs, O'Keeffe was intrigued with the complexity of what she first saw in them. As Stieglitz reported in a 1918 letter to Strand: "Whenever she looks at the proofs, she falls in love with herself—Or rather her Selves—There are very many."[6]

O'Keeffe had been fascinated with the very first photographs Stieglitz made of her during her 1917 visit to New York: "In my excitement at such pictures of myself I took them to school and held them up for my class to see," she noted sometime later. "Nothing like that had come into our world before."[7] She stated that the photographs changed her perception of herself: "You see, I'd never known what I looked like or thought about it much. I was amazed to find my face was lean, and structured. I'd always thought it was round."[8] She also implied, in reference to Stieglitz's portrait of her, that it had given her an insight into herself and had been a positive force in her work: "I know now that most people are so closely concerned with themselves that they are not aware of their own individuality. I can see myself, and it has helped me to say what I want to say—in paint."[9]

The Stieglitz photographs of her probably had a much more direct effect on her art, although she never referred to it specifically. It seems obvious that they influenced O'Keeffe's thinking about abstraction. The lines, shapes, and textures of her body interacted in the photographs to create precisely contoured, sensuous, abstract forms and patterns. Similar configurations can be found in O'Keeffe's abstractions of the late

teens, such as *Black Spot No. 2* (1919, private collection) or *Series I, No. 8* (1919, Estate of Georgia O'Keeffe).[10]

O'Keeffe first recorded how she felt about Stieglitz's work in an essay she prepared in the summer and fall of 1922 for the December number of *MSS*.[11] As part of her response to the question the title of the issue raised, "Can a Photograph Have the Significance of Art," O'Keeffe explained the appeal and importance of his photographs. They were, she wrote, "devoid of all mannerism and of all formula," and they expressed "his vision, his feeling for the world, for life" (Appendix A, no. 10).

Although she admitted "maybe I am at present prejudiced in favor of photography," she stated that she found Stieglitz's photographs "aesthetically, spiritually significant" and made it clear that, as art objects, they were a source of great inspiration to her:

> I can return to them day after day, have done so almost daily for a period of four years with always a feeling of wonder and excitement akin to that aroused in me by the Chinese, the Egyptians, Negro Art, Picasso, Henri Rousseau, Seurat, etcetera, even including modern plumbing—or a fine piece of machinery.

There is no question that she was convinced of the significance of his photographs from the beginning, and because she never considered them as anything other than an expression of his aesthetic vision, she must have expected others to respond to them in the same way. Yet Hartley's and Rosenfeld's perceptions of the O'Keeffe portrait went beyond their recognition of the photographs as art. They responded to them as art, of course, but they also responded directly to the woman the photographs characterized; and that woman represented to them an embodiment of multiple, classic female types: virgins, goddesses, or *femmes fatales*. The fact that they considered O'Keeffe a combination of pure spirit and sexual power is evident in apparently contradictory passages in their writing. For example, in "American Painting," Rosenfeld stated: "This girl is indeed the innocent one. For here there appears to be nothing that cannot be transfused utterly with spirit, with high feeling, with fierce clean passion. The entire body is seen noble and divine through love" (Appendix A, no. 6). But this sentence is also found in the same essay: "Her great painful and ecstatic climaxes make us at last to know something the man has always wanted to know."

Certainly there are conflicting types of women present in Stieglitz's portrait. But O'Keeffe as a sexually powerful woman was the dominant image in Hartley's and Rosenfeld's essays, and although the tone of what they wrote is undeniably laudatory, they found it impossible to

distinguish their perception of that woman from their perception of O'Keeffe's art. Furthermore, the extravagant language they used to characterize her art as a reflection of sexual liberation invaded every aspect of their evaluations of the artist and her work. As a result, their responses assumed a specific emphasis that O'Keeffe found humiliating but that other critics would find irresistible.

There is no indication that O'Keeffe made a connection between Stieglitz's photographs and the image of her Hartley and Rosenfeld developed in their essays, but she stated her strong objections to what they had suggested about her in a letter to Kennerley in the fall of 1922:

> You see Rosenfeld's articles have embarrassed me—[and] I wanted to lose the one for the Hartley book when I had the only copy of it to read—so it couldnt be in the book. The things they write sound so strange and far removed from what I feel of myself[.] They make me seem like some strange unearthly sort of a creature floating in the air—breathing in the clouds for nourishment—when the truth is I like beef steak—and like it rare at that.

She seemed most upset by Rosenfeld's remarks about her in "American Painting," which were full of references to the sensuality of her imagery. As she continued to Kennerley: "[Hutchins] Hapgood came in when I was reading Rosenfelds article in the Dial—I was in a fury—and he laughed—He thought it very funny that I should mind—telling me they were only writing their own autobiography—that it really wasnt about me at all—[.]"[12]

Although it could scarcely have been as upsetting as the Hartley and Rosenfeld essays, an article in the July 1922 issue of *Vanity Fair*, "The Female of the Species Achieves a New Deadliness," was particularly irksome to O'Keeffe. Illustrated with a Stieglitz photograph (fig. 7), it described her art as a "revelation of the very essence of woman as Life Giver" (Appendix A, no. 7), a phrase that had been culled from the Rosenfeld article in the *Dial*. In a letter to former classmate Doris McMurdo, which she wrote just after the article appeared, she explained: "Every time I think of that page in Vanity Fair I just want to snort—its only redeeming feature is the line at the bottom of it—I mean at the bottom of the page—[.]" That line read: "Women Painters of America Whose Work Exhibits Distinctiveness of Style and Marked Individuality."[13]

What Rosenfeld had written was already beginning to exert an influence on what other people wrote about her art, and O'Keeffe got a taste of how sensational copy in one article had a way of turning up in another one. But although she considered any publicity an assault on her privacy, she had reconciled herself to the fact that being in the

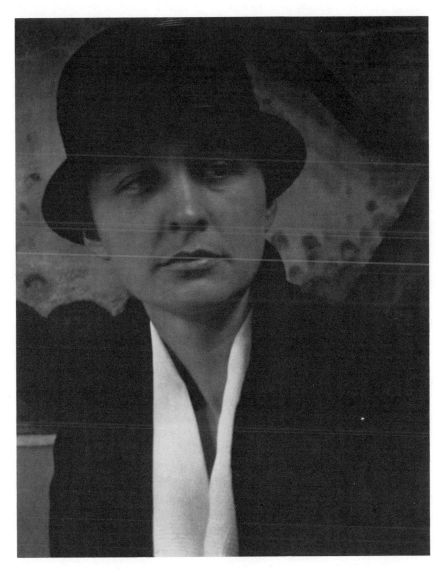

Figure 7. Alfred Stieglitz, *Georgia O'Keeffe: A Portrait*, 1918
Palladium print, 9⁵/₈ × 7⁵/₈ in.
(*National Gallery of Art, Washington, D.C., Alfred Stieglitz Collection*)

public eye and having her work discussed in print were components of her profession. As she also informed McMurdo, using words that sound very much like Stieglitz's:

> Most people buy pictures more through their ears than their eyes—one must be written about and talked about or the people who buy through their ears think your work is no good—and wont buy and one must sell to live—so one must be written about and talked about whether one likes it or not—it always seems they say such stupid things—.[14]

If O'Keeffe confided to her friends her distaste for what was being written about her and her art, one assumes that she made the same point to Stieglitz. But Stieglitz loved controversy, sensation, and all that went with them. As far as publicity was concerned, he was convinced that the ends justified the means. He revealed this in a letter to poet-critic Herbert Seligmann in which he discussed Rosenfeld's "American Painting" (he had read the piece in manuscript):

> I'd greatly regret if the essay did not appear. . . . First of all it would start a controversy in the art world which would be beneficial from every point of view. Secondly, some of the really deserving ones would be given a proper send-off—men like Marin and Dove and Hartley—not to mention O'Keeffe.[15]

O'Keeffe's thoughts about the publicity she and her art had received were very much on her mind when she prepared her contribution to *MSS*. Although her essay was on the subject of photography, its first sentences were on the subject of O'Keeffe. She began by documenting her training and her experience and included facts that she considered crucial to an understanding of her and her art:

> I studied at the Art Institute of Chicago, at the Art Students League of New York, at Teachers College, Columbia University, at the University of Virginia.
> I even studied with Chase and Bellows and Professor Dow. I am sorry to say that I missed Henri.
> I am guilty of having tried to teach Art for four summers in a university summer school and for two years in a state normal but I dont know what Art is. No one has ever been able to give me a satisfactory definition.
> I have not been in Europe.
> I prefer to live in a room as bare as possible.
> I have been much photographed.
> I paint because color is a significant language to me but I do not like pictures and I do not like exhibitions of pictures. However I am very much interested in them.
> (Appendix A, no. 10)

Obviously, O'Keeffe was trying to portray herself as a strong-willed, independent person and serious artist—one who had received an academic training and had developed very specific ideas of what she was about. And she wanted to make it clear that she was something of an iconoclast, a painter who was free of European influences and a woman who disdained the frivolous.

Late in 1922, O'Keeffe made a second effort to make a matter of record things she considered important to herself as an artist. She discussed her background and intentions in an interview with a writer for the *New York Sun*. The resultant article was published, unsigned, on 5 December 1922, and it bore the title, "I Can't Sing, So I Paint! Says Ultra Realistic Artist; Art Is Not Photography—It Is Expression of Inner Life!: Miss Georgia O'Keeffe Explains Subjective Aspect of Her Work."

O'Keeffe spoke in the interview about her general approach to the process of making paintings and about the premise of the work that would be seen in her upcoming show. Furthermore, because she told the writer about the events that had determined the course of her career, the *Sun* article was the first to introduce these facts about her into the criticism. She explained that she had rejected the tenets of the traditional training she received at the Art Institute and the Art Students League and recalled the circumstances that rekindled her interest in making art.

> In school I was taught to paint things as I saw them. But it seemed so stupid! If one could only reproduce nature, and always with less beauty than the original, why paint at all? Always I had wanted to be an artist, but now I decided to give it up. I put away my paints and brushes. Several years later I happened to be at the University of Virginia, and I went to a lecture on art. The lecturer spoke of art as decoration: Art, he said, consisted in putting the right thing in the right place. It gave me new inspiration, and I immediately took a position as supervisor of art in a Texas town. I was constantly experimenting but it was not until some time later that I made up my mind to forget all that I had been taught, and to paint exactly as I felt. (Appendix A, no. 9)

What O'Keeffe had written about herself in the *MSS*. article, though not well focused, established the foundations of an image that was clearly in opposition to the one offered by Hartley and Rosenfeld. The *Sun* writer, in response to meeting with O'Keeffe and to listening to what she said about herself and her art, made the first statement about that image in the criticism: "She is intellectual and introspective— for an artist, a curiously austere type." The writer claimed that there was "daring and originality" in the work of this "ultra modern" artist

and suggested that her integrity could be measured in terms of her "genuineness and simplicity."

In concluding, the writer called attention to notable qualities in O'Keeffe's painting, paying specific tribute to her mastery of technique, a point that would be made regularly in the criticism:[16] "Probably there are few artists in America who could draw more truly. Surely there are few at present who are doing more suggestive or more truly original work." In declaring O'Keeffe's work to be original, the writer assigned it a quality that George Moore, among others, had been able to discover in the work of few women artists.

But the word "suggestive" reminded the reader that the article had not restricted itself to an exploration of O'Keeffe's intelligence, introspection, and austerity. Some of its language had been extracted from Rosenfeld's essays on O'Keeffe, and therefore, much of its point of view reflected Rosenfeld's. In fact, the writer began an examination of O'Keeffe's work by quoting directly, if inaccurately, from Rosenfeld's October piece in *Vanity Fair:* "Our attention was first drawn to her work by a comment that interested us. 'Her pictures,' offered a certain critic, 'are permeated by the very essence of womanhood.'"

The article agreed with Rosenfeld's contention that the "essentially feminine" nature of O'Keeffe's art was its most important and distinctive feature, and then, in the style of both Rosenfeld and Hartley, it pointed out provocative contrasts in her work. It could be mysterious and tricky, "like the witchery of Redon," or it could be "something more real than mere realism!" Some of it was seductive:

> She paints apples, and the texture of their skins is reproduced so perfectly that one is almost tempted to take a bite. Her water lilies in pastel are so real one almost scents their fragrance.

It is clear that the *Sun* article was intended to be a sympathetic treatment of its subject, but it juxtaposed two contradictory images of O'Keeffe, the one she had projected to the critic and the one projected through the critic's use of Rosenfeld's language. Just how appealing that language was can be seen in the *Sun* writer's use of such phrases to describe her art as "exquisite experience—illusive, intangible, yet lovely beyond words," "impregnated . . . with her own personality," and "intense suffering, throbbing pain."

What O'Keeffe implied about her art was very different. She was quoted in the first paragraph of the article as saying: "It is only by selection, by elimination, by emphasis that we get at the real meaning of things." And although the article went on to address the complexity

of her imagery, it was full of contradictions, making it impossible to discover, finally, what the writer believed her work was about. Her painting remained as elusive as O'Keeffe herself. The *Sun* piece was the first to give her widespread, popular exposure, and in addition, it appeared less than two months before her first exhibition of the twenties.

Titled "Alfred Stieglitz Presents One Hundred Pictures, Oils, Water-colors, Pastels, Drawings, by Georgia O'Keeffe, American," the show was held from 29 January to 10 February 1923 at the Anderson Galleries, and it generated a total of nine articles in newspapers and periodicals. Seven responses were written by men—Alexander Brook, Alan Burroughs, Royal Cortissoz, Henry McBride, Herbert Seligmann, Paul Strand, and Henry Tyrrell—and two, by women—Elizabeth Luther Cary and Helen Appleton Read.

As a brochure Stieglitz prepared for the show stated, ninety of the one hundred works on display had never before been publicly shown;[17] and thus, with the exception of Strand and possibly Seligmann, who were among Stieglitz's and O'Keeffe's regular visitors and knew her work well, the critics in 1923 were unfamiliar with what they saw. Precisely what they saw was not documented in a catalogue, but because the exhibition was retrospective in scope, it is possible to suggest its character.

The earliest work probably dated from the mid-teens and the latest from the previous fall, years during which O'Keeffe explored various approaches to image-making in a variety of mediums. There was so much variation in her work of this period, in fact, that it falls most comfortably into groups based not on subject matter but rather on degree of abstraction. The imagery of one group, though derived from the natural world, is essentially nondescriptive, such as that of the charcoal drawing *Abstraction IX* (1916, Metropolitan Museum of Art, Alfred Stieglitz Collection), the watercolor *Blue No. II* (1916, Brooklyn Museum), or the oil paintings *Blue and Green Music* (fig. 8) and *Series I, No. 12* (1920, Estate of Georgia O'Keeffe). In another group, there are works with clearly recognizable subject matter, such as the oil paintings *Plums* (fig. 9), *Apple Family III* (1921, Estate of Georgia O'Keeffe), and *My Shanty* (1922, The Phillips Collection), and the pastel *Single Alligator Pear* (1922, private collection). The images of the third group lie somewhere between those of the other two. They are highly abstract, but their sources in nature are suggested both visually and through their titles. This group includes the watercolors *Sunrise and Little Clouds II* (1916, Estate of Georgia O'Keeffe) and *Light Coming on the Plains No. II* (1917, Amon Carter Museum), and the oil paintings *From the Plains I* (1919, private collection) and *Lake George with Crows* (1921, Estate of Georgia O'Keeffe).

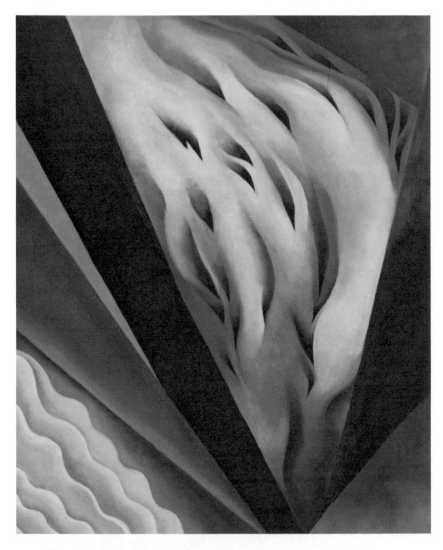

Figure 8. Georgia O'Keeffe, *Blue and Green Music*, 1919
Oil on canvas, 23 × 19 in.
(Gift of Georgia O'Keeffe to the Alfred Stieglitz Collection, 1969.835.
© *1989 The Art Institute of Chicago. All rights reserved)*

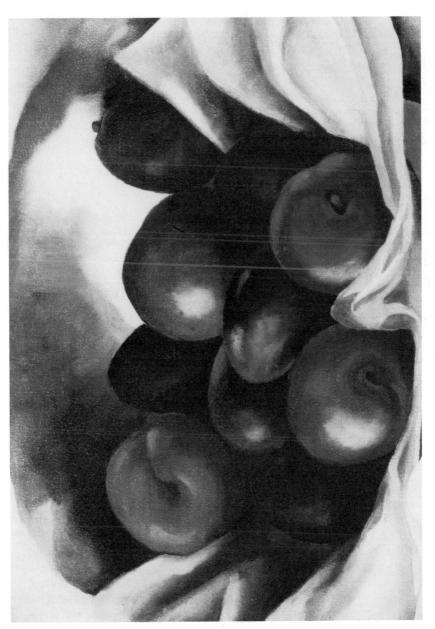

Figure 9. Georgia O'Keeffe, *Plums*, 1920
Oil on canvas, 9 × 12 in.
(Collection of Paul and Tina Schmid)

Every work in the show, whether realistic or nonrepresentational, conveyed O'Keeffe's commitment to modernism, and perhaps because of this, most of the critics found it difficult to be articulate about her work. Few actually attempted to describe it, and those who did often left the reader more puzzled than enlightened. For example, Alan Burroughs wrote in his review for the *New York Sun:*

> Flowers and fruits burn in her conception of them with deep, luminous colors that have no names in spoken or written languages. Her abstract designs and shapes are in the same key. Even more so than the still lifes they convey a sense of suppressed utterance, of song without song, words without words. (Appendix A, no. 12)

And Elizabeth Luther Cary included the following passage in her review for the *New York Times:*

> [The paintings] line the brave walls of the Anderson rooms with pinks and purples and greens that would lend themselves happily to color reproduction, and in their carrying power would make capital posters. Some of the subjects are abstract, another way perhaps of saying that you don't know what they mean. When you do know, as in the case of the fruits, some of them, it is very pleasant. It is small wonder that people buy the pears, and they do, at Fifth Avenue fruiterers' prices. (Appendix A, no. 13)

The reviews as a whole were overwhelmingly positive. But whether their evaluations were as esoteric as Burroughs' or as superficial as Cary's, critics tended to avoid the formal issues implicit in O'Keeffe's work. Rather, they sought its meaning, and especially the meaning of its abstractionism, in the fact that the artist was a woman.

In an otherwise favorable review, Alexander Brook, for example, referred to qualities he recognized in O'Keeffe's paintings in terms of what he considered to be woman's place in the social order, and his comments in this regard were particularly immoderate. Writing for *The Arts*, he explained that the precision of her technique could be most appropriately described with the word "clean" and then drew a parallel between O'Keeffe as a painter and his fantasy of O'Keeffe as a housewife. Had she "taken up the customary duties of woman, had she married and kept house," he noted, "there would have been no dust under the bed, no dishes in the sink and the main entrance would always be well swept" (Appendix A, no. 19).

In general, reviewers associated O'Keeffe's imagery with several things they understood about women: that they were more closely linked to the natural world than men and that their bodies were the source of their creativity. Herbert Seligmann, in an article published in

MSS., made his belief in O'Keeffe's kinship with nature quite plain. As he pointed out:

> Growing and elemental things are close to her, she sets down exactly what they seem. Each thing she makes has its own life, unfolds simplicities of growing plant, of sea-mighty, sky-wide rhythm of the universe. (Appendix A, no. 20)

He also felt that there were direct relationships between O'Keeffe's work and her physical being. "Her body acknowledges its kindred shapes and renders the visible scene in those terms," he stated. In describing a cloud contour in one of O'Keeffe's paintings as "breastlike" and a lake shore as a "black cleaving," he drew specific parallels between the forms of her body and those of her landscape paintings. He even stated that "the sharpness of [O'Keeffe's] bodily experience" could be found in her still-life subject matter; for instance, "in bulging apples." Seligmann was not alone in drawing these kinds of parallels; Brook, too, suggested that the intimacy he felt in O'Keeffe's work made it seem "painted with her very body" (Appendix A, no. 19).

But such words are among the most suggestive in the reviews as a whole. Using terminology far less provocative than Seligmann's or Brook's, Helen Appleton Read adopted a Freudian approach. She wrote in the *Brooklyn Daily Eagle*:

> The question comes up as to whether the average intelligentsia . . . would "get" these emotional abstractions. For some these living human documents are an open book, into which, having been given the key, we read perhaps more than the artist intended. To others the shameless naked statements are too veiled to be anything but rather disturbing abstractions. To me they seem to be a clear case of Freudian suppressed desires in paint. . . . Whether you like some of these very obvious symbols is a question of taste. (Appendix A, no. 17)

In the statement O'Keeffe had prepared for the exhibition brochure, she defined herself in a very candid way, emphasizing the fact that she was an artist who had asserted her right to make decisions concerning her work:

> I grew up pretty much as everybody else grows up and one day seven years ago I found myself saying to myself—I can't live where I want to—I can't go where I want to—I can't do what I want to—I can't even say what I want to—. School and things that painters have taught me even keep me from painting as I want to. I decided I was a very stupid fool not to at least paint as I wanted to and say what I wanted to when I painted as that seemed to be the only thing I could do that didn't concern anybody but myself—that was nobody's business but my own.—So these paintings and drawings happened and many others that are not here.—I found that

I could say things with color and shapes that I couldn't say in any other way—things that I had no words for. Some of the wise men say it is not painting, some of them say it is. Art or not Art—they disagree. (Appendix A, no. 11)

There seems to be little ambiguity in this statement, but hers was not the only statement in the brochure. It also contained a reprint of Hartley's essay on O'Keeffe from *Adventures in the Arts*.

Considering her objection to the language of the essay, it is impossible to imagine that she would have approved its inclusion. Almost fifty years after it had been written, O'Keeffe still referred to the embarrassment the essay had caused her:

I remember how upset I was once by a certain reference Marsden Hartley made to my work in a book. I almost wept. I thought I could never face the world again.[18]

Obviously, O'Keeffe exercised no control over the brochure's final form. The result was that when visitors, including critics, wondered what to think of the paintings they saw on display in the gallery, they could turn to two texts Stieglitz had provided: O'Keeffe's and Hartley's.

Some critics either misconstrued the meaning of O'Keeffe's words or used them to the advantage of their own prose. Cary, for example, paid O'Keeffe a roundabout compliment in a remark that could be read either as a comment about her inexperience as an artist or about the artlessness of her statement in the brochure. She asserted that, "naturally," the color in O'Keeffe's paintings was "rather fresh and new," since, as the artist herself had stated, "her art is only seven years old" (Appendix A, no. 13). And Burroughs toyed with O'Keeffe's words to establish doubts about the validity of her work. He asked his readers if O'Keeffe created "art or merely is [she] fighting up a blind alley" (Appendix A, no. 12). He quoted O'Keeffe to answer his question: "Some of the wise men say it is not painting; some of them say it is." He interpreted her remark ("in other words she herself doesn't care what people call it") and praised O'Keeffe for her aloofness from the opinions of others, but the implication of his initial question remained. If "the wise men" were not sure that her work was art, how could anyone else be?

Most of the articles reiterated the position about O'Keeffe's work that Hartley had assumed. Of the nine critics who wrote about her work, four quoted the Hartley essay directly. Read and Burroughs cited Hartley's comment that O'Keeffe's paintings were "living and shameless private documents," and McBride and Cary chose perhaps the most dramatic sentence of the essay: "Georgia O'Keeffe has had her feet

scorched in the laval effusiveness of terrible experience; she has walked on fire and listened to the hissing of vapors round her person." Although Brook did not refer directly to Hartley's text, it is evident that his reflections about the cleanness of O'Keeffe's art derived from Hartley's point: "All this gives her painting as clean an appearance as it is possible to imagine in painting. She soils nothing with cheap indulgence of wishing commonplace things"[19] (Appendix A, no. 5).

The references to O'Keeffe's body in the Brook and Seligmann essays, however, originated not with Hartley but with Rosenfeld. Brook's phrase "painted with her very body" and Seligmann's "her body acknowledges its kindred shapes" display a strong dependence on Rosenfeld's prose. But Rosenfeld's language is most obvious in Seligmann's essay:

> The body knows tree and fruit, breastlike contour of cloud and black cleaving of lake shore from water's reflection—all things and shapes related to the body, to its identity become conscious. . . .
> . . . The sharpness of bodily experience is here, in bulging apples, in the thrust of Congoesque arch of fruit basket over gleaming whiteness, seeming to bend the lines of picture frame. Skies are jagged in immense revolution, flame laps the human body, grey billows, curtain like or opaque white of iridescent delicacy, shut out the world. (Appendix A, no. 20)

Read used O'Keeffe's account of her artistic liberation to substantiate her own belief that O'Keeffe's paintings were documents of her sexual feelings. As a result, in Read's review, O'Keeffe became an unwitting contributor to the idea that had been developing in the criticism since Stieglitz's review of her 1916 show, that her work could best be understood in psychoanalytical terms.

> She admits that she has never done anything she wanted to do, gone anywhere she wanted to go, or even painted anything she wanted to until she painted as she is painting now. So, undoubtedly the work is in the way of being an escape. She sublimates herself in her art. (Appendix A, no. 17)

Burroughs allowed the reader to draw a conclusion similar to Read's by first referring to O'Keeffe's statement and then quoting from Hartley's in one paragraph of his review. Ostensibly to point out that they were manifestations of her "aloof, self-discovered and self-sufficient attitude," he noted that O'Keeffe's paintings, "more than any others," were "nobody's business but her own" (Appendix A, no. 12). But he followed this passage with Hartley's description of them as "shameless private documents." The result was an implication that both

Hartley and O'Keeffe were referring to the same qualities in her work. Instead of being read as a statement of her self-awareness and independence, O'Keeffe's words were affiliated with Hartley's: her shameless private documents were nobody's business but her own.

O'Keeffe was angered by the provocative tone of the criticism in 1923. Despite her attempts to set the record straight, Hartley's and Rosenfeld's ideas about her art and, in turn, the image of her they had constructed in 1921 and 1922 dominated most of the reviews. But the public response to the exhibition was probably as difficult for O'Keeffe to deal with as the critical response. Five hundred visitors crowded into the Anderson Galleries each day, and the attention the show received placed O'Keeffe in a position she found extremely uncomfortable. She hated exhibiting her work, the publicity exhibitions generated, and in general, being in the public eye.

About seven months before the exhibition opened, O'Keeffe had written to McMurdo: "I simply go along—I had two exhibitions in New York—at 291 Fifth Ave. . . . I may have a big one next winter—but I cant get very much excited over it because its lots of work about frames and hanging and publicity—and I dont like publicity—it embarrasses me—[.]"[20]

Considering O'Keeffe's attitude toward publicity in general, it is understandable that the type of attention and criticism the show received made her physically ill.[21] In 1924, she became ill even before her next exhibition took place. Three weeks before the show opened, she wrote to Sherwood Anderson: "I have had a cold—and have been shut up in my room since I knew the event was to take place—and nothing goes on in my head—[.]"[22] It is well documented that she responded similarly throughout the twenties to the events of her exhibitions.

Although the intensity of her immediate reaction to the 1923 criticism is not known, it is apparent that several months after the show O'Keeffe was still fuming about the way her work had been interpreted. In September, she wrote to Anderson: "I guess Im full of furies today—I wonder if man has ever been written down the way he has written woman down—I rather feel that he hasn't been—[.]"[23]

Among the reviewers in 1923, however, two—Henry McBride and Paul Strand—had revealed their awareness of the importance of O'Keeffe's work and their sensitivity to the fact that it had been misunderstood by others. In his article in the *New York Herald*, McBride gently poked fun at O'Keeffe. He referred to her statement as a "confession" and declared that she was "what they probably will be calling in a few years a B. F., since all of her inhibitions seem to have been removed

before the Freudian recommendations were preached upon this side of the Atlantic" (Appendix A, no. 14).

In a very subtle way, he made a connection between the language Hartley used to describe O'Keeffe and the notoriety she had gained as a result of the display of Stieglitz's photographs of her in 1921. By stating "after the storm . . . we have peace in the present collection of pictures," he attempted to disassociate O'Keeffe's work from the sensational perception of her that had grown out of the public and critical responses to Stieglitz's exhibition. He pointed out that Hartley had been wrong to suggest that O'Keeffe's "quests for truth" were "not worthy of the earth or sky they are written on." McBride wrote: "In definitely unbosoming her soul she not only finds her own release but advances the cause of art in her country." As if in answer to opinions that O'Keeffe's work was a reflection of her inner tensions, he stressed that there was "a great deal of clear, precise, unworried painting" in her show.

But he suggested, tongue-in-cheek, that "O'Keefe after venturing with bare feet upon a bridge of naked sword blades into the land of abstract truth now finds herself a moralist." And he continued:

> She is a sort of modern Margaret Fuller sneered at by Nathaniel Hawthorne for too great a tolerance of sin and finally prayed to by all the super-respectable women of the country for receipts that would keep them from the madhouse.

In the same vein, he warned her that she would be "besieged by all her sisters for advice" and that she should "get herself to a nunnery."

It is interesting that O'Keeffe did not object to this association of her work with her sex. She had an excellent sense of humor, and the fact that she enjoyed McBride's wit is clear in a letter she wrote him in response to the review: "Your notice pleased me immensely—and made me laugh—. I thought it very funny—."[24]

Strand wrote a letter to Henry Tyrrell about O'Keeffe's work just before her show opened, though it was not published in Tyrrell's column in *The World* until 11 February, the day after the show was scheduled to close.[25] The letter announced Strand's contention—which was also one of Stieglitz's—that O'Keeffe's work was part of a new development in American art. As Tyrrell quoted Strand:

> Things of the mind and of the spirit are being born here in and of America as important to us and to the world as anything which is "made in" France or Germany, in Russia, Czecho-Slovakia or anywhere else. The work of Georgia O'Keefe proclaims itself with all the power and precision of genius to be one of these things. It

is not a dilution or imitation of the work of men, nor does it derive from European influences. Here in America this amazing thing has happened. Here it is that the finest and most subtle perceptions of woman have crystallized for the first time in plastic terms, not only through line and form, but through color used with an expressiveness which it has never had before, which opens up vast new horizons in the evolution of painting as incarnation of the human spirit. (Appendix A, no. 18)

Strand described O'Keeffe's art using terminology that was used more typically to characterize the work of men—"innovative," "genius," "power," "precision," and "incarnation of the human spirit." He believed, as Stieglitz had proclaimed earlier, that O'Keeffe was the first woman artist to express the intensity of her feelings through her work. And although he referred to O'Keeffe's art as the "perceptions of woman," he made no references to sensuality in her imagery or to correspondences between her imagery and her body, like those that Rosenfeld's essays had suggested. Rather, Strand's letter seemed a deliberate attempt to supersede interpretations of O'Keeffe's art as the expression of a sexually liberated woman with one that defined it as the expression of a distinctively American woman.

His letter, of course, had no effect on the 1923 criticism. It was extraordinarily positive and suggested a new approach to what O'Keeffe was doing, but it was published after the reviews—too late to affect the thinking of other critics.[26] And although her own words had been equally ineffectual in 1923, there is evidence that O'Keeffe continued to try to inform opinion about her work. In fact, the following year, she sought assistance in the task. In a telegram of 10 February 1924, she solicited the help of Sherwood Anderson, requesting that he write something for the catalogue of her upcoming show.[27] In a letter to him written the following day, she explained her reason for doing so:

When I realize that I have asked you to write something for my catalogue—I must laugh of course—I dont want you to write anything about this exhibition—I am only telling you about it because I think it will interest you—I only want you to write anything you want to about anything that is—You see—you are read—this part of the world is conscious of you—a book has a much better chance than a picture because of its wide circulation—so the picture has to send out the printed word to get people to come and look at it—[.][28]

Anderson declined the request, and it is not clear exactly what O'Keeffe hoped a catalogue statement written by him would accomplish. But the fact that she approached Anderson for assistance indicates her desire to have her work written about by someone whose sensitivity to it she trusted.

In the same letter, O'Keeffe revealed that she had taken a very

dramatic step to attempt to change the direction of the critical response to her art: she had changed her imagery. She reported to Anderson that, in an effort to forestall a repetition of the kind of criticism her exhibition of the preceding year received, she had concentrated on making paintings for her 1924 show that had relatively straightforward subject matter drawn directly from nature. Obviously, she believed such images would be unequivocal in their meaning, unlike the abstractions that in 1923 had elicited what she considered to be overt misrepresentations of her intentions.

> My work this year is very much on the ground—there will be only two abstract things—or three at the most—all the rest is objective—as objective as I can make it—[.] . . .
> I suppose the reason I got down to an effort to be objective is that I didn't like the interpretations of my other things—so here I am with an array of alligator pears—about ten of them—calla lilies—four or six—leaves—summer green ones—ranging through yellow to the dark somber blackish purplish red—eight or ten—horrid yellow sunflowers—two new red cannas—some white birches with yellow leaves—only two that I have no name for and I dont know where they come from—[.][29]

Thus, despite her distaste for "catering to opinion," it is clear that she felt she had no alternative. Her move was intended to end critical speculation about her work, and it is the most important indication of how upset she had been with the reviews of her 1923 show.

O'Keeffe's 1924 exhibition was held in conjunction with one of Stieglitz's photographs, and her continuing concern about how her work had been received the previous year apparently compelled her to exert authority over the contents of its catalogue.[30] It contained a brief statement in which she expressed her hope that her new work would "clarify some of the issues written of by the critics and spoken about by other people"[31] (Appendix A, no. 22), and it reprinted the Burroughs, Royal Cortissoz, and McBride reviews of 1923. But the Burroughs and McBride pieces had been edited to eliminate any quotations from Hartley's essay that contained suggestive language, and McBride's had been further edited to exclude his clearest references to what the 1921 Stieglitz exhibition had done to create gossip about O'Keeffe in the art world. The Cortissoz review was included in its entirety, although as might be expected, considering Cortissoz's distrust of modernism, it had not been particularly favorable.

He had characterized the 1923 exhibition as "a quantity of formless oils, water colors and pastels . . . [that] disclose no intelligible elements of design." And although he contended that her works were "redeemed by their color," he also felt that "'abstract' art . . . , as on this occasion,

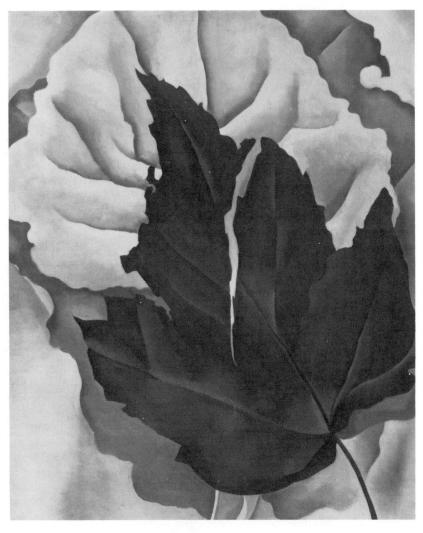

Figure 10.　Georgia O'Keeffe, *Pattern of Leaves*, ca. 1923
Oil on canvas, $22^{1}/_{8} \times 18^{1}/_{8}$ in.
(*The Phillips Collection, Washington, D.C.*)

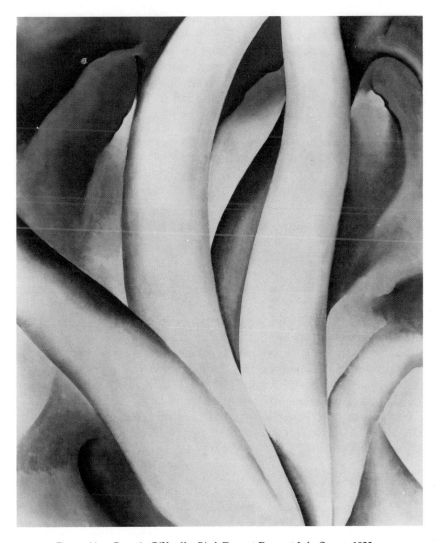

Figure 11. Georgia O'Keeffe, *Birch Trees at Dawn at Lake George*, 1923
Oil on canvas, 36 × 30 in.
(*The Saint Louis Art Museum. Gift of Mrs. Ernest Stix, St. Louis*)

leads nowhere" (Appendix A, no. 16). Yet his remarks were free of innuendoes and references to eroticism in O'Keeffe's imagery and, thus, must have been preferable to those that were not.

The 1924 show, which was held 3–16 March, featured O'Keeffe's work in one room of the Anderson Galleries and Stieglitz's in two adjacent, smaller rooms. In mounting what was in effect a joint exhibition, Stieglitz made a public statement that O'Keeffe's art was complementary to his own. O'Keeffe had informed Sherwood Anderson that Stieglitz felt correspondences existed between her painting and the photographs of clouds he had begun in the fall of 1922 and continued the following summer at Lake George:[32]

> He has done with the sky something similar to what I had done with color before—as he says—proving my case—He has done consciously something that I did mostly unconsciously—and it is amazing to see how he has done it out of the sky with the camera—.[33]

The O'Keeffe and Stieglitz exhibitions were reviewed together in six articles, and her work was discussed in two additional articles and two books later in 1924. Of the nine critics involved that year, only two were close associates of Stieglitz. Nonetheless, as in the case of the criticism the previous year, most of what was written about O'Keeffe reflected attitudes about her and her work that had originated within the Stieglitz circle.

But the 1924 reviews are especially complex. They demonstrate how the critics perceived Stieglitz's and O'Keeffe's relative positions in the art world. Moreover, because several of the reviews compared their art, they reveal the biases against women artists that were in the minds of nearly all the critics who wrote about O'Keeffe's work in the twenties.

It is understandable that most of the reviews celebrated Stieglitz's accomplishment. His name dominated the first paragraphs of two articles, the one written by Cary for the *Times* and the one written by Forbes Watson for *The World*. Cary's began:

> Alfred Stieglitz has written philosophy with his camera and expounds it starting with a tiny, beautifully textured print called "Spiritual America." Just why is a vast mystery of his own, which he chucklingly refuses to interpret for a curious public. That leads to "Songs of the Sky," a struggle through seven prints of dark and light, of value and texture, each print for some inexplicable reason emotionally tortuous. . . . There is no question of . . . [their] smashing appeal, of their suggestion of worlds beyond, of an instant made eternity controlled by esthetic structure unsentimental and unsensational. . . . If there is such a thing as chance, and this exhibition seems to prove that it is non-existent, all these prints have been made from the accident of the sky and sun and clouds. (Appendix A, no. 23)

And Watson's review opened with:

> If you want to know how Alfred Stieglitz "gets" his photographs, ask him. I cannot tell you. But any one who is sensitive to rare quality, to a fine use of tone relations, can receive what Mr. Stieglitz—not the camera—puts into the photographs now on exhibition at the Anderson Galleries. (Appendix A, no. 26)

Continuing, Watson acclaimed Stieglitz as an "artist," and raved about the distinctiveness of his work: "His photographs are a revelation of what can be done with an instrument which in the hands of most of the people who use it is nothing more than a means of recording fact— and none too truthfully at that. His control of the means of expression is extraordinary." To Watson, Stieglitz was "a path-finder, not only for himself but for others in the field of photography as well as in other fields." He was described in equally glowing terms by McBride, who declared that Stieglitz was "the master" and characterized him as a "preacher preaching art[,] administering balm to artists" (Appendix A, no. 24).[34]

Of all of the critics, Read was the only one who considered O'Keeffe to be the star of the show, but she also made the point that Stieglitz had permitted this to happen:

> O'Keefe and Stieglitz are again co-exhibitors at the Anderson Galleries, O'Keefe with the large gallery filled with her paintings and drawings, while Stieglitz takes the smaller gallery in which to exhibit his always remarkable photographs. Last year they shared honors equally. This year Stieglitz' photographs are quite as perfect as ever, but because they are of subjects such as clouds and trees and not human beings they will therefore not attract as much attention. Which incidentally is what he wanted.
> This is O'Keefe's show.[35] (Appendix A, no. 25)

In the review that followed, Read discussed O'Keeffe's work very favorably and strictly within its own context, departing from her Freudian interpretation of it in 1923 with the following explanation:

> It will be remembered that in her exhibition last season there were many abstract paintings of curious shapes. These, aided by Marsden Hartley's foreword, which described O'Keefe's mental and emotional processes and repressions, in no vague and unabashed terms, caused a public fed on Freudian catchwords to view these abstractions with suspicion. This season, however, the pictures are allowed to speak for themselves.

She also referred to O'Keeffe herself by noting her "clear-cut features and extreme simplicity of manner and spirituality" and stated that O'Keeffe's paintings were self-portraits.[36]

Read's piece is particularly significant. Published in the *Brooklyn Daily Eagle* shortly after the show opened, it was the first review to refer to O'Keeffe's physical appearance and, in addition, the first to suggest that O'Keeffe's art had been unfairly burdened with Freudian interpretations. But within less than a month, Read apparently reversed her thinking. In an article published in early April in the *Brooklyn Sunday Eagle Magazine*, Read returned to the position she had held in her review of the 1923 show—that O'Keeffe's paintings were an expression of her sexuality. That she had revised her opinion is clear in the first paragraph of the *Eagle Magazine* article:

> Alfred Stieglitz introduced Georgia O'Keeffe to the picture-loving public. Georgia O'Keeffe is now generally considered the most significant of our younger women painters. It is no exaggeration to say that she is the only American woman painter who paints like herself, who reflects no teaching or influence. She is nakedly, starkly Georgia O'Keeffe. (Appendix A, no. 30)

One of the most important components of this article is its elaboration of the severe image of O'Keeffe that had been referred to by the *Sun* writer in 1922. Read pointed out that O'Keeffe was "an ascetic, almost saintly appearing, woman with a dead-white skin, fine delicate features and black hair severely drawn back from her forehead." But although Read offered the first detailed description of her severity, she also implied that there was more to O'Keeffe than met the eye: "O'Keeffe gives one the feeling that beneath her calm poise there is something that is intensely, burningly alive . . . , capable of great and violent emotions." Thus in Read's mind, O'Keeffe's austere, public persona was a façade, masking the libidinous woman described or implied in Hartley's and Rosenfeld's essays.

It is interesting that, as she continued, she quoted a phrase from her 1923 review.

> Some of O'Keeffe's pictures, although the purest abstractions as far as representing any concrete subject, at once suggest emotional states, "Suppressed Desires" or otherwise, as the Freudians would call them. (Appendix A, no. 30)

And later in the article she stated:

> [Her paintings] are in some way an expression on canvas of an intense emotional life which has not been able to express itself through the natural channels of life. . . . They are the work of a woman who after repressions and suppressions is having an orgy of self-expression.

She supported her points by ending the essay with O'Keeffe's own words:

> Wise men say it isn't art! But what of it, if it is children and love in paint? There it is, color, form, rhythm. What matter if its origin be esthetic or emotional?

In her article of 1924, unlike her review of that year, Read paid extensive tribute to Stieglitz. She made a point of the fact that he had been "the founder of '291 Fifth avenue,' which was the meeting place . . . and the rallying point of artistic and literary New York." And she spoke of Stieglitz's "prophetic vision": "[He] was the first man to show Rodin drawings and Cezanne water colors. He introduced modern art to America." Moreover, she had noted in the first sentence of the article that "Alfred Stieglitz introduced Georgia O'Keeffe to the picture-loving public," and she implied several paragraphs later that his status in the art world had been critical to O'Keeffe's almost immediate success: "It was a pretty sure bet that if you were sponsored by Stieglitz you had arrived."

Stieglitz's role in promoting O'Keeffe was also mentioned in the Cary, Watson, and McBride reviews of 1924. In addition, along with Read's *Eagle Magazine* article, their reviews indicate how differently the art of a man and the art of a woman were perceived by some critics in the mid-twenties. The language they used in writing about Stieglitz was based directly on how they perceived his work; and it is obvious that they had decided his work was historically important. He was described variously as a pathfinder, a discoverer, an explorer, a founder, a philosopher, a master, a preacher, and a prophet. The language they used in reference to O'Keeffe, on the other hand, reveals their separatist thinking. She was expressing her femaleness, and her art, therefore, related most specifically to her body, rather than to ideas or concepts. In her *Eagle Magazine* article, for example, Read suggested that O'Keeffe's still-life paintings could be symbols of her unfulfilled wish to be a mother: "Psychoanalysts tell us that fruits and flowers when painted by women are an unconscious expression of [their] desire for children. Perhaps they are right"[37] (Appendix A, no. 30).

Biases against the art of women, at best unconscious, are apparent in comparisons by certain critics of O'Keeffe's art with that of Stieglitz or other men. Cary, for example, claimed that Stieglitz's photographs of clouds suggested "worlds beyond, of an instant made eternity controlled by esthetic structure unsentimental and unsensational" (Appendix A, no. 23). Each of his works solved a "mathematical problem" and,

in so doing, offered a "curious suggestion of other problems to come." But she described O'Keeffe's art in opposing terms:

> In every composition of Georgia O'Keeffe, with a greater simplicity and a more direct power, there is something more satisfying and complete. A chalice holding a round fruit, a grail perhaps, is a thing to wake up to in the morning, an encouragement, an assurance of the potentialities of the day, the day's problem already solved, rather than, as in the Stieglitz compositions, in spite of the solution of an existing problem there is the beginning of the next.

Cary implied that O'Keeffe's painting, in offering "an encouragement, an assurance," was not intellectual and, therefore, did not address problems beyond those intrinsic to it. She saw in O'Keeffe's work no aspirations beyond self-fulfillment: "Georgia O'Keeffe's arrangements grow, but complete themselves in their growth." While her paintings were "more satisfying and complete" than Stieglitz's photographs, Cary suggested, the fact that they did not generate new "problems" as they resolved existing ones made them less significant.

If Cary was aware that the Stieglitz circle had assigned the unconscious, emotional dimensions of the creative process priority over the intellectual, she obviously disagreed. She valued Stieglitz's work because its source was the intellect. And although Cary did not distinguish between O'Keeffe's and Stieglitz's work on the basis of quality, she did differentiate between their work on the basis of sex, recalling Tyrrell's 1916 discussion of the O'Keeffe-Duncan-Lafferty show. To Cary, O'Keeffe's art was emotional, tied to her nature—clearly, the expression of a woman. Stieglitz's, on the other hand, was intellectual, "unsentimental"—a thing outside himself.

In comparing the work of O'Keeffe and Charles Sheeler in an April article for *The Arts*, Virgil Barker assigned the intellect and emotions equal importance in the creative process: "In art, at least, emotion cannot be made concrete without intellect, nor can intellect do anything without emotion" (Appendix A, no. 31). At the same time, however, he contradicted himself by making distinctions between O'Keeffe's and Sheeler's paintings that linked qualities of emotion and intellect to sex. He discussed their painting in terms of "unlikeness[es] . . . found beneath the surface in the temperaments that produce the art." O'Keeffe, as a woman, made art that was the embodiment of "intelligent passionateness." Sheeler's work, on the other hand, was the manifestation of "passionate intelligence":

> Miss O'Keeffe's pictures are the clean-cut result of an intensely passionate apprehension of things; Mr. Sheeler's the clean-cut result of an apprehension that is intensely intellectual.

Another response to O'Keeffe's art in 1924 also referred to the issues of emotion and intellect. In *A Primer of Modern Art*, which was published in April, Sheldon Cheney offered a comparison between O'Keeffe's work and Marin's:

> Where Marin seems to capture emotional intensity rapidly, brilliantly, with feverish abandon, getting down to the palpitating image broadly in emotional outline— Georgia O'Keeffe seems to intensify calmly, to work through clear-headedly in silence, but with heart no less stirred and kept aflame. (Appendix A, no. 29)

While his comments aligned Marin's art with the emotionalism usually associated with women and O'Keeffe's with the calm but intense, passionate steadiness that related it to the work of men, Cheney also made it clear that O'Keeffe's work could not be mistaken for that of a man. Her art was that of a woman; its order, he was convinced, had been "conceived femininely."

All of the critics who wrote about O'Keeffe's art in 1923 and 1924 interpreted it as a form of female expression, and Read's *Eagle Magazine* article had related this expression directly to O'Keeffe's sexuality. Thus, the criticism of these two years was dominated by ideas formulated within the Stieglitz circle, ideas that had been reinforced by the appearance in March of 1924 of Rosenfeld's book *Port of New York*.[38] Its essay on O'Keeffe was his most elaborate celebration of the sensuality of her art. As a result, it also strengthened the image of her that he had promoted in the criticism from the first, that she was a mysterious and provocative woman.

Opposite a full-page reproduction of a Stieglitz photograph of O'Keeffe (fig. 13), the essay began: "Known in the body of a woman, the largeness of life greets us in color." And it was saturated with passages like the following:

> No man could feel as Georgia O'Keeffe and utter himself in precisely such curves and colors; for in those curves and spots and prismatic color there is the woman referring the universe to her own frame, her own balance; and rendering in her picture of things her body's subconscious knowledge of itself. The feeling of shapes in this painting is certainly one pushed from within. What men have always wanted to know, and women to hide, this girl sets forth. Essence of womanhood impregnates color and mass, giving proof of the truthfulness of a life. (Appendix A, no. 28)

In his letter to Tyrrell in 1923, Strand had pointed out that O'Keeffe was a significant American artist; that her work was highly expressive and represented a new and important phase in "the evolution of painting as an incarnation of the human spirit" (Appendix A, no. 18). In his

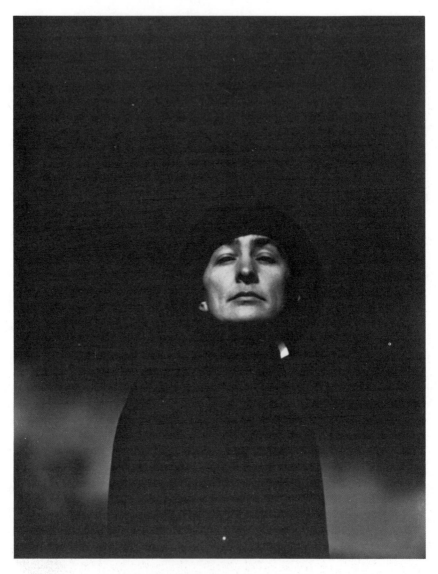

Figure 12. Alfred Stieglitz, *Georgia O'Keeffe: A Portrait—Head*, 1923
Gelatin silver print, 4⁹/₁₆ × 3⁵/₈ in.
(*National Gallery of Art, Washington, D.C., Alfred Stieglitz Collection*)

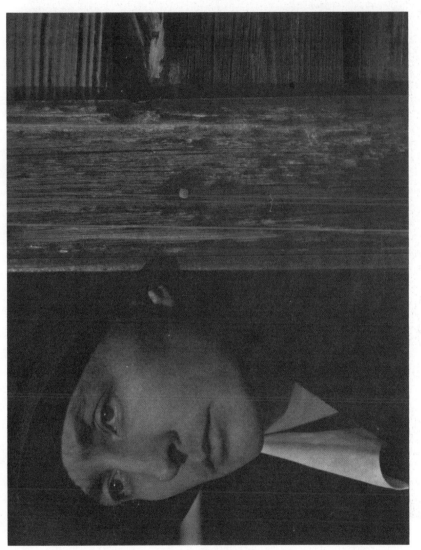

Figure 13. Alfred Stieglitz, *Georgia O'Keeffe: A Portrait—Head*, 1922
Palladium print, 7⁷/₁₆ × 9⁷/₁₆ in.
(National Gallery of Art, Washington, D.C., Alfred Stieglitz Collection)

essay about O'Keeffe, which was published in the July 1924 issue of *Playboy: A Portfolio of Art and Satire*, Strand continued to publicize the most high-minded theories about O'Keeffe and her art that had been developed in the writings of the Stieglitz circle.

As early as 1919, Stieglitz had written that O'Keeffe was a woman who was "finally actually producing Art!"[39] Strand began his *Playboy* essay with a similar declaration:

> Here in America, something rare and significant in the realm of the spirit, has unfolded and flowered in the work of Georgia O'Keeffe. Something has crystallized in the painting of this American, and neither here nor in Europe, has a similar intensity and purity of expression so found itself through a woman. (Appendix A, no. 32)

Stieglitz had also contended that woman's place in society had been responsible for the traditional weakness of her expression in art, but he believed that changes occurring in the social order had made it possible for O'Keeffe to distinguish herself as an artist. In apparent agreement, Strand wrote:

> In their various attempts to formulate a personal vision . . . women have succumbed always to the domination of masculine influences. It is precisely this which has weakened and beclouded their own perceptions and the expression of them. And it is this unconscious imitation of the work of men, this "masculine protest," which, in the painting of Georgia O'Keeffe, is so significantly absent.

He went on to relate O'Keeffe's remarkable accomplishment to the existence of "a new world for women," brought about by the "development of the modern industrial fabric" and by certain evolutionary changes—points that Stieglitz had alluded to in "Woman in Art."

One result of those changes was a new individualization among people that, as Rosenfeld had declared in an article about D. H. Lawrence,[40] was creating problems of communication. Strand explained by quoting Rosenfeld:

> There is a curious development in the race itself, a pushing away of people from the herd types like twigs from the parent branch; the moving away of men and women from a kind of general soul that made them closely alike for all the difference of sex; the production of more and more sharply individualized characters. And in the separation, the facility for the meeting of spirits becomes ever more reduced. The diminished capacity for satisfactory choice has produced in quantity a woman at war with her own sex, and a man incapable of developing beyond the rudimentary state of his own masculinity.

Strand did not believe, however, that O'Keeffe was a woman "at war with her own sex," as Rosenfeld had characterized the modern woman in his essay about Lawrence. Rather, as her work demonstrated, O'Keeffe was a combination of, and therefore transcended, the new types of women in Lawrence's fiction. Strand wrote:

> [Her vision] is that of the woman, bridging the division, closing the breech in herself through the clarity of her perceptions, released by an exquisite sensibility and crafts-manship in her handling of the plastic means. In her work the amazing potentiality of Ursula and Gudrun Brangwyn [sic], goes further towards revelation, begins to be fulfilled.

Strand maintained that O'Keeffe's art integrated the "perceptions and feelings" of Lawrence's heroines and of "the myriad evolving types of the woman today." Moreover, it conveyed an "intensity of expressiveness" that, unlike the work of Marie Laurencin, suggested the "maturity" rather than "the adolescence of the woman spirit." Indeed, O'Keeffe's was unlike the art of any other woman; thus, Strand could claim, like Stieglitz, that it was equal to the art of men.

> Hers is an achievement which distinctly ranges itself both in spirit and in importance with the painting of John Marin and the photography of Alfred Stieglitz; with the writing of Randolph Bourne, of Sherwood Anderson at his best and Jean Toomer as a potentiality. . . . And in the positiveness of its direction, in the high standard and integrity of a progressive development, her work stands as the first veritably individualized expression by a woman, in plastic terms, which is differentiated from, yet meets comparison with the best work of men.

There can be no doubt that members of the Stieglitz circle believed the power of O'Keeffe's art was equal to theirs; and Hartley, Rosenfeld, and Stieglitz had associated this power with her sexual feelings. Yet it is not clear from Strand's essay if he agreed with his colleagues. But his adoption of Rosenfeld's celebration of Lawrence's creative genius helps clarify a very interesting dimension of the Stieglitz circle's understanding of the "intensity of expressiveness" in O'Keeffe's work.

Modern literary critics have pointed out that Lawrence's notions about women were based on the assumption "that Woman exists for Man and for his ceaseless appraisal" and that Lawrence defined female sexuality in terms of male sexual experience.[41] The most conclusive evidence of the fact that Stieglitz and his friends thought of the expressive qualities of O'Keeffe's imagery in terms of their own—that is, male—sexuality in the mid-twenties can be found in Rosenfeld's comments about O'Keeffe in *Port of New York*. His statement "this modern

woman . . . has been overtaken unawares by an irradiation of brimming rose" (Appendix A, no. 28) suggests that the realization of her creative potential was dependent upon sexual union, formalizing a point that had been implicit in Stieglitz's 1918 poems as well as in Rosenfeld's earlier essays on O'Keeffe. Clearly, Rosenfeld associated O'Keeffe's creative energy with male sexual arousal: "[She] found her spirit standing up erect and strong in a translucent world."

Though the *Port of New York* essay portrayed O'Keeffe as the exotic woman who had pervaded Rosenfeld's earlier writing, it also made reference to the "newly evolved" woman who dominated Strand's piece. This "scientific" idea had its origins in Stieglitz's "Woman in Art," but Rosenfeld had introduced it into the criticism in 1922, in a very cursory way, by suggesting that O'Keeffe seemed "a forerunner of a more biologically evolved humanity" (Appendix A, no. 8). Rosenfeld ended the *Port of New York* essay by referring to O'Keeffe in similar terms.

> A woman soul is on the road, going toward the fulfillment of a destiny. The effulgent art, like a seraphic visitor, comes with the force of life. In blaze of revelation it demonstrates woman to the world and to woman. It summons a psychic capacity toward new limits. It veers nature once again to its great way. (Appendix A, no. 28)

Yet despite its nod to this elevated conception of O'Keeffe, Rosenfeld's essay could only be seen as an embellishment of the decidedly less elevated points he had been making about her and her art since 1921.

O'Keeffe as a newly evolved woman, however, was the major theme of Strand's essay. And thus, the image of her that he developed was less sensational than, and therefore at odds with, the image promoted by other members of the Stieglitz circle. Moreover, the essay was free of the provocative language that had characterized the criticism of Hartley and Rosenfeld. Strand's mid-decade writing about O'Keeffe, then, seems an attempt to redirect critical thinking, and it may have been inspired by O'Keeffe's outrage over the "strange unearthly . . . creature" Hartley and Rosenfeld had defined. Yet despite the emphasis Strand placed on "scientific" theory, he was no more liberated in his ideas about O'Keeffe's work than anyone else who had written about it.

For example, his comparison of the art of Willard Huntington Wright and O'Keeffe reveals the traditional nature of his ideas about the creative process in men and women. Wright, he proposed, worked "from the basis of a quite extraordinary intellect." O'Keeffe worked quite differently:

Compelled, by the actual impact of immediate experience, [she] achieves through an equally remarkable intuitive power fibred by a creative intelligence, the clarity of living formalization. Wright moves from conscious idea and the concept towards experience; O'Keeffe works from the unconscious to the conscious, from within out. (Appendix A, no. 32)

Rosenfeld had used this theory in 1921 when he compared the art of O'Keeffe and Dove in "American Painting," but his most elaborate exposition of the idea can be found in his essay on Dove in *Port of New York*.

Dove is very directly the man in painting, precisely as Georgia O'Keeffe is the female; neither type has been known in quite the degree of purity before. Dove's manner of uniting with his subject matter manifests the mechanism proper to his sex as simply as O'Keeffe's method manifests the mechanism proper to her own. For Georgia O'Keeffe the world is within herself. Its elements are felt by her in terms of her own person. Objects make her to receive the gift of her woman's body in disruptive pain or in white gradual beauty. Color, for her, flows from her own state rather than from the object; is there because she feels as she does and because it expresses her feeling. . . . Dove feels otherwise; from a point of view directly opposed to that of his sister artist. He does not feel the world within himself. He feels himself present out in its proper elements. Objects do not bring him consciousness of his own person. Rather, they make him to lose it in the discovery of the qualities and identities of the object. The center of life comes to exist for him outside himself, in the thing, tree or lamp or woman, opposite him. He has moved himself out into the object. (Appendix A, no. 27)

Obviously, this distinction between the nature of female and male creativity was at the heart of the Stieglitz circle's thinking. And the fact that it formed the basis of Tyrrell's analysis of the O'Keeffe-Duncan-Lafferty show of 1916 reveals once again how strongly Tyrrell was influenced by Stieglitz's ideas.

Before she came into the Stieglitz orbit, O'Keeffe had been aware that qualities within her art were affected by her sex. In her letter to Pollitzer of 4 January 1916, she implied that she believed the art of women was different from the art of men, and she confirmed her continuing commitment to this idea when she wrote to Henry McBride about his review of her 1923 show. First, she pointed out: "I was particularly pleased—that with the three women to write about you put me first. . . . I like being first—[.]" Then, after inviting him to come and see some new work by Marin, she added: "I dont mind if Marin comes first—because he is a man—its a different class—[.]"[42]

There is no evidence that O'Keeffe was any more pleased with the

newly-evolved-woman theme that appeared in 1924 than she had been with those dominating the earlier criticism. In fact, there is no document that indicates her reaction to the criticism was any different in 1924 than it had been in 1923 when she wrote to Anderson that she was "full of furies" at having been "written down" by men.

4

A Period of Adjustment

The exhibition Stieglitz staged at the Anderson Galleries in 1925 was the first group show he had sponsored since 1916 and the only one he sponsored in the twenties. Held 9–28 March and called "Alfred Stieglitz Presents Seven Americans," it was conceived by Stieglitz to demonstrate his belief in American modernism and, by featuring the artists he had continued to promote after he closed 291, his lasting commitment to it.[1] In addition to Dove, Hartley, Marin, and O'Keeffe, the show included Stieglitz, Strand, and Charles Demuth, whose work Stieglitz had admired for years.

The catalogue, as much as the exhibition itself, was a declaration of Stieglitz's contention that the work he was promoting defined a uniquely American, modern art.[2] In addition to the brief statement he prepared, it contained contributions he had solicited from individuals who shared his attitude about the art on display: Sherwood Anderson, Dove, and sculptor Arnold Rönnebeck. And to remind viewers of his long battle in behalf of modern art, Stieglitz added a postscript noting that the exhibition marked the "twentieth anniversary of the opening of 291."

Stieglitz's untitled statement began with the assertion "This Exhibition is an integral part of my life" (Appendix A, no. 34D) and, as it continued, suggested that the show was part of an ongoing discovery on his part:[3]

> The work exhibited is now shown for the first time.
> Most of it has been produced within the last year.
> The pictures are an integral part of their makers.
> That I know.
> Are the pictures or their makers an integral part of the America of to-day?
> That I am still endeavoring to know.
> Because of that—the inevitability of this
> Exhibition——American.

Anderson's was titled "Seven Alive" and addressed "the men and women of the city," who "have been a long time away from simple elemental things, from wind, clouds, rain, fire, the sea" (Appendix A, no. 34A). He proposed:

> Here are seven artists bringing to you city dwellers their moments of life.
>
> ...
>
> See them here in their moments of life—when life, pumped through their bodies, crept down into their fingers.
> When they were alive and conscious of all—everything—
> When they were conscious of canvas, of color, of textures—
> When they were conscious of clouds, horses, fields, winds, and water.

And he concluded: "This show is for me the distillation of the clean emotional life of seven real American artists."

Rönnebeck's essay, "Through the Eyes of a European Sculptor," was the most straightforward and expansive articulation of the theme. He began by asking "Do these American artists ask too much of the public?" and continued: "I was still feeling this question when I left Room 303 [at the Anderson Galleries], where I had just been confronted with these pictures for the first time. They must bewilder, I felt, even one whom the galleries of Europe and the intimate contact with the battle of the arts had ceased to startle. Was the Old World no longer the center?" (Appendix A, no. 34C). Then he defined the character of the work in the exhibition. Because it was intrinsically American, it was unlimited in its expressive importance:

> Most of the pictures in Room 303 are—to me—*essentially American* in more than the geographical sense.
>
> But what *is* essentially American?
>
> The skyscrapers, Jack Dempsey, the Five-and-Ten-Cent Store, Buffalo Bill, base-ball, Henry Ford, and perhaps even Wall Street? These form the European concep-tion: symbols of ingenuity, action, business, adventure, exploiting discovery.
>
> I see these Seven Americans using many of these and other symbols to build universal reality. . . . In this work nothing has been "Americanized." Everything *is* American, even where subtle susceptibility to the finest achievements of Europe may be felt. They belong to the New World, to the world of to-day. They belong to no "School." They fit no "ism." Their daring self-consciousness forms their har-mony.

His conception of America as the seedbed of a new art clearly paralleled Stieglitz's:

> Must not *America*, the country without Roman ruins, the country of keenest progress in mechanical technic and invention, the continent where the spirits of all peoples meet freely, offer just the atmosphere essential for the creation of *an art of to-day*? . . .

The . . . tremendous responsibility of facing the significant problems of *his* period confronts the artist to-day. And if he is able to express his reactions in universal language—

Then his "Broadway at Night" will be just as eternal as the frieze of the Parthenon. . . .

There are pictures in this exhibition which, in spite of their being "contemporary," could have been made 2,000 years ago or 5,000 years from to-day—because they are animated and dictated by the ever flowing sources of life itself.

His concluding sentence assigned the artists in the show historical importance: "I believe their creative self-discovery means nothing less than the discovery of America's independent rôle in the History of Art."

Dove called his catalogue contribution "A Way to Look at Things." More to the point of the modernist issues implicit in the show, it suggested that the objects on display, as abstractions, had the integrity of natural phenomena and should be understood for what they were. When he wrote, for example, "that the mountainside looks like a face is accidental," his point was to demonstrate the foolishness of trying to assign one thing the meaning of another (Appendix A, no. 34B).

It is unlikely that anyone today would deny that Stieglitz and the artists he promoted were important American modernists; their works have been among those repeatedly used to chart the history of early twentieth-century art in this country. In 1925, however, the five men and three women who reviewed "Seven Americans" found little evidence in what was shown to support the claims of the catalogue. Even with his long, often arduous experience as a promoter of modern art, it would have been difficult for Stieglitz to predict how unreceptive the critics would be to the exhibition as a whole.

Many of the reviews challenged a concept so fundamental to Stieglitz's thinking that he could not have imagined it needed to be addressed in the catalogue: that everything on display was, in fact, art. Although the critics were aware of Stieglitz's commitment to the new, several felt that he had gone too far in including the assemblages by Arthur Dove.[4]

In her article for the *New York Times*, Elizabeth Luther Cary evaluated the assemblages and denied their aesthetic value:

> Arthur Dove is using anything for his purpose, wood, sticks, stones, shells, glass, glue, and would use kings, surely, if he found he needed one for just the right word, and he finds the right word, in the portrait of Stieglitz himself, for instance. Dove's is a funny joke and a beautiful joke, but at the risk of being accused of an unsubtle humor, never, for this writer, does it become a serious joke. And it is only the serious, no matter how funny, with which art is concerned. Otherwise it will die tomorrow, and Arthur Dove is not really merry. (Appendix A, no. 38)

Continuing, Cary used O'Keeffe's paintings to deny one of the important claims for the show, that the works it contained were universal expressive statements. That fact had been declared by Rönnebeck in his essay and implied in the other three statements in the catalogue. O'Keeffe was showing for the first time large-format paintings of flower forms, an extension of the experiments with close-up views of flowers she had begun around 1919.[5] About them, Cary wrote: "Universal is just what Georgia O'Keefe is not, but intensely personal. Her flowers, with their tangible gradations, have the air of self portraits." But despite her feeling that they were "intensely personal," it is clear that Cary liked the flower paintings. Although she stated that they "might be overluscious were they not controlled by . . . [O'Keeffe's] esthetic sensibilities," she added "they grow—how beautifully her garden grows."

In contrast to Cary, Henry McBride found no fault with Dove's work. In fact, he stated in his review in the *New York Sun* that "it is Mr. Dove and Miss O'Keefe and Mr. Stieglitz who emerge in this exhibition above the heads of the other members of the group"[6] (Appendix A, no. 36). And referring to Dove, he submitted the following:

> It is too much to pretend that his canvases are profound, but they are undoubtedly charming. They are also genuine. It is that quality, I think, that will win them friends, but the fact that they only sink half way into cubism helps also with this public. One always knows what the picture is about, and apparently Americans are not yet ready to do without the subjects.

Furthermore, he asserted that Dove's color ("tender, imaginative and lyrical") "ought to do much toward educating the public to appreciate pure painting."

Although McBride made no reference to the issue of universality, it is apparent that he could not accept the fundamental premise of the exhibition. Through a good-natured, but pointed, critique of Hartley's painting, he denied both Stieglitz's conviction that the works of the artists he displayed were uniquely American and Rönnebeck's broader assertion that the artists in the show demonstrated "America's independent rôle in the History of Art."

> Mr. Hartley's paintings do not survive beyond the rough burlap hangings of the exhibition rooms. They seem to call for the most elegant surroundings. They are old world, old souled, and awfully fatigued. . . . It is like coming upon without previous warning the wax effigy of Charles the Second in Westminster Abbey. And those herrings. What gave Marsden Hartley this deep interest in dried herrings? It is all, certainly, old world. But I suppose one may blame most of it upon the burlap background. (Appendix A, no. 36)

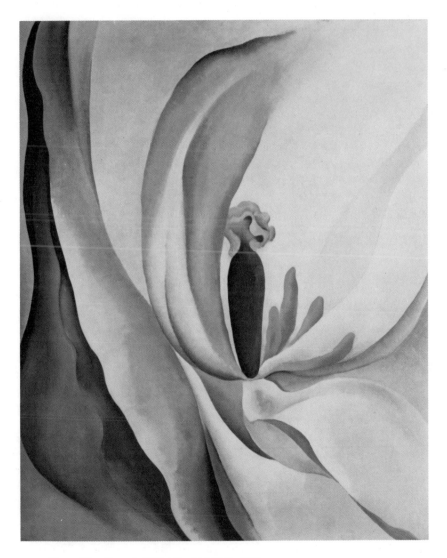

Figure 14. Georgia O'Keeffe, *Pink Tulip*, 1926
Oil on canvas, 36 × 30 in.
(*The Baltimore Museum of Art. Bequest of Mabel Garrison Siemonn in Memory of her Husband George Siemonn. BMA 1964.11.13*)

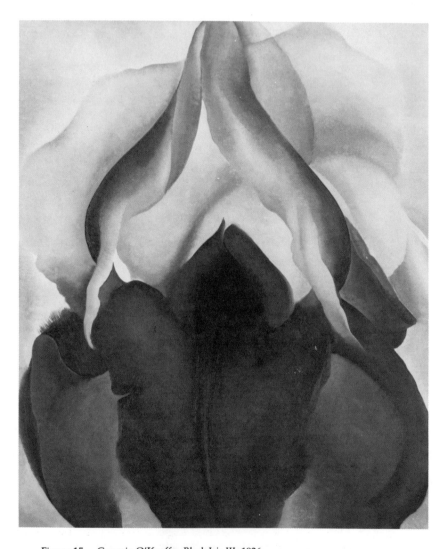

Figure 15. Georgia O'Keeffe, *Black Iris III*, 1926
Oil on canvas, 36 x 29⁷/₈ in.
(The Metropolitan Museum of Art, The Alfred Stieglitz Collection, 1949
[69.278.1]. All rights reserved)

If Hartley's art called "old world" images to mind, it could hardly support the claims made for it in the catalogue, that it was specifically American and, furthermore, a measure of America's unique contribution to art history.

Royal Cortissoz reviewed the show in the *New York Herald Tribune*. Referring to Stieglitz's catalogue reminder that the occasion of "Seven Americans" marked the twentieth anniversary of the opening of 291, Cortissoz centered his review around what he called the "commemorative meaning" of the exhibition (Appendix A, no. 39). He elaborately praised Stieglitz's efforts with 291, "because it was the only source of information on subjects it was necessary to know," and his work as a photographer, "because he has known absolutely what he was about." Then he proceeded to denounce three of the "Seven Americans" and ignore one. He called Marin's paintings "incoherencies"; Dove's, "strained pleasantries"; and Hartley's, "crudities"; and he failed to mention Strand's photographs at all. Cortissoz reserved only limited praise for O'Keeffe's and Demuth's "craftsmanship."

Margaret Breuning's review for the *New York Evening Post* expressed her impatience with what the show and its declarations implied about the Stieglitz group's importance and exclusivity:

> Alfred Stieglitz is presenting "Seven Americans" at the Anderson Galleries, and with them a vast deal of introduction and even an epilogue. . . . After all is said and done, it is hardly worth while to defend or defame an undertaking that cannot be taken very seriously by any but a limited circle of "knowing ones," and, not having the password, I must profess to be outside of the sacred shrine and quite unmoved by its artistic or literary (see catalogue) propaganda. (Appendix A, no. 35)

A review by Helen Appleton Read in the *Brooklyn Daily Eagle* was equally direct in expressing displeasure with the catalogue. In Read's mind, it was pretentious and did a disservice to the work on view.

> [Stieglitz] introduces the exhibition with a catalogue which is full of matter quite as entertaining as the exhibition itself. It commences with an esoteric foreword which envelops the exhibition "in a halo of words" and ends with a resume of the important role 291 played in the history of American art. The pictures in the present group are not allowed to speak for themselves. Sherwood Anderson, Arthur Dove and Arnold Roonebek [*sic*] add their quota of esoterics to the catalogue in the brief credos, concerning their art and American art. It is all guaranteed to make some of the visitors wonder whether or not it is a joke and others to be completely hypnotized into believing that here is something beyond just a mere exhibition of paintings, a revelation of self expression, of souls laid bare.
>
> Americanism and emotionalism are self-consciously and unduly emphasized. (Appendix A, no. 40)

Months after the show, Stieglitz wrote a letter to Dove that reveals how profoundly the "Seven Americans" reviews had upset him.[7] The letter also indicates his concern about a venture he was preparing to undertake later that year—his supervision of a room at the Anderson that would become the Intimate Gallery.[8]

> I have been trying to get next Winter clear in my mind—How to protect that spirit which means all of life to me—to keep it protected from the multiple breeding Iagos which seem to be more the fashion than ever.—I must see to it that the press gets to see nothing—that is the professional Press—the Henry McBrides & Luther Careys [sic] & all the rest of that unspeakable crowd. It's really too bad about McBride. I believe he is becoming senile. His recent article in the Dial was about the last word.— Demuth writes why don't we all go on a "strike."—So you see he feels much as I do.—I, for one, know that my own work is for the few who "know" anything about Art—And that I really don't care to have it seen by more than a few—only by those.—And I can imagine Georgia beginning to feel that way about her work.[9]

It is clear that Stieglitz felt a growing estrangement from the press as well as a growing need to isolate his work and that of the artists he represented from all but a select few within the art community.[10] After commenting to Dove about his and Demuth's feelings and what he imagined O'Keeffe's to be along those lines, he continued: "And Marin has always felt more or less that way.—And I know your feelings— Hartley wants admiration—& Cash! Cash!—?—[.]"[11]

The fact that Stieglitz placed Hartley in a category separate from the other artists he promoted reflects the friction that had materialized between the two in 1923 and that would permanently affect their friendship.[12] But Stieglitz's mention of O'Keeffe's "beginning" to think about withholding her work from critical and public scrutiny is perplexing. In 1916, she had made it quite clear to him that she did not like to show her work when she demanded that he remove her drawings from the walls of 291. But, as she reported to McMurdo in 1922, she had reconciled herself to exhibitions because she believed they were necessary to her success as an artist.

What is even more interesting about Stieglitz's comment, however, is the fact that although the critics found much fault with the "Seven Americans" exhibition and with the claims of its catalogue, as a group they responded favorably to O'Keeffe's work, thus offering her little reason to want to withdraw it from public view. In fact, many critics expressed particular admiration for the O'Keeffes in the show, especially her large paintings of flowers.[13]

Breuning's negative review of O'Keeffe's work in general was exceptional, but even it included a positive remark about her flower paintings.

> Georgia O'Keefe, who exhibited very worthwhile things last year, shows a few good flower studies, notably a fine one of calla lilies, but the rest of her show might be termed a flop both in color and design. She always paints well, but her color is sickly in many instances here, and her choice of subjects not attractive; to say the least, there was something decidedly unpleasant about them to me, they seemed clinical. (Appendix A, no. 35)

While acknowledging the high technical quality of the paintings, Breuning responded negatively to the feeling of reserve that characterizes many of O'Keeffe's paintings from the mid-twenties, in spite of the luxuriance of their subject matter and their often vibrant color. In contrast with Breuning, McBride named O'Keeffe as one of the show's stars, but he did not comment about her work beyond noting that her and Dove's "cubisms" might shock some viewers and thus evoke "outcries"[14] (Appendix A, no. 36).

In his article for the *Nation*, Glen Mullin was quite emphatic about how well-realized O'Keeffe's work was. He opened his commentary with the following statement: "Of all the painters exhibited at the Anderson Galleries, Georgia O'Keefe understood most clearly what she was about" (Appendix A, no. 43). And he went on:

> Objective reality for her is a tenuous espalier upon which the spirit expands in strange, exuberant florescence. But this expressionism of hers, unlike Mr. Marin's, communicates itself. She records her moods with an accent which imparts a definite emotion to the spectator. She takes leaf, tree, and flower motives for the most part and translates them into gorgeous patterns of color. This color is beautifully managed upon the high, intense notes of the palette. Miss O'Keefe's rapt subjectivism resolves the hues and forms of reality into their essentials. We intuitively feel and recognize the truth she has made; it is not as if we were contemplating just Miss O'Keefe's personal edition of the universe created by and for herself as a solitary, lonely possession. It is rather as if a blundering something—our way of looking at nature, perhaps—had caused us to miss the essence of things, and then, quite suddenly, the aesthetic maladjustment had vanished.

Mullin obviously disagreed with Cary's denial of the universality of O'Keeffe's art. In fact, his extraordinarily positive remarks were unqualified in any way.

In 1925, Read once again reversed her opinion of what O'Keeffe's paintings were about. She had declared in 1923 that they were a "clear case of Freudian suppressed desires in paint," a judgment that in 1924 she had first reversed in a review and then re-expressed in an article. In two reviews of "Seven Americans," however, one in the *Eagle* of 15 March and one published the following month in *The Arts*, Read returned to the earlier of the two positions she had taken in 1924—that O'Keeffe's art should not be interpreted in Freudian terms.

In the *Eagle* review, Read declared that Freudian readings of O'Keeffe's art were old-fashioned and, as she had in her review the year before, referred to how she believed they had originated in the criticism. It was, she stated, "a pity that so much beneath the surface has been read into her painting"; that the "forewords to her previous shows" had directed everyone to think along the lines of "strange double meanings" in her work[15] (Appendix A, no. 40).

Read had come to the conclusion that looking at O'Keeffe's paintings through a Freudian lens was a convenience for the critics: "In these days of psychoanalysis it is easy to interpret them in terms of Freud." But she believed that O'Keeffe's "newer motives" contained "no complexes"; rather, "just cleanly, sensitively painted flowers, the colors gay and happy, the arrangement decorative and realistic at the same time."

Read's review in *The Arts* (Appendix A, no. 42) is similar to the *Eagle* review in its tone and language. Apparently she was determined in 1925 to challenge Hartley's contention that O'Keeffe's paintings were "shameless private documents." But if she attempted to discredit one Hartley-inspired theme in the criticism she (perhaps inadvertently) perpetuated another. Her repeated use of the word "clean" in connection with O'Keeffe's art reflects a minor though important point Hartley had made. Thus Read drew continuing attention to a dimension of Hartley's essay that, to the modern reader at least, seems at odds with his appraisal of her paintings as "expositions of psychism in color and movement" (Appendix A, no. 5).

Describing his initial reaction to O'Keeffe's paintings in his review for *The World*, Forbes Watson pointed out how they dominated the exhibition: "Going into the main large gallery, the voluminous designs, in sweeping color movements, by Georgia O'Keeffe immediately hurl themselves upon the eye of the spectator" (Appendix A, no. 41). Yet his evaluation of her work was guarded. He noted, first, that as a whole it expressed "the excitements of the spirit" and formed an "extremely striking ensemble," but then he stated that "after the first gasp, one becomes aware of the fact that several of Miss O'Keeffe's canvases appear to rely upon exaggerated sizes rather than upon intensive development of the spaces."

Among those several were O'Keeffe's large flower paintings, which he described as having a "slightly balloon, or blown up, quality." But he also offered a commentary that assigned her art a new status. He stated that the larger paintings as a whole were an "aggressive group of pictures" that displayed "vividness of movement, contrast and design, originality and"—he added cautiously—"sometimes vitality, sometimes merely the appearance of vitality." By using the words "ag-

gressive," "originality," and "vitality," Watson was applying to O'Keeffe's art qualities usually associated with the works of men.

In his essay in the *New Republic*, Edmund Wilson expressed no hesitancy about O'Keeffe's work, and his evaluation of it, unlike Watson's, had the ring of unrestricted praise.

> In Miss Georgia O'Keeffe America seems definitely to have produced a woman painter comparable to her best woman poets and novelists. Her new paintings in the Stieglitz exhibition at the Anderson Galleries are astonishing. (Appendix A, no. 37)

He was particularly impressed by the powerful presence of the artist he sensed in some of them, as this passage from his review indicates:

> The razor-like scroll-edges of Miss O'Keeffe's magnified autumn leaves make themselves felt directly as the sharpness of a personality; and the dark green stalks of one of her "Corn" pictures have become so charged by her personal current and fused by her personal heat that they have the aspect of some sort of dynamo of feeling constructed not to represent but to generate, down the centre of which the fierce white line strikes like an electric spark. This last picture, in its solidity and life, seems to me one of her most successful.

In a subsequent paragraph, in which he mentioned the work of the five painters in the show, he reiterated his point about the intense energy emanating from O'Keeffe's paintings, proclaiming that "Georgia O'Keeffe outblazes the other painters in the exhibition." At the same time, however, he admitted that he could not evaluate her work in the way that he evaluated the men's.

> But it is impossible to compare her with them—even in those pictures which are closest to hers: the white-silver and black storm-clouds of Dove. If the art of women and the art of men have, as I have suggested, fundamental differences, they sometimes seem incommensurable.

Wilson's comments suggest that he was extremely conflicted about O'Keeffe's art. Whereas he was not reluctant to admit that her work was the most outstanding in the exhibition, he could not bring himself to compare it with the art of a man.

Like the other critics, Wilson recognized a particular quality in O'Keeffe's art that dominated his thinking about it. That quality—which made her work significantly different from the work it was shown with in "Seven Americans"—Wilson called a "peculiarly feminine intensity which has galvanized all her work and seems to manifest itself, as a rule, in such a different way from the masculine." As he continued, Wilson made a very eloquent declaration of his belief that this "pecu-

liarly feminine intensity" was a characteristic O'Keeffe's art shared with the art of all women.

> Men, as a rule, in communicating their intensity, seem not only to incorporate it in the representation of external objects but almost, in the work of art, to produce something which is itself an external object and, as it were, detachable from themselves; whereas women seem to charge the objects they represent with so immediate a personal emotion that they absorb the subject into themselves instead of incorporating themselves into the subject. Where men's minds may have a freer range and their works of art be thrown out further from themselves, women artists have a way of appearing to wear their most brilliant productions—however objective in form—like those other artistic expressions, their clothes.

This attitude toward O'Keeffe's art grew out of the assumption that the creative process was different in women and men—a point of view that had been most strongly expressed in the criticism by Rosenfeld in 1924. But it had been implied in assessments of O'Keeffe's work since 1916 and would continue to inform critical thinking throughout the twenties.

Later in her life, O'Keeffe said she had always resented being referred to as a woman painter, rather than as a painter.[16] But there is no evidence that she felt this way in the late teens and twenties. Like Stieglitz and his friends, she had believed from the first that her work was the *expression* of woman, and it is clear that by the mid-twenties she felt the particularities of that expression could best be understood by another woman.

Sometime after mid-November 1925 and before her 1926 show opened on 11 February, O'Keeffe sought the assistance of Mabel Dodge Luhan, whom she had come to know through Stieglitz.[17] She wrote to express her pleasure in reading an article Luhan had written about Katherine Cornell (never published) and stated that she believed Luhan would be able to help her: "I thought you could write something about me that the men cant—[.]" Beyond that statement, however, O'Keeffe was not specific: "What I want written—I do not know—I have no definite idea of what it should be—[.]" But she made it clear that she felt a woman—and Luhan, in particular—could come to terms with her work more effectively than a man:

> A woman who has lived many things and who sees lines and colors as an expression of living—might say something that a man cant—I feel there is something unexplored about woman that only a woman can explore—Men have done all they can do about it.

Yet she was not sure that Luhan would understand her: "Does that mean anything to you—or doesn't it?" she asked.[18]

Both O'Keeffe's request for help from a woman and the timing of the request are puzzling. Women had been writing about her work since 1916; and in fact, the most negative criticism it received in 1925 had come from a woman—Margaret Breuning. On the other hand, one of the most sensitive assessments of the nature of her work in the period had been written, also in 1925, by a man—Glen Mullin. Indeed, the overall critical response in 1925 should have pleased O'Keeffe. Most of the reviewers claimed or implied that her work in "Seven Americans" was equal or superior to the men's. And she could not have objected that several critics made references to what they believed were the female qualities of her work: there were no accompanying Freudian implications. O'Keeffe's letter to Luhan, then, might suggest that she did not read the reviews in 1925; but it is more likely that her assessment of what was written about her that year was colored both by Stieglitz's negative reaction to the criticism as a whole and by her own residual feelings about the reviews her shows had generated in 1923 and 1924.

If Luhan understood that O'Keeffe objected strongly to Freudian interpretations of her work, it is not apparent in what she wrote in response to O'Keeffe's request. In an extraordinarily unsympathetic essay, she allied herself with other critics who had implied that O'Keeffe's paintings were realizations of her sexual fantasies, but she was far more explicit than anyone else had been. "[In] the art of Georgia O'Keeffe," she wrote, " . . . is made manifest the classical dream of walking naked on Broadway. . . . O'Keeffe externalizes the frustration of her true being out on to canvases which, receiving her outpouring sexual juices . . ., permit her to walk this earth with the cleansed, purgated look of fulfilled life!"[19]

But Luhan's real target was Stieglitz, whom she referred to as "the showman."

> This woman's sex, Stieglitz, it becomes yours on these canvases. Sleeping, then, this woman is your thing. . . . You are the watchman standing with a club before the gate of her life, guarding and prolonging so long as you may endure, the unconsciousness within her.

Her most vitriolic remark defined O'Keeffe's art as a "filthy spectacle of frustration" that Stieglitz had chosen to "exalt . . . by the name of art." Addressing him directly, she concluded:

> Stieglitz, let live. Let live this somnolent woman by your side.
> But, Camera-man do you dare, I wonder, face the sun?

Luhan wrote about the relationship between O'Keeffe and Stieglitz from the point of view of O'Keeffe as she perceived it, and thus, in a sense, she satisfied O'Keeffe's hope that she "could write something about me that the men cant." But Luhan's premise implied that understanding O'Keeffe's art was bound up with a "recognition of . . . [this] woman's vibrant sex" and assigned O'Keeffe the role of a brainless, malleable, unfulfilled creature that Stieglitz was exploiting in his role as "showman." He was defining her as an object, his property, and Luhan asserted that his proprietary claim was compromising the source of O'Keeffe's creativity (her "unconsciousness") and, possibly, her potential as an artist. Thus, she became the only critic of the period to claim that O'Keeffe's relationship with Stieglitz, personal and professional, was affecting her art adversely.[20]

The arrogance of Luhan's language and her declarations about the meaning of her art could only have offended O'Keeffe. But O'Keeffe could not have denied Luhan's assertion of the control Stieglitz exerted over her career. She had deferred to the strength of his conviction that her drawings should remain on the walls of 291 in 1916, and subsequently, all the decisions relating to her work, from when and how it would be promoted to when and how it would be exhibited and sold had been ultimately his. But an incident involved with the "Seven Americans" exhibition demonstrates that Stieglitz's decisions about O'Keeffe's work were not always similar to hers.

When she told Stieglitz of her plans to make paintings with New York City subject matter, he made it clear that he thought it was a bad idea for her to tackle this theme. As she pointed out much later: "I was told that [painting the city] . . . was an impossible idea—even the men hadn't done too well with it."[21] She went ahead, however, and her first New York skyscraper painting was *New York with Moon* (1925, private collection). But when work was being selected for "Seven Americans" and O'Keeffe suggested the show include the painting, Stieglitz and "the men" refused to hang it.[22] In 1965, when she recalled her reaction, she said: "I was furious." But in 1978, she described it as "disappointment."[23]

Most broadly, the incident reflected the general attitude "the men" had held about her as a painter from the beginning. As she later stated in two separate interviews: "The men all thought they were right about everything";[24] "all the male artists I knew . . . made it very plain that as a woman I couldn't hope to make it—I might as well stop painting."[25] It is likely that she went ahead with the city paintings to prove that hers could be as successful as a man's, and in her one-woman show of 1926, she saw to it that *New York with Moon* was exhibited, along with several

other paintings of New York she had completed. *New York with Moon* sold quickly, and as she remembered, "No one ever objected to my painting New York after that."[26]

In a statement for the catalogue of her 1926 show, O'Keeffe offered a brief explanation of why she had decided to make large paintings of flowers.[27]

> Everyone has many associations with a flower. You put out your hand to touch it, or lean forward to smell it, or maybe touch it with your lips almost without thinking, or give it to someone to please them. But one rarely takes the time to really see a flower. I have painted what each flower is to me and I have painted it big enough so that others would see what I see. (Appendix A, no. 44)

The exhibition, titled "Fifty Recent Paintings, by Georgia O'Keeffe," was scheduled to run 11 February–11 March, but it was extended until 3 April.[28] There were eight reviews from New York critics—among them, Henry McBride, Louis Kalonyme, Murdock Pemberton, and Helen Appleton Read. But the most remarkable piece on O'Keeffe's work that year was written by Blanche Matthias, a critic for the *Chicago Evening Post*.

During Matthias' visit to New York just before the show opened, O'Keeffe talked with her, and Matthias apparently previewed the work to be exhibited.[29] Thus her essay was structured around a conversation she had had with O'Keeffe, and it is an invaluable key to the artist's perception of herself in the mid-twenties. But because it appeared in a Chicago newspaper almost a month after the show opened, it had no effect on the reviews published in New York that year.

Among New York reviews, the one in the *New York Times* was very brief. Its two sentences suggested that the writer took O'Keeffe's work less than seriously.

> A brown leaf, or the Shelton Hotel, or a roof projected into the sky (framed by other roofs and made immaterial by the very heart of the light of changing traffic signals), or an oversized flower with its tongue out, or the branches of a tree—these, in a state of flux, are the subjects of Georgia O'Keeffe's painting. All are different, all the same, dominated by her strange personality. (Appendix A, no. 47)

A critic for *The Art News*, on the other hand, took her work very seriously but was puzzled by it. The article began: "For five years we have been trying to arrive at some definite, tangible conclusion about O'Keeffe, without success. She eludes us still. Her paintings of 1926 leave us almost as baffled as did those of 1920" (Appendix A, no. 45).

The critic stated that looking at her work produced a "sense of

frustration, of a deeper and fuller enjoyment that is promised but is never fulfilled" and, in associating such feelings with a particular kind of woman, chose an unfortunate analogy to convey a very interesting point:

> Picture after picture, of the twenty odd hung, beckons the eye with promises, only to shut up like a clam when the gaze becomes too inquisitive. Like so many flappers on Broadway they will smile gaily at the stranger so long as he keeps his distance, but the merest attempt at intimacy will freeze their limbs and bring into their eyes the set expressionless vacancy of a too perfectly assumed respectability.

The critic discussed what were defined as paradoxes in O'Keeffe's use of color and design and then stated:

> We are forced to a conclusion that runs full counter to the generally accepted view. All the critical literature which has been devoted to O'Keeffe—and there has been plenty—has started with the assumption that the work of O'Keeffe is first, last and all the time autobiographical, a revelation of the thoughts and emotions that run through the mind and body of its maker. . . . [But] self-revelatory as she may be, she is also—and in the highest degree—a naturalist.

There was praise for her as a "master" at leaf and flower painting and an assertion that her series of paintings of petunias was particularly impressive: "Never sang a single individual petunia with the rich fulness of that final flower." But the critic believed that O'Keeffe's fidelity to nature was coming between her and the "complete expression that her gifts promised" and, thus, disapproved of her work on that basis.

> Her most seeming[ly] abstract pictures are only by elimination abstract. They are not only based on nature, they copy nature, line almost for line. It never seemed to occur to O'Keeffe to draw on her store house of accumulated memories. . . . Willingly or unwillingly, she has bound herself down to a copy book with a fidelity that approaches, and this particularly in her most abstract canvases, the photographic. . . . Let her cast aside her copy book, draw on the memories that must be crowding her mind, and paint her landscapes with the same splendid simplicity and intensity of actuality that inform her flowers.

The critic clearly believed that O'Keeffe's art was neither what it declared itself to be nor what it had been declared to be by most of the critics. Its highly charged expressiveness and individuality were an illusion—a conclusion similar to those reached by Watson and Breuning in 1925.

To Louis Kalonyme and Murdock Pemberton, however, O'Keeffe's art was, if nothing else, expressive. Kalonyme, who became particularly

close to Stieglitz in the late twenties, wrote four articles on O'Keeffe between 1926 and 1928, all of which show his strong attachment to the thinking of the Stieglitz circle and particularly to the image of her developed by Hartley and Rosenfeld.[30] His review in *Arts and Decoration* in 1926 can be summed up by quoting two sentences from it:

> Georgia O'Keeffe is one who begins with life. The tart contention of George Moore that women always paint in evening dress is shattered—in this instance anyway—by the burning intensity, the nakedly revealed world, of this Texan woman's pure female art. (Appendix A, no. 52)

Pemberton wrote six articles about O'Keeffe shows between 1926 and 1929. He was enthusiastic about her work in all of them, and the two that appeared in 1926 in the *New Yorker* affirm that, like Kalonyme, he believed O'Keeffe's paintings were an expression of her sexuality. In fact, he and Kalonyme were the only writers who kept the sensational tone and Freudian implications of earlier reviews alive in the criticism that year. In the first of his two essays, Pemberton wrote: "For if ever there were a raging, blazing soul mounting to the skies it is that of Georgia O'Keefe. You can see it in all its uninhibited glory these weeks at Stieglitz, Room 303" (Appendix A, no. 48).

But the day before he wrote his second essay, as he pointed out, he spent time "listening to Stieglitz talk about his Americans, in his little room blazing with the Georgia O'Keeffes" (Appendix A, no. 51), and the content of what he wrote was clearly influenced by what he had heard. He stated that O'Keeffe was "one of the few geniuses born of this generation" and that her work had continued the advancement of modern art initiated by the Armory Show. Then he pointed out what he felt was her special appeal:

> Every now and then art turns a corner . . . [and] O'Keeffe, more than any one else we have seen this year, thrusts forward the banner without removing it altogether from the sentimental eyes of the multitude. For after all you must have a following if you are to lead.

Yet at the same time that Pemberton demonstrated his agreement with Stieglitz about O'Keeffe's contribution to American art, he left his readers little choice but to believe that her work was important because it expressed female sexual feelings. Thus, both of his articles gave new life to another important component of Stieglitz's theory about O'Keeffe's art.

Psychiatrists have been sending their patients up to see O'Keeffe's canvases. If we are to believe the evidence the hall of the Anderson Gallery is littered with mental crutches, eye bandages and slings for souls. They limp to the shrine of Saint Georgia and they fly away on the wings of the libido. Something for nothing: and, ah, if this city only knew how much, the reserves would have to be called out. (Appendix A, no. 51)

In her review for the *Brooklyn Daily Eagle*, Helen Appleton Read was particularly impressed with O'Keeffe's paintings of petunias, which she described as "her special object of study" that year. They revealed, in Read's mind, O'Keeffe's "exquisite craftsmanship and ordered sense of design." She even wondered why the "architects and interior decorators" had not taken her seriously and "singled her out as THE person to design wall panels and decorations?" But her review said basically nothing new about O'Keeffe's art (Appendix A, no. 49).

Henry McBride's review, however, displayed for the first time his attempt to understand O'Keeffe's work on its own terms. He realized that she was a painter who worked "to please herself" and who in turn, he maintained, had pleased "plenty of others"—a reference to her popularity and the growing sales of her paintings (Appendix A, no. 46). Recalling an idea expressed in Fisher's review of 1917 and elaborated by later critics, he stated, "she is at times a mystic"; but he added, "though I believe she makes no pretense to being mystical," implying that whatever abstruseness existed in her work was the natural result of her fundamental approach to expression. Her purpose, McBride wrote, was "to achieve beauty" and "to avoid . . . unnecessary touches."

Like the critic for *The Art News*, he made a point of the fact that O'Keeffe worked in series. He admired her ability to take "a simple theme" and work with it until she extracted its essence; until the "only possible title of the result is 'Variation in the Key of Lemon,' or Purple, should it happen to be purple." He summarily called attention to her abstractions; to her architectural studies, in which "passages of literalness [were broken] with items that throw symbolic lights into the composition"; and to her color, which had "the cutting, acidulous quality of the moderns."

In the remaining paragraphs of his review, by turning from his own observations to the observations of a woman, McBride suggested that he felt O'Keeffe's art communicated most directly with members of her own sex. He recalled an encounter with Blanche Yurka, the actress, whose response to an O'Keeffe he had apparently witnessed while attending the Tri-National Exhibition, which included several O'Keeffes and which was still on display at the Wildenstein Galleries. As McBride pointed out, Yurka had also responded to other works in the exhibition,

praising a Juan Gris and an Aristide Maillol, but speaking less favorably about the abstractions of Picasso, Braque, and Matisse. He reported that she felt Braque and Matisse were no more than "fluent" and quoted her as saying that Picasso's work was like "a perfect and finished thing in a language I do not speak myself." But O'Keeffe's work seemed to speak to her directly. Yurka stated that one O'Keeffe was to her "the [ecstasy] of spring . . . a complete representation of what goes on in the bud before it bursts, of all the scurrying about beneath the ice on the pond before it melts and disappears."[31]

In a second commentary on O'Keeffe's show, which was published in the May issue of the *Dial*, McBride clarified the implication of his earlier review. He pointed out that he felt unable to assess O'Keeffe's work because he was not a woman. After a glowing review of Marin's early winter show at the Intimate Gallery ("when an artist has reached the heights there is nothing to do but stay there and that Mr[.] Marin certainly does"), he wrote about O'Keeffe:

> Of Georgia O'Keefe, the second candidate for fame in the Intimate Gallery, I cannot say so much; though the women do. I begin to think that in order to be quite fair to Miss O'Keefe I must listen to what the women say of her—and take notes. I like her stuff quite well. Very well. I like her colour, her imagination, her decorative sense. Her things wear well with me, and I soon accept those that I see constantly in the same way that I accept, say[,] a satisfactory tower in the landscape; but I do not feel the occult element in them that all the ladies insist is there. There were more feminine shrieks and screams in the vicinity of O'Keefe's works this year than ever before; so I take it that she too is getting on. (Appendix A, no. 53)

Just how O'Keeffe was "getting on" in 1926 was made clear in the essay by Blanche Matthias. Although it was written by a woman who was very enthusiastic about O'Keeffe's work, nothing in the tone of the piece suggested the breathlessness of McBride's "feminine shrieks and screams," and there was an outright attempt on Matthias' part to deny that O'Keeffe's art was "occult." The essay could be interpreted as a sensitive female critic's reaction to what O'Keeffe was doing, but it was essentially a record of O'Keeffe's own thinking about her work. It included several direct quotations from O'Keeffe, but even when the words appeared to be Matthias', the thought was probably O'Keeffe's. For example, when Matthias wrote "[O'Keeffe's art] is not an attempt to reveal, as so many people suggest, some morbid mood or some attitude toward sex, nor is it a desire to attract attention by outward display of the exotic," she must have been paraphrasing O'Keeffe's answer to psychoanalytical interpretations of her work (Appendix A, no. 50).

Matthias began by stating that "no woman artist in America is subject to more observation and speculation than is . . . O'Keeffe" and went on to explain how O'Keeffe's art had been misinterpreted in the criticism.

> When Alfred Stieglitz gave O'Keefe her first exhibition in the then famous, and still remembered gallery known as 291, the result was a terrific bombing directed at the unsuspecting and tranquil artist. The art critics began to study Freud and Jung in an effort to catalog and pigeon-hole a blue-ribboned bundle labeled Georgia O'Keeffe. But somehow she just managed to escape their hastily garnered strength.
>
> Perhaps one reason was that most of those whose business it is to understand art and relay it to the public were of the masculine gender, and O'Keeffe's simplicity was profoundly feminine. They were so used [to] writing about "influences," "traditions," "techniques," "style," "modernism" and so unprepared for direct contact with the art spirit of woman that they got all cluttered up and began frantically searching for the magic key that was to illumine their habit-stunted minds. Even Paul Rosenfeld, the friendliest of writers on O'Keeffe, adds to the mystery which envelopes her, and dramatizes her superb naturalness, until the reader grows weary of the aura and hungers for her bone structure.

Thus, according to the Matthias article, there was trouble from the beginning. The critics had been unwilling to change their hidebound ways and sought the meaning of O'Keeffe's art in theories, both psychoanalytical and art historical. Either they refused to see O'Keeffe's "simplicity" as "profoundly feminine," or they could not recognize it because they were male. Furthermore, even "the friendliest of writers," Rosenfeld, had contributed to the general misunderstanding.

Matthias called attention to the irony of Rosenfeld's contribution to the theories about O'Keeffe's art that had dominated the early criticism, and at the same time, she documented O'Keeffe's indebtedness and loyalty to Stieglitz himself. Quoting O'Keeffe, she wrote:

> [Stieglitz] has never had time to realize his own greatness, because he is always spending himself for others. He sees the great needs we have, and in order that we may work and yet live, Stieglitz, when he believes in one of us, fights with all his strength and force for that one, and with that one, against all the organized prejudices and politics which try to dominate the world of art, as well as that of life.

O'Keeffe was equally outspoken about the sense of frustration and alienation she felt within the larger art community. She told Matthias: "Many men here in New York think women can't be artists[,] but we can see and feel and work as they can, our struggle is not confined to one phase of life." Continuing, she implied both her recognition of the fact that, as a female artist, the validity of her work would continue to be questioned and her resentment that, because of her sex, her art had

been assigned to a single category: "Perhaps some day a new name will be coined for us and so allow men to enjoy a property right to the word art, but I hope we shall have a healthier and stronger title than Expressionists allotted to us by our nomenclators."

O'Keeffe's derision of the term "expressionist" is curious. The term had become synonymous with the intentions of the artists Stieglitz promoted, male or female. In *A Primer of Modern Art*, which was published in 1924, Sheldon Cheney, for example, had made this claim:

> Expressionism in America has a history back to the first decade of the century.
> The date might almost be fixed by reference to the calendar of exhibitions at the Photo-Secession Gallery—the famous "291"—in New York. And the artist who is likely to be named oftenest in connection with the first quarter-century of American post-Impressionism, when the history of the movement is written, is Alfred Stieglitz. He knows better, instinctively, what *expression* is than any other American. . . . He also has that gift for infecting other men with enthusiasm and creative impulse which made "291" an oasis in New York for many years. (Appendix A, no. 29)

And in 1925, Mullin had written of "Seven Americans":

> The paintings shown were all manifestations in various degrees of expressionism. The expressionist painter does not concern himself with reproducing the obvious shapes, colors, and textures of objects; what interests him is his own reveries or adventures in the emotional world which the object stimulates him to create. (Appendix A, no. 43)

But it is clear that O'Keeffe did not agree with the assumption that she was an expressionist. As Matthias reported:

> The next question I put to O'Keeffe drew forth a look of tolerant amusement. "No, no, no. I am not an exponent of Expressionism. I do not know exactly what that means, and I don't like the sound of it. I dislike cults and isms."

O'Keeffe offered the following as a statement of her purpose: "I want to paint in terms of my own thinking, and feeling the facts and things which men know." Although there can be no doubt that she believed her art must convey the singularity of her (female) feelings, she also believed it must communicate her *thoughts* about more universal concerns, "the facts and things which men know."

Unfortunately, Matthias did not explore O'Keeffe's use of the term "expressionist" any further, and thus there seems to be a clear conflict inherent in O'Keeffe's thinking about her work. At the same time that she had long been committed to the idea that her art conveyed her feelings, she was not content with its being interpreted exclusively as a form of "Expressionism."

More than anything else, the Matthias article served O'Keeffe by reintroducing information into the criticism that she believed fundamental to an understanding of her work. Matthias provided the first straightforward account in a newspaper article of the specifics of O'Keeffe's background and formal training, information O'Keeffe herself had tried to set forth in her 1922 essay for *MSS.* and in her statement for the 1923 show.[32] And as if in recognition of how the *femme fatale* of Stieglitz's photographic portrait had influenced interpretations of O'Keeffe's work, Matthias called attention to the austerity of her dress and manner. Thus, she assigned new emphasis to the image O'Keeffe had projected to the *Sun* critic in 1922. That image had been a component of Stieglitz's portrait from the beginning, but it had been given only passing attention in the criticism.

> She moves in one piece. Her black clothes have no suggestion of waist line. From the delicately poised head to the small stout shoes is a rhythm unbroken by any form of hampering. Delicate, sensitive, exquisitely beautiful, with the candor of a child in her unafraid eyes and the trained mind of an intuitive woman for a tool, it is no wonder that O'Keeffe disdains the ordinary trappings and lip rouge of her less favored sisters and faces the world unconcernedly "as is."
> . . . As a child she would not wear ornaments in her hair or on her person. She liked better the unadorned. She continues to like the unadorned, and so she works with simplicity and weaves it into fluid colors.

O'Keeffe was pleased with the article. She wrote to Matthias: "I think it one of the best things that have been done on me—and want very much to thank you—. It was nice of you to think of doing it at all—[.]"[33] And, using words that probably originated with Stieglitz, she pointed out that "the spirit of it is really fine—[.]"[34]

Apparently, Stieglitz and O'Keeffe had known Matthias since the early twenties, and although there is no way of knowing which of them initiated the interview, O'Keeffe's letter suggests that the resulting article was Matthias' idea. In any case, it is clear that O'Keeffe looked upon the interview as an opportunity to talk about the difficulties she had encountered in trying to define herself within the male-dominated art community. O'Keeffe's statement to Matthias, "you seem to feel something about women akin to what I feel" (Appendix A, no. 50), recalled the tone of her letter to Luhan. Thus, it is likely that Matthias became the sympathetic critic O'Keeffe had hoped to find in Luhan.

And because the Matthias article tried to disassociate her art from earlier interpretations, it suggests that O'Keeffe was still trying to redirect the criticism. Moreover, what she chose to discuss with Matthias reinforces the suggestion that O'Keeffe either had not read the 1925

criticism or did not understand its implications—an idea supported further by the article's insistence that Freudian interpretations continued to dominate the criticism. There had been no Freudian interpretations of her work in the 1925 reviews. Finally, despite O'Keeffe's positive response to it, the Matthias article did not characterize her art as effectively as Mullin's had the year before. What it did do was present O'Keeffe with an opportunity to speak for herself and to strengthen the image she wanted to promote in the criticism.

5

Matters of Fact and Matters of Opinion

How O'Keeffe had been perceived by others was one of the fundamen-
tal issues of an essay that appeared in *Time Exposures,* a book written
pseudonymously by critic Waldo Frank and published in October of
1926.[1] It was essentially a collection of profiles Frank had begun writing
in 1925 for the *New Yorker* under the name "Search-Light," though its
essay on O'Keeffe had not been previously published. Called "White
Paint and Good Order," the essay was an attempt by someone who
knew her very well to characterize the woman, her art, and her relation-
ship to the New York art community. And although Frank organized it
around a point that had become almost standard in the criticism—
O'Keeffe's unique, woman's vision of the world—his conclusions were
very different from those of other writers who were associated with the
Stieglitz circle or inspired by its thinking.[2]

Frank began by pointing out that although O'Keeffe was completely
at ease with herself, she was an enigma to others:

> She is a woman who has fused the dark desires of her life into a simplicity so clear
> that to most of her friends she is invisible. The smile on her face—half nun's, half
> Norn's—is due to this. (Appendix A, no. 54)

But Frank noted: "She is a woman. She dislikes this invisibility of hers.
She wants to be *seen.*" He meant that she wanted to be understood, and
he implied that she had been greatly misunderstood in New York:

> In the old days when she was a teacher of "art" in a Texas country school, she got
> used to solitudes. She dreamed not of fame then, but of a New York welcoming and
> appreciative. She did not guess that in this Manhattan vortex of artists, amateurs and
> critics she was to find a spiritual silence beside which the Texas prairies shouted with
> understanding.

In opposition to critics who maintained that O'Keeffe was an exotic
creature driven by long-repressed sexual desires or an occultist, privy

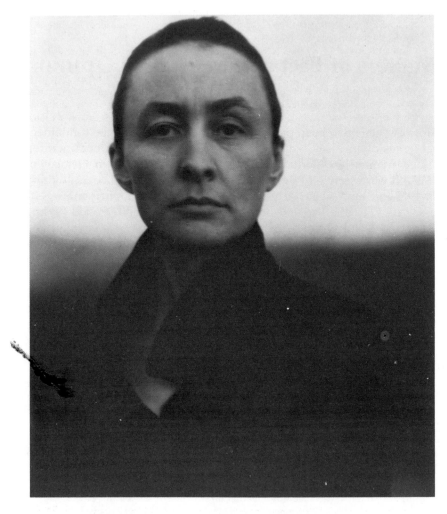

Figure 16. Alfred Stieglitz, *Georgia O'Keeffe: A Portrait—Head*, 1920
Gelatin silver print, 5¹/₈ × 4⁷/₁₆ in.
(*National Gallery of Art, Washington, D.C., Alfred Stieglitz Collection*)

to the mysterious secrets of nature, Frank believed she was an earthy, honest, and simple woman, whose work reflected her equally uncomplicated—primarily, visual—conception of what was around her:

> For O'Keeffe is a peasant—a glorified American peasant. Like a peasant, she is full of loamy hungers of the flesh. Like a peasant, she is full of star-dreams. She is a strong-hipped creature. She has Celt eyes, she has a quiet body. And as to her esoteric Wisdom, I suspect that it comes down to this: O'Keeffe has learned, walking through an autumn wood, how the seeming war of shapes and colors—the red and yellow leaves, the shrilling moods of sky—melts into a single harmony of peace. This is the secret of her paintings. Arabesques of branch, form-fugues of fruit and leaf, aspirant trees, shouting skyscrapers of the city—she resolves them all into a sort of whiteness: she soothes the delirious colors of the world into a peaceful whiteness.

Frank thought of O'Keeffe as a "spirit of quiet and of peace," and he made this clear by paralleling her to a form in nature. Using the tree-analogy quoted, in part, earlier, he wrote:

> O'Keeffe is very like a tree. Her arms and her head stir like branches in a gentle breeze. (Her ears are pointed like a faun's and her voice, like leaves, has a subtle susurration.) She is almost as quiet as a tree, and almost as instinctive. If a tree thinks, it thinks not with a brain but with every part of it. So O'Keeffe. If a tree speaks or smiles, it is with all its body. So O'Keeffe whose paintings are but the leaves and flowers of herself. If a tree moves, you don't notice it. And when you find this woman moving through the wordy whirlwind that ever rages round the rooms of Alfred Stieglitz, you have the effect of silence.

The concluding sentence of that passage supported the principal objective of Frank's essay: to demonstrate O'Keeffe's distinctiveness and to suggest how very different her nature was from that of other members of the New York art community. In directly addressing the obvious differences between O'Keeffe and Stieglitz, however, Frank also implied that Stieglitz's inner nature was compatible with O'Keeffe's, and that he had offered her refuge within the world they inhabited.

> Now, it just happens that Stieglitz is a man who must live in a whirlwind. Wherever the man is, there a whirlwind must foregather. And O'Keeffe . . . finds her haven in this whirlwind world of Stieglitz. It is always hushed and still at the vortex of a maelstrom. If you don't believe it, look at Georgia O'Keeffe.

Yet Frank also believed the quiet simplicity that formed the basis of O'Keeffe's nature also lay at the core of her art—a fact, he asserted, that New York would not accept:

Along came the experts. And they prated mystic symbols: or Freudian symbols. How could you expect New York to admit that what it likes in O'Keeffe is precisely the fact that she is clear as water? cool as water? New York is sure, it is too sophisticated to care for anything but cocktails. What a blow to our pride, to confess that it is neither more nor less than the well-water deepness of O'Keeffe which holds us! Better pour the simple stuff of her art into cunningly wrought goblets of interpretation. Better talk of "mystic figures of womanhood," of "Sumerian entrail-symbols," of womb-dark hieroglyphics. Doubtless, all this would make the woman tired—if she could not smile.

Although O'Keeffe's "smile" had sustained her through the frustration of myriad misinterpretations of her work, it was itself misunderstood:

It is a simple, kindling smile: it lights the face with a maternal splendor. But the confused men and women who behold it, will not have it so. They insist that her smile, like her pictures, is mysterious. The girl's work, they argue, is Kabala. The girl herself is the Sphinx. Really, O'Keeffe, despite her gifts and her benevolent spirit, has not had a chance.

Twice in the essay, Frank entreated his readers to "look at" O'Keeffe and to judge her by what they could see. His conclusion drove home the point that she was what she appeared to be and explained why he felt she was "of so great a value in Babylonian New York":

You know where to find the writings of our granite-marble city? In *The New Yorker*. Well, O'Keeffe's work is the script of the landside—of its loam and of its lowly hut.
 Perhaps such script is Scripture. We'll let the critics decide. This much is sure: to see her is to be minded of some Scriptural wife tilling the soil and homing with her husband under the storms and sunbeams of Jehovah. And so to see her is to understand her, and to know her place in Manhattan.

Certainly Frank's essay was not any freer of references to archetypal women than earlier contributions to the criticism, but it stands as one of the most sympathetic treatments of its subject in the period. It was probably addressed as much to O'Keeffe as to anyone else. She and Frank were friends, and he clearly thought her work was both important and grossly misunderstood. That she respected his opinion is obvious from a letter she wrote to him early in 1927, the day before her annual show was to open:

You have touched very critical happenings in my life several times without knowing it—your book was one of them—
 I dont seem to be able to think or feel of it in terms of liking or disliking—It is there—and that is all there is to it—And I feel that your intention toward me was

more kindly than toward anyone else in the book—that is—there seemed to be more of a warm kindly feeling—and less of the knife for me than for most of the others— I do not want particularly to thank you for the book—that seems relatively unimportant—I am simply glad that you *are* something sharp—and alert—working. Where you are makes no difference—so long as you have the peace—and the urge for work—[.][3]

But there are indications in the letter that O'Keeffe was deeply troubled, among which are the following passages:

I do not seem to be crystalizing anything this winter—Much is happening—but it doesn't take shape—The only sign of shape that I can see is that after I have talked with anyone—I have felt more like the lash of a stinging whip on life—than anything else—and I dont think I like it. . . .
 . . . I had halfway hoped to have a talk with you before you go—if it had happened naturally it could have happened—I haven't felt like making even half a step toward anyone—. —Maybe—partially because I am not clear—am not steady on my feet[.][4]

The letter also alluded to a realization on O'Keeffe's part that she was unwilling to identify or discuss: "I have come to the end of something— and until I am clear there is no reason why I should talk to anyone—[.]"[5]

It is impossible to know precisely what she meant when she wrote "I have come to the end of something." It is tempting to assume that the remark is related in some way to Frank's essay, but there is nothing to substantiate such a speculation. In fact, there is no evidence that she put a definitive "end" to anything related to her art until 1929, when she refused to work at Lake George that summer and traveled, without Stieglitz, to New Mexico to paint. Certainly, she had never been entirely satisfied with working conditions at the lake, and by the mid-twenties, she was finding it increasingly difficult to paint there.[6] But Frank had not alluded to this problem in his essay.

What he had suggested was that O'Keeffe was out of place in New York. He stated that Manhattan could not "be at home with her simple purity," suggesting that the city, where O'Keeffe had lived for half the year since 1918, was an unnatural environment for her. She had been "quite ready to stay on in Texas," he wrote, but "Alfred Stieglitz . . . [had drawn] her northward," and she had simply adapted: "From her pioneer fathers, wandering west, she has her ability to pitch her camp in any country and in any season" (Appendix A, no. 54). Although there can be no doubt that O'Keeffe never felt naturally suited to life in the city, by the time Frank's book was published, she had done more than merely adapt herself to living there. She had made New York a major subject in her art.

Beginning in 1919, O'Keeffe and Stieglitz had spent the winter and spring months in midtown Manhattan, and since late 1925, their home in the city had been a suite on an upper floor of the Hotel Shelton, one of New York's newest and tallest buildings. The experience of living so high up at the Shelton stimulated O'Keeffe to begin working with New York skyscraper architecture as a subject, and the panoramic views from her suite's windows, facing north and east, specifically inspired some of the most distinctive paintings she made in the late twenties (see *East River from Shelton* [fig. 17]).[7]

The assertion in Frank's essay that O'Keeffe's art had been misunderstood by the critics reinforced a point Matthias had made earlier. Using language she had clearly extracted from Stieglitz's assessment of the situation, Matthias concluded that the critics had been "unprepared for direct contact with the art spirit of woman" and thus "began frantically searching for the magic key which was to illumine their habit-stunted minds"[8] (Appendix A, no. 50). But Frank implied that it was wrong to call what O'Keeffe's art expressed anything as exalted as "the art spirit of woman." He contended that her art aspired to no more elevated matters than soothing "the delirious colors of the world into a peaceful whiteness" (Appendix A, no. 54). The "experts," however, preferred to cloak O'Keeffe and her painting in high-flown theories ("pour the simple stuff of her art into cunningly wrought goblets of interpretation") rather than to admit the essential simplicity of the woman and what she was about. Thus they filled their reviews with phrases like " 'mystic figures of womanhood' . . . [or] womb-dark hieroglyphics" and declared that O'Keeffe's art was a revelation of unconscious and formerly secret dimensions of the female nature.

O'Keeffe had made it clear to Matthias that she objected to any theory that promoted the idea that her work was either morbid, exotic, or erotic, but there is no way to know whether she agreed with Frank's contention that the criticism of her art should be stripped of all theories. It is a fact, however, that critics writing in the late twenties continued to enshroud her art in theories that had originated within the Stieglitz circle and, thus, perpetuated the image of O'Keeffe as an exotic and erotic woman. In fact, one aspect of this image can be clearly seen in the essay Stieglitz solicited from painter Oscar Bluemner for the catalogue of O'Keeffe's 1927 show.[9]

Called "Georgia O'Keeffe: Paintings, 1926," the show took place between 11 January and 27 February, and its catalogue also included a brief statement by Demuth, which celebrated O'Keeffe's color[10] (Appen-

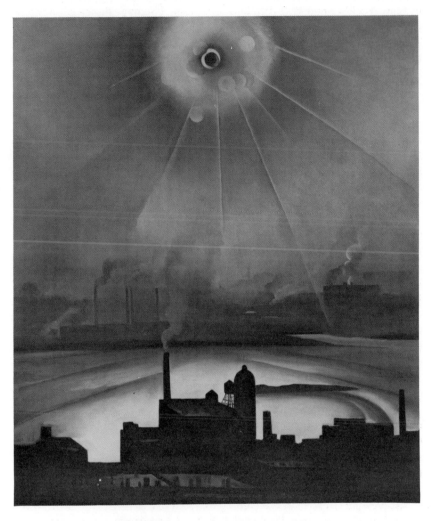

Figure 17. Georgia O'Keeffe, *East River from Shelton*, 1927–28
Oil on canvas, 27 × 22 in.
*(New Jersey State Museum Collection, Trenton. Purchased by the
Association for the Arts of the New Jersey State Museum with a Gift from
Mary Lea Johnson, FA1972.229)*

dix A, no. 57B). Bluemner's essay, on the other hand, was a celebration of a very different order. It referred to O'Keeffe as "priestess of Eternal Woman" (Appendix A, no. 57A), sounding a refrain that had been present in the criticism since Rosenfeld's essay of 1922. But most of what Bluemner wrote came directly from Stieglitz. He stated that O'Keeffe was "the foremost woman painter"[11] and continued with a point Stieglitz had begun making in the teens: "[Until O'Keeffe] we had not yet seen woman in art finding herself."

Moreover, Bluemner associated O'Keeffe's art with the "scientific" theory advanced by Stieglitz as early as 1919, which had become an official part of the criticism in 1924 in Strand's essay. Bluemner wrote that her "surface-modelling now emulates vital process, expresses biological emotion," and the conclusion of his essay related this new expression to a change in woman's place in the world.[12]

> The brainy male brute of action owns the stage of historical cultures and his male instincts have shaped their responses to supreme questions, in art—while the Feminine Principle has only occasionally stepped out from its retreat behind the scenes, to lighten up an age, a race—mental suns long since dormant. . . .
>
> In this our period of woman's ascendancy we behold O'Keeffe's work flowering forth like a manifestation of that feminine causative principle, a painter's vision new, fascinating, virgin American.

With his final phrase, Bluemner even injected the notion Stieglitz had first announced in the title of O'Keeffe's 1923 exhibition, that her work was, above all, American.

Just before the exhibition closed, the *New Republic* published a piece written by Lewis Mumford, whose close literary friendship with Rosenfeld began in 1926. Entitled "O'Keeffe and Matisse," Mumford's article combined a commentary about the O'Keeffe show with remarks about the Matisse work that was on exhibition almost simultaneously at the Valentine Dudensing Gallery.

Mumford distinguished both painters from "conventional" artists:

> Miss O'Keefe's paintings and the recent retrospective show of Matisse remind one that the pure artist is always more deeply in touch with life, even with life considered merely in the dress of our own day, than the conventional artist who does the accepted thing. (Appendix A, no. 63)

And he declared a kinship between them on the basis of the relevance of their work to the modern age: "Miss O'Keefe's paintings . . . reveal and refocus many of the dominant aspects of our time. It is the same with Matisse."

Mumford's comparison of O'Keeffe with Matisse must be considered an innovative critical observation, but most of what he wrote specifically about her art reflected his alignment with thinking traditional to the Stieglitz circle. For example, he used a natural-growth metaphor to characterize O'Keeffe:

> The point is that all these paintings come from a central stem; and it is because the stem is so well grounded in the earth and the plant itself so lusty, that it keeps on producing new shoots and efflorescences . . . all intensified by abstraction into symbols of quite different significance.

And his basic assumption was informed by the oldest Stieglitz-promoted theory in the criticism—that O'Keeffe's art was an expression of her sexuality.

In the letter Stieglitz published in *Camera Work* in 1916 (quoted earlier), Evelyn Sayer had written about O'Keeffe's charcoal drawings: "I was startled at their frankness; startled into admiration of the self-knowledge in them. How new a field of expression such sex consciousness will open" (Appendix A, no. 2). Over a decade later, a sentence in the concluding paragraph of Mumford's essay was little more than an elaborate restatement of the same idea: "Miss O'Keefe's paintings . . . tell much about the departure of Victorian prudery and the ingrowing consciousness of sex, in resistance to a hard external environment" (Appendix A, no. 63).

Mumford began his argument by claiming that "Miss O'Keefe is perhaps the most original painter in America today," and then he defined the nature of her originality:

> She has discovered a beautiful language, with unsuspected melodies and rhythms, and has created in this language a new set of symbols; by these means she has opened up a whole area of human consciousness which has never, so far as I am aware, been so completely revealed in either literature or in graphic art.

The symbols of this new language were not related to the symbols derived from "literary myths" and used by such painters as Ryder, Blake, or Redon. Mumford believed, in fact, that since O'Keeffe's art served to document her sexual feelings, it had no counterpart in literature: "Miss O'Keefe's world cannot be verbally formulated; for it touches primarily upon the experiences of love and passion." As he explained:

The fact is that words strike love stone-cold; what it is, is something much too deep in the blood for words to ejaculate; and when driven to such an indirect medium, the result is not the original quality of passion or sexual intimacy at all, but obscenity—which is but the ashes from an extinguished fire.

But because O'Keeffe's "language" was purely visual, "a direct expression upon the plane of painting, and not an illustration by means of painting of ideas that have been verbally formulated," it could communicate the intimacy of those experiences without distortion.

Creating images that are as palpable as flesh and as austere as a geometric figure, Miss O'Keefe has created a noble instrument of expression, which speaks clearly to all who have undergone the same experiences or been affected by the same perceptions. She has beautified the sense of what it is to be a woman; she has revealed the intimacies of love's juncture with the purity and the absence of shame that lovers feel in their meeting; she has brought what was inarticulate and troubled and confused into the realm of conscious beauty, where it may be recalled and enjoyed with a new intensity; she has, in sum, found a language for experiences that are otherwise too intimate to be shared.

In the next sentence of this passage, Mumford particularized his discussion of sexual expression in O'Keeffe's work by calling attention to her use of flower forms as symbols.

To do this steadily in fresh forms, and to express by new expedients in design—as in the filling of a large canvas with the corolla of a flower—her moods and meanings: these are the signs of a high aesthetic gift.

Stieglitz could have objected to very little, if anything, about the essay. It epitomized his beliefs about O'Keeffe's art, and furthermore, it contended that what she was doing made a universal comment about her time—one comparable to that in the mature work of one of Europe's most celebrated artists. And in fact, a letter he wrote to Mumford a few days after the article was published confirmed his positive reaction; but it also stated unequivocally that *both* he and O'Keeffe had been pleased with it: "[The article] took our breath away. Not only mine, but Georgia's. . . . It's a magnificent essay. Clear and New. You have touched something that has not before been said not only of Georgia but of America."[13]

Although Stieglitz confirmed O'Keeffe's reaction in a later letter to Mumford, it is impossible to believe that she had no reservations about the article.[14] Whereas she would not have objected to Mumford's assumption that her work addressed a specifically female experience—

that she had "beautified the sense of what it is to be a woman"—she could not have approved of his assertion that that experience was sexual: "She has revealed the intimacies of love's juncture . . . [and], in sum, found a language for experiences that are otherwise too intimate to be shared." This interpretation, and the implication throughout the article that her art—fraught with symbols—was the work of an expressionist, conflicted directly with O'Keeffe's declarations to Matthias in 1926, and so she cannot have agreed with either of them.

But Mumford also equated the relevance of her art and Matisse's, which could have gone as far to temper her negative reaction to the theme of the essay as it would to reinforce Stieglitz's positive reaction. Moreover, it may have been difficult to see the forest for the trees in the Mumford piece. It was filled with claims that were extraordinary if not unique in the criticism, and several of these may have tended to obscure Mumford's contention that the importance of O'Keeffe's art lay in the effectiveness of its sexual symbolism. For example, he called her work "original"—a point that had been made before in the criticism only in the 1922 *Sun* article and in Watson's 1925 review—but he based that assessment on the "beautiful language" she had developed to communicate her sexual feelings. And although he declared "her place [in art] is secure," he felt it was secure because she had proven herself able to express her sexual feelings "steadily [and] in fresh forms."

Nevertheless, Mumford did point out that O'Keeffe's position as an artist was assured, and that statement, combined with the overwhelmingly positive tone of the essay and Stieglitz's obvious enthusiasm over it, may have persuaded O'Keeffe to disregard Mumford's fundamental point. Furthermore, what Pemberton, Read, and McBride had written about her 1927 show would have made it easier to disregard anything she found distasteful in the Mumford piece. In reviews published before Mumford's essay, all three critics defined her work or qualified its importance in ways new to the criticism.

The broadest pronouncement was made by Pemberton in his article for the *New Yorker*. After defending O'Keeffe's abstractions, he extended a point about the significance of her work that he had made the year before and that Mumford's later article reinforced. He wrote: "O'Keeffe will certainly be looked back upon as one of the milestones" (Appendix A, no. 61). In the *Brooklyn Daily Eagle*, Read's more particularized discussion began by stating that O'Keeffe's imagery should be freed from all theoretical interpretations; and the effect of Frank's essay on her opinion cannot be discounted.

I, for one, am inclined to think that the writers, who insist upon interpreting her work in terms of biology and psychology, not only miss its real beauty as painting, but have done her actual harm in the eyes of the art-loving public. (Appendix A, no. 60)

It was Read's belief that O'Keeffe's importance could best be stated in terms of art history.

It is enough for any painter to stand on the merits of his work as painting. To have achieved a new interpretation of so traditional a subject as flowers and fruit still lifes, to have brought to it a new style arrangement, a new technique, is no small accomplishment. And O'Keefe has done this. She paints giant closeups of purple black petunias, of flaming cannas and dead white calla lilies, and arrangements of apples and alligator pears as no one else has done before.

Although the relationship of O'Keeffe's work to the history of women's art had been discussed in the criticism since Hartley's essay of 1921, Read's remarks had nothing to do with the fact that O'Keeffe was a woman painter. Rather, they were based on the idea that her unique handling of still-life subject matter had contributed significantly to the continuing development of a tradition in Western painting.

In 1925, McBride had opened his review of "Seven Americans" in the *New York Sun* with a comment about Stieglitz's promotional methods:

The Alfred Stieglitz group of artists is now by right of survival the most conspicuous group in town. Its ramifications in the social fabric are so great that it has arrived at the point where it can fill the rooms without the aid of publicity—but this is largely because it makes use of what might be called superpublicity—or in other words literature. From the first the Stieglitz group has known how to attach literature to itself.

This, of course, is wisdom. It gives one a double chance at immortality. (Appendix A, no. 36)

And he used the occasion of O'Keeffe's show in 1927 to elaborate that theme, again in the *Sun,* by pointing out the self-congratulatory nature of the "literature" offered in catalogues that accompanied exhibitions of the Stieglitz group and expressing mild dismay over the content of what was printed in O'Keeffe's catalogue.[15] But more important, he introduced an interpretation of O'Keeffe's work that opposed the premise of all existing ones.

The review was titled "Georgia O'Keeffe's Work Shown: Fellow Painters of Little Group Become Fairly Lyrical Over It" and began its discussion of her work with the following remark: "Miss O'Keefe be-

longs to a little group of American painters who admire each other very much and never hesitate to say so" (Appendix A, no. 58). McBride quoted without comment Demuth's catalogue statement, but he called the Bluemner essay the work of a "rather reckless stylist when it comes to writing" and used its Stieglitz-derived theme of "woman in art finding herself" (Appendix A, no. 57A) as a starting point to discuss the history of critical interpretations of O'Keeffe's work.

He began with a reference to Hartley's essay: "Marsden Hartley, who has also written of Miss O'Keefe's work, noticed the appealingly feminine quality of the work and amiably deprecated the slight tinge of morbidity in the background of it" (Appendix A, no. 58). And he suggested that the numbers of those who turned to Freudian theory to discover the meaning of that "slight tinge of morbidity" were diminishing:

> The suggestion of the clinic created considerable consternation in certain quarters when Miss O'Keefe's abstract work was first seen, but either because the public has grown used to the march of science or Miss O'Keefe has become less medical, the voice of inquiry in regard to it is less frequently heard now than formerly. Mr. Bluemner's suspicious remarks about biology and Dionysian cults, therefore, will probably not occasion outcries.

Then McBride articulated an opinion about O'Keeffe's work that his earlier reviews had suggested but never stated. He wrote: "The painting is intellectual rather than emotional, though, cool as it is, it unquestionably stirs certain natures almost to the fainting point." As he explained:

> It is not emotional work because the processes are concealed. The tones melt smoothly into each other as though satin rather than rough canvas were the base. Emotion would not permit such plodding precision.

Before McBride's review, the word "intellectual" had never been applied to O'Keeffe's work without qualification in the criticism. O'Keeffe herself had been labeled "intellectual and introspective" in the 1922 *Sun* article (Appendix A, no. 9)—the only article before Matthias' that had been based on an interview. But the most commonly held critical position in the matter was the one advanced by the Stieglitz circle and stated definitively in 1924 by Rosenfeld when he proclaimed that O'Keeffe was "one who shows no traces of intellectualization and has a mind born of profoundest feeling" (Appendix A, no. 28). The fact that Stieglitz believed O'Keeffe—like all women—functioned entirely in terms of intuition is borne out in a letter he wrote in 1922 to Rebecca

Strand: "[Georgia] is a woman—has no ideals.—Just goes ahead.—You know.—You're one of those species yourself."[16]

In 1924, Virgil Barker had introduced the idea that the emotion that propelled O'Keeffe's art was modulated with intellect when he wrote: "Miss O'Keeffe's pictures embody intelligent passionateness" (Appendix A, no. 31); but McBride's declaration that her art was intellectual *rather than* emotional ran distinctly against the grain of critical opinion. Stieglitz and his associates had waged a successful campaign from the teens to encourage others to see her art as an outpouring of emotional energy. And therefore, although he made it clear in "Woman in Art" that he believed the process of making art for both women and men involved the intellect, Stieglitz would never have agreed with McBride that O'Keeffe's art was primarily intellectual.

Stieglitz had predicated his initial opinion about the overwhelmingly emotional quality of O'Keeffe's art on the improvisational, nondescriptive drawings she had made in 1915, and over the years, he had modified his opinion only slightly. But her imagery had grown steadily less improvisational, and especially after the reviews of 1923, more overtly tied to the forms of her physical environment. By the time of her 1927 show, her paintings, whether descriptive or nondescriptive bore very little resemblance to her work of the teens.[17]

O'Keeffe herself had stated in a letter to Stieglitz that her drawings of 1915 were primarily an expression of her feelings: "I make them just to express myself—Things I feel and want to say—haven't words for."[18] By 1926, however, she had broadened her perception of her work. When she talked to Matthias that year, she implied that it was as much about her thoughts as her feelings ("I want to paint in terms of my own thinking, and feeling the facts and things which men know" [Appendix A, no. 50]).

It is possible that McBride had read the Matthias article and, by calling her work "cool," was responding to O'Keeffe's attempt in it to deny that she was an expressionist.[19] But he based his pronouncement that her art was intellectual on the deliberateness of her technique—its "plodding precision"—and what that suggested about its expressive stance. His conclusion in this regard was as distinctive in the criticism as his premise had been:

Miss O'Keefe[,] therefore, is rather French, for though Proust, Paul Morand and Jean Cocteau have done all they can do to break the old forms, and "French" may come to mean something else in the future; at present it means planning the work out in one's mind completely before beginning upon it. Readers who care to go into this

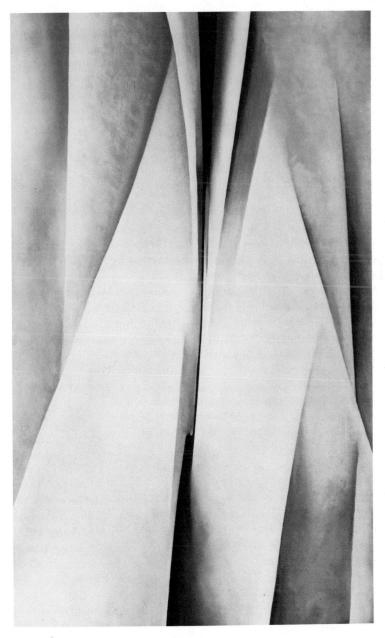

Figure 18. Georgia O'Keeffe, *Abstraction*, 1926
Oil on canvas, 30 × 18 in.
(*Collection of Whitney Museum of American Art. Purchase. 58.43*)

subject more deeply are recommended to read the dialogues of Diderot. (Appendix A, no. 58)

There can be little doubt that O'Keeffe's technique had reached prodigious refinement by the mid-twenties, and that, combined with her tendency to pre-plan her paintings, had permitted her to achieve remarkable feats of execution. For example, she later described how she had painted *The Shelton with Sunspots* (fig. 19), which was exhibited in 1927:

> I don't start until I'm almost entirely clear. It's a waste of time and paint. I've wasted a lot of canvas. . . . With that Shelton . . . I started at one corner and I went right across and came off at the other corner, and I didn't go back. For me [that was pretty unusual]. . . . I was amazed I could do it.[20]

The story is remarkable, and McBride had probably heard it at the time, but he could as well have based his opinion about the intellectual quality of her work on his observation of the increasing control O'Keeffe exerted over all aspects of her imagery.

Stieglitz could hardly have been pleased that McBride had removed O'Keeffe's work from both the expressionist and uniquely American arenas to which his theories had assigned it; but O'Keeffe was thrilled by the review. She wrote McBride the day after it appeared to thank him "for the notice in the Sun" and went on:

> I like what you print about me—and am amused and as usual dont understand what it is all about even if you do say I am intellectual[.]
> I am particularly amused and pleased to have the emotional faucet turned off—no matter what other one you turn on.
> It is grand—
> And all the ladies who like my things will think they are becoming intellectual—Its wonderful[.] And the men will think them much safer if my method is French[.][21]

Most of her remarks to McBride were tongue-in-cheek, but it is clear that O'Keeffe believed his article would help accomplish what she had been trying to do for five years: turn off "the emotional faucet" in the criticism. And indeed, his essay countered the well-established idea that her art was a spontaneous pouring forth of her feelings, a point of view that had been continually present in the criticism since the late teens.[22]

Several weeks after O'Keeffe responded to McBride's essay, however, she had ample reason to be less concerned with the critical re-

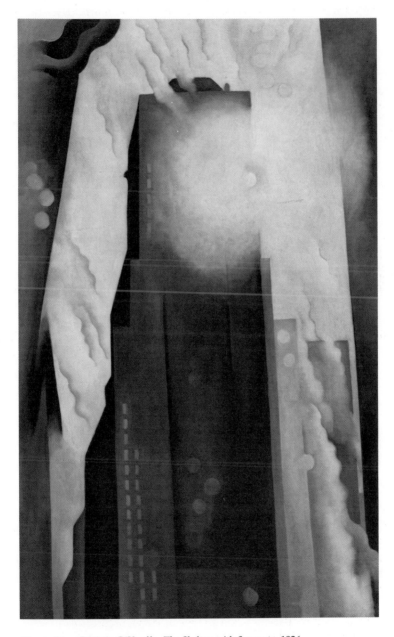

Figure 19. Georgia O'Keeffe, *The Shelton with Sunspots*, 1926
Oil on canvas, 49 × 31 in.
(Gift of Leigh B. Block, 1985.206. © 1989 The Art Institute of Chicago.
All rights reserved)

sponse to her art. By 2 February, less than a month after the show had opened, sales had generated at least $9,000, with one painting selling for $6,000.[23] This unexpected success stimulated two articles about O'Keeffe that were published after her show and that, along with the Matthias and Frank essays of 1926, introduced fresh ideas about O'Keeffe herself into the criticism.[24] In fact, these articles established a new trend that developed the image O'Keeffe had first projected in 1922, which became strong enough by the last year of the decade to counter the provocative image of her—either stated or implied—that had existed since the beginning of her New York career.

6

Across the Final Surface

Matthias had effectively described the simplicity and severity of O'Keeffe's appearance, and though the tone of Frank's essay was very different from hers, he had portrayed O'Keeffe similarly. Furthermore, Frank's characterization was supported visually by the Stieglitz photograph that accompanied his essay (fig. 16). And thus, for the first time in a commentary about O'Keeffe that was illustrated with a Stieglitz photograph, there was a correspondence between verbal and visual description.[1] In no earlier article or essay about O'Keeffe had there been a convincing correlation between what the critic implied about her and what was implied by an illustration.

Before 1926, O'Keeffe's physical appearance had been mentioned only by the *Sun* writer in 1922 and by Read in 1924. The *Sun* article described her facial features and pointed out that she was "a curiously austere type" (Appendix A, no. 9), an assessment confirmed by the Marion Beckett portrait of O'Keeffe that illustrated the article. But it also paraphrased some of Rosenfeld's language, whose provocative nature suggested a very different woman. Read reported what O'Keeffe looked like, but then stated outright that she was not necessarily what she appeared to be.

Read had known O'Keeffe in 1907–8 at the Art Students League and, in a passage quoted earlier from her *Brooklyn Sunday Eagle Magazine* article, seemed amazed at the change O'Keeffe had effected in her appearance by 1924: "What a different O'Keeffe she has become! She is no longer curly-haired and boyish but an ascetic, almost saintly appearing, woman with a dead-white skin, fine delicate features and black hair severely drawn back from her forehead" (Appendix A, no. 30). But then she added:

Saintly, yes, but not nun-like, for O'Keeffe gives one the feeling that beneath her calm poise there is something that is intensely, burningly alive, and that she is not

only possessed of the most delicate sensibilities but is also capable of great and violent emotions. These qualities written on her face are also reflected in her work.

The image O'Keeffe presented to the public had grown more severe over the years, and indeed, there was little correspondence between the austerity of the woman and the chromatic and formal lushness of many of the paintings she had produced by the mid-twenties. This apparent contradiction went far to heighten a suspicion, like Read's, that beneath O'Keeffe's composed exterior lay a seething mass of repressed emotion. The 1924 essay by Rosenfeld, published just before Read's article, furthered a similarly conflicting image of O'Keeffe. Its content emphasized the sensuality of her art, implying a sensational image of the artist, but it was accompanied by a Stieglitz photograph that presented her as a harsh and uncompromisingly unadorned woman (fig. 13).

Thus, contradictory impressions of O'Keeffe had developed in the criticism. The image of her that had been officially promoted by Stieglitz—as evidenced by the photographs or other illustrations he released to accompany articles—was dramatic, stern, and forbidding. The portraits drawn in words by Hartley and Rosenfeld proposed, on the other hand, that O'Keeffe was simultaneously ethereal and worldly, pure and sensual—notions they had derived primarily from Stieglitz's photographic portrait of her. Extremely influential in the criticism, these complex and intrinsically contradictory conceptions of O'Keeffe had determined much of the response to her art in the early twenties. And in turn, whenever her paintings were linked to her emotions, a provocative idea of the artist was evoked. The constant in this was O'Keeffe herself, whose manner of dress and public demeanor reinforced both the drama and the severity of the official photographic image.

The result was that an aura of mystery surrounded O'Keeffe. The problem had been described by Frank in 1926; and in 1927, its power over critical opinion about her work was suggested, with characteristic irony, by McBride. In his second review of her show that year, published in March in the *Dial*, he wrote:

> Miss O'Keefe is fond of gradations of tone, and with infinite patience pursues a purple down a petunia's throat until she arrives at the very gates of—I was going to say hell, but I mustn't say that, though the mere fact that I was going to say it shows that this priestess of mystery known as Miss O'Keefe almost had me in her power. (Appendix A, no. 64)

Bluemner's, Kalonyme's, and Mumford's essays in 1927 perpetuated the mystery, but two written after O'Keeffe's show did much to clear it up. Although McBride claimed that the exhibition of Stieglitz

photographs in 1921 had made O'Keeffe "a newspaper personality,"[2] it was not until 1927 that writers began to seek her out for features. That year, Dorothy Adlow and Frances O'Brien—neither of whom had written about O'Keeffe before—produced articles that provided even more extensive characterizations of her than Matthias' had a year earlier.

Their interest in O'Keeffe was stimulated, no doubt, by her growing success as an artist. For example, by the end of 1926, three of her paintings had been added to the Phillips Collection, and in 1927 one had been acquired by the Brooklyn Museum through a bequest. Furthermore, the proceeds from her sales had been unusually large in 1927; and as part of its summer exhibition that year, the Brooklyn Museum provided her a room in which Stieglitz staged a small retrospective exhibition of her work.

When Adlow and O'Brien interviewed O'Keeffe, they perceived her as a totally committed, professional woman whose paintings reflected, rather than contradicted, the way she looked, the way she lived and worked, and the way she thought. For example, Adlow—not entirely in agreement with Frank—concluded her mid-1927 piece for *The Christian Science Monitor* with the following:

> Miss O'Keeffe lacks an earthiness. She ignores the mundane. She is exotic, aloof. She is truly an independent, free of current movem[e]nts as she is of society. She has the distinction of a sensitive nature and the capacity of conveying its best to the canvas. In being true to her own perception she remains the artist and more, the woman. (Appendix A, no. 66)

But the most important revelations of these articles lay less in what their authors concluded about O'Keeffe than in simply reporting what they observed about her. Published in an October issue of the *Nation*, O'Brien's piece established a connection between the austerity of O'Keeffe's appearance and the way she worked and gave opinions about the "cleanness" of her work new authority:

> [She is] a tall, slender woman dressed in black with an apron thrown over her lap. Beside her is a glass palette, very large, very clean, each separate color on its surface remote from the next. As soon as a tone has been mixed and applied to the canvas its remains are carefully scraped off of the palette, which thus retains always its air of virginity. (Appendix A, no. 67)

And like Adlow, O'Brien found direct correspondences between O'Keeffe's paintings and the artist herself: "When you look at her pictures you know that she is chiseled, ordered, and fine just as they are."

Both writers saw the characteristics of O'Keeffe's appearance re-

flected in her life style. Adlow presented O'Keeffe as a woman so in-
volved with her work that she retreated from the pleasures of New
York:

> She is a painter that lives something of a hermit's life in the very center of New York
> where her perch on the twenty-sixth story relieves her of the storm and noise and
> incidentally offers an excellent view of the ever-changing sky line. One might as
> well live out in the country for all the advantage of theaters and endless attractions
> of the great city. When on the job, says Miss O'Keefe, one must keep away from all
> these distractions. The artist must submerge himself entirely in his work while he is
> performing. But she does not sacrifice much here for she seems disinterested in the
> theater, although the new cinema "palaces" amuse her with their sumptuousness
> and decorum. (Appendix A, no. 66)

Similarly, O'Brien opened her article with this statement: "In an
apartment on the twenty-eighth floor of the Shelton a woman sits paint-
ing," and later, she continued her description of O'Keeffe at work:

> It is late afternoon and even in this high place the room is growing dusky. The
> artist does not seem to know this. She goes on painting carefully, swiftly, surely—
> and she and the canvas and the glass palette are one world having no connection
> with anything else in existence. And then the telephone rings.
> "Hello, Georgia? This is ———[.]" "Hello, how are you? Would you mind calling
> up a little later after the light goes?" And the chastened caller ponders the twilight
> outside his window and wonders how even on a twenty-eighth floor one can go on
> painting.[3] (Appendix A, no. 67)

As O'Brien summarized: "She lives simply, almost as a recluse . . . [and]
orders carefully every detail of existence so that the maximum of time
may be given to her work."
 In addition to depicting O'Keeffe as an uncompromising profes-
sional artist, Adlow and O'Brien referred to other dimensions of her life
and interests. The result was that, between the two articles, a portrait
emerged that was more complete than any to date in the criticism, and
although less specifically focussed, it was essentially the image O'Keeffe
had projected in 1922. Adlow pointed out that O'Keeffe had established
an effective balance between her private life and her profession:

> Half the year is spent in the country where Miss O'Keeffe divides her time betwixt
> her painting and domestic life, careful to give each its own due. She is as enthusiastic
> about the labors of the household as every normal woman, prepared to care for them
> when necessary but happy to be relieved when possible. It is easier to get her started
> on the subject of menus and palates than it is on palettes and pigments. (Appendix
> A, no. 66)

But if Adlow declared O'Keeffe a "normal woman" with interests in her household, she also stated that O'Keeffe was "critical of the lack of independence in the modern young woman" and paraphrased her comment on the subject: "Each person must be able to take care of herself, to discover what are her best possibilities and find enjoyment in developing them."

On 28 February 1926, O'Keeffe had spoken at a dinner sponsored by the National Woman's Party, held at the Mayflower Hotel in Washington, D.C., to honor Jessie Dell, a recent female appointee to the United States Civil Service Commission; and she had urged those present to assume responsibility for their own lives and encouraged them to become financially independent of men.[4] Because she also made her ideas along such lines clear to Adlow and O'Brien, they emphasized her interest in feminist issues. O'Brien wrote:

> If Georgia O'Keeffe has any passion other than her work it is her interest and faith in her own sex. . . . You must not, if you value being in her good graces, call her "Mrs. Stieglitz." She believes ardently in woman as an individual—an individual not merely with the rights and privileges of man but, what is to her more important, with the same responsibilities. And chief among these is the responsibility of self-realization. O'Keeffe is the epitomization of this faith. (Appendix A, no. 67)

Frank had suggested that "O'Keeffe's years have deepened, not complicated her" (Appendix A, no. 54), and O'Brien reinforced that opinion: "Ten years [in New York] have not made a different person of Georgia O'Keeffe. Today finds her the same strong, clear, and introspective person as the girl who wandered with her classmates through the Virginia woods, studying bird life" (Appendix A, no. 67). Moreover, her integrity and sense of purpose had not been undermined by publicity and success, O'Brien implied:

> She has remained undisturbed by the worship of the culturally elite. That is why of all our modern painters she is the least influenced by any of the trivialities, the aesthetic fashions of the time. These things do not exist for her; her roots are in the earth and her kinship is with the things that grow from the soil.

Obviously, O'Brien's reference to natural growth in connection with O'Keeffe reflects the thinking of the Stieglitz circle and, thus, suggests that she, like Matthias, based the ideas expressed in her article—at least in part—on Stieglitz's.[5]

Adlow and O'Brien presented O'Keeffe as they saw her—unpretentious, uncompromising, straightforward, strong-minded, and independent. Thus the woman they characterized was remarkably different

from the paradoxical figure—part pure spirit, part *femme fatale*—that had dominated the early criticism and was still being promoted to one degree or another in 1927 by Bluemner, Kalonyme, and Mumford. And although Adlow's and O'Brien's articles were not intended to offer interpretations of O'Keeffe's art, they affirmed Frank's and Matthias' claims that her painting was a manifestation of the purity and simplicity of the artist.

By the time her 1928 show opened, critics had proposed alternatives to long-standing ideas about both O'Keeffe and her art. What was published in connection with her exhibition that year, then, reflected a mix of old, more recently proposed, and completely new ideas.[6]

In the catalogue, Stieglitz published an innocuous letter from C. Kay-Scott that praised O'Keeffe's work as an example of "real and lasting art" (Appendix A, no. 69). But Stieglitz also reprinted Mumford's essay in the catalogue and thereby gave official sanction once again to the oldest theme of the criticism—the idea that O'Keeffe's art was bound to her sexuality. O'Keeffe had reacted strongly against this idea from the beginning, and she made a point of rejecting its validity in subsequent decades and, for that matter, throughout the rest of her life.[7] Thus, considering the degree to which the Hartley essay, reprinted in the 1923 exhibition brochure, had influenced the critics, it is as difficult to believe that O'Keeffe agreed to have "O'Keeffe and Matisse" reprinted in 1928 as it is to believe she approved of it in the first place.

Stieglitz-generated ideas were very much apparent in reviews by Edward Alden Jewell and Kalonyme. In the *New York Times,* Jewell defined the nature of O'Keeffe's abstractions using words that could well be mistaken for those in "Woman in Art," although there is no indication that he had read it: "The important thing to stress is that, however arrived at, the forms Miss O'Keeffe expresses are complete realizations of spirit loosed from its shackles, free to range through fields limited only by limitations space itself imposes" (Appendix A, no. 72). And later in the essay, when he called her a "mystic in paint" and referred to her paintings as "poems" that strove to "open and un-bosom themselves of their esoteric messages," his language suggested that of Hartley's and Rosenfeld's essays, which he very well could have read. But the influence of Mumford, as much as Hartley and Rosenfeld, can be seen in Jewell's description of O'Keeffe's art.

> Throughout this work of Georgia O'Keeffe's one senses the breathing of the Mighty Mother. Here is more than a hint of the atman of Yoga and Upanishad. Once, with the highest courage of all, the artist leaves her play of colors . . . and

pictures black infinities in whose midst is a tiny sphere of luminous white that spins—whither no one knows. One feels the impulse that gives it life and makes it move. . . .

For comfort we turn back to the patterns that are warm with love and the reticent but unashamed symbolism of love; back to the rhythmic undulations of pure color—singularly pure, whether it be her red hills with the sun or a purple petunia that, in esthetic importance, to the close-held eye, becomes too immense to be held by any frame.[8]

The article by Kalonyme that appeared in the January 1928 issue of *Creative Art* was the most comprehensive of the four he wrote about O'Keeffe between 1926 and 1928.[9] It began with what was essentially a summary of Stieglitz's ideas about the singularity of O'Keeffe's work:

> The rhapsodic literature born of Georgia O'Keeffe's paintings of flowers and fruits, of hills and trees and skyscrapers, pivots inevitably upon the fact that she is a woman. It pivots upon that point, first, because it is a new experience to encounter any painting by a woman worthy of prolonged consideration in the sense that one values a Rubens or a Ryder. The history of painting, and the part woman has played in it, has long since accustomed one to the belief that painting, finally, is a male art. And so the second surprise afforded by Georgia O'Keeffe's painting is the possibility that this belief has become ingrained because no woman painter ever has made so innocent an approach in painting as she does. Innocent, that is, of the primitive, savage, naive, virile, mystical abstract, ecstatic, Promethean, Dionysian, Apollonian—innocent, in sum, of all aesthetic categories of masculine approach in painting. (Appendix A, no. 73)

And among his comments that qualified the femaleness of O'Keeffe's art were these:

> [She] discovers that female world for us by cutting through the defensive veils of those fashionable feminine sentiments which mask those hectic heroines—so touchingly painted by the Laurencins—of contemporary civilization's sensations and thrills. O'Keeffe demonstrates that the art of the Laurencins is not female, but is a super-imposed by-product of the clumsy (moral) conventions of a masculine world's butcher-shop realities: Quite undesignedly, she shows up this fashionable Laurencin art as feline.

Instead of "bloodless moods, sophisticated naivetés, [or] chic costumes," Kalonyme asserted, O'Keeffe painted "bone and flesh." Her art was "devoid of the feminine cringe and giggle" as well as being "innocent . . . of all aesthetic categories of masculine approach in painting . . . , of all feminine versions of masculine painting."

Finally, he announced the source of his thoughts about this quality in O'Keeffe's art:

This sexual distinction of O'Keeffe's painting from that of masculine painting, or from feminine imitation of masculine painting, was proclaimed by Alfred Stieglitz one afternoon some twelve years ago, after he had examined O'Keeffe's charcoal drawings in that dusk-eaten little oasis known as "291[.]"

Kalonyme further defined her art in the way Mumford had, as an expression of love: her painting was the "song of a free woman, a shamelessly joyous avowal of what it is to be a woman in love." But he was more explicit than Mumford had been about the sexual symbolism of her flower paintings:

For even if you do not care for symbols in your art O'Keeffe's lily will pass triumphantly as painting. So will all her other subjects. It will pass even as pure decoration. But symbol, nevertheless, the corolla of the lily is, just as a pair of luscious buttocks were, to put it mildly, a symbol to Renoir, and a pair of furtive breasts were a symbol to the eagle-eyed Constantin Guys.

And bowing to the way in which O'Keeffe's art had been promoted in the criticism by Stieglitz associates from the very beginning, he ended the 1928 essay almost exactly as he had ended the others: "She reveals woman as an elementary being, closer to the earth than man, suffering pain with passionate ecstasy, enjoying love with beyond good and evil delight."

The Kalonyme essays of the late twenties espoused aspects of both the psychoanalytical and newly-evolved-woman approaches to O'Keeffe's art that had originated with Stieglitz and therefore projected the early criticism's romanticized image of her. In fact, his essays in combination with Jewell's and Mumford's assigned this image as much power in the late twenties as it had had in the early years of the decade. It is somewhat surprising, then, that Kalonyme's 1928 piece also included relatively prosaic facts about O'Keeffe's career and about her discovery by Stieglitz, both of which had been important components of the O'Brien feature. Moreover, Kalonyme offered the following description of O'Keeffe:

Now in the Hotel Shelton, on one of its highest floors—the thirtieth, that same woman sits making new colors. For such they seem to one. Each year there are forty or more new works which Alfred Stieglitz, now her husband, shows at the Intimate Gallery (in the Anderson Galleries) which is a continuation of "291." And when you see O'Keeffe in that light gray little room among her paintings, the relationship is almost too blatant. Naturally, the paintings, like children, have their own individual life. But the paintings are, like her, forthright and simple. They have the same free smile that curves on O'Keeffe's thin, large lips and that twinkles in her deep, searching eyes. Her face you might say is colorless, its formation could be seen as Chinese,

but it is painted by quietness, and what one rather emptily speaks of as experience in life. You see in her noble white face, framed as it is by her black hair and set off by the black garments she almost always wears, the same radiance perceived by Gaston Lachaise. In his sculpture portrait of O'Keeffe your eyes follow a head rising like a white sun, whose flaming tranquility is fed by that same beauty which is communicated by O'Keeffe through those marvelous flowers she paints. You see too in the features of that sculptured face, its poised, affirmative lines, the sources of that beauty.

His description was broadly reminiscent of those in the Adlow, Matthias, and O'Brien articles, but more specifically, it embellished Frank's conception of O'Keeffe as a simple, quiet, self-possessed woman. Thus this image of her became visible in an essay whose ideas about the erotic content of her art still carried with them the provocative image of the early criticism. The effect of Kalonyme's description of O'Keeffe, then, was very much like the effect of the photograph that had illustrated Rosenfeld's 1924 essay. Both contradicted what was implied about her in their interpretations of her art.

Conflicting images of O'Keeffe could also be found in an article published in *Time* in February. It began with a description of her as observed at the 1928 exhibition.

There were some paintings hung on the walls of a tiny room in the Anderson Galleries; other paintings, smaller ones, rested on cabinets or stood along the floor. The room was full of people, talking to each other in awed, foolish whispers. In the corner of the room sat a lady dressed in a black cloth coat, smiling like a severe Mona Lisa. She was Georgia O'Keeffe; the paintings on the wall belonged to her because she had made them; for some reason, the room seemed hers as well. (Appendix A, no. 75)

But it concluded with this sentence: "She paints all day on the 30th floor of the Shelton Hotel, Manhattan; her face is austere and beautiful; she does not own a fur coat."

Thus the article sustained an image of O'Keeffe as a woman of mystery—silent and smiling, seated apart from the others, yet dominating the gallery through her presence and the presence of her paintings. But it also revealed her as a serious artist, one whose personal austerity would not tolerate the luxury of a fur coat—a conception confirmed by the Stieglitz photograph that illustrated the article.[10]

Both in referring to O'Keeffe as a dedicated professional and in including a short biographical sketch, the *Time* article adopted the most recent trend in the criticism; but at the same time, it carried forward only traditional attitudes about her art. It pointed out that "Miss O'Keeffe's paintings are as full of passion as the verses of Solomon's

•

Song" and quoted a portion of Mumford's essay, including his statement that O'Keeffe had "found a language for experiences that are otherwise too intimate to be shared."

McBride's review in 1928 was overwhelmingly positive and, for McBride, remarkably without nuance. Although he had never offered a description of O'Keeffe, his observations about her that year were attuned to the sobriety of the image that had recently gained strength in the criticism: "She seems to be unflustered by talk, to be unaware of much of the talk, and to pursue her way in calmness toward the ideal she clearly indicated for herself at the beginning of her career" (Appendix A, no. 70).

And his ideas about her art were equally straightforward. He pointed out that O'Keeffe was "an imaginative painter, not so much interested in facts as in the extraordinary relationships that may be established between facts," and he made it clear that the outstanding paintings of this exhibition were the result of her persistent investigation of several themes. Among her finest works was one of the Shelton Hotel:[11]

> Miss O'Keefe has painted several versions of the Shelton and has been praised for them, but her increased plasticity, increased mysticity and increased certainty in intention have enabled her this time to achieve one of the best skyscraper pictures that I have seen anywhere. It combines fact and fancy admirably and ought to be easily accepted even by those who still [stumble] over Miss O'Keefe's petunia pictures.[12]

Marya Mannes' review in *Creative Art* is the most distinctive of the decade. It conveyed no image of O'Keeffe, offered the most articulate challenge in the twenties to unqualified critical praise for her work, and was the first overt denouncement of the premise upon which most critics had based their thinking. At the outset, Mannes pointed out the irrelevance of all analyses of O'Keeffe's art that were structured on theories about the nature of woman or the differences in the creative powers of women and men.

> Before speaking of O'Keeffe's work, let us once and for all dismiss this talk of "a woman's painting" and "a man's painting." Any good creative thing is neither aggressively virile nor aggressively feminine; it is a fusion of the best of both. Anything definitely sexual (in the sense of man and woman, not in the sense of general creative passion) in a work of art immediately drags it down from the plane of ultimate impersonality which is its glory. Almost every genius in the past seems to have been an equal compound of male and female. And it seems obvious that

nothing mental or physical can be conceived by one sex, or sex quality, alone; unless one believes in immaculate conceptions.

Therefore, if we are to exalt the work of Georgia O'Keeffe, let us not exalt it because it seems to be a rare psychic perception of the world peculiar to a woman, but because it is good painting. (Appendix A, no. 74)

It was good painting ("in many ways, amazing painting"), according to Mannes, because O'Keeffe's technical expertise and her "sensibility of hand" had combined to change pigment into pure visual phenomena. But Mannes also stated that "much of her color . . . strikes me as shrill and acidulous, thinly dissonant," and she perceived a kind of vacuity in O'Keeffe's imagery—a point made earlier but less effectively by Breuning and Watson in 1925 and the critic for *The Art News* in 1926.

If there is one quality her painting lacks more than anything, it is plain, pumping blood—that kinship with the earth that even the greatest ecstasies must keep to sustain their flight. . . . Miss O'Keeffe's work suggests to me that kind of passionate mysticism that clouds the seeing eye with visions false to it, like some sweet drug. It is always a question whether the flowers in an opium dream are more beautiful than the flowers in the field; or the Garden of Eden than the first protoplasm. But all this leads nowhere—people will either like the painting of Georgia O'Keeffe or dislike it. This particular paragraph is written by one who realizes its frequent, unprecedented beauty, but is somehow repelled by the bodilessness of it.

It seems inevitable that someone, eventually, would have attempted to call a halt to definitions of O'Keeffe's art that centered around the issue of her sex. But considering the pervasiveness of separatist thinking in the period, it is remarkable that a direct challenge to the underlying structure of the criticism came in the twenties. And it is particularly interesting that the challenge came from Mannes, a critic who was not infatuated with O'Keeffe's work.

Thus her review questioned the fundamental point upon which Stieglitz had promoted O'Keeffe's art, that it was important because it was the expression of a woman. In addition, Mannes did not believe O'Keeffe's imagery revealed a particular "kinship with the earth," as Stieglitz had claimed. Indeed, Mannes' was the most direct challenge to Stieglitz's ideas about O'Keeffe's art that was published during this period.

Less than two months after Mannes' article appeared, however, an event occurred that seemed to justify Stieglitz's claims for the significance of O'Keeffe's art. During the second week in April, an American who lived in Europe walked into the Intimate Gallery and agreed to pay $25,000 for six paintings of calla lilies O'Keeffe had made in 1923. That

amount of money would have purchased twelve small O'Keeffes in 1928; it was an extraordinary sum for six.[13] Stieglitz had simply called out an exorbitant figure to discourage further questions about the paintings, and to his amazement, it was accepted.

The phenomenal sale suddenly catapulted O'Keeffe into an entirely new place in the art world. Her success, moreover, confirmed Stieglitz's visionary powers. He had been sure of the distinctiveness of her work when he first saw it, and by the spring of 1917, when he closed 291 with the O'Keeffe show, he was convinced of its importance. As he recalled: "I said to myself, 'Well . . . I've given the world a woman.' "[14] He had promoted her from the beginning as the first woman artist, but with the phenomenal sale in 1928 she transcended that claim.[15] Suddenly, she was America's most successful living artist.

Stieglitz announced the sale to the press on 15 April. The *New York Times* printed an article about it the following day, and apparently, the story was picked up shortly thereafter by other newspapers. As the *Times* reported:

> Less than three weeks since the announcement of the sale of thirty-two paintings by John Sloan for $41,000 to a collector who desired to remain unknown to the public, it was made public yesterday that six small panel paintings of lilies by Georgia O'Keeffe had been sold last week to another anonymous collector for $25,000 to hang in his own home. (Appendix A, no. 76)

But the *Times* article also made several points about O'Keeffe that compromised the professional image of her that had emerged in recent criticism. It implied that she was anything but a serious artist with appropriate training:

> Miss O'Keeffe has never tried and apparently never cared to sell her work. She painted for the love of expression on canvas, which expression is said by her friends to be chiefly inspirational, as she studied less than six months under Chase and a shorter period under Alon Bement.

On 21 April, *The Art News* published a letter Stieglitz had written to its editor. It was as much a tribute to himself and his work at the Intimate Gallery as to O'Keeffe:

> Six small O'Keeffe Calla Lily panels painted in 1923 have been acquired to go to France. She is receiving—don't faint—$25,000 for them. I can hardly grasp it all. Still I hate to see two of the panels lost to the U.S.
> Of the $25,000, O'Keeffe (according to the Room's wont) will give one-fifth to other artists—not necessarily painters or sculptors. As you know, I accept nothing for myself in any form. Nor is the Room in any way a business.

The fight continues.
Other O'Keeffes are finding homes—also Marins and Doves and Bluemners, Etc.,
Etc. (Appendix A, no. 77)

In mid-May, after the last scheduled show of the season, Stieglitz hung the six paintings, soon to leave for France, for a "farewell" appearance at the gallery. About the same time, O'Keeffe—apparently too upset by the sensation the sale had created in the popular press to remain in the city—fled to friends in Maine.[16] But in April, before leaving, she tried to correct some of the misconceptions about her that the earliest press responses had generated. She granted interviews to journalists B. Vladimir Berman and Lillian Sabine, neither of whom had written about her before. Their articles made clear O'Keeffe's objections to what the publicity had implied.

Though Sabine's article was published in the *Brooklyn Sunday Eagle Magazine* on 27 May, she had interviewed O'Keeffe on 18 April, only a few days after Stieglitz's announcement of the sale.[17] Thus, it recorded O'Keeffe's immediate reaction to the publicity. Sabine reported: "[O'Keeffe] felt that newspaper reporters were looking for a sensation, for the magic leap by which one bridges the gap between poverty and riches or obscurity and success. The subtle story of grilling years in conflict, she felt, had little appeal" (Appendix A, no. 79). And when O'Keeffe talked with Berman of the *New York Evening Graphic,* she voiced her conviction that such a "magic leap" from one state to another was not possible. As he quoted her:

> The notion that you can make an artist overnight, that there is nothing but genius, and a dash of temperament in artistic success is a fallacy . . . ; great artists don't just happen, any more than writers, or singers, or other creators. They have to be trained, and in the hard school of experience. (Appendix A, no. 78)

In answer to his question "who is this woman who a few weeks ago was virtually unknown to the world at large," Berman offered a short biography of O'Keeffe and pointed out that she had been "drawing quietly, painting, working hard over her pictures for years" before the sensational sale of her paintings. And he disclosed O'Keeffe's level-headed response to her success: "Miss O'Keefe's only plan in the face of a rather sudden acclaim and monetary success is to go on painting."

The image of O'Keeffe conveyed by Berman and Sabine was in line with the strong, independent woman who had recently materialized in the criticism, and that image was sustained by the Stieglitz photographs that accompanied their articles (figs. 20–21).[18] Furthermore, both writers, like Adlow and O'Brien before them, described O'Keeffe in her

studio at the Shelton. Sabine concentrated on the severity of O'Keeffe's environment:

> When I was directed to the thirtieth floor of the hotel, my mind ran ahead of me into an apartment vivid with insidious coloring.
> The door opened and I entered a room as bleak as the North Pole. It might have been a cloister or the reception room of an orphanage, so austere was it, with its cold gray walls, and its white covers over dull upholstery. There was no frivolous pillow, no "hangings." The only spot of color was a red flower on an easel. There was not an inch of cretonne or a dab of chintz anywhere.
> It seemed all windows—windows overlooking housetops, steel framework, chimneys; windows to the east through which the panorama of the river and the bridge came flooding.
> If the artist was not enthusiastic in her greeting, she was sincere.
> Over the telephone she had not been cordial in making the appointment. To one who lives only in her work, "interviewing" has no point. But we were both committed to a line of action—and there we were. (Appendix A, no. 79)

And Berman seemed amazed that O'Keeffe would choose to work in a skyscraper rather than a garret:

> I found Miss O'Keefe hard at work in her suite, high up in the Shelton that gives an almost unobstructed view of the great city, east, west, north and south.
> Miss O'Keefe [had a] canvas partly completed, depicting the sweep of roof-tops as seen from her studio. Even in its incomplete state the canvas gave one a sharp sense of the complication, the bewildering life down below the "mountain top." It explained partly why the artist had come to live here, high in a modern hotel, rather than to huddle with fellow artists in a conventional art colony. (Appendix A, no. 78)

In both articles O'Keeffe was directly quoted on the subject of her success, and her comments were very straightforward. She either suggested that it had been the result of many years of hard work or stated that she felt it would make living up to critical expectations even more difficult. But the Berman article also quoted Stieglitz on the subject, and his remarks, as might be expected, couched O'Keeffe's success in far loftier terms. It is surprising, however, that Stieglitz did not refer to her as proof of his theory of the ascendence of woman in the arts. Rather, he characterized O'Keeffe in the way several critics had referred to him earlier in the decade—as a trailblazer, a pathfinder. He called her "the Lindbergh of art" and went on to explain to Berman: "Like Lindbergh, Miss O'Keefe typifies the alert American spirit of going after what you want and getting it!" (Appendix A, no. 78). This is the only direct quotation of Stieglitz on the subject of O'Keeffe that was published in the twenties; and along with Pemberton's paraphrasing of his words about her and her art in 1926, it seems to indicate that Stieglitz was

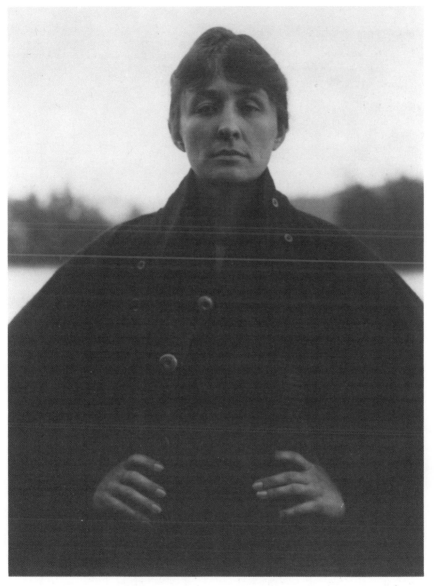

Figure 20. Alfred Stieglitz, *Georgia O'Keeffe: A Portrait*, 1918
Gelatin silver print, 4⁵/₈ × 3¹/₂ in.
(*National Gallery of Art, Washington, D.C., Alfred Stieglitz Collection*)

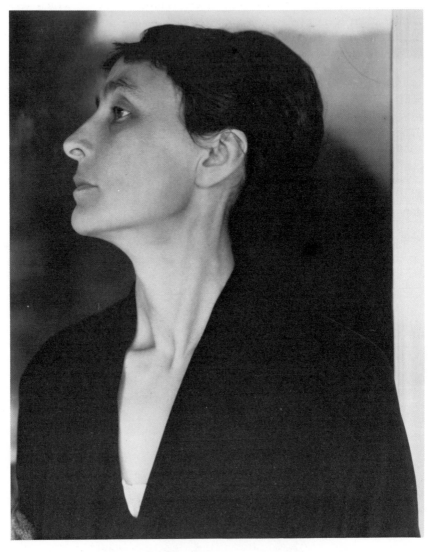

Figure 21. Alfred Stieglitz, *Georgia O'Keeffe: A Portrait—Head*, 1919?
Gelatin silver print, $9^3/_8 \times 7^1/_2$ in.
(*National Gallery of Art, Washington, D.C., Alfred Stieglitz Collection*)

beginning to promote her accomplishment less in terms of her sex than his own.

O'Keeffe was one of the subjects of an ambitious essay by Read called "The Feminine View-Point in Contemporary Art," which was published in the June 1928 issue of *Vogue*. Because it opened with a lengthy discussion of the relative significance of men's and women's art, the article might be interpreted as a response to what the recent sale of O'Keeffe's art implied about the importance of her work.

Read began by pointing out that "whether or not women have made, or ever can make, a contribution to the fine arts commensurate with that made by men continues to be fertile source for argument" (Appendix A, no. 80). But she made it clear that she thought women were doing just that: "The fact that women, as their opportunities and needs for self-expression increase, are meeting aesthetic standards with increasing ability and in increasing numbers is evident to followers of current art events." One of those events, of course, had been O'Keeffe's sale, which seemed to validate a claim Stieglitz had been making from the late teens: that her art was equal to that of any man.

Read declared that the five women she discussed in the article had proven themselves as accomplished as any other artists currently working.[19]

> They measure up to present-day aesthetic standards; their works are shown in mixed group exhibitions, are accorded praise by critics, awarded prizes by juries, and are bought by astute collectors. No one of these artists "carries the art of some man across her fan," as George Moore described the feminine attitude towards painting. No one of them makes the mistake of a Rosa Bonheur, to cite the historical example, of attempting to use a masculine formula and so producing barren imitative work. They possess sensibility, taste, and imagination without the reverse characteristics of these qualities, which are weakness and sentimentality.

Thus, at the same time Read asserted that these artists were free of characteristics traditionally linked with women, she assigned them at least two characteristics traditionally associated with men, "sensibility" and "imagination."

Read's most extraordinary claim, however, was far more general. She stated positively that the works of men and women were being judged on the same basis in 1928. As she wrote:

> One fact is outstanding and proven, and that is that the double standard for artistic accomplishment has been banished. A work of art, whether it is by a man or a woman, is measured according to the ability with which it expresses a personal reaction to life, competently set down in the medium chosen to express it.

The relative naïveté of that comment is proven by a number of mid-decade articles about O'Keeffe's art.[20]

What followed was one of the most confusing evaluations of O'Keeffe's work in the criticism. Read seemed simultaneously to agree with and contradict the point she had made in her 1927 essay, when she suggested that theories should not be applied to O'Keeffe's art. First, she mentioned those implicit in Bluemner's and Mumford's essays and referred vaguely to their negative effect.

> [O'Keeffe] is regarded by many critics and art lovers and hosts of romantically minded young people as the high priestess of woman's expression in the arts. A tendency on the part of some of these devotees to regard her work as a new symbolic language, expressing the experiences of love and passion, has proved somewhat detrimental to her aesthetic integrity.

Although the discussion implied that Read rejected theories like Mumford's, which associated O'Keeffe's imagery with her sexuality, it embraced Mumford's assumption that her paintings were symbolic and that their symbolism was not literary in derivation:

> Granting their symbolism, they are without literary symbolism in the ordinary sense of the word. A natural flower form, painted with minutest realism, becomes, through arrangement and emphasis, a symbol.

In effect, Read adopted Mumford's theory, but she defined O'Keeffe's symbols far more broadly. Mumford had called specific attention to the sexual symbolism of O'Keeffe's flower paintings, but Read stated: "Her most successful and typical expressions are gigantic close-ups of single blossoms . . . [whose] beauty of reality . . . loses not a jot in also serving as symbols of human emotions."[21]

O'Keeffe's 1929 show, titled "Georgia O'Keeffe: Paintings, 1928," was held from 4 February through 17 March. Other than a list of the thirty-five paintings on display, its catalogue contained only an excerpt from an essay by Demuth that was published in its entirety later in the year in *Creative Art:*[22]

> Across the final surface,—the touchable bloom if it were a peach,—of any fine painting is written for those who dare to read that which the painter knew, that which he hoped to find out, or, that which he whatever. (Appendix A, no. 82)

Stieglitz had claimed that O'Keeffe approved of Mumford's essay, but his reprinting of it in the 1928 catalogue had revitalized the issue of sexual symbolism in her art, and she cannot have approved of that.

Thus it is interesting that some effort seems to have been made to ensure that the 1929 catalogue would not direct critics or patrons toward any theory that might influence their thinking.

On the back of the announcement and probably before the show opened, O'Keeffe wrote a few words to McBride in which she pointed out: "The encouraging note that I want to add is that I hope not to have an exhibition again for a long—long—long time."[23] And around the time the show opened, Stieglitz announced that O'Keeffe would not exhibit her work the following year.[24] Neither gave reasons for their statements, but it is clear that events of the late twenties had compromised the time O'Keeffe needed to produce new work for her annual shows.

Her health had prevented her from maintaining her usual work schedule in 1927 and 1928. Letters written by Stieglitz in 1927 confirm that she was hospitalized twice that year. One to Mumford of 13 September mentions that O'Keeffe had spent eleven days in Mt. Sinai Hospital in August, and on 10 September, he had written to Rebecca Strand that O'Keeffe was still not feeling well and had not been able to get much work done.[25] A letter to Duncan Phillips of 30 December indicates that O'Keeffe "went under the surgeon's knife" that day; and two additional letters to Phillips in January of 1928 reveal Stieglitz's concern over her slow recovery.[26] In addition, in a letter to Richard Brixey, written on 24 May 1928 when O'Keeffe was in Maine, Stieglitz pointed out that she "never had a chance to recuperate from the two operations."[27]

For reasons not involved with her health, O'Keeffe found herself unable to work at various points during the 1928 season at Lake George. She was unmotivated to work when she first arrived in June.[28] In mid-July, she left the lake to spend a month visiting relatives in Wisconsin, and shortly after her return, Stieglitz suffered his first severe angina attack. Thus the fall months, which were usually O'Keeffe's most productive at Lake George, were given over to taking care of Stieglitz.[29] And although it is clear from a letter Stieglitz wrote to Mumford on 17 October that O'Keeffe was painting "some," he had pointed out in a 12 October letter to Seligmann that she was "about used up—the nervous strain and worry."[30]

Almost simultaneously with the announcement that she would not exhibit her work in 1930 O'Keeffe decided to spend the summer of 1929 painting in New Mexico. Even before the 1928 season at Lake George, however, she had felt she needed to get away from her life in the East. That she wanted to spend time in the West was clear to Stieglitz in June of 1928 when he wrote to Seligmann that he hoped he "might be able

to take a few months off and accompany O'Keeffe to 'her' America," adding: "I know that is what she craves for. I wonder can it ever be—I'm far from well—[.]"[31]

In 1926, O'Keeffe had written Frank: "Where you are makes no difference—so long as you have the peace—and the urge for work—[.]"[32] And although no documentation clarifies precisely why O'Keeffe decided to paint in New Mexico three years later or why she did not want to continue exhibiting her work, it seems clear that it had something to do with the fact that she had neither the "peace" nor the "urge for work" at Lake George toward the end of the decade.

Both decisions have been related to O'Keeffe's disappointment with the paintings she showed in 1929.[33] But if she were displeased, there is nothing to indicate it. Furthermore, her decision to travel to New Mexico could not have been predicated on the public's reception of the exhibition. As far as sales and attendance are concerned, she seemed quite satisfied when she wrote McBride: "The show goes well—if being jammed and selling enough to pay my bills and then some more is an indication—[.]"[34] And in a letter to Hartley, which was also written during the show, Stieglitz pointed out:

> The O'Keeffe show is universally accepted as a decided step forward. The mob of visitors is not quite as great as in other years but there are still coming over one thousand visitors a week. The man who acquired the Lilies has added four of the new O'Keeffes to his collection. . . . Two small older things of Georgia's have found owners.[35]

It has also been suggested that the reviews of her 1929 show disappointed O'Keeffe, but this is not likely.[36] As a whole they were quite favorable, although Jewell and Pemberton made comments that qualified their otherwise positive responses. Pemberton wrote twice about O'Keeffe's work that year, and his review of the show in the 9 February issue of the *New Yorker* opened with a statement of his usual enthusiasm over her work: "The miracle of Georgia O'Keeffe is again with us in the Stieglitz Room 303, at the Anderson Galleries" (Appendix A, no. 83). He isolated several specific paintings for comment and seemed particularly impressed with their color. For example, he wrote: "Her 'Calla Lilies on Red' is as exciting a painting as anything we have seen this season. The intense, pure white of the two flowers shines with an uncanny luminosity against the green leaves. Behind the leaves is red. . . . We know of few who have been able to juxtapose . . . [red and green] and achieve such beauty."

His essay for *Creative Art*, which was published a month later,

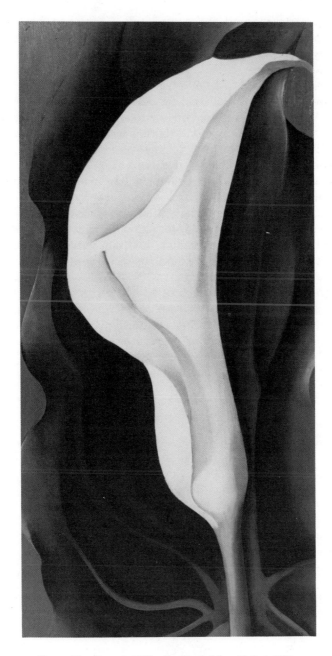

Figure 22. Georgia O'Keeffe, *Single Lily with Red*, 1928
Oil on wood, 12 × 6¼ in.
(*Collection of Whitney Museum of American Art.
Purchase. 33.29*)

conveyed a similar point of view: "The beginnings of the month had brought nothing as interesting to followers of American contemporary art as the show of Georgia O'Keeffe." Then the article assumed a slightly different tone: "Miss O'Keeffe presents a problem to the chronicler who is accustomed to rely for his account on the ever changing style of most of the artists he sees. . . . Miss O'Keeffe has always been O'Keeffe" (Appendix A, no. 87). He wrote, "We have written so much about Miss O'Keeffe that we find there is nothing new to say," and he clearly felt the work was not evolving—an idea he had implied in his 1928 review when he stated: "If there has been any change in the O'Keeffe work we would hazard that she has come into her heritage of serenity" (Appendix A, no. 71).

Toward the end of his review of the show for the *New York Times,* Jewell pointed out that O'Keeffe was showing "six out-and-out abstractions, and very beautiful abstractions" and that some of her small paintings were "extremely sensitive and delicate" (Appendix A, no. 85). However, he had opened the article with: "Miss O'Keeffe will probably be an Old Master some day, all ticketed and securely niched; but as yet we see the work in what may be called a fluid state, unstatic, mobile, alive with potentialities." For that reason, he felt her show was "most stimulating"; but his reservations were clear as he went on:

> Some may reasonably feel that the present group of paintings represents some sort of transition period in her art. Just what direction the transition is taking seems not at the moment altogether clear, and there is nothing on view that could be termed a really radical departure.

He remarked that "the new pictures [have a] somewhat less cosmic atmosphere than was present last year" and concluded: "This may be a personal reaction without real significance, or it may point, again, to the not easily assignable spirit of change in the direction this art seems to be taking."

Several critics before 1929 had expressed very strong reservations about certain aspects of O'Keeffe's art. But Pemberton, in implying that O'Keeffe was refining old ideas, and Jewell, conversely, in suggesting that her art was in a state of flux, were the first critics to refer to an apparent absence of progression in O'Keeffe's work. Whether she agreed with them or not, O'Keeffe could not deny that their remarks effectively proved what she had said to Sabine the year before: "It is much more difficult to go on now than it was before. Every year I have to carry the thing I do enough further so that people are surprised again" (Appendix A, no. 79).

McBride, however, made no reference to difficulties in her art. His review in the *Sun* was, as usual, laudatory, and he seemed especially impressed with the scale of the flower paintings O'Keeffe was exhibiting. The following passage, in fact, suggested that those paintings might be one indication that America was coming into its own:

> Miss O'Keefe's calla-lilies this year are—I beg you to believe me—fully a yard wide. I could not help thinking of Walt Whitman while studying them. Walt Whitman had grand ideas for America, as you may remember. Nothing was too good for America, and, too, it was America that produced the goods. But no painter in Walt Whitman's day ever dreamed of such calla-lilies as Miss O'Keefe has dreamed of. They represent the apotheosis of calla-lilies, and in an elusive but definite enough way for those who are at all psychic, the present grandeur of these United States. Walt Whitman knew that these calla-lilies would come some day and here they are. (Davenport newspapers please copy.) (Appendix A, no. 84)

Since with the exception of the year before, McBride's essays on O'Keeffe had always offered a gentle reproof of Stieglitz-generated ideas about her work, his statement linking O'Keeffe's calla lilies to Whitman might seem perplexing. Stieglitz, of course, would have applauded the idea that any of the artists he supported had fulfilled a Whitman prophecy about America. But McBride's parenthetical remark about Davenport newspapers suggests that his usual good-natured iconoclasm had returned.

In fact, he was probably poking fun at Stieglitz's high-minded claims for American art. For the Whitman passage came at the end of an elaborate conceit about "a group of old ladies . . . of the most intense respectability . . . who [had traveled to New York the year before] . . . all the way from Davenport, Iowa, specially to see Miss O'Keefe's paintings of petunias" and had been disappointed to find her show closed. McBride was letting this Davenport contingent know that if they ventured forth again this year seeking petunias in O'Keeffe's show, they would be disappointed, since there were none. But he assured them that they would be "consoled . . . by the calla-lilies" and proceeded to evoke Whitman.

Dorothy Lefferts Moore, who wrote about O'Keeffe's art for the first time in 1929, praised it but essentially said nothing new. In fact, specific elements of the ideas she expressed in her review for *The Arts* can be found as early as 1922 in the *Sun* article and as late as 1929 in Pemberton's most recent essay. Hers was the last review published that year, and its major point had been present in Read's reviews of 1924, 1925, and 1927 and in the essays by Matthias and Frank—that O'Keeffe's art had been misunderstood primarily because it had been

supplied "with a program" (Appendix A, no. 88). She believed that O'Keeffe's paintings did not "invite interpretation in themselves, except to those who are more curious to discover what made O'Keeffe feel that way [rather] than to feel for themselves."

In addition, Moore reiterated the point Stieglitz had made in the late teens and Kalonyme had used to underpin all of his reviews of the late twenties, that O'Keeffe painted as a "woman feels, without confusing her vision with that of men." Thus it is particularly interesting that her article made no reference to the companion idea that O'Keeffe's art was an expression of her sexuality. Moreover, when Moore referred to O'Keeffe as a woman, her comments embellished the new image that had emerged in the criticism:

> Her characteristics . . . seem to be sensitiveness, intensity of power to see and imagine, and balance under high tension; and like most women, she is capable of isolating a moment and making it seem eternal.

In a profile of O'Keeffe published in July in the *New Yorker*, Robert Coates offered the most extensive personal and professional history of her to date in the criticism. The article began by telling the story of how Pollitzer brought O'Keeffe's drawings to Stieglitz, and it referred to the success of O'Keeffe's first show in the twenties. It then offered an elaborate refutation of the point McBride had made in 1927, that O'Keeffe's art was intellectual:

> One of the cruellest misconceptions ever perpetrated was that by which the modern painters came to be called "intellectual." . . . O'Keeffe . . . has not been able to escape the inference on the part of critics that a great deal of deep thought goes into the formulation of her paintings. As a matter of fact, the reverse is more nearly true. Her years with the drawing-school classes have taught her the use of a clear, sharp line, and her own sincerity of vision uses that line as a knife-edge, cutting to the core of her emotional experience. (Appendix A, no. 89)

Yet although Coates believed O'Keeffe's art was emotional in basis, there is no suggestion in his essay that its emotionalism was an expression of her sexuality. Indeed, no one who wrote about O'Keeffe's art in 1929 made that connection. Considering the power it had been assigned in 1928 as well as the fact that it had been present in the criticism every year except 1925, when O'Keeffe was exhibited in all-male company, the absence of this connection is noteworthy. Rather than seeing O'Keeffe's art as an expression of her sexuality, Coates believed it conveyed a mood of wonder.

Most of us, sprawling out in a field in the country, have poked apart the grass-roots, fingered the soil, and studied with a kind of vague awe the minute life we found there. That mood, but sharper and clearer, is the mood that dominates all of O'Keeffe's best painting.

The article was illustrated with a caricature of O'Keeffe by Miguel Covarrubias, who pictured her holding a lily and emphasized the severity of her appearance through the angularity of his drawing. In his description of her, Coates did not deny the image Covarrubias' drawing so aptly epitomized, but he did as much as anyone in the late twenties to humanize what had clearly become an accepted perception of O'Keeffe.

[She] live[s] now, in an atmosphere of good-natured asceticism, at the Hotel Shelton and at Lake George. O'Keeffe, in spite of many illnesses, is still a great walker. She retains at forty-two the pale profile and blue-black hair, the sense of inner vitality that made her a famous beauty at the League. She wears black almost invariably— not, she says, because she prefers it, but because, if she started picking out colors for dresses, she would have no time for painting. Last winter, however, she startled everybody by appearing at the exhibitions in a bright scarlet cloak. She is, in the sophistic sense, not a modern at all: she has never read Freud, doesn't like plays, wears long skirts and long hair, and has never been to France. She is, however, an ardent feminist.

Finally, Coates made a point of O'Keeffe's professional success. In addition to mentioning the sale of 1928, he named several of her patrons:

Duncan Phillips is one of the few great collectors who have acquired O'Keeffes: he bought three flower studies for his Memorial Gallery in Washington. Another of her paintings hangs in the Brooklyn Museum; it was the bequest of Mrs. Rossin, daughter of Adolph Lewisohn.

He also made it perfectly clear that she had not attained such success on her own. Stieglitz's promotion of modern art had been noted in the criticism since 1916, and his highly idiosyncratic manner of promoting O'Keeffe's work—including its sales—was well known within the art community. But Coates was the first critic to make a matter of record the degree of control Stieglitz had exerted over her career. And his revelation of Stieglitz's reluctance to sell O'Keeffe's paintings can hardly have done anything but make them more interesting to prospective buyers.

Her original agreement with Stieglitz still holds good: no one but he has ever exhibited her work, and her paintings are usually to be seen at the Intimate Gallery, .

which he conducts, in the Anderson Galleries Building. Her output is not tremendous: a complete catalogue of all her works would not number more than three hundred paintings; of these, about a hundred have been sold. Most of the others remain unsold chiefly because Stieglitz refuses to part with them.

He has always refused to set any fixed values for her work, to build up any "market" in O'Keeffes; consequently, her prices and her sales depend very much on how Stieglitz happens to feel at the moment.

Like the information in his article as a whole, Coates' account of Stieglitz's role in promoting O'Keeffe's art was based on interviews with O'Keeffe and Stieglitz. But his perception of O'Keeffe was based on his own observation of her, and his observation confirmed the authenticity of what O'Keeffe had been promoting about herself since 1922.

As a whole, what was written about O'Keeffe in 1929 was distinctive in the decade—not as much for what it contributed to an understanding of her art as for what it did to strengthen the conception of her as a serious professional, an image she had taken an active role in promoting. The idea of sexual symbolism in her imagery—the most consistent force within the criticism—had been particularly strong in 1927 and 1928. But nothing written about her in 1929 alluded to that issue and thus to the provocative, romanticized image of O'Keeffe it implied. In its absence, the image that O'Keeffe herself had projected— and would continue to project for the rest of her life—stood unchallenged for the first time in the criticism.

Conclusion

Because the critics had seen little like it before and nothing like it from a woman, their early responses to O'Keeffe's art were easily influenced by Stieglitz. He was a persuasive, informed advocate of modernism, and furthermore, his ideas about O'Keeffe and her work were extraordinarily appealing. As a result, many of those ideas—fully elaborated by his associates—had been published before her first major exhibition of the twenties, and they formed the basis of a great deal of the subsequent criticism.

Stieglitz believed that O'Keeffe was the first woman to realize the potential of all women. Thus, she was an archetypal "new" woman, and he promoted her work as the first exclusively female art. From the beginning, he declared that it was not dependent on any male-conceived, intellectual system of expression and that it drew its energy from dimensions of woman's nature never before revealed in art—most particularly, her sexual feelings. Even though by the end of the twenties the character of O'Keeffe's work had changed significantly and several critics had offered persuasive, opposing arguments about its meaning, Stieglitz remained fast in his opinion that it was dominantly emotional in basis and expressively bound to her sexuality.

In fact, he never changed his mind about O'Keeffe and her work, as he demonstrated in a newspaper interview given late in 1945—a little over half a year before his death. As the reporter recalled:

> Stieglitz leaned back against a rumpled pillow. "When I was 11," he went on, "I read *The Rape of Lucrece*. I didn't understand with my mind what I was reading. No one in the house explained such things to the children. But I understood perfectly in some other way.
>
> "Then I read Goethe's *Faust*. I used to lie on the floor reading it over and over again. A visitor once asked me, 'Why are you reading *Faust*? What can Faust mean to you?' I said, 'I'm not interested in Faust. I'm interested in Marguerite and the Devil.'" Stieglitz twinkled at me and added, "I still am."

We wanted to know why he associated Marguerite with the Devil. "Woman," he said very seriously, "is the arch-temptress and the arch-releaser." After a pause, he went on. "Woman is the soil. Man is a moment. He comes, impregnates her in five seconds and then goes fishing. But woman is the earth. She makes the seed grow and flower. Woman is—" gravely, he touched his forehead, his heart, his forehead, his heart, his genital region. "That's what her painting should be."

Did he know of a woman whose paintings had those qualities? He looked at me as if that were a foolish question. "O'Keefe," he said. "Georgia O'Keefe."[1]

Whether O'Keeffe's ideas about the nature of women differed from Stieglitz's cannot be determined from available evidence dating from the late teens and twenties. What can be determined is their agreement that her art was about the thoughts and feelings distinctive to a woman. Moreover, in 1930 she expressed what was obviously an ongoing concern about the difficulty of maintaining such qualities in her work while functioning within a system structured and controlled exclusively by men. As she pointed out to Michael Gold, the editor of the *New Masses:*

I have had to go to men as sources in my painting, because the past has left us so small an inheritance of women's painting that has widened life. And I would hear men saying, "She is pretty good for a woman; she paints like a man." That upset me. Before I put brush to canvas, I question "Is this mine? Is it all intrinsically of myself? Is it influenced by some idea or some photograph of an idea which I have acquired from some man?" . . . I am trying with all my skill to do painting that is all of a woman, as well as all of me."[2]

It is also apparent that she strongly disagreed with Stieglitz's idea that her art was an expression of her sexuality, and the criticism itself suggests that her opposition to that idea did not go unnoticed. From 1924 until the Mumford essay was published in 1927, there were no direct references to eroticism in anything written about her or her art by critics affiliated in any way with the Stieglitz circle. And by that time, the notion of O'Keeffe as a serious professional artist had been sufficiently promoted in the criticism that it stood in opposition to what was implied about her in Mumford's eloquent celebration of sexual symbolism in her work.

To the end of her life O'Keeffe steadfastly denied that her imagery contained erotic content. But she admitted to Dorothy Seiberling in 1974 that she knew Stieglitz believed it was there and that he had inspired others to agree.

Eroticism! That's something people themselves put into the paintings. They've found things that never entered my mind. That doesn't mean they weren't there, but the things they said astonished me. It wouldn't occur to me. But Alfred talked that way and people took it from him.[3]

Although her comment confirms what is obvious from a study of the criticism, it does nothing to explain why she allowed Stieglitz to continue to talk "that way" about her art. More specifically, if she was opposed to sexualized interpretations of her work and knew they were being perpetuated by Stieglitz, why did she simply not put a stop to it?

There is reason to believe that it was not until she read the reviews of her 1923 show that she became aware of the extent to which his ideas could affect critical thinking. By that time, there was very little either she or anyone else could do to reverse the opinions of those who agreed with him, as she learned through her unsuccessful attempt to forestall sexualized readings of her art by changing the art itself. Furthermore, it is unlikely that, at any point, she could have done much to change Stieglitz's thinking about the meaning of her imagery. Besides, she knew that his devotion to her art was complete and that at that point he, not she, was the expert at promoting it. Despite her distaste for publicity in general and, specifically, for the methods Stieglitz used to arouse interest in her work, she was aware of the importance of becoming well known in the New York art community and could see, as early as 1923, that what he was doing was working.

It is interesting that whenever O'Keeffe attempted to correct misconceptions about either herself or her work in the period, she never publicly voiced a denial of any existing Stieglitz theory. Rather, she only offered opposing evidence. For example, at the height of flapper chic and of her own spectacular success, interviewers found her unadorned appearance and the austerity of the way she lived anomalies. But they dutifully reported the carefully chosen words she used to characterize herself and thus helped O'Keeffe create the image she sought—that of a dedicated professional and a feminist who believed in her right to self-realization.

From the start, this image had been conceived to invalidate the sexualized female introduced into the criticism by Marsden Hartley and Paul Rosenfeld; but by denying a fundamental dimension of O'Keeffe's femaleness, it was in fact as extreme as the image it was intended to neutralize. As Stieglitz photographs reveal, by the mid-twenties the public O'Keeffe had become a harsh, uncompromising creature whose most remarkable sexual characteristic was androgyny. This essentially sexless image gained increasing strength in the criticism, and in 1929, there was no trace of the provocative image that had dominated responses to her art in the first half of the decade.

But that provocative image returned in the early thirties, when critics reassigned O'Keeffe's imagery sexual meaning. And although for the first time she began to deny publicly the validity of such interpreta-

tions, they remained a strong component of the criticism. In fact, as some reviews of the recent centenary exhibition attest, the notion of her art as a manifestation of her eroticism, first publicized by Stieglitz in the teens, has continued to inform critical thinking.

The intensity of O'Keeffe's displeasure with sexualized readings of her art in the twenties is perhaps best measured by her response to feminist artists and art historians who, half a century later, celebrated her work as the first expression of a specifically female iconography. O'Keeffe refused to identify with what they were saying and would not cooperate with their exhibitions and publications. Clearly, their direct references to female sexuality and experience were too much like the language that had been imposed on her art by such men as Rosenfeld, and she still considered that language invalid and irrelevant to her purpose.[4]

O'Keeffe's success in the twenties, along with the professional image she cultivated to deal with it, was at least partially responsible for changing the attitude of some critics about women's capabilities as artists. But it did nothing to alter fundamental assumptions about the nature of women that prevailed in the period. The same critics who equated O'Keeffe's art with that of men and described her in traditionally male terms—as a leader, an innovator, or a genius—also believed that women were less highly evolved and, thus, biologically inferior to men. So despite their praise for O'Keeffe's work, they—like Stieglitz—never responded to it as anything but the highly personal, emotionally charged expression of a child-woman and, unconsciously at best, ranked it below the more rational art of men. Such implicit contradictions in the thinking of the critics did little to clarify the significance of her work. But by continuing to emphasize O'Keeffe's femaleness at the same time they characterized her accomplishments with words they usually reserved for males, these critics did much to support the androgynous aspects of the public image O'Keeffe promoted.

The development of the criticism suggests that O'Keeffe worked against Stieglitz to establish an image of herself that countered the one he and his associates had publicized. Yet both images of O'Keeffe that emerged in the twenties derived from dimensions of her nature that, by 1921, Stieglitz had explored in his complex photographic portrait of her. Moreover, because the photographs he released to illustrate articles about her work in the twenties epitomized the severe image O'Keeffe sought for herself, Stieglitz essentially played a part in the development of both images.

Each image contributed to the mystique that grew up around her. One or the other was implied in almost everything written about

O'Keeffe in the twenties—a notable exception being Marya Mannes' review of 1928. And though intrinsically incompatible, both images were evoked in several late-decade discussions of her art—a fact that suggests how strongly polarized critical thinking was about the meaning of her work. In terms of the public's perception of O'Keeffe, however, the two images in combination created a complex illusion, an impenetrable façade behind which O'Keeffe kept her identity hidden and found the privacy and solitude that, as she discovered in the twenties, were essential to her well-being as an artist.

Thus although the criticism makes it clear that O'Keeffe played a much greater role in attempting to shape reaction to her work in the twenties than has ever been suspected, it also makes it clear that she and Stieglitz worked together to forge one of the most complex public images of any artist, male or female, in this century. As its two opposing components appeared simultaneously with increasing frequency in the criticism, they cloaked O'Keeffe in a powerful, contradictory, and fascinating myth about the nature of women, which continues to affect critical perception of her art and which, more broadly, has helped to nourish ideas about repressed sexuality in women professionals.

But the brilliance of Stieglitz's and O'Keeffe's promotional efforts was apparent before the end of the twenties. Her annual exhibitions had become extraordinary events in the New York art world, and she had gained enough status within it to be invited to exhibit in the Museum of Modern Art's second exhibition, "Paintings by Nineteen Living Americans," which opened in December of 1929. But just as important, she had been defined as America's most successful living artist, and her financial future—and therefore her continuation as a painter—had become assured.

O'Keeffe could not have gained the type of recognition she did in the twenties, as quickly as she did, without Stieglitz. On the other hand, the inspiration and distinction she gave *his* late career should not be overlooked. His fascination with her revived his passion for photography, and the O'Keeffe portrait, which he continued well into the thirties, remains one of the most remarkable achievements in the medium. Too, her work became the touchstone of his theory of a uniquely American art, and her success allowed him to sustain his position as its prophet and spokesman.

In the absence of any authoritative study of her career and after remaining relatively silent for years, O'Keeffe began in the 1970s to make public statements that seemed designed to clear up certain questions about her early years as an artist in New York and about her association with Stieglitz. Several of her statements clarify, for example,

the degree to which many of her ideas differed from his and in fact verify what available documents from the twenties and thirties only suggest about the difficulties of their life together. In her introduction to the catalogue of "Georgia O'Keeffe: A Portrait by Alfred Stieglitz," staged at the Metropolitan Museum of Art in 1978, she wrote:

> For me he was much more wonderful in his work than as a human being. I believe it was the work that kept me with him—though I loved him as a human being. . . . I put up with what seemed to me a good deal of contradictory nonsense because of what seemed clear and bright and wonderful.[5]

O'Keeffe had first made her admiration for Stieglitz's work a matter of record in her 1922 essay for *MSS.*, and the essay she wrote over half a century later revealed that her thirty-year relationship with Stieglitz had not changed her feelings about his work:

> Thirty years have passed since I sorted out the Alfred Stieglitz photographs and made the key set which consists of the best prints that he kept mounted of every negative that he had printed.
> Since his time, much has happened in photography that is sensational, but very little that is comparable with what Stieglitz did. The body of his work, the key set—I think—is the most beautiful photographic document of our time.[6]

Through her carefully considered loans and gifts of the Stieglitz *oeuvre* to museum collections, her personal support of four major exhibitions of his photographs between his death and hers, and her cooperation with various scholarly efforts to reassess the meaning and significance of his work, she demonstrated her loyalty to him and her belief in the importance of his achievement. Thus in a curious reversal of the roles by which their early relationship had been defined, her efforts in his behalf were instrumental in stimulating the recent revival of interest in Stieglitz and his photography.

None of this would have been possible, of course, had Stieglitz not helped O'Keeffe attain a place of prominence within a profession that had seldom taken members of her sex seriously. After Stieglitz's death, she managed to maintain this position through several of the most transformational decades in the history of American art. Throughout, she continued to control her career with the same precision Stieglitz had exercised over it from the early twenties, and her expertise in this regard became quite apparent. On the heels of a resurgence of interest in her work, which began in the sixties (and has increasingly gained momentum), she took over every aspect of its promotion.[7]

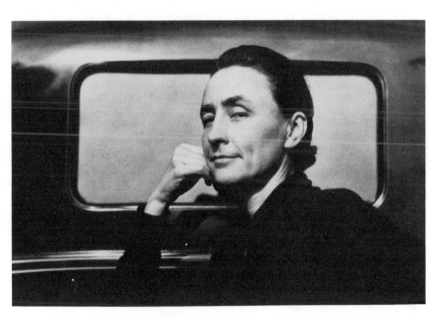

Figure 23. Alfred Stieglitz, *Portrait of Georgia O'Keeffe—After Return from New Mexico*, 1929
Gelatin silver print, 3¹/₁₆ × 4⅝ in.
(Collection of Virginia Zabriskie, courtesy of Zabriskie Gallery, New York)

O'Keeffe began to insert her voice into the criticism in 1922, and it was never stronger than in the last few decades of her life. What she said in those years indicated, among other things, that she never changed the ideas about her art and about her role as a professional that she had formulated in reaction to the early criticism. In fact, the effect of that criticism was strong enough to shape her response to public inquiry for the rest of her life.

The image she established in the criticism of the twenties was made visual in many Stieglitz photographs, but it was never more apparent than in the ones he made of her just after her return from New Mexico in the late summer of 1929 (see fig. 23). In those, just as in most of the photographs she posed for during the rest of her life, nothing is revealed about the woman but her independence and aloofness. One can only wonder what a different face she might have shown the world or, more important, how differently her imagery might have developed if references to eroticism in her art in the teens and early twenties had not carried the implication that she was a woman obsessed with her sexuality.

Appendix A

O'Keeffe and Her Work:
Selected Commentary, 1916–1929

Within each year, the items reprinted here are listed, by author, in order of publication date. Any entry of which the precise publication date is not known is placed last within its year.

1916

1. Henry Tyrrell

From "New York Art Exhibitions and Gallery News: Animadversions on the Tendencies of the Times in Art—School for Sculpture on New Lines," *The Christian Science Monitor* (2 June 1916), 10. (Review of exhibition, "Georgia O'Keeffe—C. Duncan—Réné [*sic*] Lafferty," New York, 291, 23 May–5 July 1916.)

"Never since the tower of Babel has there been such general chaos of utterance and confusion of understanding as prevails in the art world today," was the declaration lately made to the correspondent of The Christian Science Monitor by Alfred Stieglitz, whose unique gallery of the Photo-Secession, 291 Fifth avenue, is a sort of sanctuary or no-man's-land that offers a temporary resting place to any and every strange new thing that comes along.

The three-cornered exhibition at present occupying this quaintly uncommercial and seemingly spellbound place is in nowise calculated to clarify either ideas or terms of expression. It consists of a dozen or so of charcoal drawings alleged to be of thoughts, not things, by Georgia O'Keeffe of Virginia; and some further vagaries of color by Masson C. Duncan of New York and Réné Lafferty of Philadelphia.

The trio have one peculiarity in common, and that is an absolute avoidance in their pictures of any material object that eye has seen or could see. But while

Miss O'Keeffe looks within herself and draws with unconscious naïveté what purports to be the innermost unfolding of a girl's being, like the germinating of a flower, the two men essay little journeys into space and try to symbolize mentality as a fountain or a ray, playing against abysmal depths of ether, amidst wheeling suns, and ever falling back into the same vast circular basin. Of course, these are only surmises at interpretation of the pictured symbols; for in the blithe scheme of the Photo-Secession there is no such thing as a catalogue, and the things tacked up on the walls are uniformly innocent of title, number, or signature of any kind.

2. Alfred Stieglitz

"Georgia O'Keeffe—C. Duncan—Réné [sic] Lafferty," *Camera Work*, no. 48 (October 1916): 12–13. (Review of exhibition, "Georgia O'Keeffe—C. Duncan—Réné [sic] Lafferty," New York, 291, 23 May–5 July 1916; includes statement by Charles Duncan and letter from Evelyn Sayer about O'Keeffe's work.)

In spite of the lateness of the season when the chief art critics of the New York papers had already been laid off for the summer, "291," from May twenty-third to July fifth, presented to the public for the first time the work of three young people: ten charcoal drawings by Georgia O'Keeffe of Virginia, occupying the walls of the main room; two watercolors and one drawing by C. Duncan of New York, and three oils by Réné Lafferty of Philadelphia, occupying the walls of the small inner room.

This exhibition, mainly owing to Miss O'Keeffe's drawings, attracted many visitors and aroused unusual interest and discussion. It was different from anything that had been shown at "291." Three big, fine natures were represented. Miss O'Keeffe's drawings besides their other value were of intense interest from a psycho-analytical point of view. "291" had never before seen woman express herself so frankly on paper.

Relating to this exhibition we print a short critique written for, and a letter sent to, us:

The story of aesthetic is song of a widening consciousness. One contradiction is the Puritan fathers making brittle halos from narrowness, Pedantry burnished and with the nervousness of combined duty and unintelligence distributed them. Clear living though is clear assayor [sic] moving always with sensitiveness and compelling slow resource to its often tragic end.

Among the few incomparable assets are the fire and flow of a fresh sensualism; tremulous, giving—a flower, opening; colossal with rise and surge of interwinding Niagara rapid; or stifled internecine, insipid, dishonest, with the assistance of parental and social ignorance and cowardice. Its beauty in Anglo-Saxon

cultures today pays the cost of an insufficiency that must be incomparable in history.

Miss Virginia [*sic*] O'Keeffe's drawings in the season's last exhibit at "291" make this reflection unavoidable. Behind these delicate, frequently immense, feminine forms the world is distant. Poised and quick—elate—teeming a deep rain; erect, high, wide turning, unrequited in silent space this vision is exclusive to a simple reality. Once a thin scarecrow is, humorously, victim for the elements. With one exception these drawings are given passive and tumultuous upon the air.

The rear room contained drawings and paintings by C. Duncan and Réné Lafferty. Like Miss O'Keeffe, Duncan uses the method of picturing non-visual experience while Lafferty has interpreted the significance to himself of a comet, a dragonfly, and a fountain.

<div align="right">C. Duncan.</div>

My Dear Mr. Stieglitz: I feel very hesitant about trying to write an appreciation of the woman pictures.

I was startled at their frankness; startled into admiration of the self-knowledge in them. How new a field of expression such sex consciousness will open.

I felt carried on a wave which took me very near to understanding how to free and so create forces—it has receded now and leaves me without the words.

I shall never forget the moment of freedom I felt—or the inspiration of how to use it.

May I leave it this way—if it comes to me before your next issue of *Camera Work*, I will try to write it, if not, please know I should have liked to.

Self-expression is the first and last difficulty of my living.

<div align="right">Very sincerely,</div>

<div align="right">Evelyn Sayer</div>

Killiam's [*sic*] Point
Branford, Ct.

<div align="center">1917</div>

<div align="center">3. Henry Tyrrell</div>

"New York Art Exhibition and Gallery Notes: Esoteric Art at '291,'" *The Christian Science Monitor* (4 May 1917), 10. (Review of exhibition, "Georgia O'Keeffe," New York, 291, 3 April–14 May 1917.)

The recent work, in oil, water color and charcoal of Miss Georgia O'Keefe of Canyon, Tex., speaks for itself at that jumping-off place of modern art, the little gallery of the Photo-Secession, 291 Fifth Avenue. The work has to speak for itself, as it is not numbered, catalogued, labeled, lettered or identified in any

way—in fact, it is not even signed. The interesting but little-known personality of the artist, who has exhibited here once before, is perhaps the only real key, and even that would not open all the chambers of the haunted palace which is a gifted woman's heart. There is an appeal to sympathy, intuition, sensibility and faith in certain new ideals to which her sex aspires. For there can be no mistaking the essential fact that Miss O'Keefe, independently of technical abilities quite out of the common, has found expression in delicately veiled symbolism for "what every woman knows," but what women heretofore have kept to themselves, either instinctively or through a universal conspiracy of silence. Marie Bashkirtseff, the little Tartar of a Russian, who was a fellow art-student in Paris with Bastien Le Page, wrote many audacious hints and intimate self-revelations in her famous diary; but she did it more or less unconsciously, and in any case she was a temperamental variant from the average femininity. Georgia O'Keefe, offspring of an Irish father and a Levantine mother, was born in Virginia, and has grown up in the vast provincial solitudes of Texas. Whatever her natural temperament may be, the loneliness and privation which her emotional nature must have suffered put their impress on everything she does. Her strange art affects people variously, and some not at all; but many feel its pathos, some its poignancy, and artists especially wonder at its technical resourcefulness for dealing with what hitherto has been deemed the inexpressible—in visual form, at least.

But new aspirations, and yearnings until now suppressed or concealed, find their medium in the new manifestation which is one with the impulse of an age occupied with eager inquiry and unrest. "Style is the man," declared Bouffon the biologist, with fine truth in his time. Now, perhaps for the first time in art's history, the style is the woman.

"Two Lives," a man's and a woman's, distinct yet invisibly joined together by mutual attraction, grow out of the earth like two graceful saplings, side by side, straight and slender, though their fluid lines undulate in unconscious rhythmic sympathy, as they act and react upon one another: "There is a another self I long to meet, / Without which life, my life is incomplete." But as the man's line broadens or thickens, with worldly growth, the woman's becomes finer as it aspires spiritually upward, until it faints and falls off sharply—not to break, however, but to recover firmness and resume its growth, straight heavenward as before, farther apart from the "other self," and though never wholly sundered, yet never actually joined.

This is one of the "drawings," purely symbolistic, a sort of allegory in sensitized line. More directly appealing to the material beauty-sense are two oil paintings of lovely but singularly disquieting color tonality, which may be interpretively called "The Embrace," and "Loneliness"; also a water-color impression of an approaching railway train rushing steaming out of space across the limitless prairie, like a vision-bearing cloud in the skies of heaven.

4. WILLIAM MURRELL FISHER

"The Georgia O'Keeffe Drawings and Paintings at '291,'" *Camera Work,* nos. 49–50 (June 1917): 5. (Review of exhibition, "Georgia O'Keeffe," New York, 291, 3 April–14 May 1917.)

While gladly welcoming new words into our vocabulary, words which intensify and increase our sense of the complexity of modern life, it is often quite impossible not to regret the lapse of older, simpler ones, especially as such lapse implies that the meaning and force of the words has also become obsolete. I am thinking, in this connection, of a phrase much loved by Lionel Johnson: *the old magnalities,* and I feel sure he used it so often in the hope that others would not willingly let it die. But I have met with it in no other modern writer. Is it because it no longer has significance for us? Have the old magnalities indeed crumbled to dust and ashes, together with all sense of the sublime, the worshipful, and the prophetic? Is it no longer good form, in this avid and impatient age, to mention the things that are God's? Must all tribute, then, go to Caesar? These reflections are forced upon the contemplative mind, and one must take counsel with one's own self in meeting them. And it is in so communing that the consciousness comes that one's self is other than oneself, is something larger, something almost tangibly universal, since it is en rapport with a wholeness in which one's separateness is, for the time, lost.

Some such consciousness, it seems to me, is active in the mystic and musical drawings of Georgia O'Keeffe. Here are emotional forms quite beyond the reach of conscious design, beyond the grasp of reason—yet strongly appealing to that apparently unanalyzable sensitivity in us through which we feel the grandeur and sublimity of life.

In recent years there have been many deliberate attempts to translate into line and color the *visual* effect of emotions aroused by music, and I am inclined to think they failed just because they were so deliberate. The setting down of such purely mental forms escapes the conscious hand—one must become, as it were, a channel, a willing medium, through which this visible music flows. And doubtless it more often comes from unheard melodies than from the listening to instruments—from that true music of the spheres referred to by the mystics of all ages. Quite sensibly, there is an inner law of harmony at work in the composition of these drawings and paintings by Miss O'Keeffe, and they are more truly inspired than any work I have seen; and although, as is frequently the case with "given writings" and religious "revelations," most are but fragments of vision, incompleted movements, yet even the least satisfactory of them has the *quality* of completeness—while in at least three instances the effect is of a quite cosmic grandeur. Of all things earthly, it is only in music that one finds any analogy to the emotional content of these drawings—to the gigantic, swirling rhythms, and the exquisite tendernesses so powerfully and sensitively rendered—and music is the condition towards which, according to Pater, all art

constantly aspires. Well, plastic art, in the hands of Miss O'Keeffe, seems now to have approximated that.

1921

5. MARSDEN HARTLEY

"Georgia O'Keeffe," from "Some Women Artists in Modern Painting," chap. 13 in *Adventures in the Arts: Informal Chapters on Painters, Vaudeville, and Poets,* intro. Waldo Frank (New York: Boni and Liveright, 1921; reprint, New York: Hacker Art Books, 1972), 116–19. Reprinted courtesy Hacker Art Books, Inc.

With Georgia O'Keeffe one takes a far jump into volcanic crateral ethers, and sees the world of a woman turned inside out and gaping with deep open eyes and fixed mouth at the rather trivial world of living people. "I wish people were all trees and I think I could enjoy them then," says Georgia O'Keeffe. Georgia O'Keeffe has had her feet scorched in the laval effusiveness of terrible experience; she has walked on fire and listened to the hissing of vapors round her person. The pictures of O'Keeffe, the name by which she is mostly known, are probably as living and shameless private documents as exist, in painting certainly, and probably in any other art. By shamelessness I mean unqualified nakedness of statement. Her pictures are essential abstractions as all her sensations have been tempered to abstraction by the too vicarious experience with actual life. She had seen hell, one might say, and is the Sphynxian sniffer at the value of a secret. She looks as if she had ridden the millions of miles of her every known imaginary horizon, and has left all her horses lying dead in their tracks. All in quest of greater knowledge and the greater sense of truth. What these quests for truth are worth no one can precisely say, but the tendency would be to say at least by one who has gone far to find them out that they are not worthy of the earth or sky they are written on. Truth has soiled many an avenue, it has left many a drawing room window open. It has left the confession box filled with bones. However, Georgia O'Keeffe pictures are essays in experience that neither Rops nor Moreau nor Baudelaire could have smiled away.

She is far nearer to St. Theresa's version of life as experience than she could ever be to that of Catherine the Great or Lucrezia Borgia. Georgia O'Keeffe wears no poisoned emeralds. She wears too much white; she is impaled with a white consciousness. It is not without significance that she wishes to paint red in white and still have it look like red. She thinks it can be done and yet there is more red in her pictures than any other color at present; though they do, it must be said, run to rose from ashy white with oppositions of blue to keep them companionable and calm. The work of Georgia O'Keeffe startles by its actual

experience in life. This does not imply street life or sky life or drawing room life, but life in all its huge abstraction of pain and misery and its huge propensity for silencing the spirit of adventure. These pictures might also be called expositions of psychism in color and movement.

Without some one to steady her, I think O'Keeffe would not wish the company of more tangible things than trees. She knows why she despises existence, and it comes from facing the acute dilemma with more acuteness than it could comprehend. She is vastly over-size as to experience in the spiritual geometric of the world. All this gives her painting as clean an appearance as it is possible to imagine in painting. She soils nothing with cheap indulgence of wishing commonplace things. She has wished too large and finds the world altogether too small in comparison.

What the future holds for Georgia O'Keeffe as artist depends upon herself. She is modern by instinct and therefore cannot avoid modernity of expression. It is not willed, it is inevitable. When she looks at a person or a thing she senses the effluvia that radiate from them and it is by this that she gauges her loves and hates or her tolerance of them. It is enough that her pictures arrive with a strange incongruous beauty which, though metaphysically an import, does not disconcert by this insistence. She knows the psychism of patterns and evolves them with strict regard for the pictural aspects in them which save them from banality as ideas. She has no preachment to offer and utters no rubbish on the subject of life and the problem. She is one of the exceptional girls of the world both in art and in life. As artist she is as pure and free from affectation as in life she is relieved from the necessity of it.

If there are other significant women in modern art I am not as yet familiarized with them. These foregoing women [Sonia Terk Delaunay, Marie Laurencin, O'Keeffe] take their place definitely as artists within the circle of women painters like Le Brun, Mary Cassatt, Berthe Morisot, and are in advance of them by being closer to the true appreciation of esthetics in inventing them for themselves.

6. PAUL ROSENFELD

From "American Painting," *Dial* 71 (December 1921): 666–70.

If these two artists [Arthur Dove and John Marin] instance in their work the unification of the male, the oils, water-colours, and black and whites of Georgia O'Keeffe instance the complement. The pure, now flaming, now icy colours of this painter, reveal the woman polarizing herself, accepting fully the nature long denied, spiritualizing her sex. Her art is gloriously female. Her great painful and ecstatic climaxes make us at last to know something the man has always wanted to know. For here, in this painting, there is registered the manner of perception anchored in the constitution of the woman. The organs that differentiate the sex

speak. Women, one would judge, always feel, when they feel strongly, through the womb. The external world is a series of red and green signals, like the signals along a railway bed. In the womb lies the race. But it is not the femini[ni]ty that agrees with the virility of the business man that O'Keeffe's painting demonstrates. Beside her art, that of Marie Laurencin stands as Manon Lescaut might stand beside Pompilia Comparini. The American woman's work has something leonine, maternal, at once passionate and chaste in its essence. All is ecstasy here, ecstasy of pain as well as ecstasy of fulfilment. There is no mean for this woman. In her, the ice of polar regions and the heat of tropical springtides meet and mingle. Greenland's icy mountain abuts on India's coral strand. A white radiance is in all the bright paint felt by this girl. Her colours sworl and flame and explode. Everything rushes down in fiery cascade. The autumn hillside is a torrent. Her masses are like pistils, like whirlpools, like great concentric waves that spread outward and outward until they seem to embrace some sea. The sun and moon are placed in her hair. The night is a swathing garment.

It is a sort of new language her paint speaks. We do not know precisely what it is we are experiencing. She leaves us breast to breast with the fluent unformed electric nature of things. Here, if ever, one sees with Novalis "the eyes of chaos shining through the veil of order." Others make one to feel grey whenever they paint red. O'Keeffe makes us feel dazzling white in her shrillest scarlet and heavenliest blue. She takes us far indeed from Ryder, with his faint tinges. But, whatever it is that her flooding liquid pigment does, one thing it always seems to be bringing about in the beholder. It seems to be leading him always further and further into the truth of a woman's life. We have had, in our paint, no such simple and direct articulateness as records itself here. For this is the new innocency that is exhibited. The old innocency is long since dead. What in the woman dares not face itself, what has cringing hearing and enfeebled eyesight, is it not sick, or perverse, or unborn? But this girl is indeed the innocent one. For here there appears to be nothing that cannot be transfused utterly with spirit, with high feeling, with fierce clean passion. The entire body is seen noble and divine through love. There is no flesh that cannot become the seat of a god. There is no appetite that cannot burst forth in flowers and electric colour. Here speaks what women have dimly felt and uncertainly expressed. Pain treads upon the recumbent figure. Pain tears the body with knives. Pain sets the universe with shark's teeth. Then again, the span of heaven is an arch of bloom. A little red flower with pistil of flame is in paradise. A climax of many seraphic tints holds as though the final great burst of the Liebestod were sustained many minutes. Veils of ineffable purity rise as the mists of a summer morning from lakewater. And, through [sic] makes itself felt the agony of a struggle to preserve intact and pure the vessel within. This art is, a little, a prayer that the indifferent and envious world, always prepared to regard self-respect as an insult to its own frustrate and crushed emotions, may be kept from defiling and wrecking the white glowing place. It is no little sadness, no little knowledge of waiting evil, that utters itself in O'Keeffe's later, dark, purely

painted flower and fruit pieces. The artist goes through the world like one carrying aloft in her thin sensitive hands, above the shoulders of the brushing, brutal crowd of women and of men, a bubble of a bowl that is her all.

And so, confronted with the work of these three artists [Arthur Dove, John Marin, and O'Keeffe], one finds oneself turning to gaze a little more steadily, and with "wild surmise" at the phenomenon which was called 291 Fifth Avenue. For if the common trait which first suggests itself to our attention is their healthiness, the second which comes to our cognizance is the fact that all of them were intimately associated with the Photo-Secession gallery, were championed by it, exhibited, and furthered in the many ways in which that institution furthered those who came in contact with it. One had, of course, long felt the great beauty of the adventure that was the tiny place. The spirit that reigned in the two little burlap-hung rooms up under the skylight was one of the very few wholly clean and lovely things in New York. A banner was planted amid the shifting sands and moving waters of the new world. The protest made was not so much against the materialism of America. For, after all, America is not "materialistic"; for pure "materialism" one must go to Europe; Americans do not love money; they squander it madly. The protest of 291 was made against the fierce disregard of the value of human life, of the value of materials, forests, sky, against the ruthlessness of destructive children that is so terribly the Western malady. To the hate and fear of nature that cloaks itself under the vaulting ambitions of the business world, there was opposed, always with the accent on their quality, their humaneness, their personal reference, the revolutionary works of contemporary Europe and America. The inhuman world had intrenched itself in the field of art by means of the belief that all good work had been done in past time, that this was the age of the machine, and that there was something fresh, young, and athletic in the disregard for the irresponsibly beautiful. 291 showed for the very first time in this land, the washes of Rodin, the oils and water-colours of Cézanne, Matisse and Picasso both as painters and sculptors, the *douanier* Rousseau, Picabia, Brancusi, Nadelman, de Zayas, Hartley, Marin, Weber, Bluemner, Dove, Walkowitz, Steichen, negro and african sculpture, children's work, Strand photographs, all in the effort to exorcise the American devil with the truth of present-day life, the call to the inner room, the impulse to self-knowledge. The small picture-buying public, so it was hoped, would learn to purchase works of art out of love for the thing itself, in recognition of the fineness of feeling in which good work is done, and not in a spirit of personal vanity. The artist, in turn, freed from the commercial game of the galleries, was to be set free to live out his life and develop his art. Quality was to be loved.

Well, 291 closed in 1917. The world was to be saved through "getting" the Kaiser; art might wait until the millennium had been brought about by the business-men, scientists, armament manufacturers, and all the rest of the "mental" workers. Apparently, the skyscrapers of lower New York had vanquished. What could one individual, assisted by a few dreamers, do against a civilization? America was unready for the orientation. And still, to-day it does not seem so

sure that the endeavor of 291 was lost. It seems as though 291 was but a light carried along by a stream in the night that showed in which direction the stream was moving. For here are Hartley, Ray, Demuth, to show that something has been changing in the character of the American painter since the days when he first showed himself at the close of the last century. Here are Dove and Marin and O'Keeffe, moved by something of the same impulse that moved 291; reflecting something of the same human maturity. All these people, no doubt, were affected by what was going on in the gallery. But none of them was actually created by the place. There must have been in them something of 291 before ever they heard of it. Otherwise how could they have come into touch with it? No, to-day it appears much more as though all these manifestations were but lights afloat a darkling tide. It appears as though something had changed in life in America itself, that a counter-tide almost imperceptibly was commencing to move through the country. A second corner in the history of American culture may have been turned; the present has the look of a time of transition; we may all see during the next decades, the period commenced by Ryder draw to a close, transform itself into one of fullest life, change from grey to white.

Of course, there are moments when such a belief convinces the holder of his own insanity. What, America produce a great native expression, America, at this hour! And, indeed, it seems unreasonable to expect it before an hundred years are over. For if, in times of prosperity, the life of the true creator is difficult, what will it be during the next terrible years that are swagging black overhead? The human race is still busy at its little games; it is still pleased with its rôle of irresponsible little patient in psychopathic ward. Not even heaven and the psychoanalysts know what to expect next of it, whether a poem or a smiling murder. The artists themselves are still somewhat prone to sell out to their enemies; the dealers are still prone to knife the artists; the artists to knife one another. The newspapers are entrusting their criticisms to the younger variety of sob-sister before dispensing with it altogether. Radical journals sport critics who write "Ryder is one of the most beautiful things of the nineteenth century, and to-day we have Maurice Prendergast." It is not simple for a country born old to become youthful again. The palmer must wander long before his dry staff leafs. It will be long before American life, in any of its forms, will cease being predominantly grey.

And yet, again, the dry staff has once before broken into green. Why should it not once more?

All swans are fledged grey. In maturity, they become white. Are not people developed by the workings of a similar law? And to-day so many little waterfowl have been hatched and are swimming about, marvellously automatically, in the American mill-stream!

1922

7. Unidentified Writer

From "The Female of the Species Achieves a New Deadliness: Women Painters of America Whose Work Exhibits Distinctiveness of Style and Marked Individuality," *Vanity Fair* 18 (July 1922): 50. Reprinted courtesy *Vanity Fair*. (Illustrated with photograph by Alfred Stieglitz: *Georgia O'Keeffe: A Portrait*, 1918; fig. 7.)

Georgia O'Keefe

Her history epitomizes the modern artist's struggle out of the mediocrity imposed by conventional art schools, to the new freedom of expression inspired by such men as Stieglitz. Her work was undistinguished until she abandoned academic realism and discovered her own feminine self. Her more recent paintings seem to be a revelation of the very essence of woman as Life Giver[.]

8. Paul Rosenfeld

"The Paintings of Georgia O'Keeffe: The Work of the Young Artist Whose Canvases Are to Be Exhibited in Bulk for the First Time This Winter," *Vanity Fair* 19 (October 1922): 56, 112, 114. Reprinted courtesy *Vanity Fair*. (Illustrated with photograph by Alfred Stieglitz: *Georgia O'Keeffe: A Portrait*, 1920; fig. 5.)

The art of Georgia O'Keeffe combines amazingly exquisite subtleties of statement with tremendous boldness of feeling. Fused in her paintings there exist tenderest, rose-petal gradations and widest, most robust oppositions of color. The most complexly varied contraries of tone are juxtaposed with a breathtaking freshness. Chords of complementary colors are made to abut their flames directly upon one another, filling with delicate and forceful thrust and counterthrust the spaces of her canvases. Through this Virginian, the polyharmonies of the compositions of Stravinsky and of Leo Ornstein seem to have begotten sisters in the sister art of painting.

Her work exhibits passage upon passage comparable to nothing more justly than to the powerfully resistant planes of close intricate harmony characteristic of some of the modern music. She appears to have a power like the composers, of creating deft, subtle, intricate chords and of concentrating two such complexes with all the oppositional power of two simple complementary colors. And the modern music is no more removed from both the polyphony of the

madrigalists and the predominantly homophonic effects of the romantic composers, than this painting from both the ruggedly but simply interplaying areas of the renaissance, and the close, gentle, melting harmonies of the impressionists.

For Georgia O'Keeffe's seems to be the power of feeling simultaneously the profoundest oppositions. Here is not the single-tracked mind, with the capacity for feeling only a single principle at a time. She seems never conscious of a single principle without simultaneously being aware of the contrary that gives it life. And she seems aware of the opposites with a definiteness, a clearness, a condensation that is marvellous. Close upon each other in her vision there lie the greatest extremes, the greatest distances, far and near, hot and cold, sweet and bitter; two halves of any truth. Her art is a swift sounding of the abysses of the spectrum, and an immediate relation of every color to every other.

Many modern painters have perceived the relativity of all color; have felt that every hue implies the presence in some form or other of its complement, its ideal opponent that gives it force; and have expressed those complements in their works. But few have dared place a sharp triad based on red in as close juxtaposition to one equally sharp based on green as has this American. She lays them close upon each other, point against point, flame upon flame. For her, the complementariness of these two sets of colors is as natural as the process of breathing.

Other painters have recognized the relation of all colors to pure white since pure white contains them all; few have had it in them to dare abut hardest piercing white between baking scarlets and the green of age-old glaciers, and been able to make ecstatically lyrical the combination. Other painters have felt the gamut from intensest cold to intensest heat within the limits of a single color, and have registered it in their gradations; few, it seems, have been able to race the entire scale with such breathless rapidity, to proceed in one small area of green from the luxuriant Amazonian heat of green mottled with dusty yellow, to the bitter antarctic cold of green-blue.

But it is with subtlety that these tremendous oppositions are stated. They are more often implied than baldly set down. It may be a chord of burning green that is felt against one of incandescent red; a chord of intensest blue against ripe orange. But most often the greens and the blues will be represented by unusual, subtle shades. They will be implied rather more than definitely stressed; the green felt through a kindred shade of blue, the blue through a kindred green. A major triad of full rose, orange and violet will be played against one on green in which the yellow and the blue will be scarcely more than shadowed forth in yellowish green and bluish green. Besides, O'Keeffe does not play the obvious

complements of hot and cold against each other. It is more often the two warm tones in the two triads that will be found juxtaposed in her compositions, and the two cold. Warm orange-red of the calla is fronted with dissolving tropical yellow-green; acid frozen blue-green with cool violet. Oblique, close, tart harmonies are found throughout her work; to them are due much of its curious, biting, pungent savor. It is the latitude between proximate tones, between shades of the same color, that is most often stressed by this artist. Dazzling white is set directly against tones of pearl; arctic green against the hues of tropical vegetation; violet abuts upon fruity tomato-orange. It is as though O'Keeffe felt the same great width between minor seconds that Leo Ornstein, say, perceives. And although she manages to run the entire gamut between heat and coolth of a tone, within a diminutive area, her scale makes no sacrifice of subtleties. The most delicious gradations remain distinct and pure. Hence, tiny forms have the distinct rotundity which many other painters manage to obtain only in bulkier masses.

O'KEEFFE'S FORMS

A combination of boldness and subtlety like the one which exists in the color of O'Keeffe exists also in the shapes born in her mind with her color-schemes, and expressed by them. Precisely as in her harmonies, the widest plunges and the tenderest gradations play against each other, and fuse marvellously, so do severe, almost harsh forms combine with strangest, most sensitive flower-like shapes. In these masses there lives the same subtlety in bold strokes, the same profound effects in daintiness. Rigid, hard-edged forms traverse her canvases like swords through cringing flesh. Great rectangular menhirs plow through veil-like textures; lie in the midst of diaphanous color like stones in quivering membranes. Sharp, straight lines, hard as though they had been ruled, divide swimming color from color. Rounds are described as by the scratching point of a compass.

But, intertwined with these naked spires thrusting upward like Alppin[n]acles, there lie the strangest, unfurling, blossom-delicate forms. Shapes as tender and sensitive as trembling lips, seem slowly, ecstatically to unfold before the eye. It is as though one had been given to see the mysterious parting movement of petals under the rays of sudden fierce heat; or the scarcely perceptible twist of a leaf in a breath of air; of the tremulous throbbing of a diminutive bird-breast. Lines as sinuous and softly breathing as melodies for the chromatic flute climb tendril-like [beside] the severe.

And in the definition of these flower-movements, these tremblingly unfurling corollas, what precision, what jewel-like firmness! The color of O'Keeffe has an edge that is like a line's. Here, for almost the first time, one seems to see pigment used with the exquisite definiteness, the sharp presence, of linear markings. There are certain of these streaks of pigment which appear licked on with the point of the tongue, so vibrant and lyrical are they. The painter appears able to move with the utmost composure and awareness amid sensations so

intense they are wellnigh insupportable, and so rare and evanescent the mind faints in seeking to hold them; and, here, in the regions of the spirit where the light is low on the horizon and the very flames darkling, to see clearly as in fullest noon, and to sever with the delicacy and swiftness of the great surgeon aplunge in the entrails of a patient.

HER VAST DISTANCES

The sense of vasty distances imparted by even the smaller of these curiously passionate and yet crystallinely pure paintings flows directly from the rapidly and unfalteringly executed decisions of the artist. The tremendous oppositions felt between near-lying colors, the exquisite differentiations perceived between graded shades of a single hue; and the extreme delicacy and unflagging sureness with which they are registered, carry one down into profound abysses and out through cloud-spaces and to interstellar lands that appear to have scarce any rapport with the little rectangles of canvas through which they are glimpsed. One falls from a single blue to another down gulfs of the empyrean. The small intense volumes take on the bulk of protagonists in some cosmic drama. Tart, gnarled apples, smooth, naked treetrunks, strange "abstract" forms that are like the shapes of sails and curtains and cloaks billowed by sea-winds; all her masses are each in some magical fashion informed by the ruthless Titan elements that toss the earth like a baseball in their play.

There are canvases of O'Keeffe's that make one to feel life in the dim regions where human and animal and plant are one, indistinguishable, and where the state of existence is blind pressure and dumb unfolding. There are spots in this work wherein the artist seems to bring before one the outline of a whole universe, an entire course of life, mysterious cycles of birth and reproduction and death, expressed through the terms of a woman's body.

For, there is no stroke laid by her brush, whatever it is she may paint, that is not curiously, arrestingly female in quality. Essence of very womanhood permeates her pictures. Whether it be the blue lines of mountains reflecting themse[l]ves in the morning stillnesses of lakewater, or the polyphony of severe imagined shapes she represents; whether it be deep-toned, lustrous, gaping tulips or wicked, regardful alligator-pears; it is always as though the quality of the forms of a woman's body, the essence of the grand white surfaces had been approached to the eye, and the elusive scent of unbound hair. Yet, it is female, this art, only as is the person of a woman when dense, quivering, endless life is felt through her body; when long tresses exhale the aromatic warmth of unknown primaeval submarine forests, and the dawn and the planets glint in the spaces between cheeks and brows. It speaks to one ever as do those high moments when the very stuff of external nature in mountain-sides and full-breasted clouds, in blue expanse of roving water and rolling treetops, seems enveloped, as by a membrane, by the mysterious brooding principle of woman's being; and never, not ever, as speak profaner others.

THE WOMAN IN THE PAINTINGS

It is to a singularly conscious and singularly integrated personality that these canvases refer us. Beside the tremendous decisions that constitute this art, one sees the interplay of an intense consciousness of the elements of ordinary life and an absolute obedience to the promptings of the inward voice; and the simple truthfulness of living becoming the truthfulness of art, and the art in turn sharpening consciousness and trust in the intuitions. We glimpse on the plane of practical existence a woman singularly whole, moving from choice to choice with uttermost heartiness and simplicity. We see a woman who herself sees deeply into ordinary living; perceives beside good, evil; beside love, hatred; beside life-giving, destruction; beside birth, death; and who, for all her intense awareness of the way life leads, of the implications of a single choice, of the possible results of any action, nevertheless, accepts black with white in serene and relaxed composure, and for the sake of the ineffable boon of life, makes her decisions. And·what she is within herself, that, because of her [artist's] orientation, becomes visible to her in external objects.

Because she feels clearly where she is woman most; because she decides in life as though her consciousness were seated beneath her heart where the race begins; she, the painter, moves with like profundity into external nature. There is no piercing the rind of nature at any point that is not a simultaneous piercing at many points. There is no manner of deepened intercourse for the artist that does not become a corresponding approfundization of his sense of his material. There is nothing really experienced that does not become for him aesthetics. So outside herself, Georgia O'Keeffe perceives as few others have perceived, the refractions of light on solids, the relativity of color; and registers them into unswerving faithfulness. In rocks and trees, in flowers and skies, she feels the secret life. She feels in them the thing that is the same with something within herself. Through them her soul becomes visible to her.

She is the one of those persons of the hour who, like Lawrence, for instance, show[s] an insight into the facts of life of an order wellnigh intenser than we have known. She is one of those who seem the forerunners of a more biologically evolved humanity. Of that more richly evolved humanity she may not be as perfect an expression as certain other artists in the world today of their own station in evolution. Her career is very young; and to place her work beside that of some of her contemporaries is to be aware that the greater quickness, the greater juiciness, for all the subtlety and vast scope of her spirit, is not always in her canvases. But her base seems to lie high up the line of progress. Her consciousness is akin to something that one feels stirring blindly and anguishedly in the newest men and women all through the land. And in that fact there lies the cause of her high importance.

9. Unidentified Writer

"I Can't Sing, So I Paint! Says Ultra Realistic Artist; Art Is Not Photography—It Is Expression of Inner Life!: Miss Georgia O'Keeffe Explains Subjective Aspect of Her Work," *New York Sun* (5 December 1922), 22.

"Nothing is less real than realism," said Georgia O'Keeffe. "Details are confusing. It is only by selection, by elimination, by emphasis, that we get at the real meaning of things."

An ultra modern and strikingly original artist, Miss O'Keeffe first exhibited in New York at 291 Fifth avenue, in that famous little gallery which brought Rodin and Matisse to the art lovers of America. This winter she will exhibit in the Anderson Galleries.

Our attention was first drawn to her work by a comment that interested us. "Her pictures," wrote a certain critic, "are permeated by the very essence of womanhood [sic]."

Were they in reality essentially feminine? Glancing around her large, somewhat bare studio we were inclined to agree that they were. Here was a sensitiveness, a spirituality, a feeling for essentials, that seemed peculiarly feminine—a fineness of execution than men might aspire to but few could achieve.

Miss O'Keeffe's painting is intrinsically an expression of her inner life. It is more like music than any painting we have ever seen.

"Singing has always seemed to me the most perfect means of expression," she said. "It is so spontaneous. And after singing, I think the violin. Since I cannot sing I paint." Which accounts, perhaps, for that lyric quality one senses in so many of her pictures.

"In school I was taught to paint things as I saw them. But it seemed so stupid! If one could only reproduce nature, and always with less beauty than the original, why paint at all? Always I had wanted to be an artist, but now I decided to give it up. I put away my paints and brushes. Several years later I happened to be at the University of Virginia, and I went to a lecture on art. The lecturer spoke of art as decoration: Art, he said, consisted in putting the right thing in the right place. It gave me new inspiration, and I immediately took a position as supervisor of art in a Texas town. I was constantly experimenting but it was not until some time later that I made up my mind to forget all that I had been taught, and to paint exactly as I felt."

Certainly the most unusual, and perhaps the most characteristic of Miss O'Keeffe's paintings are those which express simply what she feels—a mood perhaps, or a spiritual experience. Entirely subjective, their appeal is hardly to the conscious mind, but rather, like music, to the subconscious. Studying them, it is difficult to analyze one's emotions—yet from this mass of darting lines, dull purple the predominating color, one senses intense suffering, throbbing pain—from this shell like, iridescent form comes the echo of an exquisite experience—

illusive, intangible, yet lovely beyond words. It is like the witchery of Redon—interesting to imagine what Miss O'Keeffe would do with a color organ. Something extraordinary, without doubt.

Her work, however, is not entirely subjective. Many paintings, especially those of fruits and flowers, are surprisingly realistic. Also her landscapes, although not in the usual sense. Our first impression was quite the opposite. So impregnated are they with her own personality, so moulded and transformed by her inner conception, that some might say that they bear little resemblance to the scenes that inspired them. It was amazing, however, how much more real they seemed on revisiting the studio, more real than one could have possibly imagined. Here, indeed, was something more real than mere realism!

For the past few years Miss O'Keeffe has been spending her summers at Lake George, from where she has just returned. In her studio are several pictures of the lake, painted, evidently, in very different moods.

"The people up there live such little, pretty lives and the scenery is such little, pretty scenery," she said. "That's the way I felt when I painted this," and she turned a painting that had stood on end against the wall.

We had been puzzling about it. Fascinating, but what on earth was it? Even then we weren't sure. Sweeping lines, converging at one side, ripples of rainbow colors, curious balloonlike masses—and then we understood. Mountains, and trees on the margin of the lake—reflected and repeated in the depths of the water. Here was daring and originality, and a real interpretation of the thing she had seen. And from a decorative standpoint, the picture was superb!

What a relief after the mere photography of so many paintings! Who was it said that landscape is nature seen through a personality? And here was nature seen through a very striking and very unusual personality.

The secret of that personality is not an easy thing to grasp. And yet the thing that impresses one most in Miss O'Keeffe is her absolute genuine[ne]ss and her simplicity. Is there, after all, a connection between genius and ill health? Miss O'Keeffe has known a great deal of illness in her life: she has, we imagine, been thrown back upon her own resources to a large extent. She is intellectual and introspective—for an artist, a curiously austere type. Her face is an interesting study—the features extremely sensitive and fine, the nose slender and straight, the mouth wide and thin lipped. It is significant that she rarely paints people, and when she does, merely to portray their personalities in colors, not attempting to reproduce the features. What could be more natural than that she should express the spirituality of her nature, the aloofness from life, the love of sheer beauty, in abstract harmonies of form and color? And so sensitive is she to every visual impression that objects in retrospect become strangely distorted, their salient features curiously exaggerated.

Her own explanation of one of her pictures was illuminating. "You know," she said, "how you walk along a country road and notice a little tuft of grass, and the next time you pass that way you stop to see how it is getting along and how much it has grown? Often I remember little things like that and put them into my pictures."

And she does—quite casually! Yet when the little tuft of grass appears somehow it speaks for all growing things—for Nature herself! Even skunk cabbage, as she paints it, seems a veritable ode to spring!

With the ultra modern school of painting that Miss O'Keeffe represents one is apt to associate the idea of splashing [daubs] of color, of technic which seems, at least to the layman, slovenly to an extreme. Nothing could be more different, however, than the technic that Miss O'Keeffe employs. She paints apples, and the texture of their skins is reproduced so perfectly that one is almost tempted to take a bite. Her water lilies in pastel are so real one almost scents their fragrance.

An impressionist, they say, ceases to be an impressionist when he learns how to draw. Her expressionism, at least, is not open to the same taunt. Probably there are few artists in America who could draw more truly. Surely there are few at present who are doing more suggestive or more truly original work.

10. Georgia O'Keeffe

"To MSS. and Its 33 Subscribers and Others Who Read and Don't Subscribe!," letter to the editor, *MSS.*, no. 4 (December 1922): 17–18.

I studied art at the Art Institute of Chicago, at the Art Students League of New York, at Teachers College, Columbia University, at the University of Virginia.

I even studied with Chase and Bellows and Professor Dow. I am sorry to say that I missed Henri.

I am guilty of having tried to teach Art for four summers in a university summer school and for two years in a state normal but I dont know what Art is. No one has ever been able to give me a satisfactory definition.

I have not been in Europe.

I prefer to live in a room as bare as possible.

I have been much photographed.

I paint because color is a significant language to me but I do not like pictures and I do not like exhibitions of pictures. However I am very much interested in them.

Not being satisfied with the definitions, ideas, of what is Art the approach to photography has been fairly unprejudiced. It has been part of my searching and through the searching maybe I am at present prejudiced in favor of photography.

I feel that some of the photography being done in America today is more living, more vital, than the painting and I know that there are other painters who agree with me. Compared to the painter the photographer has no established tradition to live on. Photography's only tradition of worth is the early daguerrotype and the work of Hill and Mrs. Cameron. The painter as soon as he begins to paint almost unconsciously assumes himself the honored or unap-

preciated present representative of a glorious past tradition. He has a respected past even if he has no standing as a respected citizen today. The photographer has no great tradition. He must gain all the respect he is to have by what he himself can actually do.

I have looked with great interest through rafts of photographs done before the war by Steichen, De Meyer, Coburn, Holland Day, White, Kuehn, Frank Eugene, Craig Annan, Demachy and many others. I don't know what they are doing now. I don't even hear any one talk of them with interest. As many of these men were painters or had tried to be, it was natural that they should try to make their photographs look like paintings—etching—drawing—anything but just a photograph. They did not distinctly separate the medium photography from other mediums. In the 50 numbers of Camera Work Stieglitz records the logical development of photography, the work of these men and many others beginning with Hill through 1916—excepting Charles Sheeler and Stieglitz own work.

Alfred Stieglitz has furnished most of the faith and enthusiasm during the past forty years that makes photography of enough interest to force this number of MSS. He also has faith in the painters and the writers and the plumbers and all the other fools. He seems to be the only man I know who has a real spiritual faith in human beings. I often wonder what would have happened to painting if he had been a painter. Maybe it is because he has faith in all people that he dares and is able to record what some feel the possibly too intimate and significant moments.

Photography is able to flatter or embarrass the human's ego by registering the fleeting expression of a moment. But psychological records registered in this way have nothing to do with aesthetic significance as it seems to be understood today. May be through psychology—psychoanalysis—photography—and other tendencies toward self knowledge the ideas of aesthetics may change. To me Stieglitz portraits repeat in a more recognizable form what he expresses with the photographs of trees, streets, room interiors, horses, houses, buildings, etcetera. Devoid of all mannerism and of all formula they express his vision, his feeling for the world, for life. They are aesthetically, spiritually significant in that I can return to them, day after day, have done so almost daily for a period of four years with always a feeling of wonder and excitement akin to that aroused in me by the Chinese, the Egyptians, Negro Art, Picasso, Henri Rousseau, Seurat, etcetera, even including modern plumbing—or a fine piece of machinery.

If a Stieglitz photograph of a well to do Mid-Victorian parlor filled with all sorts of horrible atrocities jumbled together makes me forget that it is a photograph, and creates a music that is more than music when viewed right side up or upside down or sideways, it is Art to me. Possibly I feel it is Art because I am not clogged with too much knowledge. Or is it Stieglitz?

Paul Strand has added to photography in that he has bewildered the observer into considering shapes, in an obvious manner, for their own inherent value. Surely bolts and belts and ball bearings and pieces of all sorts of things

that one does not recognize readily because of their unfamiliarity, or because of distortion, when organized and put together as Strand has put them together arrest one's attention. He makes more obvious the fact that subject matter, as subject matter, has nothing to do with the aesthetic significance of a photograph any more than with a painting.

Charles Sheeler, one of America's most distinguished young modern painters (this includes all under 60) also photographs. No one considering his work questions his paintings and drawings as ranking amongst the most interesting of their type in America today. To me his photographs are of equal importance. He is always an artist. He has done things with photography that he could not do with painting and vice versa. However the object that is Art must be a unity of expression so complete that the medium becomes unimportant, is only noticed or remembered as an after thought.

Man Ray—a young American painter of ultra modern tendencies and of varied experiments—seems to be photographing. I have not seen anything but reproductions of his work with the camera so have no definite idea of it excepting the fact that he seems to be broadening the field of work that can be done with it.

I can only agree with Remy De Gourmont's Antiphilos that there are as many philosophies (I add ideas on "Art") as there are temperaments and personalities.

1923

11. Georgia O'Keeffe

Statement in *Alfred Stieglitz Presents One Hundred Pictures: Oils, Watercolors, Pastels, Drawings, by Georgia O'Keeffe, American* [exhibition brochure] (New York: The Anderson Galleries, 29 January–10 February 1923), n.p.

I grew up pretty much as everybody else grows up and one day seven years ago found myself saying to myself—I can't live where I want to—I can't go where I want to—I can't do what I want to—I can't even say what I want to—. School and things that painters have taught me even keep me from painting as I want to. I decided I was a very stupid fool not to at least paint as I wanted to and say what I wanted to when I painted as that seemed to be the only thing I could do that didn't concern anybody but myself—that was nobody's business but my own.—So these paintings and drawings happened and many others that are not here.—I found that I could say things with color and shapes that I couldn't say in any other way—things that I had no words for. Some of the wise men say it is not painting, some of them say it is. Art or not Art—they disagree. Some

of them do not care. Some of the first drawings done to please myself I sent to a girl friend requesting her not to show them to anyone. She took them to 291 and showed them to Alfred Stieglitz and he insisted on showing them to others. He is responsible for the present exhibition.

I say that I do not want to have this exhibition because, among other reasons, there are so many exhibitions that it seems ridiculous for me to add to the mess, but I guess I'm lying. I probably do want to see my things hang on a wall as other things hang so as to be able to place them in my mind in relation to other things I have seen done. And I presume, if I must be honest, that I am also interested in what anybody else has to say about them and also in what they don't say because that means something to me too.

12. ALAN BURROUGHS

From "Studio and Gallery," *New York Sun* (3 February 1923), 9. (Review of exhibition, "Alfred Stieglitz Presents One Hundred Pictures: Oils, Water-colors, Pastels, Drawings, by Georgia O'Keeffe, American," New York, The Anderson Galleries, 29 January–10 February 1923.)

Georgia O'Keeffe's exhibition at the Anderson Galleries easily leads the new shows, provided one defines the leading as the most intense and the most capable in accomplishing what the artist intended. Her purpose she has herself explained:

"I grew up pretty much as everybody else grows up and one day seven years ago found myself saying to myself—I can't live where I want to—I can't go where I want to—I can't do what I want to—I can't even say what I want to—. School and things that painters have taught me even keep me from painting as I want to. I decided I was a very stupid fool not to at least paint as I wanted to and say what I wanted to when I painted, as that seemed to be the only thing I could do that didn't concern anybody but myself—that was nobody's business but my own."

Her paintings more than any others seem to be nobody's business but her own. Yet in with that aloof, self-discovered and self-sufficient attitude she mixes a most pleasant tenderness. She combines a strictly disciplined personality with a luxurious taste for color. Marsden Hartley calls her work "as living and shameless private documents as exist . . . life in all its huge abstraction of pain and misery and its huge propensity for silencing the spirit of adventure." Others speak of Georgia O'Keeffe as of one beyond criticism, probably because of their sense of her struggle, of the reality of what confronts them in her work.

Certainly Miss O'Keeffe makes other women painters in America seem inconsequential. To quote Marsden Hartley again, "She has no preachment to offer and utters no rubbish on the subject of life and the problem." She paints neatly, yet not meticulously; thoughtfully, broadly and with a beautiful sense

of textures. Flowers and fruit burn in her conception of them with deep, luminous colors that have no names in spoken or written languages. Her abstract designs and shapes are in the same key. Even more so than the still lifes they convey a sense of suppressed utterance, of song without song, words without words.

As to whether Georgia O'Keeffe creates art or merely is fighting up a blind alley—she again furnishes the clew. "Some of the wise men say it is not painting; some of them say it is." In other words she herself doesn't care what people call it. And her reserve on that point deserves emulation. If many more were to do the equivalent of what she has done the common notion of art would have to go through a lengthy process of refinement.

At the Durand Ruel exhibitions of still lifes and flower pieces one sees no canvases with the intensity of Miss O'Keeffe's. And here are two Cezanne *pommes*, Manet flowers, Monet tulips, Pissaro [sic] *pommes, cruche, verre*, evanescent Renoirs and an honest Sisley. Here are masculine qualities in great variety and reserve. But as in this unfair world, though the man spends a lifetime in careful consideration of a question his answer may seem no more sure than the one the woman gets by guesswork.

13. Elizabeth Luther Cary

"Art—Competitions, Sales, and Exhibitions of the Mid-Season: Georgia O'Keeffe, American," *New York Times* (4 February 1923), sec. 7, p. 7. (Review of exhibition, "Alfred Stieglitz Presents One Hundred Pictures: Oils, Water-colors, Pastels, Drawings, by Georgia O'Keeffe, American," New York, The Anderson Galleries, 29 January–10 February 1923.)

Just why Alfred Stieglitz, who "presents" one hundred pictures by Georgia O'Keeffe at the Anderson Galleries, should insist upon Miss O'Keeffe's Americanism, it is difficult to see, but the pictures are not. They line the brave walls of the Anderson rooms with pinks and purples and greens that would lend themselves happily to color reproduction, and in their carrying power would make capital posters. Some of the subjects are abstract, another way perhaps of saying that you don't know what they mean. When you do know, as in the case of the fruits, some of them, it is very pleasant. It is small wonder that people buy the pears, and they do, at Fifth Avenue fruiterers' prices. The plums have a look of Tyrian dyes that becomes them less well. All the color is rather fresh and new, naturally, as the artist says her art is only seven years old. She says that she does it to please herself, and there is true originality in not saying that she does it to express herself. She expresses in many of her paintings the contemporary urge—there is no other easy word for it—toward yawning

mouths of color, but not all are mouths; a few, though very few, are rectangular and prim. Marsden Hartley has written with extraordinary frankness his idea of Miss O'Keeffe, which is, among other things, that she "has had her feet scorched in the laval effusiveness of terrible experience," that she "has walked on fire and listened to the hissing of vapors round her person." Her drawings are supposed to be as frank as Mr. Hartley, but their abstract character saves the public from knowing it.

14. HENRY MCBRIDE

"Art News and Reviews—Woman as Exponent of the Abstract: Curious Responses to Work of Miss O'Keefe [sic] on Others; Free without Aid of Freud, She Now Says Anything She Wants to Say—Much 'Color Music' in Her Pictures," *New York Herald* (4 February 1923), sec. 7, p. 7. (Review of exhibition, "Alfred Stieglitz Presents One Hundred Pictures: Oils, Water-colors, Pastels, Drawings, by Georgia O'Keeffe, American," New York, The Anderson Galleries, 29 January–10 February 1923.)

Georgia O'Keefe is what they probably will be calling in a few years a B. F., since all of her inhibitions seem to have been removed before the Freudian recommendations were preached upon this side of the Atlantic. She became free without the aid of Freud. But she had aid. There was another who took the place of Freud. His success with her would give him fame at once had not his previous successes with John Marin and Marsden Hartley already placed him upon a pinnacle from which he could gaze down comfortably upon Coué and the other Great Emancipators. It is of course Alfred Stieglitz that is referred to. He is responsible for the O'Keefe exhibition in the Anderson Galleries. Miss O'Keefe says so herself, and it is reasonably sure that he is responsible for Miss O'Keefe, the artist.

Her progress toward freedom may be gauged from a confession of hers printed in the catalogue. She says that seven years ago she found she couldn't live where she wanted to, couldn't go where she wanted to go, couldn't do nor say what she wanted to; and she decided it was stupid not at least to say what she wanted to say. So now she says anything without fear. She says that she did say at first that she didn't wish this exhibition, and adds that she guesses she was lying, for she consents to this exhibition of her own newly acquired free will.

For a lady to admit she lied represents the topmost quality of freedom. After that the fences may be safe to be completely down. And as nothing that happened in San Francisco for two or three years after the earthquake seemed to matter much, so the final confession that she is not indifferent to what people say about her pictures nor even what they don't say about them is relatively

unimportant. The outstanding fact is that she is unafraid. She is interested but not frightened at what you will say, dear reader, and in what I do not say. It represents a great stride, particularly for an American.

Punch Not Greatly in Evidence

The result is a calmness. Younger critics than myself speak of the "punch," but I am not particularly interested in the punch unless there should be a knockout, when of course I must take notice. What I prefer is style, which occurs all along the line and makes the whole encounter interesting from start to finish. There was for me more of knockout in one of Miss O'Keefe's former exhibitions—the one that occurred in, I think, the Bourgeois Galleries shortly after she had burst the shackles. That was the exhibition that made O'Keefe (I think I must drop the "Miss" since everybody else does). I do not know if there were many sales, or any, nor if there was much attendance from the outside world. But certainly all the inside world went, and came away and whispered.

To be whispered about in America is practically to be famous. A whisper travels faster and further than a shout, and eventually registers upon every New York ear. The art crowd did not know that O'Keefe had formerly had inhibitions, but saw that she was without them in the Bourgeois Galleries. Such a scuffling about for draperies there never was since the premiere of Monna Vanna. Even many advanced art lovers felt a distinct moral shiver. And, incidentally, it was one of the first great triumphs for abstract art, since everybody got it.

To this day those paintings are whispered about when they are referred to at all. Even Marsden Hartley, who is a fine writer with many colorful words in his possession, whispers. He says, "Georgia O'Keefe has had her feet scorched in the laval effusiveness of terrible experience; she has walked on fire and listened to the hissing of vapors round her person."

And in another place he says: "She has seen hell, one might say, and is the Sphynxian sniffer at the value of a secret. What these quests for truth are worth no one can precisely say, but the tendency would be to say, at least by one who has gone far to find them out, that they are not worthy of the earth or sky they are written on."

Worthy of Earth and Sky

But they were worthy of the earth and the sky they were written upon. This second exhibition makes it plain. If all those vapors had not been shattered by an electrical bolt from the blue, O'Keefe would have undoubtedly suffocated from the fumes of self. There would have been no O'Keefe. In definitely unbosoming her soul she not only finds her own release but advances the cause of art in her country. And the curious and instructive part of the history is that O'Keefe after venturing with bare feet upon a bridge of naked sword blades into the land of abstract truth now finds herself a moralist. She is a sort of modern

Margaret Fuller sneered at by Nathaniel Hawthorne for a too great a tolerance of sin and finally prayed to by all the super-respectable women of the country for receipts that would keep them from the madhouse. O'Keefe's next great test, probably, will be in the same genre. She will be besieged by all her sisters for advice—which will be a supreme danger for her. She is, after all, an artist, and owes more to art than morality. My own advice to her—and I being more moralist than artist can afford advice—is, immediately after the show, to get herself to a nunnery.

And in the meantime, after the storm in the Bourgeois Gallery, we have peace in the present collection of pictures. There is a great deal of clear, precise, unworried painting in them. Alfred Stieglitz calls it color music, which is true enough. It sings almost as audibly as the birds in the "Cherry Orchard" do when the Russian actress opens that window to breathe in the morning air. That it will have the usual Stieglitz success goes without saying. Claggett Wilson told me that he rushed home from the show to put the emotions roused by it into literature and George Grey Barnard telephoned me in the midst of this writing to tell me of an extraordinary sunset picture of O'Keefe's in which there were vast evolving forms as at an earth creation, interrupted by a darting line of yellow that had been the artist's color response to the massed cries of cattle heard in her youth upon the plains of Texas. His communication materially changed the tenor of this article. I had been upon the point of telling him some of the O'Keefe things but saw there was no use in telling him what he had already got.

15. HENRY TYRRELL

From "Art Observatory: High Tide in Exhibitions Piles Up Shining Things of Art: Two Women Painters Lure with Suave Abstractions . . . ," *The* [New York] *World* (4 February 1923), 9M. (Review of exhibition, "Alfred Stieglitz Presents One Hundred Pictures: Oils, Water-colors, Pastels, Drawings, by Georgia O'Keeffe, American," New York, The Anderson Galleries, 29 January–10 February 1923.)

An extraordinary manifestation of modern art expression and feminine self-revelation through the medium of semi-abstract symbolistic painting occurs in the coincident exhibitions of Miss Georgia O'Keefe at the Anderson Galleries and Miss Henrietta Shore at Ehrich's.

Both these artists are American women—young but evidently past the novitiate state in life and in their art—and they have in common a certain eager freshness which would seem to mark them as debutantes or disciples in a new and fascinating field of aesthetic discovery. And such charmed explorers indeed they are, despite the fact that it is now about a decade since Miss O'Keefe's timorous drawings of flower germination and embryonic life first appeared

among the other incomprehensibilities offered to sceptical public by Alfred Stieglitz at 291; and despite the other significant fact that Miss Shore had gone far and successfully along the road of academic training—as is conclusively shown by such pictures as "Maternity" and the several nudes and still life paintings among the "early work" included in the present exhibition—before she stopped short and turned precipitately to the rhythmic, suave and sonorous symbolism culminating in "Two Worlds," "Unfolding of Life" and "Destiny" now before us.

There is something profoundly moving, strangely suggestive of the mystic source of our being and of creation's dawn, in all these harmonious conjurations of design and color.

Anyway, modern art at the present stage of the game required the feminine kibosh. No radical idea, whether in religion, fashion, politics or art, ever amounted to anything until the woman took it up. Then, and only then, the infusion of life blood begins, never to cease until it has been nourished to maturity and fruition.

Perhaps this art manifestation underneath the surface is nothing new but only what every woman knows and has known all through the ages, from the Princesses of the Pharaohs rudely awakened the other day out of their 4,000 years' beauty sleep in the tombs of Egypt, down to the Mary Cassatts, Berthe Morisots, Marie Laurencins, Pamela Biancas, Georgia O'Keefes and Henrietta Shores of our time.

If such be the case—well, at any rate it has required the cataclysmic upheaval and the dynamic psychology of the second decade of the twentieth century to make women let themselves go in anything like such frank freedom of expression in their lives and in their works.

Henrietta pictures a red volcanic lake, and it typifies smothered passion. Two celery stalks—if you shut your eyes and make believe hard enough—are our First Parents up against a dark destiny of original sin, or something like that.

Georgia paints a couple of pears on a battered tin plate, and you have a hunch that it really means intimations of immortality from recollections of childhood. And you have reason to suspect that her charming little picture of a heifer reaching up to nab an apple from the bough symbolizes the cosmic urge of the eternal feminine toward something or other.

It may take the general public some little time to get accustomed to this sort of thing, and that is why we can't help regretting that the shows last only two or three weeks.

The public, however, ought by now to be pretty well able to take care of itself in matters of art. It has not remained stolid and stunned these twenty years past, "since Cezanne." It may not see through modernism at a glance, but at least it can no longer be bluffed and bullied by self-elected censors and partisan critics. Since these have driven the common-sense art-loving public to desperation, the said public is now in a way to do some thinking on its own account.

One thing, though: in these two occult exhibitions we have been discussing

don't look for any help from catalogs. Miss O'Keefe has none, and Miss Shore's titles are just so many poetic crossword puzzles.

16. ROYAL CORTISSOZ

From "Random Impressions in Current Exhibitions," *New York Tribune* (11 February 1923), sec. 5, p. 8. (Review of exhibition, "Alfred Stieglitz Presents One Hundred Pictures: Oils, Water-colors, Pastels, Drawings, by Georgia O'Keeffe, American," New York, The Anderson Galleries, 29 January–10 February 1923.) Reprinted by permission of I.H.T. Corporation.

———

Miss Georgia O'Keefe, at the Anderson Galleries, has been showing a quantity of formless oils, water colors and pastels, formless in the sense that they disclose no intelligible elements of design. They are redeemed by their color. Miss O'Keefe's tints are often beautiful. It seems a pity that a sensuous glow like hers shouldn't be governed by some pictorial purpose. There is much pretty talk amongst modernists about the virtues of "abstract" art. The painting itself, as on this occasion, leads nowhere.

17. HELEN APPLETON READ

"Georgia O'Keeffe's Show an Emotional Escape," *Brooklyn Daily Eagle* (11 February 1923), 2B. (Review of exhibition, "Alfred Stieglitz Presents One Hundred Pictures: Oils, Water-colors, Pastels, Drawings, by Georgia O'Keeffe, American," New York, The Anderson Galleries, 29 January–10 February 1923.)

———

"Women can only create babies, say the scientists, but I say they can produce art, and Georgia O'Keeffe is the proof of it," said Alfred Stieglitz up at the Anderson galleries, where he may be found every day explaining and enthusing over the O'Keeffe show, for which he stands sponsor. The opinions of Stieglitz are not to be taken lightly. He has a way of being backed up by the test of time which is very disconcerting to his opponents. Take, for example, his sponsorship of Cezanne 15 years ago. The Cezanne now owned by the Metropolitan Museum and once in his possession at "291," cost the Metropolitan many thousands of dollars when they finally bought it, but when Stieglitz first offered it to them they could have had it for $200. Needless to say art should not be judged by its commercial status; but nothing so emphasizes its esthetic importance to the world at large as the cold facts of an increasing value in dollars. Stieglitz, of course, was the man to introduce Cezanne to this country, together

with Picasso and Matisse. With the passing of 291 5th ave.; known only as 291 to the initiate, there is no longer a storm and stress center of art discussions. Where now do they meet and discuss and argue about art and life as they did there? For a moment Stieglitz brings back a suggestion of that stimulating atmosphere if you will talk to him about the O'Keeffe show. His belief in the authority of her work and his unbounded enthusiasm are as contagious as was his cheering for Matisse in the old days. O'Keeffe seems to have stirred the imaginations of a lot of people whose esthetic opinions we respect. This is what Marsden Hartley writes about her work:

O'KEEFFE PICTURES LIVING DOCUMENTS

"If there are other significant women in modern art I am not as yet familiarized with them." And this: "The pictures of O'Keeffe are probably as living and shameless private documents as exist, in painting certainly, and probably in any other art[. . . .] Her pictures are essentially abstractions as all her sensations have been tempered to abstraction by the too vicarious experience with natural life." Again: "She has walked in [sic] fire and listened to the hissing of vapors round her person."

Very dramatic undoubtedly. But the question comes up as to whether the average intelligentsia, without Stieglitz's sponsorship and Hartley's foreword, would "get" these emotional abstractions. For some these living human documents are an open book, into which, having been given the key, we read perhaps more than the artist intended. To others the shameless naked statements are too veiled to be anything but rather disturbing abstractions. To me they seem to be a clear case of Freudian suppressed desires in paint. She admits that she has never done anything she wanted to do, gone anywhere she wanted to go, or even painted anything she wanted to until she painted as she is painting now. So, undoubtedly the work is in the way of being an escape. She sublimates herself in her art. Whether you like some of these very obvious symbols is a question of taste. Certainly they are not unhealthy and morbid as is another exhibition of suppressed desires now current in New York.

O'Keeffe's work is the expression of a powerful personality. It is entirely personal. She leans on no master or school. You cannot connect her with any of the "isms." Her range of color is strangely limited. Her palette is almost entirely confined to red and white. When she is not painting her abstractions she paints glorious [still lifes] of red apples, or beds of canna flowers. She repeats these motifs over and over again. There is an extraordinary quality of purity to her reds. And her patterns have clearness and decision, which again is a reflection of her personality. We are told that her life is as free from affectation as is her art.

18. Henry Tyrrell

From "Art Observatory: Exhibitions and Other Things," *The* [New York] *World* (11 February 1923), 11M. (Commentary about exhibition, "Alfred Stieglitz Presents One Hundred Pictures: Oils, Water-colors, Pastels, Drawings, by Georgia O'Keeffe, American," New York, The Anderson Galleries, 29 January–10 February 1923; includes letter to Tyrrell from Paul Strand about exhibition.)

———————

Once in a while, friends and critics of this Art Observatory say something that is not only truetalk and commonsense, but also (and what from our viewpoint is still more important) is lenient or even perchance commendatory, so that we can risk printing it.

Paul Strand, being an artist and critic of authority as well as a "disinterested" observer, is one whose pointed remarks on the subject of exhibitions in general, and of Miss Georgia O'Keefe's in particular, as set forth in the following letter, we value highly. As it happens, the event he specifies was covered by us early, if not brightly, in this particular department of The World last Sunday. Mr. Strand could not possibly have foreseen that, as he was writing his letter just at the moment we were privately viewing the pictures, in advance of the exhibition's opening. But that is merely incidental, and the critical content of the communication is all to the good.

"Dear Sir:

"As one disinterestedly but vitally interested in the growth and development of American culture, may I call your attention and that of your readers to the exhibition of paintings and drawings by Georgia O'Keefe, which opened on January the 29th at the Anderson Galleries, work the greater part of which has never before been publicly shown? I do so because of the peculiarly unfortunate delay in the matter of review under which all exhibitions of plastic art suffer. Events in the sphere of music or the drama are commented upon the day after the first performance, whereas exhibitions of painting must wait for the Sunday edition. This means, if they open on Monday, as is usually the case, a gap of a week. Thus, without special advertisement, the average exhibition of two weeks' duration is actually cut to one week as far as the public's information and knowledge of it is concerned.

"If this is unfortunate in general, it is particularly so in the case of this exhibition, which is not the average, but is, in my opinion, an event of the most profound significance for us in America. It is not merely 'another exhibition' but a rare opportunity and experience accessible at least to all the people of this city. Just now it is the fashion to bow the head in wonder before everything European, even before a tenth rate example of a second rate worker backed by money and a list of names.

"Things of the mind and of the spirit are being born here in and of America as important to us and to the world as anything which is 'made in' France or Germany, in Russia, Czecho-Slovakia or anywhere else. The work of Georgia O'Keefe proclaims itself with all the power and precision of genius to be one of these things. It is not a dilution or imitation of the work of men, nor does it derive from European influences. Here in America this amazing thing has happened. Here it is that the finest and most subtle perceptions of woman have crystallized for the first time in plastic terms, not only through line and form, but through color used with an expressiveness which it has never had before, which opens up vast new horizons in the evolution of painting as incarnation of the human spirit.

"Yours,
Paul Strand."

19. ALEXANDER BROOK

"February Exhibitions: Georgia O'Keefe [*sic*]," *The Arts* 3 (February 1923): 130, 132. (Review of exhibition, "Alfred Stieglitz Presents One Hundred Pictures: Oils, Water-colors, Pastels, Drawings, by Georgia O'Keeffe, American," New York, The Anderson Galleries, 29 January–10 February 1923.)

———————————

It seems to be Georgia O'Keefe's business to take objects, thoughts and emotions that most people would rather ignore, and glorify them in paint. She experiences all things deeply and when brought to the surface, these experiences are unfolded directly on canvas. One does not feel the arm's length that is usual between the artist and the picture; these things of hers seem to be painted with her very body. Her paintings of still-life—green apples that give one the colic, flowers forced into Woolworth vases, her landscapes imbued with tragic poetry, and finally her abstractions, these last whispered in some cases, shrieked in others, seem all to be transfixed by an absolutely clean dagger that pierces neatly and hits a vital place. Her painting is, in fact, clean. It is the first adjective that occurs to the beholder. Had Georgia O'Keefe taken up the customary duties of woman, had she married and kept house, there would have been no dust under the bed, no dishes in the sink and the main entrance would always be well swept. That is what one is forced to think of her paintings. They are well swept, but not so much by a broom as by a strong wind.

Miss O'Keefe's exhibition of more than one hundred pictures remains at the Anderson Galleries until February 10.

20. Herbert J. Seligmann

"Georgia O'Keeffe, American," *MSS.*, no. 5 (March 1923): 10.

What is an ocean wave of the Maine Coast—how represent the space of Texas plains and the skies over them—how translate the spirit of one living here and now, man or woman, or the life of a plant—how phrase immaculately one's recognition of this magnificence?

Georgia O'Keeffe has answered these questions for herself, making her research in charcoal drawing, watercolor, pastel and oil painting. She has never been, as she informs us, in Europe, though she was introduced, as were multitudes of Americans, to modern European expression through the medium of "291." Her work, entirely and locally American, with a proud and unaccustomed mastery, is therefore unique.

Color is her language. Her body acknowledges its kindred shapes and renders the visible scene in those terms. A few bold delicate strokes lay upon paper a woman's figure in vibrant red, or green and slate shot with rose. Light radiates from interpenetrating color in designs of sunrise over prairie. Heavy depths of blue swing in smooth pastel, or rhythm and plunge of wave is lightly touched, even in white, against white paper.

From early language of line and wash to later pastels and oils a song unfolds. Canvas and paper are bathed in April skies and lush greens of spring, flaming Autumn among trees and waters even jagged dazzle of starlight or notes heard are given to the eye. Georgia O'Keeffe makes one wonder why the sense of hearing and of vision are isolated when the same body houses them. For color is as intimate to her as the musical note that passes through the ear to the innermost organs of sense.

Growing and elemental things are close to her, she sets down exactly what they seem. Each thing she makes has its own life, unfolds simplicities of growing plant, of sea-mighty, sky-wide rhythm of the universe. Musician of color, Georgia O'Keeffe achieves liberation of the eye. Families of apples laugh radiantly. White [zinnias] stare quaintly. Winds blow among dark trees. The body knows tree and fruit, breastlike contour of cloud and black cleaving of lake shore from water's reflection—all things and shapes related to the body, to its identity become conscious.

Georgia O'Keeffe's intensity suggests woman as Greco's was the release of nervous energy of a man. She is of the world family that bore Henri Rousseau, singer in color; whose paintings are hushed with jungle peace and celestial calm of monkeys staring from among great white blossoms upon an alien world. O'Keeffe's is an edged and more intensely swirling accent than Rousseau's dream-like calm. The sharpness of bodily experience is here, in bulging apples, in the thrust of Congoesque arch of fruit basket over gleaming whiteness, seeming to bend the lines of picture frame. Skies are jagged in immense revolution,

flame laps the human body, grey billows, curtain like or opaque white of iridescent delicacy, shut out the world.

Her early work is an expansion of classic prescription. Solid seeming forms clash upon her design, seem to thrust out from her canvas, relieve themselves from surface. Still the texture, of uncanny, fairylike fineness, tapestry rough, pebbly, glossy or opaque is sustained; and sometimes rockets of color soar, dark planes, ribbons of flaming gold pass and are built in musical harmony. In the late green apples upon black surrounded by silver white, forms are held in their plane and green glimmers with the vibrant quality of red.

Then, too, her color cannot always be called pleasing. It is something more. As with object and design, so color clashes, of pink, yellow and purple, that would be common were they not so firm, are made part of Georgia O'Keeffe's distinction.

Through this work American aspects are identified and made personal, O'Keeffe has made the ocean wave or sky, flower or fruit, herself. She has added to America's chronicle hitherto unattempted truths of a woman's sensibility. It is in terms of the identity in her statement that all her works are related to each other and to life. She has made music in color issuing from the finest bodily tremor in which sound and vision are united.

21. HERBERT J. SELIGMANN

From "Why 'Modern' Art?: Six Artists in Search of Media for Their Variously Capricious Spirits Demonstrate That 'Modern' Art Is Not Merely Contemporary Art," *Vogue* 62 (15 October 1923): 76, 112. Courtesy *Vogue*. Copyright © 1923 (renewed 1950) by The Condé Nast Publications, Inc.

———————

Not the least of the sins committed against the painter is the complete obliteration of his living personality in some word that sweeps him up as the statistics of mortality make us all into mere units of number. Such a word is "modern," which serves equally well for those inclined to denounce the new and insurgent emanating from our disorderly world; and for those inclined to tilt against the windmill of academies and things that be. . . .

. . . It is with the idea of demolishing the word "modern" by expanding it to include vagaries of the individual taste that I would invite the reader's attention to six kinds of work, as different as possible from one another. In each is the profound harmony that we know as music, which imparts to the local and the individual its timeless character. If they are found to be of interest, as they are of value to many of those now working in the media of representation, and, if they are accepted as being modern in spirit, then, the word will have been deprived of the invidious significance it bears at present. . . .

MUSIC IN PAINTING

Since the word is of music, I should like to join, with these four spirits in the scheme [El Greco, an unknown Congolese wood carver, Arthur Dove, and Henri Rousseau], one who has transcendently made music in painting, and this one a woman, Georgia O'Keeffe. "I have heard"—and the quotation is again from the entertaining George Moore—"that some women hold that the mission of their sex extends beyond the boudoir and the nursery." The intonation is one of unbelief. This woman painter who professes no mission, challenges nearly all that has yet been written about her sex in the arts. It is difficult to speak about her work. To those who have seen her paintings, they are a personal and direct utterance, without need of eulogy. Their acid sharpness of line, the song-like loveliness of colour, the bold and looming shapes, are full of the seeming contradictoriness, the clash of opposing and contrasting tendencies that make a personality. How literally seen these compositions are, even the ones having to do with forms and colours not immediately recognizable, no one who has not accustomed himself to this directness of vision could realize. A number of her paintings are so closely associated with musical experience that it seems most natural to name one of them "Music." Quite literally, some of them are rendering the effects of musical composition, which is more often visualized as a sort of architecture[;] Miss O'Keeffe is one of the few to have rendered its equivalent in painting with complete conviction of reality. Her mastery of the brush seems to be adequate to any range of colour, from the most brilliant to the most delicate gradations of white and the sombre autumnal notes of the palette. No other woman has ever painted so, and, except for the intensity of Greco and the song-like serenity of Rousseau, no man among the painters occurs for comparison with this singularly gifted woman.

1924

22. GEORGIA O'KEEFFE

Statement in *Alfred Stieglitz Presents Fifty-One Recent Pictures: Oils, Water-colors, Pastels, Drawings, by Georgia O'Keeffe, American* [exhibition catalogue] (New York: The Anderson Galleries, 3–16 March 1924), n.p. (Statement followed by Royal Cortissoz's review of O'Keeffe's 1923 exhibition [reprinted from the *New York Tribune*, 11 February 1923] and excerpts from reviews by Alan Burroughs [reprinted from the *New York Sun*, 3 February 1923] and Henry McBride [reprinted from the *New York Herald*, 4 February 1923]. See this appendix, nos. 16, 12, 14.)

Again I am asked to write a statement for my catalogue. I present herewith Messrs. Henry McBride, Allan [sic] Burroughs and Royal Cortissoz on my exhibition of last year. My reason for the present exhibition is that I feel that my work of this year may clarify some of the issues written of by the critics and spoken about by other people. Incidentally I hope someone will buy something. I have kept my pictures small because space in New York necessitated that.

<div align="center">23. ELIZABETH LUTHER CARY</div>

"Art: Exhibitions of the Week: 'Spiritual America' Print," *New York Times* (9 March 1924), sec. 8, p. 10. (Review of simultaneous exhibitions, "Alfred Stieglitz Presents Fifty-One Recent Pictures: Oils, Watercolors, Pastels, Drawings, by Georgia O'Keeffe, American" and "The Third Exhibition of Photography, by Alfred Stieglitz," New York, The Anderson Galleries, 3–16 March 1924.)

Alfred Stieglitz has written philosophy with his camera and expounds it starting with a tiny, beautifully textured print called "Spiritual America." Just why is a vast mystery of his own, which he chucklingly refuses to interpret for a curious public. That leads to "Songs of the Sky," a struggle through seven prints of dark and light, of value and texture, each print for some inexplicable reason emotionally tortuous. Stieglitz gives elaborate explanations and follows them intellectually through from one state of struggling to another. Pictures must speak for themselves, however, and without his verbal analysis there is a question just what descriptive conclusion one would come to. There is no question of their smashing appeal, of their suggestion of worlds beyond, of an instant made eternity controlled by esthetic structure unsentimental and unsensational. "Songs of the Sky and Trees" is a portrait of a friend of this artist[,] scientist and philosopher, expressed through sky and tree, a tree that dances and sparkles in the first plates becoming in the last print a thing of dignity and completeness. He has let imagination work out two future possibilities—a happy and an unhappy ending, as it were. If there is such a thing as chance, and this exhibition seems to prove that it is non-existent, all these prints have been made from the accident of the sky and sun and clouds. Then with proper humor, and a relief to intensities the exhibition ends with a scolding old shrew of the sky, rating all humanity.

Even though each plate of Stieglitz is a solved mathematical problem, there is a curious suggestion of other problems to come. In every composition of Georgia O'Keeffe, with a greater simplicity and a more direct power, there is something more satisfying and complete. A chalice holding a round fruit, a grail perhaps, is a thing to wake up to in the morning, an encouragement, an assurance of the

potentialities of the day, the day's problem already solved, rather than, as in the Stieglitz compositions, in spite of the solution of an existing problem there is the beginning of the next. Georgia O'Keeffe's arrangements grow, but complete themselves in their growth. She designs "Calla Lilies" and "Alligator Pears," and her pears are healthier and better companions than the orchid-like lilies, with [their] thick white curling sensuous petal.

24. HENRY MCBRIDE

"Stieglitz, Teacher, Artist; Pamela Bianco's New Work: Stieglitz-O'Keefe [*sic*] Show at Anderson Galleries," *New York Herald* (9 March 1924), sec. 7, p. 13. (Review of simultaneous exhibitions, "Alfred Stieglitz Presents Fifty-One Recent Pictures: Oils, Water-colors, Pastels, Drawings, by Georgia O'Keeffe, American" and "The Third Exhibition of Photography, by Alfred Stieglitz," New York, The Anderson Galleries, 3–16 March 1924; includes letter to McBride from Louis M. Eilshemius about exhibitions.)

Photographs by "the master," Alfred Stieglitz, and new paintings by Georgia O'Keefe, provide a joint exhibition that will exorcise [*sic*] a considerable portion of the community. In this exhibition, as in the one provided by these protagonists last year, there is more than meets the eye. There is something also for the ear. The effort that used to be spent by Mr. Stieglitz during an entire year now must be compressed into a fortnight. So all those interested are hereby warned to make their arrangements to give as much of their time as possible to the Anderson Galleries for these two weeks.

Though for that matter the warning seems unnecessary. The Stieglitzites have their own method of intercommunication and foregather punctually.

It is curious that the event should have so unique an aspect. One would imagine that in this great city, where so many millions are spent for European art, that there would be all sorts of places and all sorts of people where and from whom artists could obtain soul comfort, but as far as I know there is only one preacher preaching art[,] administering balm to artists and that is Alfred Stieglitz.

Just how far his philosophy goes I do not know. I have never overheard him *tete a tete* with one of his disciples. I suppose he doesn't quite tell them to lay down their lives for art—though I hear that lately some of them seem to be on the point of doing it, and I suppose he doesn't quite go so far as to offer them exact tips as to how to compel the world to open to their desires. But that they get that help, or think that they get help, which is the same thing, is evident. All the young people in the art world, capable of an exaltation, will give the show a lookover and then hang about waiting for what they may pick up. If

nothing else they at least see each other, and to hail another mariner upon such a lonely sea as art now is, is something reassuring.

Mr. Stieglitz himself tends to grow more and more exalted. It is like him that he should now be doing cloud pictures. His "songs of the skies" in photography seem to be about as far in finish and subtlety and richness as the camera can go, or need go. Their best qualities are doubtless reserved for the student who can meet them upon terms of intimacy. Upon a wall and with a skylight is not so satisfactory an approach as might be had with, say, a library and an argand burner and a study table. Mr. Mitchell Kennerly [sic] telling me of these photographs some days before the actual show opened raised his eyes skyward several times in his enthusiasm and then, catching himself doing it, laughed and said that ever since seeing those photographs his eyes had been turning upward of their own accord. And when I told this story to Mr. Alan Burroughs, here on a flying trip from Minneapolis to Somewhere Else, and who had seen the photos, he said: "I, too, think there's something spooky in them."

MISS O'KEEFE'S EXHIBIT

Miss O'Keefe did not, as I advised her last year, get herself to a nunnery. Far from it. She gives another exhibition and courts that supreme of dangers—self-revelation. If she doesn't watch out society will rend her limb from limb. I suppose there isn't a picture in her collection that wouldn't provide volumes of information to a Freudian expert in regard to O'Keefe. Yet it passes as being mere color and design. It seems to have completely fooled dear, innocent Louis Elshemius [sic], whose letter, somewhere on this page, praises it unreservedly.

But as to color and design, it is very well, of course. Miss O'Keefe has been studying the nature of the plant we used to call a "calla lily," but which botanists assure us is not a lily at all, and finding in it the secrets of the universe. To be sure, when one understands a calla lily one understands everything. The crux, so to speak, of the calla, is the yellow rod at the base of which the real flowers occur, and it is this yellow that sounds Miss O'Keefe's new note. The best of her new pictures, to me, was a flaming arrangement of yellows, very spirited and pure. Just where yellow comes in the occult scheme of things I forget, but I used to know. I think it means progress for Miss O'Keefe. Certainly pale blue is the highest and finest to humans obtainable, and hints of this tint in Miss O'Keefe's career will be awaited with extreme interest. . . .

CORRESPONDENCE

Dear Mr. McBride—Yesterday, on entering Miss O'Keefe's exhibition at the Anderson Galleries, I was glad to be regaled by the diversity of the paintings, all beautiful in delicate color and some adorable in original designs, alive with some human appeal. Was impressed that her first show's overemphasis of abstract puzzles was reduced to only three. She is getting there, to my delight. I also noted that her fruit subjects are better in sculpturesque effect than those of

the Russian contingent. Hail to our own achievers! All who go there will receive pleasurable surprises.

Next to her show is a room devoted to our Alfred Stieglitz. "As fine as a black and white by a master painter," I told him. His cloud visions quite captivated my imaginative sense: here a Valkyre [*sic*] scene; there [a fortress] with soldiers and flag clear as in life, &c. His portrait in cloud-songs fits his multiform nature. Will you believe it, four of the others were mystery, delicacy and demoniac gorge effects?

The plots of scenery and street views fully justify his receiving the English medal. To me they are so wonderful in detail, feeling and interest to all I'd like to own them for my room.

Tell all you meet to take them in at once.

<div style="text-align:right">Louis M. Eilshemius</div>

25. HELEN APPLETON READ

"News and Views on Current Art: Georgia O'Keefe [*sic*] Again Introduced by Stieglitz at the Anderson Galleries," *Brooklyn Daily Eagle* (9 March 1924), 2B. (Review of simultaneous exhibitions, "Alfred Stieglitz Presents Fifty-One Recent Pictures: Oils, Water-colors, Pastels, Drawings, by Georgia O'Keeffe, American" and "The Third Exhibition of Photography, by Alfred Stieglitz," New York, The Anderson Galleries, 3–16 March 1924.)

———

O'Keefe and Stieglitz are again co-exhibitors at the Anderson Galleries, O'Keefe with the large gallery filled with her paintings and drawings, while Stieglitz takes the smaller gallery in which to exhibit his always remarkable photographs. Last year they shared honors equally. This year Stieglitz' photographs are quite as perfect as ever, but because they are of subjects such as clouds and trees and not human beings they will therefore not attract as much attention. Which incidentally is what he wanted.

This is O'Keefe's show.

It will be remembered that in her exhibition last season there were many abstract paintings of curious shapes. These, aided by Marsden Hartley's foreword, which described O'Keefe's mental and emotional processes and repressions, in no vague and unabashed terms, caused a public fed on Freudian catchwords to view these abstractions with suspicion. This season, however, the pictures are allowed to speak for themselves. We are allowed to look at them solely as pictures, our minds uninfluenced by literary or psychic interpretations.

O'Keefe has gone ahead. The fine clear color and austere sense of form have been supplemented with a larger color vocabulary. Gorgeous variations of gold and yellow and harmonies of green have been added to a palette which has red as a prominent note. In her present exhibition she shows only a few of

the flaming cannas of which there were so many last year. She shows a prefer-
ence for the cool tones of calla lilies and alligator pears, not forgetting, however,
the note of yellow which we find in her still lifes of sunflowers and autumn
leaves.

Calla lilies have been the mode in still life painting for several seasons past.
But probably no one has painted them so simply and with an equal appreciation
of them as pure form than Georgia O'Keefe. The cleanness and purity of her
technique, her flair for painting white so that it remains white yet suggests all
colors, make them an especially sympathetic subject. O'Keefe's lilies are the
perfect connotation of the word. She paints them unrelieved by arrangement
or juxtaposition with any other object. It is as if they were suspended in a
vacuum undisturbed by variations of light and atmosphere.

Granting the amazing cleanness of her technique, its fine drawing, pure
color and solidity of modeling, there is another element, and the most important
one, which makes her work notable. It is a clear reflection of personality, a
leaning on no one else's manner of teaching. One has only to look at the artist
and note her clear-cut features and extreme simplicity of manner and spiritual-
ity, to realize that she could not paint in any other way. Each picture is in a way
a portrait of herself.

26. FORBES WATSON

"Stieglitz-O'Keeffe Joint Exhibition," *The* [New York] *World* (9 March
1924), 11E. (Review of simultaneous exhibitions, "Alfred Stieglitz Pre-
sents Fifty-One Recent Pictures: Oils, Water-colors, Pastels, Drawings,
by Georgia O'Keeffe, American" and "The Third Exhibition of Photog-
raphy, by Alfred Stieglitz," New York, The Anderson Galleries, 3–16
March 1924.)

If you want to know how Alfred Stieglitz "gets" his photographs, ask him. I
cannot tell you. But any one who is sensitive to rare quality, to a fine use of
tone relations, can receive what Mr. Stieglitz—not the camera—puts into the
photographs now on exhibition at the Anderson Galleries.

Mr. Stieglitz has long been a path-finder, not only for himself but for others
in the field of photography as well as in other fields. His photographs are a
revelation of what can be done with an instrument which in the hands of most
of the people who use it is nothing more than a means of recording fact—and
none too truthfully at that. His control of his means of expression is extraordi-
nary. His sense of composition is very delicate. The fine precision of these little
photographs, the exactness of the statement of the qualities in the subjects
which Mr. Stieglitz wishes to express, gives them their distinction and their
preciousness.

Most people think of a photographer as b[e]longing to one of two classes. There are the matter of fact utilitarians, who make use of the camera for the purpose of having a permanent transcription of certain facts, or as a more or less inaccurate reminder of something they have enjoyed in nature. And there are those others who produce what the unsophisticated call "artistic" photographs, meaning by that term usually a vague, be-fogged landscape, or a head in some strained or unusual pose, done with the camera out of focus to make all edges "soft."

Mr. Stieglitz belongs to neither of these classes. He has had infinite experience with the camera, and he not only has taste and intelligence enough to avoid artiness, but he is artist enough to create something of his own, and has knowledge enough to know how to do it with the camera.

In the adjoining room at the Anderson Galleries, Georgia O'Keeffe is showing quite an extensive group of her paintings. There are those who claim that Miss O'Keeffe's painting is saturated with symbolism. They are welcome to all the satisfaction they can get out of the search for it. The pictures have other qualities more easily arrived at. Symbolism is fatiguing. But beautiful workmanship is not, and this Miss O'Keeffe's pictures have in remarkable degree. They are definite in their aesthetic intention, and they have distinction as well as brilliance in color. There is nothing casual about them.

The forms in the drawing of fruit and flowers are felt with intensity. The artist is like Mr. Stieglitz in her ability to make the spectator feel the character of the object represented, its essential form, more acutely than the reality itself. Some of the pictures are in water color, which is used with special clearness and intelligence.

27. PAUL ROSENFELD

From "Arthur G. Dove," in *Port of New York: Essays on Fourteen American Moderns* (New York: Harcourt, Brace and Co., 1924; reprint, with introduction by Sherman Paul, Urbana: University of Illinois Press, 1961), 170–71.

Dove is very directly the man in painting, precisely as Georgia O'Keeffe is the female; neither type has been known in quite the degree of purity before. Dove's manner of uniting with his subject matter manifests the mechanism proper to his sex as simply as O'Keeffe's method manifests the mechanism proper to her own. For Georgia O'Keeffe the world is within herself. Its elements are felt by her in terms of her own person. Objects make her to receive the gift of her woman's body in disruptive pain or in white gradual beauty. Color, for her, flows from her own state rather than from the object; is there because she feels as she does and because it expresses her feeling. And the world rendered by her brush as line and shape and color upon canvas is transfused utterly,

whether it comes in the guise of lake water and morning hills, or lilies burning like torches in stone tombs, or strange abstract surfaces and folds, with the sense of woman's flesh in martyrdom, or in state of highness and glorification through flooding unhemmed spirit. Dove feels otherwise; from a point of view directly opposed to that of his sister artist. He does not feel the world within himself. He feels himself present out in its proper elements. Objects do not bring him consciousness of his own person. Rather, they make him to lose it in the discovery of the qualities and identities of the object. The center of life comes to exist for him outside himself, in the thing, tree or lamp or woman, opposite him. He has moved himself out into the object. The object, butterfly, cow, coal-ash, tree, flower, metal, is established for him by a certain condition of light felt provenient from it; a condition which the painter feels to be binding upon himself; and which he is not at liberty to change by the addition or subtraction of any color under penalty of vitiating the integrity of the object. And in his return to the world through art, Dove brings with him a sense of the thing as it exists for itself, deep in proportion to his experience of it. If he is generally found expressing himself through pastels, it is for the reason that the blue tones which he can achieve with them render to his satisfaction those very conditions of light recurrently established by his subject-matters.

<div style="text-align:center">28. PAUL ROSENFELD</div>

"Georgia O'Keeffe," in *Port of New York: Essays on Fourteen American Moderns* (New York: Harcourt, Brace and Co., 1924; reprint, with introduction by Sherman Paul, Urbana: University of Illinois Press, 1961), 198–210. (Illustrated with photograph by Alfred Stieglitz: *Georgia O'Keeffe: A Portrait—Head*, 1922; fig. 13.)

Known in the body of a woman, the largeness of life greets us in color. A white intensity drives the painting of Georgia O'Keeffe. Hers is not the mind capable of feeling one principle merely. She is not conscious of a single principle without becoming simultaneously aware of that contrary which gives it life. The greatest extremes lie close in her burning vision one upon the other; far upon near, hot upon cold, bitter upon sweet; two halves of truth. Subtleties of statement are fused with greatest boldnesses of feeling; tenderest, rose-petal gradations with widest, most robustious oppositions of color. Complexly varied contraries of tone she juxtaposes with a breath-taking freshness. Her art is a swift sounding of the abysses of the spectrum, and an immediate relation of every color to every other one. She has the might of creating deft, subtle, intricate chords and of concentrating two such complexes with all the oppositional power of two simple complementary voices; of making them abut their flames directly upon each other and fill with delicate and forceful thrust and counterthrust the spaces of her canvases. Her work exhibits passage upon passage comparable to the pow-

erfully resistant planes of intricate harmony characteristic of some modern music. Through this American, the polyharmonies of Strawinsky and Ornstein have begotten sisters in the sister medium of painting. And the modern music is no more removed from both the linear polyphony of the madrigalists and the preponderantly homophonic effects of the romantic composers, than this art from both the ruggedly but simply interplaying areas of the Renaissance, and the close, gentle, melting harmonies of the impressionists.

Painters have perceived the relativity of all color: have felt that every hue implies the presence in some form or other of its complement, its ideal opponent that gives it force; and have expressed those complements in their works. But few have dared place a sharp triad based on red in as close juxtaposition to one equally sharp based on green as Georgia O'Keeffe has done. She lays them close upon each other, point against point, flame upon flame. For her, the complementariness of these two sets of colors is natural as the green of foliage. Other painters have recognized the relation of all colors to pure white since pure white contains them all; few have had it in them to dare lay hardest piercing white between baking scarlets and the green of age-old glaciers, and make ecstatically lyrical the combination. Others have felt the gamut from intensest cold to intensest heat within the limits of a single color, and have registered it in their gradations; few, it seems, have been able to race the entire scale with such breathless rapidity, to proceed in one small area of green from the luxuriant Amazonian heat of green mottled with dusty yellow to the bitter antarctic cold of green-blue. But it is with subtlety that these tremendous oppositions are given. They are more implied than baldly stated. It may be a chord of burning green that is felt against one of incandescent red, a chord of intensest blue against ripe orange. But most often the greens and the blues will be represented by unusual, subtle shades. They will be implied rather more than definitely stressed; the green felt through a kindred shade of blue, the blue through a kindred green. Besides, O'Keeffe does not play obvious complements of hot and cold against each other. It is more often the two warm tones in the two triads that will be found opposed in her compositions, and the two cold. Oblique, close, tart harmonies occur, flavoring much of her work with keen, pleasant, ammoniac pungency. The latitude between proximate tones, between shades of the same color, is stressed. Dazzling white is set directly against tones of pearl. Violet abuts upon fruity tomato. It is as though O'Keeffe felt as great a width between minor seconds as Leo Ornstein does. And, although she manages to run the full gamut between the heat and coolth of a tone within a diminutive area, her scale makes no sacrifice of subtleties. The most delicious gradations remain distinct and pure. Hence, tiny forms possess the distinct rotundity which many other painters manage to obtain only through bulkier masses.

A combination of immense Picasso-like power and crisp daintiness exists not alone in the color of O'Keeffe. It exists likewise in the textures of her paintings and in the shapes born in her mind with her color-schemes, and expressed through them. Precisely as the widest plunges and the tenderest gradations

point against each other in her harmonies and fuse marvelously, so in her surfaces do heavily varnished passages combine with blotting-paper textures, and severe, harsh forms with strangest, sensitive flower-like shapes. In the volumes there lives a similar subtlety in bold strokes, a similar profundity of dainty ones. Rigid, hard-edged forms traverse her canvases like swords through cringing flesh. Great rectangular menhirs plow through veil-like textures; lie stone-like in the midst of diaphanous color. Sharp lines, hard as though they had been ruled, divide swimming hue from hue. Rounds are described as by the scratching point of a compass. But, intertwined with these naked spires thrusting upward like Alp-pinnacles, there lie strangest, unfurling, blossom-delicate forms. Shapes as tender and sensitive as trembling lips make slowly, ecstatically to unfold before the eye. Lines as sinuous and softly breathed as Lydian tunes for the chromatic flute climb tendril-like. It is as though one had been given to see the mysterious parting movement of petals under the rays of sudden fierce heat; or the scarcely perceptible twist of a leaf in a breath of air; or the tremulous throbbing of a diminutive bird-breast.

And in the definition of these flower-movements, these tremblingly unfurl-ing corollas, what precision, what jewel-like firmness! The color of O'Keeffe has an edge that is like a line's. Here, for almost the first time one seems to see pigment used with the exquisite definiteness, the sharp presence, of linear markings. Much of her work has the precision of the most finely machine-cut products. No painting is purer. Contours and surfaces sing like instruments exquisitely sounded. There are certain of these streaks of pigment which appear licked on, so lyrical and vibrant are they. The painter appears able to move with the utmost composure and awareness amid sensations so intense they are well-nigh insupportable, and so rare and evanescent the mind faints in seeking to hold them; and here, in the regions of the spirit where the light is low on the horizon and the very flames darkling, to see clearly as in fullest noon, and to sever with the delicacy and swiftness of the great surgeon.

The sense of vasty distances imparted by even the smaller of these paintings flows directly from the rapidly and unfalteringly executed decisions of the artist. The intense oppositions felt between near-lying colors, the delicate differences perceived between graded shades of a single hue and the extreme crispness and unflagging sureness with which they are registered, carry one down into pro-found abysses and out through cloud-spaces and to interstellar lands that ap-pear to have scarce any rapport with the little rectangles of canvas through which they are glimpsed. One falls from a single blue to another down gulfs of empyrean. The small intense volumes take on the bulk of cosmical protagonists. Gnarled apples; smooth, naked tree trunks; abstract forms that are like the shapes of sails and curtains and cloaks billowed by sea-winds are each in magi-cal fashion informed by the elemental forces that toss the earth like a baseball in their play. There are canvases of O'Keeffe's that make one to feel life in the dim regions where human, animal and plant are one, undistinguishable, and where the state of existence is blind pressure and dumb unfolding. There are spots in this work wherein the artist seems to bring before one the outline of a

whole universe, a full course of life: mysterious cycles of birth and reproduction and death expressed through the terms of a woman's body.

It leads us, this painting, further and ever further into the verity of woman's life. We have scarcely a witness more articulate than that borne by it. There are sonnets of Elizabeth Barrett in this sworling, undulant color; this modern woman, too, has been overtaken unawares by an irradiation of brimming rose, and found her spirit standing up erect and strong in a translucent world. But no inherited rhetoric interposes between her feeling and her form of expression. Her concepts are not half in man's tradition. To a degree they come out of general American life; not out of analyses of Cézanne and Picasso. They come out of the need of personal expression of one who has never had the advantage of the art treasures of Europe and has lived life without the help of the city of Paris; out of the necessity of one who shows no traces of intellectualization and has a mind born of profoundest feeling. An austerity, a fibrousness which is most closely kin to the Amerinds' pervades this paint. But, more directly even than from the plains and the cornlands and the general conditions of life in the new continent does it stem from the nature of woman, from an American girl's implicit trust in her senses, from an American girl's utter belief, not in masculinity or in unsexedness, but in womanhood. O'Keeffe gives her perceptions utterly immediate, quivering, warm. She gives the world as it is known to woman. No man could feel as Georgia O'Keeffe and utter himself in precisely such curves and colors; for in those curves and spots and prismatic color there is the woman referring the universe to her own frame, her own balance; and rendering in her picture of things her body's subconscious knowledge of itself. The feeling of shapes in this painting is certainly one pushed from within. What men have always wanted to know, and women to hide, this girl sets forth. Essence of womanhood impregnates color and mass, giving proof of the truthfulness of a life. Whether it is the blue lines of mountains reflecting themselves in the morning stillnesses of lake-water, or the polyphony of severe imagined shapes she has represented; whether deep-toned, lustrous, gaping tulips or wicked, regardful alligator pears; it is always as though the quality of the forms of a woman's body, the essence of the grand white surfaces, had been approached to the eye, and the elusive scent of unbound hair to the nostril. Yet, it is female, this art, only as is the person of a woman when dense, quivering, endless life exists in her body; when long tresses exhale the aromatic warmth of unknown primeval submarine forests, and dawn and the planets glimmer in the spaces between cheeks and brows. It speaks to one ever as do those high moments when the very stuff of external nature in mountainsides and full-breasted clouds, in blue expanse of roving water and rolling treetops, seems enveloped in the brooding principle of woman's being; and never, not ever, as speak profaner others.

For the paintings of Georgia O'Keeffe are made out of the pangs and glories of earth lived largely. Shapes and lines, broad single fields of tone, offer pieces of mountains to the heart, thrust windows open on the great airs and lands. The painter has reds and greens and whites red and green and white with all

of passionate feeling of color it seems the hollows of the heart can hold. She has greens flameful and fiery as hottest scarlet. She has reds serene and pure as smoothest white. Marie Laurencin may give us the Watteau grace and delicacy of the Trianon in modern idiom. O'Keeffe brings a spaciousness of feeling, sweep, tumult, and calm like the spaciousness of the ocean and the Texan plains she loves. It may be the most literal representation or the most ethereal abstraction that is rendered; and the artist moves freely from one category to another; for her, the two categories are single—she paints them as one. But, whatever the subject-matter, the expression releases us with the white flames which cast fears out. It is heart-bursting joy that sings, or gaunt sorrow; it is aches and blisses scooped from the depths of the being and offered to the light; it is the hours of great morning when the spirit lifts high its hands in rapture; it is white night when the firmament is a single throbbing presence and quicksilver cuts sharp rims in black and digs a golden hollow in the lake under the mountain-wall. Darkly, purely painted flower and fruit pieces have not a little sorrow; contours silently weep. Pain treads upon the recumbent figure. Pain rends the womb to shreds with knives. Pain studs the universe with shark's teeth. Other times moods play like teasing children at tag. A prim and foolish little house winks its windows, while a flagstaff leans crazy, and mauve evening clouds tumble clownishly. An innocent orange flower is out walking of a nice Sunday morning through sweet green with a new feather stuck in its bonnet. A cow in apple time curls forth its purple watering tongue of flannel and rolls the comic muteness of its impenetrable bovine eye. Then, veils of ineffable purity steam like morning mists off tranquil lake-water. The span of heaven is an arch of bloom. Pearly shapes chant ecstatically against somber backgrounds. Life seems to rise on wing, in the dumbness of utter bestowal, into a climax of seraphic hues.

Fortune appears to have endowed Georgia O'Keeffe with two gifts which are perhaps a single one. It seems to have given her capacity of fiery passion; it has also shod her adamantine with safeguarding purity of edge. Hers is a spirit like steel-construction; all skeleton nudity and savage thrust. Burningness of life can breathe up and breathe free in her. For it rises flame-sharp of rim. Volcanic surge of feeling can find its way clean into the world. For folded in its substance there lies the whiteness of the spot where the race begins. She goes through the world upholding in her thin sensitive hands above the brushing crowd a bubble of a bowl. The world is rich for this woman because of the unfaltering swift selections of her deep unconscious principle. And it is from the white integrity with which her being is bound that the tremendous decisions which constitute the art of Georgia O'Keeffe proceed. What she herself within herself is, where she is woman most, becomes apparent to her, because of her artist's vision, in external objects. There is no manner of deepened intercourse for the artist which does not become for him a correspondingly approfondized sense of his material. There is no piercing of the rind of nature at any point that is not a simultaneous piercing at many points. There is nothing really experienced which does not become esthetics for him. And, since O'Keeffe knows life as it comes to the

passionately living; knows by the side of attraction, repulsion; by the side of life-giving, death-dealing; by the side of birth, decay, she sees scattered over the face of the world, in autumn landscapes, in baskets of fruit, in flower-cups and mountainsides the symbols of extremely concentrated feeling. She sees shapes and hues in the powerful oppositions born of intense passion. As few have seen them, she sees the refractions of light on solids, the relativity of color. She sees clashing principles lying close upon each other, speaking the subtle, wondrous high thing she knows; great forces brought close in upon each other, their virtue increased through the intensity of their mutual resistances under approxima-tion. And, in the arrowlike tongue of her pigment she registers them with unfaltering faithfulness, and gives the personal inner truth of her opalescent sphere.

The American failure has been primarily a failure in men and women. Of the two masterpieces *manqué* the greater failure has been the woman, for the reason that it is she who is the object of labors, the work upon which the care of the artist has most generously been bestowed. It is the woman who has been given the position of honor in American society, been freed not only of conven-tional restraints, but made the arbiter of education and of life. The great privi-leges of leisure have gone to the girls. And though the new world has made of the woman a marvelously shining edifice, flowing of line and rich in material, it has also made of her a dwelling uninhabited, gray and chill like the houses where the furniture stands year-long in twilight under its shrouds. For, in keeping the male undeveloped and infantile, American culture has attributed the masculine principle to the female, and divided the female against her proper intuitions. The country has men who are boys and rest sixteen at seventy; and women who are Parian glories outside and little stunted men inside. Of life based upon the whole and developed personality there is scarcely any. But the art of Georgia O'Keeffe is no art of a poor little man. With this young artist, the splendid forsaken mansion flushes suddenly with the radiance of many chande-liers, the long-speechless windows glitter with active life. She is the little girl and the [sibyl], the wild, mysterious, long-haired one and the great calm rooted tree. The freshness of vesture given the sex by the American adventure is not lost in her. It has merely been made glorious and swift by the woman-psyche accepted, respected, cherished. A woman soul is on the road, going toward the fulfillment of a destiny. The effulgent art, like a seraphic visitor, comes with the force of life. In blaze of revelation it demonstrates woman to the world and to woman. It summons a psychic capacity toward new limits. It veers nature once again to its great way.

29. SHELDON CHENEY

From "The Swing toward Abstraction" and "The Geography and Anat-omy of Modern Art," chaps. 9, 12 in *A Primer of Modern Art* (New York:

Horace Liveright, 1924; 5th ed., New York: Horace Liveright, 1929), 169–72, 232–36.

Perhaps . . . the giant of abstract creation has not yet arrived. Perhaps someone will bring architectonics into it. At present the lover of modernist art is in the paradoxical position where he likes the painter who strictly subordinates imitation to a hidden non-representational element, but finds unsatisfying the painter who goes over to non-representation entirely, attempting to create in abstract form. Certainly most of us appreciate Kandinsky's *Impressions* and *Improvisations,* and such things as his *Winter* . . . , more than we do the *Compositions.* And yet—I confess that I have moments of wobbling on the question. I find something coming into the abstract work of certain Americans—particularly Georgia O'Keeffe and Helen Torr—which is emotionally very moving.

There is a place where abstract painting borders on abstract decoration. Purely sensuous values are more easily obtained than structural ones from nonrepresentative material. From Claude Bragdon's higher-mathematical architectural ornament to the Matisse sort of painted decorative panel, there is a wide range of achievement in modern art that is hardly equalled outside of Persian or other Oriental history. Perhaps the sensuous impression afforded by an absolute decoration is a sort of first dimension of the deeper ecstasy that is afforded by a picture indubitably rich in voluminous form. At any rate I am one who would give place to the "decorative movement" in the histories of modern art, if only because the decorative ideal is a step closer to what we are after than was anything revered in the long realistic era. . . .

Expressionism in America has a history back to the first decade of the century.

The date might almost be fixed by reference to the calendar of exhibitions at the Photo-Secession Gallery—the famous "291"—in New York. And the artist who is likely to be named oftenest in connection with the first quarter-century of American post-Impressionism, when the history of the movement is written, is Alfred Stieglitz. He knows better, instinctively, what *expression* is than any other American. In his photography he has given us a record that is a miracle of the machine as slave to artistic sensibility. He also has that gift for infecting other men with enthusiasm and creative impulse which made "291" an oasis in New York for many years. In the pre-war years most of what was most worth while in American painting centered there. Cezanne, Matisse, Picasso, Braque, were introduced to America, as were lesser figures like Picabia, Henri Rousseau, de Zayas, Brancusi and Nadelman—and "special" things like Rodin's drawings, Geiger's etchings, negro sculpture and children's drawings.

The first collective exhibition of American moderns was held at "291" in 1910, and it is notable that already so important a group as Dove, Hartley, Weber and Marin was included. The first Marin show had been in 1909, and Alfred Maurer and Marsden Hartley were shown in the same year. Marin and Hartley one-man exhibitions followed at intervals until the closing of the gallery

in 1917; Max Weber had his own show in 1911, Dove in 1912, Walkowitz in 1912 and 1916 and Bluemner in 1915. And finally Georgia O'Keeffe exhibited in 1916. Stieglitz as a personality affected the art development of all these leaders.

The first big general exhibition was the famous international "Armory Show" in 1913, which fortunately was not New York's alone. It will go down in history as the most important landmark of the "movement." Since then several galleries owned by dealers have "turned modern," the Societé Anonyme has been organized to keep alive the spirit of daring and to offer wall space to the newest rebels. Independent Shows offer a haven to anything and everything, the art magazines (so-called) have opened their pages generously to the heretics—and modernism is in danger of becoming popular.

John Marin and Georgia O'Keeffe are perhaps the Americans who have escaped most freely and most joyously from the confines of the older painting. They seem to revel in a free playing with form, without the slightest trace of self-consciousness. No man anywhere is more master of the watercolor medium than is Marin. He is beyond it and free for expression. He not only is no slave to transcription of nature, but hardly holds to objectivity in the slightest degree. And yet there is never the feel of his reaching for abstraction as a separate thing: there is always enough of contact with the perceived world to quiet the mind. Beyond that the magic of emotion is almost invariably there—the realization, the rhythmic order. The only valid criticism of his work comes not from the academicians but from the modernists who feel that his achievement is too much in one key. But in its limited range it is magnificent.

Where Marin seems to capture emotional intensity rapidly, brilliantly, with feverish abandon, getting down the palpitating image broadly in emotional outline—Georgia O'Keeffe seems to intensify calmly, to work through clearheadedly in silence, but with heart no less stirred and kept aflame in her steady way. She wanders the whole field from apples to abstraction. She is bold, but always within a harmonious restraint; her canvases are compact, the design counting strongly, color emotional, the absolute feeling poised with exquisite certainty. Order here is conceived femininely, musically. In the still-lifes the corners, the patches, the objects answer each other compositionally. The abstract "arrangements"—subtly geometrical and hard as compared with Kandinsky's soft spirit-wanderings—are like planes out of space, made living with color, meeting with paper-edge sharpness or rounding into perfect breastlike contours. Incidentally her canvases more than those of any other artist might afford Thomas Wilfred the perfect theme for one of his mobile color improvisations. Contrast, organization, play of textures, woman's emotion— made expressive in paint.

30. Helen Appleton Read

"Georgia O'Keeffe—Woman Artist Whose Art Is Sincerely Feminine," *Brooklyn Sunday Eagle Magazine* (6 April 1924), 4.

Alfred Stieglitz introduced Georgia O'Keeffe to the picture-loving public. Georgia O'Keeffe is now generally considered the most significant of our younger women painters. It is no exaggeration to say that she is the only American woman painter who paints like herself, who reflects no teaching or influence. She is nakedly, starkly Georgia O'Keeffe.

George Moore in writing about women in art said that women artists carried the art of men across their fans, and cited the famous women painters of history who, despite their talents, were merely feminine versions of their masters. Berthe Morisot carried Manet's art across her fan, while Mary Cassatt was a feminized Degas. Admitting, however, that they were feminine versions, their saving grace was the very fact of their femininity. It is only art which has the flavor of sex that has enduring qualities. They did not make the mistake as did Rosa Bonheur, to quote the historic horrible example, of trying to be masculine.

Now O'Keeffe goes a step further; she is both feminine and feminine in terms of herself. I can see no traces of any man's art peering over the edge of her fan, that is, if she were sufficiently coquettish to carry one. It happens that O'Keeffe femininity is not of the fan-carrying sort. It is intensely, primitively womanly.

In 1923 O'Keeffe gave her first New York exhibition. She has recently had another one. The announcement read: "Alfred Stieglitz presents one hundred pictures by Georgia O'Keeffe, American." The majority of us knew nothing about O'Keeffe or had forgotten that we did. So that it was a distinct surprise to old Art Students Leaguers to find that "O'Keeffe, American" was none other than "Patsy" O'Keeffe, the pretty curly-haired art student whom we all knew and who was not only the toast of the school and a prize winner but had also the distinction of being painted by all the star pupils at the Art League ten years ago. Eugene Speicher's first bow to the public was a portrait of O'Keeffe. But what a different O'Keeffe she has become! She is no longer curly-haired and boyish but an ascetic, almost saintly appearing, woman with a dead-white skin, fine delicate features and black hair severely drawn back from her forehead. Saintly, yes, but not nun-like, for O'Keeffe gives one the feeling that beneath her calm poise there is something that is intensely, burningly alive, and that she is not only possessed of the most delicate sensibilities but is also capable of great and violent emotions. These qualities written on her face are also reflected in her work. It is, of course, a truism that if you are any sort of a painter your painting is bound to be a record of yourself, and the better you are, artistically speaking, the more clearly does it record you. You cannot conceal your soul on canvas. O'Keeffe's heart, soul and body are in her work.

Some of O'Keeffe's pictures, although the purest abstractions as far as representing any concrete subject, at once suggest emotional states, "Suppressed Desires" or otherwise, as the Freudians would call them.

But in order to understand how it all came about, and before going on to a discussion of her work, it is necessary to say a few words about O'Keeffe's sponsor, Stieglitz. Alfred Stieglitz was the founder of "291 Fifth avenue," which

was the meeting place, until it was recently discontinued, and the rallying point of artistic and literary New York.

Stieglitz brought out the best in every man and woman that came under his influence. He had also a prophetic vision about pictures; he knew instinctively the men who had something to say and who were to be the big men of the future, no matter how different was their language from that in current use. Stieglitz was the first man to show Rodin drawings and Cezanne water colors. He introduced modern art to America. Along with these foreign art exhibitions he also showed the work of the men in whose future he believed. It was a pretty sure bet that if you were sponsored by Stieglitz you had arrived.

And it was here that a portfolio of O'Keeffe's drawings found their way through the medium of a friend to whom she had sent them. They were abstract drawings, but which, nevertheless, conveyed definite emotions; they were intensely feminine, bare emotional statements which their author did not want the world to see. But the friend thought that here was such a remarkable artistic expression that it belonged to the world; that the woman must give way to the artist. Most naturally, Stieglitz at once appreciated O'Keeffe's unusual gifts, encouraged her to concentrate on her painting and later introduced her under his sponsorship to the world.

What is it then, concretely, that makes O'Keeffe's work different? Exactly what and how does she paint? What is there about her work that brings about an emotional response in everybody who sees it, and that inspires a writer like Marsden Hartley to burst into purple rhetoric such as this about her:

"With Georgia O'Keeffe one takes a far jump into volcanic crateral ethers, and sees the world of a woman turned inside out and gaping with deep open eyes and fixed mouth at the rather trivial world of living people. Georgia O'Keeffe has had her feet scorched in the laval effusiveness of terrible experience; she has walked on fire and listened to the hissing of vapors round her person. The pictures of O'Keeffe, the name by which she is mostly known, are probably as living and shameless private documents as exist, in painting certainly, and probably in any other art. By shamelessness, I mean unqualified nakedness of statement. Her pictures are essential abstractions, as all her sensations have been tempered to abstraction by the too vicarious experience with natural life. She looks as if she had ridden the millions of miles of her every known imaginary horizon and has left all her horses lying dead in their tracks. All in quest of greater knowledge and the greater sense of truth."

Granting that much of this is hysterical exaggeration, and granting that such an interpretation of O'Keeffe's work must influence everyone who has read it into seeing in her paintings Freudian complexes and suppressed desires, nevertheless, even without having read it, I think that the most casual gallery frequenter would find some disturbing emotional content in her work[s]. They are in some way an expression on canvas of an intense emotional life which has not been able to express itself through the natural channels of life. But distinctly they are not unhealthy or morbid.

They are the work of a woman who after repressions and suppressions is having an orgy of self-expression. O'Keeffe will not admit to personal tragedies, although her face tells a story. She is too reserved. She only tells you of one: that she had to give up the thing she loved best, painting, in order to fit into the narrow hemmed-in existence which circumstances made for her. Painting remained her passion, but it was all or nothing. Since she could not devote herself to it, she never touched a brush, could not bear the smell of paint and turpentine because of the emotions they aroused. She taught art in a public school in Texas. Then she burst the bonds of her repression and began to paint.

As an explanation of her individual style and point of view she says:

"One day seven years ago I found myself saying to myself—I can't live where I want to—I can't go where I want to—I can't do what I want to—I can't even say what I want to. School and things that painters have taught me even keep me from painting as I want to. I decided I was a very stupid fool not to at least paint as I wanted to and say what I wanted to when I painted, as that seemed to be the only thing I could do that didn't concern anybody but myself—that was nobody's business but my own. So these painting [sic] and drawings happened and many other that are not here. I found that I could say things with color and shapes that I couldn't say in any other way—things that I had no words for. Some of the wise men say it is not painting, some of them say it is. Art or not art—they disagree. Some of them do not care."

Her subjects are for the most part still lifes of red apples, purple-green alligator pears, flaming red cannas, dead white calla lilies and yellow and red autumn leaves. Then there are always her abstractions—these strange records of emotions in paint which heretofore we believed were only possible to express in music. Still life subjects such as O'Keeffe paints have been painted innumerable times, but with O'Keeffe they are different. Her flowers and fruits convey quite as much a sensation of intensity as do her abstractions. The psychoanalysts tell us that fruits and flowers when painted by women are an unconscious expression of [their] desire for children. Perhaps they are right. Certainly these fruits and flowers have something emotionally stirring in them that suggest[s] symbols of life. But turning to her work from a purely painter's point of view—her technique is austerely neat in its execution; the painting, while the color is intense and glowing, is clean, clear and precise. Her pictures look like portraits of herself, so intensely personal are they. Last year she concentrated on cannas—the walls glowed with them; this year it is lilies; again, portraits of herself. No one has ever painted lilies quite like this; it is as if she had got at the essence of the flower; saw it almost as if it were suspended in a vacuum, untouched by the changing effects of light and atmosphere.

Astuter critics and psychologists than Moore have claimed that woman can never be a true creative artist; that she can only create life. Perhaps that is what O'Keeffe meant when she said: "Wise men say it isn't art! But what of it, if it is children and love in paint? There it is, color, form, rhythm. What matter if its origin be esthetic or emotional?["]

31. Virgil Barker

From "Notes on the Exhibitions," *The Arts* 5 (April 1924): 219–23. (Commentary about simultaneous exhibitions, "Alfred Stieglitz Presents Fifty-One Recent Pictures: Oils, Water-colors, Pastels, Drawings, by Georgia O'Keeffe, American" and "The Third Exhibition of Photography, by Alfred Stieglitz," New York, The Anderson Galleries, 3–16 March 1924.)

Last year, in his essay on the work of Charles Sheeler, Forbes Watson termed it "clean-cut." At about the same time, in a note on the work of Georgia O'Keeffe, Alexander Brook enlarged upon the same idea. A commentator recording this season's exhibitions by these two artists is grateful for the lead thus given because it points the way to an interesting comparison.

All valid comparisons necessitate both likeness and unlikeness. In this instance the likeness is found in the surface aspect of the art and the unlikeness is found beneath the surface in the temperaments that produce the art. Miss O'Keeffe's pictures are the clean-cut result of an intensely passionate apprehension of things; Mr. Sheeler's, the clean-cut result of an apprehension that is intensely intellectual. Of course, there can be no splitting-up of any mentality into intellect and emotion and will after the fashion of an outworn psychology; in art, at least, emotion cannot be made concrete without intellect, nor can intellect do anything without emotion. But as long as such differentiations are understood in no exclusive sense, they may serve. And only in such a sense is it suggested that Miss O'Keeffe's pictures embody intelligent passionateness while Mr. Sheeler's embody passionate intelligence.

Something like this may account for the woman's greater abandonment to color and the man's austerity in that respect. It may also throw light upon the difference in the air, the tone, of these artists' work. All Miss O'Keeffe's paintings are intimate, some of them almost unbearably so; fruit and leaves and sky and hills nestle to one another. In contrast Mr. Sheeler's paintings are far-withdrawn; barns and flowers and jugs stand cool and quiet and remote.

"Can a Photograph be a Work of Art?" An entire number of that unperiodical periodical entitled *Manuscripts* was devoted to a symposium on that question. And all those words by all those writers, whether for or against, are turned into empty chatter by the wordless sky-songs of Alfred Stieglitz. To one individual they came as a revelation—a call to adventure, an enlargement of experience, a spiritual release. A perceiving soul has trapped sublimity in a machine and on sheets of paper a hand's breadth wide has fixed immensity.

32. Paul Strand

"Georgia O'Keeffe," *Playboy: A Portfolio of Art and Satire* 9 (July 1924): 16–20.

Here in America, something rare and significant in the realm of the spirit, has unfolded and flowered in the work of Georgia O'Keeffe. Something has crystallized in the painting of this American, and neither here nor in Europe, has a similar intensity and purity of expression so found itself through a woman. For the evolution of her work, exhibited last winter at the Anderson Galleries and the latest developments of it recently shown there, reveal the fact that without self-consciousness or mannerism, the most personal and subtle perceptions of woman are embodied for the first time in plastic terms. This is achieved not only through line and form but through color used with an expressiveness which it has not had before, which opens up new horizons in the evolution of painting as incarnation of the human spirit. Here again is disclosed that twofold significance of so-called aesthetic and social evolution, inevitably related in every profound formalization of human experience.

That such an amalgam has actually been projected upon material by a woman in America, is particularly significant. For considering the development in Europe even, of those media the enduring examples of which we choose to call Art, the achievements of women have been relatively second rate. If genius is a natural and highly differentiated impulsion away from the atavistic subjugation of the herd, women have been, from the point of view of those media, an undifferentiated species. Despite the mental and psychic differentiation of men and women as product of the physiological, that differentiation has not been expressed. The work of women in music, literature, architecture, painting or sculpture for that reason, has been weaker in dynamic imagination than that of men. In no single instance has it played a vital part in the development of those media.

In their various attempts to formulate a personal vision through the use of the media of the major arts, women have succumbed always to the domination of masculine influences. It is precisely this which has weakened and beclouded their own perceptions and the expression of them. And it is this unconscious imitation of the work of men, this "masculine protest," which, in the painting of Georgia O'Keeffe, is so significantly absent. One is made to feel at once in her work, from the early to the late, that by the widest stretch of the imagination, the line, the form or the color could not have derived from a man's consciousness or experience of life.

For this work of O'Keeffe is product of a new world for women; a world which the last one hundred years have brought into being through the invention of machinery and the consequent development of the modern industrial fabric. Women have not only been given access to but have been forced into vast new experiences which have done things for them and to them. Every-

where are the consequences of this change evident in the form of new directions of activity, new desires awakening, old needs thwarted, ending not infrequently in maladjustment and neurosis.

In a recent analysis of the work of D. H. Lawrence, Mr. Paul Rosenfeld has well described this modern world of evolving women types. He sees Lawrence as a Minnesinger who "has appeared simultaneously with the individualizing, self conscious women of the new century." Further he sees in the 12th century a parallel to "the new, complex, recalcitrant female types" in "the sudden evolution of the great countesses and heiresses, the sudden appearance in barbarous crusading Europe of grave, haughty ladies in the feudal donjon keeps, that forced the creation of the courtly poetry." But he says: "It is no longer upon the isolated peaks of society that the development, the individualization of women has taken place, but in the great lower strata. Economic conditions apparently have made women the equals of men and made them independent of the family; but beneath the economic revolution there is the curious development in the race itself, a pushing away of people from the herd types like twigs from the parent branch; the moving away of men and women from a kind of general soul that made them closely alike for all the difference of sex; the production of more and more sharply individualized characters. And in the separation, the facility for the meeting of spirits becomes ever more reduced. The diminished capacity for satisfactory choice has produced in quantity a woman at war with her own sex, and a man incapable of developing beyond the rudimentary state of his own masculinity."

This is indeed the world, these the forces at work, which have found an authentic embodiment in the painting of Georgia O'Keeffe. If Lawrence is the male vision of "the age of the war and its differentiating, self-divided women," hers is that of the woman, bridging the division, closing the breech in herself through the clarity of her perceptions, released by an exquisite sensibility and craftsmanship in her handling of the plastic means. In her work the amazing potentiality of Ursula and Gudrun Brangwyn [sic], goes further towards revelation, begins to be fulfilled. Ursula whose spirit alternates between ecstasy and despair, who reaching out toward interstellar spaces is dragged back and submerged in a love which cannot create because it is controlled by her more powerful atavistic instinct to jealously possess; Gudrun the artist, who is never convincingly the artist because she cannot envisage and use the frustration of her relationships, cannot do anything with her hatreds or resentments, whose intensity turns revengeful and destructive; these and the myriad evolving types of the woman of today, begin to find expression in the painting of O'Keeffe, through the integration of perceptions and feelings, really akin to their own. The forms move out or withdraw, sometimes timid and tender, sometimes ecstatic and savage to the point of cruelty. The line soars in a gesture of magnificent triumph, or again quivers exquisitely sensitive to the hurt of impinging reality; pain felt as beauty and beauty sometimes, as pain.

And this projection of experience is as often made upon objects which would be called "representative," a canna lily, a few apples or plums, as upon

that which is miscalled "abstract" only because it is less easily recognizable. The hocus pocus of aesthetic lingo may have its value in aesthetics, but in life it is evident that there is no such thing as "representation" in itself and that "abstraction" is merely quantitative extension or simplification, not necessarily more potent, in the perception of objectivity. For it is impossible to conceive of a human being able to perceive or to create any form which does not already exist in nature. There is only the possibility of limitless individualized combinations related to experience. Nor is it the method or way of perceiving objectivity which holds any particular virtue of itself, but only the quality and profundity of experience released thereby, that is of importance. It is this latter which is the true "abstract," the true "significant form" or whatever you want to call it; and it exists not less, as the enduring living element, in the "representations" of Memling or Dürer, as in the "abstractions" of Picasso or Marcel Duchamp. And like Picasso, O'Keeffe moves freely both in method and in medium, unfixed by the mannerism of a theory. Her work like his, exhibits the same intensity of expressiveness whether it appears as "representation" or "abstraction."

But unlike Picasso, Duchamp or even Matisse, O'Keeffe has achieved with color a new and transcendent thing. In her search for a graphic equivalent of her experience of life, she has seized upon color as one of primary importance. Color is an integral and dominant element in all her perceptions. Even the black and white drawings seem to have been felt as color and evoke a sense of it. In her work color is not a more or less local imposition upon sculptural form as in the Old Masters; neither does it intensify or even construct forms essentially sculptural as in Renoir and Cezanne; nor is it used as a series of rhythmic patterns inducing linear vitality as in Matisse. With O'Keeffe color becomes a free entity, as much an equivalent of experience as have been form, line and texture. She has, indeed, added to these plastic instruments, color as one of an importance which dominates but does not destroy the unity of her orchestra. It may be likened to the violin singing magically in a concerto above the other instruments but in perfect relationship to them. The subtlest transitions or the most acid dissonances and juxtapositions of tone and scale are brought into new harmonies, become actually psychic equivalents, deeply related to those of music.

This is precisely the differentiated use of color, which Mr. Willard Huntington Wright postulated in his recent essays when he tried to distinguish arbitrarily between the "Art of Painting" and the "Art of Color." Mr. Wright asserted, however, that emotionally significant color cannot be made out of paint upon canvas, that the color organ alone will achieve such color. This work of O'Keeffe is an unequivocal controversion of the above assertion as to the limitations of painting. The color organ may or may not have the potentiality Mr. Wright claims for it; admittedly it still remains in the realm of theory. This painting does not; it is in many instances an achieved reality. Georgia O'Keeffe has succeeded in doing what Mr. Wright is correct in saying has not been done; she has actually made color out of paint which mates with form without destroying it, and yet burns with its own flame.

Mr. Wright's error lies in the fact that his conclusions derive from the unproven and unprovable premises that sculpture ended with Michelangelo, painting with Rubens, and that the failure of Synchromism is proof of the failure of color in the medium of paint. Synchromism, however, was a theory of color and not color; the two are not synonymous. MacDonald Wright [*sic*] developed this theory of color, color scales and tones built úpon those of music, and arbitrarily imposed upon forms frankly derivative from those of Michelangelo, Rubens and Cezanne. The forms and color were not, as in O'Keeffe's work, related and fused because they are product of one and the same feeling. In Wright there was a separation and the color, limited in its use by the theory, was unconvincing. For convincing plastic expression has seldom if ever been the result of theory and intellectual concept. As Croce points out, these are the sources rather of science. And it is to this unproductive starting point, perhaps, and not to any limitations in the medium of painting, that the failure thus far of Synchromism is due. For MacDonald Wright [*sic*] and Georgia O'Keeffe start from opposite poles in their approach to painting and to experience. The former works from the basis of a quite extraordinary intellect whose analyses have not yet been kindled into an aesthetic synthesis; the latter, compelled by the actual impacts of immediate experience, achieves through an equally remarkable intuitive power fibred by a creative intelligence, the clarity of living formalization. Wright moves from conscious idea and concept toward experience; O'Keeffe works from the unconscious to the conscious, from within out. Her experimentation, far more diverse than his, and deriving from neither theory, formula nor concept, is nevertheless free of self-consciousness or self-exploitation in the exhibitionistic sense, to the point of naivete. Rather it is born of a purity and innocence of vision which although less childlike, is yet akin to that of Rousseau. Moreover, it is a vision which she has been able to maintain despite an academic training in Chicago and New York. She must have contacted as well the work of the past and various plastic developments of the present, and yet her painting is not derivative in the sense of being either reminiscent or imitative of the work of anyone. Whatever she has absorbed from the methods and achievements of others, she has recreated in a highly individualized form and has made thereby her own.

Here in America, no other woman has so created a deeply personal language, a communicable aesthetic symbology expressive of social significance of her world. And it is this very inter-relationship between social evolution and aesthetic forms, which gives the latter that vitality and livingness we call Art. It is precisely the significance of "significant form," as Mr. Clive Bell did not perceive when he discovered the phrase.

In Europe the plastic efforts of women have been equally unrealized. Consider the undifferentiated work of Rosa Bonheur with its sterile striving after the superficial aspect of the objective power of a man; or the sentimentality of Le Brun conspiring to represent the bourgeois male conception of woman. And the painting of Berthe Morisot or Mary Cassatt although on a much higher plane than these, is scarcely more individualized. Manet, Pissaro [*sic*], Degas and

Renoir, these were the innovators, the dominant forces from whom the work of both Morisot and Cassatt derived and remained derivative.

These are women who were not aware as Nora was aware "when she slammed the door." They are not a whit related to that kind of intensity which burns [in] women like Carrie Nation, Pankhurst, and Emma Goldman, which has become organized and philosophic in the painting of O'Keeffe. The contemporary work of Marie Laurencin only, seems to hold a relationship to this evolution of the "differentiating, self-divided woman" of this age of the war. But her work is more expressive of one of the intermediate types resulting from the conflict in that evolution, than of any clear individualized perception of the powerful and diverse forces involved. There is a fixation revealed by the sensitive but rather wan faces of the women and children which always appear in her canvases. One is made to feel, finally, that it is really her self thrust back upon itself, a kind of narcism, which she records in her paintings. The emotion is a sort of constant, lying somewhere between dazed wonder and self-pity. It scales neither the fiery heights of ecstasy nor does it sound the depths of disillusion and despair. In relation to the symphonic perceptions of O'Keeffe, the painting of Marie Laurencin sounds but a few simple phrases sung with a pathetic and rather wistful loveliness. It bespeaks not the maturity but the adolescence of the woman spirit.

It is this maturity as well as the freedom from all "masculine protest," which is so remarkable in the work of Georgia O'Keeffe. Moreover, here in America, let it be said again, in this land which, according to some, is spiritually sterile, whose alleged sterility is excused by others on the ground of a seemingly eternal infanthood, a miraculous expressiveness in the use of color has been added to painting, a genuinely new element thus contributed to its evolution through her work. Hers is an achievement which distinctly ranges itself both in spirit and in importance with the painting of John Marin and the photography of Alfred Stieglitz; with the writing of Randolph Bourne, of Sherwood Anderson at his best and Jean Toomer as a potentiality. Like these, it springs from roots as deeply imbedded in American soil, is equally expressive of its spiritual reality. And in the positiveness of its direction, in the high standard and integrity of a progressive development, her work stands as the first veritably individualized expression by a woman, in plastic terms, which is differentiated from, yet meets comparison with the best work of men. And in so doing it suggests that despite the perils of self-division, women have indeed set out upon a search for their own particular Grail. Georgia O'Keeffe is one who has set out, who has closed the breach in herself by releasing in her work, the deepest experiences of her search.

33. Unidentified Writer

From "We Nominate for the Hall of Fame," *Vanity Fair* 22 (July 1924): 49. Reprinted courtesy *Vanity Fair*. (Illustrated with photograph by Alfred Stieglitz: *Georgia O'Keeffe: A Portrait—Head*, 1923; fig. 12.)

Georgia O'Keefe

Because she is rapidly coming into her own as an American painter of the first magnitude; because she has been, in everything she has done since the days of the famous Stieglitz Gallery at 291 Fifth Avenue, a visionary of imagination and power; because as a black and white artist, she is a past master of pattern and design; but chiefly because, in all her paintings, teachings, and writings, she puts the unanalyzable qualities of poetry and mystery before the more obvious qualities of decision and fact[.]

1925

34A. Sherwood Anderson

"Seven Alive," in *Alfred Stieglitz Presents Seven Americans: 159 Paintings, Photographs & Things, Recent & Never Before Publicly Shown, by Arthur G. Dove, Marsden Hartley, John Marin, Charles Demuth, Paul Strand, Georgia O'Keeffe, Alfred Stieglitz* [exhibition catalogue] (New York: The Anderson Galleries, 9–28 March 1925), n.p.

The city is very tired.

The men and women of the city are very tired.

When you have been a long time away from simple elemental things, from wind, clouds, rain, fire, the sea—these things become a little terrible.

What frightened children we are!

But always there is something happening.

Men constantly die, but men are also born again.

Here are seven artists bringing to you city dwellers their moments of life.

They also are tired as you are tired; life presses down upon them as it presses down upon you.

See them here in their moments of life—when life, pumped through their bodies, crept down into their fingers.

When they were alive and conscious of all—everything—

When they were conscious of canvas, of color, of textures—

When they were conscious of clouds, horses, fields, winds, and water. This show is for me the distillation of the clean emotional life of seven real American artists.

<div align="center">

34B. ARTHUR G. DOVE

</div>

"A Way to Look at Things," in *Alfred Stieglitz Presents Seven Americans: 159 Paintings, Photographs & Things, Recent & Never Before Publicly Shown, by Arthur G. Dove, Marsden Hartley, John Marin, Charles Demuth, Paul Strand, Georgia O'Keeffe, Alfred Stieglitz* [exhibition catalogue] (New York: The Anderson Galleries, 9–28 March 1925), n.p.

We have not yet made shoes that fit like sand
Nor clothes that fit like water
Nor thoughts that fit like air.
There is much to be done—
Works of nature are abstract.
They do not lean on other things for meanings.
The sea-gull is not like the sea
Nor the sun like the moon.
The sun draws water from the sea.
The clouds are not like either one—
They do not keep one form forever.
That the mountainside looks like a face is accidental.

<div align="center">

34C. ARNOLD RÖNNEBECK

</div>

"Through the Eyes of a European Sculptor," in *Alfred Stieglitz Presents Seven Americans: 159 Paintings, Photographs & Things, Recent & Never Before Publicly Shown, by Arthur G. Dove, Marsden Hartley, John Marin, Charles Demuth, Paul Strand, Georgia O'Keeffe, Alfred Stieglitz* [exhibition catalogue] (New York: The Anderson Galleries, 9–28 March 1925), n.p.

Do these American artists ask too much of the public?

I was still feeling this question when I left Room 303, where I had just been confronted with these pictures for the first time. They must bewilder, I felt, even one whom the galleries of Europe and the intimate contact with the battle of the arts had ceased to startle. Was the Old World no longer the center?

Absorbed in these reflections I had made the mechanical movements which accompany one to a seat in the subway.

Suddenly I noticed a Chinaman sitting opposite myself, serene and solemn, deeply meditating, like a personification of Buddha himself.

Far East! Sublime spirituality!

But—his jade-like hands were holding the Wall Street Journal, and he chewed gum . . .

Was this "Americanization"? Was it true that every nationality, every profession in this country yields to the money-making business spirit with the hope for quick "prosperity"?

It seemed to me that I had just discovered the contrary—at least in the work of a few artists. Most of the pictures in Room 303 are—to me—*essentially American* in more than the geographical sense.

But what *is* essentially American?

The skyscrapers, Jack Dempsey, the Five-and-Ten-Cent Store, Buffalo Bill, baseball, Henry Ford, and perhaps even Wall Street? These form the European conception: symbols of ingenuity, action, business, adventure, exploiting discovery.

I see these Seven Americans using many of these and other symbols to build universal reality out of the "reality" which my Subway-Buddha had so intensely acquired. In this work nothing has been "Americanized." Everything *is* American, even where subtle susceptibility to the finest achievements of Europe may be felt. They belong to the New World, to the world of to-day. They belong to no "School." They fit no "ism." Their daring self-consciousness forms their harmony.

European artists in their attempt to create an art of to-day meet the obstacle of cultural traditions of centuries in their blood. Visible traces of Julius Caesar's campaigns stand in the middle of Paris, at the Rhine, and even in England. No escape for the European from the ruins of History!

Must not *America*, the country without Roman ruins, the country of keenest progress in mechanical technic and invention, the continent where the spirits of all peoples meet freely, offer just the atmosphere essential for the creation of *an art of to-day*?

Is America's to-day not already to-morrow? Aren't the evening papers out at 10 o'clock in the morning, and the next day's morning papers out the night before? Where on earth is there a second city like New York, offering to the artist's sensibility every vibration of his period?

Here in "Americanized" New York is the rhythm of to-day, mirrored in jazz. Machinery has changed our life in a way which is more than merely practical or economic.

Leonardo and Phidias and Richard Wagner are still "modern," that is, universal, and therefore they will be understood as long as humanity lives. They gave full expression to the spirit of *their period* and lived in a profoundly human contact with the "topics of the day."

The same tremendous responsibility of facing the significant problems of *his* period confronts the artist to-day. And if he is able to express his reactions in universal language—

Then his "Broadway at Night" will be just as eternal as the frieze of the Parthenon.
But that demands self-denial, loneliness, risking his existence. That is why there are so few explorers.

There are pictures in this exhibition which, in spite of their being "contemporary," could have been made 2,000 years ago or 5,000 years from to-day—because they are animated and dictated by the ever flowing sources of life itself.

These Seven Americans are explorers. They leave the traditional ruins to the archaeologist.

I believe their creative self-discovery means nothing less than the discovery of America's independent rôle in the History of Art.

34D. ALFRED STIEGLITZ

Statement in *Alfred Stieglitz Presents Seven Americans: 159 Paintings, Photographs & Things, Recent & Never Before Publicly Shown, by Arthur G. Dove, Marsden Hartley, John Marin, Charles Demuth, Paul Strand, Georgia O'Keeffe, Alfred Stieglitz* [exhibition catalogue] (New York: The Anderson Galleries, 9–28 March 1925), n.p.

This Exhibition is an integral part of my life.
The work exhibited is now shown for the first time.
Most of it has been produced within the last year.
The pictures are an integral part of their makers.
That I know.
Are the pictures or their makers an integral part of
the America of to-day?
That I am still endeavoring to know.
Because of that—the inevitability of this
Exhibition——American.

35. MARGARET BREUNING

"Seven Americans," *New York Evening Post* (14 March 1925), sec. 5, p. 11. (Review of exhibition, "Alfred Stieglitz Presents Seven Americans: 159 Paintings, Photographs & Things, Recent & Never Before Publicly Shown, by Arthur G. Dove, Marsden Hartley, John Marin, Charles Demuth, Paul Strand, Georgia O'Keeffe, Alfred Stieglitz," New York, The Anderson Galleries, 9–28 March 1925.)

Alfred Stieglitz is presenting "Seven Americans" at the Anderson Galleries, and with them a vast deal of introduction and even an epilogue. Among the works

of these Americans photography takes high rank. The "Leaves" of Paul Strand are exquisite in texture and color, as indeed are his photographs of buildings and machines. Alfred Stieglitz, himself, exhibits a series of beautiful cloud and sky effects that are worth a show to themselves.

John Marin's water colors, of course, need no comment. His work can stand on its own merits, as ever. The old posters by Charles Demuth are highly decorative and interesting.

Georgia O'Keefe, who exhibited very worthwhile things last year, shows a few good flower studies, notably a fine one of calla lilies, but the rest of her show might be termed a flop both in color and design. She always paints well, but her color is sickly in many instances here, and her choice of subjects not attractive; to say the least, there was something decidedly unpleasant about them to me, they seemed clinical.

Arthur Dove shows some harmonies in cloud effects that are effective, particularly his storm cloud in silver. The rest of his show is made up of bits of rags and painted materials pasted together in a grand ensemble of bunk. It may be "American," as per catalogue, but beyond that it would be hard to list it. Possibly it is this work that is referred to in the catalogue as "things recent and never before publicly shown." One hopes so, and that they will return to their seclusion after this show for an indefinite period.

Marsden Hartley contributes some lurid landscapes and some good still lifes in fine color, but one recalls his earlier work with its subtleties of tone with regret. It seems a sad exchange.

After all is said and done, it is hardly worth while to defend or defame an undertaking that cannot be taken very seriously by any but a limited circle of "knowing ones," and, not having the password, I must profess to be outside of the sacred shrine and quite unmoved by its artistic or literary (see catalogue) propaganda.

36. HENRY MCBRIDE

"The Stieglitz Group at Anderson's," *New York Sun* (14 March 1925), 13. (Review of exhibition, "Alfred Stieglitz Presents Seven Americans: 159 Paintings, Photographs & Things, Recent & Never Before Publicly Shown, by Arthur G. Dove, Marsden Hartley, John Marin, Charles Demuth, Paul Strand, Georgia O'Keeffe, Alfred Stieglitz," New York, The Anderson Galleries, 9–28 March 1925.)

The Alfred Stieglitz group of artists is now by right of survival the most conspicuous group in town. Its ramifications in the social fabric are so great that it has arrived at the point where it can fill the rooms without the aid of publicity— but this is largely because it makes use of what might be called superpublicity—

or in other words literature. From the first the Stieglitz group has known how to attach literature to itself.

This, of course, is wisdom. It gives one a double chance at immortality. There are some who say that Joshua Reynolds would have dropped into desuetude long ago had it not been for his friendships with Davy Garrick, Edmund Burke and old Dr. Johnson. Be that as it may, the Stieglitz group has done as well as possible in the present state of the world. In addition to Paul Rosenfeld it has annexed the talents of Sherwood Anderson. Mr. Anderson is the latest recruit. He makes his debut in the catalogue of the show this year with the following poem ["Seven Alive"; see this appendix, no. 34A]. . . .

The seven live ones are Arthur G. Dove, Marsden Hartley, John Marin, Charles Demuth, Paul Strand, Georgia O'Keefe and Alfred Stieglitz. On Monday they and their half alive friends assembled in the Anderson Galleries and something as near to a French vernissage as we can manage took place. There was an immense buzz of talk of people who were as much interested in each other as in the new pictures, for the Stieglitz premieres do bring out all the chic types in town. Those who enjoy seeing and hearing chic types will do well to hurry up at once to the show for the attendance will always be variegated. Besides there will be the pictures.

These present nothing newly revolutionary. However, the old war is still going on, and in spite of all the propaganda that has been issued there remain people who are capable of being shocked by Miss O'Keefe's and Mr. Dove's cubisms. So there may be outcries. It is Mr. Dove and Miss O'Keefe and Mr. Stieglitz who emerge in this exhibition above the heads of the other members of the group. Mr. Hartley's paintings do not survive beyond the rough burlap hangings of the exhibition rooms. They seem to call for the most elegant surroundings. They are old world, old souled, and awfully fatigued. It must have been he that Mr. Anderson referred to in his poem when he said: "They also are tired as you are tired." &c. It is true they do better upon a return to them after submission to the atmosphere of the whole room, and one suspects that elegant effects of decoration can be obtained from them, with carefully cadenced illuminations, but the first glance rather jars. It is like coming upon without previous warning the wax effigy of Charles the Second in Westminster Abbey. And those herrings. What gave Marsden Hartley this deep interest in dried herrings? It is all, certainly, old world. But I suppose one may blame most of it upon the burlap background.

Mr. Dove, due to his years of seclusion, becomes the chief curiosity of the show and rewards it well. It is too much to pretend that his canvases are profound, but they are undoubtedly charming. They are also genuine. It is that quality, I think, that will win them friends, but the fact that they only sink half way into cubism helps also with this public. One always knows what the picture is about, and apparently Americans are not yet ready to do without the subjects. Mr. Dove's color is tender, imaginative and lyrical and ought to do much toward educating the public to appreciate pure painting.

Mr. Stieglitz concentrates all of his soul upon some amazing photographs of machines. This is the machine age and he would be its Bellini. What used to be expended upon madonnas is here lavished upon pistons and revolving steel wheels. The most costly papers are used for these photographs and the printing is of the utmost preciosity. The vast public which doesn't know yet that it is living in the machine age and will not know whether this photographer is ridiculing or glorifying the period will, however, hardly be restrained from witticisms upon the subject of these wheels. After all, the turning into slang of such a word shows that the mob suspects itself, don't you think?

37. EDMUND WILSON

"The Stieglitz Exhibition," *New Republic* 42 (18 March 1925), 97–98. (Review of exhibition, "Alfred Stieglitz Presents Seven Americans: 159 Paintings, Photographs & Things, Recent & Never Before Publicly Shown, by Arthur G. Dove, Marsden Hartley, John Marin, Charles Demuth, Paul Strand, Georgia O'Keeffe, Alfred Stieglitz," New York, The Anderson Galleries, 9–28 March 1925.)

In Miss Georgia O'Keeffe America seems definitely to have produced a woman painter comparable to her best woman poets and novelists. Her new paintings in the Stieglitz exhibition at the Anderson Galleries are astonishing even to those who were astonished by her first exhibition two years ago; and they seem to represent a more considerable growth in her art for the period of the past year than the exhibition of last spring did for that of the year before. For one thing, she has gone in for larger [canvases]; she has passed from the close-rolled white lilies of her last phase to enormous yellow lilies and wide-open purple petunias. Yet at the same time that she had allowed her art to expand in this decorative gorgeousness, she has lost nothing in intensity—that peculiarly feminine intensity which has galvanized all her work and which seems to manifest itself, as a rule, in such a different way from the masculine. Men, as a rule, in communicating their intensity, seem not only to incorporate it in the representation of external objects but almost, in the work of art, to produce something which is itself an external object and, as it were, detachable from themselves; whereas women seem to charge the objects they represent with so immediate a personal emotion that they absorb the subject into themselves instead of incorporating themselves into the subject. Where men's minds may have a freer range and their works of art be thrown out further from themselves, women artists have a way of appearing to wear their most brilliant productions—however objective in form—like those other artistic expressions, their clothes. So the razor-like scroll-edges of Miss O'Keeffe's magnified autumn leaves make themselves felt directly as the sharpness of a personality; and the dark green stalks of one of her "Corn" pictures have become so charged by her personal current

and fused by her personal heat that they have the aspect of some sort of dynamo of feeling constructed not to represent but to generate, down the centre of which the fierce white line strikes like an electric spark. This last picture, in its solidity and life, seems to me one of her most successful.

One finds also among these new paintings remarkable effects of fluidity and vagueness; her white birches are mistier than last year and she has discovered a new subject in the shifting of water over the pebbly bottom of a lake. In other pictures, she combines the blurred and the sharp to produce violent dissonances; and this insistence on dissonance is one of the most striking features of the exhibition. Miss O'Keeffe seems bent on bringing together things which cannot possibly live in the same picture—not only vagueness and sharpness, but mutually repellent colors. In some pictures, which seem less successful, this gives the impression of a fault of taste. Thus, we see a red leaf painted on a green background in such a way as to give a harmony in bronze, but on the green leaf a neutral brownish leaf which jars with the other colors and seems irreconcilable with them. Again, in one of her most elaborate pictures, Red to Black, there appears above a rich foundation of flesh-like folds occupying half the canvas and in her vividest vein of red, a stratum of black, not intense, as the eye expects after the intense red, but discomfitingly washy and dim, and above this a light superstructure of sketchily outlined hills whose pinks and lavenders seem quite out of key with the deep reds and purples below; the whole effect is of an inartistically feathered and overweighted shuttle-cock dragged too heavily to earth. But in other pictures it seems plain that these anomalies are deliberate and significant and we recognize them as analogous to the dissonances of modern poetry and music. A sunken tree-trunk is seen in the water, a blurred brown under turbid green—but there floats above it a single leaf of blue-silver as livid and bright as the mercury tubes in photographers' windows and so distinctly outlined that it almost seems impossible for the eye to see both leaf and log with the same focus. Again, from a preliminary study of a plain white house with a dark open doorway, set in the greenery and lilac-bushes of spring, she develops an abstract picture (The Flag Pole) in which the actual outlines of the house have melted away into the exquisite mist of lavender and green but the rectangle of the doorway has intensified itself to black opacity and geometrical exactness in such sharp relief that it seems actually to have been projected out from the plane of the picture and to hang in the air before it. One becomes fascinated by these discords at the same time that one is shocked by them: one stares long trying to eliminate or soften the repulsion between these opposites—the harsh rectangle and the aura of springtime, the dim lake and the incandescent leaf.

Georgia O'Keeffe outblazes the other painters in the exhibition—Marin, Hartley, Dove and Demuth—but it is impossible to compare her with them—even in those pictures which are closest to hers: the white-silver and black storm-clouds of Dove. If the art of women and the art of men have, as I have suggested, fundamental differences, they sometimes seem incommensurable. The water-colors of Mr. Marin are masculine masterpieces: they are the investi-

ture of nature with the distinction of a distinguished temperament: some of the Maine seascapes, with their greens and blues and white sails, with their incomparable combination of dryness with freshness, are among the finest Marins I have seen. Mr. Marsden Hartley appears with his characteristic repertoire of plain fishes and bottles and plates, which he embrowns or dully empurples with his characteristic sullen felicity.

Mr. Stieglitz, who celebrates with this exhibition the twentieth anniversary of the opening of 291 Fifth Avenue, the small gallery with which the development of most of the painters here shown has been so intimately associated, exhibits new examples of his amazing genius for forcing the camera to become an instrument of the artist's sensibility—a genius of a sort so unusual that between the productions of Mr. Stieglitz and the photographs of the ablest of his rivals there seems to lie a difference not merely of degree but almost of kind. Mr. Stieglitz, in pushing his mastery of the camera further from mechanical reproduction and closer and closer to the freedom of plastic art, has lately deserted the earth altogether and taken to the clouds, where he seems to have found a material of maximum variability. The shapes and textures of the sky are infinitely irregular and strange, and they are never twice the same—so that the artist can have practically anything he likes. Furthermore, the person who looks at the picture is never distracted from the artist's intention by recognizing familiar objects, familiar subjects of photographs. One finds effects of a feathery softness or of a marmoreal solidity which, nonetheless, do not remind one in the least of either feathers or marble. Some of Mr. Stieglitz's recent experiments in this field are, I suppose, among his greatest triumphs. Especially impressive among these newest photographs are certain masses of striking sombreness and grandeur which lift themselves as if in grief.

38. Elizabeth Luther Cary

"Art: Exhibitions of the Week; Seven Americans," *New York Times* (15 March 1925), sec. 8, p. 11. (Review of exhibition, "Alfred Stieglitz Presents Seven Americans: 159 Paintings, Photographs & Things, Recent & Never Before Publicly Shown, by Arthur G. Dove, Marsden Hartley, John Marin, Charles Demuth, Paul Strand, Georgia O'Keeffe, Alfred Stieglitz," New York, The Anderson Galleries, 9–28 March 1925.)

———

Alfred Stieglitz presents seven Americans, 159 paintings, photographs and things, recent and never before publicly shown, by Arthur G. Dove, Marsden Hartley, John Marin, Charles Demuth, Paul Straud [*sic*], Georgia O'Keefe, Alfred Stieglitz. So much, plainly written as plain as the nose on your face. But these tremendous searchers after truth, in the midst of more noteworthy and more revealing observations, are likely to overlook the nose on your face. The exhibition is not as simple as its announcement. Stieglitz, Sherwood Anderson,

Arthur G. Dove and Arnold Ronnebeck have all written little explanatory bits in blank verse and prose, and with sincerity. Anderson calls them the "Seven Alive," a nice turn, but the European sculptor, and it is significant perhaps, that this prose form is the least self-conscious of them all, says "Leonardo and Phidias and Richard Wagner are still 'modern,' that is, universal, and therefore they will be understood as long as humanity lives. They gave full expression to the spirit of their period and lived in a profoundly human contact with the 'topics of the day.'

"The same tremendous responsibility of facing the significant problems of his period confronts the artist of today. And if he is able to express his reactions in universal language—."

Charles [sic] Marin is master here. His language is such that one feels confident he is not troubling about responsibilities and reactions. He happens to be an artist working in America today, and he works regardless, but being an artist of immeasurable sensitiveness and of America, the manifestation is inevitable. His New York is our New York, the New York of all our neighbors, within its shift and change but a final statement, and he measures with Arnold Ronnebeck's definition "universal language."

Universal is just what Georgia O'Keefe is not, but intensely personal. Her flowers, with their tangible gradations, have the air of self portraits that might be overluscious were they not controlled by her esthetic sensibilities. They grow—how beautifully her garden grows.

Arthur Dove is using anything for his purpose, wood, sticks, stones, shells, glass, glue, and would use kings, surely, if he found he needed one for just the right word, and he finds the right word, in the portrait of Stieglitz himself, for instance. Dove's is a funny joke and a beautiful joke, but at the risk of being accused of an unsubtle humor, never, for this writer, does it become a serious joke. And it is only the serious, no matter how funny, with which art is concerned. Otherwise it will die tomorrow, and Arthur Dove is not really merry. Charles Demuth's portrait posters are. An artist, of course, can do his job better than any one else, and these are posters, placards, to notify the public, in symbol certainly, of something very true pertaining to each of the artists he portrays.

There is little to say of the Stieglitz photographs, of clouds again. He calls them equivalents, and they surely in his own mind are equivalent to all sorts of joys and sorrows of life and society. They are beautiful, a beauty there for anybody who will take the trouble to dream about moving clouds. "These photographs continue the search for my truth—photography," he says. Paul Strand's seem more obvious in their truth, photographs of machinery. It is a complete cycle in a way. Science proves the truth of the poet's vision and here in another turn the poet, the artist reveals the beauty in science. Hartley is the seventh. It is astonishing how these artists differ from one another. Whether in landscape or still life Hartley works in brown turbulence that stirs and excites the imagination.

39. ROYAL CORTISSOZ

"A Spring Interlude in the World of Art Shows: '291'—Mr. Alfred Stieglitz and His Services to Art," *New York Herald Tribune* (15 March 1925), sec. 4, p. 12. (Review of exhibition, "Alfred Stieglitz Presents Seven Americans: 159 Paintings, Photographs & Things, Recent & Never Before Publicly Shown, by Arthur G. Dove, Marsden Hartley, John Marin, Charles Demuth, Paul Strand, Georgia O'Keeffe, Alfred Stieglitz," New York, The Anderson Galleries, 9–28 March 1925.) Reprinted by permission of I.H.T. Corporation.

There is an exhibition at the Anderson galleries which is amusing, for more than one reason. It is fathered by Mr. Alfred Stieglitz, who "presents" as the work of seven Americans "159 paintings, photographs and things." It is one of those affairs which involve a certain amount of explanation, and no fewer than four signatures are attached to as many prefatory flourishes in the catalogue. But the most significant words appear at the back of that pamphlet, words proclaiming that the show marks the twentieth anniversary of the opening of "291," the little gallery in Fifth Avenue where Mr. Stieglitz made his beautiful photographs and found an outlet for his generous enthusiasm by organizing displays of things ignored elsewhere. We do not recall ever having missed one of those exhibitions, beginning with the collection of Rodin's drawings that was put on the walls in 1908. There we saw similarly pioneering exhibitions of Matisse, John Marin, Marius de Zayas, Max Weber, Picabia, Brancusi, Picasso, Gino Severini and so on. Looking at the present exhibition we find ourselves thinking of it partly for its own sake and partly for its commemorative meaning. And we fall to meditating on the principle, as it were, of "291."

It was, in the first place, the admirable principle of openmindedness. Alfred Stieglitz, who clings to his own ideas with the stanchest tenacity, has never pretended to impose them upon anybody else. All he has desired to do has been to make known the ideas in which he believes, and, for the rest, to watch their fortunes. The atmosphere of "291" was thus always one of the right kind of liberalism. The place was a laboratory for the exposition of this or that experiment in contemporary art. It was valuable because it was the only source of information on subjects it was necessary to know. We have always maintained that it was wrong merely to scorn modernism, deserving though it be of scorn. The indispensable thing is to look it in the face, analyze it, grasp it for what it is. It waxes fat on ignorance. Condemnation of its vagaries must be based on the most patient of studies. For this Stieglitz supplied precious documents and thereby performed a memorable service to art. The only pang involved in frequentation of his museum, if we may so describe it, was that of disagreeing with so high-minded and devoted an advocate. But disagree with him we generally did, and, looking over the long list of exhibitions appended to his latest catalogue, we are in no wise moved to alter old impressions.

That some of the names enumerated are to-day held in greater honor—in some quarters—than they were when Stieglitz first made them known here, has no great evidential weight. Twenty years make a very short period. It remains to be seen how these names will be wearing when still another twenty years have passed and in the meantime we doubt if the tendency is in the direction given by the men represented in the list. In fact the movement is rather the other way, rather toward a return to conservative modes. We cannot dogmatize from the list. It is too heterogeneous. But there is one thought emerging from revery on its variegated types on which we venture to pause. Is not Stieglitz himself, as photographer, the one figure of them all inspiring a certain confidence? And why? Because he has known absolutely what he was about. He has known the camera with the thoroughness of a master, has exercised his instrument with complete understanding and authority. In a word, he has been a sound work-man. It is not one of the secrets on the other hand, of good art?

Revisiting "291" in memory with this catalogue before us and realizing that so many of its ghosts have been indeed ghosts, frail, insubstantial apparitions blown by the wind, we surmise that the explanation of their futility has resided in their refusal to make good workmen of themselves, their failure to play the game. Yes, we know all about their "purpose." It has been to express themselves. But they have babbled in strange, outlandish idioms, missing the language of art. That language is, among other things, a language of craftsmanship. Painting is a craft, like any other. Flout it and you land in uncouth obscurity. Which brings us to the show at the Anderson Galleries. There is some craftsmanship in it. Miss Georgia O'Keefe, for example, shows more of it than she has ever shown before and in consequence some of her "Leaf Motives" and "Autumn Trees" have, besides charm, the technical quality that commands respect. We feel the same impulse of appreciation when we encounter the curious "Portrait Posters," by Mr. Charles Demuth. But we remain utterly untouched by Mr. John Marin's incoherencies in water color, by the strained pleasantries of Mr. Arthur G. Dove and the crudities of Mr. Marsden Hartley.

Stieglitz is a courageous, resourceful man. We wish he would undertake the organization of an exhibition such as has never been held by any modernist. Let him supply each of his friends with canvases divided in the middle by a straight line. Let them paint to the left of the line pictures after their own hearts, expressing themselves in their own way. And to the right let them paint the same subjects according to Hoyle, which is to say, with all the elements of perspective, texture, light and shade, line, form, color, handled with competence. This might show whether the modernist really knows how to paint or if the fearful and wonderful expedients he adopts make the refuge of inadequacy. If he needed inspiration he could easily get it from Stieglitz. Look at the latter's photographs of cloud forms and trees. How beautiful they are! Because, for one thing, they are well done.

40. Helen Appleton Read

"News and Views on Current Art: Alfred Stieglitz Presents 7 Americans," *Brooklyn Daily Eagle* (15 March 1925), 2B. (Review of exhibition, "Alfred Stieglitz Presents Seven Americans: 159 Paintings, Photographs & Things, Recent & Never Before Publicly Shown, by Arthur G. Dove, Marsden Hartley, John Marin, Charles Demuth, Paul Strand, Georgia O'Keeffe, Alfred Stieglitz," New York, The Anderson Galleries, 9–28 March 1925.)

Alfred Stieglitz has become the impresario of a certain group of painters whom he designates as "Seven Americans." They are: Charles Demuth, Arthur Dove, John Marin, Paul Strand, Georgia O'Keefe, and himself, and their recent paintings and "things" are now on view at the Anderson Galleries. He introduces the exhibition with a catalogue which is full of matter quite as entertaining as the exhibition itself. It commences with an esoteric foreword which envelops the exhibition "in a halo of words" and ends with a resume of the important role 291 played in the history of American art. The pictures in the present group are not allowed to speak for themselves. Sherwood Anderson, Arthur Dove and Arnold Roonebek [sic] add their quota of esoterics to the catalogue in the brief credos, concerning their art and American art. It is all guaranteed to make some of the visitors wonder whether or not it is a joke and others to be completely hypnotized into believing that here is something beyond just a mere exhibition of paintings, a revelation of self expression, of souls laid bare.

Americanism and emotionalism are self-consciously and unduly emphasized. Sherwood Anderson writes: "This show is for me a distillation of the clean emotional lives of seven real American artists."

Self-consciousness and lack of humor are what ails these artists, that is some of them. Some just exhibit along with the rest, are part of the troupe, and not concerned with the rhetoric which envelops their works. The visitor, too, who reads the catalogue is affected with self-consciousness. If one could enter the gallery and have a good laugh at Arthur Dove's ingenious arrangement in the shape of a woman, made up of a mask, stockings, gloves, all Woolworth store purchases, and which when placed in a frame he calls "Miss Woolworth," it would be all right. Far be it from us to think that an artist cannot be witty. Or if we could view some of O'Keefe's lovely arrangements of flowers and fruits as such and not feel that they had a double meaning, it would be all right. But we are not conscious of any lighter moments of things just as they are; they are fraught with "inevitableness" and Americaines.

We have artists aplenty these days who make us feel that art is not necessarily a deadly serious affair and so put quaint, funny or cute ideas on canvas. They introduce the well-known light touch into art. And we, upon seeing their pictures, are put in a like frame of mind. We are not asked as in the present collection to look upon them as inevitable expressions, as "integral parts of their makers," or to recognize the exhibitors as artists "bringing their moments of life" to us.

THE EXHIBITORS

Stieglitz exhibits a group of his always-beautiful and expert photographs, in subject cloud formations and effects of light upon cloud shapes. He names his group "Equivalents" and says of them in what is the simplest and most sensible prefatory note in the catalogue: "These photographs continue my search for truth—photography."

Paul Strand's collection of photographs in their different way are equally beautiful, closeups of machines and plants. Photography as these men practice it cannot be carried further.

The Marin group is just Marin as we have come to know him, typical examples of his Maine marines and coast scenes. The Hartley group results from what the catalogue tells us was the "historic Hartley Auction." The still-lifes and landscapes are handsome in color and arrangement, but again one looks in vain for their emotional inevitableness. They seem not important enough to warrant such pompous phraseology. Demuth offers portraits of O'Keefe, Dove and others in a code for which we have not the key. Being Demuths they are necessarily beautiful in their sure and delicate craftsmanship.

The O'Keefes, of which there are 30, are of those subjects which she has made her own: calla lilies, leaf and flower arrangements, alligator pears and abstractions which look like lots of things they may not be intended to mean at all, all painted in her clean precise manner. The simple, obvious arrangements are her best. It is a pity that so much beneath the surface has been read into her painting, and it is true that some of her pictures are possible of strange double meanings of emotional states. Forewords to her previous shows have only strengthened this idea. And in these days of psychoanalysis it is easy to interpret them in terms of Freud. Of her newer motives, petunia decorative panels, a new flower in her garden, are especially attractive. No complexes here, just cleanly, sensitively painted flowers, the colors gay and happy, the arrangement decorative and realistic at the same time.

Arthur Dove also exhibits a group of decorative arrangements, some of them ingenious applications of paint and other materials on tin, which result in really lovely arrangements of color and surface.

41. FORBES WATSON

"Seven American Artists Sponsored by Stieglitz," *The* [New York] *World* (15 March 1925), 5M. (Review of exhibition, "Alfred Stieglitz Presents Seven Americans: 159 Paintings, Photographs & Things, Recent & Never Before Publicly Shown, by Arthur G. Dove, Marsden Hartley, John Marin, Charles Demuth, Paul Strand, Georgia O'Keeffe, Alfred Stieglitz," New York, The Anderson Galleries, 9–28 March 1925.)

The exhibition which Alfred Stieglitz presents at the Anderson Galleries, No. 489 Park Avenue, is beautifully arranged, and is with some exceptions a most invigorating affair. Mr. Stieglitz has devoted himself to this exhibition with great concentration for a considerable period of time.

Of course, Mr. Stieglitz would be the last person to want any one to buy the works of his group of seven from a sense of duty or charity, just as he would be the first person to condemn that timidity which permits Americans to speak in praise of their own contemporary artists, while at the same time being afraid to go on record by purchasing modern American art lest the neighbors might think them a wee bit ultra. But what about these pictures for which Mr. Stieglitz fights his great spiritual battle?

Charles Demuth introduces the visitor to the exhibition with three mildly entertaining posters and a still life, while directly facing the entrance is a well framed and beautiful Marin who, in the large gallery, is so completely shown. Each of the painting exhibitors is represented in the entrance hall by a small group, and this room in itself makes a choice exhibition.

Going into the main large gallery, the voluminous designs, in sweeping color movements, by Georgia O'Keeffe immediately hurl themselves upon the eye of the spectator. Miss O'Keeffe's pictures make an extremely striking ensemble and prove that this lady is reaping the logical fruits of labor. In a word, her painting grows more and more skilful.

Perhaps the artist would consider such a statement rather shocking, because skill is so likely to be manual, and she proclaims the excitements of the spirit. After the first gasp, one becomes aware of the fact that several of Miss O'Keeffe's canvases appear to rely upon exaggerated sizes rather than upon intensive development of the spaces.

A slightly balloon, or blown up, quality is felt in several of the larger paintings, and great distinction in color has not yet been achieved by Miss O'Keeffe. On the other hand, there is vividness of movement, contrast and design, originality and sometimes vitality, sometimes merely the appearance of vitality, in her aggressive group of pictures.

Turning to the left, the visitor is faced by the handsomest wall in the galleries, which is made of a beautifully arranged group of the work of Marsden Hartley. Mr. Hartley has traveled widely and has come under both German and

French influences. From time to time he has exhibited paintings which were mere excited bits of propaganda.

In the present group he returns to his original interest in nature, but like the boy who has been to college, he comes back from foreign influence different from the boys who never left the village, or, like the young lady in the old ribald song, "He's never been the same."

Mr. Hartley's taste has developed to an extraordinary degree, so much so that it is hard to tell whether taste or expression is his goal. He uses color with a sense of its abstract qualities, of its position in the design as a whole, rather than in its relation to the actual color of the object in nature. In other words, he does not allow naturalistic color to interfere with the planned color statement that is his own.

His still lifes, which are much better than his landscapes, are not a collection of individual objects but a rhythmically composed ensemble in which the objects are not so closely related to life that their compositional relationship is disturbed as by an outside motive.

If we think of one of Mr. Hartley's paintings as a rectangular space which Mr. Hartley wishes to make as interesting in itself as he can, and does not present as a mirror held up to nature, then we can see why the artist prefers colors and forms that may appear arbitrary so far as their resemblance to nature goes, while being positively docile in their relation to the design of the rectangle as a whole. Mr. Hartley, again I say it, has remarkably good taste, and I doubt very much if any one can yet measure just how much more he has.

The work of Arthur G. Dove reminds me of nothing so much as a bird going back to a last year's nest. It is a little over ten years since Croti's wire portrait of Marcel Duchamp was exhibited at the Montross Gallery, and if Mr. Dove could remember that portrait and could cultivate a little sense of humor he might perhaps have a clearer idea of his own aims. His work has the weakness of cloudy thinking.

Mr. Stieglitz refers to his group of photographs, which includes some very lovely examples, as his own "innocent little photographs," and Mr. Paul Strand completes the exhibition with a group of photographs which is quite magnificent. I particularly liked Nos. 83 and 85 for the very obvious reason that the subjects do not make the photograph. The vision of the photographer himself makes the subject.

42. Helen Appleton Read

"New York Exhibitions: Seven Americans," *The Arts* 7 (April 1925): 229–31. (Review of exhibition, "Alfred Stieglitz Presents Seven Americans: 159 Paintings, Photographs & Things, Recent & Never Before Publicly Shown, by Arthur G. Dove, Marsden Hartley, John Marin, Charles Demuth, Paul Strand, Georgia O'Keeffe, Alfred Stieglitz," New York, The Anderson Galleries, 9–28 March 1925.)

Alfred Stieglitz acts as impresario for the seven Americans who have been showing their "paintings, photographs and things" at the Anderson Galleries. The seven are Arthur Dove, Marsden Hartley, John Marin, Charles Demuth, Paul Strand, Georgia O'Keeffe and Alfred Stieglitz. The exhibits are not allowed to speak for themselves, but are offered to our attention via a catalogue which contains forewords by Arthur Dove, Stieglitz, Arnold Ronnebeck and Sherwood Anderson. One becomes immediately self-conscious upon reading an estimate of the exhibition such as this by Sherwood Anderson; "This show is for me the distillation of the clean emotional lives of seven Americans."

With emotionalism and Americanism stressed on all sides, the visitor finds himself looking for something beyond a mere exhibition of paintings, photographs and things. Moreover, the atmosphere is totally devoid of humor, despite Arthur Dove's laborious efforts to bring in the light touch with his arrangement of wire and tin which stands for a portrait of Stieglitz and his "Miss Woolworth," an arrangement in the shape of a woman's figure made up of materials bought at the five-and-ten-cent store. If we were asked to consider these as jokes it would be all right; but with the phrases from the foreword sounding in our ears, "integral parts of their makers," "moments of life," we must need look beneath the surface, for more than there appears.

The exhibition, beautifully arranged in group formation, was introduced to the eye as one entered the first gallery by Demuth's symbolical portraits of Georgia O'Keeffe, Arthur Dove, Marsden Hartley, and John Marin. Being by Demuth, they are necessarily attractive in their sure and delicate craftsmanship. The Marin group, of which there were twenty-six, was a representative selection from his Deer Island landscapes and marines, with a few New York scenes in addition. The paintings in the Hartley group may best be called color arrangements, although he uses natural objects for his subjects. He has a certain color harmony which irrespective of whether he paints calla lilies or landscapes or fruits, is always the same combination of tones. Both arrangement and color are distinguished.

Miss O'Keeffe's pictures are sure of eliciting interest and conjecture. A tradition that they are something other than they appear to be clings to them. Fruits, flowers and leaves, are possible of symbolical interpretations. This largely due to the pernicious suggestion of a foreword to the catalogue of one of her former shows, which stressed the fact that these pictures were veiled records of her emotional life. This year Miss O'Keeffe has added another flower to her garden—the petunia—which she paints with her usual clean exactness. In most cases she has painted them giant size and one feels for a moment transported to Brobdingnag. With each succeeding exhibition her palette becomes more varied, but one wishes for a richer, more distinguished color quality. Her technical dexterity, however, more than ever commands admiration.

The Stieglitz photographs of cloud and sky effects are as always expert and beautiful. He names his group "Equivalents" and says of them in what is the

simplest and most intelligible of the Credos found in the catalogue, "These photographs continue my search for my Truth—Photography."

The Paul Strand photographs are beautiful from quite another point of view. His is more a selection and conscious arrangement of material; attractiveness of subject matter plays no small part.

43. GLEN MULLIN

"Alfred Stieglitz Presents Seven Americans," *Nation* 120 (20 May 1925): 577–78. (Review of exhibition, "Alfred Stieglitz Presents Seven Americans: 159 Paintings, Photographs & Things, Recent & Never Before Publicly Shown, by Arthur G. Dove, Marsden Hartley, John Marin, Charles Demuth, Paul Strand, Georgia O'Keeffe, Alfred Stieglitz," New York, The Anderson Galleries, 9–28 March 1925.)

Nearly twenty years ago Alfred Stieglitz established at 291 Fifth Avenue what was then known as the Photo-Secession Gallery. It became a unique institution in American art. Through the influence of Mr. Stieglitz we came into close contact with the freshest and most significant of the new ideas which were agitating contemporary art in Europe. Extensive exhibitions of work by Matisse, Picasso, Henri Rousseau, Rodin, Toulouse-Lautrec, and others came to the Photo-Secession Gallery, or "291," as Mr. Stieglitz now prefers to call it. This gallery not only imported foreign pioneers in the strange modes; it sponsored the experiments of young Americans who had something new and vital to say. Such diverse painters as Marsden Hartley, Georgia O'Keefe, Max Weber, John Marin, Abraham Walkowitz were first made known to the public at "291." What effect Mr. Stieglitz's pioneering may have upon the development of American art only time can tell; but surely his high-minded hospitality to so many explorers and innovators could scarcely be a subversive influence in the art of any country.

Mr. Stieglitz recently presented at the Anderson Galleries "159 paintings, photographs, and things," mostly by old friends whom he had featured in past exhibitions. They included paintings by Arthur Dove, Marsden Hartley, John Marin, Charles Demuth, and Georgia O'Keefe. The photographs comprised studies by Paul Strand and Mr. Stieglitz. The paintings shown were all manifestations in various degrees of expressionism. The expressionist painter does not concern himself with reproducing the obvious shapes, colors, and textures of objects; what interests him is his own reveries or adventures in the emotional world which the object stimulates him to create. The plastic record on canvas of this experience is calculated to give one the hue and form of the emotion, the aesthetic impact of the psychic discharge itself; and so far as representation is concerned, the object responsible for the combustion is per se unimportant. So the object itself in the characteristic expressionist canvas is knocked into an

adumbrated cocked hat. The outer world is no longer the recognizable world to which our physical senses are adjusted. It emerges sublimated in the exhalations of the Inner Self. It flows out upon canvas, an arbitrary transmutation, an iridescent bubble blown out of a psychic froth. This process is a negation of realism, of course; but it is entirely legitimate provided the artist "expressing" himself uses symbols that we can understand—a language that communicates genuine aesthetic emotion. Too often one feels that the expressionist painter in attempting to liberate his confessions from his unconscious is thwarted by the very temporal limitation of painting. Anchored in an art which is simultaneous, his message really demands an art of successive impressions—poetry or music. At any rate his trouble is imperfect communication. The frequent tragedy, then, is not that the expressionist is applying a glass eye to the keyhole of his soul but that his visual adventures are related in an unintelligible idiom.

John Marin's contributions to the recent exhibition are a case in point. Mr. Marin has created in the past some of the most lovely nuances of tone that have ever been floated upon the medium of water color. There has been a steady progression in his work however, toward a mode more and more abstract, although until recently it has remained distinguished and beautiful. His admirers were puzzled by the revelation of his latest phase at the Anderson Galleries. There one was confronted by incoherent hashings of line, empty design, and very little evidence of his fine color passion. He seemed to be sporting solemnly with intellectual notations to such a degree as to stifle in the beholder all imaginative delight. Mr. Marin is groping for something; if he has found it, he alone knows what it is.

Less austere was the work of Marsden Hartley. Gifted like Mr. Marin with fine perceptions, he, too, is exploring with most dubious results. He was represented by a few landscapes and a multitude of still lifes. As the dominant color note of the entire show was terra-cotta and the pictures were all low-keyed, the general effect was depressingly monotonous. There was some sense of design in the landscapes, but the still lifes were merely amorphous accumulations of objects crudely painted. A lemon, a glass dish, a dried herring, a lily suggested no differentiation of handling. With texture, atmosphere, perspective, tone, design all carefully extracted, little was left beyond a feeling of weight. One wonders if the aesthetic value of mere volume is not overestimated these days.

Arthur Dove was represented by several storm motives that were not without beauty. These, however, were overshadowed too conspicuously by a clutter of stale jocosities made up of painted sections of wood glued together, bits of glass, sand, oyster shells, old watch springs—all assembled in glass cases and labeled Friends, Long Island, and so on. The Independent Artists, a few years ago, squeezed the last vestige of mirth out of this species of carpentry. Charles Demuth's portrait posters were excellent. Even though one as an outsider did not get the full force of the comic symbols, he could at least admire the craft employed.

Of all the painters exhibited at the Anderson Galleries, Georgia O'Keefe understood most clearly what she was about. Objective reality for her is a

tenuous espalier upon which the spirit expands in strange, exuberant flores-cence. But this expressionism of hers, unlike Mr. Marin's, communicates itself. She records her moods with an accent which imparts a definite emotion to the spectator. She takes leaf, tree, and flower motives for the most part and trans-lates them into gorgeous patterns of color. This color is beautifully managed upon the high, intense notes of the palette. Miss O'Keefe's rapt subjectivism resolves the hues and forms of reality into their essentials. We intuitively feel and recognize the truth she has made; it is not as if we were contemplating just Miss O'Keefe's personal edition of the universe created by and for herself as a solitary, lonely possession. It is rather as if a blundering something—our way of looking at nature, perhaps—had caused us to miss the essence of things, and then, quite suddenly, the aesthetic maladjustment had vanished.

As for Mr. Stieglitz's contribution to the exhibition, little need be said. His studies were beautiful, as they always are. This time he featured clouds marvel-ously lighted and composed. Paul Strand's photographs of sections of machin-ery paled beside them. Some of the painters whose work Mr. Stieglitz has championed would do well to imbibe his conscientious and lofty ideals of crafts-manship.

1926

44. GEORGIA O'KEEFFE

Statement in *Fifty Recent Paintings, by Georgia O'Keeffe* [exhibition cata-logue] (New York: The Intimate Gallery, 11 February–3 April 1926), n.p. (as reprinted in Anita Pollitzer, *A Woman on Paper: Georgia O'Keeffe*, intro. Kay Boyle [New York: Simon & Schuster, 1988], 189).

Everyone has many associations with a flower. You put out your hand to touch it, or lean forward to smell it, or maybe touch it with your lips almost without thinking, or give it to someone to please them. But one rarely takes the time to really see a flower. I have painted what each flower is to me and I have painted it big enough so that others would see what I see.

45. UNIDENTIFIED WRITER

"Exhibitions in New York: Georgia O'Keeffe, Intimate Gallery," *The Art News* 24 (13 February 1926): 7–8. (Review of exhibition, "Fifty Re-cent Paintings, by Georgia O'Keeffe," New York, The Intimate Gallery, 11 February–3 April 1926.)

For five years we have been trying to arrive at some definite, tangible conclusion about O'Keeffe, without success. She eludes us still. Her paintings of 1926 leave us almost as baffled as did those of 1920.

It is not that we are looking for hidden meanings. The patient search for nudes on staircases which so delighted the groundlings ten years back, no longer interests us. There may be a hidden meaning in the paintings of O'Keeffe, as there may for all we know be a hidden meaning in those of Greco or Piero della Francesca. Found, it would add nothing to their value, nor help one iota to our enjoyment. Once it leaves the hand of the artist, the work of art takes on an existence entirely independent of its maker, to whose intentions it may even run full counter.

The difficulty which we experience with O'Keeffe is far less one of comprehension than of enjoyment and thence of evaluation. Along with the keenest enjoyment of her personal outlook, expressed through a pure and resonant color sense, we cannot escape, before any considerable collection of her pictures, a sense of frustration, of a deeper and fuller enjoyment that is promised but is never fulfilled.

This sense of frustration the present exhibition does nothing to remove. Picture after picture, of the twenty odd hung, beckons the eye with promises, only to shut up like a clam when the gaze becomes too inquisitive. Like so many flappers on Broadway they will smile gaily at the stranger so long as he keeps his distance, but the merest attempt at intimacy will freeze their limbs and bring into their eyes the set expressionless vacancy of a too perfectly assumed respectability.

Faced with such an enigma, the critic cannot escape an appeal to analysis. He must list, such as he perceives them, the qualities, setting in the opposite column all that he conceives as hindering expression, in the hope that from the resulting balance, however crude, a concrete deduction may be drawn.

The qualities, in O'Keeffe's case, are almost all allied to the simplicity and directness of her vision. Where another painter, on a given day, would be all but bewildered by the multitude of colors and diversity of tones, O'Keeffe, on the same day, will be so intensely conscious of one tone that the multitude of others, so far from warring with it, will barely enter her consciousness. She will paint a yellow tree and that yellow will so completely saturate her mind that any other color becomes unthinkable. Or it may be a red barn, such as the one which Mr. Herschel V. Jones bought years back at the Artists' Derby, the redness of which sings in the brain as clearly as the day we saw it first. Or it may be a petunia, one of those petunias, blue to the core, that are the pride of the present show. In their very color saturation is strength, the kind of strength that is in the sustained monotone of a priest chanting mass, in those rare moments when awe gives place to joy.

It would be pleasant to end there, accepting the red barn and the petunia and the oak leaf as the essence of O'Keeffe and dismissing all that falls short of these from the memory. And so one would, did it not grow increasingly evident

that some of the forces that bind and restrict are intimately tied up with those that release. The very intensity of her color vision is allied to a curious insensitivity. Happy, so long as she is content to explore the tonal possibilities of one color or shade, she is lost so soon as she tries to leave it. In her larger compositions one is conscious of immense bridges, that the eye must jump at one leap, color bridges that disrupt, for the eye too often fails. And thence results not only disharmony, but a certain hard brilliance that repels.

Approaching from the other end, that of design, a converse phenomenon greets the critic. Appearing to possess the formal simplicity that should be the counter part of her strangely selective color sense, O'Keeffe possesses only its illusion. Apparently simple, her design is as often as not complexity itself, and complexity without discoverable purpose or discoverable justification. The formal puzzles which face her in her larger and more abstract compositions are rarely resolved. Her design, utterly independent of frame, spreads itself out to right and left, neither growing, nor yet diminishing, and finding nowhere its ending, nowhere its rhythmical pause. No strong force, one feels, either impelled or directed it, neither its beginning nor its ending are inevitable.

Seeking for a cause for this apparent paradox—extreme color selectivity wedded to an almost entire absence of design, we are forced to a conclusion that runs full counter to the generally accepted view. All the critical literature which has been devoted to O'Keeffe—and there has been plenty—has started with the assumption that the work of O'Keeffe is first, last and all the time autobiographical, a revelation of the thoughts and emotions that run through the mind and body of its maker. It may be that these enter, and for a large part, but to accept them as the whole is to get an altogether false impression of their nature. Self-revelatory as she may be, she is also—and in the highest degree—a naturalist. Her most seeming abstract pictures are only by elimination abstract. They are not only based on nature, they copy nature, line almost for line. It never seemed to occur to O'Keeffe to draw on her store house of accumulated memories. To paint a snow landscape in summer would be unthinkable to her. Her dependence on nature goes even further. A yellow tree cannot come to birth, unless that precise yellow is present before her. Willingly or unwillingly, she has bound herself down to a copy book with a fidelity that approaches, and this particularly in her most abstract canvases, the photographic. So restricted, the marvel is not that O'Keeffe at times falls short of the full and complete expression that her gifts promised, but that she is able, as time and again she is, to throw off her trammels and sing. What saves her is her habit of painting the same things, flowers, trees, lake, landscapes, over and over again, until they cease to be flowers in a vase before her, to become flowers within her. Look, only look, at the series of petunias in the present exhibition, how they grow, in richness, in intensity, in volume. Never sang a single individual petunia with the rich fulness of that final flower. Its song is the song of the race.

We need never fear for the flowers and the leaves. There O'Keeffe is master. It is only for her further mastery that we have fears. Let her cast aside her copy book, draw on the memories that must be crowding her mind, and paint her

landscapes with the same splendid simplicity and intensity of actuality that inform her flowers.

46. Henry McBride

"New Gallery for Modern Art: Valentine Dudensing Shows Paintings by Foujita—O'Keefe [*sic*] and Mezquita Exhibitions: Georgia O'Keefe's [*sic*] Art," *New York Sun* (13 February 1926), 7. (Review of exhibition, "Fifty Recent Paintings, by Georgia O'Keeffe," New York, The Intimate Gallery, 11 February–3 April 1926.)

In the little corner room of the Anderson Galleries known as the "Intimate Gallery" Georgia O'Keefe's newest paintings are being shown, and that means that for the several weeks of the show anyone in town who has a yearning to see "exceptional" people and to hear exceptional remarks will do well to go there, for that is where the exceptional people will be doing their stuff.

As an artist Georgia O'Keefe is always a success. By that I mean she is both liked and bought. Certain artists claim that they paint simply because they must and that the ultimate fate of the thing painted is a matter of indifference to them. This attitude is so incredible to me that I sometimes think these artists deceive themselves. But Miss O'Keefe undoubtedly paints to please herself and in so doing also pleases plenty of others.

She is at times a mystic though I believe she makes no pretense to being mystical. She strives merely to achieve beauty and to avoid handicapping beauty with unnecessary touches. She is often abstract, taking a simple theme and playing it up until the only possible title for the result is "Variation in the Key of Lemon," or Purple, should it happen to be purple. In her studies of architecture she breaks passages of literalness with items that throw symbolic lights into the composition. Her color has the cutting, acidulous quality of the moderns.

All this, which used to be difficult enough, is now easy to many. Miss O'Keefe's art, as I said, makes its conquests. I was interested, the other day, in seeing it succeed anonymously, for Miss Blanche Yurka, the actress, was quite bowled over by one of O'Keefe's things in the Tri-National Exhibition at Wildenstein's, not knowing in the least by what artist it was. "That's certainly the [ecstasy] of spring," said she, indicating Miss O'Keefe's canvas. "I never saw such a complete representation of what goes on in the bud before it bursts, of all the scurrying about beneath the ice on the pond before it melts and disappears in the spring."

This recognition, by Miss Yurka, of the special stir that seems to be back of all of Miss O'Keefe's paintings, led me to confront the actress with several of the test pieces in the Tri-National Show. Of the abstract painting by Picasso in the small gallery she said a good thing. "Like the Russian actors," said she, "it

seems like a perfect and finished thing in a language I do not speak myself." The Braque still life and the Matisse interior impressed her less than the Picasso. She thought them fluent but no more. The Juan Gris still life, on the other hand, roused her to great enthusiasm. "It is splendid. It would look well on a wall. I should like to own it." Her highest praise, however, was [reserved], for the bronze female torso by Maillol, which, she said, excelled anything she had ever seen in modern art.

<div align="center">47. Unidentified Writer</div>

"Foujita's Art Seen in Exhibition Here . . . : Georgia O'Keeffe," *New York Times* (14 February 1926), sec. 8, p. 12. (Review of exhibition, "Fifty Recent Paintings, by Georgia O'Keeffe," New York, The Intimate Gallery, 11 February–3 April 1926.)

———

A brown leaf, or the Shelton Hotel, or a roof projected into the sky (framed by other roofs and made immaterial by the very heart of the light of changing traffic signals), or an oversized flower with its tongue out, or the branches of a tree— these, in a state of flux, are the subjects of Georgia O'Keeffe's painting. All are different, all the same, dominated by her strange personality.

<div align="center">48. Murdock Pemberton</div>

From "The Art Galleries: Eight Out of Every Ten Are Born Blind and Never Find It Out—Here Come the Fire Engines!" *New Yorker* 2 (20 February 1926): 40. (Review of exhibition, "Fifty Recent Paintings, by Georgia O'Keeffe," New York, The Intimate Gallery, 11 February–3 April 1926.) Reprinted by permission; © 1926, The New Yorker Magazine, Inc. Copyright duly renewed.

———

We have petitioned the fire commissioner to allow us to paint our running gear red and to carry a clanging bell. We will then tear through the streets hoping that many will follow, and when we have gathered a sufficient crowd we will duck into an art gallery. We are very much excited about this being called art and the turning of a year has not lessened our childish enthusiasm. But our zeal has way outrun our vocabulary and there is no way to let you know that we are tearing our hair, crawling on our knees and crying wolf, wolf, and we don't mean maybe.

We had best stick to the fire engine device. This week, anyway. For if ever there were a raging, blazing soul mounting to the skies it is that of Georgia O'Keefe. You can see it in all its uninhibited glory these weeks at Stieglitz, Room

303. Yes, you can even see it if you are among the eight of the ten born blind. One O'Keefe hung in the Grand Central Station would even halt the home-going commuters. Here you will find fifty, count 'em, fifty; you will do well to grasp a rail or a chair and look at them one by one. Brother Stieglitz, we imagine, will have some days of rest. No longer will he have to answer the fatuous: "What do they mean?" For they mean nothing, except beauty.

Or, on the other hand, they may mean everything. One holding to the Emersonian creed of equity in all things can see here the magnificent levelling of nature. To this purpose the wiry young girl sat in her black dress in the drab school house, trying to teach the youth as she looked off across the Texas plains. All the color, all the beauty of form, denied her those years are here. Coming upon O'Keefe for the first time one must feel that it is some sort of phantasy because it is so joyous; surely if the authorities knew they would pass laws against Georgia O'Keefe, take away her magic tubes and brushes. Americans, with their eyes on success, must not be dazed by the unproductive glory of unmoral beauty. It might make them question the radiance of their legended goal.

49. HELEN APPLETON READ

"Georgia O'Keefe [*sic*]," *Brooklyn Daily Eagle* (21 February 1926), 7E. (Review of exhibition, "Fifty Recent Paintings, by Georgia O'Keeffe," New York, The Intimate Gallery, 11 February–3 April 1926.)

———————

Georgia O'Keefe's exhibition is the third of the scheduled seven to have taken place at the Intimate Gallery in the Anderson Gallery Building. Sitting about, against bookcases, walls and chairs, as is the informal habit of showing pictures in the Intimate Gallery, are the results of her past year's work. Her favorite subjects, meticulously rendered portraits of flowers and leaves or abstractions derived from flower and tree shapes, are again shown. Not that Miss O'Keefe in any way repeats herself or reduces her work to a formula. She brings to each new flower, each new tree shape, the zest of a fresh impression. In other years she has shown cannas, calla [lilies], autumn leaves and fruits. This season she has made petunias her special object of study. The deep purple black color, the velvety surface with its gray blue and rose high lights and the exactness of their shapes have offered fascinating possibilities to her exquisite craftsmanship and ordered sense of design. When a flower or fruit imposes its special quality of color and design upon her imagination, Miss O'Keefe decides to penetrate the secret of its beauty and to give it back again on canvas, simplified, arranged and synthesized. To this end she makes innumerable studies, and of these is perhaps satisfied with a half dozen finished arrangements in which she has set down the essential beauty of her subjects. The flower shapes are usually of giant size but lose nothing of their quality in so being.

As always, one must stand amazed at the [artist's] technical accomplishment—a Japanese mastery of her medium, exactness of statement, no fuzzy or blurred edges, no cloudy or muddy color. It would be easy to imagine a wall decoration by Miss O'Keefe that would show up the rather uncraftsmanlike attempts of the many would-be mural painters who disfigure our walls. Her gorgeous color and rich design plus her technical mastery should put her in the foremost ranks. What is the matter with our architects and interior decorators that they have not singled her out as THE person to design wall panels and decorations?

<div align="center">50. BLANCHE C. MATTHIAS</div>

"Georgia O'Keeffe and the Intimate Gallery: Stieglitz Showing Seven Americans," *Chicago Evening Post Magazine of the Art World* (2 March 1926), 1, 14.

The Intimate gallery is an American room. It is now used more particularly for the intimate study of seven Americans: John Marin, Georgia O'Keeffe, Arthur G. Dove, Marsden Hartley, Paul Strand, Alfred Stieglitz and Number Seven.

It is in the Intimate gallery only that the complete evolution and the more important examples of these American workers can be seen and studied.

Intimacy and concentration, we believe, in this instance, will lead to a broader appreciation.

The Intimate gallery is a direct point of contact between public and artist. It is the artist's room. It is a room with but one standard. Alfred Stieglitz has volunteered his services and is its directing spirit.

Every picture is clearly marked with its price. No effort will be made to sell anything to any one. Rent is the only overhead charge.

The Intimate gallery is not a business, nor is it a "social function." The Intimate gallery competes with no one nor with anything. "All but time killers are welcome."

Until March 11 there are on exhibition in the Intimate gallery fifty recent paintings by Georgia O'Keeffe. During the time of exhibition, probably every notable in New York will open the door of the little room. All the artists, the writers, the thinkers, the doubters will want to see what O'Keeffe has accomplished since her last exhibition. No woman artist in America is subject to more observation and speculation than is this utterly feminine O'Keeffe. No woman artist in America is so daringly herself in all that she does, which fact in itself is enough to provoke widespread discussion and comment.

When Alfred Stieglitz gave O'Keefe her first exhibition in the then famous, and still remembered gallery known as 291, the result was a terrific bombing directed at the unsuspecting and tranquil artist. The art critics began to study

Freud and Jung in an effort to catalog and pigeon-hole a blue-ribboned bundle labeled Georgia O'Keeffe. But somehow she just managed to escape their hastily garnered strength.

Perhaps one reason was that most of those whose business it is to understand art and relay it to the public were of the masculine gender, and O'Keeffe's simplicity was profoundly feminine. They were so used [to] writing about "influences," "traditions," "techniques," "style," "modernism" and so unprepared for direct contact with the art spirit of woman that they got all cluttered up and began frantically searching for the magic key which was to illumine their habit-stunted minds. Even Paul Rosenfeld, the friendliest of writers on O'Keeffe, adds to the mystery which envelopes her, and dramatizes her superb naturalness, until the reader grows weary of the aura and hungers for her bone structure.

We haven't done much in art, we women, but we are not in despair. O'Keeffe's own words to me were pregnant with the humble place in which we find ourselves today, a place that we accept until we earn a better one. The way is slow because we are not militant, we are only trying to give freedom to an almost unused force that seeks conscious expression:

"You seem to feel something about women akin to what I feel—and if what I am doing moves towards that—it is something." That is just it. Her work is moving steadily toward it—that something.

Without hesitation I say that women like O'Keeffe are dangerous to this world of affairs, especially dangerous when they are artists. The purity of woman may indeed become a virtue when she learns to express herself fearlessly in art and action. Let her add wisdom to her capacity for love and face life with the courage which her sublimest ideals demand, then look sharp, you worlds, who see in flag-waving an excuse for murder, and in power, your privilege to abuse. The O'Keeffes are coming!

Some time back in the twelfth century Kuo Jo Hsu said, "The secret of art lies in the artist himself."

O'Keeffe says the same thing today in her work and in the words which she uses haltingly and puts together in varied pattern when she is faced for an interview. Even her appearance is disclosive of the profound secret which her art is said to contain. She is like the unflickering flame of a candle, steady, serene, softly brilliant.

Unexpectedly I have come upon her mirrored in the eyes of Stieglitz, unexpectedly I have come upon her curled up in the comfort of a great chair, or braving the bitterness of snow and sleet for the life of a suicidal white lily. She moves in one piece. Her black clothes have no suggestion of waist line. From the delicately poised head to the small stout shoes is a rhythm unbroken by any form of hampering. Delicate, sensitive, exquisitely beautiful, with the candor of a child in her unafraid eyes and the trained mind of an intuitive woman for a tool, it is no wonder that O'Keeffe disdains the ordinary trappings and lip rouge of her less favored sisters and faces the world unconcernedly "as is."

One never says when looking at an O'Keeffe painting: "Good work, but where is O'Keeffe?"

Her work is O'Keeffe. It is not an attempt to reveal, as so many people suggest, some morbid mood or some attitude toward sex, nor is it a desire to attract attention by outward display of the exotic. Quite the contrary. As a child she would not wear ornaments in her hair or on her person. She liked better the unadorned. She continues to like the unadorned, and so she works with simplicity and weaves it into fluid colors. No unessential is permitted a place in the pattern—that is to say, if O'Keeffe recognizes it as an unessential. She consciously tries to leave out everything that can be left out without injuring the integrity of her subject or her impulse. Her sense of order is everywhere evident and one feels that she always finds time for work, because work is more important to her than the nonwork which the Greeks called leisure. She tries for more than her potentiality. Most of us only dream that perhaps we have one, and growl because the family or daily grind of life keeps us from finding out about it.

"Too much complaining and too little work," says O'Keeffe.

Unlike most women, O'Keeffe does not encourage compromise. She wants that which she takes, else she takes nothing. She never accepts a second choice, which is another indicator pointing to an unusually direct quality in her work, even the most casual layman must observe. She feels, too, the incompleteness of all things, nothing is quite finished in life or experience. Time even is not settled, illusion is everywhere.

An interested and alive spectator, O'Keeffe chooses from out the myriad offerings which world existence holds out. She chooses fastidiously and then thru the conscious desire to express herself she paints that which inspired her choice.

For example, her choice might be a blue color. That sounds very elementary, but when O'Keeffe finishes with that blue color it has accomplished almost unknown relationships with life. Perhaps a violet inspired the choice of that blue color. It gets itself into the painting, too.

One day in 1915, during a time when O'Keeffe was teaching art, I think in Texas or in one of the Carolinas, she decided to hold an exhibition of her work. After properly placing each canvas she turned the key in the lock of the door, and with complete detachment studied the pictures before her.

"This one," she decided, "I painted in the way Matilde would like, this one was for John."

The ruthless inquisition convinced her that not a single picture had been painted because of a positive necessity within herself to express herself. She was not doing the thing she wanted to do. Attention, Freudians! Ruthlessness continued and real adventure began, for O'Keeffe packed up the exhibition to which she had been sole visitor, and to this day it has never been unpacked.

At once she began a new kind of work, and that in all humbleness. She put away her color box, and for several months the only medium used by her was charcoal. The results she sent on to a friend in New York. This friend carried the drawings to Alfred Stieglitz, who at that time was unaware that such a person

as Georgia O'Keeffe existed. O'Keeffe had said to her friend many months earlier, "I had rather Stieglitz say I am an artist than to have it said by any other person in the world."

With instant [belief] in the potentiality of this woman who dare empty herself of the desire to paint as others paint, and experiencing himself an intense reaction to the simple drawings, Stieglitz announced an exhibition of her works. So it happened that O'Keeffe, growing bored with life in Texas, came to New York and found herself the subject of much conjecture, because of the charcoal drawings which were hanging against the walls of 291. Rumors got abroad that Stieglitz had made another "find."

Undoubtedly it was an encouraged O'Keeffe who began using a little color in her work. A suggestion of blue occurred occasionally. Green was the next color which she felt she "had" to use. Then came a series in which red was freely exploited. Yellow was mastered about two years ago, and now blue is being learned with the same care that a new language would be studied. A bed of blue petunias was grown last year for the one purpose of aiding in this study. O'Keeffe doesn't get on with words. She calls them unelastic. But to learn a color is to her a limitless problem, while the idle paint box is a constant challenge.

The next question I put to O'Keeffe drew forth a look of tolerant amusement. "No, no, no. I am not an exponent of Expressionism. I don't know exactly what that means, but I don't like the sound of it. I dislike cults and isms. I want to paint in terms of my own thinking, and feeling the facts and things which men know. One can't paint New York as it is, but rather as it is felt, nor can one be an American by going about saying that one is an American. It is necessary to feel America, live America, love America, and then work. I know that many men here in New York think women can't be artists, but we can see and feel and work as they can, our struggle is not confined to one phase of life. Perhaps some day a new name will be coined for us and so allow men to enjoy a property right to the word art, but I hope we shall have a healthier and stronger title than Expressionists allotted to us by our nomenclators."

A most interesting comparison was possible when Stieglitz placed an Arthur Dove beside an O'Keeffe. Dove's intellect was clearly discerned in the designs and harmonics of his abstract motives. But not, intellect, alone. There was an almost morbid certainty that he must scale the heights unaided, the terrific urge of a spirit so hounded by vitality and vision that the influence of death seems as present with him as the consciousness that full-flowered trees have deep roots in the earth.

Ten years ago Dove was far ahead and he hasn't stopped. The Dove which Stieglitz showed was gray and black, and black-green and brown-black-green. It knew the elements and was unafraid. Madonna-like was the O'Keeffe in

related rhythms and purity of conception. The two canvases formed a strangely complete disclosure of nature in unspoiled but sophisticated human translation.

The temptation is to speak now of Stieglitz, whose untiring devotion to art and selfless efforts to make possible the seeing of it in an atmosphere removed from commercialism has earned him the devotion of artists and public alike. He is the great power which draws and humanizes and insists upon integrity. An encourager of experimentation, he has found that freedom is necessary to sincerity. So it has been Stieglitz who has suffered in order that his young ones might be free, suffered in body and spirit.

I heard him spoken of as the "newest philosopher," "the friend of Einstein," "the discoverer of Marin," "the wizard in photography," "an impossible iconoclast," but it was to O'Keeffe that I listened when she said: "He has never had time to realize his own greatness, because he is always spending himself for others. He sees the great needs we have, and in order that we may work and yet live, Stieglitz, when he believes in one of us, fights with all his strength and force for that one, and with that one, against all the organized prejudices and politics which try to dominate the world of art, as well as that of life."

So the Intimate gallery followed the closing of 291, and so the Seven Americans follow the ideal of Stieglitz, and so Stieglitz will follow for all time to come and wherever he finds it, the unchangeable, yet ever-changing life that gives itself to him in the guise of Art. To him, as to O'Keeffe, Dove, Marin, Matisse, Brancusi, Joyce—it is the great reality.

After all, I believe Paul Rosenfeld in "The Port of New York" gives an idea of O'Keeffe, I wish I had the book here. I remember that it left me in a maze of unbounded sensations, Colors, perfumes, designs which started from no place and finished there. Seeing again the beauty of form, the miraculous flow of color which animates her work, I find myself wandering in a deep bewilderment, for how can I speak of this woman who is not only painter but poet, musician and dreamer as well? This woman who lives fearlessly, reasons logically, who is modest, unassertive and spiritually beautiful and who, because she dare paint as she feels, has become not only one of the most magical artists of our time, but one of the most stimulatingly powerful! Such easy words as texture, quality, [subtlety,] should be saved for skillful technicians. They need to be explained, while O'Keeffe needs only to be seen.

51. Murdock Pemberton

From "The Art Galleries: The Great Wall of Manhattan, or New York for Live New Yorkers," *New Yorker* 2 (13 March 1926): 36–37. (Commentary about exhibition, "Fifty Recent Paintings, by Georgia O'Keeffe," New York, The Intimate Gallery, 11 February–3 April 1926.) Reprinted

In nothing is the city so profligate as in art. Principles of economic gravitation have so drawn those who live with vision that nowhere else on this funny earth can so much abstract beauty be found. We were thinking about it yesterday, listening to Stieglitz talk about his Americans, in his little room blazing with the Georgia O'Keeffes. This amazing show has been so popular that its time has been extended another fortnight. But even with the thousand or two who have bent the knee, such a small per cent of the city's mass is aware of Georgia O'Keeffe. Here we have one of the few geniuses born of this generation which has played so much of its energy though shuffling feet and saxophones. Every now and then art turns a corner. We don't know the rhythm or tempo of the beat of time in this field. The last eruption of course was the famous armory show, a dozen years ago. O'Keeffe, more than any one else we have seen this year, thrusts forward the banner without removing it altogether from the sentimental eyes of the multitude. For after all you must have a following if you are to lead.

Psychiatrists have been sending their patients up to see O'Keeffe's canvases. If we are to believe the evidence the hall of the Anderson Gallery is littered with mental crutches, eye bandages and slings for souls. They limp to the shrine of Saint Georgia and they fly away on the wings of the libido. Something for nothing: and, ah, if this city only knew how much, the reserves would have to be called out.

52. LOUIS KALONYME

From "Art's Spring Flowers: Notable Paintings in New York Present Exhibitions," *Arts and Decoration* 24 (April 1926): 46. (Review of exhibition, "Fifty Recent Paintings, by Georgia O'Keeffe," New York, The Intimate Gallery, 11 February–3 April 1926.)

Georgia O'Keeffe is one who begins with life. The tart contention of George Moore that women always paint in evening dress is shattered—in this instance anyway—by the burning intensity, the nakedly revealed world, of this Texan woman's pure female art. The Marie Laurencins of the arts are creatures of civilized sensations. Their art is not elementary or fundamental but the superimposed product of the clumsy conventions of a masculine world's butchershop realities. It is feline, a sharpened, negative, decorative prison constructed of bloodless moods[,] sophisticated naïvetes, chic costumes set off by cloth flowers, and facial masks of a consumptive pallor with startlingly red, amorous

lips. In this rectangular latter-day Watteauesque world, bodies are merely forms to enhance coverings, at best they have a stilted life.

But the art of Georgia O'Keeffe exhibited at Alfred Stieglitz's Intimate Gallery (Anderson Galleries) ripples with luminous colors and the symphonic surge of the earth's dynamic splendors. The world she paints is maternal, its swelling hills and rolling valleys are pregnant with beauty born of a primeval sun. These sun's ray points piercing the human forms of the earth give birth to singing flowers which are fragrant chalices of a distilled golden radiance. Though there are greater painters, no one in America can paint the living quality of flowers and branches and leaves as Georgia O'Keeffe does, nor can color be made [more] organic. On her chromatic color scale, whose tones are individual and inimitable and range from the cold fresh green of the sea's mountains to the orange and red moment before the advent of a summer twilight, O'Keeffe plays a grand, maternal music which reveals the shape of the world as a woman sees and feels affirmatively toward it. She strips it bare of the defensive veils of false, feminine sentiments and exposes woman as an elementary being, closer to the earth than man, suffering pain with passionate ecstasy, and enjoying love with beyond good and evil delight.

53. HENRY MCBRIDE

From "Modern Art," *Dial* 80 (May 1926): 436–37. (Commentary about exhibition, "Fifty Recent Paintings, by Georgia O'Keeffe," New York, The Intimate Gallery, 11 February–3 April 1926.)

I aim, in the limited *Dial* space at my command, to touch upon the high-lights in the New York season and to give my readers an echo of the talk and opinions that generate when individuals who have access behind the scenes meet. . . .

If there be no new talents to mention, the familiar ones, on the other hand, have been doing very well. Mr[.] Alfred Stieglitz ensconced himself in a little room and proceeded to give a series of Intimate Exhibitions of work by his protégés. Chief of these, John Marin, led off with his usual success and possibly more so. When an artist has reached the heights there is nothing to do but stay there and that Mr[.] Marin certainly does. The variations he achieves on the heights are not to be instantly measured—a little distance is necessary for that— but the new little room was undoubtedly a more helpful background to his art than the bigger galleries where it was exposed last year. My own opinion is that nobody anywhere in water-colour makes such profound and passionate tributes to nature as John Marin. Technically his drawings are superb. The common-places of water-colour he has disdained long since and in the fury of composition, it must be allowed that he permits roughnesses that act as stumbling-blocks to all save those, like myself, who are willing to pay any price for elevation of spirit. At the same time, since Marin practically grew up in this medium,

it is never possible for him, however rough, not to be in it. He is always the worker in water-colour, and nine times out of ten, there are breath-taking passages of elegant *bravura*, thrown in by way of good measure—but never thrown in, you may be sure, for their own sakes.

Of Georgia O'Keefe, the second candidate for fame in the Intimate Gallery, I cannot say so much; though the women do. I begin to think that in order to be quite fair to Miss O'Keefe I must listen to what the women say of her—and take notes. I like her stuff quite well. Very well. I like her colour, her imagination, her decorative sense. Her things wear well with me, and I soon accept those that I see constantly in the same way that I accept, say[,] a satisfactory tower in the landscape; but I do not feel the occult element in them that all the ladies insist is there. There were more feminine shrieks and screams in the vicinity of O'Keefe's works this year than ever before; so I take it that she too is getting on.

54. WALDO FRANK

"White Paint and Good Order," chap. 3 in *Time Exposures* (New York: Boni and Liveright, 1926), 31–35. (Illustrated with photograph by Alfred Stieglitz: *Georgia O'Keeffe: A Portrait—Head,* 1920; fig. 16.)

She is a woman who has fused the dark desires of her life into a simplicity so clear that to most of her friends she is invisible. The smile on her face—half nun's, half Norn's—is due to this. She has fame as a painter: the name of Georgia O'Keeffe is known wherever people care for lovely things on canvas. But she is a woman. She dislikes this invisibility of hers. She wants to be *seen.*

So much love around her that does not touch her! So much ecstatic praise that warms her about as much as would fireworks in the air of a winter night. In the old days when she was a teacher of "art" in a Texas country school, she got used to solitudes. She dreamed not of fame then, but of a New York welcoming and appreciative. She did not guess that in this Manhattan vortex of artists, amateurs and critics she was to find a spiritual silence beside which the Texas prairies shouted with understanding.

So O'Keeffe smiles. It is a simple, kindling smile: it lights the face with a maternal splendor. But the confused men and women who behold it, will not have it so. They insist that her smile, like her pictures, is mysterious. The girl's work, they argue, is Kabala. The girl herself is the Sphinx. Really, O'Keeffe, despite her gifts and her benevolent spirit, has not had a chance.

Look at her. In her black dress, the body is subtly warm. The hands have a slow grace, as if their natural cleverness had all been turned into such arts as nursing and caressing. Her voice is like her hands. Her face is very dark and the eyes are deep: but there's a twinkle in them, both intelligent and humorous. Does a peasant want to be aloof? Does a woman want to be worshiped? Don't

you believe it. It's far more fun to be seen—and to be understood. O'Keeffe's years have deepened, not complicated her. If this town were a bit simpler, a bit less impure, it might be at home with her simple purity. If it were less daft on polysyllables, it might hear her monosyllabic speech. If it were less noisy in its great affairs, it might hear her chuckle.

For O'Keeffe is a peasant—a glorified American peasant. Like a peasant, she is full of loamy hungers of the flesh. Like a peasant, she is full of star-dreams. She is a strong-hipped creature. She has Celt eyes, she has a quiet body. And as to her esoteric Wisdom, I suspect that it comes down to this: O'Keeffe has learned, walking through an autumn wood, how the seeming war of shapes and colors—the red and yellow leaves, the shrilling moods of sky—melts into a single harmony of peace. This is the secret of her paintings. Arabesques of branch, form-fugues of fruit and leaf, aspirant trees, shouting skyscrapers of the city—she resolves them all into a sort of whiteness: she soothes the delirious colors of the world into a peaceful whiteness.

And then, along came the experts. And they prated mystic symbols: or Freudian symbols. How could you expect New York to admit that what it likes in O'Keeffe is precisely the fact that she is clear as water? cool as water? New York is sure, it is too sophisticated to care for anything but cocktails. What a blow to our pride, to confess that it is neither more nor less than the well-water deepness of O'Keeffe which holds us! Better pour the simple stuff of her art into cunningly wrought goblets of interpretation. Better talk of "mystic figures of womanhood," of "Sumerian entrail-symbols," of womb-dark hieroglyphics. Doubtless, all this would make the woman tired—if she could not smile.

She was born in a town, prettily named Sun Prairie, in Wisconsin. She liked painting so much that even her visit to New York, where she studied with Chase and at Teachers College, did not turn her off. Then she proceeded south and got her living by teaching clumsy boys in Texas how to make pictures of vases and oranges and sunsets. The War drove her north. You wonder why: and if you understand, you will begin to know the woman. O'Keeffe knew nothing about international events, and she cared even less. She had no desire to enlist; she was not aching to be a nurse in France. The War, quite simply, interfered with her teaching art to boys in Texas. O'Keeffe taught art by linking it with life—chiefly, by linking it with careless talks about all kinds of matters. And now she found that there was a subject she must steer clear of: she could no longer say she did not like bloodshed and empty rhetoric and lies—since a whole particular set of these had become sacred and patriotic. They got in the way of the lines of the vase with roses she had set up for her pupils.

Before her, to the north, had come certain charcoal drawings. O'Keeffe had a girl chum in New York. In lieu of letters, ever since 1915, she had been sending these sketches. And the girl friend, despite O'Keeffe's stern forbiddance, had shown the things to Alfred Stieglitz. And Alfred Stieglitz, after forty years in comradeship with art, said he had been waiting for just these particular modest drawings. So when the famous gallery at 291 Fifth Avenue gave its farewell show (the War having put a stop to it) O'Keeffe's things were on the walls.

You will observe the woman in all this. No conquering New York with shrewd ambition. She was quite ready to stay on in Texas. The south was quiet, and indolent. O'Keeffe got on right well with the big boys—until the War turns them loose. Then Alfred Stieglitz draws her northward. Now, it just happens that Stieglitz is a man who must live in a whirlwind. Wherever the man is, there a whirlwind must foregather. And O'Keeffe—who is the spirit of quiet and of peace—finds her haven in this whirlwind world of Stieglitz. It is always hushed and still at the vortex of a maelstrom. If you don't believe it, look at Georgia O'Keeffe.

This genius for quiet is the woman. It is the essence of her. From her pioneer fathers, wandering west, she has her ability to pitch her camp in any country and in any season. But the capacity for quiet is older: it is a deep, a peasant virtue of her mothers.

O'Keeffe is very like a tree. Her arms and her head stir like branches in a gentle breeze. (Her ears are pointed like a faun's and her voice, like leaves, has a subtle susurration.) She is almost as quiet as a tree, and almost as instinctive. If a tree thinks, it thinks not with a brain but with every part of it. So O'Keeffe. If a tree speaks or smiles, it is with all its body. So O'Keeffe whose paintings are but the leaves and flowers of herself. If a tree moves, you don't notice it. And when you find this woman moving through the wordy whirlwind that ever rages round the rooms of Alfred Stieglitz, you have the effect of silence.

This silence of hers, this deep peasant stuff of both her mind and body will explain why Georgia O'Keeffe is of so great a value in Babylonian New York. Neither in Texas nor in Wisconsin did they need her half so much as we. You know where to find the writings of our granite-marble city? In *The New Yorker*. Well, O'Keeffe's work is the script of the landside—of its loam and of its lowly hut.

Perhaps such script is Scripture. We'll let the critics decide. This much is sure: to see her is to be minded of some Scriptural wife tilling the soil and homing with her husband under the storms and sunbeams of Jehovah. And so to see her is to understand her, and to know her place in Manhattan.

55. Duncan Phillips

"Georgia O'Keeffe, Born 1887, *American*," from "Brief Estimates of the Painters," in *A Collection in the Making* (New York: E. Weyhe, 1926), 66.

A young painter of vivid personality and extraordinary skill. One may be attracted or alarmed by her unprecedented patterns, but one cannot fail to be impressed by her passionate regard for truth and her passionate sacrifice of self to color and line. It is courage which commands our attention in the art of this amazing young woman—the courage of her challenging philosophy and especially her courage in so often prolonging the intensity of a theme based on one

color, or on the intricate elaboration and enlargement of one linear motif. Georgia O'Keeffe was born in Sun Prairie, Wisconsin. When she was fourteen her family moved to Virginia. She studied drawing under Vanderpoel and later painted with Chase. The exhibitions of modern art at the Stieglitz Photo-Secession Galleries at 291 5th Avenue released her into the realm of creative adventure. After teaching school in Texas she returned to New York and exhibited under the auspices of her impresario and later her husband Alfred Stieglitz—from whose photographs and prophetic ideas she derived support and inspiration. O'Keeffe is a technician of compelling fascination, especially in her flower and leaf abstractions. They seem artificial to some and to others disturbingly loaded with symbolism. Yet all must recognize the potency of her palette. A blue petunia will cause blue to become an emotional experience in and for itself. A modulation of white will exalt or afflict the mind. There will be oppositions of glacial greens and incandescent reds, of scarlets and violets. But usually one color unaccompanied carries the solo part or, as someone said, the chanting of the ritual. And how her color-edges curl and leap like tongues of fire! O'Keeffe "burns with a hard gem-like flame." She can be feminine and dainty, or she can be formal and austere. This makes her daring moments of flaming color and introspection all the more breath-taking. "My Shanty" is one of the series of landscapes painted on Lake George. It is the stark expression of a sombre Celtic mood. "Pattern of Leaves" is in her best vein of clear-eyed concentration on a detail from Nature's sorcery.

56. Katherine S. Dreier

"Georgia O'Keeffe," in *Modern Art*, ed. Katherine S. Dreier and Constantin Aladjalov (New York: Société Anonyme, [1926]), 91. (Illustrated with photograph by Alfred Stieglitz: *Georgia O'Keeffe: A Portrait—Head*, 1920; fig. 16.)

Born in St. Paul, Wis., November 15th, 1887, she went to Chicago to study at the Chicago Art Institute and later came to New York to study at the Art Students League. In 1912–1914 she worked as teacher of art at the Virginia University under Alon Bement. In 1914 she assisted Arthur Dow and became Supervisor of Art in the public schools of Amarillo, Texas, and of the West Texas Normal School in 1916. She exhibited at 291 in 1916 and 1917 and in 1923–1924 at the Anderson Gallery. She is now one of the seven members of the Intimate Gallery. Her works are in the Philips [sic] Memorial Gallery, Washington, D.C. and in various private ones.

1927

57A. OSCAR BLUEMNER

"A Painter's Comment," in *Georgia O'Keeffe: Paintings, 1926* [exhibition catalogue] (New York: The Intimate Gallery, 11 January–27 February 1927), n.p.

At the outset, let us either meet or else let us part over the proposition, that to us Art, like Life, is not for amusement, but for serious quest; that any painting (1) spiritually, is not worth the paint, unless it be a creative vision and a contemporary expression, somehow, of the artist's and spectator's attitude towards some supreme question; that painting (2) sensually, to us is paint meaning color, and line meaning form.

Assuming that we agree—or anyway—I submit that Georgia O'Keeffe is the foremost woman painter. She conceives a new problem, or perhaps, she rekindles with a modern spark the fires of a long forgotten worship.

Although the field of Art, like that of Mind, is unlimited, we had not yet seen woman in art finding herself.

And now O'Keeffe steps forth as artist—priestess of Eternal Woman,—I may say, as imaginative biologist of all creation—form on Earth; extending, perhaps, by way of analogies, the classical conception of Life—the Dionysian cult—beyond the confines of the human body.

All nature seen as organic living flesh-form transposed into line and color surface throbbing with pulse line quivering with intense inner life color rigorously restricted with corresponding significance.

Color, not of dramatic duochrome contrast, nor triads denoting mysterious complex of musician or poet, but single color essentially felt, or at most, scales of related colors; one color to one line, one color and one line to one thought, one thought to one painting, a hundred paintings to a hundred different versions of one Idea.

The Hellenic problem of form under the modern microscope, not the Rembrandt-Beethoven psychology of space.

The human form and face as motifs avoided yet presented in every flower, tree, pebble, cloud, wall, hill, wave, thing. Surface-modelling now emulates vital process, expresses biological emotion.

The brainy male brute of action owns the stage of historical cultures and his male instincts have shaped their responses to supreme questions, in art—while the Feminine Principle has only occasionally stepped out from its retreat behind the scenes, to lighten up an age, a race—mental suns long since dormant way East or South.

In this our period of woman's ascendancy we behold O'Keeffe's work flow-

ering forth like a manifestation of that feminine causative principle, a painter's vision new, fascinating, virgin American.

57B. CHARLES DEMUTH

Statement in *Georgia O'Keeffe: Paintings, 1926* [exhibition catalogue] (New York: The Intimate Gallery, 11 January–27 February 1927), n.p.

Flowers and flames. And colour. Colour as colour, not as volume, or light,— only as colour. The last mad throb of red just as it turns green, the ultimate shriek of orange calling upon all the blues of heaven for relief or for support; these Georgia O'Keeffe is able to use. In her canvases each colour almost regains the fun it must have felt within itself, on forming the first rain-bow.

58. HENRY MCBRIDE

"Georgia O'Keeefe's [*sic*] Work Shown: Fellow Painters of Little Group Become Fairly Lyrical Over It," *New York Sun* (15 January 1927), 22B. (Review of exhibition, "Georgia O'Keeffe: Paintings, 1926," New York, The Intimate Gallery, 11 January–27 February 1927.)

Forty new paintings by Georgia O'Keefe occupy the Intimate Gallery following close upon the heels of the John Marin show of water colors, which had a phenomenal success. One of the Marin water colors sold for $6,000, which must be a record price for a work by a living man. In view of this happening the Intimate Gallery is held by some to be a lucky gallery, and great expectations, in consequence, have been aroused for the new show.

To establish a record, however, Miss O'Keefe will have to go far beyond Mr. Marin's $6,000, for she works in oils, and that Princess Somebody who used to paint portraits in the Hotel Plaza long ago commanded $25,000 for her canvases.

Miss O'Keefe belongs to a little group of American painters who admire each other very much and never hesitate to say so. Charles Demuth, himself a colorist of no mean repute, has this to say of Miss O'Keefe's use of color [for Demuth statement, see this appendix, no. 57B]. . . .

Then there is Oscar Bluemner, who is such a he-artist that the colors in his pictures seem to have been welded together upon an anvil with blows from a mighty hammer, and who has this to say:

IF YOU GET ME

"I submit that Georgia O'Keefe is the foremost woman painter. She conceives a new problem, or perhaps she rekindles with a modern spark the fires of a long forgotten worship. Although the field of art like that of mind is unlimited we had not yet seen woman in art finding herself. And now O'Keefe steps forth as artist—priestess of Eternal Woman—I may say, as imaginative biologist of all creation—form on earth; extending, perhaps by way of analogies, the classical conception of life—the Dionysian cult—beyond the confines of the human body.

"The brainy male brute of action owns the stage of historical cultures and his male instincts have shaped their responses to supreme questions in art—while the feminine principle has only occasionally stepped out from its retreat behind the scenes to lighten up an age, a race—mental suns long since dormant, way east or south. In this our period of woman's ascendancy we behold O'Keefe's work, flowering forth like a manifestation of that feminine causative principle, a painter's vision, new, fascinating, virgin America."

Mr. Bluemner is a rather reckless stylist when it comes to writing, but at least you get what he means; and readers who recall the successes of Mme. Le Brun, Mary Cassatt and other famous women of the past will agree that he says a lot. Marsden Hartley, who has also written of Miss O'Keefe's work, noticed the appealingly feminine quality of the work and amiably deprecated the slight tinge of morbidity in the background of it. The suggestion of the clinic created considerable consternation in certain quarters when Miss O'Keefe's abstract work was first seen, but either because the public has grown used to the march of science or Miss O'Keefe has become less medical, the voice of inquiry in regard to it is less frequently heard now than formerly. Mr. Bluemner's suspicious remarks about biology and Dionysian cults, therefore, will probably not occasion outcries.

MORE APPRECIATION AHEAD

The O'Keefe work has never lacked appreciation and it is likely that the forty new pictures will get their full share of this commodity. The work is more frankly decorative than it used to be and the canvases have a tendency to grow very large. The painting is intellectual rather than emotional, though, cool as it is, it unquestionably stirs certain natures almost to the fainting point. Miss O'Keefe loves endless vistas. She likes to shave off her gradations until the tall buildings in her pictures, such as the Shelton Hotel, appear to endanger the moon. It is not emotional work because the processes are concealed. The tones melt smoothly into each other as though satin rather than rough canvas were the base. Emotion would not permit such plodding precision. Miss O'Keefe[,] therefore, is rather French, for though Proust, Paul Morand and Jean Cocteau have done all they can do to break the old forms, and "French" may come to mean something else in the future; at present it means planning the work out

in one's mind completely before beginning upon it. Readers who care to go into this subject more deeply are recommended to read the dialogues of Diderot; or if those cannot be had easily, then the more recent debates between Coquelin Aine and Sir Henry Irving. Coquelin Aine took the side of Miss O'Keefe.

<div align="center">

59. Louis Kalonyme

</div>

From "Musicians Afield—Local Art Notes. In New York Galleries: Georgia O'Keeffe's Arresting Pictures . . . ," *New York Times* (16 January 1927), sec. 7, p. 10. (Review of exhibition, "Georgia O'Keeffe: Paintings, 1926," New York, The Intimate Gallery, 11 January–27 February 1927.)

Georgia O'Keeffe, whose latest paintings are being exhibited at the Anderson Galleries, is our only woman painter whose art is a natural flower of life. The tart axiom of George Moore, that woman always paints in evening dress, has been shattered forever by the burning intensity of this Texas woman's art.

For an elementary freshness animates the painting of Georgia O'Keeffe. She lives only in that feminine world furtively hidden by the Marie Laurencins of the arts. Woman, and her relation to the earth, its flowers, trees and lakes, is what O'Keeffe paints. What O'Keeffe also does in her painting is to cut through the defensive veils of those fashionable feminine sentiments that mask the hectic creatures of modern civilization's sensations and "thrills."

Though there are more accomplished painters in America, no one can paint the living quality of flowers and branches and leaves as Georgia O'Keeffe does, nor can color be made more organic. On her chromatic color scale, whose tones are individual and inimitable, and range from the cold fresh green of light blue seas to the orange and red and yellow and purple and white flowers, and blackish gray trees and glittering golden and night-blue skyscrapers (the Shelton from unbelievably beautiful angles), drawn inexorably upward by brassy suns and white, hard, hypnotic moons, O'Keeffe plays a grand, maternal music, which reveals the shape of the world as a woman sees it and feels affirmatively toward it. She reveals woman as an elementary being, closer to the earth than man, suffering pain with passionate ecstasy and enjoying love with beyond-good-and-evil-delight.

<div align="center">

60. Helen Appleton Read

</div>

"Georgia O'Keefe [*sic*]," *Brooklyn Daily Eagle* (16 January 1927), 6E. (Review of exhibition, "Georgia O'Keeffe: Paintings, 1926," New York, The Intimate Gallery, 11 January–27 February 1927.)

Georgia O'Keefe, the much-discussed painter, whom Alfred Stieglitz intro-
duced as "Georgia O'Keefe, American," on the occasion of her first one-man
show at the Anderson Galleries, four years ago, is showing 40 new paintings,
which are new variations on those subjects which she has made peculiarly her
own—closeups of flowers and fruits. The exhibition is being held in the Intimate
Gallery, Room 303, Anderson Gallery Building, which gallery is, as its name
suggests, a small, informal room, where are shown from time to time in special
exhibitions, the works of the five Americans—Marin, Dove, Hartley, Demuth
and O'Keefe—whom Stieglitz believes to be truthful interpreters of the Ameri-
can spirit.

O'Keefe's work has attracted much attention and caused much discussion—
primarily because it is starkly personal, reflecting no other painter, and because
it has been possible to read into it things which have nothing to do with paint-
ing. I, for one, am inclined to think that the writers, who insist upon interpret-
ing her work in terms of biology and psychology, not only miss its real beauty
as painting, but have done her actual harm in the eyes of the art-loving public.

O'Keefe once said to me, "Wise men have said my work isn't art. But what
if it is children and love in paint? There it is color form, r[h]ythm. What does it
matter if its origin be emotional or esthetic?"

It is enough for any painter to stand on the merits of his work as painting.
To have achieved a new interpretation of so traditional a subject as flowers and
fruit still lifes, to have brought to it a new style arrangement, a new technique,
is no small accomplishment. And O'Keefe has done this. She paints giant
closeups of purple black petunias, of flaming cannas and dead white calla lilies,
and arrangements of apples and alligator pears as no one else has done before.
She sees them, singularly removed from effects of light and shade, merely as
interesting shapes possessed of infinite gradations of color. Because of her inter-
est in clean, perfect shapes it was inevitable that she should have painted the
clean perfect shapes of sea-shells. Several large-scale versions of the common
clam shell are included in the present collection—not commonplace, however,
when she brings to her statement of them a sensitive appreciation of the subtle
color gradations which occur not only in the inner, iridescent surface, but in the
dull, chalky gray outer surface. There are few conceivable subjects which so put
to test her ability to paint cleanly and clearly a single unrelated object, and yet
relate it to all of life.

61. Murdock Pemberton

From "The Art Galleries: Those of You Who Have Heard This Story,
Please Be Good Enough to Step Out of the Room," *New Yorker* 2 (22
January 1927): 62–63. (Review of exhibition, "Georgia O'Keeffe: Paint-
ings, 1926," New York, The Intimate Gallery, 11 January–27 February

This will be Georgia O'Keeffe week. And at the risk of tiring some and of making others mad, we want to say that she is giving a swell show at Room 303, Anderson Galleries. We don't know anything in this world quite like Georgia O'Keeffe; and we don't know anyone who wouldn't be enriched by a look at the things she does, that the world calls pictures.

We suppose it all started back in the First Reader, this mad association of ideas that makes us, perforce, seek a little story, or a train of cars in a thing known as a picture. About now there should be a new word invented for the canvas that the artist paints. And that word should be something with limitless horizons, letting in all the world. It should be a word with no connotations, no previous furniture. We lug this sermon in because we come across those who say in effect, "O'Keeffe can paint but they are not pictures," meaning, usually, that her subjects are not six lemons, nudes or the tops of houses.

Well, she can paint, and as if to confound those who have hitherto been unmoved, her exhibit this year contains a new phase. Having no further to go in her flower forms, she has sought about, giving us the shore of the lake, the Shelton Hotel and many views from her window. We think she steadily enriches herself from year to year and whatever she touches seems to be magic.

Knowing full well that Time's vote will outweigh ours when it comes to the immortality of Georgia O'Keeffe, we do want to go on record for one thing. O'Keeffe will certainly be looked back upon as one of the milestones. Future historians can trace out the thin line of American endeavor, from the Revolution to 1912, and find scarce a trace of anything that will rise above the norm line of the chart. We were about to say curve, but there has not been enough movement in it to call it a curve. And we bet that among those numbered as throwing bombs into the factory of standards and forms will be the little Texas school teacher. Whatever posterity does to her prices (the American's only standard of excellence) it will surely recognize that she stood at the fork of the road and pointed out a thousand pleasant ways, never before seen. She, almost alone of contemporary painters, runs over the edge of her canvas; she is profligate where others save, generous to a bewildering degree.

The little room, of course, is inadequate. The red canna or the calla lily and roses should have a cathedral for presentation. But if you look at the paintings one at a time, the show can be managed. The exhibition will be there for six or seven weeks, so you can go as often as you like. We have quite a list of those we should like to lead around, including the Junior League girls and most of the women who paint timidly. The last word being a bit tautologous.

62. Louis Kalonyme

From "Scaling the Peak of the Art Season: Art in Infinite Variety from El Greco to Clivette," *Arts and Decoration* 26 (March 1927): 93. (Review of exhibition, "Georgia O'Keeffe: Paintings, 1926," New York, The Intimate Gallery, 11 January–27 February 1927.)

Georgia O'Keefe is the woman who can make interior decoration an exciting art. She, too, is a magician with color, a color as unlike Matisse's as woman is unlike man. In her latest paintings, exhibited at the Intimate Gallery (Anderson Galleries), she again demonstrates that she is our only woman painter whose art is a natural flower of life. For an elementary freshness animates her painting. She lives openly in that feminine world furtively hidden behind defensive veils of bloodless paint by the Marie Laurencins of the arts. Woman, and her relation to the earth, its flowers, trees and lakes, is what O'Keefe paints, and the world man has builded through woman, with its skyscrapers (the Hotel Shelton) cleaving the sun and moon.

By listening and creatively recording—as Charles Demuth points out in brief rhapsodic note to the catalogue of O'Keefe's paintings—"the last mad throb of red just as it turns green, the ultimate shriek of orange calling upon the blues of heaven for relief and support," O'Keefe invincibly proves that the art of the Laurencins is not female but feline. The Laurencin art is shown by O'Keefe, with her direct, almost primitively pure color, to be adjectival—an adjectival art of that silken felinity which is one of the mesmeric moods that emanates, like some intoxicating poison, from the clawed caresses painted in mimed movement by Angna Enters, the great mime and dancer of feminine moods, humors and distempers, in tracing the purring black, catlike outlines of her famous dance, "Feline."

Compare this Laurencin art and its negative, decorative, bloodless patterns with the world painted by Georgia O'Keefe. The Texan woman's paintings ripple with the singing colors and the symphonic surge of the earth's dynamic music. She paints the living quality of flowers and branches and leaves as no other American does, and her color is like no one else's. This color ranges from the cold fresh green of blue seas to orange and red and purple and white—she converts white into a color—flowers and blackish gray tree trunks and glittering golden and night-blue skyscrapers (the Shelton again from overpoweringly beautiful angles) drawn inexorably upward by brassy suns and white, hard, hypnotic moons. Woman always emerges a being closer to the earth than man in O'Keefe's paintings, an elementary being to whom pain and pleasure are but contrapuntal in the scale of human music we call [ecstasy].

63. LEWIS MUMFORD

"O'Keefe [sic] and Matisse," New Republic 50 (2 March 1927): 41–42. (Includes commentary about exhibition, "Georgia O'Keeffe: Paintings, 1926," New York, The Intimate Gallery, 11 January–27 February 1927.)

Miss O'Keefe is perhaps the most original painter in America today. The present show of her recent work leaves one wondering as to what new aspects of life she will make her own. I do not wish to dwell on her paintings as separate canvases, although in The Wave, and the sun blazing behind The Shelton, and in what is nominally one of her flower-interiors, as well as in several more abstract designs, she has produced pictures upon whose excellence one might well linger for a while. The point is that all these paintings come from a central stem; and it is because the stem is so well grounded in the earth and the plant itself so lusty, that it keeps on producing new shoots and efflorescences, now through the medium of apples, pears, egg-plants, now through leaves and stalks, now in high buildings and sky-scapes, all intensified by abstraction into symbols of quite different significance.

Miss O'Keefe has not discovered a new truth of optics, like Monet, nor invented a new method of aesthetic organization, like the Cubists; and while she paints with a formal skill which combines both objective representation and abstraction, it is not by this nor by her brilliant variations in color that her work is original. What distinguishes Miss O'Keefe is the fact that she has discovered a beautiful language, with unsuspected melodies and rhythms, and has created in this language a new set of symbols; by these means she has opened up a whole area of human consciousness which has never, so far as I am aware, been so completely revealed in either literature or in graphic art. Unlike the painters who have taken refuge in abstract art to hide their inner barrenness, Miss O'Keefe has something to communicate; and the human significance of her pictures is enriched rather than contracted by the symbols and the formal figures she employs.

In thinking of Miss O'Keefe, my mind drifts back inevitably to another distinguished American artist, Albert Pinkham Ryder. He, too, in his landscapes and in his more deliberately symbolic pictures, sought to use the objective fact as a means of projecting a more interior and less articulate world; but, like Blake and Redon, his mind ran most easily in the groove of literary myths, and in his paintings of Time Riding Around a Racetrack or the Witches in Macbeth or Jonah and the Whale, he was dependant upon irrelevant suggestions for his theme, conveying by literary allusion feelings for which he had no direct language. Miss O'Keefe has found her symbols without the aid of literary accessories; hers is a direct expression upon the plane of painting, and not an illustration by means of painting of ideas that have been verbally formulated. Indeed, Miss O'Keefe's world cannot be verbally formulated; for it touches

primarily upon the experiences of love and passion. Whitman said that the best was that which must be left unsaid, and anyone who has reflected upon his passionate experiences is always a little appalled at the fact that they become so inarticulate in actual life, or so evasive, so skittishly evasive, when they seize hold of the poet.

The premonitions of love, its pre-nuptial state as it were, are the constant themes of poetry; but in literature love and passion retain something of the desire of the moth for the star; when we become conscious of them in other terms, we are faced either by the empty swaggering of a Swinburne or a Wilde, whose personal history gives one reason to doubt if they had anything more than a literary background for their emotions, or by the all too literal allusions of a Rochester. The fact is that words strike love stone-cold; what it is, is something much too deep in the blood for words to ejaculate; and when driven to such an indirect medium, the result is not the original quality of passion or sexual intimacy at all, but obscenity—which is but the ashes from an extinguished fire.

What is true of love holds for other emotions and feelings: if their warm impalpability is to be extracted from consciousness, they must be transformed by painting into their own special symbols, and not first done into a verbal medium; a blasted tree may convey more human anguish than the most scarified and tear-stained face, labeled Antigone. Perceiving this fact, and creating images that are as palpable as flesh and as austere as a geometric figure, Miss O'Keefe has created a noble instrument of expression, which speaks clearly to all who have undergone the same experiences or been affected by the same perceptions. She has beautified the sense of what it is to be a woman; she has revealed the intimacies of love's juncture with the purity and the absence of shame that lovers feel in their meeting; she has brought what was inarticulate and troubled and confused into the realm of conscious beauty, where it may be recalled and enjoyed with a new intensity; she has, in sum, found a language for experiences that are otherwise too intimate to be shared. To do this steadily in fresh forms, and to express by new expedients in design—as in the filling of a large canvas with the corolla of a flower—her moods and meanings: these are the signs of a high aesthetic gift. A minor painter might achieve this once; and would perhaps carve a prosperous career by doing it over and over again; Miss O'Keefe, on the contrary, has apparently inexhaustible depths to draw upon, and each new exhibition adds richness and variety to her central themes. Her place is secure. "If this be madness, and upon me proved, / I never writ, nor no man ever loved."

Miss O'Keefe's paintings and the recent retrospective show of Matisse remind one that the pure artist is always more deeply in touch with life, even with life considered merely in the dress of our own day, than the conventional artist who does the accepted thing. Superficially speaking, it would seem that commercial illustrators are of all people the ones most closely in touch with "life": do they not have to meet business men, face actual problems in advertising, produce marketable goods? Far from it: there is a complete lack of living relationship in their magazine covers and subway ads: the girl whose skin you love

to touch tells nothing about our own day. Such drawings are a complete blank; if an Elie Faure were to examine them five hundred years hence, the only inference he could draw would be that our civilization lacked an aesthetic sense.

Miss O'Keefe's paintings, on the other hand, would tell much about the departure of Victorian prudery and the ingrowing consciousness of sex, in resistance to a hard external environment; were Sherwood Anderson's novels destroyed, were every vulgar manifestation in the newspapers forgotten, were the papers of the Freudian psychologists burned, her pictures would still be a witness; for, apart from their proper beauty and significance, they reveal and refocus many of the dominant aspects of our time. It is the same with Matisse. He began his career as a conventional painter of "studies"; gradually, two things developed in his work: a clarity of structure, a feeling for what we were executing in other forms with the aid of equations and mechanical drawings, and, side by side with this, a certain lush sensual quality, conveyed partly by color and partly by sleek oriental women and soft upholstery. Is not this the essence of our contemporary spiritual dilemma? There is war between our vital needs and our mechanical routine. Looking at Matisse's pictures, I remembered a factory I had recently inspected, in which the machinery was here and there furtively plastered with pictures of variously naked hussies, cut out from contemporary magazines of "art." There was the exact equivalent in "life." Is not the conflict, indeed, pretty obvious everywhere? The artist, unconsciously perhaps, attempts to transmute it into beauty; but the divorce is a critical one, and the passage to beauty not easy. Matisse succeeds best, I think, in his still-lifes, where color and form are orchestrally handled in superb, intricate, vibrant designs.

64. HENRY MCBRIDE

From "Modern Art," *Dial* 82 (March 1927): 262–63. (Review of exhibition, "Georgia O'Keeffe: Paintings, 1926," New York, The Intimate Gallery, 11 January–27 February 1927.)

Upon the eve of *The Dial*'s going to press, Miss Georgia O'Keefe, the feminine ace of the Intimate Gallery, exposed in that sanctum forty of her new canvases. It is too soon to report, therefore, the response—always very hearty hitherto—that Miss O'Keefe is to receive from her own sex, but two of her gentlemen admirers who had been permitted to see the pictures in advance of the show, put no limit to their enthusiasm. Mr[.] Charles Demuth, who weighs words well before he uses them, said: "In her canvases each colour almost regains the fun it must have felt within itself on forming the first rainbow," and Mr[.] Oscar Bluemner, who may not be so particular about words but who weighs them nevertheless, said: "And now O'Keefe steps forth as artist—priestess of Eternal Woman—I may say, as imaginative biologist of all creation-form on earth; ex-

tending, perhaps by way of analogies, the classical conception of life—the Dionysian cult—beyond the confines of the human body."

Miss O'Keefe's subjects remain the same, flowers and buildings. She has enlarged her sizes. She always drew large petunias, but now she makes them the size of pumpkins. The petunia occupies the entire canvas, almost, with just a little bit of blue at the far edge to indicate sky or water. Decorators accept them willingly and seem to know how to place them so that they become doubly attractive. Certain others obtain hidden meanings from them. It is clear that Mr[.] Oscar Bluemner does, with his reference to Dionysian cults and the Eternal Woman. Miss O'Keefe is fond of gradations of tone, and with infinite patience pursues a purple down a petunia's throat until she arrives at the very gates of—I was going to say hell, but I mustn't say that, though the mere fact that I was going to say it shows that this priestess of mystery known as Miss O'Keefe almost had me in her power. Ladies said last year that gazing into Miss O'Keefe's petunias gave them the strangest imaginable sensations and as the petunias are larger and better this year than ever before, I shall await an account of a ladies' day at this exhibition with real interest. A novel feature of the advertisement of Miss O'Keefe's show announces that the hours from ten to twelve in the morning on certain days of the week are to be "hours of silence." If Llewelyn Powys ever hears of this he will be more than ever convinced that the Stieglitz Group is a religious organization.

65. FRANK JEWETT MATHER, JR.

"Georgia O'Keefe [*sic*]," from "Recent Visionaries—The Modernists," chap. 16 in *The American Spirit in Art*, by Frank Jewett Mather, Jr., Charles Rufus Morey, and William James Henderson, vol. 12 of *The Pageant of America*, ed. Ralph Henry Gabriel (New Haven: Yale University Press, 1927), 166. Reprinted courtesy Whiteman World-Wide Marketing Corporation.

Georgia O'Keefe works at times in the syncopated and simple geometrical manner of Cézanne, with easily recognizable subject matter, and also in abstract forms akin to those of the Futurists, commanding in either vein dignity of composition and rare force of color. The abstraction for music which we reproduce may be regarded as a projection of a strongly moving current of sound. Refinements of interpretation, as to what visualizes harmony and what melody, will easily occur to the musical reader. Often Miss O'Keefe bases her abstractions on plane forms greatly magnified and highly simplified in color, and she does effective still life in the new manner. Her most startling innovations have been in forbidden juxtaposition of clashing tones, and in the systematic balance and contrast of complementary colors.

66. Dorothy Adlow

"Georgia O'Keeffe," *The Christian Science Monitor* (20 June 1927), 11.

The number of feminine names affixed to canvases within recent years has become notably large. Nor is the lady that has been brought up with the proper education, dabbling in water color included. There are girls that paint at art schools with all earnestness. They copy the old masters and invent compositions of their own. They exhibit. They sell. Most of them are as average in their work as the majority of men, the same breadth, the same limitations. For there is little difference between one mediocre thing and another. It is only in the finer things that there is a distinction. Only there does art become more searching, more personal, when the artist demonstrates his ability to see for himself with his own peculiar vision and in the light of his own experience.

Georgia O'Keeffe is one of the few women artists in America who impress us with the strange qualities of feminine feeling and imagination. She is a painter that lives something of a hermit's life in the very center of New York where her perch on the twenty-sixth story relieves her of the storm and noise and incidentally offers an excellent view of the ever-changing sky line. One might as well live out in the country for all the advantage of theaters and endless attractions of the great city. When on the job, says Miss O'Keefe, one must keep away from all these distractions. The artist must submerge himself entirely in his work while he is performing. But she does not sacrifice much here for she seems disinterested in the theater, although the new cinema "palaces" amuse her with their sumptuousness and decorum.

Half the year is spent in the country where Miss O'Keeffe divides her time betwixt her painting and domestic life, careful to give each its own due. She is as enthusiastic about the labors of the household as every normal woman, prepared to care for them when necessary but happy to be relieved when possible. It is easier to get her started on the subject of menus and palates than it is on palettes and pigments. She is an exponent of simplicity in all the matters of style in living, simplicity in costume and food, simplicity that must be enforced by one that is independent and eager to enjoy his time creatively to the best advantage.

She is critical of the lack of independence in the modern young woman. Each person must be able to take care of herself, to discover what are her best possibilities and find enjoyment in developing them. Miss O'Keeffe is not ambitious. One works only as long as one enjoys it, she says, and as long as one desires it, and then stops. She does not seem to be interested in pushing on and on. To her the joy of the work is an end in itself. The woman of the present day must learn this. She is not yet acquainted with herself or her possibilities. She has not yet learned how to interpret the privileges that are hers.

When it comes to the subject of modern art, Miss O'Keeffe is naturally interested. She has likes and dislikes. "It is difficult to understand the new

things but one must be awake to what is being done in one's own time. It is very much easier to know the things of the past. Many people prefer to follow the easiest path and so they are supercilious about those things that are expressive in some way of their own lives." Miss O'Keeffe to some may decisively be a "modern" but in many of her pictures she manages to remain individual enough to escape designation.

Pens more mellifluous then this have sung her praises and evinced all sorts of mystical associations from her pictures. There is mysticism in her work as there is in any work of art that penetrates beyond mere surface impres[s]ion, and ignores the conventional interpretation. When she looks at a blossom its color and shape, its hardiness or delicacy becomes an extension of a certain mood and it is that mood that she in turn extends to the canvas in the language of contour and color. It is finding oneself manifested in the things of nature, the one that has a richer inner life sees more sensitively the counterpart of that life in these details of trees and flowers and all the things of the outdoors.

She has moments when she is hard and incisive, cutting her lines onto the canvas, and there are other moments when she is light, volatile, when the picture is an evanescence, a pale cloud-like vision that rises out of the imagination. There is completeness in her work so far as such things can be called complete. There is tidiness and delicacy. There is a sureness that shows conviction. A relief after so much of the half-done product that one has become accustomed to in the gallery.

Miss O'Keeffe lacks an earthiness. She ignores the mundane. She is exotic, aloof. She is truly an independent, free of current movem[e]nts as she is of society. She has the distinction of a sensitive nature and the capacity of conveying its best to the canvas. In being true to her own perception she remains the artist and more, the woman.

67. FRANCES O'BRIEN

"Americans We Like: Georgia O'Keeffe," *Nation* 125 (12 October 1927): 361–62.

In an apartment on the twenty-eighth floor of the Shelton a woman sits painting. A tall, slender woman dressed in black with an apron thrown over her lap. Beside her is a glass palette, very large, very clean, each separate color on its surface remote from the next. As soon as a tone has been mixed and applied to the canvas its remains are carefully scraped off of the palette, which thus retains always its air of virginity.

It is late afternoon and even in this high place the room is growing dusky. The artist does not seem to know this. She goes on painting carefully, swiftly, surely—and she and the canvas and the glass palette are one world having no connection with anything else in existence. And then the telephone rings.

"Hello, Georgia? This is ———[.]" "Hello, how are you? Would you mind calling up a little later after the light goes?" And the chastened caller ponders the twilight outside his window and wonders how even on a twenty-eighth floor one can go on painting. But of such intensive work as this is born the beauty which annually, on the walls of the Intimate Gallery, makes that little room the largest place there ever was in the world. Paintings of flowers and leaves and the music of flowers and leaves. Paintings also of tall buildings, of tiny shells, of Lexington Avenue. The flowers are painted very large, the leaves are painted very large, until you begin to feel large yourself. And the colors make some people say "gorgeous" and make other people keep quiet altogether.

All this is because Georgia O'Keeffe has never allowed her life to be one thing and her painting another. She has never left her life in disorder while she sat down to paint a picture that should be clean, simple, and integrated. To her art is life; life is painting. What you are is also the thing you put on canvas, or into a symphony or a book. When you look at her pictures you know that she is chiseled, ordered, and fine just as they are. You know that she lives simply, almost as a recluse, that she orders carefully every detail of existence so that the maximum of time may be given to her work.

Georgia O'Keeffe is an iconoclast to the old European traditions of art and artists. All the thrilling tales we have heard of life in a studio, of Bohemianism, of cocktail-inspired masterpieces become remote fabrications beside the serenity of this woman of many paintings. We begin to believe that inspiration really comes out of introspection, human sympathy, profound contacts rather than, as we were taught to believe, out of a bottle. America is versatile—producing alongside of jazz and the Black Bottom so austere and ascetic a religion for artists.

O'Keeffe is America's. Its own exclusive product. It is refreshing to realize that she has never been to Europe. More refreshing still that she has no ambition to go there. Born in Sun Prairie, Wisconsin, and with a childhood spent in Virginia and Texas, she absorbed an atmosphere untainted by theories, by cultural traditions. When she came to New York, William Chase, at the Art Students' [sic] League, was explaining to young America the brushwork technique of the Paris salons. Georgia, being just seventeen, listened politely and wielded her brush with such dexterity that Mr. Chase awarded her the medal in his still-life class.

But the candor that was to distinguish both her life and her painting was even then playing its role. She may have said: "Why should I receive a medal for being an obedient, intelligent child? Is not this supposed to be a class in painting? What has a medal to do with me? Moreover, what has all this painting to do with me?" She may have said all this. Those who know O'Keeffe best will admit that this would have been characteristic of her. And presently she abandoned the league and with it New York and its esoteric painting. All painting, in fact.

The next few years found her doing advertising work in Chicago. "Commercial art" they call it nowadays. Then it was just making pictures of alarm

clocks and tomato cans. Our aesthetes may well lift their eyebrows in horror. But I have no doubt that then, as now, Georgia O'Keeffe was "working herself out." This period of work having afforded her the means to do so, she journeyed to the University of Virginia and spent the years 1912–1914 under the paternal baton of Alan [sic] Bement. She studied everything except painting and presently found herself in Texas with the title "Supervisor of Schools." Later on she became the "Art" of the West Texas Normal College.

Meanwhile, having purged herself of New York's borrowed art theories and the academic technique, she would lock herself in her room evenings and tentatively draw with charcoal. And nothing was urging her to draw save the pure need of expression. No one was to see what she did. Having struggled by herself with life, she was free to set down her feeling about it. No instructor was standing behind her to signify with sophisticated squint his approval of what she did—or his disgust. It was very nice; life was complete in a bit of charcoal carefully rubbed on a sheet of paper. And Georgia impulsively showed two drawings to a friend.

The woman to whom she showed the drawings took them to New York; and that is why this past February we could walk into the Anderson Galleries and see hanging there "Forty New Paintings by Georgia O'Keeffe."

At that time, Alfred Stieglitz was making his brave struggle to present America with its own artists and Europe's in his famous "291" Fifth Avenue, an institution remembered today by but a few of the intelligentsia, but an all-important chapter in the history of American art—when we get to the point where we can write one. To "291" came the academicians and native art dealers to shake with uproarious laughter at walls hung with Matisse and Picasso. Also a select and very small group of the far-seeing to gaze with religious awe at new and significant manifestations such as these, and to quarrel about their virtues. Verily, they were days of travail for Stieglitz. And then, one day when he was feeling his weariest from the fruitless endeavor to explain to Babbitt that this, also, was art, there walked into "291" the woman to whom O'Keeffe had confided the two drawings.

To Alfred Stieglitz nothing was ever so refreshing as those two drawings. Long after the woman who brought them had gone they remained on the walls of "291."

A controversial correspondence followed between Stieglitz and the young lady who was teaching art in the West Texas Normal College, the upshot of which was that there presently arrived in New York an artist with approximately $40 in her pocket-book, but with an indomitable enthusiasm. True, artists have arrived in New York with less than $40 and quite immeasurable enthusiasm and—well, I can't help recalling George Bridgeman's boast that he never has to pay any subway fare because all his former students at the Art Students' [sic] League are now officiating in the ticket booths.

Ten years have not made a different person of Georgia O'Keeffe. Today finds her the same strong, clear, and introspective person as the girl who wandered with her classmates through the Virginia woods, studying bird life. Geor-

gia never saw the birds; but no flower or leaf or tree escaped her passionate exploration. "If only people were trees," she has said, "I might like them better." That is why she has remained undisturbed by the worship of the culturally elite. That is why of all our modern painters she is the least influenced by any of the trivialities, the aesthetic fashions of the time. These things do not exist for her; her roots are in the earth and her kinship is with the things that grow from the soil.

Yet there is one potent bond uniting her with the world of humanity. If Georgia O'Keeffe has any passion other than her work it is her interest and faith in her own sex. She married Alfred Stieglitz about eight years ago, and you must not, if you value being in her good graces, call her "Mrs. Stieglitz." She believes ardently in woman as an individual—an individual not merely with the rights and privileges of man but, what is to her more important, with the same responsibilities. And chief among these is the responsibility of self-realization. O'Keeffe is the epitomization of this faith. In her painting as in herself is the scattered soul of America come into kingdom.

68. C. J. BULLIET

From "The American Scene," in *Apples & Madonnas: Emotional Expression in Modern Art* (Chicago: Pascal Covici, 1927), 200–201, 204–5.

The cradle of "Modernism" in America is the famous "291," Alfred Stieglitz's immortal little Photo-Secession gallery, 291 Fifth Avenue, New York. Matisse and Rodin were introduced to the Western World there, before the Armory Show.

The first collective exhibition of the work of "Younger American Painters" was made there in March, 1910. The exhibitors, according to the list Mr. Stieglitz furnished Arthur Jerome Eddy for his book, were Arthur G. Dove, Arthur B. Carles, L. Fellows, Marsden Hartley, Putnam Brinley, John Marin, Alfred Maurer, Steichen, and Max Weber. . . .

In May, 1916, Stieglitz introduced the work of Miss Georgia O'Keeffe, of South Carolina, now the best-known woman painter in America. Others who are products of "291" are Marion H. Beckett, Katherine [sic] N. Rhoades, Rene D. Lafferty and C. Duncan. . . .

The group Stieglitz brought out are still reckoned the "aristocrats." Georgia O'Keeffe has done the best work, perhaps, of any American, male or female, in the pure abstract. Miss O'Keeffe works with surfaces, rather than lines, surfaces vaguely defined, like gently drifted snow. Her pictures arouse some such emotion as is felt after a vaguely remembered dream. They do not fight you, as do the pictures of the belligerent Cubists—their effect is soft and soothing. If emotion be the soul of art, then Miss O'Keeffe's abstractions are tenuous art bodies sublimated nearly to the essence. It has been said of her work that it is

purely feminine. It does not strike me as such, as Marie Laurencin's. It seems vaguely sexless—without any sex suggestion. Laurencin, like Sappho, is the quintessence of sex.

Arthur G. Dove, too, revels in the abstract, but without the irresponsible abandon of Georgia O'Keeffe. He can be sensed usually as definitely conscious of form.

1928

69. C. KAY-SCOTT [FREDERICK CREIGHTON WELLMAN]

Letter to Georgia O'Keeffe, in *O'Keeffe Exhibition* [exhibition catalogue] (New York: The Intimate Gallery, 9 January–27 February 1928), n.p.

———————

July 21, 1927.

Dear Miss O'Keeffe:

I went to the Brooklyn Museum to see your paintings. These other things confirm almost exactly the feeling I had about the four I saw at Lake George, although I refrained from expressing a measured opinion on so few.

I shall try to convey (as well as words of mine can convey anything so intricate as my reactions to another artist's record of himself) what your work, so far as I have seen it means to me.

My heart finds in your pictures a deep satisfaction. I am convinced that this comes from (among other elements which perhaps I cannot yet snare in words) a fearless clarity of vision—from what I might call perfect purity of purpose. You have wide movements of color-forms which give me a sense of that peace-in-intensity which I have sought in my own life and work.

The absence of all emotional fumbling is so very comforting to one like myself who knows that in life we all fumble sometimes, but who also knows that fumbling has no place in completed art. Your spirit is passionate-cool, strong-gentle, seeking-disciplined. This amazing psychic balance comes from a courageous self-acceptance, without which no real and lasting art is possible. With this to stand on, you have dared, and loved, to paint what seem to me the organs of the spiritual universe. I think of your pictures as I write this, of the white birch, for instance. There is thus in your work a fine virility in the widest and truest sense of that term.

I spare you a string of superlative and meaningless adjectives. I do not use them about any painting—from Giotto's to my own. The thing I want to say is that you do what is your own, and that I believe that your own is significant to painting and to our time.

I have turned the above over in my mind rather carefully and am ready to say it to others besides yourself. . . .

Yours sincerely,

C. Kay Scott.

70. Henry McBride

"Georgia O'Keefe's [sic] Recent Work: Her Annual Display at the Intimate Gallery Now Open to the Public," *New York Sun* (14 January 1928), 8. (Review of exhibition, "O'Keeffe Exhibition," New York, The Intimate Gallery, 9 January–27 February 1928.)

The annual exhibition of the work of Georgia O'Keefe is now open to the public in the Intimate Gallery. An annual exhibition is a severe test upon any artist's powers, and, as a rule, is not to be recommended, for it implies that something new in the artist's experience has been recorded, and it is not every year that presents such new experiences.

Miss O'Keefe, however, is better suited, temperamentally, to this open progress toward fame than certain others who might be mentioned. She seems to be unflustered by talk, to be unaware of much of the talk, and to pursue her way in calmness toward the ideal she clearly indicated for herself at the beginning of her career.

She comes nearer to it this year than ever before. She is an imaginative painter, not so much interested in facts as in the extraordinary relationships that may be established between facts. She is in love with long lines, with simple, smooth surfaces that change so slowly in tone that it sometimes appears as though a whole earth would be required to make them go all the way round; and she yearns so for purity of color that the impure pigments supplied by the shops must often appal[l] her and it would not surprise her annual critics too much to find, a few years hence, that she was carrying out her designs in colored glass rather than in paint.

Themes That Haunt

There are two or three themes that haunt Miss O'Keefe in the same way that Mlle. Pogany haunts Brancusi. One is the "Red Hill with the Sun." She got the theme in Texas, where she was born, or lived, or went once, I forget which. But the plain with the glaring sun impressed her psychologically, and until she gives out all that she got from it, she will go right on painting that terrific theme. This year's version does, however, seem complete to at least one outsider. The blaz-

ing sun on the red, red hills is as good as it can possibly be. It probably, in consequence, is the last of that series.

Another theme is the Shelton Hotel. Miss O'Keefe lives there—by choice. It has long lines, long surfaces—it has everything. At night it looks as though it reached to the stars, and the searchlights that cut across the sky back of it do appear to carry messages to other worlds. Miss O'Keefe has painted several versions of the Shelton and has been praised for them, but her increased plasticity, increased mysticity and increased certainty in intention have enabled her this time to achieve one of the best skyscraper pictures that I have seen anywhere. It combines fact and fancy admirably and ought to be easily accepted even by those who still [stumble] over Miss O'Keefe's petunia pictures.

ANOTHER ABSORPTION

Petunias are a third absorption of Miss O'Keefe's. Or rather there is a group of flower[s] on which she dwells lingeringly. They can be taken just as decoration or as essays in pure color. There is the "Dark Iris, No. 1," which began as a simple study of an innocent flower, but which now presents abysses of blackness into which the timid scarcely dare peer. Or there is the "White Rose—Abstraction," in which there are rows upon rows of filmy transparencies, like one of Pavlowa's best ballet skirts. These and similar paintings, content those who respond to the painter's touch and to her clarity of color—and mean just what the spectator is able to get from them and nothing more. To overload them with Freudian implications is not particularly necessary.

71. MURDOCK PEMBERTON

From "The Art Galleries: 'But We Know What We Like,'" *New Yorker* 3 (21 January 1928): 44–45. (Review of exhibition, "O'Keeffe Exhibition," New York, The Intimate Gallery, 9 January–27 February 1928.) Reprinted by permission; © 1928, The New Yorker Magazine, Inc. Copyright duly renewed.

Georgia O'Keeffe is having her annual show in Room 303, the Anderson Galleries, under the Stieglitz banner. The followers of O'Keeffe have doubtless all been in to see the display by now. If you haven't, and are interested, the exhibit will be on until the last of February. There is no use arguing with you about it; after three years we have found that there are as many strange bed-fellows in art as in any of the other industries. The only course of procedure is to march ahead confident that every one else is out of step.

O'Keeffe we like, if you do not already know. She took paint and canvas and created a whole new world. Yet in this creation she did not feel she needed the crutch of ambiguity or the veil of mysticism. She found beauty in the forms

of a flower and she proceeded to interpret that beauty in the chromatic scale. We doubt if any other of her sex has crowded as much beauty, per se, into the confines of a canvas.

Well, now that we have said that and there can be no doubt about our position, we are willing to grant a stay of execution to all those who do not agree with us. O'Keeffe will never appeal to the primer-minded who construe the field of painting as one glorified first reader, done in color. She holds no lure at all for those who think of pictures only in the definitive sense and are not happy unless they see images of little men, houses where they dwell, cows that nourish them, or choo choo trains that carry them about. Yet now and then O'Keeffe becomes pictorial, as if to show them that she can do it. We looked at her canvas of the East River at twilight for half an hour, trying to find the tricks by which she made this subject conform to all the laws of the Medes and Persians. If there were tricks, we could not find them. There is the far side of the river in gray, the river itself in silver, and the foreground in black. Three tones of gray and yet we have seen thousands of pictures that did not contain one tenth the color.

There are forty-odd canvases in the present show. We think next to the East River series, we like best the abstraction of the white rose. Call us a fool if you must but we imagine we could put that white rose up where the current ikon sits, and drift off into Nirvana without much regret. Unless, of course, we happened to look at the far wall and saw the Red Hills and Sunset, a battle flag fit for a revolution. If there has been any change in the O'Keeffe work we would hazard that she has come into her heritage of serenity. Her beauty is not so militant and seems to approach you unarmed.

<center>72. EDWARD ALDEN JEWELL</center>

"Georgia O'Keeffe, Mystic: Her Patterns Weave through Boundless Space," *New York Times* (22 January 1928), sec. 10, p. 12. (Review of exhibition, "O'Keeffe Exhibition," New York, The Intimate Gallery, 9 January–27 February 1928.)

Rolled into a corner of the Intimate Gallery, out of sight save for prying eyes or chance discovery, is a small crystal ball. It may mean nothing in particular. On the other hand, into this crystal some at least of the Intimate dwellers—Arthur Dove, John Marin, Alfred Stieglitz, Georgia O'Keeffe—gaze possibly from time to time, seeking the strange, evanescent beauties they portray. Especially, somehow, Miss O'Keeffe; although it is quite conceivable, too, that she needs no such recourse.

In Georgia O'Keeffe's work some excellent examples of which are now on view, abstraction is treated with an understanding that has deepened and broadened with experience in art-forms the most difficult, the most eluding. Such abstractions as she weaves are created through simplification, if by simpli-

fication we mean essentially the paring away of all that is non-essential. No doubt a surer way of defining any genuine abstraction is to call it a transformation from what is representational into what is seized directly by the mind as an idea. The important thing to stress is that, however arrived at, the forms Miss O'Keeffe expresses are complete realizations of spirit loosed from its shackles, free to range through fields limited only by limitations space itself imposes.

It may well strike one as a little marvelous that themes so visionary should prove amenable to treatment so precise and so boldly affirmative. The mind questions sparingly, and yet all here is the stuff of which question is born. Those who do not respond to the language of this mystic in paint can hardly remain unmoved by the sheer loveliness of her color shapes and patterns. Even the botanist would be likely to find in these poems, based for the most part upon flowers and leaves, an invitation to re-examine his fund of knowledge. Yet botany is perhaps the last word that submits itself to the inquiring thought.

Here are speculations that tend to lose themselves in an outer vast. What we are given in most of the studies is only a tiny segment of nature's plan; but looking into the heart of a flower one may feel the world dissolve. In a perfection of silence the shapes that drift and sway and flow are ever taking new forms, as in the play of the color organ. . . .

Occasionally, but rarely, this cosmic passion beats into flame. Sometimes, as rarely, a static note is struck—or so we imagine—as in a study of three or four still Autumn leaves laid one upon another. But let the eye travel to another picture in which these leaves attain their abstraction and it is seen that they have come to life, have begun their stately undulating dance, falling out of the body concept and into the concept of a spiritual fluidity: rustling, fluttering, curling, ebbing and flowing, coiling and recoiling, opening out, closing—again to open and un-bosom themselves of their esoteric messages.

Sometimes the forms appear to be marching rather than swaying; but always it is the march that does not tire; that need not pause for darkness or repose; a moving on and on, constantly refreshed with the refreshment that is conceived in reciprocity, in giving as well as receiving. And sometimes there are the lines or streams that seem in their nameless quests about to meet, but do not quite. "Not yet," they seem to whisper as they pass. However, if the joy of a perfect confluence be deferred, there is time enough, where time has been divorced from what is calculable. Even now, as Alice Meynell puts it, "their joy is flying away from them on its way home."

Throughout this work of Georgia O'Keeffe's one senses the breathing of the Mighty Mother. Here is more than a hint of the atman of Yoga and Upanishad. Once, with the highest courage of all, the artist leaves her play of colors, leaves even the "White Rose Abstraction," and pictures black infinities in whose midst is a tiny sphere of luminous white that spins—whither no one knows. One feels the impulse that gives it life and makes it move. Infinite space is black. Our little vault of sky, they tell us, is blue only a few miles up; then the void sets in,

engulfing, swallowing all things, dispersing and yet retaining them eternally inviolate.

For comfort we turn back to the patterns that are warm with love and the reticent but unashamed symbolism of love; back to the rhythmic undulations of pure color—singularly pure, whether it be her red hills with the sun or a purple petunia that, in esthetic importance, to the close-held eye, becomes too immense to be held by any frame.

73. LOUIS KALONYME

"Georgia O'Keeffe: A Woman in Painting," *Creative Art* 2 (January 1928): xxxiv–xl.

The rhapsodic literature born of Georgia O'Keeffe's paintings of flowers and fruits, of hills and trees and skyscrapers, pivots inevitably upon the fact that she is a woman. It pivots upon that point, first, because it is a new experience to encounter any painting by a woman worthy of prolonged consideration in the sense that one values a Rubens or a Ryder. The history of painting, and the part woman has played in it, has long since accustomed one to the belief that painting, finally, is a male art. And so the second surprise afforded by Georgia O'Keeffe's painting is the possibility that this belief has become ingrained because no woman painter ever has made so innocent an approach in painting as she does. Innocent, that is, of the primitive, savage, naive, virile, mystical abstract, ecstatic, Promethean, Dionysian, Apollonian—innocent, in sum, of all aesthetic categories of masculine approach in painting. Innocent, too, of all feminine versions of masculine painting.

When you have adjusted your eye's ear to Georgia O'Keeffe's quiet way of orchestrating color so that it does the melodic singing for those contrapuntal growths and forms which the sun and earth and sea nourish, you apprehend that this woman has rediscovered our world—male version—with a new divining rod. I mean that her way of looking at the world is unobstructed by the reports or rearrangements men painters have made of it, or by the adjustments women painters have made within the limits of those reports or rearrangements. O'Keeffe's song is direct and affirmative, free of introspective agonies, devoid of the feminine cringe and giggle. It is the song of a free woman, a shamelessly joyous avowal of what it is to be a woman in love. And so you see for the first time in paint form what the world we live in looks like to one woman.

It is because no man ever has perceived that world in quite the same organic aspect that O'Keeffe does, that it seems natural to stress the woman-slant. The meaninglessness of this distinction, however, in considering O'Keeffe's painting, is the realization that neither has any woman painter ever so perceived that world, or anything like it, even in intention. O'Keeffe's perception is not a slant.

Berthe Morisot saw, and Marie Laurencin sees, a man-made world: O'Keeffe perceives the world which gave birth to man and woman, and which gives birth eternally to itself. She perceives the world the first woman saw. I do not say world as the first woman saw it—God would have to be my witness for so absolute a deduction—but I do say that O'Keeffe's painting is the only unmasculine approach to that art to be made by a woman. To that extent, at least, her painting is purely female.

Now Georgia O'Keeffe is neither a revolutionary nor an innovator in the art of painting, rather is she an explorer. Her distinction is not that she has perceived better or differently the things Seurat, Rousseau, Renoir or Ryder saw, or that John Marin sees, but that she has seen those things as a woman. Her relation to those things is akin to woman's relation to man. And in opening flowers and opened seashells, in twisting branches and thrusting seawaves, she has revealed the world as a woman functions in it. She has made symbols of a lily, a rose, the maternal folds of a hillside awakened by the red premonition of a rising sun. Yet she has not changed the recognizable aspect of those things. She has made the lily larger than it actually ever is, as if to let one see it for the first time, but she has done nothing to it. For even if you do not care for symbols in your art O'Keeffe's lily will pass triumphantly as painting. So will all her other subjects. It will pass even as pure decoration. But symbol, nevertheless, the corolla of the lily is, just as a pair of luscious buttocks were, to put it mildly, a symbol to Renoir, and a pair of furtive breasts were a symbol to the eagle-eyed Constantin Guys. Only O'Keeffe's symbolism is, perhaps, purer, because there is no recourse to obvious physical or literary associations. The forms her flowers and fruits and skyscrapers take, resolved in O'Keeffe's integral designs, speak for themselves; and in their inner natural relationships they communicate with evocative purity the role of a woman in love, and her role in life.

This sexual distinction of O'Keeffe's painting from that of masculine painting, or from feminine imitation of masculine painting, was proclaimed by Alfred Stieglitz one afternoon some twelve years ago, after he had examined O'Keeffe's charcoal drawings in that dusk-eaten little oasis known as "291" (Fifth Avenue) where America cultivated its first taste (now become a gargantuan "correct" thirst flatteringly and profitably whetted by the art dealers) for the experimental fire-waters of Cézanne and his spiritual brood (by voluntary incubation) of wild aesthetic beasts, his step-nephews, the Fauve gang.

"Finally a woman on paper!"—or words to that general effect—Stieglitz is reported to have said, quite moved, to the New York girl friend of O'Keeffe's who had brought the drawings to him.

Now it might seem odd to Mr. Coolidge, or to Mr. Ford, that it should be so important for a woman to be herself in the art of painting, or of life; but to Alfred Stieglitz—from what one knows and has read of his efforts to manoeuver America into a golden age—it would not be only important, it would be miraculous.

A teacher-idealist, Stieglitz, it seems perhaps erroneously to one who is forty years his junior, has been concerned during those forty years not so much

with art as an end but as a means, as an open sesame on the slow road the world blazes towards truth, beauty, or what have you. Art, I dare say, is not enough for Stieglitz, to him it is at best the bread with which one endures the stumbling search for the promised land. And, possibly, O'Keeffe's drawings vouchsafed Stieglitz a new truth, a sustenance Cezanne, Matisse, Picasso, Dove, and Marin could not, being men, provide. This, I know, sounds perilously like metaphysical aesthetics, but it is the only way I know to explain Stieglitz's excitement about O'Keeffe's drawings. And since without Stieglitz's excitement it is altogether probable that O'Keeffe's paintings never would have been seen, its part in this chronicle becomes obvious.

In his excitement it was natural for Stieglitz to wish further knowledge of this woman who was herself in line. But even the girl friend, who had been admonished by O'Keeffe never to show the drawings, knew no more than that O'Keeffe had been born in Sun Prairie, Wisconsin, and had studied art under Chase at the Art Students' League until he had awarded her the medal for her outstanding proficiency in the still life class. Apparently the medal had made O'Keeffe wonder somewhat about art, for she thereupon gave up art. It may have been that she thought she had learned all Chase had to teach, or it may have been her need of food. She was now, said the girl friend who had struck up friendship with O'Keeffe in the still life class, teaching art in the Texas State Normal College, after some years of work in Chicago as a commercial artist. Those Chicago years had provided her with the means to attend the University of Virginia where Alan [sic] Bement, now the director of the Art Center, was one of her teachers. The drawings, the girl friend explained, were O'Keeffe's letters to her, it was her way of carrying on a correspondence. Words, it seemed, did not come easy to O'Keeffe, or they did not say what she intended.

A correspondence between Stieglitz and O'Keeffe ensued with the result that ten years ago a tall slender woman, not quite thirty years, arrived in New York City with a few dollars just in time to see the last exhibition of "291." The exhibition was of Georgia O'Keeffe's drawings. To Alfred Stieglitz it was dramatically right that the last exhibition in "291"—which was destroyed, one gathers from the records, by the war, poverty and misunderstandings—should be of a woman's work. Not all of Stieglitz's friends and audience of artists saw what he saw in those drawings, but ten years make a difference.

Now in the Hotel Shelton, on one of its highest floors—the thirtieth, that same woman sits making new colors. For such they seem to one. Each year there are forty or more new works which Alfred Stieglitz, now her husband, shows at the Intimate Gallery (in the Anderson Galleries) which is a continuation of "291." And when you see O'Keeffe in that light gray little room among her paintings, the relationship is almost too blatant. Naturally, the paintings, like children, have their own individual life. But the paintings are, like her, forthright and simple. They have the same free smile that curves on O'Keeffe's thin, large lips and that twinkles in her deep, searching eyes. Her face you might say is colorless, its formation could be seen as Chinese, but it is painted by quietness, and what one rather emptily speaks of as experience in life. You

see in her noble white face, framed as it is by her black hair and set off by the black garments she almost always wears, the same radiance perceived by Gaston Lachaise. In his sculpture portrait of O'Keeffe your eyes follow a head rising like a white sun, whose flaming tranquility is fed by that same beauty which is communicated by O'Keeffe through those marvelous flowers she paints. You see too in the features of that sculptured face, its poised, affirmative lines, the sources of that beauty.

For Georgia O'Keeffe is one who begins with life. She is our only woman painter whose art is a natural flower of life. George Moore's tart axiom that women always paint in evening dress is gutted by the burning intensity, the nakedly revealed world, of this American woman's art.

An elemental freshness animates her painting. She lives openly in that feminine world furtively hidden by the Marie Laurencins. Woman, and her relation to the earth, its flowers, trees and lakes, is what O'Keeffe paints, and the world man has builded through woman, with its skyscrapers cleaving the sun and moon. And she discovers that female world for us by cutting through the defensive veils of those fashionable feminine sentiments which mask those hectic heroines—so touchingly painted by the Laurencins—of contemporary civilization's sensations and thrills. O'Keeffe demonstrates that the art of the Laurencins is not female, but is a super-imposed by-product of the clumsy (moral) conventions of a masculine world's butcher-shop realities: Quite undesignedly, she shows up this fashionable Laurencin art as feline—of that silken felinity which is one of the mesmeric adjectives that emanate, like some aphrodisiacal narcotic, from the clawed caresses painted in mimed movement by Angna Enters, that greatest mime and dancer of feminine moods, humors, and distempers, in tracing the purring black catlike outlines of her famous dance, "Feline."

Only the warm, if sinister, positive purr which relates the Enters' feline movement to the bone and flesh of the elemental world O'Keeffe paints is missing in the Laurencin world; for that world is a sharpened negative decorative prison, constructed of bloodless moods, sophisticated naivetés, chic costumes set off by cloth flowers meaninglessly perched on brittle boyish shoulders, and of facial marks of a consumptive pallor, slashed with unlikely red amorous lips. In that rectangular latter-day Watteauesque world—where a thin, modish stringiness is the [couturier's] command and the masseur's bread and butter—bodies are merely coverings, at best they have a stilted life.

Compare that world and its aesthetic patterns—compare even the world of the earlier Berthe Morisot's adorable retiring (to bed) women, beside whose virginal robustness the Laurencin lettuce-green ladies are bloodless rectangular shadows—to the world painted by O'Keeffe, and you immediately see how sensationally straightforward, clear and intimate her form of expression is. Her paintings ripple with the luminous colors and the symphonic surge of the earth's dynamic splendors. The world she paints is maternal, its swelling hills and reclining valleys are pregnant with a beauty born of a primeval sun. The

sun's ray points piercing the human forms of the earth give birth through her to singing flowers which are fragrant chalices of a golden radiance.

There are more accomplished men painters, but no one can paint the living quality of flowers and branches and leaves quite like O'Keeffe, nor can color be made more organic. On her chromatic color scale, whose tones are individual and inimitable and range from the cold fresh green of the sea's mountains of ice and the singing blue of sun-blenched summer seas, to the orange and red moment before the advent of late summer twilight, the crimson flush which streaks the gray dawn, the yellow and purple and white—she makes of white a new color—flowers, the blackish gray trees and glittering golden and nightblue-green skyscrapers (the Shelton) inexorably drawn upward by brassy suns and white hard hypnotic moons, Georgia O'Keeffe plays a grand maternal music which reveals the shape of the world as a woman feels affirmatively towards it. She reveals woman as an elementary being, closer to the earth than man, suffering pain with passionate ecstasy, enjoying love with beyond good and evil delight.

74. Marya Mannes

"Gallery Notes: Intimate Gallery," *Creative Art* 2 (February 1928): 7. (Review of exhibition, "O'Keeffe Exhibition," New York, The Intimate Gallery, 9 January–27 February 1928.)

Before speaking of O'Keeffe's work, let us once and for all dismiss this talk of "a woman's painting" and "a man's painting." Any good creative thing is neither aggressively virile nor aggressively feminine; it is a fusion of the best of both. Anything definitely sexual (in the sense of man and woman, not in the sense of general creative passion) in a work of art immediately drags it down from the plane of ultimate impersonality which is its glory. Almost every genius in the past seems to have been an equal compound of male and female. And it seems obvious that nothing mental or physical can be conceived by one sex, or sex quality, alone; unless one believes in immaculate conceptions.

Therefore, if we are to exalt the work of Georgia O'Keeffe, let us not exalt it because it seems to be a rare psychic perception of the world peculiar to a woman, but because it is good painting.

It is, in many ways, amazing painting. O'Keeffe, with incredible dexterity and sensibility of hand, has transmuted pigment into pure light, pure color. She has made growing and surging and impalpable waves of tone out of the petals of a flower, leaves, sun over hills, skyscrapers. The "Dark Iris, No. I" is to me the climax of her art. It is a symphonic poem, utterly achieved. Then her East River views, and a strange [paean] to a white, palpitating sun. Much of her color, however, strikes me as shrill and acidulous, thinly dissonant. If there is one quality her painting lacks more than anything, it is plain, pumping blood—

that kinship with the earth that even the greatest ecstasies must keep to sustain their flight. Like the sap that shoots up in the most fragile pinnacles of trees. Miss O'Keeffe's work suggests to me that kind of passionate mysticism that clouds the seeing eye with visions false to it, like some sweet drug. It is always a question whether the flowers in an opium dream are more beautiful than the flowers in the field; or the Garden of Eden than the first protoplasm. But all this leads nowhere—people will either like the painting of Georgia O'Keeffe or dislike it. This particular paragraph is written by one who realizes its frequent, unprecedented beauty, but is somehow repelled by the bodilessness of it.

75. Unidentified Writer

From "Art: On View," *Time* 11 (20 February 1928): 21–22. (Review of exhibition, "O'Keeffe Exhibition," New York, The Intimate Gallery, 9 January–27 February 1928. Illustrated with photograph by Alfred Stieglitz: *Georgia O'Keeffe: A Portrait—Head,* 1926 [NGA D 1545].)

There were some paintings hung on the walls of a tiny room in the Anderson Galleries; other paintings, smaller ones, rested on cabinets or stood along the floor. The room was full of people, talking to each other in awed, foolish whispers. In the corner of the room sat a lady dressed in a black cloth coat, smiling like a severe Mona Lisa. She was Georgia O'Keeffe; the paintings on the wall belonged to her because she had made them; for some reason, the room seemed hers as well.

If the people who looked at them appeared silly and ungainly, it was partly by contrast, because the paintings were neither. They are difficult paintings to write about. When Georgia O'Keeffe paints flowers, she does not paint fifty flowers stuffed into a dish. On most of her canvases there appeared one gigantic bloom, its huge feathery petals furled into some astonishing pattern of color and shade and line. A bee, busy with a paint brush, might so have reproduced the soft, enormous caves in which his pasturage is found. One of the insects out of Henri Fabre, some thoughtful, sensitive caterpillar who had read Freud, might have so pictured the green and perpendicular avenues of his morning's promenade. But no caterpillar, however sensitive, no bee, however dexterous, could have traced, in the lines of a flower's petal, so suave, so decorative a design.

Most of the pictures were the images of flowers seen through two lenses; the first a powerful magnifying glass, the second the iris of a perspicacious inward eye, whose function was to give clarity a significance beyond the decorative. In the way a purple petunia spread its violent petals, there was a hint, a symbol for truths not necessarily too deep for words to reach but outside the meanings from which words have been derived. It is enough to say that Miss O'Keeffe's paintings are as full of passion as the verses of Solomon's Song.

Of this woman Critic Lewis Mumford has said: "She has beautified the sense of what it is to be a woman; she has revealed the intimacies of love's juncture with the purity and the absence of shame that lovers feel in their meeting; she has brought what was inarticulate and troubled and confused into the realm of conscious beauty, where it may be recalled and enjoyed with a new intensity; she has, in sum, found a language for experiences that are otherwise too intimate to be shared."

Georgia O'Keeffe is generally addressed by her last name; her husband is Alfred Stieglitz who was the first connoisseur to see her paintings and the first to discover the merit in them. Georgia O'Keeffe had been brought up in Wisconsin and Virginia, had studied in Manhattan under William Chase, who, as she calmly observes, would immediately perish of bewilderment should he, by an accident, walk into the room where her paintings are on view. She was teaching drawing to young people in Texas, when she sent two of her charcoal drawings to a girl in New York. The girl took them to Stieglitz, whose gallery was then full of Matisse and Picasso, whose senseless innovations caused academicians to expire from apoplexy.

She has been incautiously heralded so often since that it pleases her to ponder a question which few painters would be brave enough to frame: "What do they think about these things when they go home to supper?" The people who stare at her pictures of apples, pears, eggplants, leaves, stalks, high buildings, rivers and tremendous flowers, interest her enormously. She, like George Bellows and unlike almost every other U.S. artist, has never gone abroad and doesn't want to; she paints all day on the 30th floor of the Shelton Hotel, Manhattan; her face is austere and beautiful; she does not own a fur coat.

76. UNIDENTIFIED WRITER

"Artist Who Paints for Love Gets $25,000 for 6 Panels," *New York Times* (16 April 1928), 23. Copyright © 1928 by The New York Times Company. Reprinted by permission.

Less than three weeks since the announcement of the sale of thirty-two paintings by John Sloan for $41,000 to a collector who desired to remain unknown to the public, it was made public yesterday that six small panel paintings of lilies by Georgia O'Keeffe had been sold last week to another anonymous collector for $25,000 to hang in his own home.

The O'Keeffe paintings are of calla lilies. They have been displayed in the Intimate Gallery of Alfred Stieglitz, through whose hands the painting[s] passed to the collector.

Miss O'Keeffe has never tried and apparently never cared to sell her work. She painted for the love of expression on canvas, which expression is said by

her friends to be chiefly inspirational, as she studied less than six months under Chase and a shorter period under Alon Bement.

<p style="text-align:center">77. ALFRED STIEGLITZ</p>

"O'Keefe [*sic*] and the Lilies," letter to the editor, *The Art News* 26 (21 April 1928): 10.

———————

<p style="text-align:right">April 16, 1928.</p>

My Dear [Deogh] Fulton:
 Six small O'Keeffe Calla Lily panels painted in 1923 have been acquired to go to France. She is receiving—don't faint—$25,000 for them. I can hardly grasp it all. Still I hate to see two of the panels lost to the U.S. Many youngsters—15–17, girls and boys—used to play hookey from school in order to come to The Room to see the O'Keeffe Lilies. They went so far as to suggest to the Fathers to acquire them for the church!
 Of the $25,000, O'Keeffe (according to the Room's wont) will give one-fifth to other artists—not necessarily painters or sculptors. As you know, I accept nothing for myself in any form. Nor is the Room in any way a business.
 The fight continues.
 Other O'Keeffes are finding homes—also Marins and Doves and Bluemners, Etc., Etc.

<p style="text-align:right">Greetings,</p>

<p style="text-align:right">Stieglitz</p>

<p style="text-align:center">78. B. VLADIMIR BERMAN</p>

"She Painted the Lily and Got $25,000 and Fame for Doing it! Not in a Rickety Atelier but in a Hotel Suite on the 30th Floor, Georgia O'Keefe [*sic*], New Find of Art World, Sets Her Easel," *New York Evening Graphic* (12 May 1928), 3M. (Illustrated with photograph by Alfred Stieglitz: *Georgia O'Keeffe: A Portrait*, 1918; fig. 20.)

———————

Not a rouged, cigarette smoking, bob-haired, orange-smocked Bohemian, but a prim ex-country school-mistress who actually does her hair up in a knot is the art sensation of 1928!
 This extraordinary lady, who has set the art world of the metropolis agog, hails from the wilds of Wisconsin, but is as much in love with the hustling, bustling city as with her work. And she paints her pictures of lilies and rooftops

not in a rickety *atelier*, but in a spick and span suite on the thirtieth floor of the Hotel Shelton!

But on the Avenue, where the connoisseurs of art old and new meet, and even in Greenwich Village, where only the virtues of the new are raucously proclaimed, they are singing hosannas for Georgia O'Keefe, whose six paintings of lilies, displayed at the Intimate Gallery, recently brought $25,000 from an American business man.

"She is the Lindbergh of art," enthusiastically declaims Alfred Stieglitz, internationally famous photographer of internationally famous creators in the various fields of art. "Like Lindbergh, Miss O'Keefe typifies the alert American spirit of going after what you want and getting it!"

Human Flowers

"There is an ironical quality about the flowers she paints that makes them almost human—and sometimes even more expressive than human beings," declares Joe Kling, the artist-poet-editor who runs the International Art Shop on Christopher Street and is known as "the Sage of the Village."

And thousands who have visited the Intimate Gallery in the Anderson Building at Park Avenue and 59th Street—art lovers and art students from all walks of life,—enthusiastically beam assent.

Who is this woman who a few weeks ago was virtually unknown to the world at large?

True, she has been drawing quietly, painting, working hard over her pictures for years, but a couple of weeks ago when an anonymous art lover paid $25,000 for half a dozen of Miss O'Keefe's paintings, the world at large was amazed. A few tiny pictures of lilies by a comparatively unknown painter to bring such a sum!

Yet Stieglitz, who runs the Intimate Gallery as a "direct point of contact between public and artist," would not have let the pictures go for a penny less.

"We all felt that these remarkable pictures belonged here, in the gallery, where any one could come and see them," he said earnestly. "But so fine a gesture from this business man who so freely and readily paid for a few pictures unheralded because he himself sensed their genuine worth was something that couldn't be ignored."

I found Miss O'Keefe hard at work in her suite, high up in the Shelton that gives an almost unobstructed view of the great city, east, west, north and south.

Miss O'Keefe [] canvas partly completed, depicting the sweep of roof-tops as seen from her studio. Even in its incomplete state the canvas gave one a sharp sense of the complication, the bewildering life down below the "mountain top." It explained partly why the artist had come to live here, high in a modern hotel, rather than to huddle with fellow artists in a conventional art colony.

"When I came to live at the Shelton about three years ago," Miss O'Keefe confided, "I couldn't afford it. But I can now, so of course I'm going to stay. Yes

I realize it's unusual for an artist to want to work way up near the roof of a big hotel in the heart of the roaring city but I think that's just what the artist of today needs for stimulus. He has to have a place where he can behold the city as a unit before his eyes but at the same time have enough space left to work. Yes, contact with the city this way has certainly helped me as no amount of solitude in the country could.

HIDDEN MEANINGS

"Today the city is something bigger, grander, more complex than ever before in history. There is a meaning in its strong warm grip we are all trying to grasp. And nothing can be gained from running away. I wouldn't if I could."

Miss O'Keefe started painting [] still a school teacher. She worked hard and earnestly, but in the beginning had no desire or hope of profiting financially. Even a longing for fame was absent, because she does not, quite obviously, relish the attention and the plaudits her work has won her.

"I just want to be let alone and to work and paint," she said, and there was no doubting her sincerity. "This craving for attention or wealth is what is wrong with so many of our artists today. Their idea of monetary gain or winning fame is uppermost in their minds. But I truly may say that I worked all these years just for the sheer joy, the love of creating. The love of accomplishment is my true reward. I have but one desire as a painter—that is to paint what I see, as I see it, in my own way, without regard for the desires or taste of the professional dealer or the professional collector. I attribute what little success I have had to this fact. I wouldn't turn out stuff for order, and I couldn't. It would stifle any creative ability I possess."

CITY HER THEME

Miss O'Keefe's only plan in the face of a rather sudden acclaim and monetary success is to go on painting. Her newer work shows a decided tendency to play with city themes, to depict the colorful variations of the great metropolis that is booming about her. But in her skyscrapers and rooftops there is that same subtle sardonic play of humor with which she invests her flower pictures.

Although painting is her chief delight, Miss O'Keefe does not regret the years she spent teaching. "They were some of the happiest of my life. I'd teach now if I had the time—and they'd let me."

During her career as a pedagogue, she taught at the University of Virginia, and acted as school supervisor in Texas.

Miss O'Keefe's early art training was gained at the Art League here, and the Art Institute in Chicago. She has also studied under Chase and Alon Bement.

Back of her seemingly phenomenal rise to fame, however, are years of the hardest sort of work with paint and brush.

"The notion that you can make an artist overnight, that there is nothing but genius, and a dash of temperament in artistic success is a fallacy," she asserted. "Great artists don't just happen, any more than writers, or singers, or other creators. They have to be trained, and in the hard school of experience."

79. LILLIAN SABINE

"Record Price for Living Artist. Canvases of Georgia O'Keeffe Were Kept in Storage for Three Years until Market Was Right for Them," *Brooklyn Sunday Eagle Magazine* (27 May 1928), 11. (Illustrated with photograph by Alfred Stieglitz: *Georgia O'Keeffe: A Portrait—Head*, 1919?; fig. 21).

"Success doesn't come with painting one picture. It results from taking a certain definite line of action and staying with it."

Thus spoke Georgia O'Keeffe, six of whose small panels of white calla lilies had recently been sold for $25,000, when interviewed in the Hotel Shelton.

She is still a young woman of slender build, with dark eyes and dark hair brushed back, uncompromisingly. She has neither "wave" nor "bob." But there is rare steadiness in her eyes and a quality one trusts. Her features are fine, and she has beautiful straight teeth that are seen occasionally when she smiles.

Georgia O'Keeffe had taken her line of action—and stayed with it. Throughout her years as a teacher in Western schools, bravely bearing the burden of supporting herself and a younger sister and later entering a world where men challenged woman's right to success, she has painted as no other artist has painted. She has kept alive that vital spark—herself.

All the way to the Hotel Shelton I had been wondering what a woman would do with $25,000 suddenly dropping like manna. The shops on Lexington avenue were alluring, with colorful gowns to greet the spring.

What fun it would be to fling not only the "winter garment of repentance," but one's whole winter wardrobe of last year—and year before last—into the bonfires of spring, and burst forth in subtly spotless raiment.

When I was directed to the thirtieth floor of the hotel, my mind ran ahead of me into an apartment vivid with insidious coloring.

The door opened and I entered a room as bleak as the North Pole. It might have been a cloister or the reception room of an orphanage, so austere was it, with its cold gray walls, and its white covers over dull upholstery. There was no frivolous pillow, no "hangings." The only spot of color was a red flower on an easel. There was not an inch of cretonne or a dab of chintz anywhere.

It seemed all windows—windows overlooking housetops, steel framework, chimneys; windows to the east through which the panorama of the river and the bridge came flooding.

If the artist was not enthusiastic in her greeting, she was sincere.

Over the telephone she had not been cordial in making the appointment. To one who lives only in her work, "interviewing" has no point. But we were both committed to a line of action—and there we were.

Moreover, she was wholly honest in her point of view. She felt that newspaper reporters were looking for a sensation, for the magic leap by which one bridges the gap between poverty and riches or obscurity and success. The subtle story of grilling years in conflict, she felt, had little appeal.

Occasionally as we talked, she would say, "That doesn't make any difference"—or she would prefer not to answer a question. She had her own standards—and one must respect them. One knew that the O'Keeffe reticence was as sincere as the O'Keeffe lilies.

Opposite us were calla lilies so huge that one could easily crawl inside and go to sleep. They are known as the O'Keeffe "floral interiors."

On a second easel was the newest O'Keeffe [painting]—the city as we saw it from those windows, the city thirty floors below, as we watched it through haze and smoke, with "Old Man River" and the slow quiet freight wending its way upstream.

One couldn't ask an artist what she planned to do with so much money; but one could discuss the surroundings.

"Don't you like color?" we queried. "There's no color here."

She smiled over the disappointment.

"Color does something to me," she replied. It was in this total absence of color, she explained, that she was "free to think."

For our unaesthetic soul calla lilies had always possessed a queer antipathy. Those stiff, waxen petals were the most unflower-like of flowers.

"How did you come to take calla lilies for your subject?" was our next venture.

"I started thinking about them because people either liked or disliked them intensely, while I had no feeling about them at all."

Then the artist proceeded to refute some of the reports concerning her work.

Our newspaper soul sank as low as it can—when one's shoes are thirty stories above sea level!

"Isn't it true about the $25,000?" we asked bluntly.

"Oh, yes,["] she replied, "that's true. But the story sounds as though I had just been painting a little while. It's a much better story than that—much more subtle."

Then Georgia O'Keeffe, who is a native of Wisconsin, unfolded the panorama of her own life, spreading out before me those years of teaching in small towns, in Texas and Virginia, where the students thirsted for knowledge.

"I liked teaching," she said. "I have missed it terribly. I liked the contact with those students who earned the money they spent."

During these years, which involved not only teaching during the regular sessions but also instructing in Summer schools, the young artist—then in her

twenties—arranged her classes so that she could paint during the hours that were free.

Sometimes her teaching left much time in which to paint; at other times the brushes had to be laid aside because a heavy program gave no opportunity for her own development.

Then, about 1908, she went as a student to the "laboratory" of Alfred Stieglitz, at 291 Fifth Avenue, known now throughout the world as "291"—a spiritual force, where, as she says, there was profoundest respect for the artist as spirit. It was in that little room that were first introduced to America the drawings of Rodin and the paintings of Matisse and Henri Rousseau, Cezanne, Picasso, in fact the whole modern movement.

A friend had taken some of her black and white drawings to see if Stieglitz would be interested in showing them at "291."

Alfred Stieglitz, originally a photographer, who had believed thoroughly in the work of artists, had opened "291," to further the work of young artists. He was carrying on then in the same spirit with which he is still exhibiting, his gallery now being known as the Intimate Gallery, "Room 303," of the Anderson Galleries.

Among the artists who were discovered by "291" at the time were John Morrin [*sic*], Max Weber, Marsden Hartley, Arthur G. Dove and Georgia O'Keeffe.

Since that first exhibition of the O'Keeffe drawings, in 1916, there have been six exhibitions of her work; and in these twelve years appreciation has deepened—and her work has progressed—until the present, when two paintings, covering 768 square inches, brought $20,000, and another group of four, all white lilies, sent the [figure] up to $25,000—so far as can be learned, the largest sum ever paid for so small a group of modern paintings by a present day American.

It is remarkable, too, that this American painter has never been abroad; she is wholly a product of her own land, a faithful interpreter of the life around her—and within her.

Through all these years, since the first exhibit when people called her price of $200 for one painting "an outrage," Georgia O'Keeffe has gamely faced the tremendous odds.

But she was out to win.

Four years ago she began "doing" New York, speaking in terms of art. It is her firm belief that "you have to live in today."

Her first painting of the city brought $1,200; last year she received $6,000 for another on the same subject.

"I am going to live as high as I can this year," she said, when she moved to the thirtieth floor of her New York hotel—and there she paints what she sees from her windows. There are no distractions in the room, it is colorless. All the charm of life is out there beyond the windows.

One might anticipate great elation in the artist's manner, at reaching a

point—comparatively early in life—when she is economically free. But apparently money plays small part in her scheme of things.

"It is building step by step against great odds," was her feeling. "It is much more difficult to go on now than it was before. Every year I have to carry the thing I do enough further so that people are surprised again."

Of course she has studied—at Columbia, with Dow, with Vanderpool [*sic*] in Chicago, with Chase of New York, and with Bement, now head of the Art Centre.

Then we took a cab to the Intimate gallery, where the O'Keeffe paintings had recently been exhibited.

The artist had thrown around her [a] colorful garment, a red coat, of henna shade. She seemed a changed being from the woman in the dark dress.

At the gallery we found Alfred Stieglitz, who has all his life been waging for artists a fierce battle to liberate them economically—enabling them to preserve their spiritual integrity.

Mr. Stieglitz was hanging a group of Picabia's paintings, soon to be exhibited, the kind of French art that depicts—to the uninitiated—a procession of skeletons on a spree!

But he deserted his task to show the O'Keeffe lilies, so soon to leave his gallery for France.

When a visitor desires a Georgia O'Keeffe he is apt to remark, "She's a poor girl. She is doing something nobody has done before. If you want these flowers you must give her an equivalent in terms of money. These white flowers are priceless."

80. HELEN APPLETON READ

From "The Feminine View-Point in Contemporary Art," *Vogue* 71 (15 June 1928): 76–77, 96. Courtesy *Vogue*. Copyright © 1928 (renewed 1955) by The Condé Nast Publications, Inc.

Whether or not women have made, or ever can make, a contribution to the fine arts commensurate with that made by men continues to be fertile source for argument. That there has never been a feminine equivalent to Rembrandt or Michelangelo, Phidias or Rodin is frequently used as the conclusive argument regarding the quality and extent of their contribution, clinched with Plato's dictum that women are of the same faculty as men, only less in degree.

But the highest peaks of accomplishment are not the sole gauge of value. If they were, then the works of the many accomplished and interesting artists of the masculine sex, falling short of the genius of the first order, would be dismissed for the same reason. The atmosphere of Parnassus is somewhat rarified for a sojourn of three hundred and sixty-five days. Talent of a less lofty order has its important place in the scheme of things. And the fact that women,

as their opportunities and needs for self-expression increase, are meeting aesthetic standards with increasing ability and in increasing numbers is evident to followers of current art events.

WOMEN AND THE ARTS

Seventy years ago, Emerson expressed a fundamental truth when he said, "When women engage in any art or trade, it is usually as a resource, not a primary object. The life of the affections is primary to them." But this resource has become of necessity also a primary object, as economic and social conditions oblige women to engage in some art or trade for the purpose of making a livelihood, and, if they would succeed in their chosen field, it imposes upon them the necessity of producing competent work.

The question as to whether creative genius of the highest order is incompatible with feminine psychology and physiology can not be argued with any degree of satisfaction. The facts are not forthcoming. Theories may be advanced that for a woman a full emotional life precludes creative expression, but this remains, after all, an unproved theory. History in this case is not an infallible gauge. Such drastic changes have occurred in economic conditions and in the opportunities for self-expression offered to women within the last twenty-five years that any conclusions or prophesies as to their future accomplishment are unsafe ventures. One fact is outstanding and proven, and that is that the double standard for artistic accomplishment has been banished. A work of art, whether it is by a man or a woman, is measured according to the ability with which it expresses a personal reaction to life, competently set down in the medium chosen to express it. But since every work of art must carry with it the flavour of personality, and since personality carries with it inevitably the quality of sex, the feminine view-point and reaction to life are an essential ingredient in woman's expression in the fine arts. Femininity does not, however, mean the traditional feminine subjects, such as flowers, babies, and delicate colour schemes. The feminine character has many facets.

REPRESENTATIVE FEMININE PAINTERS

The paintings that have been chosen to illustrate this article have the common denominator of being executed by women. The artists are Georgia O'Keeffe, Lauren Ford, Marguerite Zorach, Katherine Schmidt, and Thelma Cudlipp Grosvenor. They represent widely divergent points of view and personalities; they measure up to present-day aesthetic standards; their works are shown in mixed group exhibitions, are accorded praise by critics, awarded prizes by juries, and are bought by astute collectors. No one of these artists "carries the art of some man across her fan," as George Moore described the feminine attitude towards painting. No one of them makes the mistake of a Rosa Bonheur, to cite the historical example, of attempting to use a masculine formula and so producing barren imitative work. They possess sensibility, taste, and imagination with-

out the reverse characteristics of these qualities, which are weakness and senti-mentality. Their works are excellent investments for the amateur collector in that their prices are as yet comparatively low, but the increasing favor with which they are regarded by connoisseurs would lead one to believe that this situation will not remain the same for long.

FLOWERS OF THE ARTISTIC FIELD

Georgia O'Keeffe, whose flower arrangement, "White Petunia and Salvia," is reproduced at the top of page 76, is regarded by many critics and art lovers and hosts of romantically minded young people as the high priestess of woman's expression in the arts. A tendency on the part of some of these devotees to regard her work as a new symbolic language, expressing the experiences of love and passion, has proved somewhat detrimental to her aesthetic integrity. It is not, however, solely the fact that she is the first woman to put down on canvas "in a beatified [sic] sense what it is to be a woman in love," as one critic describes her art, that accounts for the high place accorded her, but because she paints flowers and fruits and, occasionally, landscapes extremely well. Her view-point is unique and personal, and her technical equipment extraordinarily competent and individual. Her most successful and typical expressions are gigantic close-ups of single blossoms (petunias, callas, orchids, and roses are her preference) in which beauty of reality, that is texture, shape, perfume, and colour, loses not a jot in also serving as symbols of human emotions. Granting their symbolism, they are without literary symbolism in the ordinary sense of the word. A natural flower form, painted with minutest realism, becomes, through arrangement and emphasis, a symbol. Georgia O'Keeffe is one of the Seven Americans sponsored by Alfred Stieglitz at the Intimate Gallery, Room 303, Anderson Galleries. All of these artists are, according to Mr. Stieglitz, exponents in their own personal way of a purely American quality. "White Petunia and Salvia" may be pur-chased at the Intimate Gallery for about two thousand dollars.

81. UNIDENTIFIED WRITER

From "We Nominate for the Hall of Fame," *Vanity Fair* 30 (August 1928): 63. Courtesy *Vanity Fair.* Copyright © 1928 (renewed 1955) by The Condé Nast Publications, Inc. (Illustrated with photograph by Al-fred Stieglitz: *Georgia O'Keeffe: A Portrait—Head*, 1919?; fig. 21.)

GEORGIA O'KEEFFE

Because she is an American painter who was originally discovered by Alfred Stieglitz, whose wife she is, and who made this photograph of her; because for a month she held an amazingly successful exhibition at Anderson Galleries last

winter; because her painting has an originality which gives it especial impor-
tance; and finally because she is a black and white artist of unusual distinction[.]

1929

82. CHARLES DEMUTH

Statement in *Georgia O'Keeffe: Paintings, 1928* [exhibition catalogue]
(New York: The Intimate Gallery, 4 February–17 March 1929), n.p.

Across the final surface,—the touchable bloom if it were a peach,—of any fine
painting is written for those who dare to read that which the painter knew, that
which he hoped to find out, or, that which he whatever.

83. MURDOCK PEMBERTON

From "The Art Galleries: A Fortunate Lady and Some Mere Mortals,"
New Yorker 4 (9 February 1929): 73–74. (Review of exhibition, "Georgia
O'Keeffe: Paintings, 1928," New York, The Intimate Gallery, 4 Febru-
ary–17 March 1929.) Reprinted by permission; © 1929, The New Yorker
Magazine, Inc. Copyright duly renewed.

The miracle of Georgia O'Keeffe is again with us in the Stieglitz Room 303, at
the Anderson Galleries. In a country where the norm rather than the departure
is worshipped, her way of doing things causes contention. However, she is
fortunate in attracting two great classes of picture lovers—the laymen who
indulge themselves in the simple pleasure aroused by color, and the artists who
have had to learn what she seems to have been given as a gift from the gods.

We suppose it is a gift. We find it hard to believe that any one in a normal
span of life could learn as much about color as Miss O'Keeffe has or, having
learned it, find the time to apply the knowledge. Her color relations seem to
flow out of her fingers, subconsciously and certain in the necessary note and
degree. Now and then, when Miss O'Keeffe combines this accuracy of color
with the proper sense of form, she achieves a thrilling and dramatic picture.
Her "Calla Lilies on Red" is as exciting a painting as anything we have seen this
season. The intense, pure white of the two flowers shines with an uncanny
luminosity against the green leaves. Behind the leaves is red. We believe it was
Marsden Hartley, writing of O'Keeffe, who once said that she seems to catch
red at the point where it turns into green. We know of few who have been able
to juxtapose the two and achieve such beauty.

Miss O'Keeffe's favorite canvas, we believe, is a large one—"Yellow Hickory Leaves with Daisy." It too is a superb composition on the scale of yellow, running through the pure golds into orange. It takes more time to accomplish its purpose than the "Calla Lilies" does, or perhaps we should say it sets out on another errand; its mood is an autumnal one. The "Dark Leaves" is still another kind of picture. Nature here has imposed a mold on the artist, and we feel that the painter has made a generous gesture and allowed Nature to dictate. There is a Japanese feeling in the treatment, as there is in "Faded and Black Leaves."

Some of the other canvases show what Miss O'Keeffe can do when she has a mind to turn her hand to the pictorial. Her "Red Barn, Wisconsin" has some fine painting and almost achieves greatness. Her "Wave—Night" is a tour de force in mood and somewhat gentle compared with the singing flowers.

84. HENRY MCBRIDE

"Paintings by Georgia O'Keefe [*sic*]: Decorative Art That Is Also Occult at the Intimate Gallery," *New York Sun* (9 February 1929), 7. (Review of exhibition, "Georgia O'Keeffe: Paintings, 1928," New York, The Intimate Gallery, 4 February–17 March 1929.)

Paintings by Georgia O'Keefe are now on view in the Intimate Gallery. I shall do my best to tell you about them, but would much prefer, in the case of this particular exhibition, to write it up on the last day of the show rather than on the first; for in any Georgia O'Keefe exhibition the paintings are only the half of it; it's the behavior of the people who attend it that counts.

For Miss O'Keefe is occult. People come from long distance to consult her works. Last year, a week after the expiration of her show, and on the opening day of an exhibition by a totally different artist, a group of old ladies arrived, of the most intense respectability and with a pious air as well, who said that they had come all the way from Davenport, Iowa, specially to see Miss O'Keefe's paintings of petunias, and who seemed heartbroken at missing them. There was a poignancy to their grief that was highly complimentary to Miss O'Keefe's skill as an artist and reflected as well the high grade of aesthetic sensibility to which Davenport, Iowa, has attained.

Should they arrive this year in time for the show, the ladies will again be disappointed, for there are no petunias. They will be consoled, though, by the calla-lilies. Miss O'Keefe's calla-lilies this year are—I beg you to believe me—fully a yard wide. I could not help thinking of Walt Whitman while studying them. Walt Whitman had grand ideas for America, as you may remember. Nothing was too good for America, and, too, it was America that produced the goods. But no painter in Walt Whitman's day ever dreamed of such calla-lilies as Miss O'Keefe has dreamed of. They represent the apotheosis of calla-lilies,

and in an elusive but definite enough way for those who are at all psychic, the present grandeur of these United States. Walt Whitman knew that these calla-lilies would come some day and here they are. (Davenport newspapers please copy.)

Personally I got the most direct message from the picture of a wave at night. In this there is an expanse of dark water and just over a distant hill, in the direct center of the canvas, a single star glitters. There is something about the relent-less way in which this star is made the center of the universe that is unquestion-ably hypnotic. It is in front of this picture, I feel sure, that the chief drama of the Intimate Gallery will be unrolled during the six weeks of the exhibition. It is a decorative picture and well painted, but it is its direct appeal to the subconscious that gives it distinction.

Dropping her mystic powers for the nonce, Miss O'Keefe pays tribute to the city of her transient stay by a large aerial study of its rivers and environs. This has been done from the top of the Shelton Hotel. It had been intended as, and is a sufficiently literal rendering of, one of the most amazing scenes on earth. The harbor of New York, as seen from the air, is wonderfully beautiful but also breath-taking; and the mere facts are overpowering without any mysti-cism.

A smaller and shorthand version of this scene is in a freer style and in fact has more style. It is in a way the most modern thing in the collection. This small view of the river, a view of the Ritz Tower at night, the study of the wave at night, and the enormous calla-lilies, are the four works in the exhibition that I would honorably mention. However, as I said at the beginning, these are only the pictures—the events will now begin.

85. Edward Alden Jewell

"Georgia O'Keeffe," *New York Times* (10 February 1929), sec. 9, p. 12. (Review of exhibition, "Georgia O'Keeffe: Paintings, 1928," New York, The Intimate Gallery, 4 February–17 March 1929.) Copyright © 1929 by The New York Times Company. Reprinted by permission.

At the Intimate Gallery, Georgia O'Keeffe is holding her annual show. These appearances never fail to constitute "events" in the art world. Miss O'Keeffe will probably be an Old Master some day, all ticketed and securely niched; but as yet we see the work in what may be called a fluid state, unstatic, mobile, alive with potentialities. It is a most stimulating show.

Some may reasonably feel that the present group of paintings represents some sort of transition period in her art. Just what direction the transition is taking seems not at the moment altogether clear, and there is nothing on view that could be termed a really radical departure. There is a red barn, painted in Wisconsin; but Miss O'Keeffe has approached that type of subject before. There

are two more or less literal views of the East River from the Shelton and there is one impression of the Ritz Tower at night—again familiar subjects, though less touched with genius, one may feel, than are the flowers and abstractions.

Perhaps the new note is allied with an increased emphasis upon the decorative, contrived not so much by heightened color as by more striking juxtapositions than has been customary in the past. The latest work from her brush, a still life—pink bowl against a window with an urban view—is definitely decorative, though nothing that Miss O'Keeffe does could be called decorative in any superficial sense. There is perhaps a tendency just now on her part to orient from an objective rather than a subjective angle. Yet designs that have obviously been worked from the inside out are plentiful, too. The writer felt in looking at the new pictures [a] somewhat less cosmic atmosphere than was present last year. This may be a personal reaction without real significance, or it may point, again, to the not easily assignable spirit of change in the direction this art seems to be taking.

There are six out-and-out abstractions, and very beautiful abstractions. There are semi-abstractions, like "Wave—Night." A red pepper and some green grapes are attractively combined, and among the flowers, the calla lilies, red cannas and poppies predominate. There are a few extremely sensitive and delicate small paintings that quite hold their own in the presence of expressions that are larger and more flaming.

It will be appropriate to include here a sentence written by Charles Demuth, which appears as a foreword for the catalogue. It is a bit cryptically phrased, yet the essence fits the occasion very well:

"Across the final surface—the touchable bloom if it were a peach—of any fine painting is written for those who dare to read that which the painter knew, that which he hoped to find out, [*sic*]

86. EDWARD ALDEN JEWELL

From "Lost Chord Retrieved: Demuth's Divining Rod Works Whether Applied to O'Keeffe or to Old Masters," *New York Times* (24 February 1929), sec. 10, p. 18. (Commentary about exhibition, "Georgia O'Keeffe: Paintings, 1928," New York, The Intimate Gallery, 4 February–17 March 1929.) Copyright © 1929 by The New York Times Company. Reprinted by permission.

A fortnight ago on this page a sentence from the prose works of Charles Demuth was quoted in connection with the current showing of pictures by Georgia O'Keeffe—misquoted, rather, since through some unfathomable fault in nursing the page past its concluding milestones of preparation, the pat and well-packed observation had its tail cut off. We open our columns once more to Mr.

Demuth, always an honored guest, for, in addition to the amends that have until now remained in arrears, his comment is again, pithily, apropos:

"Across the final surface—the touchable bloom if it were a peach—of any fine painting is written, for those who dare to read, that which the painter knew, that which he hoped to find out, or that which he whatever."

The last five words went the way of all newspaper lead, but somewhat, alas, before their allotted time. Yes, they savored prematurely the bubbling experience of the melting pot, in which type that has served its purpose becomes molten—only to cool and re-emerge as the vehicle for fresh expression of the morrow. . . . But the phrase "that which he whatever," if cryptic, is still oracular. And by way of proof we use it now (in conjunction, of course, with the rest of Mr. Demuth's sentence) as a text for Old Masters.

Old Masters, far though they be in cry from that new master Miss O'Keeffe, are with us in considerable array this week. You are at liberty to choose your gallery. If you are wise you will choose both galleries. . . .

One can grow positively excited over these Old Masters. To tell the truth, at Knoedler's just now and chez Edouard Jonas you are offered fare quite as piquant as that customarily served at, say, the Daniel, or at the Dudensing or the Valentine, or at the Intimate—for we are stealing, by degrees, back to Demuth and his tribute to O'Keeffe. . . .

What is true of Miss O'Keeffe's final surfaces (if any surfaces can actually be called final) is also true of those across which is writ what bygone creators had to say for themselves and concerning the world as they saw it.

87. Murdock Pemberton

From "Mostly American," *Creative Art* 4 (March 1929): l–li. (Review of exhibition, "Georgia O'Keeffe: Paintings, 1928," New York, The Intimate Gallery, 4 February–17 March 1929.)

The beginnings of the month had brought nothing as interesting to followers of American contemporary art as the show of Georgia O'Keeffe. Miss O'Keeffe will tarry into the new month, at Room 303 in the Anderson Galleries, so that those who care may admire.

We have written so much about Miss O'Keeffe that we find there is nothing new to say. She has gone ahead along a certain line of achievement but her rhythm is not the sort that shows so well on the yearly chart. Some years we have thought she has made more progress than others, and some years we have quar[r]eled a bit with her offering. Miss O'Keeffe presents a problem to the chronicler who is accustomed to rely for his account on the ever changing style of most of the artists he sees. One year you can say "Mr. Heerman is pretty bad

Zuloaga," or next year "Mr. Heerman is very bad Heinz 57." Miss O'Keeffe has always been O'Keeffe.

We think that her study of *Calla Lilies on Red* is a painting that might be used as a text book. It has all the form and design necessary and presents almost a chemist's balance of the proper amounts and degrees of color. We thought that this picture was a good deal more thrilling than some of the larger ones, such as the huge yellow leaves with the small daisy. But we are always willing to waive any prejudice we may have and leave the last word to O'Keeffe. Her barns are thrilling in a way, though we felt we would have liked a little breaking up of the space given to the larger wing. Bits of this composition we found quite sublime.

One of Miss O'Keeffe's chief patrons lives in Paris, according to the well-guarded legend. We think this is just, as nowhere else on earth would they be as sympathetic to what this painter is doing than in the eternal city. There she will be welcomed, we are sure, as a fit crusader from the land of Fords and towers. If you are marching along with the procession these days you will have seen O'Keeffe or will manage to drop everything and get into the Stieglitz room. Few efforts would be better repaid.

88. DOROTHY LEFFERTS MOORE

From "Exhibitions in New York," *The Arts* 15 (March 1929): 185–87. (Review of exhibition, "Georgia O'Keeffe: Paintings, 1928," New York, The Intimate Gallery, 4 February–17 March 1929.)

Georgia O'Keeffe has become so much an institution, her point of view is so definitely familiar to the many who have known it since Alfred Stieglitz first exhibited her drawings at "291," that it is difficult to find a point of departure for criticism. That greatest sin of so-called critical writing, interpretation, is all too easy. And yet her pictures do not invite interpretation in themselves, except to those who are more curious to discover what made O'Keeffe feel that way than to feel for themselves. The people who feel that to understand Beethoven's or Tchaikowsky's symphonies, they must pry into their personal affairs and determine the precise state of their feelings, elated or dejected, at the moment of composing, are those who will tire themselves out trying to interpret the subject-matter of O'Keeffe's painting. Just as I feel this is the most deadening approach to great music, and can be possible only after one is completely famil-iar with the score, I feel that one misses entirely the intention of O'Keeffe by supplying her work with a program. And yet half the visitors to the Intimate Gallery can be heard asking each other what it *means*. The definiteness and cleanness with which the painter crystallizes what in her must have been a transitory state, is one of the factors which mislead people to think the stimulus of the emotion must be there, as evident as the resultant form and color. This

is to misapprehend the nature of subjective art, in which the object stimulating a mental and emotional reaction is lost sight of in the crystallization of that state of mind and emotion.

It is, of course, challenging the limitations of a graphic art to attempt so pure a subjectivism. But it is not impossible, and this is an honest attempt. The difficulty, of course, is to combine technical skill and sophistication with an honest expression of an inner feeling, evading a sterile self-consciousness. Those who are shocked by an artist who translates her most personal emotions into paint, forget that this is the inner compulsion of every artist, although only few succeed in tearing away all the wrappings of tradition and artistic convention. Only last year Eugene O'Neill was subjected to public scrutiny for attempting to bring the unspoken feelings of his characters directly into his drama; by now the popular vote has established the success of his attempt. As a technique, the experiment was similar to O'Keeffe's. Painting, however, permits a more precise definition of an emotion without recourse to known objects by means of words. In this way, less of the exquisiteness of the emotion is lost; although unfortunately the civilized West is so representationally-trained, that it will go out of its way to relate pure form to known objects.

I cannot help wishing that O'Keeffe would experiment with the Clavilux, although I do not share the feeling of those who object to her pictures because they can only transfix one moment, and because they feel that a moment of emotion cannot be looked at more than once. But it seems to me that the Clavilux would free her more completely from representation, where such was her desire, and would also free the observer from his previous habits of observation. Its essentials are form and colored light, and these are the materials over which O'Keeffe has developed such perfect control in pigment. The addition of dynamic movement should enhance the exhilaration of the observer.

It would do so, in the event that O'Keeffe has an equal command over moving and continuous design as she has over the selected moment. But the one thing that can be said most positively of O'Keeffe's art is that it is essentially a woman's. It is her great triumph that she has painted as a woman feels, without confusing her vision with that of men, however good as artists they may be. It is the result of her ability to analyze feeling in herself and to represent that feeling. Others have tried, but have been led astray by what they think they do or ought to feel. O'Keeffe, having succeeded with an extraordinary power of concentration, inevitably gives us a woman's personality. Moreover, her characteristics as a woman seem to be sensitiveness, intensity of power to see and imagine, and balance under high tension; and like most women, she is capable of isolating a moment and making it seem eternal. Possibly the psychologists know whether these are virtues peculiar to women, and whether to men belong the more active capabilities of conceiving mass in motion, of making the sustained effort involved in such a medium as Lumina, the art of the Clavilux. That there would be exceptions is natural; but the majority of creative work up to the present seems to me to substantiate the idea.

It is only after having seen the work of Georgia O'Keeffe that one realizes vaguely what is the matter with the New York Society of Women Artists. The exhibition of that body at the Anderson Galleries had several bright spots, but the good work was done by a few, very few individuals. The majority not only show undistinguished work, but seem to be on the wrong track. Most of their pictures can be traced to the influence of some masculine painter. They have probably studied with men-teachers, and have absorbed the style and, as far as possible, the personality of the teacher or some other man whom they admire. One painter and two sculptors stand out for the quality of their ideas and execution, and these happen to be the three who have most succeeded in asserting their own very individual and feminine personalities.

89. ROBERT M. COATES

"Profiles: Abstraction—Flowers," *New Yorker* 5 (6 July 1929): 21–24. Reprinted by permission; © 1929, 1956, The New Yorker Magazine, Inc.

Toward the close of a gloomy afternoon in November, 1915, a girl named Anita Pollitzer walked into the little picture gallery at 291 Fifth Avenue where for several years Alfred Stieglitz had been exposing the paintings of the French modernists to the gaze of a dismayed and irritated public. She had a roll of drawings under her arm; they had been sent, it appeared, by a friend of hers named Georgia O'Keeffe, a teacher of drawing in the public schools in Amarillo, Texas. "She told me particularly not to show these around—she said to throw them away when I'd done with them," the girl explained, impenitently, "but I just couldn't bear to. I felt I had to show them to somebody."

Stieglitz turned the gaslights a little higher, and the drawings were unrolled. They were flower subjects, done in charcoal, and the treatment was in the manner which, for want of a better word, has come to be called "abstract." Stieglitz looked at them; he knew at once that he had struck on something very close to genius, and, in spite of Miss Pollitzer's objections, he insisted on exhibiting them. "There'll be trouble when O'Keeffe hears about this!" she warned him.

There was trouble. O'Keeffe came flying on to New York; she marched into No. 291 with all her Irish anger flaring. "What do you mean by showing these drawings?" she demanded. "I gave you no permission at all." But Stieglitz, with his air of a weary prophet, wore down her wrath. They walked about the room together; he discovered that her attitude was mainly defensive—she was afraid that those strange interlacing patterns she had drawn from the hearts of flowers or from their curling petals would seem incomprehensible and foolish to others. "Do you know what they mean?" he asked her. "Do you think I'm an idiot?" she countered. He showed her some drawings by Matisse, Picasso, Braque; she

was amazed to learn that others beside herself were trying to release design from the limitations of realism. In the end, when she went back to her school-children in Texas, she had promised to send him all her drawings, for exhibition.

The drawings came: she sent them carelessly, two or a dozen in a bunch, without even bothering to insure them. When finally in 1917—with the war coming louder and louder, intervening between him and his friends, saddening him—Stieglitz decided to close the door of No. 291 forever, he ended the history of that famous gallery with an exhibition of her work.

There was a hubbub among the critics. O'Keeffe came on to New York again, this time determined to stay. The drawings hadn't sold; she had no money, but she wanted to paint. Stieglitz lent her twelve hundred dollars, and she lived on that for a year, painting in a little back room she had rented in Fifty-ninth Street. She struggled through another year and then, in 1920, her first big uptown show was arranged, at the Anderson Galleries.

She was still unknown and still a mystery, but the aesthetic principles on which she and many other artists based their work had all been hashed and rehashed by eager and sometimes too-willing apologists. So the spectacle of an entire canvas devoted to the corolla of a flower, or of another composed of two straight lines and labelled simply "Abstraction II," was nowhere near so startling as formerly. O'Keeffe's show was a success. She happened to be present in the gallery when the first picture was sold. It was a flower study, and the price was four hundred dollars. O'Keeffe's face went white as the canvas itself— not at the price, as she later explained, but at the sudden realization that she would never see that painting any more.

She was born on a Wisconsin wheat farm, near the little town of Sun Prairie, in 1887. Her father, Francis O'Keeffe, was of course an Irishman; her mother, Ida Totto, was Hungarian. There were six other children—four girls, two boys. She lived in the little prairie town until she was fourteen—she remembers that a neighbor named Mrs. Mann taught her to copy pansies—and then in 1901 the whole family moved to Williamsburg, West Virginia [*sic*].

They had their ups and downs. Francis O'Keeffe went into the trucking business, failed, and started over again. Mrs. O'Keeffe died. The children were marrying, moving away, but Georgia didn't want to get married; she wanted to be a painter, and so, in 1904, she was packed off to Chicago, to study at the Art Institute. A year later she came on to New York, and entered classes at the Art Students' [*sic*] League.

Old-timers at the League still remember her as she was in those days. She had jet back hair and her skin was ivory white, she had a dashing air, an Irish gaiety: everybody called her "Patsy." She had learned to draw under Vander-poel in Chicago, and now she began to study with William Merritt Chase, who wore a monocle, and interspersed his lectures with anecdotes of Whistler and Sargent, and who could paint a codfish so glitteringly that the thing seemed actually to be scaly. She studied under Chase and F. Luis Mora for a year; she

learned to dab on highlights and put purple in the shadows—and then, suddenly, she wasn't interested any more.

Everywhere, at that time, little groups of young artists had been losing interest likewise. Painting, they felt, had become nothing more than a pure technique of representation and so, to the consternation (and perhaps the secret envy) of their elders, they were rising in revolt, forming vociferous and impertinent schools—of Cubism, Futurism, Dynamism, Simultanéism, Dadaism—whose first rules were to have no rules at all.

O'Keeffe, however, knew nothing of this, and consequently, when she lost interest, she concluded that it must be herself, and not the system, that was to blame. The upshot was that in 1906 she decided she could never be a painter, and gave the whole thing up for good. As a matter of fact, it was almost ten years later that she took up her brushes again.

In the meantime, however, she had to earn a living, and drawing was the only trade she knew. She drifted about, doing the handy-man jobs of the arts. She worked in Chicago at various advertising agencies, she studied at Teachers College in New York, taught drawing in Virginia. Little record of these wandering years remains, save that she once startled some school board or other by advancing, apparently as her chief qualification for a teacher's position, that she "knew nothing whatever about art," and that she scandalized everybody in a sedate Virginia town by her practice of rising hours before dawn to take long solitary rambles over the countryside. She ended her peregrinations, as has been noted, at Amarillo, Texas; she had been teaching there a year when some strange impulse prompted her unaccountably to draw flowers, for once, as she really felt flowers ought to be drawn and (not daring to show them to anyone in Texas) to send the sketches off to New York. Flowers have been either the subject or the basis for abstract design in most of her paintings ever since.

One of the cruellest misconceptions ever perpetrated was that by which the modern painters came to be called "intellectual." Its implications still remain to confuse the layman and stultify the artist in spite of the fact that by now everyone should know that the only mental process involved in non-representational art is a negation, eliminating or otherwise nullifying the methods—of perspective, foreshortening, highlighting, and shadowing—by which the older painters tried to rationalize three dimensions out of two. With this exception, intellectually, the modern artist starts from scratch. O'Keeffe, however, has not been able to escape the inference on the part of critics that a great deal of deep thought goes into the formulation of her paintings. As a matter of fact, the reverse is more nearly true. Her years with the drawing-school classes have taught her the use of a clear, sharp line, and her own sincerity of vision uses that line as a knife-edge, cutting to the core of her emotional experience.

For the rest, she paints as she feels, impulsively. She does no under-painting on her canvases; she rarely even blocks out her design in advance. Sometimes, in the midst of an evening's conversation, she will be seen furtively sketching a few lines on a bit of paper or the back of an envelope; when she sets

up her canvas, she begins at one corner and paints right across it, as one would write a letter.

Very often, however, she paints the same subject over and over again, until the final canvas satisfies her; it is in this way that most of her "abstractions" are developed. Thus with the famous "shingle-and-shell" series, painted some three years ago after a period of convalescence at her summer home on Lake George. While she lay abed, she had been playing with a clamshell someone had brought in from the beach; she added an old shingle whose weather-beaten color attracted her, and a leaf. When she was strong enough, she started to paint.

The first panel was sober and realistic. In the second, her interest had centered on the shell; it occupied more than half her space, while the leaf had diminished to a streak of green, and the shingle to a monotone of burnt sienna in the background. The third and last became a study of color-values, in which the outlines of the objects had been completely lost, in her effort to make the pigments themselves move and harmonize.

Sometimes, it might be said, this unordered approach to the subject flaws her abstract painting: such work, having no intellectual limitations, must obey an all the more strictly imposed emotional rule. But in her other pictures—in her flower paintings and her still-lifes—this same impulsive quality becomes her greatest charm. Here she focuses her entire canvas on a single petal or a single bud: it is as if she brought the flower nearer and nearer, as if she kept peering more and more closely, trying to find the secret of beauty there.

Most of us, sprawling out in a field in the country, have poked apart the grass-roots, fingered the soil, and studied with a kind of vague awe the minute life we found there. That mood, but sharper and clearer, is the mood that dominates all of O'Keeffe's best painting.

She was married, in December, 1924, to Alfred Stieglitz. They tried to do it quietly, planning to ferry over to New Jersey and get the business over with the least fuss possible, but the expedition turned out to be quite an event, if not for their friends, at least for the Jersey police. John Marin, the watercolorist, met them at Weehawken with a new car he had just bought, and he proceeded to demonstrate his skill at the wheel by bouncing off a grocery wagon, caroming across the road, and demolishing one of New Jersey's most substantial electric-light poles. There were crowds, altercations, exchangings of license numbers, but O'Keeffe and Stieglitz patched up their bruises and went on to Cliffside, where the local hardware merchant, doubling as J.P., delivered them their marriage license.

They live now, in an atmosphere of good-natured asceticism, at the Hotel Shelton and at Lake George. O'Keeffe, in spite of many illnesses, is still a great walker. She retains at forty-two the pale profile and blue-black hair, the sense of inner vitality that made her a famous beauty at the League. She wears black almost invariably—not, she says, because she prefers it, but because, if she started picking out colors for dresses, she would have no time for painting. Last winter, however, she startled everybody by appearing at the exhibitions in a

bright scarlet cloak. She is, in the sophistic sense, not a modern at all: she has never read Freud, doesn't like plays, wears long skirts and long hair, and has never been to France. She is, however, an ardent feminist.

Her original agreement with Stieglitz still holds good: no one but he has ever exhibited her work, and her paintings are usually to be seen at the Intimate Gallery, which he conducts, in the Anderson Galleries Building. Her output is not tremendous: a complete catalogue of all her works would not number more than three hundred paintings; of these, about a hundred have been sold. Most of the others remain unsold chiefly because Stieglitz refuses to part with them.

He has always refused to set any fixed values for her work, to build up any "market" in O'Keeffes; consequently, her prices and her sales depend very much on how Stieglitz happens to feel at the moment. Last year, for instance, a collector who stated that he wished to remain anonymous asked for the price of a series of five paintings of lilies. Stieglitz, piqued, demanded twenty-five thousand dollars, and no one was more surprised than he when the price was accepted without question. O'Keeffe herself was so astounded that she couldn't paint for three months thereafter. The buyer still remains anonymous.

Duncan Phillips is one of the few great collectors who have acquired O'Keeffes: he bought three flower studies for his Memorial Gallery in Washington. Another of her paintings hangs in the Brooklyn Museum; it was the bequest of Mrs. Rossin, daughter of Adolph Lewisohn. Most of her work, however, is sold to more intimate admirers, and with these Stieglitz sometimes makes strange treaties. Thus, Maurice Wertheim, one of the sponsors of the Theatre Guild, recently acquired an O'Keeffe landscape by contracting to pay the artist twelve hundred dollars annually for a period of five years; the "shingle-and-shell" series was sold to another lady who agreed to turn over to Stieglitz the money she would otherwise have spent on a new Rolls-Royce.

Sometimes, however, he refuses to sell at all. At the last show, a lady from Cleveland or thereabouts indicated rather patronizingly her willingness to buy a certain canvas, but there was something about her attitude that didn't appeal to him. "Why do you want that painting?" he demanded. "Give me some reason why you want it." Since the lady couldn't give him a satisfactory reason, she didn't get the picture.

90. Suzanne La Follette

From "Modern Painters and Sculptors," chap. 10 in *Art in America: From Colonial Times to the Present Day* (New York: Harper & Bros., 1929), 329–30.

For his etchings Mr. [Walter] Pach has found much inspiration in the recent monumental architecture of New York. Some of his best plates are those in which he has taken for subjects such buildings as the Shelton, the New York

Telephone building, or the impressive grouping of the skyscrapers on lower Manhattan. He has not been the only artist to perceive the possibilities offered by architecture in building up the rigorously ordered masses that form so important an element in modern design. . . . Georgia O'Keeffe has found in the great buildings inspiration for those canvases in delicate tones of gray which to one observer at least are more satisfying than the symbolic flower pieces upon which her reputation chiefly rests.

Miss O'Keeffe is a painter of ability and originality whose work is distinguished by refinement of perception—a refinement which sometimes, indeed, borders on the precious—and such a control of her medium as is not often met with among American artists.

Appendix B

Contributors to the Criticism

Adlow, Dorothy (1901/4?–64). Critic, educator. Studied, Radcliffe. Art critic, *The Christian Science Monitor;* lecturer, Boston Museum of Fine Arts. Recipient Art Critics Award, American Federation of Arts, 1953. Citation of Merit, Creative Arts Conference, Boston University, 1957 (citations also awarded to, among others, Maxwell Anderson, Brooks Atkinson, Eugene Ormandy, Karl Zerbe). *See Appendix A, no. 66.*

Anderson, Sherwood (1876–1941). Writer. Born Camden, Ohio. Attended public schools. Worked as newsboy, house painter, and stable groom before serving in Spanish-American War. After war, was advertising copywriter in Chicago and manager of paint manufacturing firm in Ohio. In 1913, apparently walked away from job and family and began life as a writer (rejection of materialistic middle-class life was subject of first novel, *Windy McPherson's Son* [1916]). Became affiliated with Stieglitz circle, October 1917. Among American authors, was one of first to investigate the intricacies of motivation and the psychological process, particularly the psychology of sexuality and the unconscious. Other novels and short story collections include *Winesburg, Ohio* (1919), *Poor White* (1920), *Horses and Men* (1923), *Dark Laughter* (1925), and *Kit Brandon* (1936); two autobiographical works are *A Story Teller's Story* (1924) and *Tar, A Midwest Boyhood* (1926). *See Appendix A, no. 34A.*

Barker, Virgil (1890–1964). Educator, critic, writer, lecturer. Born Abingdon, Va. Attended Harvard and Corcoran School. Curator, Carnegie Institute, 1919–20; Director, Kansas City Art Institute, 1920–21; professor, University of Miami, from 1931. Contributor, art magazines. Publications include *Pieter Breugel the Elder* (1926), *A Critical Introduction to American Painting* and *Henry Lee McFee* (1931), *American Painting: History and Interpretation* (1950), and *From Realism to Reality in Recent American Painting* (1959). *See Appendix A, no. 31.*

Berman, Berel Vladimir (1896–). Newspaperman. Educated privately. Early career as police reporter, the *New York Tribune;* general reporter and copy reader, the *Brooklyn Standard Union* and the *Brooklyn Times.* Copy reader and drama reviewer, the *New York Evening Graphic.* Reporter, the *Illustrated Daily News;*

rewrite manager, New York City News Association. Contributed verse and articles to various newspapers and magazines. *See Appendix A, no. 78.*

Bluemner, Oscar Florianus, Jr. (1867–1938). Architect, painter. Born Hanover, Germany. Studied, Royal Academy of Design, Berlin; exhibited, Royal Academy, Berlin, 1892. To Chicago, 1893; practiced architecture until 1903. Exhibited in Armory Show, at 291 in 1915, in Forum Exhibition in 1916, and at Intimate Gallery in 1928. Articles for *Camera Work*, 1913: "Auditor et Altera Pars: Some Plain Sense on the Modern Art Movement," and "Walkowitz." *See Appendix A, no. 57A.*

Breuning, Margaret Wilbur Gaines (–). Critic, writer. Art critic for the *New York Evening Post* from early twenties to early thirties. Then, to late 1950s, contributed articles to *Arts Weekly, Studio* (London), *Magazine of the Arts, Parnassus*. From mid-forties to January 1961, contributing editor and regular columnist for *Arts Digest/Arts Magazine*. Novel: *You Know Charles* (1921). Other publications include *Exploring New York's Art Galleries* (1928), *Maurice Prendergast* (1931), and *Mary Cassatt* (1944). *See Appendix A, no. 35.*

Brook, Alexander (1898–1980). Painter. Born Brooklyn. Attended Art Students League, 1915–19. Studied with Kenneth Hayes Miller. From 1929 into fifties, awards in major national exhibitions (Chicago Art Institute, Carnegie Institute, Pennsylvania Academy of Fine Arts, etc.). Member Society of Independent Artists. Included in major American museum collections. Husband of illustrator-printmaker, Peggy Bacon, 1920–40. *See Appendix A, no. 19.*

Bulliet, Clarence Joseph (1883–1952). Writer, critic, educator. Studied, Indiana University. Early career as news editor, the *Louisville Herald*. Art and drama critic, the *Chicago Evening Post*, 1924–32; art and music critic, the *Chicago Daily News*, 1932–46. Chosen as one of ten Americans to be founding member of International Association of Art Critics, Paris. Publications include *The Significant Moderns* (1936) and *French Art from David to Matisse* (1941). *See Appendix A, no. 68.*

Burroughs, Alan (1897–1965). Critic, newspaperman, art analyst. Born Norwich, Conn. (father, Sam Bryson Burroughs, was artist and Curator of Paintings, Metropolitan Museum of Art). Degree, Harvard, 1920. General reporting, then art editor of the *Brooklyn Daily Eagle*, editor *The Arts*, and, later, editorial writer for the *New York Evening Sun*. From 1923 to 1926, painting curator, Minneapolis Museum of Art. In 1924, discovered X-ray analysis of paintings; much noted for expertise at authenticating works of art (witness for defense in lawsuit brought against Sir Joseph Duveen, heard before New York Supreme Court in 1929). Authenticated many works for major museums. Lecturer, Harvard, 1932–47; research fellow, Fogg Art Museum, 1936–47. Publications include *Note On the Principles and Process of X-Ray Examination of Paintings* (1928), *Kenneth Hayes*

Miller (1931), *Limners and Likeness: Three Centuries of American Painting* (1936), *Art Criticism from a Laboratory* (1938), and *John Greenwood in America, 1745–1752* (1943). *See Appendix A, no. 12.*

Cary, Elizabeth Luther (1867–1936). Critic, writer. Born Brooklyn. Educated privately. Wrote series of books about literary and art figures, 1898–1907 (Tennyson, Robert Browning, the Rossettis, William Morris, Emerson, Henry James, William Blake, Daumier); began monthly art journal, *Scrip*, in 1905. In 1908, became first person hired by the *New York Times* to write, exclusively, art criticism; held position of art editor until 1936, though after 1927, generally did not write weekly reviews. Considered *doyenne* of American newspaper art critics. Other publications include *The Works of James McNeill Whistler* (1913) and *George Luks* (1931). *See Appendix A, nos. 13, 23, 38.*

Cheney, Sheldon (1886–1980). Writer, critic, art historian, lecturer. Born Berkeley, Calif. Studied, University of California, Berkeley, and California College of Arts and Crafts. Art critic, various newspapers and magazines, 1910–16; founded *Theatre Arts* in 1916 and was editor to 1921. Freelance writing from then to end of career. Work with Equity Players, New York City, 1921–25. Lectured, museums and universities, 1935–47, and taught art, Union College, 1937–40. Publications include *The New Movement in the Theatre* (1914), *The Open Air Theatre* (1918), *The Art Theatre* (1925), *The Theatre: Three Thousand Years of Drama, Acting, and Stagecraft* (1929), *New World Architecture* (1930), *Expressionism in Art* (1934), *Art and the Machine* (1936), *A Primer of Modern Art* (1939), *Story of Modern Art* (1941), *Men Who Have Walked with God* (1945), *A World History of Art* (1952), *Stage Decoration* (1966), and *Sculpture of the World* (1968). *See Appendix A, no. 29.*

Coates, Robert Myron (1897–1973). Critic, writer. Born New Haven, Conn. Studied, Yale. To Paris, 1921; walked to Rome, then returned to live in Giverny. Member, expatriate set (introduced Hemingway to Gertrude Stein). Back to U.S. in 1926, when novel, *Eater of Darkness*, was published (called first Dada novel in English language). Wrote book reviews and Sunday features for the *New York Times*, the *New York Tribune*, etc. Then, through efforts of James Thurber, joined staff of the *New Yorker* in 1927; contributed over 100 short stories to magazine and was its art critic, 1937–67. In addition to books about travel adventures in Italy, his publications include *The Outlaw Years* (1930), *Yesterday's Burdens* (1933), *Wisteria Cottage* (1948), *The Hour After Westerly and Other Stories* (1957), *The View from Here* (1960), and *The Man Just Ahead of You* (1962). *See Appendix A, no. 89.*

Cortissoz, Royal (1869–1948). Critic, writer, lecturer. Born Brooklyn. Attended public schools. Around 1885 began working for McKim, Mead, & White, New York; travel in Italy with McKim laid foundation for belief in academic classicism. Published first article on art in 1886. Art critic for the *New York Commercial Advertiser*, 1890. Became art critic for the *New York Tribune*, 1891, and held posi-

tion, after merger with the *Herald*, for total of fifty-three years. Contributor to *Harper's* and *Century* in 1890s. After Armory Show, vocal adversary of modernism. Considered *doyen* of American art critics. Publications include *Augustus Saint-Gaudens* (1907), *John La Farge* (1911), *Art and Common Sense* (1913), *Personalities in Art* (1925), and *Arthur B. Davies* and *Guy Pène DuBois* (1931). *See Appendix A, nos. 16, 39.*

Demuth, Charles (1883–1935). Painter. Born Lancaster, Pa. Student at Drexel Institute, 1901–4. Visited Europe, 1904, then studied with Thomas Anshutz and William Merritt Chase at Pennsylvania Academy of Fine Arts, Philadelphia, until 1911. In 1907, to Europe for five months; return visit, 1912–14. Became acquainted with the Steins, other American expatriates, and members of Parisian avant-garde. Back in U.S., became friends with Duchamp and the Arensbergs. Illustrated works by Balzac, Henry James, Poe, Frank Wedekind, and Zola. Associated with Stieglitz from mid-twenties, with paintings exhibited at the Intimate Gallery in 1926 and 1929, and at An American Place, 1930–32, 1936, and 1939. Work included in major American museum collections. *See Appendix A, nos. 57B, 82.*

Dove, Arthur G. (1880–1946). Painter, illustrator. Born Canandaigua, N.Y. Attended Hobart College, Geneva, N.Y.; graduated from Cornell in 1903. Studied art with illustrator Charles Wellington Furlong at Cornell. To New York City in 1903 as illustrator; sold work to *Harper's*, *Scribner's*, and the *Saturday Evening Post*. In 1908, to Paris to study; there, met Alfred Maurer and others. Showed in Salon d'Automne exhibitions, 1908 and 1909. Returned to U.S. in 1909. Work first shown at 291 in 1910; first one-man show there in 1912. Part of Stieglitz group from then to end of life. Patronized by Duncan Phillips beginning in 1922. *See Appendix A, no. 34B.*

Dreier, Katherine S. (1877–1952). Painter, lecturer, writer, women's rights advocate. Born Brooklyn. Attended Art Students League and Pratt, 1895–97. Studied with Walter Shirlaw at Brooklyn Art School, 1904–7. To Paris, 1907, and to London, 1909. Exhibited Salon des Beaux Arts, Paris, 1911. First one-woman show, Macbeth Gallery, New York, 1913. Exhibited Armory Show. Founded Société Anonyme with Marcel Duchamp and Man Ray, 1920; bought and exhibited work of modernists and sent travelling exhibitions around country (entire Société Anonyme collection given to Yale Art Gallery in 1941). Publications include a translation of *Personal Recollection of Van Gogh*, by Elizabeth Duquesne van Gogh (1913), *Five Months in the Argentine* (1920), *Western Art and the New Era or An Introduction to Modern Art* (1923), *Stella* and *Kandinsky* (1923), and *The Invisible Line* (1928). *See Appendix A, no. 56.*

Duncan, [Masson?] Charles (1892–?). Painter, poet. Essay, "What 291 Means to Me," published in *Camera Work*, no. 47 (July 1914). Showed two watercolors and a drawing at 291 along with O'Keeffe's and Lafferty's works in 1916. Published

poetry in Duchamp's the *Blind Man* (May 1917) and *MSS.* (March 1922). Later earned living as a sign painter. Close to Stieglitz circle into 1920s (subject of Demuth "portrait poster," which was exhibited in "Seven Americans," 1925). Visitor, Lake George, 1920. *See Appendix A, no. 2.*

Eilshemius, Louis Michel (1864–1941). Painter. Born Laurel Manor, N.J. Lived Europe, 1873–81. Studied, Cornell, 1882–84; with Kenyon Cox at Art Students League, New York, 1884–86; with Bouguereau at Académie Julian, Paris, 1886–87. Believing his work misunderstood, stopped painting in 1921. Work in major museum collections, including Cleveland Museum; Detroit Institute of Art; Luxembourg Museum, Paris; Metropolitan Museum; Museum of Fine Arts, Boston; Museum of Modern Art, New York; Phillips Collection, Washington; Whitney Museum of American Art. *See Appendix A, no. 24.*

Fisher, William Murrell (1889–?). Critic, writer, poet. Contributor to *Camera Work,* 1914. Wrote *The Toady's Handbook* (1929); *A History of American Graphic Humor* (2 vols., 1933–38, published for Whitney Museum); and in 1920s and 1930s, books on American painters for the Whitney's "Younger Artists" Series, e.g., Peggy Bacon, Charles Demuth. *See Appendix A, no. 4.*

Frank, Waldo David (1889–1967). Critic, historian, writer. Born Long Branch, N.J. M.A. degree, Yale. On staff of the *New York Evening Post* and the *New York Times,* 1912–13. With poet James Oppenheim, founded the *Seven Arts,* 1916, with Van Wyck Brooks as co-editor. In 1930s, associate editor, the *New Republic.* Friend of Stieglitz from 1918. Joined various social protests from 1930s through 1960s (with Edmund Wilson and others, ejected from state of Kentucky after assisting striking coal miners in 1930s; pro-Castro during and after Cuban revolution). Prolific writer. In addition to novels and dramas, publications include the following: *Our America* (1919), *City Block* (1922), *Salvos: An Informal Book about Books and Plays* (1924), *Virgin Spain* (1926), *The Rediscovery of America* (1929), *Tales from the Argentine* (1930), and *South American Journey* (1943). *See Appendix A, no. 54.*

Hartley, Marsden (1877–1943). Painter, poet. Born Lewiston, Maine. Studied, Cleveland (Ohio) Art School. To New York, 1898: worked with William Merritt Chase, Frank Vincent Dumond, and F. Luis Mora; attended classes at National Academy of Design and Art Students League, 1900–1905. First one-man show at 291 in 1909; first trip to Europe in 1912, funded through efforts of Stieglitz and Arthur B. Davies. Spent three years travelling, especially in Germany. Exhibited with Blaue Reiter group and also in Berlin at first Autumn Salon of Der Sturm. Exhibited Armory Show. Showed European work at 291 in 1914. Painted in New Mexico, 1918–19. Back and forth to Europe until Depression (Stieglitz-organized auction of work in 1923 netted $4000, permitting return to Europe: first, Venice, then Aix-en-Provence, where he painted, 1926–28). After 1911, poetry and es-

says a major creative outlet. Contributed to the *Dial, Poetry,* and William Carlos Williams' *Contact. See Appendix A, no. 5.*

Jewell, Edward Alden (1888–1947). Critic, writer, lecturer. Born Grand Rapids, Mich.; attended high school there and, later, at Friends School in Washington, D.C. On the stage a few years. Reporter, the *Grand Rapids Herald,* 1911–14, and the *New York Tribune,* 1915. Managing editor, the *World Court Magazine* and associate editor, *Everybody's Magazine,* 1916. Back to *Tribune* as Sunday editor in 1917. Travelled and wrote fiction, 1919–23. Briefly, in 1923, associate editor, *Success Magazine;* then joined staff of the *New York Times* Sunday edition, as head copy editor and writer. Became assistant to Elizabeth Luther Cary in 1928; succeeded her in 1936. Wrote novels, such as *The Charmed Circle* (1921), *The White Kami* and *The Moth Decides* (1922), and books on art, including *Americans* (1930), *Alexander Brook* (1931), *Have We an American Art* (1939), *French Impressionists and Their Contemporaries* (1944), and *Vincent Van Gogh* (1946). *See Appendix A, nos. 72, 85–86.*

Kalonyme, Louis (1900/1901–61). Critic, writer. Contributing art critic to the *New York Times;* art and drama critic, *Arts and Decoration.* In addition to art criticism, major *Times* articles in twenties about Eugene O'Neill and his work, new discoveries in learned behavior, and new college testing procedures. Friend and advisor to John Marin and to O'Neill. Married to Angna Enters, the dancer, with whom he collaborated on *Love Possessed Juana.* Visitor, Lake George, beginning 1929. *See Appendix A, nos. 52, 59, 62, 73.*

Kay-Scott, C[yril] [Frederick Creighton Wellman] (1871–1960). Writer, scientist, artist, explorer. B.A., Chicago Seminary; M.D., Kansas City Medical College. After a varied career as entomologist, physician, medical researcher, anthropologist, rancher, farmer, miner, and writer, in Africa, South America, and the U.S., took up painting in the 1920s. Studied in Paris, then founded school of painting in Santa Fe. Later, turned school over to Denver University and was appointed Dean of University Art School; organized, then directed, Denver Art Museum. Author of over 150 articles, monographs, notes, etc., on medicine, science, art. Autobiography: *Life is Too Short* (1943). Visitor, Lake George, 1927. *See Appendix A, no. 69.*

La Follette, Suzanne (1893–1983). Writer, editor, feminist, politician. Born Washington State (daughter of Rep. William L. La Follette; cousin of Robert N. La Follette, senator from Wisconsin, 1906–25). Positions as writer or editor for the *Nation* and the *American Mercury.* Founding editor of the *Freeman,* begun 1930. Wrote *Concerning Women* (1926), which argued for civil rights for women. Strongly supported anti-Soviet causes. Secretary to commission headed by John Dewey investigating Soviet trials of Leon Trotsky, which found that exiled communist leader had been framed. Ran unsuccessfully for House of Representa-

tives from Manhattan's 19th district on Conservative Party ticket in 1964. *See Appendix A, no. 90.*

McBride, Henry M. (1867–1962). Critic, writer, educator. Born West Chester, Pa. To New York City, 1897. Studied art with John Ward Stimson at Artists' and Artisans' Institute, then at Art Students League. Began teaching art in 1900 and inaugurated art department of Educational Alliance in New York City. In 1901, became director of School of Industrial Art in Trenton, N.J., where he taught Jo Davidson, Jacob Epstein, and Abraham Walkowitz, among others. In 1913, joined art criticism staff of the *New York Sun.* Wrote for the *New York Herald* 1920–24, returning to the *Sun* in 1925. Contributor to the *Dial,* 1920–29, and *Creative Art,* 1930–32 (was also editor in this period). In 1930, when the *Sun* merged with the *World Telegram,* not kept on. Hired to write monthly column for *Art News,* which he did until 1955. After WWI, frequent trips to Europe; became friends with major figures within European avant-garde. Important early advocate of modern art; promoted Dada and other experimental movements and became apologist for School of Paris. Later, championed Pollock, Rothko, Tomlin, and others. Publications include *Matisse* (1930), "John Marin," in *John Marin, Water Colors, Oil Paintings, Etchings* (1936), *Florine Stettheimer* (1946). *See Appendix A, nos. 14, 24, 36, 46, 53, 58, 64, 70, 84.*

Mannes, Marya (1904–). Journalist, writer, feminist. Born New York City (daughter of David and Clara Damrosch Mannes, founders of Mannes College of Music; niece of Walter Damrosch, the conductor). Entered field of journalism as reviewer for art magazines and started a short-lived magazine edited by Rockwell Kent during 1920s. Wrote criticism, articles, and, under the pseudonym "Sec," satirical verse for the *Reporter,* for which she served on editorial staff from 1952. Earlier contributions to *Vogue, Glamour,* and *Harper's.* Feature editor, feature writer, *Vogue,* 1933–36; freelance work for the *New Yorker.* Publications include *Message from a Stranger* (1948), *More in Anger* (1958), *Subverse: Rhymes For Our Times* (1959), *The New York I Know* (1961), *But Will It Sell?* (1964), and *They* (1968). *See Appendix A, no. 74.*

Mather, Frank Jewett, Jr. (1868–1953). Writer, museum director, amateur artist. Born Connecticut. B.A. degree, Williams, 1889. Ph.D. degree, Johns Hopkins, 1892. Attended University of Berlin, 1893, and Écoles des Hautes Études, Paris, 1897–98. Taught at Williams, 1893–1900. In 1901, turned to journalism. Assistant editor of the *Nation;* editorial writer for the *New York Evening Post.* Served as *Post* art critic, 1905–6 and 1910–11. Art history faculty, Princeton, 1910–33. First director, Museum of Historic Art at Princeton (now Princeton Art Museum), 1922–46. Publications include *The Collectors* (1912), *Estimates in Art* (1916), *Portraits of Dante Compared with the Measurements of His Skull and Reclassified* (1921), *A History of Italian Painting* (1923), *Ulysses in Ithaca: A Drama in Four Acts* (1926), *Eugene Speicher* (1931), *The Isaac Master* (1932), *Concerning Beauty* (1935), *Venetian*

Painters (1936), and *Western European Painting of the Renaissance* (1939). *See Appendix A, no. 65.*

Matthias, Blanche Coates (1887–?). Critic, poet. Art critic, the *Chicago Evening Post.* Contributions to *Arts and Decoration* (dance criticism) and the *Forum* (poetry) in the twenties. *See Appendix A, no. 50.*

Moore, Dorothy Lefferts (1905–). Critic, community planner. Born New York City. A.B., Bryn Mawr, 1926. Masters degree in city planning, Yale, 1958. Assistant editor and contributing editor, *The Arts,* 1928–30. President, League of Women Voters, 1941–43, Wilton, Conn. Partner, Technical Planning Associates, New Haven, 1957. *See Appendix A, no. 88.*

Mullin, Glen Hawthorne (1885–1952). Educator, writer, critic. Degree from University of Illinois, 1907; studied, Chicago Art Institute, 1907–10; graduate courses, University of Chicago, 1912–14; M.A. degree, Columbia, 1917. Taught literature at Texas Agricultural and Mechanical College, 1914–16. Contributed stories, articles, and reviews to periodicals. Wrote *Adventures of a Tramp Scholar* (1925)—account of 7,000 mile trip around country as a bum. At death, assistant professor of English, School of General Studies, Columbia. *See Appendix A, no. 43.*

Mumford, Lewis (1895–). Writer, critic, historian. Born Flushing, L.I., N.Y. Studied, CCNY, Columbia, New School for Social Research. Honorary degrees, Edinburgh University, 1965, and University of Rome, 1967. Was an editor of *American Caravan,* 1928–36, and, in 1930s, associate editor of the *New Republic.* Member, Board of Higher Education, New York City, 1935–37. Teaching or research positions at Stanford, 1942–44; University of Pennsylvania, 1951–59; MIT, 1957–60 and 1973–75; University of California, Berkeley, 1961–62; and Wesleyan, 1963–64. Work with National Film Board of Canada, 1964 (documentary films), and the BBC, 1976 (lectures). Many national and international awards and honors, including U.S. Medal of Freedom, 1964. Publications include *Sticks and Stones* (1924), *The Golden Day: A Study in American Experience and Culture* and *Architecture* (1926), *The Brown Decades* (1931), *Technics and Civilization* (1934), *The Culture of Cities* (1938), *Art and Technics* (1951), *The City in History* (1961), and *The Pentagon of Power* (1971). *See Appendix A, no. 63.*

O'Brien, Frances (–). Critic, educator, painter. Born Rochester, N.Y. Studied with George Luks. Contributions to the *Nation* and, with George Garfield, her husband, to the *Reflex.* Taught in private schools in 1920s. Exhibited paintings at the Art Centre in New York in 1930. Visitor, Lake George, in the mid-twenties. *See Appendix A, no. 67.*

Pemberton, Murdock (1888–1982). Critic. Born Emporia, Kans. (brother of Brock Pemberton, who produced *Harvey* on Broadway). Reporter for the *Emporia Ga-*

zette, the *Kansas City Star*, the *Philadelphia North American*. In June 1925, became first art critic for the *New Yorker*, a position he held until 1932. Returned to *New Yorker* in 1950s and retired from full-time writing in the sixties. In 1928, declared that the Metropolitan Museum was a "discourager of art in America." Believed he had inadvertently begun the traditional literary lunch at the Algonquin Hotel, which evolved into the Algonquin Round Table. Wrote *Picture Book* (1930) and a Broadway play, *Sing High, Sing Low* (1931). *See Appendix A, nos. 48, 51, 61, 71, 83, 87.*

Phillips, Duncan (1886–1966). Collector, museum director, writer, lecturer, critic, amateur painter. Born Pittsburgh. A.B., Yale, 1908 (edited *Yale Literary Magazine*, 1907–8); many honorary degrees, various institutions, 1933–55. Wrote essays and book reviews for magazines; earned reputation as lecturer and commentator. Founded Phillips Memorial Gallery in 1918. Chairman, regional committee, Public Works of Art Project, 1932–33. Member of acquisitions committee and trustee, National Gallery of Art, Washington; trustee, Museum of Modern Art, New York; and honorary trustee, Washington Gallery of Modern Art. Numerous national and international museum and exhibition affiliations, awards, and honors. Contributor and member editorial board, the *Magazine of Art*. Publications include *The Enchantment of Art* (1914), *The Artist Sees Differently* (1931), and *The Leadership of Giorgione* (1937). *See Appendix A, no. 55.*

Read, Helen Appleton (1887–1974). Art historian, lecturer. Graduated from Smith in 1908. Studied, Art Students League, 1909–12, and with Robert Henri. Art critic, the *Brooklyn Daily Eagle*, 1916–17 and 1922–38; contributor to *The Arts*, 1923–30. Director, Art Alliance of America, New York, and associate art editor, *Vogue*, 1925–31. During 1930s, art editor of the *American German Review*. From 1943, held administrative positions at the gallery, Portraits, Inc. Travelled widely and lectured at colleges, universities, museums, and art organizations throughout the U.S. Wrote *Robert Henri* (1931) and *Caspar David Friedrich* (1939). *See Appendix A, nos. 17, 25, 30, 40, 42, 49, 60, 80.*

Rönnebeck, Arnold H. (1885–1947). Sculptor. Born Nassau, Germany. Graduated from Berlin Realgymnasium, 1905. Studied architecture at Royal Art School, Berlin, 1905–7, and sculpture in Munich, 1907–8. Worked in Paris, 1908–14, with Bourdelle and Maillol. Bronzes exhibited at 291 in 1914. Came to U.S. in 1923. Was Director of Denver Art Museum and taught sculpture at University of Denver, 1929–35. Visitor, Lake George, 1924. *See Appendix A, no. 34c.*

Rosenfeld, Paul Leopold (1890–1946). Music, art, and literary critic; writer. Born New York City. Studied, Yale, 1908–12. Litt.B. degree, Columbia School of Journalism, 1914. For six months thereafter, reporter for the *New York Press*. Travel in Europe in 1915. Wrote articles for the *New Republic* and the *Seven Arts* in 1916, and in 1920, became music critic for the *Dial*. In the 1920s, wrote for *Vanity Fair*, the *Nation*, and *Modern Music*. With Van Wyck Brooks, Alfred

Kreymborg, and Lewis Mumford, edited several numbers of *American Caravan*, issued 1928–36. Publications include *Musical Portraits* (1920), *Musical Chronicle: 1917–1923* (1923), *Men Seen: Twenty Four Modern Authors* (1925), *Modern Tendencies in Music* (1927), *By Way of Art* (1928), *Self Discoveries of a Music Critic* (1936), and the novel, *The Boy in the Sun* (1928). At death, contributor to *Commonweal*, the *Kenyon Review, Tomorrow*, etc. Regular visitor, Lake George, from 1920. *See Appendix A, nos. 6, 8, 27–28.*

Sabine, Lillian Keal (1880–?). Playwright, short story writer, newspaperwoman, educator. Born Detroit. Graduate of University of Michigan. Early career as writer for newspapers. Later, taught in public schools in Bloomington, Ill., and Washington, D.C. In 1913, won the Century Theater Club's award given to the best American play by a "non-professional playwright," for *The Great Middle Class*. Dramatization of William Dean Howells' story "The Rise of Silas Lapham" (written 1915, published 1927) became first American play produced by the New York Theater Guild. *See Appendix A, no. 79.*

Seligmann, Herbert J. (1891–1984). Writer, poet, critic. Born New York City. B.A. degree, Harvard. Work for the *New Republic* and several New York newspapers. Publicity director, NAACP, 1919–32 (in this period, Harmon Foundation award for best publication in field of social advancement). Publications include *The Negro Faces America* (1924), *Letters of John Marin* (1931), *Race Against Man* (1939), essays on John Marin and Marsden Hartley (1955), and *Alfred Stieglitz Talking: Notes on Some of His Conversations, 1925–1931* (1966). Visitor Lake George, from 1921. *See Appendix A, nos. 20–21.*

Strand, Paul (1890–1976). Photographer and filmmaker. Born New York City. Educated public schools. One-person show at 291 in 1916. Exhibited in "Seven Americans" in 1925, in 1929 at the Intimate Gallery, and in 1932 at An American Place. Thereafter, work seen in major national and international exhibitions and publications. Numerous awards and honors. In 1921, produced film, *Mannahatta*, with Charles Sheeler; other, intermittent film work to early forties. Contributed many articles to professional journals. Visitor, Lake George, from 1919. *See Appendix A, nos. 18, 32.*

Tyrrell, Henry (1865–1933). Newspaperman, writer. Born Utica, N.Y. Graduated from Cornell, 1890. Editorial work, to 1901, with Mrs. Frank Leslie's *Popular Monthly* magazine, and contributor to, among others, *Judge, Puck, Collier's*. Newspaper work in Rochester and Albany before joining staff of *The* [New York] *World* in 1903, where he remained until 1931, when the paper ceased publication. Author of *Lee of Virginia*, published serially in *Pall Mall* (London, 1897); a novel, *Shenandoah* (1912); a one-act verse play, *Nevermore, Edgar Poe*; and a comedy, *Dr. Tarr*, produced 1905. *See Appendix A, nos. 1, 3, 15, 18.*

Watson, Forbes (1879/80–1960). Writer, art critic, lecturer. Degree, Harvard; law degree, Columbia (admitted to bar, but never practiced). Before WWI, freelance writer, then art critic for the *New York Evening Post*. From early 1920s until 1931, art critic for *The* [New York] *World*. At same time, editor of *The Arts* and contributor to *Arts and Decoration* and *Parnassus*. Also had articles published in the *New York Times* and the *New York Herald Tribune*. Later, lectured at Art Students League and elsewhere. In early Roosevelt administration, advisor to Section of Painting and Sculpture, Procurement Division, of the Treasury Department (responsible for murals in federal buildings). Toured country during WWII with collection of art by military combat artists to raise money for war bonds. While in Washington, contributor to the *American Magazine of Art*. In later years, chairman of the Allen Tucker Memorial, which administered tuition scholarships to the Arts Students League. Publications include *William Glackens* (1923), *Mary Cassatt* and *Allen Tucker* (1932), *American Painting Today* (1939), *Aaron Sopher* (1940), and *Winslow Homer* (1942). *See Appendix A, nos. 26, 41*.

Wilson, Edmund (1895–1972). Critic, writer. Born Red Bank, N.J. A.B., Princeton, 1916. Reporter, the *New York Evening Sun*, 1916–17; managing editor, *Vanity Fair*, 1920–21; associate editor, the *New Republic*, 1926–31; book reviewer, the *New Yorker*, 1944–48. Aspen Award, Aspen Institute of Humanistic Studies, 1968. Wrote literary and social criticism as well as novels, plays, poems, and stories. Publications include *Discordant Encounters: Plays and Dialogues* (1926), *Poets, Farewell!* (1929), *Axel's Castle* (1931), *To the Finland Station* (1940), *The Wound and the Bow* (1941), *Memoirs of Hecate County* (1946), *Classics and Commercials* (1950), *The Shores of Light* (1952), *Patriotic Gore* (1962), and *Window on Russia* (1972). *See Appendix A, no. 37*.

Notes

The following are abbreviations used throughout the notes to indicate specific archival sources of certain letters cited.

ADP Arthur Dove Papers, microfilm, Archives of American Art, Smithsonian Institution, Washington, D.C.

ASA Alfred Stieglitz Archive, Collection of American Literature, Beinecke Rare Book and Manuscript Library, Yale University, New Haven.

HMP Henry McBride Papers, microfilm, Archives of American Art, Smithsonian Institution, Washington, D.C.

PSC Phillips-Stieglitz Correspondence, 1926–30, The Phillips Collection Archives, Washington, D.C.

Introduction

1. All of the letters exchanged between O'Keeffe and Stieglitz that are held in the Collection of American Literature, Beinecke Rare Book and Manuscript Library, Yale University, New Haven, are restricted from public use until twenty-five years after O'Keeffe's death. Particularly useful to this study would be those they wrote between 1916 and 1918, when O'Keeffe was variously in South Carolina, Virginia, and Texas, and between May and August 1929, when O'Keeffe was in New Mexico.

2. See also Appendix B, which provides biographical and professional information about the critics who responded to O'Keeffe's art.

Chapter 1

1. O'Keeffe and Pollitzer met during the academic year 1914–15, but precisely where they met is not clear. Pollitzer stated: "It was in Charles J. Martin's oil painting class at the Art Students League in New York that I first came to know Georgia O'Keeffe" (Anita Pollitzer, *A Woman on Paper: Georgia O'Keeffe*, intro. Kay Boyle [New York: Simon & Schuster, 1988], 1). It is a fact that O'Keeffe attended Teachers College at Columbia University for two terms in 1914–15. Furthermore, a letter she wrote to Pollitzer suggests that O'Keeffe had taken courses at Teachers College from Martin (see O'Keeffe to Pollitzer, 25 August 1915, in Jack Cowart, Juan Hamilton, and Sarah Greenough, *Georgia O'Keeffe: Art and Letters* [Washington, D.C.: National Gallery of Art, 1987], letter 2, p. 142). The same letter implies that Pollitzer had been enrolled

at Teachers College but was considering transferring to the Art Students League in the fall of 1915. (O'Keeffe discouraged her.) Therefore, unless Martin was teaching both at Columbia and at the Art Students League in 1914–15, and O'Keeffe took courses from him at both institutions, O'Keeffe and Pollitzer met in Martin's oil painting class at Teachers College.

2. O'Keeffe to Pollitzer, 11 October 1915, in Pollitzer, *A Woman on Paper*, 24–26.

3. O'Keeffe to Pollitzer, October 1915, in Pollitzer, *A Woman on Paper*, 35. This letter was written in response to one from Pollitzer dated 26 October.

4. Pollitzer to O'Keeffe, 16 November 1915, in Pollitzer, *A Woman on Paper*, 37–38.

5. O'Keeffe to Pollitzer, December 1915, in Pollitzer, *A Woman on Paper*, 39. This letter probably predates the one documented in the following note.

6. O'Keeffe to Pollitzer, 13 December 1915, in Pollitzer, *A Woman on Paper*, 40.

7. Several of the drawings O'Keeffe sent Pollitzer in late 1915 are reproduced in Cowart, Hamilton, and Greenough, *Art and Letters*. They are: *Special No. 2* (1915, Estate of Georgia O'Keeffe), *Special No. 4* (1915, Estate of Georgia O'Keeffe), *Special No. 5* (1915, Estate of Georgia O'Keeffe), and *Special No. 9* (1915, Menil Foundation). For a list of drawings that have been identified within the group, see *Art and Letters*, 147n.

8. Barbara Haskell, "Georgia O'Keeffe, Works on Paper: A Critical Essay," in *Georgia O'Keeffe: Works on Paper*, intro. David Turner (Santa Fe: Museum of New Mexico Press, 1985), 2.

9. Pollitzer, *A Woman on Paper*, 43.

10. Pollitzer's taking O'Keeffe's work to Stieglitz was not as impulsive as it might seem. In her letter to Pollitzer of 11 October, O'Keeffe had written: "Anita—do you know—I believe I would rather have Stieglitz like something—anything I had done—than anyone else I know of—I have always thought that—if I ever make anything that satisfies me even ever so little—I am going to show it to him to find out if its any good—Don't you often wish you could make something he might like?" (O'Keeffe to Pollitzer, 11 October 1915, in Pollitzer, *A Woman on Paper*, 24). In Pollitzer's 16 November letter to O'Keeffe, after she stated, "I don't know what to say about it," as quoted above, she added: "I'd love to ask Mr. Stieglitz. . . . Of course I never should till you said the word & I don't feel the time's come yet—" (Pollitzer to O'Keeffe, 16 November 1915, in Pollitzer, *A Woman on Paper*, 38).

11. "James Huneker in the *N.Y. Sun*," *Camera Work*, no. 36 (October 1911): 47.

12. One real irony is that ultra-conservative critic Royal Cortissoz, writing in the *New York Tribune*, was perhaps the first to make this clear: "Visitors at the Armory, when they are studying Matisse and the rest, may well recall that it was in the Photo-Secession Gallery that so many of the 'revolutionaries' were first introduced to the New York public" (reprinted in "Notes on '291,'" *Camera Work*, nos. 42–43 [issue dated April–July 1913; published November 1913]: 47).

13. Over sixty years later, O'Keeffe recalled Stieglitz's commitment to this idea: "He had the idea that there must be a woman somewhere who could paint. When he saw my watercolors on regular school exercise paper, he thought I was that woman" (in Mary Lynn Kotz, "Georgia O'Keeffe at 90," *Art News* 76 [December 1977]: 43).

14. Quoted in Pollitzer to O'Keeffe, 1 January 1916, in Jan Garden Castro, *The Art and Life of Georgia O'Keeffe* (New York: Crown Publishers, 1985), 31. In the late 1970s, O'Keeffe recalled Stieglitz's continuing enthusiasm about her work: "Stieglitz had a portfolio of my drawings which he used to carry around with him all the time, and Hartley used to call them 'Stieglitz's Celestial Solitude'" (in Kotz, "O'Keeffe at 90," 44). But writing very much earlier, Pollitzer remembered—probably more accurately—that Hartley had called the drawings "Stieglitz's celestial solitaire" (Pollitzer, *A Woman on Paper*, 143). For other commentary about Stieglitz's reaction to O'Keeffe's work in the period, see Pollitzer, *A Woman on Paper*, 48–49, and Herbert J. Seligmann, *Alfred Stieglitz Talking: Notes on Some of His Conversations, 1925–1931* (New Haven: Yale University Library, 1966), 23–76.

15. Although O'Keeffe restricted public access to this and all other correspondence between her and Stieglitz, making it unavailable until 2011 (see intro., n. 1), a few examples have been published recently. See Cowart, Hamilton, and Greenough, *Art and Letters*, letters 8, 12–13, pp. 150, 153–56; Sarah Greenough and Juan Hamilton, *Alfred Stieglitz: Photographs & Writings* (Washington, D.C.: National Gallery of Art, 1983), documents 22–24, 26–27, pp. 201–2; and Pollitzer, *A Woman on Paper*, 123–24, 139–43, 148–49, 159.

16. O'Keeffe to Stieglitz, January 1916, in Pollitzer, *A Woman on Paper*, 123.

17. Stieglitz to O'Keeffe, mid-January 1916, in Pollitzer, *A Woman on Paper*, 124.

18. Lafferty's given name was spelled "Réné" in two publications in 1916: *Camera Work* and *The Christian Science Monitor*. The show opened on 23 May, but Stieglitz was probably planning it as early as March, because in a letter to critic Arthur Jerome Eddy of 30 March 1916 he wrote that he had had his eye on these three artists for a while and thought their work was mutually compatible (as mentioned in William Innes Homer, *Alfred Stieglitz and the American Avant-Garde* [Boston: New York Graphic Society, 1977], 387). Also, there is no official record of the number of O'Keeffe's charcoal drawings Stieglitz included in the exhibition, but Stieglitz stated in his review of the show that there were ten (see Appendix A, no. 2).

19. There is some confusion about how many times O'Keeffe visited 291 in the spring of 1916. Pollitzer and Sue Davidson Lowe stated that O'Keeffe did not go there that year until after Stieglitz put her work on display (Pollitzer, *A Woman on Paper*, 133; Sue Davidson Lowe, *Stieglitz: A Memoir/Biography* [New York: Farrar Straus Giroux, 1983], 203). Laurie Lisle and Greenough, however, indicated that she had made earlier visits to the gallery (Laurie Lisle, *Portrait of an Artist: A Biography of Georgia O'Keeffe*, rev. ed. [New York: Washington Square Press, 1987], 89; Sarah Greenough, "Notes to the Letters," in Cowart, Hamilton, and Greenough, *Art and Letters*, letter 12, p. 276). O'Keeffe herself remembered that before she visited the gallery in late May, she had seen two exhibitions at 291 in 1916, Marin's (shown 18 January–12 February) and Hartley's (shown 4 April–22 May) and that Stieglitz had loaned her a Hartley painting (Georgia O'Keeffe, introduction to *Georgia O'Keeffe: A Portrait by Alfred Stieglitz* [New York: Metropolitan Museum of Art, 1978], n.p.). Obviously, she had visited 291 that spring before the O'Keeffe-Duncan-Lafferty exhibition and, in addition, had conversed with Stieglitz.

20. O'Keeffe made it clear to Perry Miller Adato that it was difficult to change Stieglitz's mind after he had decided on something. She stated in response to a question about why her drawings stayed on the walls at 291: "Listen, you try arguing with him and

see where you get" (in Perry Miller Adato [producer and director], *Georgia O'Keeffe*, videotape, 59 min. [produced by WNET/THIRTEEN for Women in Art, 1977; Portrait of an Artist, no. 1, series distributed by Films, Inc./Home Vision, New York]).

21. Stieglitz to O'Keeffe, June 1916, in Pollitzer, *A Woman on Paper*, 139–40.

22. Stieglitz to O'Keeffe, 10 July 1916, in Pollitzer, *A Woman on Paper*, 140.

23. When he defended his decision to show the work of Pamela Colman Smith, Stieglitz characterized his gallery as follows: "The Secession Idea is neither the servant nor the product of a medium. It is a spirit. Let us say it is the Spirit of the Lamp; the old and discolored, the too frequently despised, the too often discarded lamp of honesty; honesty of aim, honesty of self-expression, honesty of revolt against the autocracy of convention. The Photo-Secession is not the keeper of this Lamp, but lights it when it may; and when these pictures of Miss Smith's, conceived in this spirit and no other, came to us, although they came unheralded and unexpectant, we but tended the Lamp in tendering them hospitality" ([Alfred Stieglitz], "The Editors' Page," *Camera Work*, no. 18 [April 1907]: 37). Also, in a letter to photographer Anne Brigman, written after he closed 291 in 1917, Stieglitz described the ambience of the "tiny room" he then occupied in the building where the gallery had been. He pointed out that the spirit of 291, which he identified as "my spirit," was still alive and had not changed "one iota" (Stieglitz to Brigman, [1917], ASA).

24. Stieglitz to O'Keeffe, 31 July 1916, in Pollitzer, *A Woman on Paper*, 141. The drawing Stieglitz referred to was probably *Special No. 13* (1915), which Stieglitz owned at the time of his death and which is now part of the Alfred Stieglitz Collection, Metropolitan Museum of Art.

25. Stieglitz to O'Keeffe, 1917, in Pollitzer, *A Woman on Paper*, 143. In his letter to O'Keeffe of 31 July (see above, n. 24), Stieglitz stated that the drawings would be shown again in the fall, but he also asked her to send him some work she had recently made. Her immediate response is not known; in fact, no available document or existing account of this period offers evidence of how and precisely when additional O'Keeffe work reached Stieglitz before June 1918, when she moved to New York.

26. Stieglitz to O'Keeffe, 31 March 1918, in Pollitzer, *A Woman on Paper*, 159.

27. In 1977, O'Keeffe pointed out: "I have always been very annoyed at being referred to as a woman artist rather than an artist" (in Kotz, "O'Keeffe at 90," 44). Judy Chicago stated her perception of O'Keeffe's position in a discussion of Anaïs Nin, O'Keeffe, and Virginia Woolf: "O'Keeffe is the only one of the three who resisted articulating her commitment to a female art, despite the fact that her work clearly reflects that commitment" (Judy Chicago, *Through the Flower* [Garden City, N.Y.: Doubleday & Co., 1975], 177). Whether there is a distinctively female imagery has been the subject of much scholarly debate since the early 1970s. For discussions of this issue, see, for example, Lawrence Alloway, "Notes on Georgia O'Keeffe's Imagery," *Womanart* 1 (Spring–Summer 1977): 18–19, and "Women's Art in the 70s," *Art in America* 64 (May–June 1976): 64–72; Chicago, *Through the Flower*, 142–44; Judy Chicago and Miriam Schapiro, "Female Imagery," *Womanspace Journal* 1 (Summer 1973): 11–14; "Forum: What Is Female Imagery?" *Ms. Magazine* 3 (May 1975): 62–65, 80–83; Harmony Hammond, "Feminist Abstract Art—A Political Viewpoint," *Heresies: A Feminist Publication on Art and Politics*, no. 1 (January 1977): 66–70; Donald Kuspit, "Betraying the Feminist Intention: The Case against Feminist Decorative Art,"

Arts Magazine 54 (November 1979): 124–26; Lucy R. Lippard, *From the Center: Feminist Essays on Women's Art* (New York: E. P. Dutton, 1976), 80–90, and "Projecting a Feminist Criticism," *Art Journal* 35 (Summer 1976): 337–39; Cindy Nemser, "Art Criticism and Gender Prejudice," *Arts Magazine* 46 (March 1972): 44–46; Linda Nochlin, "Some Women Realists: Part I," *Arts Magazine* 48 (February 1974): 46–51, and "Women Artists after the French Revolution," in *Women Artists: 1500–1950,* ed. Ann Sutherland Harris and Linda Nochlin (New York: Alfred A. Knopf, 1976), 64–67; Barbara Rose, "Vaginal Iconology," *New York Magazine* 7 (11 February 1974): 59; and Lisa Tickner, "The Body Politic: Female Sexuality and Women Artists since 1970," *Art History* 1 (June 1978): 236–51. For more recent considerations, see Rosemary Betterton, ed., *Looking On: Images of Femininity in the Visual Arts and Media* (New York: Pandora Books, 1987), and Thalia Gouma-Peterson and Patricia Mathews, "The Feminist Critique of Art History," *Art Bulletin* 69 (September 1987): 334–37.

28. Although the word "sex" has long been used interchangeably with the word "gender" to make distinctions between men and women, the terms have recently been defined more specifically. For example, Esther Greenglass has written: "*Sex* is defined as a person's biological status, while *gender* refers to a person's learned or cultural status" (Esther R. Greenglass, *A World of Difference: Gender Roles in Perspective* [Toronto: John Wiley & Sons, 1982], 9–10). Stieglitz and the critics, however, made no such distinctions and used either "sex" or "gender" to imply biological or learned-cultural particularities in men and women. Thus, in this book, my own use of the terms should be seen as an accommodation to the broad, nonspecific meanings they were assigned in the criticism.

29. O'Keeffe to Pollitzer, 4 January 1916, in Pollitzer, *A Woman on Paper,* 120–21. Considering the context, it is likely that O'Keeffe was using the word "effeminate" to mean "having the qualities generally attributed to women."

30. O'Keeffe to Pollitzer, 4 January 1916, in Pollitzer, *A Woman on Paper,* 121.

31. For example, three of her paintings were included in "Exhibition of Paintings and Drawings Showing the Later Tendencies in Art," held at the Pennsylvania Academy of the Fine Arts, 16 April–15 May 1921. But as O'Keeffe recalled it, there was resistance at the time to the idea of exhibiting a woman's work alongside the work of men: "It was hard going, as a woman. Arthur B. Carles of Philadelphia came in to Stieglitz and wanted him to hang a group show there. 'But I don't want any goddamn women in the show,' he told Stieglitz. 'Take it or leave it,' Stieglitz said. 'There'll be no show without her' " (in Kotz, "O'Keeffe at 90," 45).

32. Stieglitz to O'Keeffe, 31 May 1917, in Greenough and Hamilton, *Alfred Stieglitz,* document 26, p. 202.

33. Marius De Zayas, "The Evolution of Form, Introduction," *Camera Work,* no. 41 (January 1913): 45.

34. Ibid., 47–48.

35. M[arius] De Zayas, "The Sun Has Set," *Camera Work,* no. 39 (July 1912): 21.

36. Benjamin De Casseres, "The Unconscious in Art," *Camera Work,* no. 36 (October 1911): 17.

37. Henri Bergson, "What Is the Object of Art?" *Camera Work,* no. 37 (January 1912): 23–24.

38. Ibid., 24.

39. Ibid.

40. "An Extract from Bergson," *Camera Work*, no. 36 (October 1911): 20–21.

41. Ibid., 21.

42. Wassily Kandinsky, *Concerning the Spiritual in Art*, trans. M. T. H. Sadler (New York: Dover Publications, 1977), 1.

43. Ibid., 2, 4.

44. Ibid., 19, 56.

45. For recent discussions of attitudes toward women in Western religious traditions, see John A. Phillips, *Eve: The History of an Idea* (San Francisco: Harper & Row, 1984), and Vern L. Bullough and Bonnie Bullough, "Christianity, Sex, and Women," "Byzantium: Actuality versus the Ideal," and "Sex Is Not Enough: Women in Islam," chaps. 5–7 in *The Subordinate Sex: A History of Attitudes toward Women* (Urbana: University of Illinois Press, 1973), 97–152.

46. For an excellent consideration of the sexist and racist implications of traditional versions of evolutionary theory, see Bram Dijkstra, "Evolution and the Brain: Extinguished Eyes and the Call of the Child; Homosexuality and the Dream of Male Transcendence," chap. 6 in *Idols of Perversity: Fantasies of Feminine Evil in Fin-de-Siècle Culture* (New York: Oxford University Press, 1986), 160–209.

47. Charles Darwin, *The Origin of Species by Means of Natural Selection or the Preservation of Favored Races in the Struggle for Life; and The Descent of Man and Selection in Relation to Sex* (New York: Modern Library, [1936]), 525.

48. Carl Vogt, *Lectures on Man: His Place in Creation, and in the History of the Earth*, ed. James Hunt (London: Longman, Green, 1964), 81.

49. Darwin, *Origin; Descent*, 867.

50. Ibid., 873.

51. Ibid.

52. Herbert Spencer, *The Principles of Biology* (1873; American ed., 2 vols., New York: D. Appleton and Co., 1898), 2:409–11, 489–93, and *The Study of Sociology* (1866; American ed., New York: D. Appleton and Co., 1921), 340–50.

53. Stieglitz's denouncement of Moore was quoted in one article by Helen Appleton Read (Appendix A, no. 17), and she repudiated Moore's position directly in another (Appendix A, no. 30). See also articles by Herbert J. Seligmann (Appendix A, no. 21) and Louis Kalonyme (Appendix A, no. 73), in which Moore's opinions are dismissed.

54. George Moore, *Modern Painting* (London: Walter Scott, 1893), 220.

55. Ibid., 221, 226, 228.

56. Ibid., 222.

57. The bias of Moore's point of view toward women is also seen in the following: Giles Edgerton, "Is There a Sex Distinction in Art? The Attitude of the Critic toward Women's Exhibits," *Craftsman* 14 (June 1908): 239–51; Arthur Hoeber, "Famous

American Women Painters," *Mentor* 2 (16 March 1914): 1–11; and Walter Shaw Sparrow, *Women Painters of the World* (New York: Frederick A. Stokes Co., 1905), 11–12.

58. Arthur Edwin Bye, "Women and the World of Art," *Art World and Arts and Decoration* 10 (December 1918): 87.

59. Ibid.

60. In Peninah R. Y. Petruck, *American Art Criticism: 1910–1939* (New York: Garland Publishing, 1981), 20.

61. In Dorothy Norman, *Alfred Stieglitz: An American Seer* (New York: Random House, 1973), 131.

62. Alfred Stieglitz, "Woman in Art," in Norman, *Stieglitz: Seer*, 138. Though the essay was written in 1919 in response to a request from Macdonald-Wright, it was not published until Norman included part of it in *Stieglitz: Seer*, 136–38.

63. The degree to which Stieglitz had convinced others of the importance of modern art can be seen in the sixty-nine responses to the question "What is 291" that made up an entire special number of *Camera Work* (no. 47 [issue dated July 1914, published January 1915]).

64. It is not possible to prove that Stieglitz wrote this unsigned review, but there are several indications, including its language, that leave little doubt of its authorship.

65. See, for example, Tyrrell's review of the 1911 Picasso show at 291 in "Mr. Tyrrell in the *N.Y. Evening World*," *Camera Work*, no. 36 (October 1911): 49.

66. See William Murrell [Fisher], "Poesy Unbound," *Camera Work*, no. 44 (issue dated October 1913, published March 1914): 59.

67. The relationship between art and music had been the subject of articles in *Camera Work* since it began publication. See, for example, Sadakichi Hartmann [Sidney Allan, pseud.], "Repetition, with Slight Variation," *Camera Work*, no. 1 (January 1903): 30–34. For a discussion of the evolution of theories that linked expression in music and art, see Judith Katy Zilczer, "Musical Analogy and Theories of Abstract Art in America," chap. 2 in "The Aesthetic Struggle in America, 1913–1918: Abstract Art and Theory in the Stieglitz Circle" (Ph.D. diss., University of Delaware, 1975), 43–110.

68. Although no available records specify which O'Keeffes were exhibited in either 1916 or 1917, it can be confirmed from photographs Stieglitz made of the gallery that *Sunrise and Little Clouds II* was included in the 1917 show. Among other works displayed that year were the following watercolors: *Blue No. I* (1916, Brooklyn Museum of Art), *Blue No. IV* (1916, Brooklyn Museum of Art), *Blue Lines X* (1916, Metropolitan Museum of Art, Alfred Stieglitz Collection), *Train at Night in the Desert* (1916, Museum of Modern Art, New York), and *Blue I* (ca. 1917, private collection). In addition, *Abstraction IX* (1916, Metropolitan Museum of Art, Alfred Stieglitz Collection), *Special No. 15* (1916, Estate of Georgia O'Keeffe), and *Special No. 17* (1916?, Estate of Georgia O'Keeffe?) were three of the drawings shown in 1917. See frontispiece.

69. In Norman, *Stieglitz: Seer*, 137.

70. See, for example, Henry McBride's confirmation of this fact in his review of O'Keeffe's show in 1923 (Appendix A, no. 14).

71. The phrase "musician of color" was used by Herbert J. Seligmann in a 1923 essay about O'Keeffe. See Appendix A, no. 20.

72. As expressed by Helen Appleton Read in her 1928 essay on O'Keeffe (Appendix A, no. 80). For discussions of the language that has been traditionally used to describe women's art and its subject matter, see Svetlana Alpers, "Art History and Its Exclusions: The Example of Dutch Art," in *Feminism and Art History: Questioning the Litany*, ed. Norma Broude and Mary D. Garrard (New York: Harper & Row, 1982), 183–99; Carol Duncan, "When Greatness Is a Box of Wheaties," *Artforum* 14 (October 1975): 60–64; Nemser, "Art Criticism and Gender Prejudice," 44–46; Nochlin, "Women Artists after the French Revolution," 45–67; and Wendy Slatkin, *Women Artists in History: From Antiquity to the 20th Century* (Englewood Cliffs, N.J.: Prentice Hall, 1985).

73. See Katherine Hoffman, "Georgia O'Keeffe and the Feminine Experience," *Helicon Nine, A Journal of Women's Arts and Letters* 6 (Spring 1982): 6–15, and "The Feminine Experience," chap. 5 in *An Enduring Spirit: The Art of Georgia O'Keeffe* (Metuchen, N.J.: Scarecrow Press, 1984), 59–72; and Marilyn Hall Mitchell, "Sexist Art Criticism: Georgia O'Keeffe—A Case Study," *Signs* 3 (1978): 681–87.

74. For a particularly extensive treatment of this subject, see Dijkstra, *Idols of Perversity*, 14–17, 56–58, 94–99, 240–42.

75. See De Casseres, "The Unconscious in Art," and De Zayas, "The Sun Has Set."

76. Stieglitz to Anderson, 10 December 1925, in Greenough and Hamilton, *Alfred Stieglitz*, document 45, pp. 212–13.

77. In Dorothy Norman, "From the Writings and Conversations of Alfred Stieglitz," *Twice a Year: A Semi-Annual Journal of Literature, the Arts and Civil-Liberties*, no. 1 (Fall–Winter 1938; reprint, New York: Kraus Reprint Corporation, 1967): 77.

78. O'Keeffe to Matthias, March 1926, in Cowart, Hamilton, and Greenough, *Art and Letters*, letter 36, p. 183.

79. O'Keeffe to Toomer, 10 January 1934, in Cowart, Hamilton, and Greenough, *Art and Letters*, letter 68, p. 217.

80. William Wasserstrom, *The Time of the Dial* (Syracuse, N.Y.: Syracuse University Press, 1963), 54–55. For an analysis of how this issue relates to the concept of nationalism that emerged within the Stieglitz circle, see Wanda M. Corn, "Apostles of the New American Art: Waldo Frank and Paul Rosenfeld," *Arts Magazine* 54 (February 1980): 159–63.

81. Paul Rosenfeld, "The Water-Colours of John Marin: A Note on the Work of the First American Painter of the Day," *Vanity Fair* 18 (April 1922): 48.

82. For discussions of the origins of this language and its specific use within the Stieglitz circle, see Sarah E. Greenough, "From the American Earth: Alfred Stieglitz's Photographs of Apples," *Art Journal* 41 (Spring 1981): 46–54; Sherman Paul, "Paul Rosenfeld," introduction to *Port of New York: Essays on Fourteen American Moderns*, by Paul Rosenfeld (1924; reprint, Urbana: University of Illinois Press, 1961), xli–lvi; and Wasserstrom, "Lost, Right and Left: Alfred Stieglitz," chap. 2 in *Time of the Dial*, 27–57.

83. In Edmund Wilson, "The Stieglitz Exhibition," in *The American Earthquake* (Garden City, N.Y.: Doubleday & Co., 1958), 102.

84. The whole of Tyrrell's explanation of the meaning of this work may have originated with Stieglitz. Haskell has written the following about *Blue Lines X*: "F. S. C. Northrop . . . used the watercolor as the frontispiece to his book, *The Meeting of East and West*. In the book he quoted Stieglitz' interpretation of . . . [it] as being a representation of the male and female sensibilities, merging from a common base and following distinct, yet mutually interdependent courses" (Haskell, "A Critical Essay," 3).

85. Freud's influence in America is discussed in Nathan G. Hale, Jr., *Freud and the Americans: The Beginnings of Psychoanalysis in the United States, 1876–1917*, vol. 1 of *Freud in America* (New York: Oxford University Press, 1971).

86. I have been unable to discover anything about Sayer.

87. In "Woman in Art," Stieglitz wrote: "Art is not Science—although there is Science in Art" (in Norman, *Stieglitz: Seer*, 137). It is clear that he had a continuing respect for the authority of science and often referred to O'Keeffe's art as a form of scientific proof of his theories about her. For example, in a letter to collector Duncan Phillips he stated: "I know the significance of O'Keeffe's work. There is none more important being done in this country. She is the first real woman painter not only of this country but in the world. That I have scientific proof of" (Stieglitz to Phillips, 1 February 1926, PSC). A similar declaration, offering O'Keeffe as proof of his theory that women could produce art, had been quoted in 1923 by Helen Appleton Read; and, in his 1924 catalogue statement, he had described his own work, in part, as "scientific fact." See Appendix A, no. 17, and Alfred Stieglitz, "Chapter III," in *The Third Exhibition of Photography, by Alfred Stieglitz [Songs of the Sky—Secrets of the Skies as Reveald* [sic] *by My Camera & Other Prints]* [exhibition catalogue] (New York: The Anderson Galleries, 3–16 March 1924), n.p. (photocopy on file at the Archives of American Art, Smithsonian Institution, Washington, D.C.).

88. For examples of recent studies that have discussed the gender biases of Freudian theory, see Hannah Lerman, *A Mote in Freud's Eye: From Psychoanalysis to the Psychology of Women* (New York: Springer Publishing Co., 1986), 24–26, 33–34, 70–80; Juliett Mitchell, *Psychoanalysis and Feminism* (New York: Pantheon, 1974); and Juliett Mitchell and Jacqueline Rose, eds., *Feminine Sexuality: Jacques Lacan and the école freudienne* (London: Macmillan, 1982).

Chapter 2

1. Stieglitz mentioned the number thirty-seven in a letter to J. P. Cooney of August 1938 (partially quoted in Norman, *Stieglitz: Seer*, 134). For a historical interpretation of the ideas set forth in *Camera Work*, see Jonathan Green's introduction to *Camera Work: A Critical Anthology*, ed. Jonathan Green (Millerton, N.Y.: Aperture, 1973), 9–23, and especially 15–16, where Green explains how the emphasis of the periodical changed dramatically after 1911.

2. One of these was Eduard Steichen. Stieglitz and Steichen had worked together from the beginning to produce the periodical and to organize 291, but Steichen objected to what Stieglitz had done in recent years with the gallery (and, by implication, with *Camera Work*), on his own or with the advice of others. This is clear from his response to Stieglitz's question "What is 291" (see Eduard J. Steichen, "291," *Camera Work*, no.

47 [issue dated July 1914, published January 1915]: 65–66, and see also chap. 1, n. 63). Although Stieglitz was praised by most of the respondents, Steichen made no effort to mask his disapproval of him and of his activities. By publishing Steichen's remarks, Stieglitz demonstrated his belief in the right of others to express themselves. He did not, however, tolerate contradiction well, and Steichen's essay hastened the termination of their already unsteady friendship (see Lowe, *Stieglitz: A Memoir*, 184). According to O'Keeffe, Stieglitz repeated a pattern of drawing people to him and then driving them away, especially if they disagreed with him. As she pointed out: "He was the leader or he didn't play. It was his game and we all played along or left the game. Many left the game, but most of them returned to him occasionally, as if there existed a peculiar bond of affection that could not be broken, something unique that they did not find elsewhere" (Georgia O'Keeffe, "Stieglitz: His Pictures Collected Him," *New York Times Magazine* [11 December 1949], 24). Steichen, who was disaffiliated with Stieglitz and his activities after 1917, did not "return" until June of 1940 and, then, only to visit the ailing older man.

3. *291* was published in twelve numbers between March 1915 and February 1916. De Zayas, Haviland, and Meyer also convinced Stieglitz that 291 should have a commercial branch. Although Stieglitz had always objected to commercializing art, he realized that 291 was in trouble financially and went along with his friends at first. The 7 October 1915 opening of the Modern Gallery was announced in *291*, and the enterprise was described as "but an additional expression of '291' [the gallery]" (reprinted in *291 No. 1–12: 1915–1916*, intro. Dorothy Norman [New York: Arno Press, 1972]: n.p.). But by late December, Stieglitz had decided to withdraw his support from the Modern Gallery, because he could not bring himself to think of a work of art as an article of commerce (see Lowe, *Stieglitz: A Memoir*, 200). For Stieglitz's official explanation of the inception of the gallery and its ultimate separation from 291, see [Alfred Stieglitz], "'291' and the Modern Gallery," *Camera Work*, no. 48 (October 1916): 63–64.

4. Alfred Stieglitz, "One Hour's Sleep Three Dreams," *291*, no. 1 (March 1915; reprinted in *291 No. 1–12: 1915–1916*, intro. Dorothy Norman [New York: Arno Press, 1972]): n.p. The Stieglitz biography in Rosenfeld's *Port of New York* pointed out: "'One Hour's Sleep—Three Dreams' was first published in *291*, No. 1. It was reprinted in *Manuscripts*, No. 2, with two hitherto unpublished poems by Stieglitz" (Paul Rosenfeld, *Port of New York: Essays on Fourteen American Moderns* [1924; reprint, intro. Sherman Paul, Urbana: University of Illinois Press, 1961], 311). It is true that "One Hour's Sleep Three Dreams" was reprinted in *MSS.*, no. 2 (March 1922): 8, but there were *three* thitherto unpublished poems by Stieglitz printed on pp. 9–10. Each of two of those poems was titled "Portrait—1918," and the third was titled "Portrait: 1910–21." For a discussion of the two titled "Portrait—1918," see Meridel Rubenstein, "The Circles and the Symmetry: The Reciprocal Influence of Georgia O'Keeffe and Alfred Stieglitz" (Master's thesis, University of New Mexico, 1977), 19–21.

5. Feminists have made associations between the prevalence of the *femme fatale* in late nineteenth- and early twentieth-century art and literature and men's fears of women's sexual power. See, for example, Nina Auerbach, *Woman and the Demon: The Life of a Victorian Myth* (Cambridge: Harvard University Press, 1982); Dijkstra, *Idols of Perversity*; and Carol Duncan, "Virility and Domination in Early Twentieth-Century Vanguard Painting," in Broude and Garrard, *Feminism and Art History*, 293–313.

6. In Pollitzer, *A Woman on Paper*, 48–49.

7. Stieglitz's recollection of this meeting is recorded in Norman, *Stieglitz: Seer*, 130–31.

8. Stieglitz continued to photograph O'Keeffe until 1937. In 1980, O'Keeffe donated several hundred of the resulting prints to the National Gallery of Art, Washington, D.C. There are, at present, 329 photographs of O'Keeffe in the Alfred Stieglitz Collection there.

9. O'Keeffe had been professionally trained, and by the time she moved to New York in 1918, she had been working with modernist ideas for five years. In addition, her experience and her reading had made her aware of the most up-to-date movements and theories. In letters she wrote to Pollitzer during the years 1915–17, she referred often to the titles of books and periodicals she was reading. See Sarah Greenough, "From the Faraway," in Cowart, Hamilton, and Greenough, *Art and Letters*, 136, as well as letters 1, 7, 15–16, 18, pp. 141, 149, 157–63, in *Art and Letters*.

10. Stieglitz to Dove, 18 June 1918, ADP, roll 725.

11. Stieglitz to Dove, [1918], ADP, roll 725. There are several indications in this undated letter that Stieglitz wrote it in 1918; for example, he also states: "I was 'kicked' out of the Camera Club 10 years ago," an event that took place in early February 1908.

12. In Norman, *Stieglitz: Seer*, 137. All subsequent extracts from "Woman in Art" can be found in *Stieglitz: Seer*, 136–38. See chap. 1, n. 62.

13. The long-standing belief that the womb was a powerful force in determining women's feelings had been given authenticity in the nineteenth century by the medical community. See Charles Rosenberg, "The Female Animal: Medical and Biological Views of Women," chap. 2 in *No Other Gods: On Science and American Social Thought* (Baltimore: Johns Hopkins University Press, 1961), 54–70, and Rosalind Rosenberg, *Beyond Separate Spheres: Intellectual Roots of Modern Feminism* (New Haven: Yale University Press, 1982), 5–6.

14. De Casseres had made this point in *Camera Work* in 1911. See chap. 1, n. 36.

15. Dow's theory of "filling a space in a beautiful way" informed O'Keeffe's thinking for the rest of her life. It is possible that Stieglitz's initial, positive response to her work was due in part to its being based on abstract principles like those that underlie Oriental art. According to Barbara Rose, Fenollosa, who was Dow's mentor, "did more than anyone else to introduce Japanese art to America." Rose also stated that "through Dow, if not directly, O'Keeffe was aware of Fenollosa's approach; it is possible that she transmitted his ideas to the Stieglitz circle" (Barbara Rose, "O'Keeffe's Trail," *New York Review of Books* 24 [31 March 1977]: 30). Gillian Szekely has pointed out that articles in *Camera Work* demonstrate that as early as 1903 the Stieglitz circle had an interest in Oriental art (Gillian Szekely, "The Beginnings of Abstraction in American Art and Theory in Alfred Stieglitz's New York Circle" [Ph.D. thesis, University of Edinburgh, 1971], 53–57). Also, the fact that Stieglitz had exhibited twenty-one Japanese prints from the F. W. Hunter Collection at 291 in 1909 is evidence that Eastern art was among his interests before he met O'Keeffe.

16. For a discussion of the sphinx as a personification of female sexual power, see Dijkstra, *Idols of Perversity*, 327–35.

17. Yong Kwon Kim pointed out that on 3 April 1918 Stieglitz sent a handwritten copy of an untitled poem to his friend Marie Rapp (Boursault), who had assisted him at 291 (see Yong Kwon Kim, *Alfred Stieglitz and His Time: An Intellectual Portrait* [Seoul, Korea: American Studies Institute; Seoul National University, 1970], 89). The "poem" Kim referred to is, in fact, the *two* poems that were published in 1922 in *MSS.*, each titled "Portrait—1918." See above, n. 4.

18. The nature of their relationship will no doubt be clarified when it becomes possible to read their early correspondence.

19. Stieglitz believed the only accurate portrait of a person would be made up of photographs dating from birth to death. Thus he referred to the whole of his photographs of O'Keeffe as a single "portrait." In 1921, however, when he first exhibited prints of O'Keeffe under the title "A Demonstration of Portraiture," he divided them into categories: "A Woman," "Hands," "Feet," "Hands and Breasts," and "Torsos"—each called "One Portrait." Of the series, only two prints, titled "Interpretations," were not categorized as a portrait.

20. Greenough has pointed out that in some of the photographs O'Keeffe occasionally resembles "a somewhat softer version of the late nineteenth-century *femme fatale*" (Greenough, "From the Faraway," 136).

 For examples of Stieglitz photographs made between 1918 and 1920 for which O'Keeffe posed nude or semi-nude, see Doris Bry, *Alfred Stieglitz: Photographer* (Boston: Museum of Fine Arts, 1965), plates 13–14, 17, 19; Greenough and Hamilton, *Alfred Stieglitz*, plates 38–40; and *Georgia O'Keeffe: A Portrait by Alfred Stieglitz*, plates 7, 9–12, 24–29.

21. Henry McBride, "Art News and Reviews: Steiglitz's [*sic*] Life Work in Photography— Emil Fuchs' Sculpture," *New York Herald* (13 February 1921), sec. 2, p. 5.

22. Ibid.

23. Henry McBride, "O'Keeffe at the Museum," *New York Sun* (18 May 1946), 9.

24. Lowe made it clear that everyone involved with the exhibition was aware of the scandal some of the photographs could provoke: "Alfred had withheld the most intimate images of Georgia after dress rehearsals before family and friends had elicited fears of censure" (Lowe, *Stieglitz: A Memoir*, 241).

25. Alfred Stieglitz, "A Statement," in *An Exhibition of Photography, by Alfred Stieglitz [145 Prints, Over 128 of Which Have Never Been Publicly Shown, Dating from 1886–1921]* [exhibition catalogue] (New York: The Anderson Galleries, from 7 February 1921), n.p. (photocopy on file at the Archives of American Art, Smithsonian Institution, Washington, D.C.).

26. Henry McBride, "Modern Art," *Dial* 70 (April 1921): 180–82. In a letter to McBride, Stieglitz denied having destroyed the negative of the "nude," but he did not deny having affixed a $5,000 price tag to the print. See Stieglitz to McBride, 25 March 1921, HMP, roll 12.

27. For various points of view about how the female body has been objectified in art, see John Berger et al., *Ways of Seeing* (London: British Broadcasting Corporation and Penguin Books, 1987), 45–64; Chicago, *Through the Flower*, 156; Duncan, "Virility and Domination," 293–313; Linda Nochlin, "Eroticism and Female Imagery in Nineteenth-Century Art," in *Woman as Sex Object: Studies in Erotic Art, 1730–1970*, ed. Thomas B. Hess and Linda Nochlin (New York: Newsweek, 1972), 9–15; and Dorothy

Seiberling, "The Female View of Erotica," *New York Magazine* 7 (11 February 1974): 54–58.

28. Brief descriptions of the public reaction to the show can be found in Lisle, *Portrait*, 134–35, and Lowe, *Stieglitz: A Memoir*, 241.

29. In Norman, *Stieglitz: Seer*, 142.

30. See Hutchins Hapgood, *A Victorian in the Modern World* (New York: Harcourt, Brace and Co., 1939), 339, and Herbert J. Seligmann, "291: A Vision through Photography," in *America & Alfred Stieglitz: A Collective Portrait*, ed. Waldo Frank et al. (New York: Doubleday, Doran & Co., 1934), 116–17.

31. Paul Rosenfeld, "Stieglitz," *Dial* 70 (April 1921): 397–409, and Paul Strand, "Alfred Stieglitz and a Machine," printed privately in New York (14 February 1921), reprinted in *MSS.*, no. 2 (March 1922): 6–7, and included, with revisions, in Frank et al., *America & Alfred Stieglitz*, 281–85. For additional essays on Stieglitz's 1921 show, see Walter Pach, "An Exhibition of Photography," *Freeman* 2 (23 February 1921): 565, and "Photographs by Alfred Steiglitz [*sic*]" *New York Times* (13 February 1921), sec. 6, p. 8.

32. Rosenfeld, "Stieglitz," 399.

33. Ibid., 408–9.

34. Ibid., 400.

35. Ibid., 398.

36. Ibid., 398, 397.

37. In Dorothy Norman, *Encounters: A Memoir* (San Diego, Calif.: Harcourt Brace Jovanovich, 1987), 102. Critic Lewis Mumford also referred to the sensuality of Stieglitz's photographs of O'Keeffe, declaring that in them "Stieglitz achieved the exact equivalent of the report of the hand or the face as it travels over the body of the beloved" (Lewis Mumford, "The Metropolitan Milieu," in Frank et al., *America & Alfred Stieglitz*, 57).

38. The work Rosenfeld considered must have included some of the following: *Evening Star VI* (1917, Estate of Georgia O'Keeffe), *Series I, No. 1* (1918, American National Bank Collection), *Black Spot III* (1919, Albright-Knox Art Gallery), *Fifty-ninth Street Studio* (1919, private collection), *Red Canna* (ca. 1920, Yale University Art Gallery), *Plums* (fig. 9), *Lake George with Crows* (1921, Estate of Georgia O'Keeffe), and *Lake George and Woods* (ca. 1922, private collection). The imagery of these paintings demonstrates O'Keeffe's broad range of interests in the late teens and early twenties.

39. For several decades, ideas similar to Rosenfeld's and Stieglitz's about the source of female creativity have informed the thinking of those feminist artists, critics, and art historians who conclude that women's art is intricately intertwined with female experiences, including experiences relating to sexuality. See chap. 1, n. 27.

40. Havelock Ellis, *Studies in the Psychology of Sex*, 4 vols. (New York: Random House, 1936), 4:173.

41. Paul Rosenfeld, "American Painting," *Dial* 71 (December 1921): 665.

42. Ibid., 651–52.

43. Ibid., 655.

44. Rosenfeld, "Stieglitz," 408–9.

45. About the Hartley essay, Lisle wrote: "One of the first articles [on O'Keeffe] was published in 1920. . . . Written by Marsden Hartley, it . . . was published the next year in the book *Adventures in the Arts*" (Lisle, *Portrait*, 164). I have been unable to find any other indication that either "Some Women Artists" or its section "Georgia O'Keeffe" was published before the essay appeared in *Adventures in the Arts*.

46. Marsden Hartley, "Our Imaginatives," chap. 7 in *Adventures in the Arts* (1921; reprint, New York: Hacker Art Books, 1972), 67.

Chapter 3

1. O'Keeffe, *O'Keeffe: A Portrait*, n.p.

2. Ibid.

3. In Pollitzer, *A Woman on Paper*, 168.

4. O'Keeffe, *O'Keeffe: A Portrait*, n.p.

5. Pollitzer, *A Woman on Paper*, 168.

6. In Greenough and Hamilton, *Alfred Stieglitz*, n. 30, p. 231.

7. O'Keeffe, *O'Keeffe: A Portrait*, n.p.

8. In Kotz, "O'Keeffe at 90," 44.

9. In Lisle, *Portrait*, 133–34.

10. More broadly, O'Keeffe paintings dating from the late teens also reveal her interest in the abstract qualities of Paul Strand's photographs of the period. She first saw his work in 1917, when she went to New York to visit Stieglitz, and became more familiar with it after her move to New York the following year. In 1922, she pointed out that she believed Strand's photographs made "more obvious the fact that subject matter, as subject matter, has nothing to do with the aesthetic significance of a photograph any more than with a painting" (Appendix A, no. 10).

11. Norman pointed out that O'Keeffe also designed the cover of this issue of the magazine (Norman, *Stieglitz: Seer*, n. 6 to chap. 10, p. 242). The credit line read: "For the cover design: apologies to 'Dada' (American), Marcel Duchamp, Man Ray, and acknowledgment to 'Anonymous'" (*MSS.*, no. 4 (December 1922): 20). *MSS.*, which appeared six times between February 1922 and May 1923, was another Stieglitz inspiration. In 1921, he encouraged a group of young writers in his circle to form their own magazine, which would be funded by individual contributors and, thus, be free from editorial control of any kind.

12. O'Keeffe to Kennerley, fall 1922, in Cowart, Hamilton, and Greenough, *Art and Letters*, letter 26, p. 170. O'Keeffe was apparently recalling the Hapgood incident, because the Rosenfeld article had been published in December 1921. Author-critic Hapgood was a Stieglitz friend of long standing.

13. O'Keeffe to McMurdo, 1 July 1922, in Cowart, Hamilton, and Greenough, *Art and Letters*, letter 25, p. 169.

14. Ibid., 170.

15. Stieglitz to Seligmann, 6 July 1921, ASA.

16. Many critics responded to O'Keeffe's technical proficiency. See, for example, Helen Appleton Read in 1924 (Appendix A, no. 25), Read and Forbes Watson in 1925 (Appendix A, nos. 40–41), and Duncan Phillips in 1926 (Appendix A, no. 55).

17. A photocopy of the brochure is on file at the National Gallery of Art, Gallery Archives, RG 17B.

18. In Grace Glueck, "Art Notes: 'It's Just What's in My Head . . . ,'" *New York Times* (18 October 1970), sec. 2, p. 24.

19. For brief discussions of the importance of the word "clean" to the language of the Stieglitz circle, see Kim, *Alfred Stieglitz and His Time*, 52–53, and Robert E. Haines, *The Inner Eye of Alfred Stieglitz* (Lanham, Md.: University Press of America, 1982), 18.

20. O'Keeffe to McMurdo, 1 July 1922, in Cowart, Hamilton, and Greenough, *Art and Letters*, letter 25, p. 170.

21. O'Keeffe's illness after her exhibition in 1923 is confirmed in a letter Stieglitz wrote to McBride (see Stieglitz to McBride, 4 February 1923, HMP, roll 12).

22. O'Keeffe to Anderson, 11 February 1924, in Cowart, Hamilton, and Greenough, *Art and Letters*, letter 30, p. 176.

23. O'Keeffe to Anderson, September 1923?, in Cowart, Hamilton, and Greenough, *Art and Letters*, letter 29, p. 174.

24. O'Keeffe to McBride, February 1923, in Cowart, Hamilton, and Greenough, *Art and Letters*, letter 27, p. 171. Stieglitz also expressed to McBride his and O'Keeffe's pleasure at reading the article (see Stieglitz to McBride, 4 February 1923, HMP, roll 12).

25. Strand also prepared an essay on O'Keeffe's work, probably during the run of the show, which was summarily rejected by the *Dial* but which was published in July of 1924 in *Playboy: A Portfolio of Art and Satire* (Appendix A, no. 32). For an exchange of letters between Strand and the *Dial* about this essay, see Wasserstrom, *Time of the Dial*, 60–62.

26. Strand's letter might be seen as an attempt on the part of one member of the Stieglitz circle to counteract the flood of sensational interpretations of O'Keeffe's art he suspected was coming in the reviews.

27. The telegram is part of the Sherwood Anderson Papers, The Newberry Library, Chicago.

28. O'Keeffe to Anderson, 11 February 1924, in Cowart, Hamilton, and Greenough, *Art and Letters*, letter 30, p. 176.

29. Ibid.

30. O'Keeffe's exhibition had its own catalogue and was titled "Alfred Stieglitz Presents Fifty-One Recent Pictures, Oils, Water-colors, Pastels, Drawings, by Georgia O'Keeffe, American" (photocopy of catalogue on file at the National Gallery of Art, Gallery Archives, RG 17B). The catalogues of O'Keeffe's shows in the 1920s list works only by titles. Because much of what she exhibited during this period was renamed later, it is impossible to determine precisely what each show included. In 1924, eight

works were exhibited under the single title "Leaves" and three under the title "Birch Trees," and thus the show could well have included *Pattern of Leaves* (fig. 10) and *Birch Trees at Dawn at Lake George* (fig. 11), both of which were painted in 1923.

31. O'Keeffe had also written to Anderson: "I wanted it [the 1924 show] to confirm what started last year," which may have been a reference to the potential critical direction she sensed in McBride's and Strand's comments about her work in 1923 (O'Keeffe to Anderson, 11 February 1924, in Cowart, Hamilton, and Greenough, *Art and Letters*, letter 30, p. 175).

32. Stieglitz's exhibition in 1924 was titled "The Third Exhibition of Photography, by Alfred Stieglitz [Songs of the Sky—Secrets of the Skies as Revealed by My Camera & Other Prints]." He first exhibited a series of cloud photographs in 1923, in his second Anderson Galleries exhibition, under the title "Music—A Sequence of Ten Cloud Photographs." But the year he began photographing clouds in series has been variously reported as 1921 by Bry (*Alfred Stieglitz: Photographer*, 19n) and Lisle (*Portrait*, 126) and as 1922 by Greenough (Greenough and Hamilton, *Alfred Stieglitz*, n. 35, p. 233) and Lowe (*Stieglitz: A Memoir*, 256). Stieglitz himself claimed to have begun the project in response to a statement written about his work by Waldo Frank, and he read Frank's statement in the summer of 1922. See Alfred Stieglitz, "How I Came to Photograph Clouds," *Amateur Photographer and Photography* 56 (19 September 1923): 255 (reprinted in Greenough and Hamilton, *Alfred Stieglitz*, 206–8), and Greenough's analysis of the document in *Alfred Stieglitz*, n. 35, pp. 232–33.

33. O'Keeffe to Anderson, 11 February 1924, in Cowart, Hamilton, and Greenough, *Art and Letters*, letter 30, p. 176.

34. This appendix entry also includes a brief, rhapsodic tribute to "our Alfred Stieglitz" by painter Louis Eilshemius, contained in a letter to McBride that was published in conjunction with McBride's review. In the letter, Eilshemius stated that Stieglitz's photographs were "as fine as . . . black and white[s] by a master painter" and that his "portrait in cloud-songs fits his multiform nature." He also offered his interpretations of the various images ("a Valkyre [*sic*] scene . . . , [a fortress] with soldiers and flag clear as in life, . . . and demoniac gorge effects"). In addition, he praised O'Keeffe's work and made it clear that, because "her first show's overemphasis of abstract puzzles was reduced to only three," he was able to announce: "She is getting there, to my delight."

35. Although it is true that both Stieglitz and O'Keeffe had exhibitions in 1923, Read's suggestion that the exhibitions were simultaneous was erroneous.

36. Stieglitz apparently agreed. He wrote to Rosenfeld later in 1924 about the arrangements of wildflowers that O'Keeffe's sister, Ida, had made while visiting at Lake George: "She has done things in a way which compare with Georgia's best paintings—the same spirit—the same balanced sensibility—the amazing feeling for color and texture—the unconscious expression of woman in every touch.—Self portrayed through flowers and fruits and nuts found in the fields" (Stieglitz to Rosenfeld, 9 November 1924, ASA). His comments imply that he believed the works of both women were essentially self-portraits.

37. This remark demonstrates that even O'Keeffe's more "objective" paintings did not escape Freudian analysis, a fact alluded to by Greenough in "From the Faraway," 137.

38. Later in 1924, O'Keeffe was nominated to the *Vanity Fair* "Hall of Fame" (see Appendix A, no. 33). By pointing out that O'Keeffe "puts the unanalyzable qualities of poetry and mystery before the more obvious qualities of decision and fact," the magazine's brief statement promoted the Stieglitz-generated idea that her work was supremely feminine—bound to her emotional being. For the Stieglitz photograph that accompanied the article, see fig. 12.

39. In Norman, *Stieglitz: Seer*, 137.

40. Paul Rosenfeld, "D. H. Lawrence," *New Republic* 32 (27 September 1922): 125–26.

41. Joyce Carol Oates, "'At Least I Have Made a Woman of Her': Images of Women in Yeats, Lawrence, Faulkner," in *The Profane Art: Essays and Reviews* (New York: E. P. Dutton, 1983), 54. In addition to the discussion of Lawrence's attitude toward women in Oates, "At Least I Have Made a Woman of Her," 49–56, see also Kate Millett, *Sexual Politics* (Garden City, N.Y.: Doubleday & Co., 1970), 237–93.

42. O'Keeffe to McBride, February 1923, in Cowart, Hamilton, and Greenough, *Art and Letters*, letter 27, p. 171. Greenough also pointed out that O'Keeffe thought of herself as belonging to a class that was different from but not inferior to men (Greenough, "Notes to the Letters," letter 27, p. 278).

Chapter 4

1. The full title was "Alfred Stieglitz Presents Seven Americans: 159 Paintings, Photographs & Things, Recent & Never Before Publicly Shown, by Arthur G. Dove, Marsden Hartley, John Marin, Charles Demuth, Paul Strand, Georgia O'Keeffe, Alfred Stieglitz."

2. A photocopy of the catalogue is on file at the National Gallery of Art, Gallery Archives, RG 17B.

3. Waldo Frank wrote about Stieglitz: "Quite literally this man is devoting *all his life* to a quest of the truth. . . . Eating, sleeping, friendship, work and play have no reality for Alfred Stieglitz, save in so far as they serve him in his quest. He has helped more persons than are required by any church: but he does not care about persons. He has launched the art of a new century in a new world: but he does not care about art. He is hunting the truth" (Waldo Frank, "The Prophet," chap. 20 in *Time Exposures* [New York: Boni & Liveright, 1926], 177).

4. Dove began making assemblages in 1924, and they accounted for over one-third of his works shown in "Seven Americans." For a discussion of this aspect of his *oeuvre*, see Ann Lee Morgan, *Arthur Dove: Life and Work, with a Catalogue Raisonné* (Newark: University of Delaware Press, 1984), 49–52.

5. O'Keeffe recalled Stieglitz's initial response to what she described as "my first big flower": "I sat down to paint it . . . and it was wonderful. Stieglitz came in while I was painting and he laughed. 'I wonder what you think you're going to do with that,' he said. 'Oh, I'm just painting it,' I said" (in Kotz, "O'Keeffe at 90," 42). Of the thirty works she exhibited in 1925, eight had subject matter of flowers. And although *Pink Tulip* (fig. 14) and *Black Iris III* (fig. 15) were not painted until the following year, they typify the large-scale flower paintings she began to show in 1925. Examples of O'Keeffe's early experimentation with close-up views of flower forms in smaller

formats are *Red Flower* (ca. 1918–19, The Warner Collection of Gulf States Paper Corporation) and *Inside Red Canna* (1919, private collection).

6. But McBride was, in fact, singling out Dove, O'Keeffe, and Strand. He mistook Strand's photographs for Stieglitz's and thus began his discussion of Stieglitz's work by noting: "Mr. Stieglitz concentrates all of his soul upon some amazing photographs of machines" (Appendix A, no. 36). The twenty-eight Stieglitz photographs in the show were exhibited under the title "Equivalents," and their subject matter was the sky; whereas ten of Strand's photographs were exhibited under the title "Machine." Stieglitz wasted no time in pointing out the error to McBride. The day McBride's review was published, he wrote him: "I'm tickled you like those machine photographs so much. And call them masterpieces. . . . I agree with your enthusiasm about [them]. . . . —But unfortunately—they are by Paul Strand & not by me or should I say they are fortunately by Paul Strand" (Stieglitz to McBride, 14 March 1925, HMP, roll 12).

7. In late April, Stieglitz had written to Lewis Mumford: "I've had a mean time of it. It was an awful lapse on my part to break down during the show" (Stieglitz to Mumford, 27 April 1925, ASA). Stieglitz had fallen ill during the run of the exhibition, and his condition demanded bed rest. According to Lowe, he declared that had he been able to be on hand at the gallery, he could have effectively changed the opinion of some of the critics and reversed much of the negative reaction of the public (Lowe, *Stieglitz: A Memoir*, 271).

8. This was room 303 at the Anderson, later called "The Room" by him and his associates. Apparently, Stieglitz had control of the space as early as the winter of 1925. See Rönnebeck's statement quoted above from Appendix A, no. 34c.

9. Stieglitz to Dove, 7 July 1925, ADP, roll 725. In his letter to Lewis Mumford of 27 April (see above, n. 7), Stieglitz had also commented about McBride's article in the *Dial*: "I fear McBride did not get its spirit or anything else in those Rooms.—I'm sorry—maybe—for McBride." McBride had criticized Hartley again in his May 1925 essay for the *Dial* and made it very clear that he felt the American contribution to abstract art had been minimal, which may help explain Stieglitz's comment about his senility. But Stieglitz's opinion of McBride's mental capacities was probably most influenced by the error McBride had made in his review of "Seven Americans" in the *Sun*. See above, n. 6.

10. A brief commentary about the history of Stieglitz's relationship with critics is part of Deogh Fulton's extraordinarily even-handed review of "Seven Americans." See Deogh Fulton, "Cabbages and Kings," *International Studio* 81 (May 1925): 144–47.

11. Stieglitz to Dove, 7 July 1925, ADP, roll 725.

12. In October 1923, Hartley sent Stieglitz some autobiographical notes. Stieglitz was infuriated because in the notes Hartley ignored the role 291 had played in promoting his work, and he responded: "Ye Gods, Hartley, I'm beginning to feel I must be a lunatic. You have really made me feel that in reading what you say about me in these Notes & your relationship to me[.] Not a mention of 291.—Not a mention of the real generous spirit of the place—a place the like of which never was nor will be—*I know that*. For there will never be another quite such a fool as I happened to be born. It's a rare joke. And if I didn't have a keen sense of humor & one of values & a very good memory . . . what you wrote would make me commit suicide I'd be so

ashamed" (Stieglitz to Hartley, 27 October 1923, ASA). The same day, he wrote to Strand's wife, Beck: "What an ass a man like Hartley is in spite of his talents" (Stieglitz to Rebecca Strand, 27 October 1923, ASA). Although Stieglitz explained to Hartley that he would not hold the incident against him and continued to promote his work, their relationship was permanently affected by what he considered Hartley's ingratitude.

13. Lowe stated that there was "widespread resistance to Georgia's huge flowers" in 1925 (Lowe, *Stieglitz: A Memoir*, 271). Clearly, Lowe could not have been referring to critical resistance.

14. In other articles of the period, McBride often used the term "cubism" to mean "abstractionism." Certainly, there was nothing resembling cubist structure in the paintings O'Keeffe exhibited in 1925.

15. Read was not entirely accurate. Only the foreword to the 1923 show, with its reprint of Hartley's 1921 essay, could have directed anyone's attention to Freudian interpretations of O'Keeffe's art.

16. See chap. 1, n. 27.

17. For an account of the beginnings of Luhan's self-appointed role as "mistress of the spirit of her age" and the part Stieglitz played in her realization of it, see Lois Palken Rudnick, *Mabel Dodge Luhan: New Woman, New Worlds* (Albuquerque: University of New Mexico Press, 1984), 62–66. How Luhan defined women can be seen in her curious response to the question "What is 291," which Stieglitz published among others in *Camera Work* in 1915 (see Mabel Dodge [Luhan], "The Mirror," *Camera Work*, no. 47 [issue dated July 1914, published January 1915]: 9–10; see also chap. 1, n. 63). She claimed in her poem that women were the "fruit," the "ground," the "road," the "force that quickens all but death," the "death," the "plowman," the "good, the bad, the infinite all." She declared, as woman, "I am Fate," "I am God," "I am the mirror of all man ever is—I am the sum of all that has been his—For I am life." Clearly, Luhan believed women were powerful forces, and O'Keeffe may have turned to her because she thought of women in similar ways.

18. O'Keeffe to Luhan, 1925?, in Cowart, Hamilton, and Greenough, *Art and Letters*, letter 34, p. 180. This letter is on Hotel Shelton stationery, and because O'Keeffe moved to the Shelton with Stieglitz around 15 November 1925, she could have written it in late 1925 or January of 1926. It was probably not written later than that: in early February she was interviewed by critic Blanche Matthias, whose article, published in early March (and discussed in detail below), seemed to satisfy O'Keeffe's desire to have a woman "write something about me that the men cant."

19. An undated typescript of Luhan's unpublished essay, "The Art of Georgia O'Keeffe," is in the Mabel Dodge Luhan Archive, Collection of American Literature, Beinecke Rare Book and Manuscript Library, Yale University, New Haven.

20. It has been suggested that Luhan's response to O'Keeffe's art was that of a sexually confused woman. See Rudnick, *Mabel Dodge Luhan*, 235.

21. O'Keeffe, *Georgia O'Keeffe*, n.p.

22. In 1978, O'Keeffe implied that it was Stieglitz who refused to let her exhibit the painting (O'Keeffe, *Georgia O'Keeffe*, n.p.); but over a decade earlier, when she de-

scribed the incident to Ralph Looney, she stated that the refusal had come from "the men" (in Ralph Looney, "Georgia O'Keeffe," *Atlantic* 215 [April 1965]: 108).

23. See Looney, "Georgia O'Keeffe," 108, and O'Keeffe, *Georgia O'Keeffe*, n.p.

24. Kotz, "O'Keeffe at 90," 44.

25. In Glueck, " 'It's Just What's in My Head.' "

26. Ibid.

27. This statement was published in Pollitzer, *A Woman on Paper*, 189. I have been unable to locate a copy of the 1926 catalogue.

28. A Hartley exhibition, originally announced as opening 11 March and closing 7 April was, apparently, cancelled, and the O'Keeffe show was continued to fill the interval.

29. The interview took place before 8 February. In a letter to Matthias of that date, Stieglitz stated: "O'Keeffe tells me she had a most enjoyable session with you" (Stieglitz to Matthias, 8 February 1926, ASA).

30. The Kalonyme articles, which appeared in 1926 and 1927 in *Arts and Decoration*, in 1927 in the *New York Times*, and in 1928 in *Creative Art* (Appendix A, nos. 52, 59, 62, 73), are essentially four versions of the same essay. Because the last is the most polished and complex, it is the best illustration of Kalonyme's point of view about O'Keeffe's art and will be discussed at length in chap. 6.

31. Almost half a century later, Yurka recalled the incident at the Wildenstein in her autobiography but did not mention her remarks about the O'Keeffe, reporting only that "Robert" McBride had asked her about a single painting, probably the Picasso: "Now tell me what, if anything, does that picture say to you? Tell me frankly." She remembered that she replied: "Frankly, it says nothing to me. But I'm sure it's good. I feel as I might were I listening to someone who was speaking in Hindustani, for instance; I shouldn't understand what he was saying, but I should sense that he was saying it beautifully" (Blanche Yurka, *Bohemian Girl: Blanche Yurka's Theatrical Life* [Athens: Ohio University Press, 1970], 244–45).

32. The only published biography of O'Keeffe had been in an appendix to Rosenfeld's book (see Rosenfeld, *Port of New York*, 308).

33. O'Keeffe to Matthias, March 1926, in Cowart, Hamilton, and Greenough, *Art and Letters*, letter 36, p. 183.

34. Ibid. Many phrases in O'Keeffe's writing, like this one, can also be found in Stieglitz's writing. It would be an interesting study to determine the extent to which the words O'Keeffe used in this period derived from those Stieglitz had been using since the turn of the century.

Chapter 5

1. Another book was published in 1926 that contained a brief essay on O'Keeffe. It was *A Collection in the Making*, written by Duncan Phillips to serve as a guide to his collection. In line with that intention, his remarks about O'Keeffe were broadly focussed—summarizing her background and training, referring to various attitudes about her art that had developed in the criticism, and capsulizing his own opinions (see Appendix A, no. 55).

Summary biographical and professional information about O'Keeffe also appeared in the heavily illustrated catalogue of the "International Exhibition of Modern Art," which opened at the Brooklyn Museum in November of 1926 under the auspices of Katherine Dreier and the Société Anonyme and which included O'Keeffe and the other Intimate Gallery regulars. See Katherine S. Dreier, *Modern Art*, ed. Katherine S. Dreier and Constantin Aladjalov (New York: Société Anonyme, [1926]). For Dreier's entry on O'Keeffe, see Appendix A, no. 56; and for the Stieglitz photograph that, in a slightly different format, illustrated both it and the essay in Frank's *Time Exposures*, see fig. 16.

2. Frank was close to Stieglitz from the late teens, but increasingly, his outspokenness had created tension in their relationship. See Haines, *The Inner Eye of Alfred Stieglitz*, 22, 26–28, 39–42.

3. O'Keeffe to Frank, 10 January 1927, in Cowart, Hamilton, and Greenough, *Art and Letters*, letter 38, p. 185.

4. Ibid., 184–85.

5. Ibid., 185.

6. Lowe reported that even Stieglitz, who preferred being surrounded by family and friends during summers at Lake George, wrote to Beck Strand in 1925 that the summer had been "slashed to pieces" by visitors (Lowe, *Stieglitz: A Memoir*, 272).

7. Paintings of the city were important components of O'Keeffe's exhibitions during the years 1926–29. That was particularly true in 1927, when one-sixth of the total works shown were of New York subject matter.

8. There are several indications in the Matthias article that a part of her interview with O'Keeffe took place at the Intimate Gallery in Stieglitz's presence.

9. Bluemner had been a Stieglitz associate for over a decade. In the letter to Anne Brigman, cited earlier, Stieglitz listed Bluemner as being among those who gathered around him after he had closed 291 (see chap. 1, n. 23).

10. The show included thirty-six works, among which was *Dark Iris No. III*, no doubt the painting now titled *Black Iris III* (fig. 15). A photocopy of the catalogue is on file at the National Gallery of Art, Gallery Archives, RG 17B.

11. As pointed out earlier, Stieglitz had written to Duncan Phillips in 1926: "[O'Keeffe] is the first real woman painter not only of this country but in the world" (Stieglitz to Phillips, 1 February 1926, PSC).

12. It seems clear that Stieglitz believed woman's time had come. For example, in a letter congratulating Marie Rapp Boursault on the birth of her daughter in 1921, he stated: "As you know the future is in the hands of the Woman." And about a year later, he wrote to Beck Strand: "I'm beginning to realize we males are a lot of minus bugs— you are Plussers" (Stieglitz to Boursault, 8 June 1921, and Stieglitz to Rebecca Strand, 4 August 1922, ASA).

13. Stieglitz to Mumford, 3 March 1927, ASA. The issue of the *New Republic* in which Mumford's article appeared, though dated 2 March 1927, was published on or before 25 February.

14. Later in 1927, Stieglitz reported to Mumford: "O'Keeffe read your article on her the other day again and said, 'It's very, very beautiful'" (Stieglitz to Mumford, 13 September 1927, ASA).

15. In 1927, as in 1926, McBride also reviewed O'Keeffe's show in the *Dial* (see Appendix A, no. 64).

16. Stieglitz to Rebecca Strand, 4 August 1922, ASA.

17. For an example of a nonrepresentational painting of the period, see *Abstraction* (fig. 18).

18. O'Keeffe to Stieglitz, January 1916, in Pollitzer, *A Woman on Paper*, 123–24.

19. Stieglitz had kept copies of the article at the Intimate Gallery during the run of O'Keeffe's 1926 show and made them available to visitors. As O'Keeffe explained in a letter to Matthias: "A pile of the papers with your article on the front page are in the room. People often pick it up and read it and sometimes ask to carry it away—" (O'Keeffe to Matthias, March 1926, in Cowart, Hamilton, and Greenough, *Art and Letters*, letter 36, p. 183).

20. In Adato, *Georgia O'Keeffe* (videotape).

21. O'Keeffe to McBride, 16 January 1927, in Cowart, Hamilton, and Greenough, *Art and Letters*, letter 39, p. 185.

22. In contrast to McBride, C. J. Bulliet, whose brief comments about O'Keeffe's art were published in 1927 in his *Apples & Madonnas: Emotional Expression in Modern Art*, perpetuated the idea that her paintings were emotional. He wrote: "If emotion be the soul of art, then Miss O'Keeffe's abstractions are tenuous art bodies sublimated nearly to the essence." Yet, at the same time, he also disassociated such emotionalism from gender issues: "It has been said of her work that it is purely feminine. It does not strike me as such, as Marie Laurencin's. It seems vaguely sexless—without any sex suggestion." Stieglitz, who felt that O'Keeffe's work was the quintessence of femaleness, would have strongly disagreed; and indeed, in the twenties, O'Keeffe would have objected to Bulliet's point that her art was unrelated to gender. Yet both could only have approved of another of Bulliet's points: "Georgia O'Keeffe has done the best work, perhaps, of any American, male or female, in the pure abstract." See Appendix A, no. 68.

23. In 1977, O'Keeffe pointed out: "I've made my living selling my paintings since 1927" (in Kotz, "O'Keeffe at 90," 44). But there is conflicting information about the amount of money O'Keeffe's show generated that year. Figures range from $9,000 to $23,000. In a letter to Duncan Phillips dated 2 February 1927, Stieglitz reported: "Tonight an O'Keeffe sold for $6,000. Another smaller one for $3,000. Many others at various figures"; and in a letter to Phillips of 13 February, Stieglitz reported the sale of *The Shelton with Sun Spots* to a patron who agreed to pay O'Keeffe $6,000 over a period of five years (Stieglitz to Phillips, 2 and 13 February 1927, PSC). Whether the $6,000 sale Stieglitz referred to in his first letter to Phillips was that of *The Shelton with Sun Spots* is not clear. Also on 2 February 1927, Stieglitz wrote collector Clara Rossin that she could have two of O'Keeffe's paintings for $2,000, and her agreement to his proposal is implied in a letter he wrote her four days later (see Stieglitz to Rossin, 2 and 6 February 1927, ASA). Lowe and Lisle concur that sales from the show generated $17,000, but neither offers documentation to verify this figure (Lowe, *Stieglitz:*

A Memoir, 282; Lisle, *Portrait*, 188). On 22 February 1927, however, a brief article in the *Chicago Evening Post* reported that six paintings from O'Keeffe's show had been sold for a total of $23,000 ("Six Georgia O'Keeffe Canvases Net $23,000," *Chicago Evening Post* [22 February 1927], page unknown [hand-dated clipping in vertical file, "Georgia O'Keeffe," National Museum of American Art/National Portrait Gallery Library, Smithsonian Institution, Washington, D.C.]). Because approximately six weeks after O'Keeffe's show closed in *1928*, Stieglitz sold six of her paintings for $25,000, it would be tempting to believe the clipping refers to the 1928 sale, though if so, it would have to be both mis-dated and incorrect in its quotation of the amount. But the *Post* article states that the paintings were sold "from the exhibition" and that the exhibition was still on view. Thus there can be no doubt that it refers to 1927.

24. A brief paragraph about O'Keeffe by Frank Jewett Mather, Jr., was included in *The American Spirit in Art*, also published in 1927. It was at best a superficial assessment of her work (see Appendix A, no. 65).

Chapter 6

1. As pointed out earlier, Stieglitz photographs of O'Keeffe had been used to illustrate two articles in *Vanity Fair* in 1922 (Appendix A, nos. 7–8); and in 1924, the essay in *Port of New York* (Appendix A, no. 28) and another piece in *Vanity Fair* (Appendix A, no. 33). See figs. 7, 5, 13, 12.

2. See chap. 2, n. 23.

3. Both Adlow and O'Brien were mistaken about the height at which O'Keeffe lived and worked in the Shelton. She and Stieglitz occupied Suite 3003, on the thirtieth floor.

4. See "Starts a Campaign to Elect More Women: Woman's Party Dinner at Capital Emphasizes Need of More Sex in Office," *New York Times* (1 March 1926), 2; see also Lowe, *Stieglitz: A Memoir*, 280. In addition, documents relating to this event can be found in the Papers of the National Woman's Party, 1913–1974 (microfilm edition, reel 31). O'Keeffe was a member of the National Woman's Party. She had come into contact with the group through Anita Pollitzer, who was one of its organizers and, much later, its director. For a discussion of the origin and early development of the NWP, see Nancy Cott, *The Grounding of Modern Feminism* (New Haven: Yale University Press, 1987), 53–81.

5. O'Brien was not a stranger to either O'Keeffe or Stieglitz. While she was visiting Lake George in 1925, in fact, Stieglitz photographed her in the nude (for two of the prints, see accession nos. D 636, D 637, National Gallery of Art, Washington, D.C., Alfred Stieglitz Collection).

6. The exhibition in 1928, called, simply, "O'Keeffe Exhibition," was held from 9 January through 27 February and contained forty-seven works. A photocopy of the catalogue is on file at the National Gallery of Art, Gallery Archives, RG 17B.

7. The first time O'Keeffe was quoted in print about this issue was in Henry McBride's review of her 1931 show. In response to critics who found erotic content in her paintings, O'Keeffe had said to McBride: "If they write about me like that I shall quit being an artist. I can't bear to have such things said of me" (in Henry McBride, "The Palette Knife," *Creative Art* 8 [February 1931]: suppl. 45). The introduction O'Keeffe

prepared for the catalogue of her 1939 show formalized a response to such criticism: "Well—I made you take time to look at what I saw and when you took time to really notice my flower you hung all your associations with flowers on my flower and you write about my flower as if I think and see what you think and see of the flower—and I don't" (Georgia O'Keeffe, "About Myself," *Georgia O'Keeffe: Exhibition of Oils and Pastels* [exhibition catalogue] [New York: An American Place, 22 January–17 March 1939], n.p. [photocopy on file at the National Gallery of Art, Gallery Archives, RG 17B; statement partially quoted in Pollitzer, *A Woman on Paper*, 226]).

8. The black painting with "a tiny sphere of luminous white" was *Black Abstraction* (1927, Metropolitan Museum of Art, Alfred Stieglitz Collection).

9. See chap. 4, n. 30.

10. For the photograph, see *Georgia O'Keeffe: A Portrait—Head*, 1926 (NGA D 1545).

11. The only painting listed in the 1928 catalogue with "Shelton" in the title was *The Shelton at Night* (1927, present title and whereabouts unknown).

12. At O'Keeffe's request, Kotz quoted a portion of this passage in her 1977 article (see Kotz, "O'Keeffe at 90," 45). McBride's opinion of the quality of O'Keeffe's skyscraper paintings in 1928 was paralleled in Suzanne La Follette's *Art in America: From Colonial Times to the Present Day*, published the following year (see Appendix A, no. 90).

13. Lisle estimated the equivalent in 1979 dollars as about $200,000 (Lisle, *Portrait*, 188).

14. Jean Evans, "Stieglitz: Always Battling—and Retreating," *PM* (23 December 1945), 13M.

15. Stieglitz's most persistent claim about the importance of O'Keeffe's work had been eloquently expressed in his 1 February 1926 letter to Duncan Phillips. See chap. 1, n. 87.

16. In existing accounts of the sale and subsequent events, there is some disagreement. Lowe reported that the sale took place in 1927 and that, afterward, O'Keeffe traveled to Bermuda (Lowe, *Stieglitz: A Memoir*, 282–83)—a trip mentioned but assigned to 1928 in the chronology in Cowart, Hamilton, and Greenough, *Art and Letters*, 292. But there is no evidence that O'Keeffe was in Bermuda in the late twenties. A letter Stieglitz wrote to collector Richard Brixey documents the fact that she was in Maine in late May 1928, where since 1920 she had spent brief periods of time at York Beach (see Stieglitz to Brixey, 24 May 1928, ASA). To determine precisely when she was there, however, presents a problem. Lisle suggested she left for Maine in April (Lisle, *Portrait*, 191). And indeed, in a letter she wrote to McBride from Lake George, which she dated 11 May, O'Keeffe stated: "I took myself to Maine for a little over two weeks" (O'Keeffe to McBride, 11 May 1928, HMP, roll 11). But Stieglitz's letter to Brixey, cited above, indicates that he and O'Keeffe were intending to move to Lake George that year around 6 June. So O'Keeffe's letter to McBride was probably misdated and must have been written on 11 June. At any rate, she was in Maine on 24 May, and if she stayed there about two weeks, she could not have been there in April.

17. Sabine mentioned in her article that on the day of her interview with O'Keeffe, Stieglitz was hanging a Picabia show. That show opened at the Intimate Gallery on 19 April; and because the previous show had closed on 17 April, her interview had to have occurred on the intervening day. The exact date of the Berman interview is

not clear, but his article indicated that the sale had taken place about two weeks before. O'Keeffe's paintings sold during the second week in April, so he must have talked with her sometime between 22 and 28 April.

18. The photograph used to illustrate the Sabine article (fig. 21) is a precise visual equivalent of Helen Appleton Read's description of O'Keeffe in 1924 as "an ascetic, almost saintly appearing, woman with a dead-white skin, fine delicate features and black hair severely drawn back from her forehead" (Appendix A, no. 30).

19. In addition to O'Keeffe's, Read examined the work of Lauren Ford, Thelma Cudlipp Grosvenor, Katherine Schmidt, and Marguerite Zorach.

20. For examples, see Appendix A, nos. 23, 26, 29, 37.

21. About two months after Read's article, *Vanity Fair* published the following reasons for a second nomination of O'Keeffe to its "Hall of Fame": "Because she is an artist who was originally discovered by Alfred Stieglitz, whose wife she is, and who made this photograph of her; because for a month she held an amazingly successful exhibition at Anderson Galleries last winter; because her painting has an originality which gives it especial importance; and finally because she is a black and white artist of unusual distinction" (Appendix A, no. 81). The Stieglitz photograph (fig. 21) had also been used to illustrate the Sabine article.

22. See Charles Demuth, "Across a Greco Is Written," *Creative Art* 5 (29 September 1929): 629–34. A photocopy of the 1929 catalogue is on file at the National Gallery of Art, Gallery Archives, RG 17B.

23. O'Keeffe to McBride, February 1929, in Cowart, Hamilton, and Greenough, *Art and Letters,* letter 42, p. 188.

24. The day after it opened, Stieglitz wrote Hartley that "the O'Keeffes are on the wall and I have announced that it will be her last show for a while" (Stieglitz to Hartley, 5 February 1929, ASA). And about a month later, Stieglitz wrote to Dove: "I've decided that no matter what happened there will be no O'Keeffe show next year" (Stieglitz to Dove, 1 March 1929, ADP, roll 725).

25. See Stieglitz to Mumford, 13 September 1927 and Stieglitz to Rebecca Strand, 10 September 1927, ASA.

26. Stieglitz to Phillips, 30 December 1927, and see Stieglitz to Phillips, 20 and 27 January 1928, PSC.

27. Stieglitz to Brixey, 24 May 1928, ASA.

28. See O'Keeffe to McBride, 11 May [June?] 1928, HMP, roll 11; see also above, n. 16.

29. See O'Keeffe to Ettie Stettheimer, 21 September 1928, in Cowart, Hamilton, and Greenough, *Art and Letters,* letter 40, p. 186. Stettheimer was one of three sisters, including painter Florine Stettheimer, whose apartment in New York became a gathering place for artists, composers, critics, and writers in the twenties.

30. Stieglitz to Mumford, 17 October 1928, and Stieglitz to Seligmann, 10 October 1928, ASA.

31. Stieglitz to Seligmann, 28 June 1928, ASA.

32. O'Keeffe to Frank, 10 January 1927; see chap. 5, n. 3.

33. See Lisle, *Portrait*, 212, and Lowe, *Stieglitz: A Memoir*, 292.

34. O'Keeffe to McBride, in Cowart, Hamilton, and Greenough, *Art and Letters*, letter 33, p. 179 (this undated letter was tentatively assigned the date March 1925 in *Art and Letters*; but because it refers to other articles on McBride's "page" in the *Sun* of 9 February 1929, as well as to specific points in his review of O'Keeffe's exhibition of that date [Appendix A, no. 84], the letter was written in 1929, and probably, on or just after 9 February). There is reason to believe that O'Keeffe had no financial worries at the time of her exhibition in 1929. About ten days after the probable date of her letter to McBride, Stieglitz wrote to Duncan Phillips: "It will interest you to know that there is one man who has acquired 9 of her important pictures within the last ten months—extraordinary examples—and has virtually assured to her a very generous income for life" (Stieglitz to Phillips, 20 February 1929, PSC).

35. Stieglitz to Hartley, 22 February 1929, ASA. In this letter, Stieglitz described one of the "new O'Keeffes" that had been bought by "the man who acquired the Lilies" as "a small white lily with a green leaf and red background." That painting was probably *Single Lily with Red* (fig. 22).

36. Lisle mentioned the "lowkey [sic] reactions" of the critics (Lisle, *Portrait*, 212), and Lowe reported that they "had been gentle but hardly thrilled" (Lowe, *Stieglitz: A Memoir*, 292). Stieglitz, however, suggested in his letter of 20 February to Duncan Phillips that there had been unqualified critical approval of O'Keeffe's show; he expressed regret that Phillips could not see it and pointed out: "I am sure . . . [her paintings] will be a revelation to you. There is but one voice about them" (Stieglitz to Phillips, 20 February 1929, PSC). A letter Stieglitz wrote Hartley just after the O'Keeffe show opened may have contributed to the confusion about her show's critical reception. It states: "The critics as you will have seen by the clippings I sent you, were both kindly disposed and some decidedly the reverse." But he also makes it clear in the letter that he was referring to *Hartley's* work, which was shown at the Intimate Gallery just before O'Keeffe's: "McBride, whose dictum counts more than all the others put together, although liking you as a person, frankly did not like your work" (Stieglitz to Hartley, 5 February 1929, ASA).

Conclusion

1. Evans, "Stieglitz: Always Battling."

2. Gladys Oaks, "Radical Writer and Woman Artist Clash on Propaganda and Its Uses," *The* [New York] *World* (16 March 1930), Women's section, pp. 1, 3.

3. Seiberling, "The Female View of Erotica," 54.

4. Lisle made the point that O'Keeffe's negative response to feminist artists like Judy Chicago, who declared that her "flowers were symbols of femininity," was probably conditioned by the early criticism (Lisle, *Portrait*, 427).

5. O'Keeffe, *O'Keeffe: A Portrait*, n.p.

6. Ibid.

7. For an indication of how, by the late seventies, O'Keeffe had attempted to extend control over the promotion of her art to include even what was written about it, see Lawrence Alloway's "Author's Note" in his "Notes on Georgia O'Keeffe's Imagery," 18.

Selected Bibliography

Archival Sources

Anderson, Sherwood. Papers. The Newberry Library, Chicago.

Dove, Arthur. Papers. Collection William C. Dove. Microfilm. Archives of American Art, Smithsonian Institution, Washington, D.C.

Frank, Waldo. Collection. Special Collections, Van Pelt Library, University of Pennsylvania, Philadelphia.

Kennerley, Mitchell. Papers. Rare Books and Manuscript Division, The New York Public Library, Astor, Lenox, and Tilden Foundations.

McBride, Henry. Papers. Collection of American Literature, Beinecke Rare Book and Manuscript Library, Yale University, New Haven. Microfilm. Archives of American Art, Smithsonian Institution, Washington, D.C.

O'Keeffe, Georgia. Archive. Collection of American Literature, Beinecke Rare Book and Manuscript Library, Yale University, New Haven.

———. Vertical File. National Museum of American Art/National Portrait Gallery Library, Smithsonian Institution, Washington, D.C.

———. Vertical File. Whitney Museum of American Art Library, New York.

Phillips, Duncan, and Alfred Stieglitz. Correspondence, 1926–30. The Phillips Collection Archives, Washington, D.C.

Stieglitz, Alfred. Archive. Collection of American Literature, Beinecke Rare Book and Manuscript Library, Yale University, New Haven.

———. Vertical File. National Museum of American Art/National Portrait Gallery Library, Smithsonian Institution, Washington, D.C.

Sources Relating to O'Keeffe, 1916–1929

A[dlow], D[orothy]. "Georgia O'Keeffe." *The Christian Science Monitor* (20 June 1927), 11. (Reprinted in Appendix A, no. 66.)

Alfred Stieglitz Presents Fifty-One Recent Pictures: Oils, Water-colors, Pastels, Drawings, by Georgia O'Keeffe, American [exhibition catalogue]. New York: The Anderson Galleries, 3–16 March 1924. Photocopy in National Gallery of Art, Gallery Archives, RG 17B. (Includes untitled statement by O'Keeffe; Royal Cortissoz's review of O'Keeffe's 1923 exhibition [*New York Tribune*, 11 February 1923]; excerpts from reviews by Alan Burroughs [*New York Sun*, 3 February 1923] and Henry McBride [*New York Herald*, 4 February 1923]; and exhibition checklist. See Appendix A, nos. 22, 16, 12, 14.)

Alfred Stieglitz Presents One Hundred Pictures: Oils, Water-colors, Pastels, Drawings, by Georgia O'Keeffe, American [exhibition brochure]. New York: The Anderson Galleries, 29 January–10 February 1923. Photocopy in National Gallery of Art, Gallery Archives, RG 17ʙ. (Includes untitled statement by O'Keeffe and "Georgia O'Keeffe," extract from "Some Women Artists in Modern Painting," chap. 13 in *Adventures in the Arts*, by Marsden Hartley [New York: Boni and Liveright, 1921]. See Appendix A, nos. 11, 5.)

Alfred Stieglitz Presents Seven Americans: 159 Paintings, Photographs & Things, Recent & Never Before Publicly Shown, by Arthur G. Dove, Marsden Hartley, John Marin, Charles Demuth, Paul Strand, Georgia O'Keeffe, Alfred Stieglitz [exhibition catalogue]. New York: The Anderson Galleries, 9–28 March 1925. Photocopy in National Gallery of Art, Gallery Archives, RG 17ʙ. (Includes untitled statement by Stieglitz; "Seven Alive," by Sherwood Anderson; "A Way to Look at Things," by Arthur G. Dove; and "Through the Eyes of a European Sculptor," by Arnold Rönnebeck. Also includes exhibition checklist and list of selected exhibitions held at 291, 1905–17. See Appendix A, nos. 34ᴅ, 34ᴀ, 34ʙ, 34ᴄ.)

Anderson, Sherwood. "Seven Alive." In *Alfred Stieglitz Presents Seven Americans: 159 Paintings, Photographs & Things, Recent & Never Before Publicly Shown, by Arthur G. Dove, Marsden Hartley, John Marin, Charles Demuth, Paul Strand, Georgia O'Keeffe, Alfred Stieglitz* [exhibition catalogue], n.p. New York: The Anderson Galleries, 9–28 March 1925. (Reprinted in Appendix A, no. 34ᴀ.)

"Art." *New Yorker* 1 (28 March 1925): 17.

"Art: On View." *Time* 11 (20 February 1928): 21–22. (Partially reprinted in Appendix A, no. 75.)

"Artist Who Paints for Love Gets $25,000 for 6 Panels." *New York Times* (16 April 1928), 23. (Reprinted in Appendix A, no. 76.)

Barker, Virgil. "Notes on the Exhibitions." *The Arts* 5 (April 1924): 212–23. (Partially reprinted in Appendix A, no. 31.)

Berman, B. Vladimir. "She Painted the Lily and Got $25,000 and Fame for Doing it! Not in a Rickety Atelier but in a Hotel Suite on the 30th Floor, Georgia O'Keefe [sic], New Find of Art World, Sets Her Easel." *New York Evening Graphic* (12 May 1928), 3M. (Reprinted in Appendix A, no. 78.)

Bluemner, Oscar. "A Painter's Comment." In *Georgia O'Keeffe: Paintings, 1926* [exhibition catalogue], n.p. New York: The Intimate Gallery, 11 January–27 February 1927. (Reprinted in Appendix A, no. 57ᴀ.)

Breuning, Margaret. "Seven Americans." *New York Evening Post* (14 March 1925), sec. 5, p. 11. (Reprinted in Appendix A, no. 35.)

Brook, Alexander. "February Exhibitions: Georgia O'Keefe [sic]." *The Arts* 3 (February 1923): 130, 132. (Reprinted in Appendix A, no. 19.)

Bulliet, C. J. "The American Scene." In *Apples & Madonnas: Emotional Expression in Modern Art*, 196–225. Chicago: Pascal Covici, 1927. (Partially reprinted in Appendix A, no. 68.)

[Burroughs, Alan.] "Studio and Gallery." *New York Sun* (3 February 1923), 9. (Partially reprinted in Appendix A, no. 12.)

[Cary, Elizabeth Luther.] "Art—Competitions, Sales, and Exhibitions of the Mid-Season: Georgia O'Keeffe, American." *New York Times* (4 February 1923), sec. 7, p. 7. (Reprinted in Appendix A, no. 13.)

[———.] "Art: Exhibitions of the Week; Seven Americans." *New York Times* (15 March 1925), sec. 8, p. 11. (Reprinted in Appendix A, no. 38.)

[———.] "Art: Exhibitions of the Week; 'Spiritual America' Print." *New York Times* (9 March 1924), sec. 8, p. 10. (Reprinted in Appendix A, no. 23.)

Cheney, Sheldon. "The Swing toward Abstraction" and "The Geography and Anatomy of Modern Art." Chaps. 9, 12 in *A Primer of Modern Art*, 155–75, 217–49. New York:

Horace Liveright, 1924. 5th ed. New York: Horace Liveright, 1929. (Partially reprinted in Appendix A, no. 29.)

Coates, Robert M. "Profiles: Abstraction—Flowers." *New Yorker* 5 (6 July 1929): 21–24. (Reprinted in Appendix A, no. 89.)

C[omstock], H[elen]. "Stieglitz Group in Anniversary Show." *The Art News* 23 (14 March 1925): 5.

[Cortissoz, Royal.] "Random Impressions in Current Exhibitions." *New York Tribune* (11 February 1923), sec. 5, p. 8. (Partially reprinted in Appendix A, no. 16.)

———. "A Spring Interlude in the World of Art Shows: '291'—Mr. Alfred Stieglitz and His Services to Art." *New York Herald Tribune* (15 March 1925), sec. 4, p. 12. (Partially reprinted in Appendix A, no. 39.)

Demuth, Charles. Statement in *Georgia O'Keeffe: Paintings, 1926* [exhibition catalogue], n.p. New York: The Intimate Gallery, 11 January–27 February 1927. (Reprinted in Appendix A, no. 57B.)

———. Statement in *Georgia O'Keeffe: Paintings, 1928* [exhibition catalogue], n.p. New York: The Intimate Gallery, 4 February–17 March 1929. (Reprinted in Appendix A, no. 82.)

Dove, Arthur G. "A Way to Look at Things." In *Alfred Stieglitz Presents Seven Americans: 159 Paintings, Photographs & Things, Recent & Never Before Publicly Shown, by Arthur G. Dove, Marsden Hartley, John Marin, Charles Demuth, Paul Strand, Georgia O'Keeffe, Alfred Stieglitz* [exhibition catalogue], n.p. New York: The Anderson Galleries, 9–28 March 1925. (Reprinted in Appendix A, no. 34B.)

Dreier, Katherine S. "Georgia O'Keeffe." In *Modern Art*, ed. Katherine S. Dreier and Constantin Aladjalov, 91. New York: Société Anonyme, [1926]. (Reprinted in Appendix A, no. 56.)

"Exhibitions in New York: Georgia O'Keeffe, Intimate Gallery." *The Art News* 24 (13 February 1926): 7–8. (Reprinted in Appendix A, no. 45.)

"The Female of the Species Achieves a New Deadliness: Women Painters of America Whose Work Exhibits Distinctiveness of Style and Marked Individuality." *Vanity Fair* 18 (July 1922): 50. (Partially reprinted in Appendix A, no. 7.)

Fifty Recent Paintings, by Georgia O'Keeffe [exhibition catalogue]. New York: The Intimate Gallery, 11 February–3 April 1926. (Includes untitled statement by O'Keeffe. See Appendix A, no. 44.)

Fisher, W[illia]m Murrell. "The Georgia O'Keeffe Drawings and Paintings at '291.'" *Camera Work*, nos. 49–50 (June 1917): 5. (Reprinted in Appendix A, no. 4.)

"Foujita's Art Seen in Exhibition Here . . . : Georgia O'Keeffe." *New York Times* (14 February 1926), sec. 8, p. 12. (Reprinted in Appendix A, no. 47.)

Frank, Waldo [Search-Light, pseud.]. "White Paint and Good Order." Chap. 3 in *Time Exposures*, 31–35. New York: Boni and Liveright, 1926. (Reprinted in Appendix A, no. 54.)

Fulton, Deogh. "Cabbages and Kings." *International Studio* 81 (May 1925): 144–47.

Georgia O'Keeffe: Paintings, 1926 [exhibition catalogue]. New York: The Intimate Gallery, 11 January–27 February 1927. Photocopy in National Gallery of Art, Gallery Archives, RG 17B. (Includes "A Painter's Comment," by Oscar Bluemner; untitled statement by Charles Demuth; and exhibition checklist. See Appendix A, nos. 57A, 57B.)

Georgia O'Keeffe: Paintings, 1928 [exhibition catalogue]. New York: The Intimate Gallery, 4 February–17 March 1929. Photocopy in National Gallery of Art, Gallery Archives, RG 17B. (Includes untitled statement by Charles Demuth and exhibition checklist. See Appendix A, no. 82.)

Hartley, Marsden. "Some Women Artists in Modern Painting." Chap. 13 in *Adventures in the Arts: Informal Chapters on Painters, Vaudeville, and Poets*, 116–19. Introduction by Waldo Frank. New York: Boni and Liveright, 1921. Reprint. New York: Hacker Art Books, 1972. (Partially reprinted in Appendix A, no. 5.)

"I Can't Sing, So I Paint! Says Ultra Realistic Artist; Art Is Not Photography—It Is Expression of Inner Life!: Miss Georgia O'Keeffe Explains Subjective Aspect of Her Work." *New York Sun* (5 December 1922), 22. (Reprinted in Appendix A, no. 9.)

[Jewell, Edward Alden.] "Georgia O'Keeffe." *New York Times* (10 February 1929), sec. 9, p. 12. (Reprinted in Appendix A, no. 85.)

J[ewell], E[dward] A[lden]. "Georgia O'Keeffe, Mystic: Her Patterns Weave through Boundless Space." *New York Times* (22 January 1928), sec. 10, p. 12. (Partially reprinted in Appendix A, no. 72.)

――――. "Lost Chord Retrieved: Demuth's Divining Rod Works Whether Applied to O'Keeffe or to Old Masters." *New York Times* (24 February 1929), sec. 10, p. 18. (Partially reprinted in Appendix A, no. 86.)

Kalonyme, Louis. "Art's Spring Flowers: Notable Paintings in New York Present Exhibitions." *Arts and Decoration* 24 (April 1926): 46–47, 76. (Partially reprinted in Appendix A, no. 52.)

――――. "Georgia O'Keeffe: A Woman in Painting." *Creative Art* 2 (January 1928): xxxiv–xl. (Reprinted in Appendix A, no. 73.)

K[alonyme], L[ouis]. "Musicians Afield—Local Art Notes. In New York Galleries: Georgia O'Keeffe's Arresting Pictures. . . ." *New York Times* (16 January 1927), sec. 7, p. 10. (Partially reprinted in Appendix A, no. 59.)

――――. "Scaling the Peak of the Art Season: Art in Infinite Variety from El Greco to Clivette." *Arts and Decoration* 26 (March 1927): 57, 88, 93. (Partially reprinted in Appendix A, no. 62.)

Kay-Scott, C. [Frederick Creighton Wellman]. Letter to Georgia O'Keeffe. In *O'Keeffe Exhibition* [exhibition catalogue], n.p. New York: The Intimate Gallery, 9 January–27 February 1928. (Reprinted in Appendix A, no. 69.)

La Follette, Suzanne. "Modern Painters and Sculptors." Chap. 10 in *Art in America: From Colonial Times to the Present Day*, 299–350. New York: Harper & Bros., 1929. (Partially reprinted in Appendix A, no. 90.)

McBride, Henry. "Art News and Reviews—Woman as Exponent of the Abstract: Curious Responses to Work of Miss O'Keefe [sic] on Others; Free without Aid of Freud, She Now Says Anything She Wants to Say—Much 'Color Music' in Her Pictures." *New York Herald* (4 February 1923), sec. 7, p. 7. (Reprinted in Appendix A, no. 14.)

[――――.] "Georgia O'Keeefe's [sic] Work Shown: Fellow Painters of Little Group Become Fairly Lyrical Over It." *New York Sun* (15 January 1927), 22B. (Partially reprinted in Appendix A, no. 58.)

[――――.] "Georgia O'Keefe's [sic] Recent Work: Her Annual Display at the Intimate Gallery Now Open to the Public." *New York Sun* (14 January 1928), 8. (Reprinted in Appendix A, no. 70.)

――――. "Modern Art." *Dial* 80 (May 1926): 436–39. (Partially reprinted in Appendix A, no. 53.)

――――. "Modern Art." *Dial* 82 (March 1927): 261–63. (Partially reprinted in Appendix A, no. 64.)

――――. "New Gallery for Modern Art: Valentine Dudensing Shows Paintings by Foujita—O'Keefe [sic] and Mezquita Exhibitions: Georgia O'Keefe's [sic] Art." *New York Sun* (13 February 1926), 7. (Reprinted in Appendix A, no. 46.)

[_____.] "Paintings by Georgia O'Keefe [sic]: Decorative Art That is Also Occult at the Intimate Gallery." *New York Sun* (9 February 1929), 7. (Reprinted in Appendix A, no. 84.)

_____. "Stieglitz, Teacher, Artist; Pamela Bianco's New Work: Stieglitz-O'Keefe [sic] Show at Anderson Galleries." *New York Herald* (9 March 1924), sec. 7, p. 13. (Reprinted in Appendix A, no. 24.)

_____. "The Stieglitz Group at Anderson's." *New York Sun* (14 March 1925), 13. (Partially reprinted in Appendix A, no. 36.)

Mannes, Marya. "Gallery Notes: Intimate Gallery." *Creative Art* 2 (February 1928): 7. (Reprinted in Appendix A, no. 74.)

Mather, Frank Jewett, Jr. "Georgia O'Keefe [sic]." From "Recent Visionaries—The Modernists." Chap. 16 in *The American Spirit in Art*, by Frank Jewett Mather, Jr., Charles Rufus Morey, and William James Henderson, 155–78. Vol. 12 of *The Pageant of America*. Edited by Ralph Henry Gabriel. New Haven: Yale University Press, 1927. (Partially reprinted in Appendix A, no. 65.)

Matthias, Blanche C. "Georgia O'Keeffe and the Intimate Gallery: Stieglitz Showing Seven Americans." *Chicago Evening Post Magazine of the Art World* (2 March 1926), 1, 14. (Reprinted in Appendix A, no. 50.)

M[oore], D[orothy] L[efferts]. "Exhibitions in New York." *The Arts* 15 (March 1929): 173–92. (Partially reprinted in Appendix A, no. 88.)

Mullin, Glen. "Alfred Stieglitz Presents Seven Americans." *Nation* 120 (20 May 1925): 577–78. (Reprinted in Appendix A, no. 43.)

Mumford, Lewis. "O'Keefe [sic] and Matisse." *New Republic* 50 (2 March 1927): 41–42. (Reprinted in Appendix A, no. 63.)

O'Brien, Frances. "Americans We Like: Georgia O'Keeffe." *Nation* 125 (12 October 1927): 361–62. (Reprinted in Appendix A, no. 67.)

O'Keeffe, Georgia. Statement in *Alfred Stieglitz Presents Fifty-One Recent Pictures: Oils, Water-colors, Pastels, Drawings, by Georgia O'Keeffe, American* [exhibition catalogue], n.p. New York: The Anderson Galleries, 3–16 March 1924. (Reprinted in Appendix A, no. 22.)

_____. Statement in *Alfred Stieglitz Presents One Hundred Pictures: Oils, Water-colors, Pastels, Drawings, by Georgia O'Keeffe, American* [exhibition brochure], n.p. New York: The Anderson Galleries, 29 January–10 February 1923. (Reprinted in Appendix A, no. 11.)

_____. Statement in *Fifty Recent Paintings, by Georgia O'Keeffe* [exhibition catalogue], n.p. New York: The Intimate Gallery, 11 February–3 April 1926. (Reprinted in Appendix A, no. 44, as found in Anita Pollitzer, *A Woman on Paper: Georgia O'Keeffe*, intro. Kay Boyle [New York: Simon & Schuster, 1988], 189.)

_____. "To MSS. and Its 33 Subscribers and Others Who Read and Don't Subscribe!" *MSS.*, no. 4 (December 1922): 17–18. (Reprinted in Appendix A, no. 10.)

O'Keeffe Exhibition [exhibition catalogue]. New York: The Intimate Gallery, 9 January–27 February 1928. Photocopy in National Gallery of Art, Gallery Archives, RG 17B. (Includes letter from C. Kay-Scott to O'Keeffe; "O'Keeffe and Matisse," by Lewis Mumford, reprinted from the *New Republic* [2 March 1927]; and exhibition checklist. See Appendix A, nos. 69, 63.)

P[emberton], M[urdock]. "The Art Galleries: A Fortunate Lady and Some Mere Mortals." *New Yorker* 4 (9 February 1929): 73–74. (Partially reprinted in Appendix A, no. 83.)

_____. "The Art Galleries: 'But We Know What We Like.'" *New Yorker* 3 (21 January 1928): 44–46. (Partially reprinted in Appendix A, no. 71.)

_____. "The Art Galleries: Eight Out of Every Ten Are Born Blind and Never Find It Out—Here Come the Fire Engines!" *New Yorker* 2 (20 February 1926): 40–42. (Partially reprinted in Appendix A, no. 48.)

_____. "The Art Galleries: The Great Wall of Manhattan, or New York for Live New Yorkers." *New Yorker* 2 (13 March 1926): 36–37. (Partially reprinted in Appendix A, no. 51.)

_____. "The Art Galleries: Those of You Who Have Heard This Story, Please Be Good Enough to Step Out of the Room." *New Yorker* 2 (22 January 1927): 62–65. (Partially reprinted in Appendix A, no. 61.)

_____. "Mostly American." *Creative Art* 4 (March 1929): l–lii. (Partially reprinted in Appendix A, no. 87.)

Phillips, Duncan. "Georgia O'Keeffe, Born 1887, American." From "Brief Estimates of the Painters." In *A Collection in the Making*, 66. New York: E. Weyhe, 1926. (Reprinted in Appendix A, no. 55.)

Read, Helen Appleton. "The Feminine View-Point in Contemporary Art." *Vogue* 71 (15 June 1928): 76–77, 96. (Partially reprinted in Appendix A, no. 80.)

[_____.] "Georgia O'Keefe [sic]." *Brooklyn Daily Eagle* (21 February 1926), 7E. (Reprinted in Appendix A, no. 49.)

_____. "Georgia O'Keefe [sic]." *Brooklyn Daily Eagle* (16 January 1927), 6E. (Reprinted in Appendix A, no. 60.)

_____. "Georgia O'Keeffe—Woman Artist Whose Art Is Sincerely Feminine." *Brooklyn Sunday Eagle Magazine* (6 April 1924), 4. (Reprinted in Appendix A, no. 30.)

_____. "Georgia O'Keeffe's Show an Emotional Escape." *Brooklyn Daily Eagle* (11 February 1923), 2B. (Reprinted in Appendix A, no. 17.)

[_____.] "News and Views on Current Art: Alfred Stieglitz Presents 7 Americans." *Brooklyn Daily Eagle* (15 March 1925), 2B. (Reprinted in Appendix A, no. 40.)

[_____.] "News and Views on Current Art: Georgia O'Keefe [sic] Again Introduced by Stieglitz at the Anderson Galleries." *Brooklyn Daily Eagle* (9 March 1924), 2B. (Reprinted in Appendix A, no. 25.)

_____. "New York Exhibitions: Seven Americans." *The Arts* 7 (April 1925): 229–31. (Reprinted in Appendix A, no. 42.)

Rönnebeck, Arnold. "Through the Eyes of a European Sculptor." In *Alfred Stieglitz Presents Seven Americans: 159 Paintings, Photographs & Things, Recent & Never Before Publicly Shown, by Arthur G. Dove, Marsden Hartley, John Marin, Charles Demuth, Paul Strand, Georgia O'Keeffe, Alfred Stieglitz* [exhibition catalogue], n.p. New York: The Anderson Galleries, 9–28 March 1925. (Reprinted in Appendix A, no. 34c.)

Rosenfeld, Paul. "American Painting." *Dial* 71 (December 1921): 649–70. (Partially reprinted in Appendix A, no. 6.)

_____. "Arthur G. Dove." In *Port of New York: Essays on Fourteen American Moderns*, 166–74. New York: Harcourt, Brace and Co., 1924. Reprint, with introduction by Sherman Paul. Urbana: University of Illinois Press, 1961. (Partially reprinted in Appendix A, no. 27.)

_____. "Georgia O'Keeffe." In *Port of New York: Essays on Fourteen American Moderns*, 198–210. New York: Harcourt, Brace and Co., 1924. Reprint, with introduction by Sherman Paul. Urbana: University of Illinois Press, 1961. (Reprinted in Appendix A, no. 28.)

_____. "The Paintings of Georgia O'Keeffe: The Work of the Young Artist Whose Canvases Are to Be Exhibited in Bulk for the First Time This Winter." *Vanity Fair* 19 (October 1922): 56, 112, 114. (Reprinted in Appendix A, no. 8.)

Sabine, Lillian. "Record Price for Living Artist. Canvases of Georgia O'Keeffe Were Kept in Storage for Three Years until Market Was Right for Them." *Brooklyn Sunday Eagle Magazine* (27 May 1928), 11. (Reprinted in Appendix A, no. 79.)

Seligmann, Herbert J. "Georgia O'Keeffe, American." *MSS.*, no. 5 (March 1923): 10. (Reprinted in Appendix A, no. 20.)

_____ . "Why 'Modern' Art?: Six Artists in Search of Media for Their Variously Capricious Spirits Demonstrate That 'Modern' Art Is Not Merely Contemporary Art." *Vogue* 62 (15 October 1923): 76–77, 110, 112. (Partially reprinted in Appendix A, no. 21.)

[Stieglitz, Alfred?] "Georgia O'Keeffe—C. Duncan—Réné [sic] Lafferty." *Camera Work*, no. 48 (October 1916): 12–13. (Reprinted in Appendix A, no. 2.)

Stieglitz, Alfred. "O'Keefe [sic] and the Lilies." Letter to the editor. *The Art News* 26 (21 April 1928): 10. (Reprinted in Appendix A, no. 77.)

_____ . Statement in *Alfred Stieglitz Presents Seven Americans: 159 Paintings, Photographs & Things, Recent & Never Before Publicly Shown*, by Arthur G. Dove, Marsden Hartley, John Marin, Charles Demuth, Paul Strand, Georgia O'Keeffe, Alfred Stieglitz [exhibition catalogue], n.p. New York: The Anderson Galleries, 9–28 March 1925. (Reprinted in Appendix A, no. 34D.)

Strand, Paul. "Georgia O'Keeffe." *Playboy: A Portfolio of Art and Satire* 9 (July 1924): 16–20. (Reprinted in Appendix A, no. 32.)

Tyrrell, Henry. "Art Observatory: Exhibitions and Other Things." *The* [New York] *World* (11 February 1923), 11M. (Partially reprinted in Appendix A, no. 18.)

_____ . "Art Observatory: High Tide in Exhibitions Piles Up Shining Things of Art; Two Women Painters Lure with Suave Abstractions. . . . " *The* [New York] *World* (4 February 1923), 9M. (Partially reprinted in Appendix A, no. 15.)

[_____.] "New York Art Exhibition and Gallery Notes: Esoteric Art at '291.'" *The Christian Science Monitor* (4 May 1917), 10. (Reprinted in Appendix A, no. 3.)

[_____.] "New York Art Exhibitions and Gallery News: Animadversions on the Tendencies of the Times in Art—School for Sculpture on New Lines." *The Christian Science Monitor* (2 June 1916), 10. (Partially reprinted in Appendix A, no. 1.)

[Watson, Forbes.] "Seven American Artists Sponsored by Stieglitz." *The* [New York] *World* (15 March 1925), 5M. (Reprinted in Appendix A, no. 41.)

[_____.] "Stieglitz-O'Keeffe Joint Exhibition." *The* [New York] *World* (9 March 1924), 11E. (Reprinted in Appendix A, no. 26.)

"We Nominate for the Hall of Fame." *Vanity Fair* 22 (July 1924): 49. (Partially reprinted in Appendix A, no. 33.)

"We Nominate for the Hall of Fame." *Vanity Fair* 30 (August 1928): 63. (Partially reprinted in Appendix A, no. 81.)

Wilson, Edmund. "The Stieglitz Exhibition." *New Republic* 42 (18 March 1925): 97–98. (Reprinted in Appendix A, no. 37.)

General Sources

Abrahams, Edward. "The Image Maker." Includes reviews of *Georgia O'Keeffe: Art and Letters*, by Jack Cowart, Juan Hamilton, and Sarah Greenough; *Georgia O'Keeffe: One Hundred Flowers*, edited by Nicholas Callaway; *Some Memories of Drawings*, by Georgia O'Keeffe (edited by Doris Bry); and *A Woman on Paper: Georgia O'Keeffe*, by Anita Pollitzer. *New Republic* 200 (30 January 1989): 41–45.

_____ . *The Lyrical Left: Randolph Bourne, Alfred Stieglitz, and the Origins of Cultural Radicalism in America*. Charlottesville: University of Virginia Press, 1986.

Adato, Perry Miller (producer and director). *Georgia O'Keeffe*. Videotape, 59 min. Produced by WNET/THIRTEEN for Women in Art, 1977. Portrait of an Artist, no. 1. Series distributed by Films, Inc./Home Vision, New York.

Alfred Stieglitz. The Aperture History of Photography Series. Introduction by Dorothy Norman. Millerton, N.Y.: Aperture, 1976.

352 Selected Bibliography

Alloway, Lawrence. "Notes on Georgia O'Keeffe's Imagery." *Womanart* 1 (Spring–Summer 1977): 18–19.

———. "Women's Art in the 70's." *Art in America* 64 (May–June 1976): 64–72.

Alpers, Svetlana. "Art History and Its Exclusions: The Example of Dutch Art." In *Feminism and Art History: Questioning the Litany,* edited by Norma Broude and Mary D. Garrard, 183–99. New York: Harper & Row, 1982.

Anderson, Dennis R. *American Flower Painting.* New York: Watson-Guptill Publications, 1980.

Anderson, Sherwood. *Letters.* Edited by Howard Mumford Jones and Walter B. Rideout. Boston: Little, Brown, 1953.

Arkin, Diane Lynne. "Georgia O'Keeffe: Her Work 1915–30." Master's thesis, University of Chicago, 1976.

"As a Bachelor Sees Women: In Which He Frankly Explains Why He Has Never Married." *Ladies' Home Journal* 25 (January 1908): 12.

Auerbach, Nina. *Woman and the Demon: The Life of a Victorian Myth.* Cambridge: Harvard University Press, 1892.

Bachmann, Donna, and Sherry Piland, eds. *Women Artists: An Historical, Contemporary and Feminist Bibliography.* Metuchen, N.J.: Scarecrow Press, 1978.

Bade, Patrick. *Femme Fatale: Images of Evil and Fascinating Women.* New York: Mayflower Books, 1979.

Banner, Lois. *Women in Modern America: A Brief History.* New York: Harcourt Brace, 1974.

Bannister, Robert C. *Social Darwinism: Science and Myth in Anglo-American Social Thought.* Philadelphia: Temple University Press, 1979.

Banta, Martha. *Imaging American Women: Idea and Ideals in Cultural History.* New York: Columbia University Press, 1987.

Barker-Benfield, G. J. *The Horrors of the Half-Known Life: Male Attitudes toward Women and Sexuality in Nineteenth-Century America.* New York: Harper & Row, 1976.

Baur, John I. H. *Revolution and Tradition in Modern American Art.* Cambridge: Harvard University Press, 1951; New York: F. A. Praeger, 1967.

Bement, Alon. *Figure Construction.* New York: Gregg Publishing Co., 1921.

Berger, John, Sven Blomberg, Christ Fox, Michael Dibbe, and Richard Hollis. *Ways of Seeing.* London: British Broadcasting Corporation and Penguin Books, 1987.

Bergson, Henri. "The Comic in Character." Chap. 3 in *Laughter: An Essay on the Meaning of the Comic,* 132–200. Translated by Cloudesley Brereton and Fred Rothwell. London: Macmillan and Co., 1911.

———. *Creative Evolution.* Translated by Arthur Mitchell. Foreword by Irwin Edman. New York: The Modern Library, 1944.

———. "An Extract from Bergson." *Camera Work,* no. 36 (October 1911): 20–21.

———. "What Is the Object of Art?" *Camera Work,* no. 37 (January 1912): 22–26.

Betterton, Rosemary, ed. *Looking On: Images of Femininity in the Visual Arts and Media.* New York: Pandora Books, 1987.

Brooks, Van Wyck. "'Highbrow' and 'Lowbrow'" and "'Our Poets.'" Chaps. 1–2 in "America's Coming of Age: 1915." In *Three Essays on America,* 15–76. New York: E. P. Dutton and Co., 1934.

Broude, Norma, and Mary D. Garrard, eds. *Feminism and Art History: Questioning the Litany.* New York: Harper & Row, 1982.

B[runo], G[uido]. "The Passing of '291.'" *Pearson's Magazine* 38 (March 1918): 402–3.

Bry, Doris. *Alfred Stieglitz: Photographer.* Boston: Museum of Fine Arts, 1965.

Bulliet, C. J. *The Courtezan Olympia: An Intimate Survey of Artists and Their Mistress-Models.* New York: Covici, Friede, 1930.

Bullough, Vern L., and Bonnie Bullough. *The Subordinate Sex: A History of Attitudes toward Women.* Urbana: University of Illinois Press, 1973.

Bunnell, Peter. *A Photographic Vision: Pictorial Photography, 1889–1923.* Salt Lake City: Peregrine Smith Books, 1980.

Bye, Arthur Edwin. "Women and the World of Art." *Art World and Arts and Decoration* 10 (December 1918): 86–89.

Caffin, Charles. *The Story of American Painting.* New York: Frederick A. Stokes Co., 1907.

Callaway, Nicholas, ed. *Georgia O'Keeffe: One Hundred Flowers.* New York: Alfred A. Knopf, 1987.

Castro, Jan Garden. *The Art and Life of Georgia O'Keeffe.* New York: Crown Publishers, 1985.

———. "Pictures without a Frame." Review of *Georgia O'Keeffe: Art and Letters,* by Jack Cowart, Juan Hamilton, and Sarah Greenough; and *Georgia O'Keeffe: One Hundred Flowers,* edited by Nicholas Callaway. *Women's Review of Books* 5 (September 1988): 21–22.

Chicago, Judy. *Through the Flower.* Garden City, N.Y.: Doubleday & Co., 1975.

Chicago, Judy, and Miriam Schapiro. "Female Imagery." *Womanspace Journal* 1 (Summer 1973): 11–14.

Clement, Clara Erskine. *Women in the Fine Arts from the Seventh Century B.C. to the Twentieth Century A.D.* Boston: Houghton, Mifflin, 1904.

Cohn, Susan. "An Analysis of Selected Works by Georgia O'Keeffe and a Production of Drawings by the Researcher." Ph.D. diss., New York University, 1974.

Corn, Wanda M. "Apostles of the New American Art: Waldo Frank and Paul Rosenfeld." *Arts Magazine* 54 (February 1980): 159–63.

Cortissoz, Royal. *American Artists.* New York: Charles Scribner's Sons, 1923.

Cott, Nancy. *The Grounding of Modern Feminism.* New Haven: Yale University Press, 1987.

Cowart, Jack, Juan Hamilton, and Sarah Greenough. *Georgia O'Keeffe: Art and Letters.* Washington, D.C.: National Gallery of Art, 1987.

Cravens, Hamilton. *The Triumph of Evolution: American Scientists and the Heredity-Environment Controversy, 1900–1941.* Philadelphia: University of Pennsylvania Press, 1978.

Darwin, Charles. *The Origin of Species by Means of Natural Selection or the Preservation of Favored Races in the Struggle for Life; and The Descent of Man and Selection in Relation to Sex.* New York: Modern Library, [1936].

De Casseres, Benjamin. "The Unconscious in Art." *Camera Work,* no. 36 (October 1911): 17.

Demuth, Charles. "Across a Greco Is Written." *Creative Art* 5 (29 September 1929): 629–34.

De Zayas, Marius. "The Evolution of Form, Introduction." *Camera Work,* no. 41 (January 1913): 44–48.

———. "The Sun Has Set." *Camera Work,* no. 39 (July 1912): 17–21.

Dijkstra, Bram. *The Hieroglyphics of a New Speech: Cubism, Stieglitz, and the Early Poetry of William Carlos Williams.* Princeton: Princeton University Press, 1969.

———. *Idols of Perversity: Fantasies of Feminine Evil in Fin-de-Siècle Culture.* New York: Oxford University Press, 1986.

Dow, Arthur Wesley. *Composition.* 20th ed. New York: Doubleday, Doran & Co., 1938.

———. *Theory and Practice of Teaching Art.* 2d ed. New York: Teachers College, Columbia University Press, 1912.

Drohojowska, Hunter. "Beyond Flower Power." *Harper's Bazaar,* no. 3312 (November 1987): 224, 258.

Duncan, Carol. "Virility and Domination in Early Twentieth-Century Vanguard Painting." In *Feminism and Art History: Questioning the Litany,* edited by Norma Broude and Mary D. Garrard, 293–313. New York: Harper & Row, 1982.

———. "When Greatness Is a Box of Wheaties." *Artforum* 14 (October 1975): 60–64.

Eddy, Arthur Jerome. *Cubists and Post-Impressionism.* Chicago: A. C. McClurg and Co., 1914.

Edgerton, Giles. "Is There a Sex Distinction in Art? The Attitude of the Critic towards Women's Exhibits." *Craftsman* 14 (June 1908): 239–51.

"Editorial: Asher Benjamin on Ornament—Women in the Arts." *Architecture* 30 (October 1914): 211–14.

Eldredge, Charles C., III. "Georgia O'Keeffe: The Development of an American Modern." Ph.D. diss., University of Minnesota, 1971.

Ellet, Mrs. Elizabeth Fries (Lummis). *Women Artists in All Ages and Countries.* New York: Harper & Bros., 1859.

Ellis, Havelock. *Studies in the Psychology of Sex.* 4 vols. New York: Random House, 1936.

Ellman, Mary. *Thinking about Women.* New York: Harcourt Brace, 1968.

Evans, Jean. "Stieglitz: Always Battling—and Retreating." *PM* (23 December 1945), 12–14M.

"Exhibitions in New York: Georgia O'Keeffe, An American Place." *The Art News* 28 (22 February 1930): 10–12.

"Exhibitions in New York: Georgia O'Keeffe, An American Place." *The Art News* 29 (24 January 1931): 9.

Fass, Paula S. *The Damned and the Beautiful: American Youth in the 1920s.* New York: Oxford University Press, 1977.

Fine, Elsa Honig. *Women and Art: A History of Women Painters and Sculptors from the Renaissance to the 20th Century.* Montclair, N.J.: Abner Schram, 1978.

[Fisher], William Murrell. "Poesy Unbound." *Camera Work,* no. 44 (issue dated October 1913, published March 1914): 59.

Flint, Ralph. "Around the Galleries." *Creative Art* 6 (March 1930): suppl. 61.

———. "1933 O'Keeffe Show: A Fine Revelation of Varied Powers." *The Art News* 31 (14 January 1933): 9.

"Forum: What Is Female Imagery?" *Ms. Magazine* 3 (May 1975): 62–65, 80–83.

Foshay, Ella M. *Reflections of Nature: Flowers in American Art.* New York: Alfred A. Knopf, 1984.

Frank, Waldo. *Our America.* New York: Boni and Liveright, 1919.

——— [Search-Light, pseud.]. "The Prophet." Chap. 20 in *Time Exposures,* 175–79. New York: Boni & Liveright, 1926.

Frank, Waldo, Lewis Mumford, Dorothy Norman, Paul Rosenfeld, and Harold Rugg, eds. *America & Alfred Stieglitz: A Collective Portrait.* New York: Doubleday, Doran & Co., 1934.

Freedman, Estelle B. "The New Woman: Changing Views of Women in the 1920s." *Journal of American History* 61 (September 1974): 372–93.

———. "Separatism as Strategy: Female Institution Building and American Feminism, 1870–1930." *Feminist Studies* 5 (Fall 1979): 512–29.

Galloway, John. "American Painting: Art Criticism in the United States Since the New York Armory Show in 1913." Master's thesis, American University, 1950.

Geddes, Patrick, and J. Arthur Thomson. *The Evolution of Sex.* London: W. Scott, 1889.

"Georgia O'Keeffe—An American Place." *The Art News* 30 (2 January 1932): 9.

Gerdts, William. "Women Artists of America 1707–1964." In *Women Artists of America 1707–1964,* 6–19. Newark, N.J.: The Newark Museum, 1965.

Gherman, Beverly. *Georgia O'Keeffe: The "Wideness and Wonder" of Her World.* New York: Atheneum, 1986.

Gilbert, Sandra, and Susan Gubar. *The Female Imagination and the Modernist Esthetic.* Vol. 1 of *Studies in Gender and Culture.* New York: Gordon and Breach, 1986.

Glueck, Grace. "Art Notes: 'It's Just What's in My Head. . . .'" *New York Times* (18 October 1970), sec. 2, p. 24.

Goodrich, Lloyd, and Doris Bry. *Georgia O'Keeffe.* New York: Prager, 1970.

Goossen, E. C. "O'Keeffe." *Vogue* 149 (1 March 1967): 174–79, 221–24.

Gould, Stephen Jay. *Ever Since Darwin: Reflections in Natural History.* New York: W. W. Norton & Co., 1977.

———. *The Mismeasure of Man.* New York: W. W. Norton & Co., 1981.

Gouma-Peterson, Thalia, and Patricia Mathews. "The Feminist Critique of Art History." *Art Bulletin* 69 (September 1987): 326–57.

Green, Jonathan, ed. *Camera Work: A Critical Anthology.* Millerton, N.Y.: Aperture, 1973.

Greenglass, Esther R. *A World of Difference: Gender Roles in Perspective.* Toronto: John Wiley & Sons, 1982.

Greenough, Sarah E. "From the American Earth: Alfred Stieglitz's Photographs of Apples." *Art Journal* 41 (Spring 1981): 46–54.

———. "From the Faraway." In *Georgia O'Keeffe: Art and Letters,* by Jack Cowart, Juan Hamilton, and Sarah Greenough, 135–39. Washington, D.C.: National Gallery of Art, 1987.

Greenough, Sarah, and Juan Hamilton. *Alfred Stieglitz: Photographs & Writings.* Washington, D.C.: National Gallery of Art, 1983.

Greer, Germaine. *The Obstacle Race: The Fortunes of Women Painters and Their Work.* New York: Farrar Straus Giroux, 1979.

Haines, Robert E. "Alfred Stieglitz and the New Order of Consciousness in American Literature." *Pacific Coast Philology* 6 (April 1971): 26–34.

———. *The Inner Eye of Alfred Stieglitz.* Lanham, Md.: University Press of America, 1982.

Hale, Nathan G., Jr. *Freud and the Americans: The Beginnings of Psychoanalysis in the United States, 1876–1917.* Vol. 1 of *Freud in America.* New York: Oxford University Press, 1971.

Hammond, Harmony. "Class Notes." *Heresies: A Feminist Publication on Art and Politics,* no. 3 (Fall 1977): 34–36.

———. "Feminist Abstract Art—A Political Viewpoint." *Heresies: A Feminist Publication on Art and Politics,* no. 1 (January 1977): 66–70.

Hapgood, Hutchins. *A Victorian in the Modern World.* New York: Harcourt, Brace and Co., 1939.

Harris, Ann Sutherland, and Linda Nochlin, eds. *Women Artists: 1550–1950.* New York: Alfred A. Knopf, 1977.

Hartley, Marsden. "Our Imaginatives." Chap. 7 in *Adventures in the Arts: Informal Chapters on Painters, Vaudeville, and Poets,* 65–73. Introduction by Waldo Frank. New York: Boni and Liveright, 1921. Reprint. New York: Hacker Art Books, 1972.

———. "A Second Outline in Portraiture." In *Georgia O'Keeffe: Exhibition of Recent Paintings, 1935* [exhibition catalogue], n.p. New York: An American Place, 7 January–27 February 1936.

Hartmann, Sadakichi [Sidney Allen, pseud.]. "Repetition, with Slight Variation." *Camera Work,* no. 1 (January 1903): 30–34.

Haskell, Barbara. "Georgia O'Keeffe, Works on Paper: A Critical Essay." In *Georgia O'Keeffe: Works on Paper,* 1–13. Introduction by David Turner. Santa Fe: Museum of New Mexico Press, 1985.

Hess, Thomas B., and Elizabeth Baker, eds. *Art and Sexual Politics: Women's Liberation, Women Artists, and Art History.* New York: MacMillan, 1973.

Hess, Thomas B., and Linda Nochlin, eds. *Woman as Sex Object: Studies in Erotic Art, 1730–1970.* New York: Newsweek, 1972.

Hinkle, Rita. "The Critics of Georgia O'Keeffe." Master's thesis, Bowling Green University, 1975.

Hoeber, Arthur. "Famous American Women Painters." *Mentor* 2 (16 March 1914): 1–11.

Hoffman, Katherine. *An Enduring Spirit: The Art of Georgia O'Keeffe*. Metuchen, N.J.: Scarecrow Press, 1984.

————. "Georgia O'Keeffe and the Feminine Experience." *Helicon Nine, A Journal of Women's Arts and Letters* 6 (Spring 1982): 6–15.

————. "A Study of the Art of Georgia O'Keeffe from 1916–1974." Ph.D. diss., New York University, 1976.

Hollis, Janette. "Two American Women in Art—O'Keeffe and Cassatt." *Delphian Quarterly* 28 (April 1945): 7–10, 15.

Homer, William Innes. *Alfred Stieglitz and the American Avant-Garde*. Boston: New York Graphic Society, 1977.

————. *Alfred Stieglitz and the Photo-Secession*. Boston: Little, Brown & Co., 1983.

"Horizons of a Pioneer." *Life* 64 (1 March 1968): 40–49.

Hughes, Robert. "Art: Loner in the Desert." *Time* 96 (12 October 1970): 64–67.

Huneker, James. "James Huneker in the *N. Y. Sun*." *Camera Work*, no. 36 (October 1911): 47.

Hunter, Vernon. "A Note on Georgia O'Keeffe." *Contemporary Arts of the South and Southwest* 1 (November–December 1932): 7.

Janeway, Elizabeth. "Images of Woman." *Arts in Society* [Issue titled "Women and the Arts"] 11 (Spring–Summer 1974): 9–18.

Jullian, Philippe. *Dreamers of Decadence: Symbolist Painters of the 1890s*. New York: Praeger, 1974.

Kandinsky, Wassily. *Concerning the Spiritual in Art*. Translated by M. T. H. Sadler. New York: Dover Publications, 1977.

Kim, Yong Kwon. *Alfred Stieglitz and His Time: An Intellectual Portrait*. American Studies Monograph Series, no. 2. Seoul, Korea: American Studies Institute, Seoul National University, 1970.

Kinnear, Mary. *Daughters of Time: Women in the Western Tradition*. Ann Arbor: University of Michigan Press, 1982.

Kootz, Samuel Mervin. *Modern American Painters*. New York: Brewer and Warren, 1930.

Kotz, Mary Lynn. "Georgia O'Keeffe at 90." *Art News* 76 (December 1977): 37–45.

Kozloff, Joyce. "Art Hysterical Notions of Progress." *Heresies: A Feminist Publication on Art and Politics*, no. 4 (Winter 1978): 38–42.

Kuh, Katherine. *The Artist's Voice: Talks with Seventeen Artists*. New York: Harper & Row, 1962.

Kuspit, Donald. "Betraying the Feminist Intention: The Case against Feminist Decorative Art." *Arts Magazine* 54 (November 1979): 124–26.

Larkin, Oliver W. *Art and Life in America*. New York: Holt, Rinehart and Winston, 1966.

Lasch, Christopher. *The New Radicalism in America, 1889–1963: The Intellectual as a Social Type*. New York: Alfred A. Knopf, 1965.

Lauter, Estella. *Women as Mythmakers: Poetry and Visual Art by Twentieth-Century Women*. Bloomington: Indiana University Press, 1984.

Lawson, Karol Ann. "Vitality in American Still-Life: The Flowers of Martin Johnson Heade and Georgia O'Keeffe." *Athanor III* (1983): 41–44.

Lerman, Hannah. *A Mote in Freud's Eye: From Psychoanalysis to the Psychology of Women*. New York: Springer Publishing Co., 1986.

Lifson, Ben. "O'Keeffe's Stieglitz, Stieglitz's O'Keeffe." *Village Voice* 23 (11 December 1978): 107.

Lippard, Lucy. *From the Center: Feminist Essays on Women's Art.* New York: E. P. Dutton, 1976.

———. "Projecting a Feminist Criticism." *Art Journal* 35 (Summer 1976): 337–39.

Lisle, Laurie. *Portrait of an Artist: A Biography of Georgia O'Keeffe.* New York: Seaview Books, 1980; rev. ed., New York: Washington Square Press, 1987.

Looney, Ralph. "Georgia O'Keeffe." *Atlantic* 215 (April 1965): 106–10.

Lowe, Sue Davidson. *Stieglitz: A Memoir/Biography.* New York: Farrar Straus Giroux, 1983.

Lucie-Smith, Edward. *Eroticism in Western Art.* New York: Praeger, 1972.

Luhan, Mabel Dodge. "The Art of Georgia O'Keeffe" [undated typescript]. Mabel Dodge Luhan Archive. Collection of American Literature, Beinecke Rare Book and Manuscript Library, Yale University, New Haven.

———. "Georgia O'Keeffe in Taos." *Creative Art* 8 (June 1931): 407–10.

[Luhan], Mabel Dodge. "The Mirror." *Camera Work*, no. 47 (issue dated July 1914; published January 1915): 9–10.

———. *Movers and Shakers.* Vol. 3 of *Intimate Memories.* New York: Harcourt, Brace and Co., 1936.

[McBride, Henry.] "Art News and Reviews—Stieglitz's [*sic*] Life Work in Photography—Emil Fuchs' Sculpture." *New York Herald* (13 February 1921), sec. 2, p. 5.

———. "Georgia O'Keeffe's Exhibition." *New York Sun* (14 January 1933), 10.

———. "Modern Art." *Dial* 70 (April 1921): 180–82.

———. "O'Keeffe at the Museum." *New York Sun* (18 May 1946), 9.

———. "The Palette Knife." *Creative Art* 8 (February 1931): suppl. 45.

———. "Skeletons on the Plain." *New York Sun* (2 January 1932), 8.

McCabe, Lida Rose. "Some Painters Who Happen to Be Women." *Art World* 4 (March 1918): 488–93.

McCausland, Elizabeth. "O'Keeffe Exhibition Shows Progress from 1926 to 1932." *Springfield* [Mass.] *Sunday Union and Republican* (22 January 1933), 6E.

McCoy, Garnett. "The Artist Speaks: Reaction and Revolution 1900–1920." *Art in America* 53 (August/September 1965): 68–87.

Malcolm, Janet. "Photography: Artists and Lovers." Review of *Georgia O'Keeffe: A Portrait* by Alfred Stieglitz, with introduction by Georgia O'Keeffe. *New Yorker* 55 (12 March 1979): 118–20.

Mathews, Patricia. "What Is Female Imagery?" *Women Artists News* 10 (November 1984): 5–7.

Matthews, Glenna. *Just a Housewife: The Rise and Fall of Domesticity in America.* New York: Oxford University Press, 1987.

May, Henry F. *The End of American Innocence: A Study of the First Years of Our Own Time, 1912–1917.* New York: Alfred A. Knopf, 1959.

Merritt, Anna Lea. "A Letter to Artists: Especially Women Artists." *Lippincott's Magazine* 65 (March 1900): 463–69.

Messinger, Lisa Mintz. *Georgia O'Keeffe.* New York: Thames and Hudson, 1988.

Metzger, Deena. "In Her Image." *Heresies: A Feminist Publication on Art and Politics*, no. 2 (May 1977): 2–12.

Millett, Kate. *Sexual Politics.* Garden City, N.Y.: Doubleday & Co., 1970.

Mitchell, Juliett. *Psychoanalysis and Feminism.* New York: Pantheon, 1974.

Mitchell, Juliett, and Jacqueline Rose, eds. *Feminine Sexuality: Jacques Lacan and the école freudienne.* London: Macmillan, 1982.

Mitchell, Marilyn Hall. "Sexist Art Criticism: Georgia O'Keeffe—A Case Study." *Signs* 3 (1978): 681–87.

Mitchell, Peter. *European Flower Painters*. London: A. & C. Black, 1973.

Moffatt, Frederick. *Arthur Wesley Dow*. Washington, D.C.: Smithsonian Press, 1977.

M[oore], D[orothy] L[efferts]. "In the Galleries: 'An American Place.'" *The Arts* 16 (March 1930): 495.

Moore, George. *Modern Painting*. London: Walter Scott, 1893.

Moore, James. "Georgia O'Keeffe's *Gray Cross with Blue*." *Artspace: Southwestern Contemporary Arts Quarterly* 10 (Summer 1986): 32–39.

Morgan, Ann Lee. *Arthur Dove: Life and Work, with a Catalogue Raisonné*. Newark: University of Delaware Press, 1984.

_____. *Dear Stieglitz, Dear Dove*. Newark: University of Delaware Press, 1988.

Moss, Irene. "Georgia O'Keeffe and These People." *Feminist Art Journal* 1 (Spring 1973): 14.

Mumford, Lewis. "The Art Galleries." *New Yorker* 8 (21 January 1933): 48–49.

_____. *The Brown Decades: A Study of the Arts in America, 1865–1895*. New York: Harcourt, Brace and Co., 1931.

_____. "The Metropolitan Milieu." In *America & Alfred Stieglitz: A Collective Portrait*, edited by Waldo Frank, Lewis Mumford, Dorothy Norman, Paul Rosenfeld, and Harold Rugg, 33–58. New York: Doubleday, Doran & Co., 1934.

Munro, Eleanor. *Originals: American Women Artists*. New York: Simon & Schuster, 1979.

Munsterberg, Hugo. *The History of Women Artists*. New York: Clarkson N. Potter, 1975.

Naef, Weston. *The Collection of Alfred Stieglitz: Fifty Pioneers of Modern Photography*. New York: Metropolitan Museum of Art, 1978.

Nead, Lynda. "Representation, Sexuality and the Female Nude." *Art History* 6 (June 1983): 227–36.

Neilson, Frances, and Winthrop Neilson. *Seven Women: Great Painters*. Philadelphia: Chilton Book Co., 1968.

Nemser, Cindy. "Art Criticism and Gender Prejudice." *Arts Magazine* 46 (March 1972): 44–46.

Newhall, Beaumont. *The History of Photography: From 1839 to the Present*. Rev. ed. New York: Museum of Modern Art, 1982.

"New York Criticism." *Art Digest* 6 (15 January 1932): 18.

"New York Season." *Art Digest* 4 (1 March 1930): 17–18.

"New York Season." *Art Digest* 5 (1 February 1931): 14.

Nochlin, Linda. "Some Women Realists: Part I." *Arts Magazine* 48 (February 1974): 46–51.

_____. "Why Have There Been No Great Women Artists?" *Art News* 69 (January 1971): 22–39, 67–71.

_____. "Women Artists after the French Revolution." In *Women Artists: 1500–1950*, edited by Ann Sutherland Harris and Linda Nochlin, 45–50. New York: Alfred A. Knopf, 1976.

Norman, Dorothy. *Alfred Stieglitz: An American Seer*. New York: Random House, 1973.

_____. *Encounters: A Memoir*. A Helen and Kurt Wolff Book. San Diego, Calif.: Harcourt Brace Jovanovich, 1987.

_____. "From the Writings and Conversations of Alfred Stieglitz." *Twice a Year: A Semi-Annual Journal of Literature, the Arts and Civil-Liberties*, no. 1 (Fall–Winter 1938): 77–110. Reprint. New York: Kraus Reprint Corporation, 1967.

Oaks, Gladys. "Radical Writer and Woman Artist Clash on Propaganda and Its Uses." *The* [New York] *World* (16 March 1930), Women's section, pp. 1, 3.

Oates, Joyce Carol. "'At Least I Have Made a Woman of Her': Images of Women in Yeats, Lawrence, Faulkner." In *The Profane Art: Essays and Reviews*, 35–62. New York: E. P. Dutton, 1983.

O'Keeffe, Georgia. "About Myself." In *Georgia O'Keeffe: Exhibition of Oils and Pastels* [exhibition catalogue], n.p. New York: An American Place, 22 January–17 March 1939.

_____ . *Georgia O'Keeffe*. New York: Viking Press, 1976; New York: Penguin Books, 1985.
_____ . Introduction to *Georgia O'Keeffe: A Portrait by Alfred Stieglitz*, n.p. New York: Metropolitan Museum of Art, 1978.
_____ . "Stieglitz: His Pictures Collected Him." *New York Times Magazine* (11 December 1949), 24–26, 28–30.
"O'Keeffe's Woman Feeling." *Newsweek* 27 (27 May 1946): 92, 94.
Olson, Arlene R. *Art Critics and the Avant-Garde: New York 1900–1913*. Studies in the Fine Arts: Criticism, no. 3. Ann Arbor: UMI Research Press, 1980.
Orenstein, Gloria. "Art History." *Journal of Women in Culture and Society* 1 (Winter 1975): 505–25.
Ortner, Sherry. "Is Female to Male as Nature Is to Culture?" *Feminist Studies* 1 (Fall 1972): 5–31.
Pach, Walter. "At an Exhibition of Photography." *Freeman* 2 (23 February 1921): 565.
Paintings by Nineteen Living Americans [exhibition catalogue]. New York: Museum of Modern Art, 1929.
Parker, Rozsika, and Griselda Pollock. *Framing Feminism: Art and the Women's Movement 1970–85*. London: Pandora Press, 1987.
_____ . *Old Mistresses: Women, Art and Ideology*. New York: Pantheon Books, 1981.
Patrick, G. T. W. "The Psychology of Woman." *Popular Science Monthly* 47 (June 1895): 209–25.
Paul, Sherman. "Paul Rosenfeld." Introduction to *Port of New York: Essays on Fourteen American Moderns*, by Paul Rosenfeld, xli–lvi. New York: Harcourt, Brace and Co., 1924. Reprint. Urbana: University of Illinois Press, 1961.
Pepper, Stephen. *The Basis of Criticism in the Arts*. Cambridge: Harvard University Press, 1949.
Petersen, Karen, and J. J. Wilson. *Women Artists: Recognition and Reappraisal from the Early Middle Ages to the Twentieth Century*. New York: Harper & Row, 1976.
Petruck, Peninah R. Y. *American Art Criticism: 1910–1939*. New York: Garland Publishing, 1981.
Phillips, John A. *Eve: The History of an Idea*. San Francisco: Harper & Row, 1984.
"Photographs by Alfred Steiglitz [sic]." *New York Times* (13 February 1921), sec. 6, p. 8.
Plagens, Peter. "The Critics: Hartmann, Huneker, De Casseres." In "The Silent Decade: 1900–1910." *Art in America* 61 (July–August 1973): 66–71.
_____ . "A Georgia O'Keeffe Retrospective in Texas." *Artforum* 4 (May 1966): 27–31.
Platt, Susan Noyes. "Formalism and American Art Criticism in the 1920s." *Art Criticism* 2 (April 1986): 69–84.
Pollitzer, Anita. "That's Georgia." *Saturday Review of Literature* 33 (4 November 1950): 41–43.
_____ . *A Woman on Paper: Georgia O'Keeffe*. Introduction by Kay Boyle. New York: Simon & Schuster, 1988.
Pollock, Griselda. *Vision & Difference: Femininity, Feminism and Histories of Art*. London: Routledge, Chapman & Hall, 1988.
Pritchard, J. P. *Criticism in America: An Account of the Development of Critical Techniques from the Early Period of the Republic to the Middle Years of the Twentieth Century*. Norman: University of Oklahoma Press, 1956.
Raven, Arlene. "O'Keeffe at the Met: Flowers." *Village Voice* 33 (6 December 1988): 115, 117.
Rich, Daniel Catton. *The Flow of Art: Essays and Criticism of Henry McBride*. New York: Atheneum, 1975.

Richardson, E. P. *A Short History of Painting in America: The Story of 450 Years*. New York: Crowell, 1963.

Rieff, Philip. *Freud: The Mind of the Moralist*. 3d ed. Chicago: University of Chicago Press, 1979.

Robinson, Paul. *The Modernization of Sex: Havelock Ellis, Alfred Kinsey, William Masters and Virginia Johnson*. New York: Harper & Row, 1976.

Rose, Barbara. *American Art since 1900: A Critical History*. Rev. ed. New York: Holt, Rinehart and Winston, 1975.

———. "Georgia O'Keeffe: The Paintings of the Sixties." *Artforum* 9 (November 1970): 42–46.

———. "Introduction: The Practice, Theory, and Criticism of Art in America." In *Readings in American Art since 1900: A Documentary Survey*, edited by Barbara Rose, 3–34. New York: Frederick A. Praeger, 1968.

———. "O'Keeffe's Trail." Review of *Georgia O'Keeffe*, by Georgia O'Keeffe. *New York Review of Books* 24 (31 March 1977): 29–33.

———. "The Self, the Style, the Art of Georgia O'Keeffe." *Vogue* 177 (October 1987): 432–33, 482.

———. "Vaginal Iconology." *New York Magazine* 7 (11 February 1974): 59.

———. "Visiting Georgia O'Keeffe." *New York Magazine* 3 (9 November 1970): 60–61.

Rosenberg, Charles. *No Other Gods: On Science and American Social Thought*. Baltimore: Johns Hopkins University Press, 1961.

Rosenberg, Rosalind. *Beyond Separate Spheres: Intellectual Roots of Modern Feminism*. New Haven: Yale University Press, 1982.

———. "In Search of Woman's Nature, 1850–1920." *Feminist Studies* 3 (Fall 1975): 141–54.

Rosenfeld, Paul. "After the O'Keeffe Show." *Nation* 132 (8 April 1931): 388–89.

———. "D. H. Lawrence." *New Republic* 32 (27 September 1922): 125–26.

———. "Stieglitz." *Dial* 70 (April 1921): 397–409.

———. "The Water-Colours of John Marin: A Note on the Work of the First American Painter of the Day." *Vanity Fair* 18 (April 1922): 48, 88.

Rothman, Sheila M. *Woman's Proper Place: A History of Changing Ideals and Practices, 1870 to the Present*. New York: Basic Books, 1978.

Rubenstein, Charlotte Streiffer. *American Women Artists: From Early Indian Times to the Present*. Boston: G. K. Hall, 1982.

Rubenstein, Meridel. "The Circles and the Symmetry: The Reciprocal Influence of Georgia O'Keeffe and Alfred Stieglitz." Master's thesis, University of New Mexico, 1977.

Rudnick, Lois Palken. *Mabel Dodge Luhan: New Woman, New Worlds*. Albuquerque: University of New Mexico Press, 1984.

Sacks, Karen. *Sisters and Wives: The Past and Future of Sexual Equality*. Contributions in Women's Studies, no. 10. Westport, Conn.: Greenwood Press, 1979.

Schapiro, Meyer. *Modern Art*. New York: George Braziller, 1978.

Schjeldahl, Peter. "She Would Not Yield." *7 Days* 2 (18 January 1989): 51–52.

Schnakenberg, H. E. "Exhibitions: The Ladies; Georgia O'Keefe [*sic*]." *The Arts* 17 (March 1931): 426–27.

Schwartz, Sanford. "Books: Georgia O'Keeffe Writes a Book." Review of *Georgia O'Keeffe*, by Georgia O'Keeffe. *New Yorker* 54 (28 August 1978): 87–93.

Scott, Nancy. "The O'Keeffe-Pollitzer Correspondence, 1915–17." *Source* 3 (Fall 1983): 34–41.

Seiberling, Dorothy. "The Female View of Erotica." *New York Magazine* 7 (11 February 1974): 54–58.

_____ . "A Flowering in the Stieglitz Years." *Life* 64 (1 March 1968): 50–53.

Seligmann, Herbert J. *Alfred Stieglitz Talking: Notes on Some of His Conversations, 1925–1931.* New Haven: Yale University Library, 1966.

_____ . "291: A Vision through Photography." In *America & Alfred Stieglitz: A Collective Portrait,* edited by Waldo Frank, Lewis Mumford, Dorothy Norman, Paul Rosenfeld, and Harold Rugg, 105–25. New York: Doubleday, Doran & Co., 1934.

Shields, Stephanie. "Functionalism, Darwinism, and the Psychology of Women: A Study in Social Myth." *American Psychologist* 30 (July 1975): 739–54.

Slatkin, Wendy. *Women Artists in History: From Antiquity to the 20th Century.* Englewood Cliffs, N.J.: Prentice-Hall, 1985.

Smith, Bernard. *Forces in American Criticism: A Study in the History of American Literary Thought.* New York: Harcourt, Brace and Co., 1939.

Sparrow, Walter Shaw. *Women Painters of the World.* New York: Frederick A. Stokes Co., 1905.

Spencer, Herbert. *The Principles of Biology.* 1873. American ed. 2 vols. New York: D. Appleton and Co., 1898.

_____ . *The Study of Sociology.* 1866. American ed. New York: D. Appleton and Co., 1921.

Steichen, Eduard J. "291." *Camera Work,* no. 47 (issue dated July 1914, published January 1915): 65–66.

Stieglitz, Alfred. "Chapter III." In *The Third Exhibition of Photography,* by Alfred Stieglitz *[Songs of the Sky—Secrets of the Skies as Reveald* [sic] *by My Camera & Other Prints]* [exhibition catalogue], n.p. New York: The Anderson Galleries, 3–16 March 1924.

[_____ .] "The Editors' Page." *Camera Work,* no. 18 (April 1907): 37–38.

_____ . "How I Came to Photograph Clouds." *Amateur Photographer and Photography* 56 (19 September 1923): 255. Reprinted in *Alfred Stieglitz: Photographs & Writings,* by Sarah Greenough and Juan Hamilton, 206–8. Washington, D.C.: National Gallery of Art, 1983.

_____ . "One Hour's Sleep Three Dreams." *291,* no. 1 (March 1915): n.p. Reprint. *291 No. 1–12: 1915–1916.* Introduction by Dorothy Norman. New York: Arno Press, 1972.

_____ . "Portrait—1918" [two poems]. *MSS.,* no. 2 (March 1922): 8.

_____ . "A Statement." In *An Exhibition of Photography,* by Alfred Stieglitz *[145 Prints, Over 128 of Which Have Never Been Publicly Shown, Dating from 1886–1921]* [exhibition catalogue], n.p. New York: The Anderson Galleries, from 7 February 1921.

[_____ .] "'291' and the Modern Gallery." *Camera Work,* no. 48 (October 1916): 63–64.

_____ . "Woman in Art." Partially printed in *Alfred Stieglitz: An American Seer,* by Dorothy Norman, 136–38. New York: Random House, 1973.

Strand, Paul. "Alfred Stieglitz and a Machine." *MSS.,* no. 2 (March 1922): 6–7.

Suleiman, Susan R., ed. *The Female Body in Western Culture.* Cambridge: Harvard University Press, 1986.

Sydie, Rosalind A. *Natural Women, Cultured Men: A Feminist Perspective on Sociological Theory.* New York: New York University Press, 1987.

Szekely, Gillian. "The Beginnings of Abstraction in American Art and Theory in Alfred Stieglitz's New York Circle." Ph.D. thesis, University of Edinburgh, 1971.

Taft, Lorado. "Women Sculptors of America." *Mentor* 6 (1 February 1919): 1–11.

Tickner, Lisa. "The Body Politic: Female Sexuality and Women Artists since 1970." *Art History* 1 (June 1978): 236–51.

Tomkins, Calvin. "Profile." Introduction to *Paul Strand: Sixty Years of Photographs,* edited by Michael E. Hoffman, 15–35. Millerton, N.Y.: Aperture, 1976.

_____ . "Profiles: The Rose in the Eye Looked Pretty Fine." *New Yorker* 50 (4 March 1974): 40–66.

Tufts, Eleanor. *Our Hidden Heritage: Five Centuries of Women Artists.* New York: Paddington Press, 1974.

Tyrrell, Henry. "Mr. Tyrrell in the *N.Y. Evening World.*" *Camera Work,* no. 36 (October 1911): 49.

Van Dyke, John C. *American Painting and Its Tradition.* New York: Charles Scribner's Sons, 1919.

Vogel, Lise. "Fine Arts and Feminism: The Awakening Consciousness." *Feminist Studies* 2 (April 1974): 3–37.

Vogt, Carl. *Lectures on Man: His Place in Creation, and in the History of the Earth.* Edited by James Hunt. London: Longman, Green, 1964.

Warner, Marina. *Monuments and Maidens: The Allegory of the Female Form.* New York: Atheneum, 1985.

Wasserstrom, William. *The Time of the Dial.* Syracuse, N.Y.: Syracuse University Press, 1963.

Weisman, Celia. "O'Keeffe's Art: Sacred Symbols and Spiritual Quest." *Woman's Art Journal* 3 (Fall 1982/Winter 1983): 10–14.

Wilson, Edmund. *The American Earthquake.* Garden City, N.Y.: Doubleday & Co., 1958.

Yeh, Susan Fillin. "Innovative Moderns: Arthur G. Dove and Georgia O'Keeffe." *Arts Magazine* 56 (June 1982): 68–72.

Young, Mahonri Sharp. *Early American Moderns.* New York: Watson-Guptill Publications, 1974.

Yurka, Blanche. *Bohemian Girl: Blanche Yurka's Theatrical Life.* Athens: Ohio University Press, 1970.

Zilczer, Judith Katy. "The Aesthetic Struggle in America, 1913–1918: Abstract Art and Theory in the Stieglitz Circle." Ph.D. diss., University of Delaware, 1975.

Index

Adlow, Dorothy, 136, 139, 143, 307, 341 n. 3
 1927 article (O'Keeffe), 133, 134–35, 268–69
Adventures in the Arts (Hartley), 50, 52, 53,
 68, 332 n. 45
 essays in (*see also* Hartley, Marsden, 1921
 commentaries in *Adventures in the Arts*)
 "Our Imaginatives," 52
 "Some Women Artists in Modern
 Painting," 50, 332 n. 45
"Alfred Stieglitz Presents Fifty-One Recent
 Pictures, Oils, Water-colors, Pastels,
 Drawings, by Georgia O'Keeffe,
 American" (1924), 333–34 n. 30. *See
 also* Exhibitions, O'Keeffe, 1924
"Alfred Stieglitz Presents One Hundred
 Pictures, Oils, Water-colors, Pastels,
 Drawings, by Georgia O'Keeffe,
 American" (1923), 63. *See also* Exhibi-
 tions, O'Keeffe, 1923
"Alfred Stieglitz Presents Seven Ameri-
 cans: 159 Paintings, Photographs &
 Things, Recent & Never Before Pub-
 licly Shown, by Arthur G. Dove,
 Marsden Hartley, John Marin, Char-
 les Demuth, Paul Strand, Georgia
 O'Keeffe, Alfred Stieglitz" (1925),
 89, 335 n. 1. *See also* Exhibitions,
 O'Keeffe included, 1925
"American Painting" (Rosenfeld), 45, 46,
 48, 57, 58, 60. *See also* Rosenfeld,
 Paul, 1921 essays
 Stieglitz on, 60
The American Spirit in Art (Mather), 341 n.
 24. *See also* Mather, Frank Jewett, Jr.,
 1927 commentary
Anderson, Sherwood, 20, 70, 72, 73, 76, 85,
 88, 89, 95, 307, 334 n. 31
 1925 catalogue statement ("Seven
 Alive"), 90, 221–22
Anderson Galleries, 9, 26, 27, 41, 44, 63,
 66, 70, 76, 77, 89, 90, 95, 96, 97, 99,
 106, 138, 139, 150, 156, 334 n. 32, 336
 n. 8, 343 n. 21. *See also* Intimate Gal-
 lery
*Apples and Madonnas: Emotional Expression in
 Modern Art* (Bulliet), 340 n. 22. *See
 also* Bulliet, C. J., 1927 commentary
Armory Show, 5, 105, 320 n. 12
*Art in America: From Colonial Times to the Pre-
 sent Day* (La Follette), 342 n. 12. *See
 also* La Follette, Suzanne, 1929 com-
 mentary
Art Institute of Chicago, 34, 60, 61
The Art News, criticism or publicity in
 1926 review (O'Keeffe show), 103–5, 106,
 141, 240–43
 1928 Stieglitz letter to the editor (sale of
 O'Keeffe's paintings), 142–43, 285
"The Art of Georgia O'Keeffe" (Luhan), 337
 n. 19. *See also* Luhan, Mabel Dodge,
 undated essay
Art Students League, 34, 60, 61, 131, 155,
 319–20 n. 1

Barker, Virgil, 307
 1924 commentary (O'Keeffe and Stieglitz
 shows), 80–81, 126, 215
 on O'Keeffe's and Sheeler's art, 80–81
Beckett, Marion, 6
 portrait of O'Keeffe, 131
Bellows, George, 60
Bement, Alon, 34, 142
Bergson, Henri, 11–12, 16
 Creative Evolution (1911), 11–12
 Laughter (1911), 11
Berman, B. Vladimir, 307–8
 1928 article (O'Keeffe), 143, 144, 285–88,
 342–43 n. 17
 O'Keeffe, quotation of, 143
 Stieglitz on O'Keeffe, quotation of, 144

Blake, William, 121
Bluemner, Oscar, 118, 143, 308
 influenced by Stieglitz, 120
 1927 catalogue essay, 120, 125, 132, 136,
 148, 257–58
 and Stieglitz, affiliation, 339 n. 9
 on women, ascendancy of, 120
Bonheur, Rosa, mentioned by Read, 147
Bourne, Randolph, 21, 85
Boursault, Marie Rapp, 330 n. 17, 339 n. 12
Braque, Georges, mentioned by McBride, 107
Breuning, Margaret, 308
 1925 review ("Seven Americans"), 95,
 101, 104, 141, 224–25
 on O'Keeffe's art, 96–97
Brixey, Richard, 149, 342 n. 16
Brook, Alexander, 63, 308
 influenced by Hartley and Rosenfeld, 69
 1923 review (O'Keeffe show), 66, 67, 194
Brooklyn Museum, 133, 155, 338–39 n. 1
Brooks, Van Wyck, 21
Bulliet, C. J., 308
 1927 commentary (O'Keeffe), 272–73, 340
 n. 22
Burroughs, Alan, 63, 308–9
 Hartley on O'Keeffe, quotation of, 68,
 69–70
 1923 review (O'Keeffe show), 66, 68, 69,
 73, 185–86
Bye, Arthur Edwin
 on female creativity in "Women and the
 World of Art," 15–16

Caffin, Charles, 10
Camera Work, 5, 27, 327 n. 1, 327–28 n. 2
 articles, as indications of interests of
 Stieglitz and his circle, 10, 11, 12, 17,
 20, 25, 121, 322 n. 23, 325 n. 67, 329
 n. 15
 no. 47 ("What is 291"), 325 n. 63, 327–28 n.
 2
"Can a Photograph Have the Significance
 of Art," 57. *See also MSS.*, no. 4
Carles, Arthur B., 5, 323 n. 31
Cary, Elizabeth Luther, 63, 309
 on Dove's art, 91
 Hartley on O'Keeffe, quotation of, 68–69
 1923 review (O'Keeffe show), 66, 68, 186–87
 1924 review (O'Keeffe and Stieglitz
 shows), 76–77, 79, 80, 198–99
 1925 review ("Seven Americans"), 91–92,
 97, 229–30
 on O'Keeffe's art
 flower subject matter in, self-portrait
 quality of, "universality" of, 92
 and Stieglitz's, 76, 79–80

Catalogue, "Seven Americans," 89–91, 92,
 96, 335 n. 1, 335 n. 2
 literature in (*see* 1925 catalogue statement
 under Anderson, Sherwood; Dove,
 Arthur; Stieglitz, Alfred; *see also*
 Rönnebeck, Arnold, 1925 catalogue
 essay)
 Breuning on, 95
 Read on, 95
Catalogues, Stieglitz exhibitions, 43, 330 n.
 25
 literature in (*see* Stieglitz, Alfred, writ-
 ings, 1921 catalogue statement, 1924
 catalogue statement)
Catalogues or brochures, O'Keeffe exhibi-
 tions, 63, 72, 73, 103, 118, 120, 136,
 148, 149, 333–34 n. 30, 339 n. 10, 341
 n. 6, 341–42 n. 7, 342 n. 11, 343 n. 22
 literature in
 effect on critical opinion (*see* influence
 on other critics *under* Hartley,
 Marsden; Mumford, Lewis)
 McBride on, 124–25
 Read on, 77, 98
Cézanne, Paul, 5
 mentioned by
 Read, 79
 Rosenfeld, 48
Chase, William Merritt, 60, 142
Cheney, Sheldon, 309
 on expressionism in America, 109
 1924 commentary (abstractionism; mod-
 ernism in America) in *A Primer of
 Modern Art*, 81, 209–11
 on O'Keeffe's and Marin's art, 81
Chicago, Judy, 344 n. 4
 on O'Keeffe, 322–23 n. 27
"Cleanness" in O'Keeffe's art, critics on.
 See O'Keeffe, Georgia, her art, critics
 on "cleanness" in
Coates, Robert M., 309
 1929 profile (O'Keeffe), 154–56, 301–6
 on O'Keeffe as feminist, 155
 on Stieglitz's promotion of O'Keeffe,
 155–56
Cocteau, Jean, mentioned by McBride, 126
A Collection in the Making (Phillips), 338–39
 n. 1. *See also* Phillips, Duncan, 1926
 commentary
Color in O'Keeffe's art, critics on. *See*
 O'Keeffe, Georgia, her art, critics on
 color in
Cornell, Katherine, 100
Cortissoz, Royal, 63, 309–10
 on Little Galleries of the Photo-Seces-
 sion, 320 n. 12

1923 review (O'Keeffe show), 73, 76, 191
1925 review ("Seven Americans"), 95, 231–32
on Stieglitz, 95
Covarrubias, Miguel, 155
Creative Evolution (Bergson), 11. *See also under* Bergson, Henri
Creative process, 2, 13, 19, 20, 23, 32, 33, 100, 126
theories about, 11, 12
Criticism, language of. *See* Man, described as; Organicism, language of, applied to O'Keeffe; Woman, described as

Darwin, Charles, 12–14, 15
The Descent of Man (1871), 13–14
On the Origin of Species (1859), 13
on women and men, differences between, 13–14
De Casseres, Benjamin, 329 n. 14
on the unconscious in art, 10
Demuth, Charles, 9, 89, 95, 96, 310
1927 catalogue statement, 118, 124, 258
1929 catalogue statement, 148, 294
The Descent of Man (Darwin), 13. *See also under* Darwin, Charles
De Zayas, Marius, 27, 328 n. 3
on the artist and the unconscious in art, 10
Dial
Strand essay on O'Keeffe (1923), rejection of, 333 n. 25
Diderot, Denis, mentioned by McBride, 126
Dodge, Mabel. *See also* Luhan, Mabel Dodge
1915 poem, 337 n. 17
Dove, Arthur, 5, 20, 32, 45, 48, 49, 60, 87, 89, 96, 99, 143, 310
his art in "Seven Americans," critical opinion of, 91–92, 95, 97
1925 catalogue statement ("A Way to Look at Things"), 91, 222
on O'Keeffe, 16
and Stieglitz, affiliation, 9
Dow, Arthur Wesley, 60
influence on O'Keeffe, 34, 329 n. 15
Dreier, Katherine, 310
1926 commentary (O'Keeffe) in *Modern Art*, 256, 338–39 n. 1
Duchamp, Marcel, 85, 332 n. 11
Duncan, Charles, 6, 19, 25, 310–11. *See also* Exhibitions, O'Keeffe included, 1916 spring (291)
1916 commentary (O'Keeffe), 20, 24, 166–67

Eilshemius, Louis, 311
1924 letter to McBride (O'Keeffe and Stieglitz shows), 200–201, 334 n. 34
El Greco, mentioned by Rosenfeld, 48
Ellis, Havelock, 46
Engelhard [Cromwell], Georgia, 9
Evolution. *See also* evolution of *under* Man; Woman
theories of, 12–14, 324 n. 46
"Exhibition of Paintings and Drawings Showing the Later Tendencies in Art" (1921), 323 n. 31
"An Exhibition of Photography, by Alfred Stieglitz, 145 Prints, Over 128 of Which Have Never Been Publicly Shown, Dating from 1886–1921," 41. *See also* Exhibitions, Stieglitz, 1921
Exhibitions, O'Keeffe
1917 (291), 7, 17, 31, 325 n. 68 (*for related criticism, see* Fisher, William Murrell; Tyrrell, Henry)
1923 (Anderson Galleries), 9, 25, 63 (*for related criticism, see* Brook, Alexander; Burroughs, Alan; Cary, Elizabeth Luther; Cortissoz, Royal; McBride, Henry; Read, Helen Appleton; Seligmann, Herbert J.; Strand, Paul; Tyrrell, Henry; *see also* Rosenfeld, Paul, 1922 preview)
1924 (Anderson Galleries), 9, 73, 76, 333–34 n. 30 (*for related criticism, see* Barker, Virgil; Cary, Elizabeth Luther; Eilshemius, Louis; McBride, Henry; Read, Helen Appleton; Rosenfeld, Paul; Strand, Paul; Watson, Forbes; *Vanity Fair*)
1926 (Intimate Gallery), 9, 103, 338 n. 28 (*for related criticism, see The Art News*; Kalonyme, Louis; Matthias, Blanche; McBride, Henry; *New York Times*; Pemberton, Murdock; Read, Helen Appleton)
1927 (Brooklyn Museum), 133
1927 (Intimate Gallery), 9, 118 (*for related criticism, see* Kalonyme, Louis; McBride, Henry; Mumford, Louis; Pemberton, Murdock; Read, Helen Appleton)
1928 (Intimate Gallery), 9, 136, 341 n. 6 (*for related criticism, see* Jewell, Edward Alden; Kalonyme, Louis; McBride, Henry; Mannes, Marya; Pemberton, Murdock; Read, Helen Appleton; *Time* [magazine]; *Vanity Fair*)

1929 (Intimate Gallery), 9, 148 (*for related criticism, see* Jewell, Edward Alden; McBride, Henry; Moore, Dorothy Lefferts; Pemberton, Murdock)
Exhibitions, O'Keeffe included
1916
spring (291), 6–7, 17, 23, 80, 87, 102, 321 nn. 18–19, 321–22 n. 20, 325 n. 68 (*for related criticism, see* Duncan, Charles; Sayer, Evelyn; Stieglitz, Alfred; Tyrrell, Henry)
fall (291), 9
1917 (Society of Independent Artists), 9
1921 (Pennsylvania Academy of the Fine Arts), 323 n. 31
1925 (Anderson Galleries), 9, 89–91, 335 n. 1, 337 nn. 13–14 (*for related criticism, see* Breuning, Margaret; Cary, Elizabeth Luther; Cortissoz, Royal; McBride, Henry; Mullin, Glen; Read, Helen Appleton; Watson, Forbes; Wilson, Edmund)
1926
(Brooklyn Museum), 338–39 n. 1
(Wildenstein Galleries), 106, 338 n. 31
1929 (Museum of Modern Art), 161
Exhibitions, Stieglitz
1921 (Anderson Galleries), 27, 41, 43, 53 (*for related criticism, see* McBride, Henry; Rosenfeld, Paul; Strand, Paul)
1923 (Anderson Galleries), 334 n. 31
1924 (Anderson Galleries), 73, 76, 334 n. 32 (*for related criticism, see* 1924 under Barker, Virgil; Cary, Elizabeth Luther; Eilshemius, Louis; McBride, Henry; Read, Helen Appleton; Watson, Forbes)
Exhibitions, various, Stieglitz-organized, 9, 325 n. 65, 338 n. 28, 342–43 n. 17
Exhibitions, women artists, Stieglitz-organized, 6, 16
Expressionism, 109

Feminine qualities in O'Keeffe's art, critics on. *See* O'Keeffe, Georgia, her art, critics on feminine qualities in
Fenollosa, Ernest, 34, 329 n. 15
"Fifty Recent Paintings by Georgia O'Keeffe," 103. *See also* Exhibitions, O'Keeffe, 1926
Fisher, William Murrell, 106, 311
on musicality of O'Keeffe's art, 18
1917 review (O'Keeffe show), 17, 18, 169–70
Frank, Waldo, 150, 311, 334 n. 32

on criticism of O'Keeffe's art
as misdirected, 116
use of Freudian theory in, 116
1926 essays in *Time Exposures*
(O'Keeffe), 21, 113, 115–16, 117, 118, 123, 130, 131, 132, 133, 135, 136, 139, 153, 253–55, 338–39 n. 1
(Stieglitz), 335 n. 3
on Stieglitz, 115
and Stieglitz, relationship, 339 n. 2
Freud, Sigmund, 23, 24, 25, 46
mentioned by
Coates, 155
Matthias, 108
Freudian theory
appeal of, 24
biases against women within, 327 n. 88
in criticism of O'Keeffe's art, 2, 23, 24, 25, 35, 46, 48, 49, 50, 52, 53, 58, 67, 69, 71, 72, 77, 78–79, 81, 84, 98, 101, 102, 105, 106, 107, 108, 111, 116, 121, 122–23, 136–38, 148, 149, 155, 156, 157, 158, 159, 160, 334 n. 37, 337 n. 15
in promotion of O'Keeffe's art, 23, 24, 25

Fuller, George, 52, 53
Fulton, Deogh
1925 review ("Seven Americans"), 336 n. 10

Gold, Michael, 158
Gris, Juan, mentioned by McBride, 107
Guys, Constantin, mentioned by Kalonyme, 138

Hapgood, Hutchins, 58, 332 n. 12
Hartley, Marsden, 5, 9, 45, 60, 85, 86, 89, 92, 95, 150, 311–12, 321 n. 14, 321 n. 19, 335 n. 1, 336 n. 9, 336–37 n. 12, 338 n. 28, 343 n. 24, 344 n. 36
Freudian theory, use of, 52
influence on other critics, 68–69, 69–70, 71, 136–37
influenced by
Stieglitz, 53
Stieglitz's photographs of O'Keeffe, 52–53
1921 commentaries in *Adventures in the Arts*
(George Fuller), 52
(O'Keeffe), 26, 50, 52, 53, 57, 58, 61, 62, 68, 73, 77, 78, 86, 98, 105, 124, 125, 132, 136, 159, 170–71, 332 n. 45, 337 n. 15
on O'Keeffe's art
"cleanness" of, 69, 98

color in, 52
creative source of, 50
sexuality in, 52–53, 85, 98
and Stieglitz, affiliation, 96, 336–37 n. 12
Hartmann, Sadakichi, 10
Haskell, Barbara
on *Blue Lines X*, Stieglitz's interpretation of, 327 n. 84
on O'Keeffe, 4, 320 n. 8
Haviland, Paul, 328 n. 3
and Stieglitz, affiliation, 27
Hawthorne, Nathaniel, 52, 53
Henri, Robert, mentioned by O'Keeffe, 60

Image of O'Keeffe. *See* O'Keeffe, Georgia, public image
"International Exhibition of Modern Art" (1926), 338–39 n. 1
Interviews with O'Keeffe in 1920s, 61–63, 102, 107–9, 109–10, 111, 125, 133–35, 143–44, 154–56
Intimate Gallery, 9, 96, 107, 138, 141, 142, 156, 338 n. 28, 339 n. 8

Jewell, Edward Alden, 138, 150, 312
Freudian theory, use of, 136
influenced by Stieglitz circle, 136–37
1928 review (O'Keeffe show), 136–37, 276–78
1929 reviews (O'Keeffe show), 152, 297–98
Jung, Carl, mentioned by Matthias, 108

Kalonyme, Louis, 103, 104, 154, 312
Freudian theory, use of, 104, 138
influenced by Stieglitz circle, 105, 136, 137, 138
1926 review (O'Keeffe show), 104, 251–52, 338 n. 30
1927 reviews (O'Keeffe show), 104, 132, 136, 260, 263, 338 n. 30
1928 essay (O'Keeffe), 104, 137–39, 278–82, 338 n. 30
and Stieglitz, affiliation, 104–5
Kandinsky, Wassily, 11, 16
Concerning the Spiritual in Art (1911), 12
Kay-Scott, C[yril], 312
1928 letter to O'Keeffe, 136, 273–74
Kennerley, Mitchell, 41, 58

Lachaise, Gaston, mentioned by Kalonyme, 139
Lafferty, Réné, 6, 19, 321 n. 18. *See also* Exhibitions, O'Keeffe included, 1916 spring (291)
La Follette, Suzanne, 312–13

1929 commentary (O'Keeffe) in *Art in America*, 306, 342 n. 12
Lake George, N.Y., 322 n. 25, 334 n. 36, 339 n. 6. *See also* O'Keeffe, Georgia, and Stieglitz, at Lake George
Language of criticism. *See* Criticism, language of
Laughter (Bergson), 11
Laurencin, Marie, 85, 137, 340 n. 22
Lawrence, D. H., 46, 84, 85, 335 n. 41
Lectures on Man (Vogt), 13
Lisle, Laurie
on feminist artists, O'Keeffe's reaction to, 344 n. 4
on Hartley on O'Keeffe, 332 n. 45
on O'Keeffe show in 1929, critical reception of, 344 n. 36
Little Galleries of the Photo-Secession, 5, 320 n. 12. *See also* 291
Lowe, Sue Davidson
on O'Keeffe show in 1929, critical reception of, 344 n. 36
on O'Keeffe's flower paintings, critical reception of, 337 n. 13
on Stieglitz's photographs of O'Keeffe, 330 n. 24
Luhan, Mabel Dodge, 100–101, 110. *See also* Dodge, Mabel
Freudian theory, use of, 101
undated essay ("The Art of Georgia O'Keeffe"), 101–2

McBride, Henry, 87, 96, 103, 149, 150, 313
Bluemner as critic, repudiation of, 125
Demuth 1927 catalogue statement, quotation of, 125
on Dove's art, 92
Freudian theory, use of, 71
Hartley on O'Keeffe
quotation of, 68–69, 71
reference to, 125
on Hartley's art, 92, 95, 336 n. 9
1921 reviews (Stieglitz show), 41, 43
1923 review (O'Keeffe show), 63, 69, 70–71, 73, 187–89
1924 review (O'Keeffe and Stieglitz shows), 77, 79, 199–201, 334 n. 34
1925 review ("Seven Americans"), 92, 95, 97, 124, 225–27, 336 n. 9
1926 commentary (O'Keeffe show), 107, 252–53, 340 n. 15
1926 review (O'Keeffe show), 106–7, 243–44
1927 reviews (O'Keeffe show), 123, 124–25, 126, 128, 132, 258–60, 266–67, 340 n. 15

1928 review (O'Keeffe show), 140, 274–75
1929 review (O'Keeffe show), 153, 295–96
 on O'Keeffe, 71
 on O'Keeffe's art
 color in, 106
 feminine qualities of, 106–7
 French qualities of, 126
 intellectual qualities of, 125, 126, 128
 musicality of, 326 n. 70
 subject matter in, 106, 140, 153
 on Stieglitz, 41, 77
 on "Stieglitz's" art in "Seven Ameri-
 cans," 92, 336 n. 6, 336 n. 9
 Stieglitz's photographs of O'Keeffe
 attitude toward, 132–33
 on sensation of, 43
Macdonald-Wright, Stanton, 9, 325 n. 62
Maillol, Aristide, mentioned by McBride,
 107
Man. *See also* Women and men
 as artist, 15, 16, 17, 25, 32, 33, 48, 100, 102
 art of, 15, 20, 33, 35, 48, 49, 99, 100, 137,
 147
 described as brainy brute, 120
 evolution of, 13, 85
 notions about the nature of, 13, 14, 15,
 19, 22, 32, 67, 72, 80, 81, 85, 87, 100,
 120, 160
 superiority of, 13, 14, 15
Mannes, Marya, 313
 on criticism of O'Keeffe's art as misdi-
 rected, 141
 1928 review (O'Keeffe show), 140–41,
 161, 282–83
Marin, John, 5, 21, 45, 60, 81, 85, 87, 89, 95,
 96, 97, 107, 143
 and Stieglitz, affiliation, 9
Martin, Charles J., 319–20 n. 1
Mather, Frank Jewett, Jr., 313–14
 1927 commentary (O'Keeffe) in *The
 American Spirit in Art*, 267, 341 n. 24
Matisse, Henri, 5, 85, 107, 120, 121, 123,
 136, 320 n. 12
Matthias, Blanche, 20, 103, 110, 118, 123,
 125, 126, 130, 131, 133, 135, 139, 314,
 338 n. 29, 339 n. 8
 on criticism of O'Keeffe's art as misdi-
 rected, 107–8
 1926 article (O'Keeffe), 107–10, 136, 153,
 246–50
 on Stieglitz's promotion of O'Keeffe, 108
Maurer, Alfred, 5
Meyer, Agnes Ernst, 328 n. 3
 and Stieglitz, affiliation, 27

Modern Art (Dreier), 338–39 n. 1. *See also*
 Dreier, Katherine, 1926 commentary
Modern Gallery, 328 n. 3
Modern Painting (George Moore), 15
Moore, Dorothy Lefferts, 314
 1929 review (O'Keeffe show), 154, 299–
 301
Moore, George, 62, 105, 147
 influence of, 15–16, 324–25 n. 57
 Modern Painting (1893), 15, 16
 on Morisot, 15
 repudiated by critics in 1920s, 15, 324 n. 53
 on women and men artists, 15
Morand, Paul, mentioned by McBride, 126
Morisot, Berthe, 15
MSS. (periodical), 60, 61, 67, 110, 162, 328
 n. 4, 330 n. 17, 332 n. 11
 no. 4 ("Can a Photograph Have the Sig-
 nificance of Art"), 57, 332 n. 11 (*see
 also* O'Keeffe, Georgia, writings,
 1922 essay)
Mullin, Glen, 314
 on expressionism, 109
 1925 review ("Seven Americans"), 97,
 101, 109, 111, 238–40
 on O'Keeffe's and Marin's art, 97
Mumford, Lewis, 132, 136, 148, 149, 158,
 314
 influence on other critics, 136, 138, 140
 1927 essay (Matisse and O'Keeffe), 120–
 22, 264–66
 on O'Keeffe's art
 and Matisse's, 120–21, 123
 sexual symbolism in, 121–22, 123
 on Stieglitz's photographs of O'Keeffe,
 331 n. 37
Murrell, William. *See* Fisher, William
 Murrell
Musicality of O'Keeffe's art, critics on. *See*
 O'Keeffe, Georgia, her art, critics on
 musicality of

National Woman's Party, 135, 341 n. 4
New York Sun, criticism in
 1922 article (O'Keeffe), 61–63, 78, 110,
 123, 125, 131, 153, 180–82
 influence of Rosenfeld on, 62
New York Times, criticism or publicity in
 1926 review (O'Keeffe show), 103, 244
 1928 announcement (sale of O'Keeffe
 paintings), 142, 284-85

Oates, Joyce Carol, on D. H. Lawrence, 85,
 335 n. 41

O'Brien, Frances, 314
 1927 article (O'Keeffe), 133, 134, 135, 136, 269–72
 on O'Keeffe's feminism, 135
 as subject of Stieglitz photographs, 341 n. 5
O'Keeffe, Georgia
 art, decision to give up, 34
 articles about, based on interviews (*see* Adlow, Dorothy, 1927 article; Berman, B. Vladimir, 1928 article; Coates, Robert M., 1929 profile; Matthias, Blanche, 1926 article; *New York Sun,* criticism in, 1922 article; O'Brien, Frances, 1927 article; Sabine, Lillian, 1928 article)
 biographical information, published 1916–29, 60, 61, 110, 143, 154, 338 n. 32, 338–39 n. 1
 criticism of her art
 attempts to redirect, 53, 72–73, 100–101, 103, 111, 118
 attitude toward, 70, 136
 attitude toward newly evolved women theme in, 87–88
 efforts to recruit a woman to write, 100, 101, 337 n. 18
 by Mumford, reaction to, 122–23, 136, 148, 340 n. 14
 on criticism of her art, 73, 341–42 n. 7
 by Frank, 116–17
 by Hartley, 58, 68
 by McBride, 71, 87, 128
 by Matthias, 110, 340 n. 19
 by Rosenfeld, 58
 drawings, charcoal (1915–16), 3–4, 5, 6, 7, 8, 9, 10, 12, 17, 19, 22, 23, 24, 25, 30, 31, 32, 34, 320 n. 7, 321 n. 18, 322 n. 24, 322 n. 25
 education
 academic training, rejection of, 3, 34
 Art Institute of Chicago, 34, 60, 61
 Art Students League, 34, 60, 61
 Teachers College, Columbia University, 3, 6, 34, 60, 319–20 n. 1
 University of Virginia, 34, 60, 61
 exhibition, 1923
 critical response, reaction to, 70, 73
 public response, reaction to, 70
 on exhibitions, 60
 on expressionism and being called an expressionist, 109
 as feminist, 135, 155, 159
 feminist artists and writers in the 1970s, attitude toward, 160, 344 n. 4

 her art
 critics on "cleanness" in, 66, 69, 80, 98, 133
 critics on color in, 18, 46, 49, 52, 66, 68, 72, 73, 81, 85, 87, 97, 98, 104, 106–7, 115, 118, 136–37, 141, 150
 critics on feminine qualities in, 24, 48, 62, 81, 100, 108, 120, 125, 335 n. 38, 340 n. 22
 critics on musicality of, 18, 326 nn. 70–71
 critics on sexuality in, 23, 24, 25, 35, 46, 48, 50, 52, 53, 57, 69, 78–79, 81, 85, 86, 87, 101, 105, 107, 108, 121, 122, 123, 138, 141, 157
 effect of criticism on, 73
 as expression of woman, 6, 7, 8, 9, 16, 19, 23, 24, 25, 34, 35, 46, 48–49, 52, 57, 62, 71–72, 79, 80, 81, 84, 86, 87, 99, 108, 120, 122, 136–37, 141, 148, 154, 157, 158
 influenced by Stieglitz's photography, 56, 57
 influenced by Strand's photography, 332 n. 10
 sales of, 130, 133, 141–42, 147, 150, 155, 342 n. 13, 344 n. 34
 self-promotion of, 2, 53, 73, 61, 159, 161, 162
 her art, compared by critics with work of
 Anderson, 85
 Bourne, 85
 Duchamp, 85
 Laurencin, 137, 340 n. 22
 Marin, 81, 85, 97
 Matisse, 85, 120, 123
 Picasso, 85
 Sheeler, 80–81
 Stieglitz, 80, 85
 Toomer, 85
 Willard Huntington Wright, 86–87
 her art, subject matter of, 63
 critics on, 62, 66, 67, 69, 78, 80, 92, 97, 99, 103–5, 106–7, 124, 138, 140, 148, 153
 on her art, 60, 61, 62–63, 67–68, 73, 79, 103, 109, 117, 126, 128, 152–53, 320 n. 10, 334 n. 31, 335–36 n. 5, 341–42 n. 7
 color in, 60, 76
 denial of erotic content in, 158, 341–42 n. 7
 "feminine" qualities of, 8
 sales of, 340–41 n. 23
 subject matter in, 73, 102–3, 341–42 n. 7

on herself, 20, 31, 60, 61, 117
National Woman's Party, affiliation with, 135, 341 n. 4
and Pollitzer, correspondence, 3–4, 8, 87, 320 n. 10
public image, 2, 132
 androgyny of, 159
 appearance described in print, 77, 78, 110, 115, 116, 131–32, 133, 138–39, 155
 attempts to define, 53, 60, 61, 62, 143, 159, 161, 162
 Hartley's and Rosenfeld's contributions to, 26, 50–51, 53, 57, 58, 61, 69, 70, 77, 78, 86, 105, 132, 159
 Stieglitz's shows' (1921, 1923) contribution to, 41, 43, 71, 73, 110, 132, 133, 330 n. 24
 Stieglitz's published photographs' contribution to, 131, 132, 139, 143, 159, 343 n. 18
 Stieglitz's contribution to, 132, 144, 161
 various critics' contributions to, 78, 110, 111, 113, 115–16, 118, 130, 133, 134, 135, 136–37, 138–39, 142, 144, 154, 155, 156
publicity
 attitude toward, 58, 60, 70, 96
 illness as reaction to, 70, 333 n. 21
 response to, reported by Sabine, 143
quoted, 55–56, 102–3, 158, 162, 320 n. 10, 320 n. 13, 321 n. 14, 321–22 n. 20, 322–23 n. 27, 323 n. 31, 327–28 n. 2, 332 n. 10, 335–36 n. 5, 337–38 n. 22, 340–41 n. 23, 341–42 n. 7
 in 1920s, 61, 62, 63, 68, 73, 79, 103, 108, 109, 110, 126, 134, 143, 152
quoted on Stieglitz, 162
 in 1920s, 108, 320 n. 10
as sexual being, celebrated by Stieglitz circle, 46, 48, 50, 53, 57
and Stieglitz
 confrontation over first show, 6, 31, 96, 102, 321–22 n. 20
 correspondence, 6, 7, 319 n. 1, 321 n. 15, 330 n. 18
 disagreement over exhibiting *New York with Moon*, 102–3, 337–38 n. 22
 disagreement over interpretation of her art, 158
 disagreement over painting cityscapes, 102
 early personal relationship, 6, 31, 32, 35, 37, 52, 53, 330 n. 18
 early professional relationship, 6, 7, 8, 9, 31

at Lake George, 1, 8, 31, 76, 117, 149, 150, 155, 339 n. 6, 342 n. 16
 marriage, 8
 in New York City, 1, 6, 7, 8, 31, 37, 118, 337 n. 18
 promotion of his art, 161, 162
on Stieglitz
 being photographed by, 55
 his early reaction to her art, 320 n. 13, 321 n. 14
 as inspiration to critics who found erotic content in her art, 341–42 n. 7
 his photography, 55–56, 57
 his promotion of her art, 158
 his response to contradiction, 327–28 n. 2
 his response to her first large-scale flower painting, 335–36 n. 5
 his stubbornness, 102, 161, 321–22 n. 20
on Strand's photography, 332 n. 10
teaching positions
 Columbia College, Columbia, S.C., 3
 University of Virginia, 60, 61
 West Texas State Normal College, 7
travel to
 Maine, 143, 149, 342 n. 16
 New Mexico, 1, 117, 150, 164
 New York City, 7, 31
 Washington, D.C., 135
 Wisconsin, 149
291, visits to, 321 n. 19
woman artist
 on being, 102, 108–9, 323 n. 31
 on being referred to as, 322–23 n. 27
 being referred to as, attitude toward, 8, 100
works
 Abstraction (1926), *127*, 340 n. 17
 Abstraction IX (1916), 63, 325 n. 68
 Apple Family III (1921), 63
 Birch Trees at Dawn at Lake George (1923), *75*, 333–34 n. 30
 Black Abstraction (1927), 342 n. 8
 Black Iris III (1926), *94*, 335–36 n. 5, 339 n. 10
 Black Spot No. 2 (1919), 57
 Black Spot III (1919), 331 n. 38
 Blue and Green Music (1919), 63, *64*
 Blue Lines X (1916), 22, 325 n. 68, 327 n. 84
 Blue No. I (1916), 325 n. 68
 Blue No. II (1916), 63
 Blue No. IV (1916), 325 n. 68
 Blue I (ca. 1917), 325 n. 68
 East River from Shelton (1927–28), 118, *119*

Evening Star VI (1917), 331 n. 38
Fifty-ninth Street Studio (1919), 331 n. 38
From the Plains I (1919), 63
Inside Red Canna (1919), 335–36 n. 5
Lake George and Woods (1912), 331 n. 38
Lake George with Crows (1921), 63, 331 n. 38
Light Coming on the Plains No. II (1917), 63
Music—Pink and Blue I (1919), 50, *51*
My Shanty (1922), 63
New York with Moon (1925), 102, 103
Pattern of Leaves (ca. 1923), *74*, 333–34 n. 30
Pink Tulip (1926), *93*, 335–36 n. 5
Plums (1920), 63, *65*, 331 n. 38
Red and Orange Streak (1919), 18
Red Canna (1920), 331 n. 38
Red Flower (1918–19), 335–36 n. 5
Series I, No. 1 (1918), 331 n. 38
Series I, No. 8 (1919), 18, 57
Series I, No. 12 (1920), 63
The Shelton at Night (1927), 342 n. 11
The Shelton with Sunspots (1926), 128, 129
Single Alligator Pear (1922), 63
Single Lily with Red (1928), *151*, 344 n. 35
Special No. 2 (1915), 320, n. 7
Special No. 4 (1915), 320, n. 7
Special No. 5 (1915), 320, n. 7
Special No. 9 (1915), 320, n. 7
Special No. 13 (1915), 322 n. 24
Special No. 15 (1916), 325 n. 68
Special No. 17 (1916?), 325 n. 68
Sunrise and Little Clouds II (1916), 18, 63, 325 n. 68
Train at Night in the Desert (1916), 325 n. 68
untitled sculpture, plaster (1916), *frontispiece*, 50, *51*
writings
 language of, influenced by Stieglitz, 338 n. 34
 1922 essay (photography), 57, 60, 110, 162, 182–84
 1923 catalogue statement, 67–68, 110, 184–85
 1924 catalogue statement, 73, 197–98
 1926 catalogue statement, 103, 240
 1939 catalogue statement, 341–42 n. 7
O'Keeffe, Ida Ten Eyck, 334 n. 36
O'Keeffe-Duncan-Lafferty exhibition, 6, 17, 19, 20, 22, 23, 80, 321 n. 18. *See also* Exhibitions, O'Keeffe included, 1916, spring (291)
"O'Keeffe Exhibition," 341 n. 6. *See also* Exhibitions, O'Keeffe, 1928

"One Hour's Sleep Three Dreams" (Stieglitz), 28, 37, 328 n. 4. *See also* Stieglitz, Alfred, writings, 1915 poem
On the Origin of Species (Darwin), 13
Oppenheim, James, 21
Organicism, 21
 language of, applied to O'Keeffe, 19, 20, 21, 22, 25, 49, 50, 115, 121, 135
"Our Imaginatives" (Hartley). See *Adventures in the Arts*, essays in

"Paintings by Nineteen Living Americans" (1929), 161
Pemberton, Murdock, 104, 314–15
 Freudian theory, use of, 105
 influenced by Stieglitz, 104, 105
 1926 commentary and review (O'Keeffe show), 103, 105–6, 244–45, 250–51
 1927 review (O'Keeffe show), 123, 261–62
 1928 review (O'Keeffe show), 275–76
 1929 reviews (O'Keeffe show), 150, 152, 294–95, 299
Phillips, Duncan, 149, 315, 327 n. 87, 333 n. 16, 340–41 n. 23, 344 nn. 34, 36
 1926 commentary (O'Keeffe) in *A Collection in the Making*, 255–56, 338–39 n. 1
 as O'Keeffe's patron, 133, 155
Picabia, Francis, 342–43 n. 17
Picasso, Pablo, 5, 57, 85, 107, 325 n. 65, 338 n. 31
Pollitzer, Anita, 12, 55, 56, 154, 321 n. 14, 321 n. 19, 322 n. 25
 National Woman's Party, affiliation with, 341 n. 4
 and O'Keeffe
 correspondence, 3–4, 8, 87, 320 n. 10
 friendship, 3, 319–20 n. 1
 O'Keeffe's early career, relationship to, 3, 4, 6, 7, 8, 320 n. 10
Port of New York (Rosenfeld), 48, 81, 86, 87, 328 n. 4, 338 n. 32, 341 n. 1. *See also* Rosenfeld, Paul, 1924 essays in
"Portrait—1918" (Stieglitz), 35–36, 328 n. 4, 330 n. 17. *See also* Stieglitz, Alfred, writings, 1921 poems
"Portrait: 1910–21" (Stieglitz), 328 n. 4. *See also* Stieglitz, Alfred, writings, 1921 poems
A Primer of Modern Art (Cheney), 81, 109. *See also* Cheney, Sheldon, 1924 commentary
Proust, Marcel, mentioned by McBride, 126
Public image of O'Keeffe. *See* O'Keeffe, Georgia, public image

Read, Helen Appleton, 315, 324 n. 53
 on criticism of O'Keeffe's art as misdirected, 98
 Freudian theory
 use of, 67, 69, 78, 78–79, 98
 on use of, 78, 98, 123
 Hartley on O'Keeffe, quotation of, 68
 influenced by
 Hartley, 98
 Mumford, 148
 1923 review (O'Keeffe show), 63, 67, 69, 78, 97, 191–92
 1924 article (O'Keeffe), 78–79, 81, 97, 131–32, 211–14
 1924 review (O'Keeffe and Stieglitz shows), 77–78, 97, 153, 201–2
 1925 reviews ("Seven Americans"), 95, 97–98, 153, 233–34, 236–38
 1926 review (O'Keeffe show), 103, 106, 245–46
 1927 review (O'Keeffe show), 123–24, 153, 260–61
 1928 article (featuring O'Keeffe), 147, 148, 291–93
 on O'Keeffe's art
 art-historical significance of, 124
 decorative qualities of, 106
 feminine qualities of, 79
 self-portrait quality of, 77
 sexuality in, 69, 78–79, 131–32
 subject matter in, 106
 on Stieglitz, 79
 his art, 77
 his promotion of O'Keeffe, 79
 on women's art, 147
 feminine qualities of, 19
Redon, Odilon, mentioned by Mumford, 121
Rembrandt van Rijn, mentioned by Rosenfeld, 48
Renoir, Auguste
 mentioned by
 Kalonyme, 138
 Rosenfeld, 48
Rhoades, Katharine, 6
Rodin, Auguste, mentioned by Read, 79
Rönnebeck, Arnold, 96, 315
 1925 catalogue essay ("Through the Eyes of a European Sculptor"), 90–91, 92, 222–24
Rose, Barbara, on O'Keeffe and Fenollosa, 329 n. 15
Rosenfeld, Paul, 21, 78, 85, 86, 108, 160, 315–16, 331 nn. 38–39, 334 n. 36, 338 n. 32
 on art, "greatness" of, 48–49
 1921 essays
 (American painting), 26, 45, 46, 48–49, 50, 53, 57, 58, 61, 70, 72, 78, 87, 105, 132, 136, 159, 171–74, 332 n. 12
 (Stieglitz), 44–45, 50
 1922 essays
 (D. H. Lawrence), 46, 84, 85
 (Marin), 21
 1922 preview (1923 O'Keeffe show), 18, 26, 45, 46, 49, 53, 57, 58, 61, 62, 70, 72, 78, 86, 105, 120, 132, 136, 159, 175–79, 331 n. 38
 1924 essays in *Port of New York*
 (Dove), 48, 49, 87, 203–4
 (O'Keeffe), 22–23, 81, 86, 100, 125, 132, 139, 204–9, 341 n. 1
 on Dove, 48–49, 87
 influence on other critics, 60, 62, 69, 70, 105, 131, 136
 influenced by
 Stieglitz, 48, 50, 53
 Stieglitz's photographs of O'Keeffe, 45–46, 48, 49–50
 on O'Keeffe, as newly evolved woman, 46, 86
 O'Keeffe's art
 sexuality in, 46, 48, 49, 85
 on O'Keeffe's art
 creative source of, 46
 emotional qualities in, 22–23, 49, 125
 as equal to art of men, 48–49
 as expression of "new" woman, 86
 as expression of sexual union, 49, 86
 as expression of woman, 57
 musicality of, 18
 sexuality in, 46, 48, 49, 57, 86
 on Ryder, 48
 on women, evolution of, 85, 86
Rubens, Peter Paul
 mentioned by
 Kalonyme, 137
 Rosenfeld, 48
Ryder, Albert Pinkham, 121
 mentioned by
 Kalonyme, 137

Sabine, Lillian, 316
 1928 article (O'Keeffe), 143, 144, 152, 288–91, 342–43 n. 17
Sales of O'Keeffe's paintings. *See* O'Keeffe, Georgia, her art, sales of
Sayer, Evelyn, 24, 25, 327 n. 86
 1916 letter to Stieglitz (O'Keeffe's charcoal drawings), 24, 121, 167
 on sexuality in O'Keeffe's art, 24

Search-Light, 113. *See also* Frank, Waldo
Seligmann, Herbert J., 60, 149, 150, 316
 influenced by Rosenfeld, 69
 on musicality of O'Keeffe's art, 326 n. 71
 1923 essay (modern art), 196–97, 326 n. 71
 1923 essay (O'Keeffe), 63, 66–67, 69, 195–96
"Seven Alive" (Anderson), 90, 221–22
"Seven Americans." *See* "Alfred Stieglitz
 Presents Seven Americans: 159
 Paintings, Photographs & Things,
 Recent & Never Before Publicly
 Shown, by Arthur G. Dove,
 Marsden Hartley, John Marin, Char-
 les Demuth, Paul Strand, Georgia
 O'Keeffe, Alfred Stieglitz"
Sexuality in O'Keeffe's art, critics on. *See*
 O'Keeffe, Georgia, her art, critics on
 sexuality in
Sheeler, Charles, 80–81
Smith, Pamela Colman, 6, 322 n. 23
Société Anonyme, 338–39 n. 1
"Some Women Artists in Modern Paint-
 ing." See *Adventures in the Arts,* es-
 says in
Spencer, Herbert, 12–13, 14, 15
 on women and men, differences be-
 tween, 14–15
Steichen, Eduard J.
 and Stieglitz, association, 327–28 n. 2
 on Stieglitz and 291, 327–28 n. 2
Stettheimer, Ettie, 343 n. 29
Stieglitz, Alfred
 on art
 American, 20
 modern, 22
 role of the intellect in creation of, 33
 science in, 327 n. 87
 the unconscious in, 12, 16, 20
 art, attitude toward
 American, 5, 153
 commercialism in, 328 n. 3
 Eastern, 329 n. 15
 the unconscious in, 9, 10, 12, 33, 80
 Arthur B. Carles, remark to about exhib-
 iting O'Keeffe's art, 323 n. 31
 discussed by
 anonymous critic, 21–22
 Cary, 76
 Cheney, 109
 Cortissoz, 95
 Frank, 335 n. 3
 Luhan, 101–2
 McBride, 41, 43, 336 n. 6
 O'Keeffe, 55, 76, 108, 320 n. 10, 321 n.
 14, 335–36 n. 5
 Read, 78, 79
 Rosenfeld, 44
 Watson, 77
 exhibitions sponsored by, effect of ideas
 on critical and public reaction to, 5,
 17, 22, 43–44
 on Hartley, 96, 336–37 n. 12
 on Hartley's art, critical reaction to, 344
 n. 36
 health, 149
 his art
 discussed by critics, 43, 44, 45, 76, 77,
 79–80, 92, 109
 self-promotion of, 43
 on his art, 45
 Lake George, on problem of visitors
 there, 339 n. 6 (*see also* O'Keeffe,
 Georgia, and Stieglitz, at Lake
 George)
 on McBride
 as critic, 96, 336 n. 9
 his review of "Seven Americans," er-
 ror in, 336 n. 6
 mentioned by
 Breuning, 95
 Cary, 91
 Coates, 156
 Eilshemius, 334 n. 34
 Frank, 115, 117
 Kalonyme, 138
 McBride, 92, 124
 Matthias, 108
 Pemberton, 105
 Pollitzer, 56
 Strand, 85
 Vanity Fair writer, 343 n. 21
 Wilson, 99
 Mumford's response to O'Keeffe's art, at-
 titude toward, 122, 136
 on Mumford's response to O'Keeffe's
 art, 122, 340 n. 14
 New York art community, position in, 1,
 4–5
 O'Keeffe
 as first female American modernist, be-
 lief in, 6
 as newly evolved woman, concept of,
 32, 33, 34, 37, 84, 157
 public image, contribution to, 43–44,
 71, 73, 110, 131, 132, 133, 139, 141,
 143, 144, 158, 159, 160, 161, 330 n.
 24, 343 n. 18
 and O'Keeffe, correspondence, 6, 7, 319
 n. 1, 321 n. 15, 330 n. 18
 on O'Keeffe, 6, 8, 9, 32, 33–34, 56, 126, 144
 as "new" woman, 33

374 Index

O'Keeffe's art
charcoal drawings, attitude toward, 9,
322 n. 24, 322 n. 25
as equal to art of men, 33
as expression of sexual union, concept
of, 50
as expression of woman, 25, 35, 154, 157
importance to American art, belief in,
31, 120, 128, 161
self-portrait quality of, belief in, 334 n.
36
sexuality in, 24, 35, 50, 53, 85, 106, 154,
157, 158
on O'Keeffe's art, 6, 16, 150, 158, 327 n.
87, 340–41 n. 23, 343 n. 24, 344 n. 34,
344 n. 36
charcoal drawings, 6, 7, 8
critical reaction to, 344 n. 36
as different from the art of women, 30,
33–34
as different from the art of men, 35
as equal to art of men, 34, 35
as expression of woman, 6, 7, 8, 23,
33–34, 158
large-format flower paintings, 335–
36 n. 5
musicality of, 18
sexuality in, 23, 158
significance of, 144, 327 n. 87
on Ida O'Keeffe, 334 n. 36
photographic portrait of O'Keeffe, 26, 27,
37, 41, 43–45, 49, 50, 52, 53, 55–56,
57, 71, 73, 110, 131, 132, 133, 139,
143, 159, 160, 161, 330 n. 24, 330–31
n. 27, 343 n. 18
sensation of, 41, 43–44, 330 n. 24
photographs of O'Keeffe
Georgia O'Keeffe: A Portrait, 1918 (NGA
D 1388), 58, *59*
Georgia O'Keeffe: A Portrait, 1918 (NGA
D 1393), 41, *42*
Georgia O'Keeffe: A Portrait, 1918 (NGA
D 1403), 143, *145*
Georgia O'Keeffe: A Portrait, 1918 (NGA
D 1409), 37, *40* .
Georgia O'Keeffe: A Portrait, 1920 (NGA
D 1473), 45, *47*
Georgia O'Keeffe: A Portrait, 1922 (NGA
D 1504), 81, *83*
*Georgia O'Keeffe: A Portrait—After Re-
turn from New Mexico*, 1929 (NGA D
1563), 164, *163*
Georgia O'Keeffe: A Portrait—Head, 1918
(NGA D 1338), 37, 41, *38*
Georgia O'Keeffe: A Portrait—Head, 1918
(NGA D 1348), 37, *39*

Georgia O'Keeffe: A Portrait—Head,
1919? (NGA D 1515), 143, *146*
Georgia O'Keeffe: A Portrait—Head, 1920
(NGA D 1460), 131, 338–39 n. 1, *114*
Georgia O'Keeffe: A Portrait—Head, 1923
(NGA D 1518), 335 n. 38, 341 n. 1, *82*
Georgia O'Keeffe: A Portrait—Head, 1926
(NGA D 1545), 139, 342 n. 10
*Georgia O'Keeffe: A Portrait—Painting
and Sculpture*, 1919 (NGA D 1454),
50, *51*
*Georgia O'Keeffe: A Portrait—Show at
"291,"* 1917 (NGA D 1332), *frontis-
piece*
photographs of the sky, 334 n. 32
portrait, concept of, 330 n. 19
progressivism, 5, 13, 16, 17, 25
promotion of American art, 5, 89
promotion of European art, 5
promotion of modern art, 27, 155, 157
promotion of O'Keeffe's art, 1, 7, 9, 17,
22, 63, 76, 102, 105, 108, 118, 132,
136, 138, 142–43, 144, 147, 148, 155–
56, 158, 161, 162, 343 n. 24
use of Freudian theory in, 23, 24, 25
quoted in print, 22, 144, 157–58
on Rosenfeld essay on American paint-
ing as promotion for his group of
artists, 60
"Seven Americans"
critical reaction to, attitude toward,
100, 336, n. 7
on critical reaction to, 96
on his illness during, 336 n. 7
theories about O'Keeffe, influence of, 17,
22, 24–25, 50, 53, 87, 105, 120, 136,
157
on 291, 23, 322 n. 23
woman
ideal, concept of, 30
"new," concept, 32, 33, 34, 37, 84, 157
women
conception of, 28, 29, 30
evolution of, attitude toward, 32
on women, 28, 29, 30, 126, 339 n. 12
ascendancy of, 339 n. 12
creative source in, 33, 36
women and men, creative process in, at-
titude toward, 20, 36
on women and men
differences between, 339 n. 12
differences between art of, 32, 33
differences between creative process
in, 32, 33
women artists, attitude toward, 6, 16
on women artists, 32, 33

women's art, as equal to men's, 32
on women's art, as equal to men's, 16–17
WWI, reaction to, 27
writings
 1907 editorial (Pamela Colman
 Smith's work), 322 n. 23
 1915 poem ("One Hour's Sleep Three
 Dreams"), 28–30, 36, 37, 328 n. 4
 1916 review (O'Keeffe-Duncan-Laf-
 ferty show), 17, 23, 166–67, 325, n.
 64
 1918 poems ("Portrait—1918"), 35–36,
 86, 328 n. 4, 330, n. 17
 1919 essay ("Woman in Art"), 16, 17,
 18, 32–35, 46, 84, 86, 126, 136, 325 n.
 62, 327 n. 87, 329 n. 12
 1921 catalogue statement, 43
 1924 catalogue statement, 327 n. 87
 1925 catalogue statement, 89, 224
 1928 letter to the editor (sale of
 O'Keeffe's paintings), 142–43, 285
Stieglitz [Davidson], Elizabeth, 8
Strand, Paul, 8, 9, 56, 63, 95, 100, 120, 316
 influenced by Stieglitz, 84
 influence on O'Keeffe, 332 n. 10
 1921 essay (Stieglitz), 44
 1923 letter to Tyrrell (O'Keeffe show), 70,
 71–72, 81, 193–94
 1924 essay (O'Keeffe), 84–85, 86–87, 216–
 20
 and O'Keeffe, friendship, 63
 O'Keeffe as newly evolved woman, 86
 on O'Keeffe as newly evolved woman, 84
 on O'Keeffe's art
 color in, 85
 as different from or superior to art of
 other women, 84, 85
 as equal to art of men, 85
 as expression of newly evolved
 woman, 84
 as expression of woman, 71–72, 84
 as superior to art of men, 85
 and Willard Huntington Wright's, 86–87
 Rosenfeld on D. H. Lawrence, quotation
 of, 84
 Stieglitz's photography, attitude toward, 44
 on women, evolution of, 84, 85
Strand, Rebecca, 125, 149, 336–37 n. 12, 339
 n. 6, 339 n. 12
Subject matter in O'Keeffe's art. *See*
 O'Keeffe, Georgia, her art, subject
 matter of

Teachers College, Columbia University, 3,
 6, 34, 60, 319–20 n. 1

"The Third Exhibition of Photography by
 Alfred Stieglitz [Songs of the Sky—
 Secrets of the Skies as Revealed by
 My Camera & Other Prints]," 334 n.
 32. *See also* Exhibitions, Stieglitz, 1924
"Through the Eyes of a European Sculptor"
 (Rönnebeck), 90. *See also*
 Rönnebeck, Arnold, 1925 catalogue
 essay
Time (magazine), criticism in
 1928 review (O'Keeffe show), 139, 283–84
Time Exposures (Frank), 21, 113, 338–39 n. 1
 essays in (*see also* Frank, Waldo, essays
 in *Time Exposures*)
 "White Paint and Good Order," 113
Toomer, Jean, 20, 85
Tri-National Exhibition ("Exhibition of Tri-
 National Art—French, British, &
 American"; 1926), 106
291 (gallery), *frontispiece*, 4, 5, 6, 7, 9, 10,
 16, 17, 20, 23, 27, 28, 31, 35, 41, 45,
 70, 79, 89, 95, 96, 102, 108, 109, 138,
 142, 321 n. 19, 321–22 n. 20, 322 n.
 23, 325, n. 65, 327–28 n. 2, 328 n. 3,
 329 n. 15, 330 n. 17, 336–37 n. 12, 339
 n. 9
291 (periodical), 5, 28, 328 n. 3, 328 n. 4
Tyrrell, Henry, 63, 81, 316
 Freudian theory, use of, 25
 influenced by Stieglitz, 22, 24-25, 87
 1916 review (O'Keeffe-Duncan-Lafferty
 show), 17, 18–19, 20, 22, 23, 80, 87,
 165–66
 1917 review (O'Keeffe show), 17, 22, 24–
 25, 167–68
 1923 commentary and review (O'Keeffe
 show), 22, 71, 189–91, 193–94
 on sexuality in O'Keeffe's art, 25
 Stieglitz on modern art, quotation of, 22
 on *291*, 17
 women and men, creative process in, at-
 titude toward, 19, 23

The unconscious in art, 9, 10, 11, 12, 16, 19,
 20, 21, 22, 23, 33, 79, 80
University of Virginia, 34, 60, 61

Valentine Dudensing Gallery, 120
Vanity Fair, criticism in
 1922 article (featuring O'Keeffe), 58, 175
 1924 article (featuring O'Keeffe), 221, 335
 n. 38
 1928 article (featuring O'Keeffe), 293–94,
 343 n. 21

Vogt, Carl
Lectures on Man (1864), 13
on women and men, differences be-
tween, 13

Walkowitz, Abraham, 9
on O'Keeffe's art and 291, 31
Wasserstrom, William, on organicism, 21
Watson, Forbes, 317
1924 review (O'Keeffe and Stieglitz
shows), 76, 77, 79, 202–3
1925 review ("Seven Americans"), 98–99,
104, 123, 141, 235–36
"A Way to Look at Things" (Dove), 91, 222
Weber, Max, 5
"What is 291" (*Camera Work*, no. 47), 325 n.
63, 327–28 n. 2, 337 n. 17
"White Paint and Good Order" (Frank). *See
Time Exposures*, essay in
Wilson, Edmund, 21, 317
1925 review ("Seven Americans"), 99–
100, 227–29
Woman. *See also* Women and men
as artist, 6, 8, 15, 16, 17, 19, 25, 27, 32,
33, 34, 49, 62, 66, 72, 76, 84, 100, 102,
108–9, 142, 147
art of, 9, 15, 16, 17, 19, 20, 33, 34, 49, 79,
80, 81, 87, 99, 100, 147, 326 n. 72, 331
n. 39
history of, 124, 137
traditional concerns of, 19, 147
ascendancy of, 120, 144, 339 n. 12
creative powers of, 13, 14, 16, 32, 33, 36,
67
described as
creative force, 14–16, 36
Eve, 30
femme fatale, 30, 57, 110, 136
flower, 19

goddess, 57
Life–Giver, 58
sphinx, 45
tree, 19
virgin, 30, 57
evolution of, 32, 84, 85, 86
notions about nature of, 6, 13, 14, 15–16,
19, 22, 25, 27, 28, 30, 32, 33, 34, 35,
36, 46, 52, 57, 58, 66, 67, 80, 81, 84,
85, 86, 87, 100, 104, 109, 110, 118,
120, 125, 138, 140, 147, 154, 157, 158,
160, 161, 337 n. 17, 339 n. 12
superiority of, 14, 16
"Woman in Art" (Stieglitz), 16, 17, 18, 32,
34, 35, 47, 84, 126, 136, 325 n. 62, 327
n. 87, 329 n. 12. *See also* Stieglitz, Al-
fred, writings, 1919 essay
Womb
power of, 329 n. 13
as source of creativity in women, 33, 36,
46
Women and men
art of
differences between, 15, 19, 33, 79, 80,
81, 87, 99, 100
equality of, 16, 25, 32, 35, 33, 85, 85, 87
notions about nature of, 13, 15, 19, 32,
33, 46, 48–49, 80–81, 87, 100
creative powers of, 11–16, 19, 21, 23, 36,
140–41
differences between, 13, 19, 87, 100
differences between, 13, 14, 15, 16, 30,
66, 160, 339 n. 12
"Women and the World of Art" (Bye), 15–
16
Wright, Willard Huntington, 86–87

Yurka, Blanche, 106, 107, 338 n. 31